THE MAKING OF MASTERPIECES

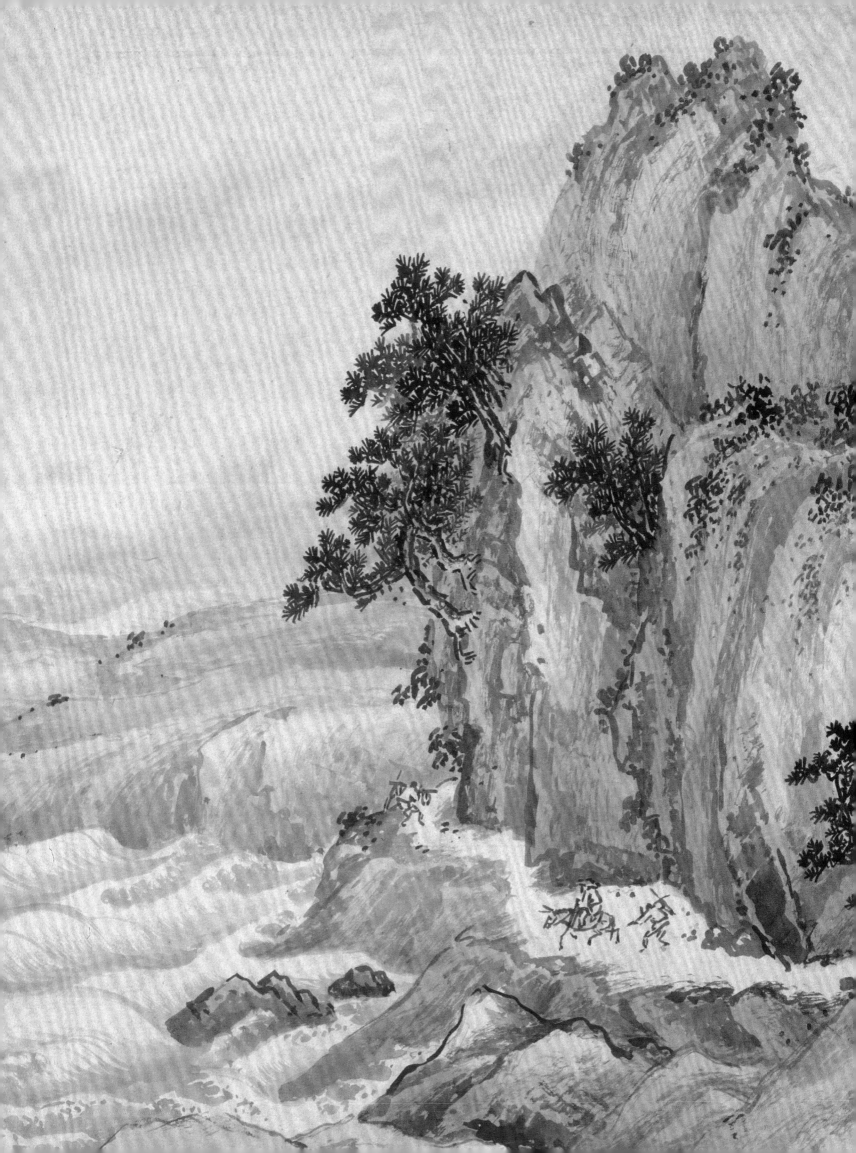

The Making of Masterpieces
Chinese Painting and Calligraphy from the Palace Museum

Edited by David Ake Sensabaugh, Raphael Wong, and Jiang Fangting

With essays by Lou Wei, Roderick Whitfield, Robert E. Harrist, Jr., Wang Yimin, David Ake Sensabaugh, Yu Wentao, Jiang Fangting, and Raphael Wong, and entries by curatorial staff from the Hong Kong Palace Museum and the Palace Museum

HONG KONG PALACE MUSEUM | PALACE MUSEUM

The Making of Masterpieces: Chinese Painting and Calligraphy from the Palace Museum accompanies the exhibition of the same name jointly organised by the Hong Kong Palace Museum and the Palace Museum (3 July–7 October, 2022).

www.hkpm.org.hk
First edition, 2022

ISBN: 978-962-07-0614-1

Published by the Hong Kong Palace Museum and the Palace Museum.

Content editor: David Ake Sensabaugh
Lead editors: Raphael Wong, Jiang Fangting
Copyeditors: Tom Fredrickson, Benjamin Chiesa, Domenica Wong, Pearl Lam, Michelle Siu
Proofreader: Annie Knibb
Digital asset management: Edward Zhou
Design: Binocular, New York

Published in Hong Kong, China. Printed in Guangdong, China.
Publisher for editing, printing, and distribution: The Commercial Press (Hong Kong) Ltd.

Cover image: Detail of *Watering Horses in Autumn* (cat. 22)
Frontispiece: Detail of *Ten Thousand Li of Rivers and Mountains* (cat. 15)
Part dividers: Detail of *Water* (cat. 14)

This publication was made possible by the generous support of its Lead Sponsor, the Bei Shan Tang Foundation.

Contents

Director's Foreword
Palace Museum

The opening of the Hong Kong Palace Museum coincides with the twenty-fifth anniversary of the establishment of the Hong Kong Special Administrative Region. To celebrate this historic moment, the Palace Museum is presenting treasures from its collection in a series of exhibitions at this new museum. An indisputable highlight is "The Making of Masterpieces: Chinese Painting and Calligraphy from the Palace Museum". This is the second time works of painting and calligraphy from the Palace Museum's collection dating from before the Yuan dynasty have been exhibited in Hong Kong, the first being "The Pride of China: Masterpieces of Chinese Painting and Calligraphy of the Jin, Tang, Song, and Yuan Dynasties from the Palace Museum", held to mark the tenth anniversary of the city's return to the Motherland in 2007.

The Jin, Tang, Song, and Yuan dynasties were the golden age of Chinese calligraphy and painting. The practical aesthetics of script and imagery that originated in ancient times gradually evolved into the fully fledged art forms of calligraphy and painting during the Eastern Jin dynasty, which saw the emergence of ground-breaking masters such as Wang Xizhi and Gu Kaizhi. In the Tang and Song dynasties, these arts became more diverse, with painting embracing a wider range of subjects and calligraphy becoming ever more expressive. Generation after generation, accomplished masters created works that continue to fascinate us to this day. During the Yuan dynasty, the extensive participation of the literati in calligraphy and painting elevated their cultural status to new heights. The aesthetic evaluation of these two art forms became increasingly interwoven, while the integration of poetry, prose, and painting gave rise to a unique artistic tradition. This combination of poetry, calligraphy, and painting formed a new Chinese aesthetic that has left a lasting imprint on the cultural developments that have followed. The works selected for this exhibition are timeless pieces that span a millennium, from the Eastern Jin dynasty to Yuan dynasty. Celebrated in their own time as well as in the centuries that followed, they embody the essence of traditional Chinese culture.

We would not be able to appreciate these masterpieces today were it not for the rigorous conservation and research efforts of generations of connoisseurs. The inscriptions and seals by renowned collectors have become part of these works of art. This unique way of handling and showing appreciation for artworks allows us to trace the collection's past, as well as the vicissitudes of history. Most of the

works in this exhibition are from the Qing imperial collection, some of which were dispersed and damaged during wars in the late Qing dynasty and Republican era and recovered through the efforts of the People's Republic of China. Through this chaotic time, Hong Kong played a significant role in the preservation and repatriation of lost cultural relics. Many precious works of Chinese calligraphy and painting were returned to the Palace Museum under the leadership and coordination of the Central Government as well as through the continuous effort of patriots in Hong Kong. *Viewing the Tidal Bore on the Qiantang River* by Li Song (cat. 17) is one such example, having been returned to the Palace Museum via Hong Kong in the 1950s. These masterpieces, therefore, represent not just the leisure pursuits of emperors and the literati but also the Chinese people's deep familial ties to their nation and its history.

Hong Kong, while separated from the Motherland for a hundred years, has never lost touch with its roots in Chinese culture. Since the city's return to China, the Palace Museum has frequently collaborated with cultural institutions there. The resulting exhibitions have become more innovative and the academic exchanges more thorough, especially under the guidance of "Xi Jinping Thought on Socialism with Chinese Characteristics for a New Era". "The Making of Masterpieces" and its accompanying publication are the fruits of our partnership with the Hong Kong Palace Museum. Thanks to the concerted effort of all parties, we have overcome obstacles introduced by the pandemic and offered the public a high-quality exhibition and research. This not only promotes Chinese art and culture but also strengthens the cultural cohesion and national pride of Hong Kong and the Mainland.

I wish the exhibition and academic exchange programmes every success!

Wang Xudong
Director
Palace Museum

Director's Foreword
Hong Kong Palace Museum

Chinese painting and calligraphy have a special significance in Hong Kong. Since the mid-twentieth century, collectors, connoisseurs, and museums here have made major contributions to the preservation and study of some of the most important examples of these works. Hong Kong is also home to several major collections of Chinese painting and calligraphy, as well as many renowned scholars who specialise in these fields. In 2007, I had the pleasure of leading the planning of the major exhibition "The Pride of China: Masterpieces of Chinese Painting and Calligraphy of the Jin, Tang, Song, and Yuan Dynasties from the Palace Museum" at the Hong Kong Museum of Art. Commemorating the tenth anniversary of the establishment of the Hong Kong Special Administrative Region (SAR), the exhibition welcomed tens of thousands of enthusiastic visitors — testifying to the high level of interest in Chinese painting and calligraphy in the city.

On the occasion of the grand opening of the Hong Kong Palace Museum in July 2022, and the twenty-fifth anniversary of the establishment of the Hong Kong SAR, I am delighted to see another major exhibition come to fruition. "The Making of Masterpieces: Chinese Painting and Calligraphy from the Palace Museum" features thirty masterpieces of early painting and calligraphy which, together with over nine hundred other works travelling from the Forbidden City, represent one of the largest and most notable loans from the Palace Museum to a cultural institution.

The exhibition is accompanied by this important catalogue of the same name. Jointly published by the Hong Kong Palace Museum and the Palace Museum, it is the first English-language scholarly publication to provide an in-depth exploration of these crown jewels of the Palace Museum's painting and calligraphy collection. Many of the works illustrated have never been published in their entirety, and the volume breaks new ground by looking at how they were produced and circulated: essentially, how they came to be masterpieces on their centuries-long journeys through different collections. Notably, it provides full documentation of the seals and inscriptions on each work — an invaluable resource for studying their production and transmission histories. And by presenting readers around the world with a rare opportunity to gain new insights into the Palace Museum's spectacular treasures, it ties in perfectly with the Museum's mission of promoting the global understanding of Chinese art.

The essays and entries in the book have been written by an impressive team of international scholars. Lead editors and co-curators of the exhibition Raphael Wong and Jiang Fangting have worked closely with distinguished colleagues from the Palace Museum, including Lou Wei, Deputy Director; Zeng Jun, Head of the Painting and Calligraphy Department; and Wang Yimin, Curator, to select and study these spectacular works. Raphael Wong in collaboration with the team has steered the concept and content development for this exhibition and this publication since the early stage of this project. David Ake Sensabaugh and Wang Yimin played a key role in the content editing of the English and Chinese editions, respectively. Other esteemed contributors include Roderick Whitfield, Robert E. Harrist, Jr., and Yu Wentao, as well as curatorial staff from both museums, who have written insightful entries. Together, this team of authors offers fresh and dynamic research that presents these iconic works in a new light. The publication has also benefitted from the invaluable expertise of leading scholars such as Szeto Yuen Kit and Harold Mok. I am also pleased to see the two institutions and the Forbidden City Publishing House partnering together to publish a Chinese-language edition of the catalogue.

I would like to express our gratitude to the Palace Museum team, led by Wang Xudong, for their exceptional support of the historic exhibition and this landmark volume. Our thanks also go to the Bei Shan Tang Foundation for sponsoring the publication, which we hope will play a formative role in encouraging global interest in the Palace Museum's collection of Chinese painting and calligraphy. I have no doubt that it will remain a key reference work for lovers of Chinese art for decades.

Louis Ng
Director
Hong Kong Palace Museum

Preface

The year 2022 marks the opening of the Hong Kong Palace Museum. To celebrate this landmark event, the Museum and the Palace Museum have jointly organised the special exhibition "The Making of Masterpieces: Chinese Painting and Calligraphy from the Palace Museum", featuring generous loans from the Palace Museum.

The Hong Kong Palace Museum is an inclusive museum. The curatorial team feels a deep responsibility for making masterpieces of Chinese art accessible to people from all walks of life. To that end, one simple question anchors this exhibition: how do works become "masterpieces"? The exhibition as well as the English and Chinese catalogues answer this question through art historical, cultural, and historical approaches. In their development, it became clear to us that the question was more important, but also far more complicated, than first appears.

We are deeply honoured to be joined by five distinguished scholars to explore this question in this volume. Lou Wei introduces in "Clouds and Mist without End: A Brief History of the Palace Museum Collection of Painting and Calligraphy" lesser known aspects of the inventory system of the Palace Museum collection. He explains how the collection transformed from a private collection built to accommodate the personal interests of emperors into an open and inclusive collection that strives to be comprehensive, educational, and adaptive.

In "Transformative Landscapes", Roderick Whitfield guides the reader through the paintings on view in the exhibition and in the Palace Museum collection through his eyes. He analyses how masterpieces reinterpret earlier models, and how landscapes became central themes in Chinese painting, through a study of the relationship between landscapes and figures. He also discusses the dating and originality of works.

Robert E. Harrist, Jr. focuses on calligraphy in his essay "Special Delivery: Letters from Wang Xizhi and Xie An, Copies, and Colophons". He traces the evolution of letters and paper slips into the canon of calligraphic masterpieces through processes of reproduction. He also explains how various types of calligraphy formats promoted the work of specific artists.

In his essay "Wang Xizhi's *Orchid Pavilion Preface*: Its Historical Position and Fabricated Attributions among Copies and Rubbings", Wang Yimin highlights the role of reproduction in the making of masterpieces. He also emphasises the impact fabricated attributions had on the perceived value of later copies.

Yu Wentao's essay "The Red Cliff in the Song–Jin Period" addresses how literary masterpieces inspired pictorial representations, and illustrates the compositional and representational evolution of Red Cliff paintings. His essay provides an exemplar for the study of the two copies of *Nymph of the Luo River* on display, which were based on another literary masterpiece composed by Cao Zhi in the Three Kingdoms period.

In "The Role of Colophons and Inscriptions in the Unfolding of *Wenrenhua* during the Yuan Dynasty", David Ake Sensabaugh focuses on inscriptions and colophons — a distinctive feature of Chinese paintings. He explains how these elements defined and shaped the genre of *wenrenhua*, or "literati painting", from the Yuan dynasty onwards, and how they contributed to the status of paintings as masterpieces.

Jiang Fangting's essay "Art Collecting in the Ming Dynasty: A Case Study of *Returning Boats on a Snowy River*" traces the transmission history of the only extant landscape painting by Emperor Huizong of the Song dynasty. Her essay provides an example of how connoisseurship in the Ming and Qing dynasties affected the status of works.

After a lively journey through different dynasties, we return to the starting point of the Palace Museum collection with Raphael Wong's essay, "Unsung Heroes: The Hong Kong Acquisition Team". This text explores the activities of the Hong Kong Acquisition Team and its contributions to the formation of the Palace Museum's painting and calligraphy collection in the early years of the People's Republic of China, and emphasises the symbiotic relationship between people, institutions, and art.

Following the essays are thirty entries in which contributors from the Hong Kong Palace Museum and Palace Museum explain the canonisation of each work in terms of its artistic content and transmission history. The catalogue closes with transcriptions of the inscriptions, colophons, and seals on the thirty works, which have never before been published in full. These transcriptions are a cornerstone of painting and calligraphy research, and will provide a valuable point of reference to scholars.

From pictures and colophons to object biographies and the way we conceptualise a museum collection, the essays and entries in this work bring together the concept of "the making of masterpieces" — a dynamic process that involves a plethora of actors. We hope that they serve as a fresh impetus for the study of the Palace Museum's historic collection.

It is noteworthy that the Palace Museum and the Hong Kong Palace Museum co-published the Chinese-language edition of this catalogue, *Guo zhi guibao: Gugong Bowuyuan cang Jin Tang Song Yuan shuhua* (Gugong Chubanshe 2022). The Chinese and English editions form the inaugural publications of the Hong Kong Palace Museum, which is committed to advancing the understanding of Chinese art and culture both at home and abroad.

Editorial Team

Acknowledgements

We are immensely grateful for the guidance of Wang Xudong, Director of the Palace Museum; and Lou Wei and Ren Wanping, Deputy Directors. Many colleagues from the Palace Museum have generously facilitated research and loans. We thank Li Shaoyi, Dong Dan, and Guo Zili for their indispensable role in coordinating the exhibition, as well as Zeng Jun, Li Yongxing, and Xu Kai for their hard work to coordinate the loans. Wang Yimin made significant contributions to the exhibition and publication. Other colleagues who contributed to exhibition planning and research include Mao Xiangyu, Li Tianyin, Lu Ying, Wang Zhe, Huang Aimin, Zhao Bingwen, Zeng Jun, Hao Yanfeng, Lou Wei, Li Shi, Hua Ning, Nie Hui, Wang Qi, Tian Yimin, Ma Shunping, Wang Zhongxu, Yu Wentao, Shi Hanmu, Zhao Ziru, Jiang Tong, and Qin Chongtai. We recognise the outstanding conservation work performed by Yang Zehua and Wang Lu, as well as Sun Miao's spectacular exhibition design work, Sun Zhiyuan's stunning photography, and Sun Jing's work to ensure smooth and timely image delivery.

This publication is the fruition of stellar contributions from all authors. David Ake Sensabaugh, Raphael Wong, and Jiang Fangting led the editorial work on the manuscript. At the Hong Kong Palace Museum, the publication has been expertly guided by Louis Ng, Director of the Hong Kong Palace Museum; Daisy Yiyou Wang, Deputy Director; and Tianlong Jiao, Head Curator. The curatorial team includes Raphael Wong, Jiang Fangting, Li An Tan, Yau Sum Yin, Lung Tak Chun, Phoebe Yiu Yin, and Jay Lee. In particular, we thank Li An Tan, Yau Sum Yin, Phoebe Yiu Yin, and Raphael Wong for compiling the bibliography, and Sharon Chu, Caveny Chiu, Raphael Wong, and David Ake Sensabaugh for compiling the index. We are appreciative of Wang Yimin and Jiang Fangting's expertise in proofreading the Chinese transcription at the final stage. Lung Tak Chun, Li An Tan, and Raphael Wong contributed significantly to the Chinese transcription review. We also thank Benjamin Chiesa, Domenica Wong, Pearl Lam, and Michelle Siu for the excellent copy editing work. Ingrid Yeung played a significant role in publishing management, and Yang Xu took the lead in condition checking loans in Beijing. Lin Miaomiao, Stephanie Cheng, Cara Tsui, and Zenia Choy provided critical expertise in exhibition planning and management. Exhibition design, fabrication, and multimedia projects were managed by Maggie Cheng, Lavinia Wong, Sonjia Yu, and Chao Chan. The conservation expertise of

Zhichao Lyu, Jessie Liang, and Emma Lau ensured the safety of artworks. Pik Ki Leung, Stella Lau, Mandy Chung, and Wing Hang Cheung contributed to exhibition interpretation and educational programming.

We would like to thank Szeto Yuen Kit and Winnie Kwan for their advice on research, publications, and exhibition design. Our appreciation also goes to Dong Baohou, Philip Fan, Ling Lizhong, Kingsley Liu, and Xing Jin who facilitated image requests and provided expert advice, as well as Grace Tao, who provided calligraphy for the exhibition graphics.

We extend our heartfelt gratitude to the publication's Lead Sponsor the Bei Shan Tang Foundation for making this ambitious project possible.

Editorial Team

Note to the Reader

Chinese transliterations follow the pinyin system of romanisation — excluding commonly used place names such as Macao (pinyin: Aomen). All foreign terms are italicised unless commonly used in English.

Dimensions exclude mounts or frames. Unless otherwise noted, all images are provided courtesy of the Palace Museum.

NAMES AND TITLES

Chinese names are given in the traditional order, surname first, except for scholars and authors who have adopted the Western order of surname last.

Beginning in the Ming dynasty, Chinese emperors were usually referred to by their reign titles rather than their given names. Accordingly, the form "the Qianlong Emperor" is followed rather than "Emperor Qianlong" because Qianlong is the reign title. For empresses, their simplified posthumous names are used. Cixi and Ci'an are exceptions as their simplified honorific names are better known.

DATES

Many of the people discussed in this book have been identified in historical records. Where available, their lifespans or approximate dates of activity are included in parentheses. Figures about whom less is known are discussed more generally in the context of the centuries in which they are thought to have been active.

Reign dates begin from the year when the reign title was changed, not when the emperor ascended the throne.

TRANSLATED TEXTS

The entries for cats. 3–6, 9, 11–14, 17, 20, 22, 24, 26–27, 30, and essays by Lou Wei, Wang Yimin, Yu Wentao, and Jiang Fangting, have been translated into English from Chinese. Some have also been abridged; please refer to the Chinese volume for the full version.

INSCRIPTIONS AND SEALS

Squares are used to indicate illegible characters in inscriptions and seals. Blurry characters are shown in blue.

Timeline of Chinese Dynasties

Xia dynasty (unconfirmed)	ca. 2100–1600 BCE
Shang dynasty	ca. 1600–1100 BCE
Zhou dynasty	ca. 1100–256 BCE
Western Zhou ca. 1100–771 BCE	
Eastern Zhou 770–256 BCE	
Spring and Autumn Period 770–476 BCE	
Warring States Period 475–221 BCE	
Qin dynasty	221–207 BCE
Han dynasty	206 BCE–220 CE
Western Han 206 BCE–8 CE	
Eastern Han 25–220	
Six Dynasties	220–589
Three Kingdoms 220–265	
Jin dynasty 265–420	
Western Jin dynasty 265–316	
Eastern Jin dynasty 317–420	
Period of Northern and Southern Dynasties 420–589	
Sui dynasty	581–618
Tang dynasty	618–907
Five Dynasties and Ten Kingdoms	907–960
Liao dynasty	907–1125
Song dynasty	960–1279
Northern Song 960–1127	
Southern Song 1127–1279	
Jin dynasty	1115–1234
Yuan dynasty	1271–1368
Ming dynasty	1368–1644
Qing dynasty	1644–1911

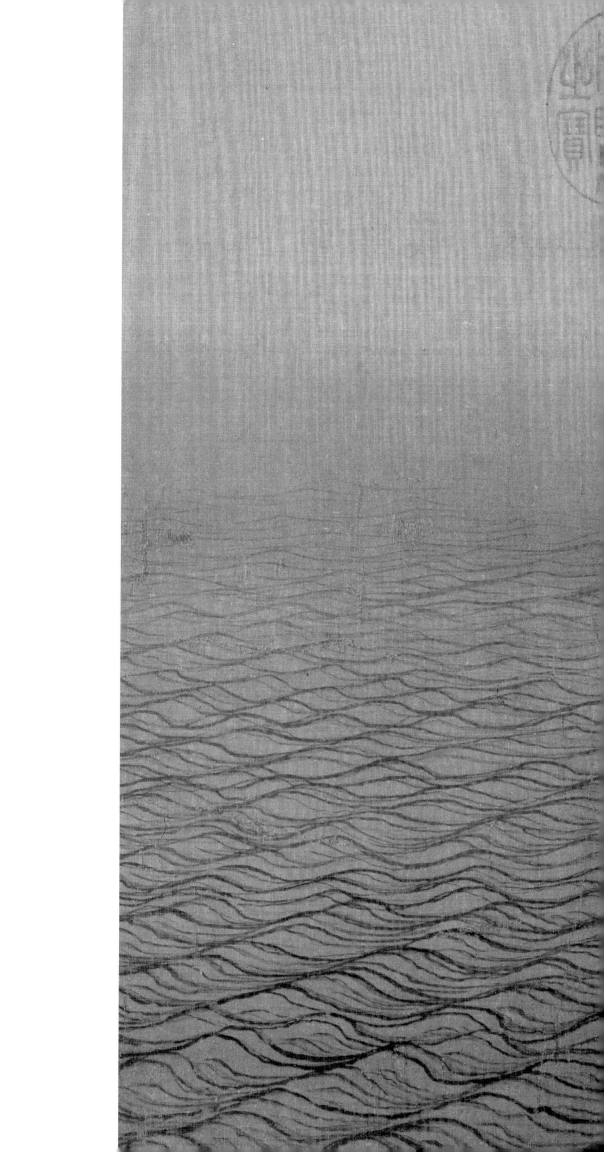

PART ONE | ESSAYS

郭河丙沛巳葛耕小詫渾筆絜

依恩汙揺寅老高第卅一灌地懷
大嘗示窖巷乃末妾史耸

遐亮嘗子仲國安亨百姓華徐
陰陽和車風雨时苦荒示岂崇煌
未妃毛裒凱朱吳坙蓝連博士
克生長乐嘗極老凌丁

大德三年三月十日爲理仲雍壽于
大都慶壽寺僧房巳西鄧文原

Lou Wei

Clouds and Mist without End
A Brief History of the Palace Museum Collection of Painting and Calligraphy

ON 10 MAY 1941, THE RENOWNED FRENCH HISTORIAN MARC BLOCH (1886–1944) noted that his book *The Historian's Craft* was "a simple anecdote by which, amid sorrows and anxieties both personal and collective, I seek a little peace of mind."[1] Meanwhile, a group of precious loans from the Palace Museum were on view at an exhibition in Leningrad, the former Soviet Union, including fifty paintings and textiles from the Tang to the Qing dynasties, forty archaic jades, and ten ancient bronzes. Forty-three days later, war broke out between the Soviet Union and Germany, forcing this exhibition to close.[2] Having been moved from Beijing to Sichuan and Guizhou provinces to protect them from the Japanese invasion of 1937, these works had to be relocated again, this time from Leningrad to Sverdlovsk Oblast, to evade the German assault.

Three years later, on 16 June 1944, the anti-fascist Bloch was executed by German forces. Around this time, the Palace Museum loans mentioned above had been returned to China and were placed in their temporary storage in Sichuan province. In the autumn of that year, Ma Heng (1881–1955), director of the Palace Museum and a renowned scholar of epigraphic studies, was stirred by the years-long dislocation of the Museum's collection to write a couplet: "Guarding many objects of the Palace Museum, I have become a noble exile on Mount Emei" (fig. 1). Like Bloch, Ma sought consolation in writing. The two scholars, in these darkest moments, did not despair. They were willing to sacrifice their lives to safeguard the cultural heritage of humanity and ensure the continuity of civilisations.

In *The Historian's Craft*, Bloch stated that historical narratives and memoirs are "consciously intended to influence others" because they are written with the intent of shaping historical understanding. By contrast, archival documents, private letters, and cultural objects might contain less such intent, as Bloch remarked: "… in the course of its development, historical research has gradually been led to place more and more confidence in the second category."[3] Shortly after the establishment of the Palace Museum in 1925, a scholar noted the value of the Museum in a similar vein, "The culture of an era has its context, which, aside from writing, remains today in the form of cultural objects…. During the Ming and the Qing dynasties, thanks to flourishing maritime activities, Western culture entered China, while Chinese culture remained largely unchanged. These periods can be seen as the crystallisation of the five millennia of Chinese history, and they open an

unprecedented new chapter that would shape China's future. Therefore, the culture [of the Ming and Qing periods] is significant to world history … which is manifested mainly in the Palace Museum and its collection…."[4] Indeed, the over 1.86 million objects in the Palace Museum collection are precious vehicles for the five thousand years of civilisation in China; they are valued not only for their artistic merit but also for their historical, political, material, and literary significance.

QING IMPERIAL COLLECTION AND PALACE MUSEUM COLLECTION

The majority of the Palace Museum's vast holdings came from the collection formed by the Qing imperial court. While the imperial collection was unparalleled in volume and quality in comparison to many other private collections, it had limitations. Often with strong political connotations and cultural symbolism, it was a private collection assembled by the emperors and the imperial families primarily for aesthetic appreciation and didactic purposes, and some objects were gifts. The collection was never intended to be comprehensive, nor was there an attempt to treat each category in the collection with equal attention. By contrast, modern public museums have the mission to collect, preserve, study, and exhibit tangible and intangible cultural heritage. Within their areas of specialisation, modern museums often strive to establish their collections in a comprehensive and systematic manner to facilitate research and exhibition programmes and, ultimately, to serve and educate the public. To build a coherent and well-structured collection is key to a museum's sustainable development.

The Palace Museum's responsibilities go beyond taking care of the former Qing imperial palace and its collection, or bringing back dispersed items formerly in the imperial collection. The positioning of the Museum has shifted from being the "largest museum of historical culture and art in China" in the twentieth century to being "an indispensable window into China's history and culture" in the twenty-first century. The Museum is increasingly recognised for its unique and irreplaceable role in the preservation and exhibition of Chinese history, culture, and art.[5] In order to maintain its vitality the Museum should aim for continuous improvement of its collection. This is demonstrated by one of its collecting criteria: to collect dispersed objects from the former Qing imperial collection, and outstanding art and cultural objects of all categories from the prehistoric era to the present day, especially those with high or relatively high historical, artistic, and scientific values, as well as important materials that can fill gaps in the Palace Museum collection.[6]

Historically, the most prominent categories in the Palace Museum collection were calligraphy, paintings, bronzes, and ceramics. This reflects the traditional antiquarian interest rather than the perspectives of art history or the history of civilisation. The Museum's collection is much broader in scope. For instance, the vast number of high-quality textiles, jades, rare books, sculptures, and decorative

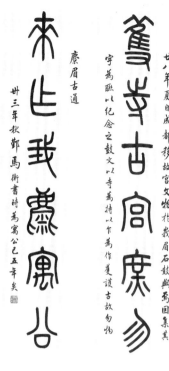

FIGURE 1
Couplet in Stone Drum Script (*Ma Heng zhuanshu ji shiguzi liuyan lian*). Ma Heng (1881–1955). 1944. Hanging scrolls, ink on paper. The Palace Museum.

art objects can present a full picture of the historical development of each of
these categories or art forms. Unquestionably, calligraphy, paintings, bronzes, and
ceramics are important categories in the Palace Museum collection and Chinese art
history in general, and, when placed in a broader context of the Museum's overall
collection and the history of Chinese art, they allow us to gain a better under-
standing of the artistic achievements and highly advanced civilisation of China.
In 1959 the Palace Museum used an art historical framework to create the Gallery
of Art of Successive Dynasties. Many excellent works in the exhibition traced the
origins, development, as well as decline of each art form. For each historical period,
the exhibition aimed to demonstrate the influences among various ethnic groups,
regions, and art categories, and together these elements presented a relatively
comprehensive picture of Chinese art history.

OLD AND NEW

More than 85 percent of the objects in the Palace Museum's vast collection came
from the collection formed by the Qing imperial court. The Palace Museum
collection can be divided into three main groups. The Gu — which stands for "the
former palace" or "old" — group encompasses objects accessioned prior to the 1949
founding of the People's Republic of China, while the Xin — meaning "new" —
group consists of works acquired after 1949.[7] In 2010, after the completion of a
seven-year collection documentation project, the Palace Museum Library's rare
books and manuscripts were formally accessioned under the third group, Shu,

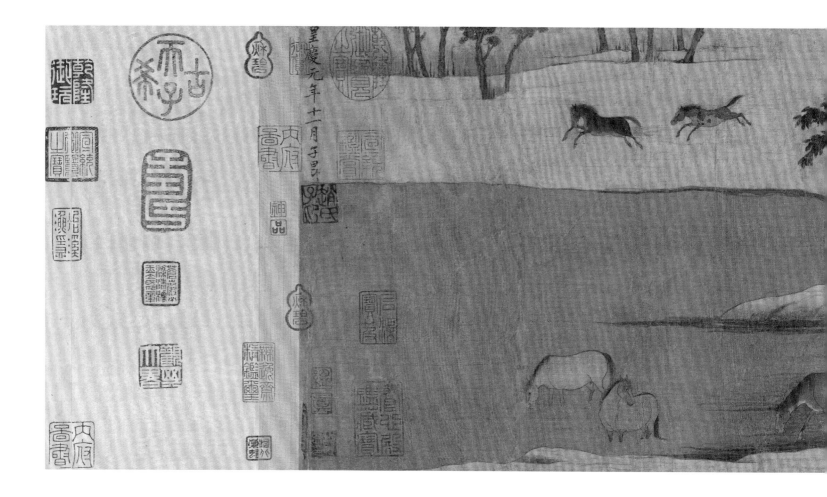

which means "library".[8] Today the Gu group constitutes about 86.3 percent of the Museum's overall collection, and the Xin group approximately 13.7 percent.

The Gu–Xin group ratio above varies a great deal when one looks at specific categories in the collection. The Qing imperial collection included a great number of high-quality functional objects, such as ceramics and textiles, and the quantity of these items in the Gu group is large (fig. 2). The number of Gu group objects collected primarily for aesthetic appreciation at the Qing court, including calligraphy, paintings, and stele ink rubbings, is relatively small. Some items entered the Palace Museum collection under the Xin group after 1949 as government allocations, museum purchases, and gifts.

As of December 2021, out of the 53,459 paintings in total, 15,428 (28.9 percent) are in the Gu group, and 31,808 (59.5 percent) in the Xin group. Out of the 74,277 calligraphic works, 22,280 (30 percent) have Gu inventory numbers and 51,535 (69.4 percent) are from the Xin group. Out of 29,760 stele ink rubbings, 5,881 (19.8 percent) are in the Gu group, with 22,907 (77 percent) in the Xin group. In addition to the Gu and Xin groups, the Palace Museum collection contains a group of objects as study and reference materials.

FIGURE 3
Detail of *Watering Horses in Autumn* (cat. 22) with the seal of the Xuantong Emperor (Puyi). Zhao Mengfu (1254–1322). Yuan dynasty, 1312.

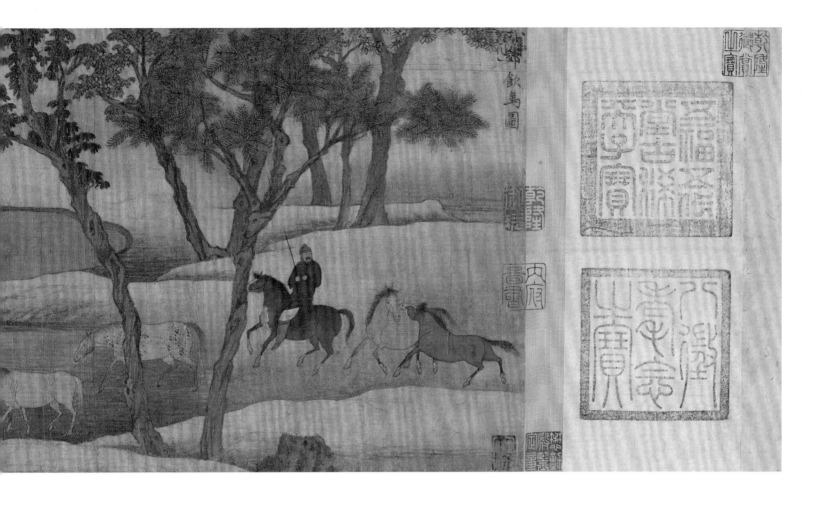

Scholars tend to associate the Gu group with the Qing imperial collection, and view the Xin group as unrelated. The actual situation is more complex. New acquisitions made prior to 1949 included items from both the Qing imperial collection and other sources. Some objects in the Xin group were dispersed from the Qing court collection, and were returned to the Forbidden City after 1949. For example, a number of paintings and calligraphic works were transferred to the Palace Museum in 1946 from the residence of the former Xuantong Emperor Puyi (1906–1967, r. 1909–1911) and his brother Puxiu (1896–1956) in Tianjin, including *Illustration to the Latter Fu-rhapsody on the Red Cliff* (*Hou Chibi fu tu*) by Ma Hezhi (active 12th century), *Hasty Writing in Draft-Cursive Script* by Deng Wenyuan (1259–1328, cat. 25), and *Watering Horses in Autumn* by Zhao Mengfu (1254–1322, fig. 3). That year the Museum also received a donation of bronzes unearthed in Henan province and other places from Werner Jannings (Yang Ningshi, b. 1886), including a well-known vessel of the Warring States period with scenes of feasting, fishing, hunting, and war. In the same year Guo Zhaojun donated a group of ceramics assembled by his father, the renowned collector Guo Baochang (1879–1942). In 1948 the Institute for Exhibiting Antiquities (Guwu chenlie suo) with its

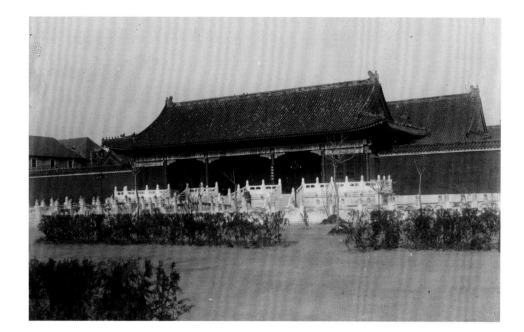

FIGURE 4
The Institute for Exhibiting Antiquities, ca. 1915. The Palace Museum.

collection of 88,202 objects, including over 6,400 calligraphic works and paintings formerly in the Qing imperial collection, was incorporated in the Palace Museum.[9] The Institute was established in 1914 in the Hall of Martial Valour (Wuying dian) by the government under the leadership of Xiong Xiling (1870–1937) and Zhu Qiqian (1872–1964) to provide a better environment to preserve and display objects originally housed in the Qing imperial palace in Shenyang and the imperial garden complex in Chengde (fig. 4).

After 1949, many objects previously in the Qing imperial collection came back to the Forbidden City under the auspices of the Central Committee of the Communist Party and the Central Government. In 1952 the Ministry of Culture issued a call for the restitution of palace items: among antiquities from the Palace Museum discovered during the Three-Antis and Five-Antis campaigns, items that had been confiscated or were in the possession of local governments should be submitted in a timely manner to the Central Government and then allocated to the Palace Museum as a central repository. In the 1950s the government purchased in Hong Kong a few works with prestigious pedigrees, including *Mid-Autumn Manuscript* (*Zhongqiu tie*) attributed to Wang Xianzhi (344–386), *Letter to Boyuan in Running Script* (*Boyuan tie*) by Wang Xun (349–400), *Five Oxen* (*Wuniu tu*) by Han Huang (723–787), *The Xiao and Xiang Rivers* (*Xiaoxiang tu*) by Dong Yuan (d. ca. 962), and *Night Revels of Han Xizai* (*Han Xizai yeyan tu*) by Gu Hongzhong (910–980), which entered the Palace Museum collection (fig. 5). Mao Zedong (1893–1976) set a good example by handing to the government the gifts from his friends, including the calligraphic piece *Ascent to Yangtai Palace* (*Shang Yangtai tie*) by Li Bai (701–762), which were then transferred to the Palace Museum. *Female Immortals in Elysium* (*Langyuan nüxian tu*) by Ruan Gao (active 10th century, cat. 8) was a gift from the

FIGURE 5
Detail of *Five Oxen*. Han Huang (723–787). Tang dynasty, 8th century. Handscroll, ink and colour on paper. The Palace Museum.

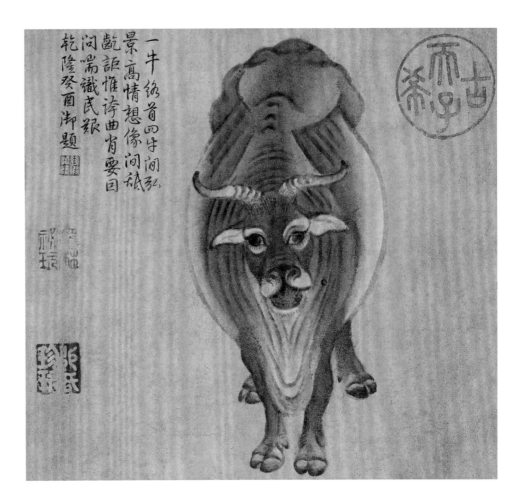

former emperor Puyi to Liu Junye to thank him for helping Puyi build relations with political dignitaries through gifts of art from the Palace collection (fig. 6). This painting became part of the dowry Liu prepared for his daughter, was later donated to the government, and was eventually returned to the Palace Museum. Patriotic collectors made significant donations to the Palace Museum. For example, Zhang Boju (1898–1982) gifted eight calligraphic masterpieces, including *The Letter on Recovery from Illness* (*Pingfu tie*) by Lu Ji (261–303) and *The Poem on Zhang Haohao* (*Zhang Haohao shi*) by Du Mu (803–852), which were transferred to the Palace Museum by the National Administration of Cultural Heritage. In addition, the Palace Museum purchased a number of significant works formerly in the Qing imperial collection, including *Illustrating Ten Poems* (*Shiyong tu*) by Zhang Xian (990–1078), *Ode to the Military Expedition* (*Chushi song*) of the Sui dynasty, and *Poems on Historic Places in the Southern Part of the Capital* (*Nancheng yong gushi tie*) by Nai Xian (b. 1309).

THE COLLECTION OF THE QING IMPERIAL COURT

The collection of the Qing imperial court has three main categories. The first category comprises items collected by the Qing court, such as calligraphic works

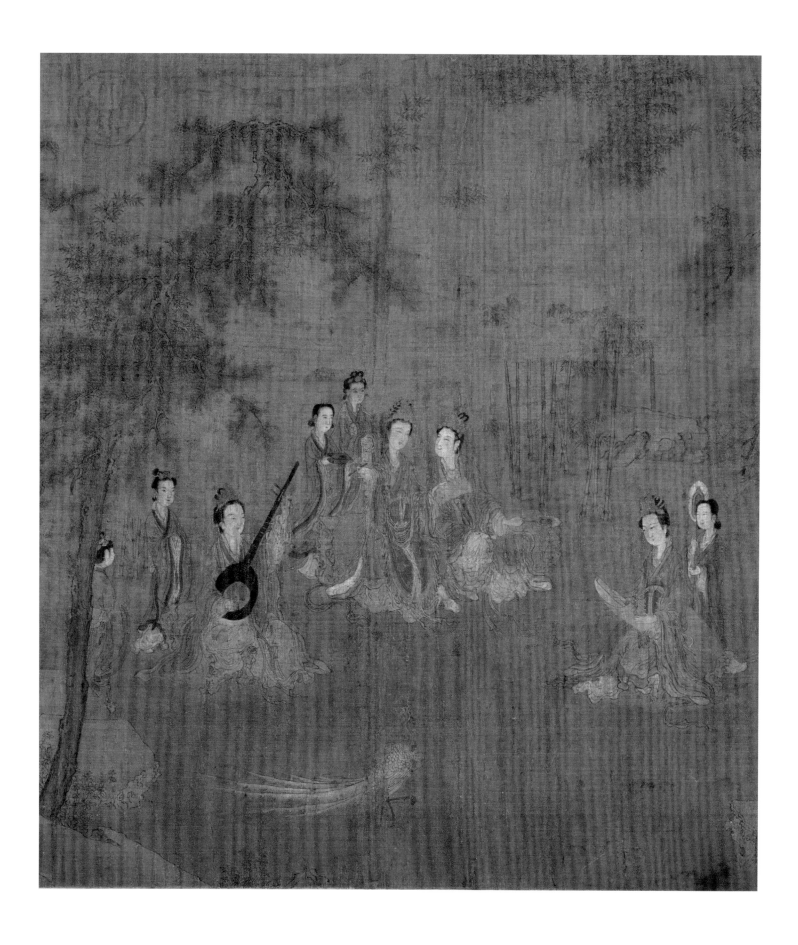

and paintings by pre-Ming masters, rare books and manuscripts of the Song, Yuan, and Ming dynasties; ceramics produced by imperial kilns; archaic jades; and ancient ritual bronzes. The other two categories are artefacts left behind by the Qing court. The second category contains objects that were mainly for interior decoration and valued for their craftsmanship and the use of precious materials. Some of the imperially commissioned objects were created by the Qing Imperial Workshops, regional manufactories, or master artisans. Some were purchases or gifts. The third category consists of objects for daily use, such as printed books and manuscripts, furniture, dining utensils, costume and fabric, and musical instruments. More than 90 percent of the Palace Museum's holdings are considered precious cultural artefacts and even these utilitarian items are far superior in quality to non-court objects of the same period.

Works in the first category were considered superior to those in other categories from the perspective of the imperial family. However, their value needs to be re-examined today through the lenses of art history and cultural history. On the one hand, some prized items in the first category might no longer considered highly significant due to issues of authenticity or misattribution. On the other hand, certain items in the second and third categories might be deemed more important today because of their historical, cultural, aesthetic, and scientific merits, or because they were made by celebrated craftsmen or with a high degree of technical achievement.

THE TRANSMISSION OF IMPERIAL COLLECTIONS

Imperial collections transmitted through successive dynasties are important sources for the Qing imperial collection. This does not necessarily mean the direct handing down of artefacts from one dynasty to another. Many objects moved back and forth between court and non-court collections in their long journeys over the centuries.

The scholar Zhuang Yan (1899–1980) wrote "The imperial court of many dynasties in China assembled rich collections of calligraphy and painting…. The Song emperor Huizong (r. 1101–1125), the Ming Xuande Emperor (r. 1425–1435), and the Kangxi (r. 1662–1722) and Qianlong (r. 1736–1795) emperors of the Qing dynasty were all authoritative connoisseurs…. Therefore, imperial collections were far superior to private ones. Fortunately, the Manchu army conquered Beijing and took over the Forbidden City without employing destructive warfare, and before that the rebel leader Li Zicheng (1606–1645) had also taken the city easily. As a result, the treasures in the [Ming] palace remained largely intact. The Ming palace collection contains many works from the Song and Yuan imperial collections."[10]

After the fall of the Northern Song dynasty, Emperor Huizong's calligraphy and painting collection was largely dispersed. Some works entered the imperial collection of the Jin dynasty, and some ended up in private hands. After relocating the capital to southern China, Emperor Gaozong (r. 1127–1162) gathered talented artists to revive the Imperial Painting Academy while enriching his collection by

FIGURE 7
Treasured Boxes of the Stone Moat.
Qing dynasty, Qianlong period,
1745. Woodblock printed book, ink
on paper. The Palace Museum.

acquiring dispersed works from northern China. The imperial collection of the Yuan dynasty was primarily a combination of works from the imperial collections of the Jin and Southern Song dynasties, and works acquired elsewhere. The Ming imperial collection was built on the Kuizhang ge Collection of the Yuan emperor Wenzong (r. 1328–1332). The Ming Hongwu Emperor (r. 1368–1398) gifted a large number of precious calligraphic works and paintings to his sons in provincial courts. As the Ming prince of the Jin State wrote in the preface in *The Compendium of Ancient Calligraphic Models of the Hall of the Precious and the Wise* (*Baoxian tang ji gufatie*), "My august ancestor, Prince Gong, was fond of calligraphy at a young age. In the early years of the dynasty, the Hongwu Emperor bestowed [on him] a large number of calligraphic works of previous dynasties."[11] A painting by Qian Xuan (ca. 1235–1305) and two other paintings unearthed in Shandong province from the mausoleum of Zhu Tan (1370–1390), the tenth son of the Hongwu Emperor, all bear impressions of a seal of the early Ming court reading "*siyin*", evidence of their imperial pedigree.[12] In the mid- and late Ming dynasty, particularly during the Longqing (1567–1572) and Wanli (1573–1620) periods, rulers gifted precious paintings and calligraphic works from the imperial collection to nobles and ministers in lieu of their monthly salaries, leading to the dispersal of many treasures into private hands.[13] A significant number of works included in the *Treasured Boxes of the Stone Moat* (*Shiqu baoji*), a catalogue of the Qing imperial collection commissioned by the Qianlong Emperor, came from several major early Qing art collectors, such as Liang Qingbiao (1620–1691), Gao Shiqi (1645–1703), and An Qi (1683–after 1745, fig. 7).

FIGURE 8
Detail of *Copy of the Orchid Pavilion Preface in Running Script* (cat. 6). Attributed to Yu Shinan (558–638). Tang dynasty, 7th century.

PUBLISHING AND ACCESSING THE QING IMPERIAL PAINTING AND CALLIGRAPHY COLLECTION

A relatively small portion of the Qing imperial painting and calligraphy collection was recorded in catalogues compiled by the court such as the *Treasured Boxes of the Stone Moat* and the *Jewel Forest of the Secret Hall* (*Midian zhulin*). For example, the *Treasured Boxes of the Stone Moat* documented about 1,001 paintings and 228 calligraphic works out of the 15,428 paintings and 22,280 calligraphic works in the Gu group of the current Palace Museum collection.[14] Some of the works not included in this catalogue, particularly large-scale paintings mounted on walls, oil paintings, and prints, are highly significant from historical and artistic perspectives.

The *Treasured Boxes of the Stone Moat* includes numerous important and high-quality works, such as *Copy of the Orchid Pavilion Preface in Running Script* (fig. 8) by Yu Shinan (558–638) and *Six Arhats* (cat. 7) attributed to Lu Lengjia (active 730–760), both featured in this exhibition. The latter was once concealed by a eunuch who failed to steal it from the palace. The *Treasured Boxes of the Stone Moat* also shows a few areas of weakness in the imperial collection, which was not systematically

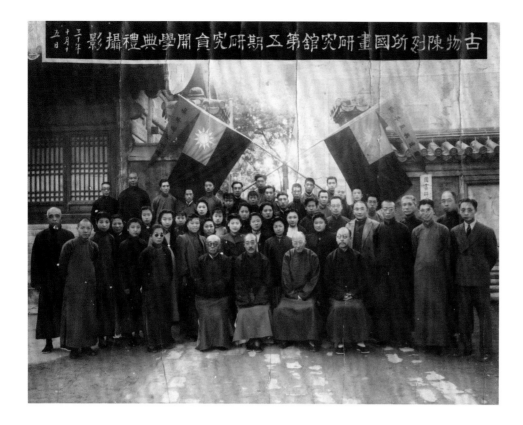

FIGURE 9
The inauguration ceremony for
the "Fifth Group of Researchers"
in the Chinese Painting Research
Department of the Institute for
Exhibiting Antiquities. 1941. The
Palace Museum.

formed and often reflected the emperor's idiosyncrasies and taste. For example,
mid-to-late Qing works are scarce and a few important artists are absent from this
catalogue. Moreover, the authenticity of several works has been called into question
due to the inadequate connoisseurship of the Qianlong Emperor.[15]

It is true that works from the imperial collection tend to be better preserved and
mounted than those from other collections. But they were also at significant risk.
The imperial collection could be vulnerable to natural or man-made disasters, and
the high concentration of the finest works exclusively for the use of the emperor
and his court could be a hindrance to artists outside the court. It was not until the
fall of the Qing dynasty that these hidden treasures became accessible through the
exhibition and publication programmes of the Institute for Exhibiting Antiquities.
The Institute displayed three-dimensional objects in the Hall of Martial Valour, and
paintings and calligraphic works in the Hall of Literary Brilliance (Wenhua dian)
inside the Forbidden City and published the *Catalogue of Paintings and Calligraphic
Works by Yuan and Ming Masters* (*Yuan Ming ren shuhua jice*) and the *Catalogue
of Paintings and Calligraphic Works in the Collection of the Institute for Exhibiting
Antiquities under the Interior Department* (*Neiwubu guwu chenliesuo shuhua mulu*).
It placed a great emphasis on the practice of copying; artists such as Yang Lingfu
(1887–1978) and Yu Ming (1884–1935) were able to study masterpieces of the Tang
and Song dynasties to hone their skills (fig. 9). The art historian Lang Shaojun
noted that at the Institute "… painters could study and copy masterpieces of various

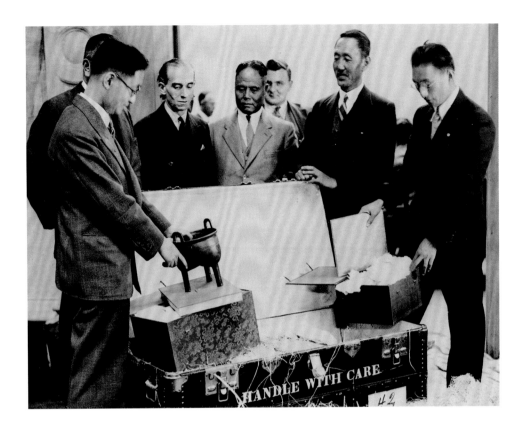

dynasties which were not accessible to them. This prompted a shift in the Chinese painting history in the early [twentieth] century. Painters gradually moved away from the style of the four famous Qing landscape painters with the family name of Wang or 'Four Wangs' [Si Wang] to embrace Song and Yuan styles." Thanks to the Institute, renowned artists including Jin Cheng (1878–1926), Wu Hufan (1894–1968), Feng Chaoran (1882–1954), Zhang Daqian (1898–1983), and Xie Zhiliu (1910–1997) proudly paid homage to Song and Yuan works. In particular, *gongbi* painting in a highly detailed and refined style flourished.[16]

After the establishment of the Palace Museum, the finest works of painting and calligraphy in the Qing imperial collection became even more accessible to the public. The front and rear halls of the Palace of Accumulated Purity (Zhongcui gong) became the designated spaces for the display of Song, Yuan, and Ming works and fan paintings; the Palace of Compassion of Tranquillity (Cining gong) became the Qing painting gallery; and the Hall of Diligence (Maoqin dian) presented paintings by the Jesuit court painter Giuseppe Castiglione (Lang Shining, 1688–1766). Portraits of emperors of successive dynasties were on display in the Hall of Imperial Supremacy (Huangji dian) and the Palace of Tranquillity and Longevity (Ningshou gong). Early periodicals, such as *Palace Museum Weekly* (*Gugong zhoukan*), *Palace Museum Periodical* (*Gugong xunkan*), which was published every ten days, and *Palace Museum* (*Gugong*), published 2,238 paintings and works of calligraphy in total. Another periodical, *Compilation of Palace Museum Painting*

and Calligraphy Collection (*Gugong shuhuaji*), published 940 works in its forty-sixth issue. The Museum published numerous books on painting and calligraphy with hundreds of illustrated works, such as *A Myriad of Famous Paintings* (*Minghua linlang*), *Select Paintings of Song and Yuan Dynasties* (*Song Yuan huacui*), *Important Calligraphic Works of Song Masters* (*Songren fashu*), and *A Grand Selection of Important Calligraphic Works* (*Fashu daguan*).[17] The 1935–1936 "International Exhibition of Chinese Art" in London and the 1940 "Exhibition of Chinese Art" in Moscow featured in total nearly 200 paintings and calligraphic works from the Museum (figs. 10 and 11). Between 1943 and 1946, multiple exhibitions of Palace Museum paintings and calligraphic works travelled to Chongqing, Guiyang, and other cities, raising the public's awareness of the collection. The works on display at these exhibitions included calligraphic works from the Jin to the Yuan dynasties by masters such as Wang Xizhi (303–361) and Zhao Mengfu, as well as paintings from the Tang to the Qing dynasties by Zhou Fang (ca. 780–ca. 810), Emperor Huizong, Wen Zhengming (1470–1559) and the Four Wangs.[18]

Since 1949, and especially after China pursued the Reform and Opening Up policy and entered the twenty-first century, the Palace Museum has broadened its collection access to global audiences at an unprecedented level through its robust publishing programmes and a wide range of exhibitions, from displays of objects in their original palatial settings to rotating and thematic exhibitions, digital shows, as well as travelling exhibitions in collaboration with domestic and international partners. These projects have provided rich sources of inspiration for the development of art in China, fostered research, and broadened the reach of Chinese traditional culture.

THE POSITIONING AND SIGNIFICANCE OF PAINTING AND CALLIGRAPHY IN THE PALACE MUSEUM COLLECTION

The Palace Museum is a treasure house, and its collection has played and continues to play an indispensable role in the history of Chinese art. Its 1.86 million objects organised into twenty-five main categories encompass virtually every type and medium of traditional Chinese art, and many works in each category can trace the historical development of the art form. Take the painting and calligraphy collection as an example: many years of collection building have broadened the scope of the collection, which was previously limited by its imperial nature. It has become more systematic and comprehensive in its coverage of periods, schools, genres, subjects, mediums, and the formats of works. The Museum has filled the gaps in the imperial collection through new acquisitions of works by the Four Monks (Siseng) of the early Qing dynasty, painters of the Yangzhou and Jingjiang schools, and works of the late Qing Shanghai School of painting. The Museum has also enriched in a focused and thoughtful way a few existing areas of the imperial collection by adding works by masters already well represented. In the 1950s and

FIGURE 11
Cover of the *Illustrated Catalogue of Chinese Government Exhibits for the International Exhibition of Chinese Art in London*. Vol. III, *Painting and Calligraphy*. Shanghai: Shanghai Press, 1936.

The exhibition "The Pride of China: Masterpieces of Chinese Painting and Calligraphy of the Jin, Tang, Song and Yuan Dynasties from the Palace Museum" at the Hong Kong Museum of Art in 2007. Photo courtesy of the Hong Kong Museum of Art.

1960s the Museum's expert connoisseurs set out detailed collecting goals: "In principle, we should acquire works by important Ming and Qing painters. However, collecting activities in this area may vary according to the specific conditions of our existing collection. The emphasis should be on works by artists absent from or little represented in the Museum's collection…. In these cases, we may choose to be more inclusive in terms of criterion. The artists whose works are represented in the collection but may not be the finest of their oeuvre … may also be considered focuses of acquisition, but we should use higher standards and collect only their best works".[19] The Palace Museum has assembled a unique collection of works by modern and contemporary masters, such as Zhang Daqian, Qi Baishi (1864–1957), Pu Xinyu (1896–1963), Huang Binhong (1865–1955), Chen Banding (ca. 1876–1970), and Fu Baoshi (1904–1965).

Chinese painting and calligraphy occupies a unique and illustrious place in world art history. Inscriptions on bronzes and steles, murals, paintings on lacquer, and silk produced prior to the Qin dynasty demonstrate a highly sophisticated understanding of plastic arts. During the Six Dynasties, calligraphy and painting, which formerly served utilitarian purposes, became distinct art forms. Calligraphic styles further developed, and the art of painting reached maturity. The period from the Sui to the Song dynasties saw the further development and enrichment of calligraphic styles, painting genres, and a flourishing of writings on art theory. In the Yuan dynasty, artists established the unity of the arts of painting and calligraphy as the quintessential expression of Chinese aesthetics. The development of Chinese painting and calligraphy reached its climax in the Jin (265–420), Tang, Song, and Yuan dynasties, when countless masterpieces were created, and their impact is far-reaching. Due to their age, many works were lost and those very few that survived became priceless treasures.

The Palace Museum houses 599 paintings and 506 calligraphic works of the Jin, Tang, Song, and Yuan dynasties, each of which, being a rare treasure and crown jewel of the Museum's collection, has been rigorously studied and authenticated.[20] The Hong Kong Palace Museum's inaugural exhibition "The Making of Masterpieces: Painting and Calligraphy from the Palace Museum" presents to the public some of the finest and rarest works from this prestigious collection. We hope visitors will gain a deeper appreciation of these national treasures and a fuller understanding of Chinese civilisation. While we must carefully consider each work's physical condition and conservation requirements, the works in this show are carefully selected to complement those featured in "The Pride of China: Masterpieces of Chinese Painting and Calligraphy of the Jin, Tang, Song and Yuan Dynasties from the Palace Museum", a landmark exhibition the Hong Kong Museum of Art presented in 2007 to commemorate the tenth anniversary of the reunification of Hong Kong with China (fig. 12).

In 1934, soon after the Palace Museum began to move its collection to Southern China to protect the priceless works from the aggression of Japanese troops, the renowned aesthetician Zong Baihua (1897–1986) wrote:

> World aesthetics of the future should not be confined to the artistic expression of a particular time or place. Rather it should be an organic synthesis of the artistic ideals of both the past and the present across the globe. Such aesthetics values universal aesthetic principles without neglecting distinct individual styles. This is because beauty and fine art originate from the depth of our soul, which is touched by the environment. Every form of fine art is deeply rooted in a particular cosmology and a particular set of feelings. Chinese art and aesthetic theory have their distinct and remarkable spiritual significance. The study of Chinese painting, therefore, will make a uniquely important contribution to world aesthetics of the future.[21]

The importance of Chinese art and its place in the world cultural arena are well recognised. As the Chinese saying "The soup is delicious because of the harmonious combination of different ingredients" suggests, diversity is a universally embraced value. Deeply rooted in Chinese civilisation, works of calligraphy and painting bear witness to the interactions among various ethnic groups in China and world civilisations. They are vivid manifestations of Chinese concepts of time, space, and the universe, as well as Chinese philosophy and values. The Palace Museum's painting and calligraphy collection is among the finest in China, and its significance goes beyond its artistic merit. The richness and diversity of painting and calligraphy are manifested in materials and tools such as ink, paper, brushes, and inkstones, in the combination of poetry, calligraphy, painting, and seal, as well as their literary and sonic dimensions. These works embody the lofty

spirit of the Chinese people in each historical period and constitute reliable sources for the study of the material culture and history of Chinese civilisation. The stories of the Palace Museum painting and calligraphy collection in the past century are part of the history of modern China, demonstrating the vitality of its people and civilisation.

(Translation by Daisy Yiyou Wang and Alan Yeung)

NOTES

1 Bloch 1992: 4.
2 Zhu et al. 2016: 122–123.
3 Bloch 1992: 50–51.
4 Wu Y. 2005: 154.
5 *Zhongguo Dabaike Quanshu Bianji Wei-yuanhui* 1993: 192; Remarks of Xi Jinping, President of the People's Republic of China during his visit to the Palace Museum with Donald and Melania Trump, President and First Lady of the United States of America on 8 November, 2017.
6 To broaden the Palace Museum's collection in a systematic way does not mean unrestrained collecting; rather, collection building needs to factor in the Museum's capacity in conservation, research, and display.
7 The dividing line is neither the 1911 Xinhai Revolution, the 1912 abdication of the last emperor, nor the 1925 founding of the Palace Museum.
8 The Shu group includes all items acquired by the Library before and after 1949. Over 11,000 items, which constitute a small portion of the substantial Shu group, were accessioned after 1949.
9 Unlike the Palace Museum collection, the objects in the Institute's collection did not travel to southwestern China during the Sino-Japanese War.
10 Zhuang 2006: 76–77.
11 Ke L. 2016: 76.
12 Ke L. 2016: 98.
13 *Juan* 6 of *Midian zhulin*, reprinted in Zhang Zhao et al. 1998: 86.
14 These works are presently in the Palace Museum collection: 743 paintings in the Gu group and 258 in the Xin group; 156 works of calligraphy in the Gu group and 72 in the Xin group.
15 The first director of the Palace Museum Yi Peiji (1880–1937) was accused of theft. The Nanjing City Court stated that "the imperial collection should not contain any fakes. If a forgery is found, it must be one that was substituted by Yi Peiji for the original work he stole." This statement needs to be reconsidered because the imperial collection may have contained a number of inauthentic works.
16 Duan Y. 2004: 30. *Gongbi* painting reached its peak between the Tang and Song dynasties.
17 Zhu S. 2011: 124–128.
18 Fu Z. 1990: 8.
19 The document *An Outline of the Palace Museum's Acquisition Policy* lists a number of artists absent from or poorly represented in the Museum's collection such as Bian Jingzhao, Wang Fu, Dai Jin, Wu Wei, Lü Ji, Lin Liang, Guo Xu, Du Jin, Zhang Ling, Tang Yin, Qiu Ying, Cui Zizhong, Kuncan, Hongren, Wang Shishen, and Yun Shouping. Artists whose works are represented in the collection but may not be the finest of their oeuvre include Xia Chang, Shen Zhou, Wen Zhengming, Chen Daofu, Xu Wei, Xiang Shengmo, Chen Hongshou, Zhu Da, Yuanji (Shitao), Gong Xian, Hua Yan, Jin Nong, Luo Pin, Zheng Xie, Li Shan, Li Fangying, Zhao Zhiqian, Ren Yi, and Wu Changshuo. It should be noted that the terms in this quotation such as "little represented", "higher standards" should be considered in light of the overall high quality and large volume of works in the Palace Museum collection.
20 As of December 2021, in the Museum's collection of works of the Jin, Tang, Song, and Yuan dynasties, 20.9 percent, or 125 works out of 599 paintings are in the Gu group, and 79.1 percent, or 474 works are in the Xin group; 20.2 percent, or 102 works out of 506 calligraphic works are in the Gu group, and 79.8 percent, or 404 works are in Xin group.
21 Zong 1987: 81.

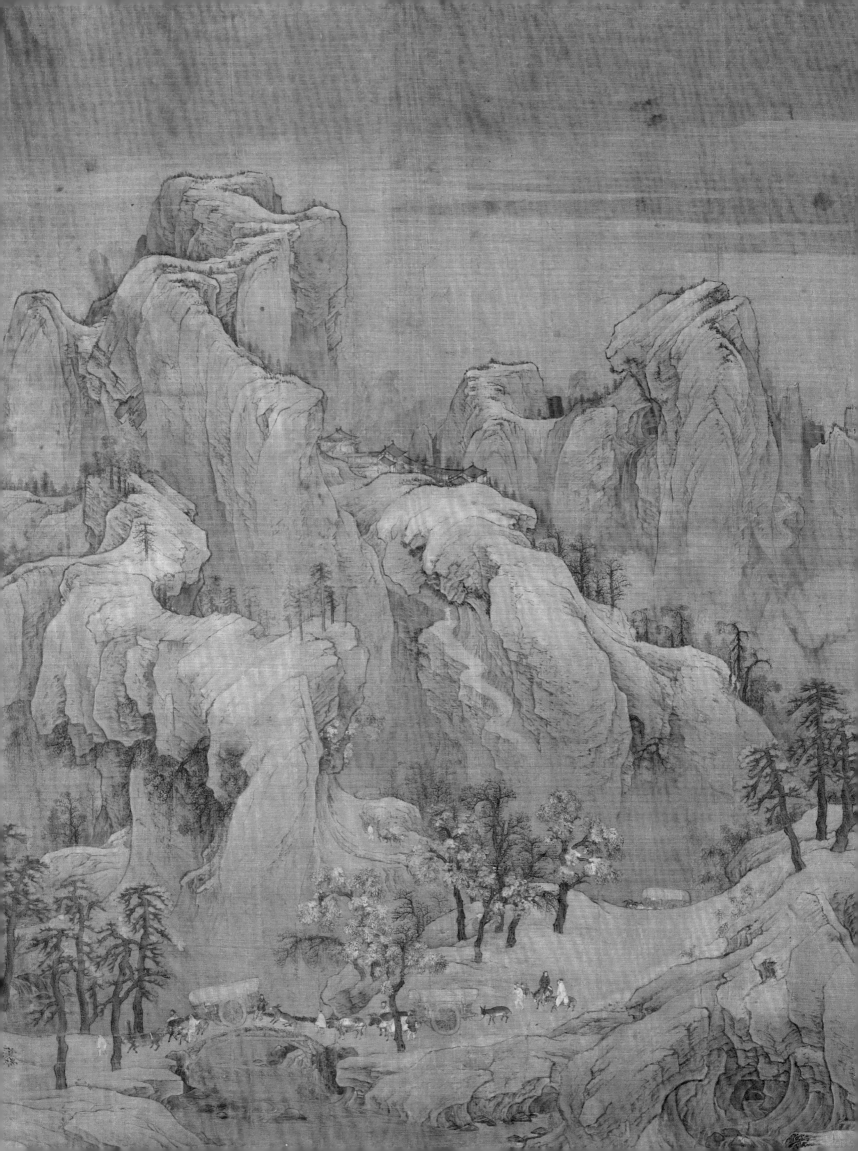

Roderick Whitfield

Transformative Landscapes

TO VISIT AN EXHIBITION OF EARLY CHINESE PAINTING IS TO BE drawn into a vast continuum stretching back into antiquity and through many centuries up to the present. "The Making of Masterpieces" includes several paintings from the Palace Museum in which human figures appear in landscape settings. This brief essay seeks to show how the relationship between figure and landscape changed over time and how artists transformed the models that had reached them from earlier centuries and dynasties. Two handscrolls with very different renderings of the same subject provide a striking example.

The first scroll, entitled *Nymph of the Luo River* (11th or early 12th century; cat. 3), takes us back to the early days of known masters of Chinese painting. It illustrates a rhapsody or prose-poem (*fu*) written by Prince Cao Zhi (192–232) in 222 or 223 as he made his way back from the Wei capital of Xuchang to his home fief in the east, after a visit to his brother Cao Pi, the emperor of Wei (r. 220–226).[1] In painting, the subject is forever associated with the name of Gu Kaizhi (346–407), China's most famous figure painter, but neither scroll bears his name.

The opening section of the scroll shows grooms and horses enjoying their release from drawing Cao Zhi's chariot as they reach the banks of the Luo River at the start of his homeward journey. Throughout the scroll, landscape motifs are used both to suggest an otherworldly scene and to separate one episode from the next. In keeping with the characteristics of early landscape painting, the mountains retain the basic shape of the character *shan* (山), and the different species of trees crowning the mountaintops — typically ginkgo and willow — can be identified by the shapes of the very few leaves they bear. Cao Zhi and his retinue (fig. 1) form a close-set group like those shown in the early sixth-century reliefs of the Northern Wei emperor Xiaowen (r. 471–499) (fig. 2) and his empress from the Binyang Cave at Longmen. The figures are tall and aristocratic, with oval faces; honorific parasols are held above the prince in the scroll and the emperor in the rock-cut relief.[2]

Besides the prince and his retinue, the Nymph, as the guardian spirit of the Luo River, appears numerous times along the length of the scroll. Other motifs, such as the sun and moon, swans, and a dragon in flight, describe the loveliness of the Nymph and her companions in their ethereal surroundings. She glides through the landscape, the delicate ribbons of her costume fluttering behind her as she yearns towards yet shies away from the prince, who, as the poem tells us, muses

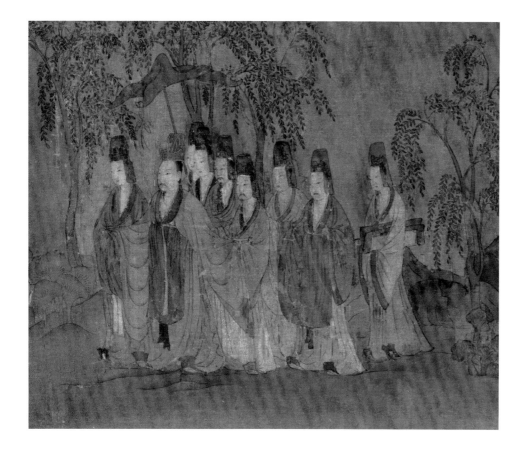

FIGURE 1
Detail of *Nymph of the Luo River* (cat. 3). Gu Kaizhi (346–407). Northern Song dynasty, 11th or early 12th century.

on her charms and accomplishments (she is described as "familiar with the Rites, understanding of the Odes") before offering her a jade token of his love, only to ultimately decline her invitation to join her below the waves. Thereafter more spirits and deities appear, as the Nymph prepares to leave in her dragon-drawn cloud chariot, guarded by aquatic monsters and escorted by sea birds. The last section of the scroll depicts the prince's hopeless pursuit, his inconsolable grief, and his eventual resignation to resume his journey, thus marking the end of the scroll — which is also the point where the Qianlong Emperor (r. 1736–1795) inscribed a ringing endorsement, hailing it as the foremost example of the subject.

That was in 1741, when the scroll entered the imperial collection. Other versions exhibiting the same archaic style, in the Liaoning Provincial Museum and the Freer Gallery of Art, are evidently based on the same original as they share the same style and composition.[3] The Liaoning scroll, rated by Qianlong as the runner-up, is additionally inscribed by the Southern Song emperor Gaozong (r. 1127–1162) with the text of Cao Zhi's poem. Both versions clearly aimed to perpetuate the style and presence of the original, both of the figures and of the landscape motifs. That Gaozong (or someone close to him) personally transcribed the text of the poem on the Liaoning scroll gives us a strong indication that both scrolls were inspired by his interest.

No such lofty motivation applies to the second scroll (probably 12th century; cat. 4). For a start, this version is twice as long as the version we have just

examined. Although at first sight the groups of figures appear similar, the elaborate landscape is a world away from the austere presentation of the versions praised by Qianlong. Crucially, however, this larger scroll, having suffered little damage, depicts the whole story from the very beginning, with the prince travelling in his carriage, then halting on the banks of the Luo River and unharnessing the horses, a scene that gives us some idea of the painter's approach: where one groom accompanied two horses, now there are three grooms and three horses. When it comes to the prince and his retinue, they too are expanded, with the addition in this scroll of Cao Zhi's coachman on the left (fig. 3). As recounted in the rhapsody, he cannot see the Nymph but is able to tell the prince what he knows about her. In her monograph on the Luoshen scrolls, Chen Pao-chen suggests that this whole scene — and, indeed, the next as well, when prince and Nymph come face to face — is an addition by later artists, though we might note that an encounter at close quarters is faithful to the text.[4]

There are other changes too: gone are the ubiquitous ginkgo trees of the earlier design; gone also are the willow trees. Miasmic mists rise from the ground, which features an abundance of "immortals' mushrooms" (*lingzhi*). Beyond, the landscape stretches away into the distance, and the figure groups occupy a little less than a third of the available width of the silk. Selected verses from Cao Zhi's poem are placed in framed cartouches along the length of the scroll to remind the viewer of the story. Progressively, the mountain formations seem to grow in size and complexity, while on each occasion the prince and his retinue appear out in the open, no longer, as in the earlier scroll, sheltered by willow trees. When the time comes for the Nymph's departure in her dragon-drawn cloud chariot, the artists of this larger scroll have excelled in the depiction of the waves, the dragons, the sea

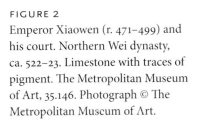

FIGURE 2
Emperor Xiaowen (r. 471–499) and his court. Northern Wei dynasty, ca. 522–23. Limestone with traces of pigment. The Metropolitan Museum of Art, 35.146. Photograph © The Metropolitan Museum of Art.

FIGURE 3
Detail of *Nymph of the Luo River* (cat. 4). Gu Kaizhi (346–407). Southern Song dynasty, 12th century.

monsters, and lifelike birds; in the distance there is even the fountain-like spout
of a whale.

In depicting the prince's pursuit of the Nymph, the latter scroll shows two
smaller boats being energetically rowed toward the large architectural ship, giving
a sense of dramatic urgency lacking in the earlier versions. When the prince
finally gives up hope, the landscape softens to convey a sense of leaving the banks
of the Luo River. Throughout, clouds are used to highlight important scenes and
increase the dramatic effect: this is a scroll meant to entertain and amaze. Chen
Pao-chen and the scholars in the Palace Museum's Institute of Gugong Studies
date this large scroll to the Southern Song dynasty, but to this writer, details of the
landscape — including but not limited to a mountain temple and an impressive
waterfall — suggest an earlier Northern Song date. Lastly, it should be mentioned
that another almost identical scroll is in the collection of the British Museum.[5]
Although the London scroll is missing several scenes at the beginning, adjustments
to the placing of the text cartouches and a more colourful overall effect suggest that
it is the final version.

Very little is known about the Five Dynasties painter Ruan Gao. Although he
is listed among other figure painters in volume six of the *Xuanhe Catalogue of
Paintings* (*Xuanhe huapu*), the brief entry devoted to him begins with a query —
"Where is this man from?" — from which it would appear that he was already
obscure by the 1120s. We learn that he was Court Gentleman for Fasting at the
Imperial Ancestral Temple, just outside the Forbidden City in Beijing, and that
he was especially noted for his paintings of women and female immortals, about
whom he collected all manner of fine and delicate detail. Of the painting *Female
Immortals in Elysium* in the Song imperial collection (cat. 8), the record states

that the scene has an atmosphere of a jade pool and a feminine realm, with multi-coloured clouds floating past; this corresponds to the impression we get of a landscape that is out of this world, inhabited by refined beings engaged in music and poetry. The composition has an antique flavour, leading us back to the Tang dynasty. It begins with a tall and graceful lady, with two attendants, one of whom carries a wrapped seven-stringed *guqin*, approaching the seashore. A natural rock bridge leads them toward the main scene, but the lady gazes upward to where another small group are about to descend from high in the sky; two more ride a dragon and a scarlet-crested crane.

The centre of the painting is framed by tall pine trees, two on either side, their crowns silhouetted by clouds, through which a clump of bamboo breaks out, with stems visible below and foliage above. In the glade between, the principal lady, in a red dress, holds a brush in one hand and a paper in the other. Two maids stand by, one holding an inkstone with a pool of ink. In the foreground on the left, a lady tunes a five-stringed *yueqin*, while on the right another holds an open scroll of paper, ready to recite. A magnificent phoenix with rippling neck struts in the centre, displaying its long, fringed tail feathers. This music-making scene is reminiscent of recent discoveries of eighth-century Tang tombs, such as that of Han Xiu (d. 740), which contain landscapes alluding to immortality and scenes of music and dance portrayed in an elegant garden setting (fig. 4). It finds an echo, too, in Emperor Huizong's (r. 1101–1125) own portrayal of music making, *Listening to the Qin* (*Tingqin tu*, fig. 5), where the scene takes place in a garden with a single pine tree of similar stature and growth to those in Ruan Gao's painting.

In the Tang and early Northern Song dynasties, the walls of the Jade Hall in the Hanlin Institute in the imperial city were painted with "massive and vast" seascapes evoking the scenery of the Isles of the Immortals, creating, in Ping Foong's words, "environments for scholars in earlier times, in which they were metaphorically transformed into immortals by the paradisiacal motifs of their surroundings."[6] The clouds and waves, not forgetting the dragon, that we see in *Female Immortals in Elysium* must surely reflect such watery murals. The green pine needles and the stunning alternation of coral-red and green in the foam-flecked waves (fig. 6) are very different from the monochrome landscapes of Li Cheng (919–967) and Guo Xi (active 11th century) as well as from Ma Yuan's (active late 12th–early 13th century) detailed studies of water in the album discussed below (cat. 14).

The landscape by Emperor Huizong called *Returning Boats on a Snowy River* (cat. 10) is a rare exception to his colourful works in the genre of birds and flowers. Under a leaden winter sky, the figures in this painting – boatmen, travellers, wood-cutters – carry on with their daily tasks or hasten to be home before darkness falls. Dwarfed by the landscape, these details go unnoticed by Huizong's Grand Councillor Cai Jing (1047–1126), whose glowing inscription (dated 1110) echoes

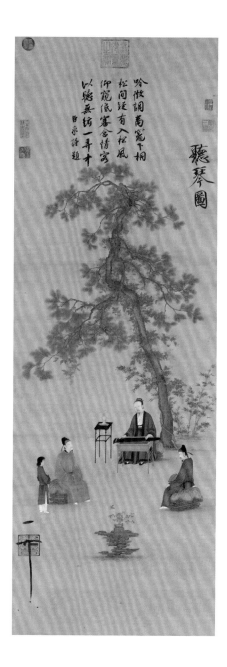

FIGURE 5
Listening to the Qin. Zhao Ji (Emperor Huizong, 1082–1135, r. 1101–1125). Northern Song dynasty. Hanging scroll, ink and colours on silk. The Palace Museum.

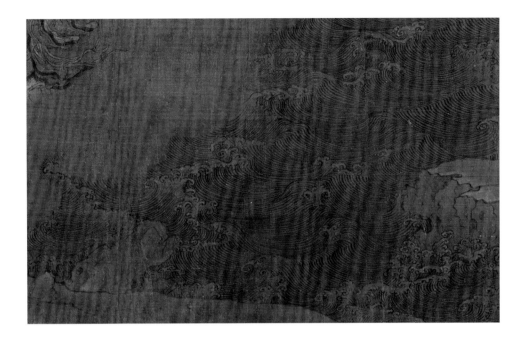

phrases such as "distant water has no ripples" (*Yuanshui wubo*) from Guo Xi's *An Essay on Landscape Painting* (*Linquan gaozhi*) of the previous generation and commends the way in which the painting characterises the subject, presuming that the painting was once part of a set of four. Guo Xi's influence can also be seen in the trees, fully branched in the foreground and then diminishing in size in the middle distance, and in the impressive group of peaks that bring the composition to a climax, shortly before the end.

The inscriptions that follow are from the late Ming dynasty. Wang Shizhen (1526–1590), who wrote twice, began by noting the subject matter, a departure from Huizong's bird-and-flower paintings in the manner of Huang Jucai (933–993) and Yi Yuanji (1000–1064). His second inscription refers to Cai Jing's suggestion that there were originally four paintings, noting that this wintry scene must be the last. In his inscription, Wang Shizhen's younger brother Wang Shimao (1536–1588) is lost in admiration of the precious materials used in the mounting of this scroll: "The ancient brocade of the wrapper, the mutton-fat jade of the fastening pin; the dark green 'fish-gall' jade roller ends, and the Song dynasty dragon robe tapestry-weave of the inner wrapper" — all typical of expensive Suzhou mounting techniques. Finally, the connoisseur and calligrapher Dong Qichang (1555–1636), writing in 1618, notes that fewer than one in ten bird-and-flower paintings bearing the distinctive "slender gold" calligraphy of Emperor Huizong were genuine, but among landscapes he singles out this one for its brushwork and composition and for its relationship to the art of the Tang master Wang Wei (ca. 701–761), the patriarch of the Southern School.

Coming down to the present day, Yu Hui has written that Huizong was particularly active and fulfilled in the decade between 1102 and 1110, establishing or

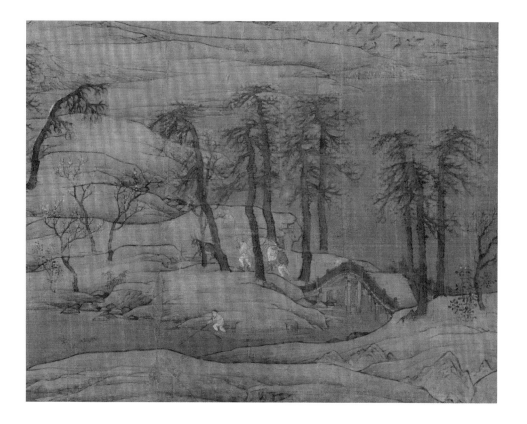

FIGURE 7
Detail of *Autumn Colours over Rivers and Mountains* (cat. 12). Attributed to Zhao Boju (active 12th century). Southern Song dynasty.

re-establishing ten commanderies, mainly on the western borders.[7] Little could he imagine that a mere seventeen years later the rivers and mountains he captured in *Returning Boats on a Snowy River*, intended as an expression of an orderly world under the benevolent rule of an august emperor, would be part of the Great Jin state.

Autumn Colours over Rivers and Mountains (cat. 12) is a painting whose origins remain mysterious. The earliest seal on the painting, in the lower right corner, is that of the discriminating collector Liang Qingbiao (1620–1691), while an unsigned inscription at the end of the scroll was written in 1375, early in the reign of the first Ming emperor, Hongwu (r. 1368–1398). It reads:

> Hongwu [reign] eighth year, it being already autumn, I went to the mounting studio. The mounter asked to present a painting, inscribed with the title "Zhao Qianli: Painting of Rivers and Mountains". Anyone unrolling the scroll with his mind intent on the pictured space would be magically transported among flowery peaks and cliffs, amid strange rocks and hidden valleys, discovering the depth and elegance of Zhao Qianli's ideas. Looking at this painting, someone actually travelling in the mountains could not surpass it, even with bone-crushing effort. One could say that the spirit of the landscape is in no way less than that of real mountains. What is tremendously moving here is that it is not just seen from one perspective: for instance,

Detail of *Autumn Colours over Rivers and Mountains* (cat. 12). Attributed to Zhao Boju (active 12th century). Southern Song dynasty.

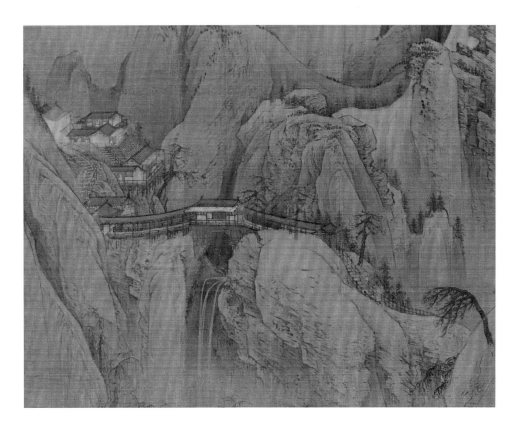

where the mountains are lofty there are multiple ranges and piled-up peaks; as to water, there are banks and brooks and winding streams, trees on banks and narrows, like dark dragons emerging from the water, while distant peaks are hidden or appear like tight curls at the edge of heaven. Close-by mountains are suddenly revealed or obscured. The halls and towers of a monastery hang dangerously over the water of a ten-thousand-foot blue cliff like clouds in flight. Stands of trees look up to the mists, where a causeway allows men to pass. Then there are transport carts with mules and camels, and men with shoulder poles, boats and oars, woodsmen bearing firewood, cowherds driving oxen, gentlemen with staff or whip, old and young together. When we look at the scenes in this painting, there are scenes where the foreground closes in and the background looks up, movement and stillness or gentle strolling. This is an autumn scene with an air of melancholy; there are red leaves and yellow flowers, creating a thousand *li* [a traditional Chinese unit of distance] of fine scenery. The painting master is Zhao Qianli. How could one bear to part with this?

Hongwu [reign] eighth year, autumn, inscribed in the Wenhua Hall.[8]

The anonymous writer provides us with an excellent summary of the contents of the scroll. We have only his word for it that it is the work of Zhao Boju (active 12th

century) — here referred to by his literary name Zhao Qianli; he was born in the closing years of Huizong's reign and is now known only for a very few fan paintings in the blue-and-green style. If we examine this scroll closely, many details imply knowledge of an earlier time. Cloud-filled valleys surround the first major peak and confine the viewer to the foreground, where a traveller and his servant are beginning a climb punctuated by clumps of pine trees. Their way leads them to a heavily fortified building controlling access to a steep ascent and a gate, beyond which stands a five-storey pagoda. Further to the left, the landscape opens into a wide valley with a zigzag stretch of water — a distancing motif strongly recalling the landscapes of Tang mural paintings in the Dunhuang caves.

Back in the foreground a fisherman is at work, his sampan barely visible through the blue wash that, here as elsewhere in the scroll, appears to have been applied after the initial drawing. Behind him is a steep humpback bridge, sited such that we first see the upper surface and then the solidly built wooden structure beneath (fig. 7). Two men driving a wheelbarrow drawn by a donkey are seen passing through the trees, having just negotiated the bridge.

The line of trees, gradually diminishing in height, leads toward a village along the other shore. In the distance is a second Buddhist pagoda, three storeys high but dwarfed by the mountain above it. Standing back, we see that the bridge marks the confluence of two rivers, while powerful ridges lead to three main peaks, toward which the viewer is encouraged to proceed. The ascent is gentle at first, with steps to a small rest house, then steeper past a deep ravine. At the top, a rider and his servant stop to admire the view. They gaze at an impressive waterfall, but it is clear that it is out of their reach: one has to climb from the other side, where a fenced path shows the way and vanishes, then reappears as a flight of steep steps.

A closer view shows the pavilion, hanging "dangerously" above a stunning waterfall (fig. 8). With its curved wings, the pavilion recalls the suspended Liao dynasty sutra cabinets of the Lower Huayansi in Datong. But we are not yet done with climbing: more steps lead up to other buildings built out from the sheer cliffs, gravity defying yet safely ensconced beneath the mighty peak above.

The viewpoint here is high, but as we return to the foreground, where the pool flows out, the scene shifts to one more at our own level (fig. 9). Here another group of figures converse outside a three-bay pavilion. The anchoring roots of the twisted pines are similar to those seen in the landscape painting found in a Liao tomb (fig. 10). Snow still lingers on some of the branches. The stream passes immediately behind the pavilion, and another river in front descends from the mountains, zigzagging through stands of bamboo. High above, a train of pack animals laden with sacks is making a perilous descent from the heights, while from another ridge a bullock cart is also coming down. The track is set to pass behind deciduous trees with pinnate leaves, not unlike those seen in the anonymous Liao painting *Deer in Autumn Forest* (*Danfeng youlu tu*).[9]

FIGURE 9
Detail of *Autumn Colours over Rivers and Mountains* (cat. 12). Attributed to Zhao Boju (active 12th century). Southern Song dynasty.

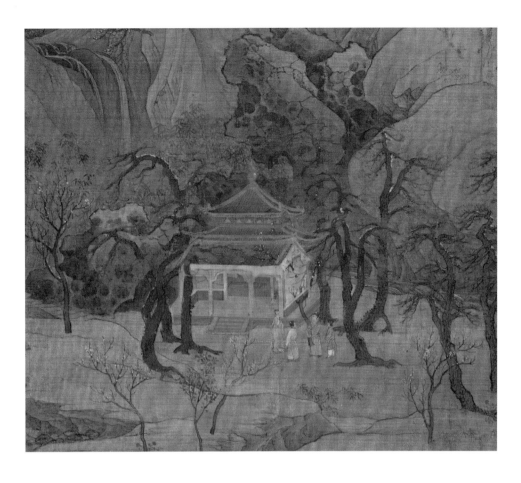

FIGURE 10
Detail of *Chess Match in the Deep Mountains* (*Shenshan huiqi tu*). Shenyang, Liao dynasty, 10th century. Hanging scroll, ink and colours on silk. Liaoning Provincial Museum.

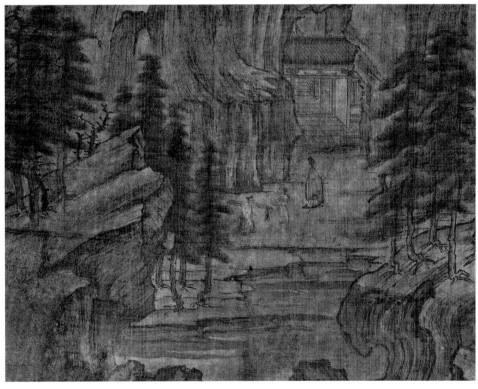

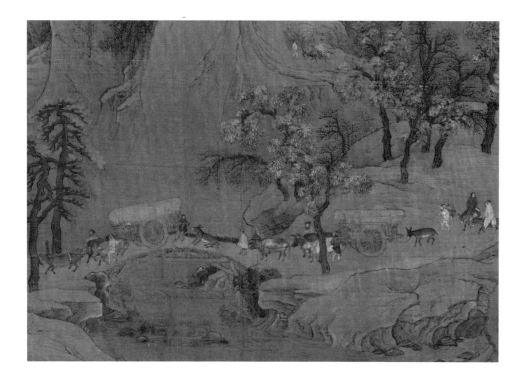

FIGURE 11
Detail of *Autumn Colours over Rivers and Mountains* (cat. 12). Attributed to Zhao Boju (active 12th century). Southern Song dynasty.

Further down, beside the trunks of these trees, yet another bullock cart is coming into view, while two gentlemen on donkeys, with a servant carrying a wrapped *guqin* and a small table, ride ahead (fig. 11). The bullock cart in front of them has come to a standstill, so that we can see how it works: three bullocks of different colours, three drivers, and a donkey on a loose rein at the rear. This cart, it turns out, is waiting while another negotiates the humpback bridge over a larger stream. Although on a smaller scale, this bridge displays a cantilevered structure identical with the great bridge over the Bian canal in *Spring Festival on the River* (*Qingming shanghe tu*) of the early twelfth century by Zhang Zeduan (ca. 1085–1145; fig. 12): no other bridge in Chinese painting is depicted in this way. The wheels of the cart have just passed the highest point, and the drivers are bracing themselves against the steep slope. Here we see the reason for the donkey at the rear: evidently it is not a stand-in for one of the bullocks nor a spare mount; instead, one of the drivers wields a whip to threaten the poor beast, which reacts by digging its hooves in, braking the descent of the heavy vehicle.

By this time we have arrived at the closing scenes of the scroll: a final huge ridge ascends, perpendicular cliffs folded back; a temple, again with curving verandas, barely visible behind vast rocks; and, in the foreground, a rocky cascade passing through a stand of yet more pine trees with sturdy trunks and branches. Throughout the foreground are many flowering shrubs and small trees, red camellias and white prunus blossoms (fig. 13), echoing those in Tang dynasty landscapes, such as *Minghuang's Flight to Shu* (*Minghuang xing Shu tu*) in the Palace Museum, Taipei.

Detail of *Spring Festival on the River*.
Zhang Zeduan (ca. 1085–1145).
Song dynasty, early 12th century.
Handscroll, ink and colours on silk.
The Palace Museum.

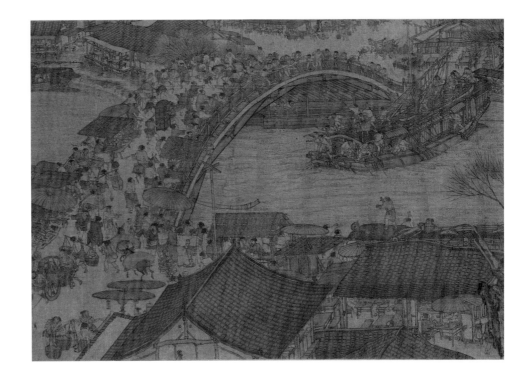

Despite sharing many features with the Tang scroll — such as death-defying causeways cantilevered out from the cliffs, flat bridges with railings, and many flowering shrubs and trees — *Autumn Colours over Rivers and Mountains* is a very different painting. Conspicuously, the figures in *Minghuang's Flight to Shu* are aristocratic or military, and it contains no scenes from ordinary life. That work also displays more evidence of ageing in the silk, in the form of horizontal cracks. Perhaps we should agree with the anonymous inscriber that this work does indeed date from Zhao Boju's time but that it is a copy of an earlier painting.

There is nothing mysterious about the extraordinary *Pasturing Horses after Wei Yan*[10], a veritable tour de force. Painted at the behest of Emperor Shenzong (r. 1068–1085) by the foremost painter of the day, Li Gonglin (1049–1106), a master renowned for his ability in the painting of horses, it is also a reflection of and a tribute to the skill of another famous painter, Wei Yan (active 8th century), one of the giants of the Tang dynasty. Above all, it is a masterpiece of narrative: at the very beginning of the scroll, we find ourselves at the tail end of a vast drove of horses, with three or four men on foot rounding up the stragglers, leaving none behind. From this point on, one can hardly see the ground, so closely packed are the steeds. It might be a cattle drive in the American West, but these are horses, vital to the Tang economy. Being horses each with a mind of its own, there are many different reactions: one does not move forward at all but stares straight out at the viewer; another does the same without breaking step. There is an infinite variety of coat and mane patterns and colours. In front of this dense mass of horseflesh, a space opens

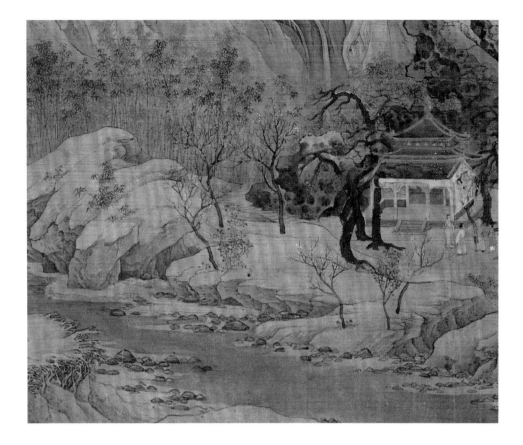

FIGURE 13
Detail of *Autumn Colours over Rivers and Mountains* (cat. 12). Attributed to Zhao Boju (active 12th century). Southern Song dynasty.

up, with two riders keeping a tight rein on their mounts, one of which has its tail docked and tasselled, while the tail of the other is beautifully combed, in contrast to the unkempt tails of the as-yet-unbroken horses of the drive.

Pressing on, we find a mass of riders as tightly packed as the unbroken horses, while in the middle ground another group appears at a gallop to catch up with the rest. Tang painters — as we can see from archaeological excavations of princely tombs of the early eighth century, such as those of Li Xian and Li Zhongrun[11] — were masters at marshalling figures in groups. Here, there are far more riders than would be needed to control the drive; perhaps they are officials coming to inspect the new recruits to the imperial stud. Building on Wei Yan's accomplishment, Li Gonglin brought his own privileged access to and knowledge of the steeds in the imperial stables to enhance his rendering of the subject.

An outrider in the foreground warns off a few horses that have ventured too close to this cohort of officials. Subsequently, the ground grows more uneven, and the horses spread out across the landscape, which is succinctly suggested with just a few rocky outcrops and occasional trees in autumnal foliage. Now, there is no urgent need to press onward, and there is a change of mood, with more exchanges between individual horses, greeting or quarrelling, lashing out with hind hooves, or rolling on the ground, just as in the scrolls depicting the *Nymph of the Luo River*. Some of the drovers, evidently exhausted by the day's march, are bivouacking in

the shade of a pair of trees. This is where the entire contingent will spend the night, before they are all gathered together again for the next day's trek, and, fittingly, this is where the scroll ends.

The anonymous hanging scroll called *Travelling Bullock Carts* (cat. 19) not only brings a change of format but a very different mode altogether — one that speaks not of an ideal world with leisure to wonder and explore, but of the here and now: life in a period of prosperous economic activity. To the right in the foreground, we look down on a wheelbarrow. Its heavy load of sacks of flour is securely lashed to the framework so as to be balanced on either side. Power is provided by a bullock, while the two drivers — at the front and back, in step with each other — guide and balance it, protected by a mudguard over the large central wheel. Their route leads past a huge overhanging rock, but if we look beyond, we see a bigger cart drawn by a team of five bullocks on a different stretch of road heading in the same direction but from a different angle and on a gentler slope. Though the roads appear to converge, neither team is aware of the other, inviting us to consider the spaces behind them as they enter the composition from either side, broadening the narrow limits of the painted silk. Even the rocks and trees, so serried and busy in the foreground, seem to calm down as the road reaches a clearing in front of a roadside inn. Other teams have got there already: four camels are standing or kneeling at a drinking trough, their carrying frames and a laden cart glimpsed above the foliage of an evergreen tree. Food is being brought to a guest seated inside the inn, another has fallen asleep over his meal, and a third can be seen at the far right. Above and beyond rise the mountains and tree-filled valleys, hinting at another tough day on the road ahead.

The realism of the scene can be compared to Zhang Zeduan's *Spring Festival on the River* (fig. 12) and to the anonymous Northern Song painting *The Watermill* (*Panche tu*) in the Shanghai Museum (fig. 14).[12] In his study of the latter, Heping Liu has documented a total of eight visits to imperial watermills by Emperors Taizu (r. 960–976) and Taizong (r. 976–997) in the 970s.[13] The Liaoning painting depicts heavily laden transport carts arriving, officials keeping record, and the operations of winnowing, husking, pounding, and milling. Mirroring the constant turning of the waterwheels, we even see the person in charge of the millstones and the circle of soft peaks of flour before it is bagged up and hauled away on the backs of workers or by boat from the two landing stages. The subject remained popular during the Southern Song dynasty: an anonymous hanging scroll, *Bullock Carts and Inn in Snow* (*Xuezhan niuche tu*), combines the theme of carts travelling in winter with an inn, a watermill, a landing stage, and a barge.[14] The mill boasts three horizontal waterwheels turning in the current but is untenanted; the landing stage and boat are empty. The feeding trough and resting oxen in the inn yard seem to have been inspired by the camels in *Travelling Bullock Carts*.

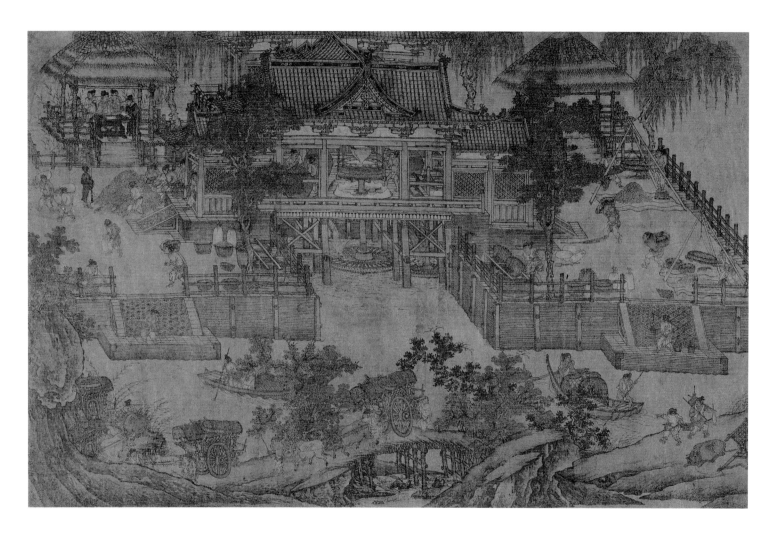

FIGURE 14
Detail of *The Watermill*. Northern
Song dynasty. Handscroll, ink and
colour on silk. Shanghai Museum.

The Taipei painting could well be the work of Zhu Rui (active early 12th century), who also depicted carts travelling in a snow-bound landscape in a pair of album leaves in the Shanghai Museum; in a fan painting in the Palace Museum, Taipei;[15] and in an album leaf in the Palace Museum, Beijing.[16] The carts come and go busily but aimlessly, fording a stream or crossing a bridge in the foreground and coming into view or disappearing out of sight in the distance.

Yet another hanging scroll — signed "respectfully painted by officer Zhu Rui" — is clearly based on *Travelling Bullock Carts,* with the same view of the inn and camels in the yard (fig. 15). However, by omitting the man-powered wheelbarrow and incorporating a cart fording a river in the foreground, it lacks the dramatic orchestration of its model.[17]

A very different atmosphere is conjured up by Ma Hezhi (active 12th century) in the short handscroll *Second Ode to the Red Cliffs.*[18] The ink is pale and almost ethereal, appropriate to a poem redolent of Daoist imagery. The viewer is invited to admire Ma Hezhi's light touch, his dreamlike evocation of a scholarly excursion to the site of the famous naval battle between the warlords Liu Bei (161–223) and Cao Cao (150–220) in the winter of 208. The painting reflects the changed circumstances and nostalgia of the Southern Song dynasty. Rather than impressive mountains and far-reaching waterways, there is a new focus at close range. In the poem *Second Ode to the Red Cliffs,* Su Shi (1037–1101) recounts the journey he and his companions took by boat to the famous site, where the coincidental appearance of a crane added special drama to the occasion. Instead of telling historical or geographical detail, the landscape here is evanescent; even the cliff is no more solid than the branches of a tree or the waves lapping at the sides of the boat. The new interest is in the rhythm of individual brushstrokes, every one of which reveals the character of the painter, something that has eluded us in most of the other paintings discussed here.

Finally, we come to a painting, or rather a whole sequence of paintings, in which there are no figures at all, and no painter's signature, but which nevertheless leaves no doubt as to the identity of both artist and patron. Originally an album, now mounted as a handscroll, *Water,* dated around 1222 (cat. 14), consists of studies of water in its many transformations, each captioned in the distinctive hand of Empress Yang (1162 or 1172–1233) and securely attributed to the court artist Ma Yuan (active late 12th–early 13th century), who often complemented the empress's calligraphy with elegant paintings. Moreover, each leaf is dedicated, in far smaller characters, to one of two brothers in Empress Yang's adopted family. Hui-shu Lee has shown how this gift of a set of paintings was actually intended as a remonstrance meant to curb the self-importance of the elder brother; and how the choice of water as the sole subject perfectly matched Empress Yang's own character: yielding and yet having the ability to wear away the hardest stone. Guo Xi stated that "water is a living thing" (*shui huowu ye*).[19]

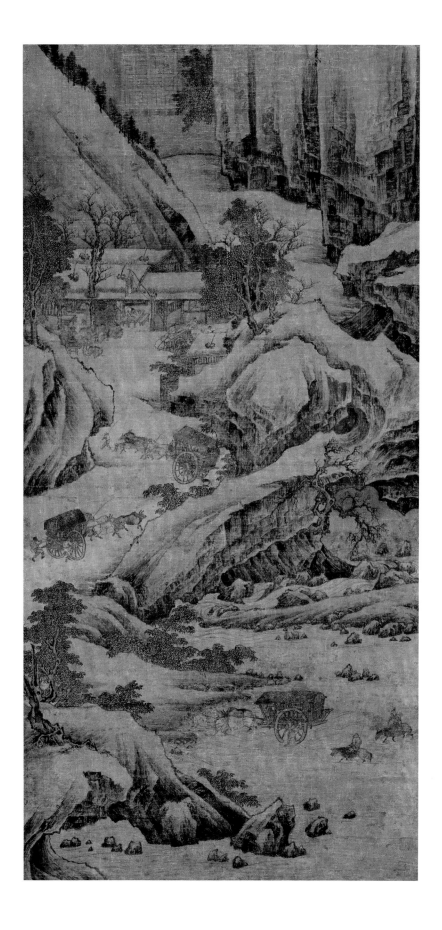

FIGURE 15
Bullock Carts Traveling over Rivers and Mountains. Attributed to Zhu Rui (active early 12th century). Southern Song dynasty, 12th century. Hanging scroll, ink and light colour on silk. Museum of Fine Arts, Boston, 08.115. Photograph © 2022 Museum of Fine Arts, Boston.

Lee has summed it up perfectly, saying that the album "demonstrates more than a talented court painter's ability to paint a subject of 'inconstant form but constant principle' and more than the marvellous interplay possible between poetic words and poetic images. The paintings are a superb example of the collaboration between empress and court painter producing an object of beauty that was also capable of communicating meaning. At the same time, these paintings preserve an image of personal significance to Empress Yang. Water, the ultimate image of feminine power and virtue, was the perfect correlative to this remarkable woman."[20]

Ultimately, "The Making of Masterpieces" has taken us on a journey that began with the heartbreaking story of Prince Cao Zhi and the Nymph of the Luo River, in which landscape is used to suggest a dreamlike setting as well as to articulate the narrative — and where human figures are larger than trees and even mountains. By the Tang and Northern Song dynasties, the roles are reversed: all kinds of human activities, both lofty and the everyday, are dwarfed by and serve to animate landscapes that are almost incomprehensibly vast. Finally, in the Southern Song, men and women have at times vanished entirely, and we are invited to view landscapes at close range, to be understood solely through the transformative skills of calligrapher and painter.

NOTES

1 Whitaker 1954.
2 The emperor is shown in fig. 2; the empress, in Nelson-Atkins Museum of Art (40–38).
3 See Freer Gallery of Art (F1914.5) and Liaoning Provincial Museum.
4 Chen P. 2012: 237.
5 See British Museum (1930,1015,0.2).
6 Foong 2015: 49.
7 Yu H. 2018.
8 Translation by the author.
9 This work is housed in the Palace Museum, Taipei.
10 This work was not able to travel to Hong Kong for conservation reasons and has been removed from the catalogue of exhibited works.
11 Shaanxi Sheng Bowuguan 1974a and 1974b.
12 See Shanghai Bowuguan 2005: 115.

13 Liu H. 2002; Zheng W. 1978: 18–19, 24–25.
14 This work is housed in the Palace Museum, Taipei. See Lin and Zhang 1989, no. 14.
15 Ibid., no. 12.
16 Zhongguo Gudai Shuhua Jiandingzu 1987–2000, vol. 21: 346.
17 Wu Tung believes that the version of *Travelling Bullock Carts* from the Palace Museum is "slightly later" than the Boston painting, but this is certainly not the case. See Wu T. 1997: 157–158.
18 This work was not able to travel to Hong Kong for conservation reasons and has been removed from the catalogue of exhibited works.
19 Lee H. 2010, 218.
20 Ibid.

郎耶逝没二旬痛傷崩慟

五情破裂不自堪忍痛

當復何言當奈

慕斷絶踊躍何

情心奈何何可言安臥

Robert E. Harrist, Jr.

Special Delivery
Letters from Wang Xizhi and Xie An,
Copies, and Colophons

AT AN OUTDOOR GATHERING IN THE SPRING OF 353 HOSTED BY
Wang Xizhi (303–361) at the Orchid Pavilion near Kuaiji in Zhejiang province,
guests drank from wine cups that had been floated down a small stream on lotus
leaves and composed poems to celebrate the occasion. Collected at the end of the
day, the forty-one poems formed what came to be known as the *Orchid Pavilion
Collection* (*Lanting ji*).[1] Wang Xizhi composed and brushed in his own calligraphy
a preface for these verses that became the most famous work in the history of
Chinese calligraphy.[2] Although he is known as the "sage" of calligraphy, Wang was
not the only notable calligrapher present at the Orchid Pavilion gathering. Among
the guests was Xie An (320–385), who composed two poems that day. Like his close
friend Wang Xizhi, Xie An was a member of a large and prestigious clan whose
origins lay in northern China. When the dynasty under which they lived collapsed,
both the Wang and Xie clans fled south of the Yangzi River and became prominent
under the Eastern Jin dynasty, whose capital was located at Jiankang, known today
as Nanjing.

The Wang, Xie, and other aristocratic clans of the Eastern Jin were united not
only by their political and social prestige but also by ties of marriage and friend-
ship, shared religious beliefs, and aesthetic preferences. One of the manifestations
of these ties was the regular exchange of handwritten letters, usually short missives
inquiring about the recipient's health or reporting on the writer's own, passing on
family news, or remarking on political events.[3] Participating in this exchange of
letters was one of the activities that signified membership in the Eastern Jin elite.

Two works from the Palace Museum included here — copies of letters titled
After Rain in Running Script by Wang Xizhi (cat. 1) and *Death of a Palace Attendant
in Running Script* by Xie An (cat. 2) — originated within the epistolary culture of
the Eastern Jin. The history of these fragile sheets of paper, mounted today in the
same album, carry us deep into the history of Chinese art, to the moment in the
fourth century when letters by Wang Xizhi, Xie An, and other Eastern Jin writers
came to be treasured not for their content but for the beauty of their calligraphy.

Writing created with brush and ink had existed since antiquity in China,
and beautifully written letters were being collected no later than the Eastern
Han dynasty, but it was not until the era of Wang Xizhi and Xie An that we
detect evidence of calligraphy being understood as a fine art, more or less as it is

OPPOSITE
Detail of *Death of a Palace
Attendant in Running Script* (cat. 2).
Xie An (320–385). Southern Song
dynasty, 12th century.

59

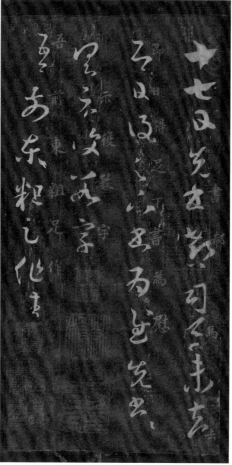

FIGURE 1
On the Seventeenth. After Wang
Xizhi (303–361). Song dynasty,
13th century. Ink rubbing on paper.
The Metropolitan Museum of Art,
Gift of Mr and Mrs Wan-go H. C.
Weng, 1991 (1991.380). Photograph
© The Metropolitan Museum of Art.
Image source: Art Resource, NY.

understood today. Often only a few columns in length, personal letters written on
paper with brush and ink were amassed by collectors, subjected to critical evalua-
tion in a new discourse on calligraphy, changed hands in a burgeoning art market,
and were forged by unscrupulous dealers.[4] Seen in the long history of Chinese art,
letters of the Eastern Jin like those by Wang Xizhi and Xie An stand near the begin-
ning of the formation of a classical tradition of calligraphy that endured over many
centuries.[5] But works such as these would not have achieved canonical status or
shaped the history of calligraphy as they did without their transmission by copying
and replication or without the addition of laudatory colophons through which later
writers enhanced the prestige of letters composed centuries earlier.

READING THE MAIL

Letters are intended to be read, and a good approach to studying the two letters
attributed to Wang Xizhi and Xie An is to begin, as their recipients began, by seeing
what the senders had to say.

The title of the letter attributed to Wang Xizhi, *After Rain*, comes from two
characters in the first line: *yu hou*. As with the titles of most early letters, these

identifying characters are followed by the word *tie* — literally, "a slip of paper" — a term applied more generally to signify handwritten letters. A transcription of the letter provided by the Palace Museum can be translated as follows:

Today, after the rain, I was not able to present [my request?]. If you can speak [to somebody?], you must ask for [a letter?] at your convenience. I will keep it as a model forever. [The calligraphy?] is wonderful and superior, as shown in every movement. I sent a letter to [someone] in the capital. [Someone named?] Dai just stopped by.

Xizhi[6]

Even for experienced readers of the highly abbreviated running script in which the letter is written, the calligraphy is not easy to decipher. This problem is not new. Rubbings of letters by Wang Xizhi were frequently annotated by collectors to make them legible for less expert readers. Such annotations appear in a thirteenth-century album of rubbings of letters by Wang Xizhi known as *On the Seventeenth* (*Shiqi tie*, fig. 1). Writing in red ink, an unknown annotator helpfully added next to each cursive script character the same character in easily readable small standard script.

The legibility of a letter does not ensure its intelligibility. *After Rain* can be understood well enough as a request that the unnamed recipient acquire a sample of someone else's calligraphy; it is, in effect, a letter about Wang Xizhi's desire to own a piece of writing, which Wang says he will treasure. The identity of the recipient, that of the writer of the hoped-for letter, and that of someone named Dai mentioned in the last line cannot be determined — uncertainties indicated in the translation by brackets and question marks.

Death of a Palace Attendant, by Xie An, like many letters of the Eastern Jin, conveys bad news:

On the fifth day of the eighth month, I report to Yuan, Lang, Kuo, You, Jing, Xuan, Yun, and others. I did not expect such a calamity that has suddenly occurred. Zhonglang [the palace attendant] has withered and died. I am in great sorrow, and my heart is broken. I cannot endure it. How painful it is! What can I do! [I know] you all will lament our loss, wailing and weeping. How can the heart bear it? Alas! Alas!

Xi An[7]

The letter is addressed collectively to members of Xie An's family, including several nephews, informing them of the death of his brother Xie Wan (320–361), who held the rank of palace attendant (*zhonglang*) and whose death date provides that of the original letter. Xie Wan had also been a guest at the Orchid Pavilion gathering and was a notable calligrapher and letter writer himself.[8]

Although Eastern Jin letters might have been dashed off in haste or concern trivial matters — such as Wang Xizhi's letter known as *Presenting Oranges* (*Fengju tie*), which is about sending a friend a gift of fruit[9] — the writers expected that samples of their calligraphy would be preserved. To do otherwise was an affront. For example, after receiving a letter from Wang Xianzhi (344–386), the son of Xizhi and a famous calligrapher in his own right, Xie An insulted the younger man by returning his letter, on which Xie had scribbled a reply.[10] Writers could also expect that recipients would show their letters to other readers. Through inheritance or purchase, letters changed hands after the lifetimes of both writers and recipients. But the dissemination of a writer's calligraphic style displayed in personal letters, and their achievement of fame as a calligrapher, required the production of copies.

Although copies of letters were made by other Eastern Jin calligraphers, including Xie An, we know far more about the copies of letters by Wang Xizhi. It was during Wang's lifetime that copies of his writing first were mistaken for originals. According to the critic and historian of calligraphy Yu He (active ca. 470), among the first to be confused by such copies was Wang Xizhi himself: "[Wang] Xizhi personally wrote a memorial to Emperor Mu [r. 345–361]. The emperor had Zhang Yi make a copy of it, which differed not by a single hair. He then wrote an answer after [the copied memorial and returned it to Wang]. At first, Xizhi did not recognise [that it was a copy]. He examined it more closely, then sighed and said, 'This fellow almost confounded the real.'"[11]

Emperor Mu's prank heralded the growth of a cottage industry producing copies of Wang Xizhi's calligraphy, including his correspondence. Some copies were intended to preserve and transmit Wang's style by providing models for aspiring calligraphers; others were forgeries intended to deceive collectors eager to own samples of Wang Xizhi's writing.[12] Skilful forgers not only perfected the ability to imitate Wang's style with brush and ink but also used tricks such as soaking copies in dirty water to make them look older. Although some imitations of Wang's calligraphy were pure inventions not based on original works, early sources rarely mention such forgeries, devoting far more attention to discerning the differences between originals and copies.[13]

Two methods of reproducing calligraphy were in use by the sixth century. The simplest, known as *lin* (leaning over), reproduced calligraphy through freehand copying, the copyist working with the original on a writing desk next to the paper — or, more rarely, the silk — on which the reproduction was to be made. Although freehand copies could closely approach the appearance of their models, the most accurate copies were produced through a more laborious process known in Chinese as *mo* (tracing). In the most precise form of tracing, called *shuanggou*

FIGURE 2

Letter to the Two Xie. After Wang Xizhi (303–361). Tang dynasty, 8th century. Section of a hand-scroll, ink on paper. Sannomaru Shozokan (Museum of the Imperial Collections).

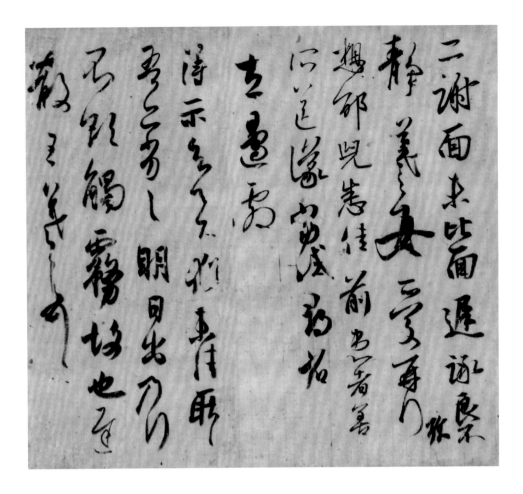

tianmo (double outline filled-in ink), a sheet of paper was placed over the original brushwork to be reproduced, and the outlines of the strokes were carefully traced and then filled in with ink.[14] The result was a copy exactly the same size as the original, in the same medium, and it was often indistinguishable from the original without the aid of magnification. One telltale feature of tracings done in this method are minute "swallow-tails" created by the overlapping of traced lines.[15]

Made through the outline and fill-in process, the earliest known copies of Wang Xizhi's letters have been preserved since the eighth century in Japan, where they were brought from China as gifts to the Japanese emperor Kanmu (r. 781–806). One of these extraordinary copies, *Letter to the Two Xie (Erxie tie),* was almost certainly addressed to Xie An and his brother Xie Wan (fig. 2).[16] There is good reason to believe that this letter, executed in a combination of running and cursive script, was traced directly from an ink-written original in the Tang imperial collection, likely during the reign of Emperor Taizong (r. 627–649). It was this ruler who assured the status of Wang Xizhi as the most illustrious of all calligraphers, making the study of Wang's style mandatory among members of his court and acquiring by fiat or trickery every known piece of Wang's calligraphy.[17] Produced thanks to

Taizong's efforts and inspired by political goals as well as aesthetic taste, the Tang tracing copies probably bring us as close as we will ever get to the brushwork of Wang Xizhi.

Although tracing copies of letters by Wang Xizhi and others in his orbit potentially made knowledge of their styles available to people who did not have access to imperial or private collections, they were not widely circulated, and the tracing copies alone were not sufficient to reach large numbers of viewers or calligraphers who hoped to emulate masters whose names they might have heard but whose calligraphy they had never seen. To make this dissemination possible, rubbings were indispensable. The first step in producing a rubbing is like that for making a tracing copy.[18] A tracing of a brush-written original is engraved on stone or wood, and from that large numbers of rubbings can be made by a placing a moistened sheet of paper over the intaglio characters and tamping the paper with an ink pad. The characters are reproduced as white shapes on a black background, as seen in the rubbing of *On the Seventeenth* noted above (fig. 1). The capacity of this process to replicate details of brushwork is remarkable, as demonstrated by a comparison of a tracing of Wang Xizhi's *Letter about my Great Aunt* (*Yimu tie*), dated to the year 697, and a rubbing of the same letter from the sixteenth century (figs. 3–4).[19] The rubbing preserves all but the finest details of brushwork, such as beginnings and endings of strokes, which were simplified in the process of making the rubbing.

In the tenth century, the Song emperor Taizong (r. 976–997), assuming the mantle of imperial arbiter of calligraphic taste inherited from his Tang predecessor, sponsored the first compendium of rubbings, never officially titled but known most commonly as *Model Letters in the Imperial Archives in the Chunhua Era* (*Chunhua bige fatie*), completed in 992.[20] The ten volumes of this work comprise 419 rubbings of letters, 160 of them by Wang Xizhi. Among other letters by writers of the Eastern Jin in *Model Letters* is *Always Remembering the Gentleman* (*Meinian jun tie*, fig. 5) by Xie An. As the term *fatie* (model letters) indicates, the collected rubbings were intended to provide models to be copied by calligraphers and to preserve revered works for the delectation of connoisseurs. Although the selection of letters in Taizong's compendium was harshly criticised soon after it appeared, many reproductions of the *Model Letters* were cut and widely disseminated.

Relatively few compendia were published in the later Song and Yuan periods, but a boom in publishing and art collecting during the Ming dynasty was accompanied by the production and marketing of collections of model letters, which continued to be published into modern times.[21] These collections, dominated by personal letters, profoundly shaped the history of Chinese calligraphy. For writers who wished to base their art on near-legendary Eastern Jin works in the hope of creating their own masterpieces, as well as for collectors and antiquarians eager to gain knowledge of lost or inaccessible works, copies in the form of model letters were the most accessible guides.

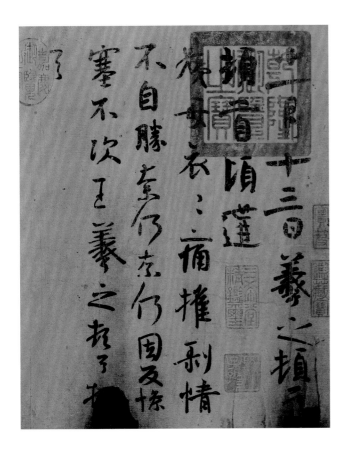
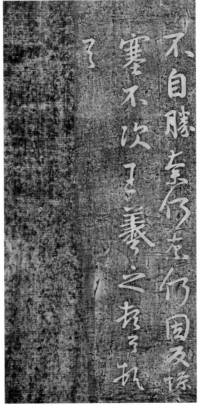
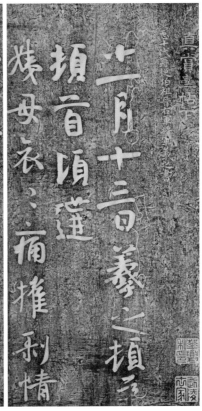

FIGURE 3
Letter about my Great Aunt.
After Wang Xizhi (303–361).
Tang dynasty, 697. Section of
a handscroll, ink on paper.
Liaoning Provincial Museum.

FIGURE 4
Letter about my Great Aunt.
After Wang Xizhi (303–361).
Ming dynasty, 1522. Ink rubbing
from *Letters from the Studio of
True Enjoyment* (*Zhenshang zhai
tie*). The Palace Museum.

Reproduced with brush and ink as freehand or traced copies or through rubbings, the Eastern Jin letters that are the foundation of the classical tradition of Chinese calligraphy each have tangled histories; each exist at varying degrees of separation from artefacts that in almost all cases no longer exist. Even a brief exploration of the histories of *After Rain* and *Death of a Palace Attendant* demonstrates some of these complexities.

The one short and four long columns of *After Rain* are written on paper darkened by age.[22] The tonality of the ink is uniform, indicating that the calligrapher kept the brush loaded with thick, dark ink, not allowing the brush to become dry enough for separating hairs of the brush tip to produce the effect known as "flying white" (*feibai*). Although the spacing of the cursive script characters in the first two columns is generally uniform, the spacing becomes more irregular and the writing freer in the third column, where ligatures join characters and individual strokes. Far below the two characters of the short final column is Wang Xizhi's signature and an unidentified name: Yumin.

Like *every* piece of calligraphy attributed to Wang Xizhi, *After Rain* raises questions that connoisseurs have been asking for many centuries.

First: Is it real?

If by "real" is meant a work from the brush of Wang Xizhi, the answer is almost surely no. Letters on paper from even earlier than the fourth century have survived, mainly in archaeological contexts, but they are exceedingly rare; that the history of the transmission of calligraphy by Wang Xizhi is known to be one of copying and forgery reduces to almost nil the chances that even a few lines brushed by Wang himself have survived.[23] In the absence of any visual evidence of tracing, curators at the Palace Museum have concluded that *After Rain* is a freehand copy.

From this conclusion follows a second question: If it is not by Wang Xizhi, is it a copy of something he *did* write?

To answer requires comparing *After Rain* with scores of other letters attributed to Wang Xizhi. The tracings datable to the Tang period are the best evidence of Wang's style, but even among these copies there is considerable variation. Compare, for example, the *Letter about my Great Aunt* introduced earlier (fig. 3) and *Disorder during Mourning* (*Sangluan tie*, fig. 6), from the Japanese imperial collection, a traced copy believed by some scholars to have been made even earlier than the Tang period. In spite of their shared status as very early copies of writing ostensibly by the same person, they differ significantly in style. The blunt, deliberate strokes of *Letter about my Great Aunt* show little of the dashing and varied brushwork, alternation of thick and thin lines, and dense and sparse characters that enliven *Disorder during Mourning*. A survey of other early tracings would broaden further the range of calligraphic styles that collectively form our vision of how a work of calligraphy by Wang Xizhi should look. The range is broad but not limitless. If *After Rain* is

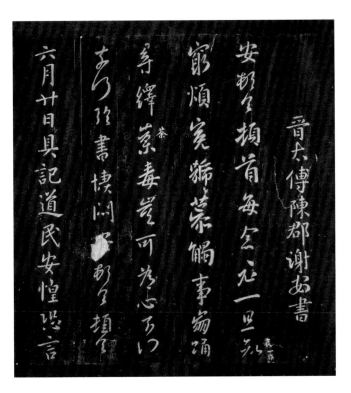

FIGURE 5
Always Remembering the Gentleman.
After Xie An (320–385). Northern
Song dynasty, 992. Ink rubbing from
*Model Letters in the Imperial Archives
in the Chunhua Era* (*Chunhua bige
fatie*). The Palace Museum.

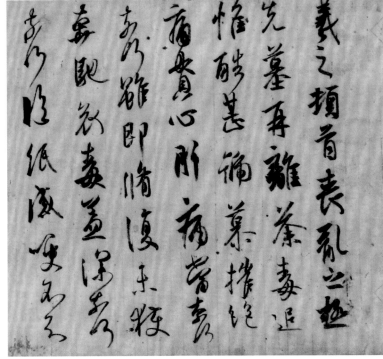

FIGURE 6
Detail of *Disorder during Mourning.*
After Wang Xizhi (303–361). Tang
dynasty, possibly 8th century.
Section of a handscroll, ink on paper.
Sannomaru Shozokan (Museum of
the Imperial Collections).

FIGURE 7
Thousand-Character Classic.
Emperor Gaozong (r. 1127–1162)
after Yu Shinan (558–638). Song
dynasty. Section of a handscroll,
ink on silk. Shanghai Museum.

based, however remotely, on a work by Wang Xizhi, it is a very free copy; the somewhat coarse brushwork is most likely the product of a calligrapher acquainted with Wang's style but lacking the sureness of touch seen in the early tracings.

No early records of Wang Xizhi's calligraphy mention *After Rain*. Seals stamped on the letter include two ostensibly from the sixth century: One reads "Shi Nan", the name of the famous Tang dynasty calligrapher Yu Shinan (558–638) to whom a copy of the *Orchid Pavilion Preface* is attributed (cat. 6); the other reads "Correctly inspected" (*zhenguan*), the legend of a seal used during the reign of the Tang emperor Taizong to authenticate works of calligraphy. Both are clumsily painted in black ink: obviously the work of someone attempting to provide an impressive pedigree for the letter. A seal reading *Shaoxing* — used by the Song emperor Gaozong (r. 1127–1162) after his first abdication — stamped on the letter is authentic and supports dating *After Rain* to no later than the twelfth century. Although the letter is recorded in several Qing dynasty catalogues, is does not appear in any model-letters compendia.

Death of a Palace Attendant has a history of transmission and appreciation far richer and more complex than that of *After Rain*.[24] The seven-column letter opens with generously spaced characters in a combination of standard and running script; as the letter continues, the writing becomes more cursive, the strokes lighter and joined by thin ligatures. Examples of calligraphy attributed to Xie An with which this writing might be compared are far rarer than those attributed to Wang Xizhi. The slanting brushwork and tilting characters of the earliest datable evidence of Xie An's writing — his letter in the *Model Letters in the Imperial Archive in the Chunhua Era* (fig. 5) — more closely resemble features in copies of Wang Xizhi's letters, such as *Disorder during Mourning*, than they do *Death of a Palace Attendant*. Through comparisons such as this, as well as through close examination of ink and paper, curators at the Palace Museum have identified the letter as a free-hand copy from the time of Emperor Gaozong, whose *Deshou* seal, which also appears on *After Rain,* is stamped on the letter. Gaozong himself was a noted calligrapher and frequently made copies of works in his collection. Placed next to the emperor's copy of Yu Shinan's *Thousand-Character Classic* (*Qianziwen*, fig. 7), the Xie An letter in Beijing displays a "family resemblance" to the emperor's fluid but somewhat bland brushwork in both standard and cursive script.[25]

Decades before the Beijing copy of Xie An's letter was made, a letter consisting of the same sixty-five characters had entered the history of calligraphy as a revered masterpiece. It was acquired in 1101 by the great calligrapher and connoisseur Mi Fu (1051–1107), who is represented in *The Making of Masterpieces* by his scroll *Encomium on a Mountain Inkstone in Running Script* (cat. 9). In a colophon written for the letter, Mi identifies it simply as *Letter by Xie Anshi* (*Xie Anshi tie*), referring to the calligrapher by his polite name.[26] Mi Fu had seen the letter during the *yuanyou*

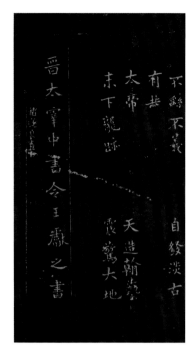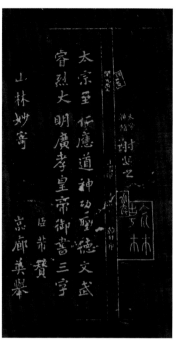

reign period (1086–1195) along with thirteen other works by Jin masters mounted in a scroll owned by the Grand Preceptor Li Wei (active late eleventh–early twelfth centuries). According to Mi Fu, the letter bore an impressive array of Tang dynasty imperial seals and seals of early private collectors. Also adding to the prestige of the letter were the characters "Written by Xie An" from the hand of the Song emperor Taizong, who borrowed the letter for inclusion in the *Model Letters of the Imperial Archive* but ultimately did not include it in the compendium and returned it to its owner bearing these traces of the imperial brush. By Mi Fu's own account, the letter entered his collection more than ten years after he had first seen it:

> I especially loved this piece and wanted to obtain it by trading rare objets d'art. I negotiated for ten years without success. But during the *yuanfu* era (1098–1100) it came into the possession of the President of the Hanlin Academy, Lord Cai Jing (1046–1126). On the tenth day of the second lunar month of the first year of the Jianzhongjingguo era (1101) he allowed it to come to me, because I loved it so sincerely.[27]

Trying to establish the fate of Mi Fu's collection after his death in 1107 leads, as Lothar Ledderose put it, "into obscurity".[28] A work by Xie An titled *Death of a Palace Attendant* (*Zhonglang tie*) is listed in the *Xuanhe Catalogue of Calligraphy* (*Xuanhe shupu*), the inventory of Emperor Huizong's collection compiled around 1120, and it has been identified by some scholars as the letter owned by Mi Fu, though Xue Lei recently has argued that this was a different piece of calligraphy.[29]

FIGURE 8
Death of a Palace Attendant. After Xie An (320–385). Song dynasty, 13th century. Ink rubbing from *Model Letters of the Studio where the Jin is Treasured* (*Baojinzhai fatie*). Shanghai Library.

FIGURE 9
Left: detail of *Death of a Palace
Attendant in Running Script* (cat. 2).
Xie An (320–385). Southern Song
dynasty. Right: detail of *Death of a
Palace Attendant* (fig. 8).

FIGURE 10
Death of a Palace Attendant. Mi Fu
(1051–1107) after Xie An (320–385).
Song dynasty, 12th or 13th century.
Ink rubbing. Shanghai Library.

It was long believed that Mi Fu was so enamoured with the Xie An letter that
in 1104 he had it, along with letters by Wang Xizhi and Wang Xianzhi from his
collection, engraved on stones. The stones were damaged by a fire, but recuttings
of them, based on rubbings made before the fire, became the core of a model-
letters compendium assembled in 1268, *Model Letters of the Studio where the Jin
is Treasured* (*Baojin zhai fatie*), a title taken from the name of Mi Fu's studio.[30]
A rubbing from this collection reproduces the letter Mi Fu so ardently prized as
well as some of the Tang seals and the Song emperor Taizong's inscription that
Mi Fu recorded, followed by a *zan,* praising the calligraphy of the emperor's three
characters — "the calligraphy of Xie Gong" identifying the letter as the work of
Xie An (fig. 8).[31] There can be no doubt that the model followed by the copyist of
the Xie An letter in Beijing derived, however indirectly, from the letter owned by
Mi Fu, though a comparison starkly reveals the absence of fine details of brushwork
in the ink-written freehand copy that can be seen in the rubbing (fig. 9).

Preserved also in a rubbing datable to the Song period is a copy of the Xie An
letter by Mi Fu himself, now in the Shanghai Library (fig. 10).[32] Mi captured the
elegant fluidity of Xie An's writing but did not attempt to create a facsimile of the

letter: abbreviations of characters, elongations of brushstrokes, and striking juxta-positions of thick and thin lines are features of Mi Fu's own distinctive style. Rather than a copy, this work can be understood as an admiring reinterpretation of the Eastern Jin masterpiece — a fusion of the styles of Xie An and Mi Fu.

POSTSCRIPTS

Rubbings of *Death of a Palace Attendant*, like rubbings of hundreds of Eastern Jin letters, continued to be preserved and disseminated in model-letters compendia, including the famous but controversial *Model Letters from the Hall of Playing Geese* (*Xihong tang fatie*) produced by the eminent painter, calligrapher, and theorist Dong Qichang (1555–1636).[33] Also, like other Eastern Jin letters transmitted as both ink copies and rubbings, *After Rain* and *Death of a Palace Attendant* inspired the production of more writing in the form of colophons. Usually consisting of appre-ciative comments and art historical observations, colophons written for Chinese paintings and works of calligraphy often achieved the status of major works of art in their own right. Those composed by eminent artists, collectors, or connoisseurs also had the potential to increase not only the aesthetic but also the monetary value of works to which they were appended.

The earliest colophon concerning the Xie An letter, datable to around 1087, is a short but superb sample of Mi Fu's calligraphy, written when the work was still

FIGURE 11
Grand Preceptor Li (*Li Taishi tie*). Mi Fu (1051–1107). Song dynasty, around 1087. Album leaf mounted as a handscroll, ink on paper. Tokyo National Museum, TB1458. Photograph © TNM Image Archives.

FIGURE 12
Detail of *Death of a Palace
Attendant* (fig. 8).

FIGURE 13
*Encomium on the Calligraphy of
Emperor Taizong of Song.* Wang Duo
(1592–1652) after Mi Fu (1051–1107).
Ming dynasty. Hanging scroll,
ink on paper. Anhui Provincial
Museum.

in the possession of Li Wei (fig. 11). Preserved in the Tokyo National Museum, the colophon alludes to the story of Xie An's insult to Wang Xianzhi mentioned in the opening section of this essay:

> The Grand Preceptor Li Wei has the "Fourteen Pieces by Sages of the Jin Dynasty" in his collection. The calligraphy of emperor Wu of Jin (r. 265–290) and of Wang Rong (234–305) are like the great seal script. Xie An's style is even superior to that of Wang Xianzhi. Indeed, Xie An was right when he wrote his answers at the end of [Wang Xianzhi's] letter.[34]

Once the Xie An letter entered his collection, Mi Fu composed the much longer colophon quoted above recording his years-long attempt to acquire the letter; he also composed a celebratory poem sent to a friend.[35] Many centuries later, Mi Fu's

encomium to the three characters written by the Song emperor Taizong inspired a monumental hanging scroll by Wang Duo (1592–1652; figs. 12–13). It was not, however, the style of Mi Fu's calligraphy but the text of his verses praising the Song emperor's writing that Wang appropriated for his scroll, following a practice common in his oeuvre of freely rewriting the texts of earlier works — including letters by Wang Xizhi — in his own distinctive calligraphy. Wang Duo's spectacular scroll adds yet another link in the long chain of works extending back to Xie An's original letter.[36]

Colophons often record intimate encounters between the writer and a work of calligraphy. Such an encounter is the subject of a colophon for *After Rain* written by the Yuan dynasty calligrapher Deng Wenyuan (1259–1328; fig. 14):

To the right is *After Rain,* an authentic work of Wang Youjun [Xizhi].

A table by a bright window
As evening snow begins to clear
Obtaining and opening this to enjoy
What a happy pleasure!

Fifteenth day of the twelfth month, Deng Wenyuan of Zuoxian viewed [this] at the Studio of Unadorned Shoes of his Wulin residence.

Deng Wenyuan is known as a master of draft-cursive script, but his colophon is written in a dashing running script style that recalls that of his great contemporary Zhao Mengfu (1254–1322), who based his calligraphy on intensive study of works by Wang Xizhi.

It is not clear if Deng Wenyuan owned *After Rain;* his seals appear below the signature of his colophon but not on the letter itself, and it is possible that the enjoyment of viewing the letter he writes about was made possible by borrowing it from a friend. Deng identifies the letter as an "authentic trace" (*zhenji*) from the hand of Wang Xizhi — a conclusion, as argued earlier, rejected by scholars today. Apparent in countless other colophons is a tendency to accept attributions that now seem far-fetched; written by collectors or their friends, these texts usually are laudatory and take a liberal view of issues of authenticity. This is true of the colophon to *After Rain* datable to 1629 by Dong Qichang (fig. 15). At the time he saw the letter, it apparently was mounted with another work attributed to Wang Xizhi, both of which Dong considered authentic. Even more surprisingly, Dong seems to have accepted as genuine the forged seal of Yu Shinan painted on *After Rain*. The value of Dong's colophon lies not in its art historical or connoisseurial insights but in the excellence of his calligraphy, written in the elegant small running script he often used for writing colophons and inscribing paintings.[37]

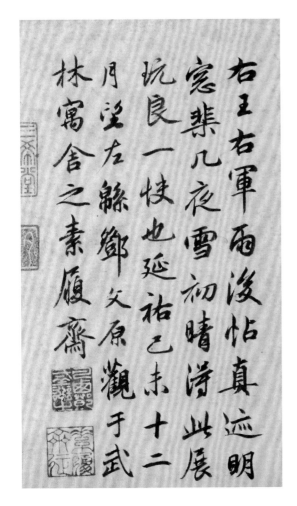

FIGURE 14
Colophon for *After Rain in Running Script* (cat. 1). Deng Wenyuan (1259–1328). Yuan dynasty, 1319.

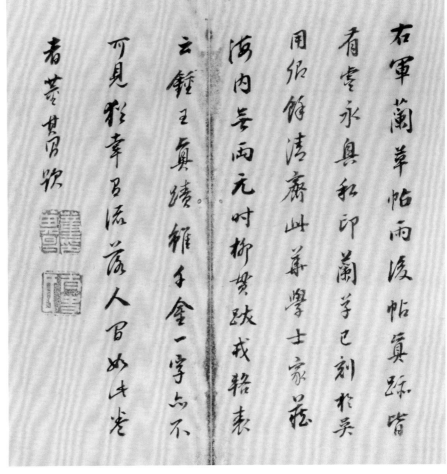

FIGURE 15
Colophon for *After Rain in Running Script* (cat. 1). Dong Qichang (1555–1636). Ming dynasty, 1629.

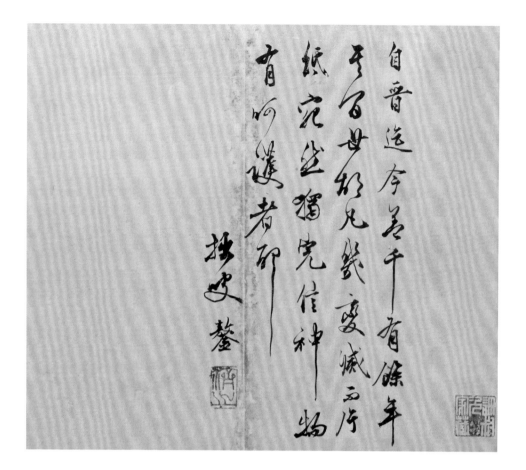

FIGURE 16
Colophon for *Death of a Palace Attendant in Running Script* (cat. 2). Wang Ao (1450–1524). Ming dynasty.

Colophons appended to Eastern Jin letters that were accepted as artefacts from the remote past, regardless of their more likely status as copies, inspired expressions of amazement by those fortunate enough to have owned or viewed them. In his colophon for *Death of a Palace Attendant in Running Script* (fig. 16), the Ming calligrapher Wang Ao (1450–1524) wrote of the near miraculous survival of early letters in a world where everything passes away:

> From the Jin [dynasty] to the present has been more than a thousand years, during which almost all things of the world have changed and been destroyed, yet these slips of paper alone have survived. I believe these sacred objects have had a [supernatural] protector.

It was not merely the physical survival of artefacts from the past that touched colophon writers. An individual named Xuanzheng, whose identity and dates are uncertain, wrote of the spiritual bond he felt with the calligraphers of old letters as he looked at *Death of a Palace Attendant* (fig. 17):

> I am living a thousand one hundred years after [the letter was written] … yet the feelings and ideas of ancients and moderns are the same. The words and

FIGURE 17
Colophon for *Death of a Palace
Attendant in Running Script* (cat. 2).
Xuanzheng. Ming dynasty.

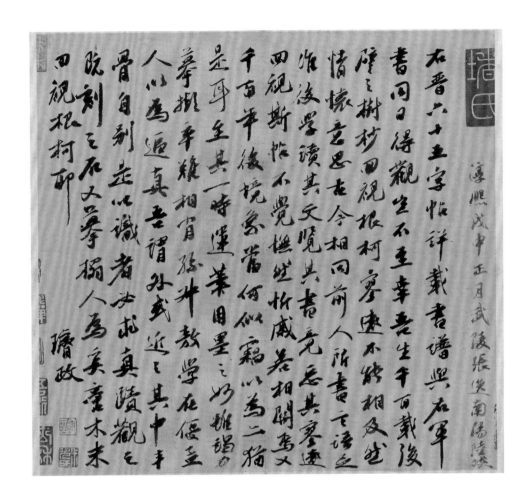

phrases written by former men are enough, so that after reading their words
and examining their calligraphy, one completely forgets their remoteness.
Looking back at this letter does one not feel startled by mutual happiness
and grief?

Calligraphers of the Eastern Jin may have expected that their beautifully
written missives would be preserved, but it is unlikely that they or the recipients
of their letters could have imagined that these slips of paper would join a canon of
calligraphic masterpieces and that reading other people's mail would play a central
role in the history of Chinese art.

NOTES

1 For an introduction to the Orchid Pavilion
Gathering and translations of the poems, see
Schwartz 2012.
2 The original manuscript, known as the *Orchid
Pavilion Preface* (*Lantingji xu*), disappeared

forever when it was buried with the Tang
emperor Taizong (r. 627–649), but it has been
transmitted to our own day in the form of
ink-written copies and rubbings. One such copy,
attributed to the Tang court calligrapher Yu

Shinan, is preserved in the Palace Museum and is included in the present exhibition (cat. 2).

3 For early letters in China, see Richter 2013; see also Bai 1999.

4 Harrist 2004.

5 The best introduction in a Western language to the early history of Chinese calligraphy remains Ledderose 1979. The current essay is deeply indebted to Professor Ledderose's pioneering work.

6 See Li Yanxia, "Wang Xizhi xingcaoshu Yuhou tieye (Song moben)", Palace Museum website, accessed 15 March 2021, https://www .dpm.org.cn/collection/handwriting/231120 .html. For a slightly different transcription of the text of the letter, see Liu et al. 1991–, vol. 19: 31. My translations of this letter and that attributed to Xie An are based on translations prepared by Professor Xue Lei, to whom I am most grateful for allowing me to read his study of the letter by Xie An. See Xue 2021.

7 The Xie An letter has been known by several titles, including *Letter on the Fifth Day of the Eighth Month* (*Bayue wuri tie*) and *Letter Reporting to Yuan and Lang* (*Bao Yuan Lang tie*). See Liu et al. 1991–, vol. 20: 339.

8 Liu et al. 1991–, vol. 20: 339–340. I am grateful to Dr Alfreda Murck for her help in translating Xie Wan's title.

9 Ledderose 1979: pl. 18.

10 See Sturman 1997: 101; and Richter 2013: 33.

11 "Lunshu biao" in Zhang Yanyuan 1993.

12 My use of the term "forgery" refers not simply to an artefact but to a set of circumstances through which an act of deception takes place. See Harrist 2004.

13 Harrist 2004.

14 This is the method recommended by the Daoist master Tao Hongjing (456–536) for copying magical talismans. Ledderose 1984.

15 Ledderose 1979: pl. 20.

16 Liu et al. 1991–, vol. 18: 79.

17 Ledderose 1979: 25–26.

18 For a concise account of this process, see Xue 2019: 13–14.

19 The rubbing is from *Model Letters from the Studio of True Enjoyment* (*Zhenshang zhai fatie*), compiled by Hua Xia (1490–1563) and reproduced in Ledderose 1979: pl. 9.

20 McNair 1994.

21 Xue 2019: 90–92.

22 See the notes prepared by the Palace Museum concerning paper and brushes used for this letter by Li Yanxia (see note 24). As

pointed out in that entry, bamboo paper of the kind used for *After Rain* was not produced during the time of Wang Xizhi. See also the observations by the scholar writing under the pen name Ahtao, who points out cogent reasons why the letter cannot be from the hand of Wang Xizhi: Liu et al. 1991–, vol. 19: 366.

23 Harrist 2002.

24 For a brief entry concerning the letter, see Li Yanxia, "*Zhonglang tie*", Palace Museum website, accessed 13 March 2021, https://www .dpm.org.cn/collection/handwriting/231119 .html. See also "Xi An, Zhonglang tie, Gugong Bowuyuan, Xingshu baiben", Zhongguo shuhua wenhua gongyi chuanbo (website), September 26, 2018, http://www.shuhua5000 .com/content/?1393.html.

25 For a study of Gaozong's calligraphy, see Chu 1991.

26 The text of this colophon is recorded in collections of Mi Fu's comments published long after his death. See Mi Fu 1985: 1, 7.8a–b; and *Haiyue tiba*, 3a–b, cited in Ledderose 1979: 112, 168. The earliest version of the text ostensibly preserved in Mi Fu's own calligraphy appears on the rubbing of the Xie An letter in *Model Letters from the Hall of Playing Geese* (*Xihong tang fatie*). For the complex history of the transmission of Mi Fu's colophon, see Xue 2021.

27 Translation in Ledderose 1979: 111–12 and 112, 168.

28 Ledderose 1979: 94.

29 Xue 2021.

30 The history of *Model Letters of the Studio where the Jin is Treasured* (*Baojin zhai fatie*) is summarised in Ledderose 1979: 61–62. Certain details of this account are challenged in Xue 2021.

31 A rubbing of the letter datable to 1188 bearing a colophon by Mi Fu's great-grandson appears in *Model Letters of the Hall of Pine and Cassia* (*Songgui tang tie*), a model-letters compendium in the collection of the Palace Museum, Beijing. Xue Lei argues that this rubbing may better preserve the appearance of the Xie An letter than the more widely known rubbing in *Model Letters of the Studio where the Jin is Treasured* (*Baojin zhai fatie*). See Xue 2021.

32 A rubbing of a different version of Mi Fu's copy of the Xie An letter is preserved in the National Museum of China, Beijing. In that copy, said to date from the Southern Song

period, the spacing of the characters has been rearranged. Following the letter is another version of Mi Fu's encomium to the calligraphy of the Song emperor Taizong, written in larger characters. See Lü 2018: 32–35.

33 For a concise account of this compendium, see Xue 2019: 93–96.

34 Ledderose 1979: 112. See also "*Li Taishi tie (Xingshu santie juan)*" Tokyo National Museum (website), 23 October 2015, https://webarchives .tnm.jp/imgsearch/show/C0016622.

35 Mi Fu 1985: 16. Sent to a friend named Wang Yanzhou, Mi Fu's poem celebrates his good fortune in acquiring the Xie An letter.

36 Wang Duo apparently mistook the content of Mi Fu's encomium as the Xie An letter itself, though the object of Mi's effusive praise was the writing of the Song emperor Taizong. For Wang Duo's practice of rewriting early letters, see Ching 1999.

37 I am grateful to Celia Carrington Riely for her authentication of Dong Qichang's colophon and for information about its seals and probable date. Email to the author, 28 January 2021.

是日也天朗氣清惠風和暢仰
觀宇宙之大俯察品類之盛
所以遊目騁懷足以極視聽之
娛信可樂也夫人之相與俯仰
一世或取諸懷抱悟言一室之內
或因寄所託放浪形骸之外雖
趣舍萬殊靜躁不同當其欣
於所遇暫得於己快然自

Wang Yimin

Wang Xizhi's *Orchid Pavilion Preface*
Its Historical Position and Fabricated Attributions among Copies and Rubbings

THE ORCHID PAVILION PREFACE MARKED NOT ONLY THE REALISATION of Wang Xizhi's (303–361 CE) mature calligraphic style but also the transformation of Chinese calligraphy into an art form in its own right. Originally little more than a practical skill of minor scribes, calligraphy was now elevated to a form of expression through which nobles and scholars manifested their personality such that aesthetics eclipsed functionality. A calligrapher's background, style, text, tools, and state of mind began to matter and were deemed to be interrelated. The preface came to define a high point of calligraphy and has served as a model that calligraphers have sought to match ever since. Like any legendary artwork, it has been the subject to myth making and has lent itself to disparate theories and suppositions. In the Tang and Song dynasties, when the original was lost, copies — traced or freehand — proliferated along with carvings, which were often controversially attributed to calligraphers of great renown. Despite the innumerable scholarly writings it has inspired, this masterpiece can be properly understood and evaluated only when its author, Wang Xizhi, and the Tang calligraphers to whom its copies and rubbings have been attributed are put in perspective.

WANG XIZHI: THE EMERGENCE OF CALLIGRAPHERS FROM PRIVILEGED BACKGROUNDS

The long history of Chinese calligraphy charts a continuous process of beautification and simplification of written Chinese characters.[1] These characters have been exemplified by neatness and consistency since their earliest mature form was seen in oracle-bone inscriptions during the Shang dynasty. Before the Han dynasty, calligraphers remained anonymous no matter how meritorious their work might be. At that time, calligraphy was generally produced on bronzes, stones, bamboo slips, or silks by lowly scribes who were limited, by status and available script types, from gaining recognition for their skill. During the Eastern Han period, scholar-officials who commanded respect in society began to turn to calligraphy as a means for self-expression, drawing on a wider range of script types to choose from. It was then that calligraphy was liberated from mere functionality to become a way of showcasing one's learning, cultivation, personality, and social status. By the Wei and Jin periods, the art of writing had come into vogue in the upper echelons of Chinese society, and the more adept writers were recognised as calligraphers.

Works of calligraphy were thus associated with their authors, and anonymity was soon a thing of the past. During this period, when idiosyncrasy prevailed over conformity to established norms, the world of calligraphy saw the emergence of new script types, styles, masters, and theories. Calligraphy emerged as an independent art form that was exemplified by Wang Xizhi and his *Orchid Pavilion Preface*. Together with Zhong You (151–230 CE), a predecessor who likewise came from a prestigious family of political importance, Wang Xizhi created works regarded as exemplars that were passionately emulated by followers of the model-calligraphy school which began to take shape in the Song dynasty.

Prior to the time of Zhong You and Wang Xizhi, it was rare to ascribe works to calligraphers or to document the authorship of inscriptions on stones or bronzes and writings on bamboo slips or silk. During the Han dynasty, calligraphy was understood to be a job for petty officials too unimportant to be recognised for their art.[2] This disdain was even shared by Cai Yong (132–192 CE); a high official of the Eastern Han dynasty and a calligrapher so revered that he was entrusted with writing the imperially commissioned *Stone Classics of the Xiping Reign* (*Xiping shijing*), he spoke out against preparing artistic and literary talents for any worthy official positions.[3] For example, while Shi Zhou (active 8th century BCE), a Grand Scribe during the Western Zhou dynasty was credited with standardising great seal script, and Li Si (d. 208 BCE), who served as prime minister in the Qin dynasty, was understood to have simplified it to create small seal script, no works were attributed to either men.[4]

During the Tang dynasty, however, impressive attributions, especially to Wang Xizhi and Zhong You, were often made based on nothing more than pure imagination, perhaps in order to enhance the standing of calligraphy among elites. As a result, Shi Zhou was thought to be the creator of the *Stone Drum Inscriptions* (*Shigu wen*), while the *Stele of Mount Tai* (*Tai Shan keshi*) and the *Stele of Mount Yi* (*Yi Shan keshi*) were both credited to Li Si. Later steles were also ascribed at will to unrelated eminences, even if they bore the signature of the actual calligrapher. Thus, the unsigned *Stele for Fan Shi* (*Fan Shi bei*) was attributed to Cai Yong, who was also widely believed to have been the calligrapher of *Stele Inscription of the Mount Hua Temple at the West Peak in Clerical Script* (*Xiyue Hua Shan miaobei*; fig. 1), even though that work is signed by a scribe named Guo Xiangcha (active 2nd century).[5] This phenomenon of spurious attribution illuminates the Tang conviction that masterpieces *must* have come from the hands of distinguished calligraphers in high positions, even in ancient times, although high-ranking officials did not see calligraphy skills as something worthy of boasting of or a stepping stone to higher office.

As time went by, the number of lovers and accomplished practitioners of calligraphy in the upper echelons of society grew. Zhang Zhi (d. ca. 192 CE) and Zhang

FIGURE 1

Stele Inscription of the Mount Hua Temple at the West Peak in Clerical Script. Song dynasty. Rubbing, ink on paper. The Palace Museum.

Chao (active 2nd century), for instance, were lauded for their cursive script, and Cui Yuan (77–142 CE) was celebrated for his treatise "Configuration of Cursive Script" ("Caoshu shi") in the *History of the Later Han Dynasty* (*Houhan shu*), which chronicles the Eastern Han through biographies.[6] In the late Eastern Han, cursive script was commonly used for personal letters. By the Wei and Jin periods it had developed into a casual script that was by far the favourite among scholar-officials and one of the three script types at which Zhong You excelled.[7] Unlike more formal scripts — such as ornamental bird-insect script reserved for emblems and talismans, the solemn seal and clerical scripts used for stone inscriptions, and regular script used for textbooks and official documents — running and cursive scripts gave calligraphers greater freedom of expression, providing elites with a means to artistically project their personality. Among the pioneers of this new calligraphic preference, Zhong You was most familiar with stone-inscription script, while Wang Xizhi was an expert in all script types. Indeed, Wang Xizhi was later considered by the Song emperor Huizong (r. 1101–1125) to have inherited the best traits of Zhang Zhi and Zhong You — and hence was peerless in the realm of calligraphy, especially running script. These skills and accomplishments reached their culmination in the stylistic breakthrough of the *Orchid Pavilion Preface*.[8]

The innovations Wang Xizhi achieved in the *Orchid Pavilion Preface* hinged on the calligrapher's emotional state in his later years, on the preferences of the period, and on the context of its creation. Despite his prestigious background, Wang Xizhi did not aspire to a career in the civil service.[9] Instead, he took pleasure in gathering with like-minded men of letters in the embrace of nature. As might be expected, the works he produced in such a state of mind convey an ease absent from earlier works. Unlike inscriptions on steles or writings on bamboo slips, Wang's preface was not intended to be an official document and was thus unrestricted by format or context. Since its readers were meant to be friends or relatives, Wang Xizhi was apparently focused more on content than calligraphy. In this particular work, unrestrained calligraphy, genuine emotion, and beautiful language combine perfectly to reach an artistic level that was to be pursued by calligraphers for centuries to come.

The running-cursive script in which the preface is written was derived from the casual script mentioned above. It is the type of script seen in the correspondence that comprises the greatest number of Wang Xizhi's calligraphic works extant during the Tang dynasty and documented in *Essentials of Calligraphy* (*Fashu yaolu*) by Zhang Yanyuan (815–907). Unlike those missives, which deal with daily affairs, or the *Essay on Yue Yi* (*Yueyi lun*) and the *Scripture of the Yellow Court* (*Huangting jing*), which are copies of texts composed by other authors, the preface was written from scratch.

Notes on the Orchid Pavilion (*Lanting ji*) by He Yanzhi (active early 8th century) makes plain that the circumstances culminating in the creation of the preface — and the elements that helped it define calligraphy as an independent form of art — were unprecedented.[10] First, calligraphers had at the time of its composition achieved superior status in society. This can be deduced from the fact that Wang Xizhi is introduced in *Notes on the Orchid Pavilion* as an esteemed luminary of noble descent. Second, it is clear that diverse script types were being practised at the time, as Wang is said to excel above all in cursive and regular scripts. Third, writing implements had reached a level of quality — whether in material or manufacture — conducive to artistic innovation and diverse manipulation; this is suggested by Wang's preference for silky paper and weasel-hair brushes. Finally, it had become acceptable for the writing of calligraphy to suit personal purposes and satisfy private appreciation.

And so, the preface, a work where literary quality and emotion took precedence over calligraphic style, was written on a whim in the leisurely company of friends and young relatives in observation of the late spring purification custom called Xiuxi.[11] Having completed his transformation of running-cursive script, Wang Xizhi was at the height of his intellectual insight, literary cultivation, life experience, and calligraphic expertise. With mind and hand working in perfect

unison, Wang Xizhi — whose creativity was likely unbound by the wine served at this fete — succeeded in producing a masterpiece that was beyond that of any of his contemporaries, let alone petty scribes. In fact, even the calligrapher himself could not replicate it afterwards no matter how hard he tried. It is, therefore, no hyperbole to say that the work is "extraordinarily refined and free of vulgarity".[12]

The Tang emperor Taizong (r. 627–649) — a staunch admirer who stopped at nothing to gain possession of the *Orchid Pavilion Preface* — was the first to celebrate Wang Xizhi's role in taking calligraphy to a peak that exceeded that of even the late Eastern Han masters Zhang Zhi and Liang Gu (active 3rd century). In the commentary that he personally added to the calligrapher's biography in the imperially commissioned *History of the Jin Dynasty* (*Jin shu*) — which included the entire text of the preface — Taizong described the sage's calligraphy as "perfection", even when compared with works by Zhong You or anyone else.[13] In the emperor's view, the brushwork, structuring of characters, and composition were all so fascinating that the preface was an inexhaustible source of delight. In his estimation, Wang Xizhi was the only master worthy of his emulation.[14] Probably composed with the *Orchid Pavilion Preface* before him, Taizong's remarks reveal the new emphases on the calligrapher's artistic individuality, the cultural aspects of calligraphic development, and the impressionistic evaluation that had emerged since the Wei and Jin periods. There is thus no doubt that the *Orchid Pavilion Preface* came to symbolise a stylistic transformation of calligraphy that was not merely personal but, in a real sense, epochal.

THE PREFACE AND THE TANG IMPERIAL COLLECTION

Wang Xizhi cherished his impromptu preface so dearly that he left it to his children with the stipulation that no one outside the family could view it.[15] All that was known to the public was a portion of the text recorded in *A New Account of Tales of the World* (*Shishuo xinyu*), complied by Liu Yiqing (403–444). It was not until the early Tang dynasty that the crown prince, various princes, and favoured courtiers had access to the preface through the copies Taizong had commissioned upon obtaining the original. The preface soon went out of sight again, however, when it was buried with the emperor in the Zhao Mausoleum in 649. This brief period of availability only added to the mysteries surrounding the preface — the foremost being when exactly Taizong gained possession of the masterpiece.

The earliest accounts of the preface appeared during the reign of the Tang emperor Xuanzong (r. 712–756) in He Yanzhi's *Notes on the Orchid Pavilion* and *Anecdotes of the Sui and Tang Dynasties* (*Sui–Tang jiahua*) by Liu Su (active 8th century). Yet neither work was regarded as a history: the Southern Song court bibliographer Chen Zhensun (1179–ca. 1261) categorised the former (included in *Essentials of Calligraphy*) as a treatise on art and the latter as fiction.[16] The discrepancies between these two accounts — and among the various editions of the

latter — centre mainly around how the preface was transmitted prior to its acquisition by Taizong and when the acquisition actually occurred. According to He Yanzhi, the preface remained in Wang Xizhi's family until Monk Zhiyong (active late 6th or early 7th century), a seventh-generation descendant of the calligrapher, passed it on to Monk Biancai (active early 7th century) — from whom it was taken through deception by an official named Xiao Yi (active early 7th century) on the orders of Taizong. Although this account goes into great detail about how Xiao Yi went about gaining the monk's trust, it falls short of stating the exact year all of this happened.

Contradicting this narrative is Liu Su, who claimed the preface was the property of the Liang state during the time of the Northern and Southern Dynasties before falling into the hands of Monk Zhiyong, who later offered it to the Emperor Xuan of Chen (r. 569–581). Following the conquest of Chen in 589, it was acquired by the Prince of Jin, who would become Emperor Yang of Sui (r. 605–618). The masterpiece was subsequently borrowed by Monk Zhiguo (active early 7th century) for copying and, upon his death, was passed to his disciple Monk Biancai. What is more, Liu Su said the preface left Monk Biancai's possession *before* Taizong became emperor; that is, he acquired it while still Prince of Qin — specifically, in the fourth year of the Tang emperor Gaozu's reign, or 621.

Exactly who carried out the scheme to deceive Monk Biancai is similarly open to dispute. While Xiao Yi is named in all extant editions of *Anecdotes of the Sui and Tang Dynasties*, the Song dynasty titles *Investigations of the Orchid Pavilion Preface* (*Lanting kao*) and *Supplementary Investigations of the Orchid Pavilion Preface* (*Lanting xukao*) allege that the scholar-calligrapher Ouyang Xun (557–641) was the swindler — an attribution sourced, paradoxically enough, to a citation in *Anecdotes of the Sui and Tang Dynasties*.[17]

In fact, the reliability of *Anecdotes of the Sui and Tang Dynasties* was questioned as early as the Song dynasty by Jiang Kui (ca. 1155–ca. 1221), who argued that the preface would have appeared in the discussions of Wang Xizhi's calligraphic works by Emperor Wu of Liang (r. 502–548) had it been in the imperial collection.[18] That the preface could have been acquired in 621 is similarly unlikely. The imperially commissioned *Classified Extracts from Literature* (*Yiwen leiju*), compiled by Ouyang Xun and others between 622 and 624, includes the preface — but only an excerpt (comprising the first half of the text, with 167 fewer characters than the full version) that better corresponds with earlier literature, such as *Preface to the Riverbank Gathering* (*Linhe xu*) found in the annotations of Liu Xiaobiao (463–521) to *A New Account of Tales of the World*.[19] Had the original been in the imperial collection at the time Ouyang Xun and his colleagues were assembling their anthology, surely it would have included a version of the preface whose length tallies with copies of the masterpiece that can be seen today.[20] The full text *did* appear without any alteration in Wang Xizhi's biography in the *History of the Jin Dynasty,* compiled in the latter

Copy of the Orchid Pavilion Preface in Running Script (cat. 6). Attributed to Yu Shinan (558–638). Tang dynasty, 7th century.

half of Taizong's reign, possibly because the original was then available. In other words, the partial text in *Classified Extracts from Literature* was probably adapted from a literary source rather than the calligraphic work itself. Furthermore, if the original version of the preface was not in Ouyang Xun's possession when he started work on the compilation in 622, he could not have obtained it in 621 as alleged in *Anecdotes of the Sui and Tang Dynasties*. Finally, it is worth noting that while the original version of the preface largely agrees with extant copies in structure, it carries quite a number of variant expressions, suggesting that multiple versions were in circulation at the time.

He Yanzhi *did* provide a key clue to the provenance of the preface when he noted that, after obtaining the masterpiece, Xiao Yi was assisted by Qi Shanxing (active early 7th century), commander of Yuezhou. According to the *Gazetteer of Kuaiji of the Jiatai Reign* (*Jiatai Kuaiji zhi*), Qi Shanxing was transferred to Yuezhou in 643, meaning that Taizong could not have acquired the *Orchid Pavilion Preface* before that date.[21] What is more, this dating does not conflict with the inclusion of the full text in the *History of the Jin Dynasty*, which was compiled between 646 and 648.

The judgment of Zhang Yanyuan also helps establish the credibility of this dating. When compiling *Essentials of Calligraphy,* he vetoed the version of the preface that appeared in *Anecdotes of the Sui and Tang Dynasties* (even though its esteemed author, Liu Su, was the son of the eminent historian Liu Zhiji) in favour of He Yanzhi's *Notes on the Orchid Pavilion.* This decision was perhaps made on the grounds that the account in *Notes* was narrated in detail by Monk Biancai's disciple Xuansu (active 7th century), that this account was intended to preserve the event for posterity, and that a copy of *Notes* was presented by He Yong (active 8th century), He Yanzhi's son, to the Tang emperor Xuanzong (r. 712–756) in 722 — a gesture indicative of the gravity *Notes* was understood to possess.

During the six years between its acquisition in 643 (or shortly thereafter) and its burial in the Zhao Mausoleum in 649, the preface was copied by court copyists including Zhao Mo, Han Daozheng, Zhuge Zhen, and Tang Puche (all active 7th century) on the order of Taizong, and the copies were then bestowed on the crown prince, various princes, and favourite courtiers.[22] Those who were privileged enough to have personally viewed the authentic piece were even fewer in number. Upon the burial of the original with Taizong, these court copies became coveted items fetching great sums during Xuanzong's reign, according to *Notes on the Orchid Pavilion*. It followed that the copies were themselves fervently copied in myriad ways and formats and gave rise to freehand copies and stone carvings and re-carvings at the original and reduced sizes. This prompted the Northern Song poet and statesman Ouyang Xiu (1007–1072) to lament that the prolific surviving copies were all copied indirectly from Tang copies and were thus a far cry from the original.[23] These secondary copies were often fictitiously attributed to established masters or to earlier periods and were supported with fabricated provenances, all in an effort to enhance their appeal to collectors lured by the stature bestowed by antiquity and fame.

The most notable examples of these questionably ascribed secondary copies are found in the collection of the Palace Museum. The copies attributed to Yu Shinan (558–638), Chu Suiliang (596–658), and Feng Chengsu (617–672) are three of the "Eight Pillars of the Orchid Pavilion" carved in stone under the aegis of the Qing Qianlong Emperor (r. 1736–1795; figs. 2, 3, and 4). The Museum also possesses carvings and rubbings taken from carvings of a version attributed to Ouyang Xun. Following definitive studies conducted by experts and connoisseurs, the version attributed to Feng Chengsu — also known as the "Shenlong version" for the impression it bears of a small seal reading "Shenlong", the name of the reign period of the Tang emperor Zhongzong (705–706) — has been commonly accepted as the most faithful Tang copy and is believed to retain many features exclusive to the original. This judgment led the Yuan dynasty calligrapher Guo Tianxi (1227–1302) to conclude in his colophon to the Shenlong version that it *could* have been produced directly from the original by a court copyist, such as Feng Chengsu, during Taizong's reign.[24] If we accept this view, the copies attributed to Ouyang Xun, Yu Shinan, and Chu Suiliang are likely to have been derived from copies made during the Tang or Song dynasties and, hence, are comparatively less faithful to the original than the Feng Chengsu/Shenlong version.[25]

The Yu Shinan, Ouyang Xun, and Chu Suiliang attributions first appeared during the Northern Song dynasty in a colophon to *Notes on the Orchid Pavilion* by Li Zhiyi (active late 11th–early 12th century), where they are named with Lu Jianzhi (585–638) as copyists of the preface (though none had previously been documented as such).[26] But Yu Shinan and Ouyang Xun could not have seen the

FIGURE 3
Orchid Pavilion Preface in Running Script. Attributed to Chu Suiliang (596–658). Tang dynasty. Handscroll, ink on paper. The Palace Museum.

preface, let alone made copies of it, as they died — in 638 and 641, respectively — before Taizong obtained the work in 643.[27] As for Lu Jianzhi, the first reference to his copying the preface (and writing a poem about the Orchid Pavilion) appeared in *Xuanhe Catalogue of Calligraphy* (*Xuanhe shupu*), compiled during the time of the Song emperor Huizong (r. 1101–1125), making it likely that this attribution was made retroactively — and unlikely that Lu was the copyist.[28]

Chu Suiliang's versions of the preface were phenomenally popular during the Song dynasty and were widely believed to be copied from the original. Evidence for this can be found in his *List of Calligraphic Works by Wang Xizhi* (*Jin Youjun Wang Xizhi shumu*), which purported to include all the masterpieces that Chu had copied; there, the preface opens the section on works in running script.[29] Yet the eminent Song painter-calligrapher Mi Fu (1051–1107) questioned this notion. In his colophon to the copy attributed to Chu among the "Eight Pillars" and in the colophon appended to Chu's copy belonging to a prestigious Su family, which was based on the *Essentials of Calligraphy*, Mi Fu registered his reservations about Chu's authorship.[30] Thus, it is likely these copies by Chu Suiliang were actually derived from copies by Tang court copyists.

Vying for importance with Chu Suiliang's freehand ink copies during the Song dynasty, which were likely by a copyist in the court, were rubbings made from a stone stele bearing an engraving of the preface. It is known as the "Dingwu version" as the stele was discovered at Dingwu in Hebei province, and as its calligraphy resembled that of Ouyang Xun, this version was commonly attributed to him. Coinciding with the rumour that the original preface had re-emerged after Wen Tao (d. 928) raided the Zhao Mausoleum in the late Tang, it was sometimes suggested the stele was created during the Five Dynasties period, for the purpose of surpassing existing Tang copies. Song literature traces the evolving connections between Ouyang Xun and the Dingwu version, illustrating how acclaimed masters came to be ever more closely associated with the preface. Ouyang Xiu's entry on the preface in his *Colophons from the Records of Collecting Antiquities* (*Jigu lu bawei*), compiled between 1062 and 1072, notes that he had seen several rubbings of the preface but makes no mention of Ouyang Xun.[31] Subsequently, Li Zhiyi's colophon to *Notes on the Orchid Pavilion* comments that the calligraphy of the Dingwu version resembles that of Ouyang Xun, and proposes that he might have been the copyist.[32] This supposition becomes a definitive statement in *History of Stone Engraving* (*Shike puxu*) of 1248 by Zeng Hongfu (active 13th century).[33] The general acceptance of this view may have led Sang Shichang (active 13th century) to include in his *Investigations of the Orchid Pavilion Preface* the version of the story related in *Anecdotes of the Sui and Tang Dynasties*, where Ouyang Xun, and not Xiao Yi, was said to be the person who cheated Monk Biancai.

Imperial interest was instrumental in making the *Orchid Pavilion Preface* the masterpiece it is. Taizong's acquisition of the preface ignited a passion for copying

it, and the devotion of the Song emperor Gaozong (r. 1127–1162) to copies and rubbings of the work fuelled its re-carving, circulation, and collection. Gaozong himself assiduously studied and copied the masterpiece — his favourite among all Wei, Jin, and Six Dynasties specimens — and he even had his son, the future Emperor Xiaozong (r. 1163–1189), copy *his* copy of the preface as many as five hundred times.[34] Inspired by Emperor Gaozong's zealous collecting — as evidenced by his imperial seals on the three Tang or Song copies among the "Eight Pillars of the Orchid Pavilion Preface" and re-carvings of the various versions — scholar-officials took pride in collecting versions of the preface and having the Dingwu version re-carved.[35] Prime minister You Si (d. 1252) was known to have possessed more than one hundred rubbings of the masterpiece. In time, the proliferation of copies and rubbings resulted in the prevalence of fabricated ascriptions and problematic provenances. Confronted with the glut of re-carvings of the Dingwu version and rubbings of various other versions — such as the Yuzhen version, which is reduced in size, and the Kaihuang version, which some claimed to date from the Sui dynasty; that is, even earlier than the Tang — the literati, in addition to copying the calligraphy itself, began to authenticate the rubbings to demonstrate their connoisseurship and scholarship. During the Tang and Song dynasties, enthusiasm for the preface spread beyond calligraphy to infuse the full spectrum of the arts, so that in time the Orchid Pavilion gathering was celebrated in poems, essays, and paintings as well as calligraphy and became a limitless source of creative inspiration.

NOTES

1 Qi 1999b: 103.

2 For a historical record of the scribes in Han court, see "Baiguan 5" in Fan Ye 1991, *zhi* 28: 3621.

3 "Cai Yong zuan" in Fan Ye 1991, *juan* 60 *xia*: 1996.

4 Xu Shen 1977: 314–315; "Zhouwen" in Zhang Huaiguan's *Shu duan, juan* 7 of Zhang Yanyuan's *Fashu yaolu*, see Liu S. 2021: 364; "Yipin" in Li Sizhen's *Shuhoupin, juan* 3 of *Fashu yaolu*, see ibid.: 146; see also "Shenpin" in *Shu duan*, ibid.: 409–410.

5 For instance, *Stele for Fan Shi* (*Fan Shi bei*) was regarded by Li Sizhen of the Tang as the best of Cai Yong's (132–192) calligraphic works. See "Shangpin" in Li Sizhen's *Shuhoupin, juan* 3 of *Fashu yaolu*, in Liu S. 2021: 150. Zhao Mingcheng (1081–1129) questioned this attribution by pointing out that the stele was

erected forty-three years after the calligrapher's death. See Zhao Mingcheng 1985: 365. As for *Stele for Mount Hua* (*Xiyue Huashan bei*), Xu Hao (703–782) of the Tang ascribed it to Cai Yong. See Xu Hao's *Guji ji* in Liu S. 2021: 365.

6 Fan Ye 1991, "Huangfu Zhangduan liezhuan", *juan* 65: 2144; "Huang Wenyuan liezhuan", *juan* 80 *xia*: 2653; and "Cui Yin liezhuan", *juan* 52: 1724.

7 Zhong You excelled at stone-inscription script (*mingshishu*), official script (*zhangchengshu*), and casual script (*xingxiashu*). See Wang Zengqian, *Lunshu*, in Liu S. 2021, *juan* 1: 31.

8 See *Xuanhe shupu, juan* 7, in Zhongguo Shuhua Quanshu Bianzuan Weiyuanhui 1993–2000, vol. 2: 23.

9 *Letter to Yin Hao* (*Bao Yin Hao shu*) in *Wang Xizhi chuan*, see Fang Xuanling et al. 1993: 2094.

10 He Yanzhi's account is included in *juan* 3 of *Fashu yaolu*, see Liu S. 2021: 177.

11 See Zhang Huaiguan's *Views on Calligraphy* (*Shu yi*), *juan* 4 of *Fashu yaolu*, in Liu S. 2021: 218.

12 See Sun Guoting's *Treatise on Calligraphy* (*Shu pu*), the original of which is housed in the Palace Museum, Taipei.

13 See Fang Xuanling et al. 1993: 2107–2108.

14 Fang Xuanling et al. 1993: 2108.

15 See He Yanzhi's *Lanting ji*, *juan* 3 of *Fashu yaolu*, in Liu S. 2021: 177.

16 See Chen Zhensun 2005, *juan* 14: 408–409 and *juan* 11: 318.

17 See Zhongguo Shuhua Quanshu Bianzuan Weiyuanhui 1993–2000, vol. 2: 582 and 622; and Liu Su 1997: 54.

18 Jiang Kui, "A study of the transmission history of the Preface of Orchid Pavilion" (*Xitie yuanliu kao*). Jiang's text was copied out by Zhao Mengfu in small regular script and is now in the collection of the Palace Museum, Taipei. Zhao's calligraphic work is documented in "Pavilion of Prolonged Spring 15" (*Yanchunge 15*) in *Treasured Boxes of the Stone Moat, Third Series* (*Shiqu baoji sanbian*).

19 Ouyang Xun 1982: 71; Liu Yiqing 2001: 346.

20 See "Linghu Defen zuan" in Liu Xu 1995: 2596.

21 It was previously believed that the monk was cheated out of the preface before the twelfth year of the Zhenguan reign (638) based on a reference in the *Old Book of Tang* (*Jiu Tang shu*), which had Qi Shanxing quelling a rebellion that very year while serving in Kuizhou, assumedly a post he held after he left Yuezhou. In fact, these postings were erroneously ordered, hence the fallacious assumption. Shi Su 1986: 41. Wang R. 2003: 192.

22 Among these five copyists, the first four are recorded in Han Yanzhi's *Notes on the Orchid Pavilion* (*Lanting ji*), the last, in Wu Pingyi's *Xu's Calligraphy Record* (*Xushi fashu ji*). See Liu S. 2021: 162 and 184.

23 *Jigu lu bawei*, *juan* 4, in Ouyang Xiu 2001: 2162.

24 Qi 1999c: 153–154.

25 See Xu B. 2015b, vol. 10: 82–84; Qi 1999b: 49.

26 Shi Y. 2019: 144.

27 The death date of Yu Shinan is recorded in Liu Xu 1995: 49. Ouyang Xun's is found in Zhang Huaiguan's *Fashu yaolu*, see Liu S. 2021: 442.

28 *Xuanhe shupu* in Zhongguo Shuhua Quanshu Bianzuan Weiyuanhui 1993–2000, *juan* 8: 27. The poem attributed to Lu Jianzhi has survived as an ink rubbing now in the Shanghai Museum and has been identified as the "You Si version" of the Southern Song. The ink version of this poem is lost, although it is said to be in a private collection in Hong Kong. For a study of this work, see Xu B. 2005, vol. 1: 71–75.

29 See *Fashu yaolu*, *juan* 3, in Liu S. 2021: 142.

30 Both works bearing Mi Fu's colophons are in the collection of the Palace Museum. Among them, the Su family version is also called the "Chen Jian version", as it was once collected by Chen Jian (1594–1676) in the Ming dynasty.

31 *Jigu lu bawei*, *juan* 4, in Ouyang Xiu 2001: 2162.

32 Shi Y. 2019: 144.

33 Zeng Hongfu 1985, vol. 51: 401.

34 Zhao Gao, *Hanmo zhi*, in Zhongguo Shuhua Quanshu Bianzuan Weiyuanhui 1993–2000, vol. 2: 1; Lu You 2019: 151.

35 According to Xu Bangda, both Feng's copy and Chu's copy bear authentic imperial seals of Gaozong, but the one on Yu's copy might have been taken from another piece. See Xu B. 2015b, vol. 10: 76, 83, and 87. As for the re-carvings of the preface by the Southern Song court, Sang Shichang has listed five versions in his *Study of Lanting* (*Lanting kao*). See Zhongguo Shuhua Quanshu Bianzuan Weiyuanhui 1993–2000, vol. 2: 608.

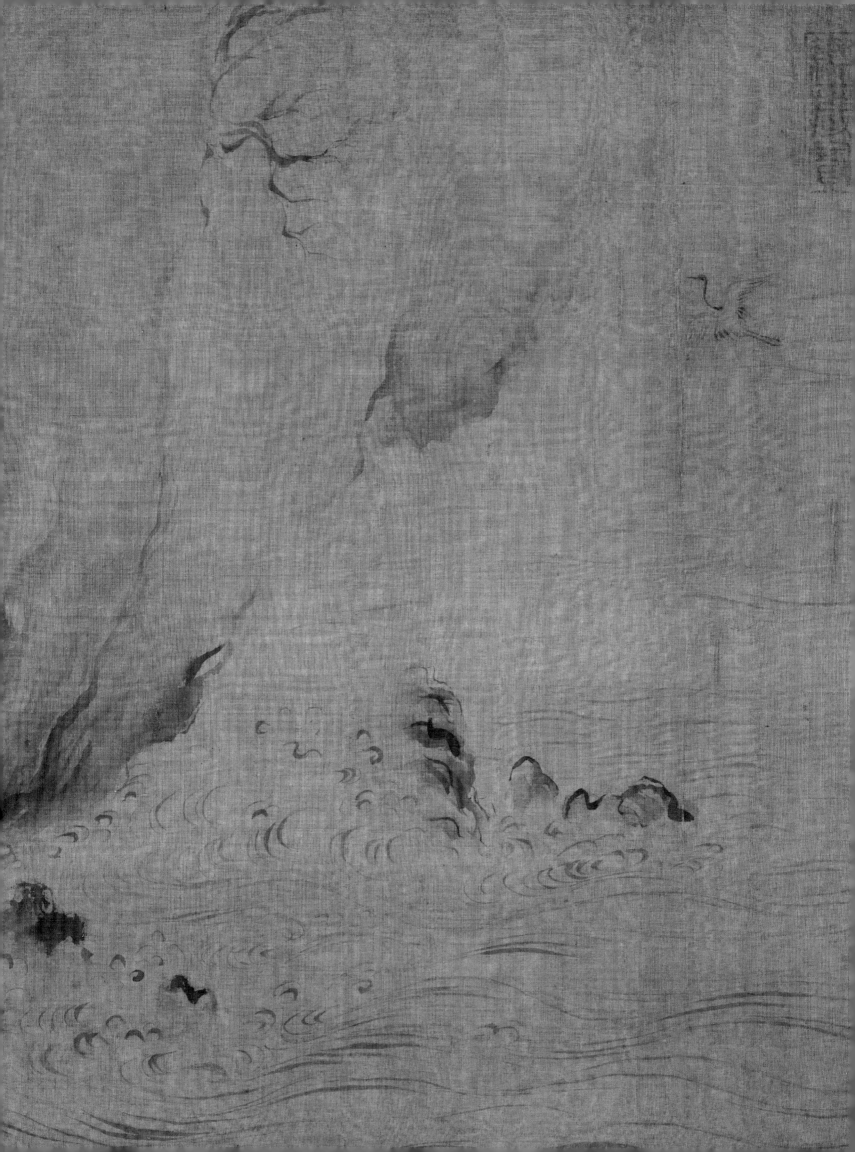

The Red Cliff in the Song–Jin Period

ORIGIN OF RED CLIFF PAINTINGS

The Red Cliff has long been a favourite subject in Chinese art. The place is famous on account of a historic battle purportedly fought there during the Three Kingdoms period. And yet, according to literature and extant paintings, this illustrious site has rarely been represented as a battlefield except in book illustrations. As noted by the Southern Song poet Wang Yan (1137–1218) in a poem titled *The Red Cliff* the site in Huangzhou (now Huanggang, Hubei) was much better known than that in Wulin (in present-day Honghu, Hubei) where the legendary battle actually took place.[1] The former owes its cultural importance to Su Shi (1037–1101) and the literary masterpieces on the Red Cliff that he composed during his banishment in Huangzhou.

A Northern Song statesman noted for his literary output and calligraphy, Su Shi was banished to Huangzhou in 1079 in response to his opposition to government policies. His writings were used to impeach him for slandering the court and the Song emperor Shenzong (r. 1068–1085), and he was imprisoned for more than a hundred days in the Censorate, known as the Crow Terrace. The prosecution of Su Shi thus came to be known as the "Crow Terrace Poetry Trial". Although the banishment was a serious political setback for Su Shi, it ushered in a highly productive period in his writing that was marked by a number of works associated with the Red Cliff. These include *Former Fu-rhapsody on the Red Cliff* (*Qian Chibi fu*), *Latter Fu-rhapsody on the Red Cliff* (*Hou Chibi fu*), *Memories of the Past at Red Cliff* (*Niannujiao Chibi huaigu*), and *Li Wei Playing the Flute, with Headnote* (*Li Wei chuidi bingyin*).

Su Shi is known to have recreated his own *fu*-rhapsodies on the Red Cliff on a number of occasions. His inscription on one such piece that has survived to this day divulges how he shied away from showing the poem to anyone lest it be used as incriminating evidence against him.[2] Such cautiousness was no proof against persecution, however, and his political woes followed him even after his death: in 1101, shortly after Su Shi died, the Northern Song emperor Huizong (r. 1101–1125) instigated an extensive persecution of the "Yuanyou faction", of which Su Shi was a member.[3] In 1103 an imperial edict banned writings by that group — including those of Su Shi, which were too well known to be spared — and decreed that even the woodblocks used to print his writings and those of his disciples (including

Huang Tingjian [1045–1105], Zhang Lei [1054–1114], Chao Buzhi [1053–1110], and Qin Guan [1049–1100]) were to be burned along with those by Ma Juan (d. 1126), Fan Zuyu (1041–1098), Fan Zhen (1007–1088), Liu Ban (1023–1089), and Monk Wenying (d. ca. 1060).[4]

As the political winds changed, so did the court's attitude toward the Yuanyou faction. In 1106 Huizong restored the reputation of its members and removed steles that announced their association with the faction. Yet the injunction against Su Shi's works was not lifted.[5] It was not until the ascension of Qinzong as emperor (r. 1126–1127) that the suppression of the faction and its intellectual tradition ended and the rehabilitation of Su Shi's reputation began.[6] In 1128 the Southern Song emperor Gaozong (r. 1127–1162) posthumously reinstated the poet and in 1131 honoured him as Academician of the Hall for Aid in Governance and Grand Master for Court Service.[7] His successor, Xiaozong (r. 1163–1189), continued the process, bestowing on Su Shi an honorific name in 1170 and the title of Grand Preceptor in 1173.[8]

Gaozong was a great admirer of Su Shi's art and writings. When he approached the calligrapher's nephew, Su Chi (d. 1155), to acquire his uncle's artworks in 1130, he explained to the prominent courtier Zhang Shou (1084–1145) that they were to be cherished for not only their artistic sophistication but also their wisdom.[9] Xiaozong, who referred to the literatus-calligrapher with his courtesy name or pseudonym, was no less a devotee. Apart from extolling Su Shi's writings as epochal in an encomium, he adopted the poet's texts for his own calligraphic works, as in a scroll in the Liaoning Provincial Museum transcribing the *Latter Fu-rhapsody on the Red Cliff* and a fan featuring one of Su Shi's poems in the Museum of Fine Arts, Boston.[10]

Because of the vindication of the court and the recognition of emperors, Su Shi's literary works became so highly esteemed that familiarity with them indicated a high level of education and was virtually a gateway to prosperity.[11] Su Shi was studied by every scholar, and his books were expected to be found in every study.[12] Su Shi is showered with praise in five inscriptions by Jin subjects to his *Poems by the Immortal Li Bai* (*Li Bai xianshi*), now in the Osaka City Museum of Fine Arts. Among these inscribers, Shi Yisheng (1091–1163) was acquainted with Su Shi's friend Zhao Lingchou (1064–1134), and Cai Songnian (1107–1159) was a renowned *ci*-poet who modelled his works after Su Shi's and is known to have composed two responses to Su Shi's *Memories of the Past at Red Cliff*. His works were also popular among the Jurchens and continued throughout the Jin dynasty, and studies of his works are believed to have flourished in the north.[13] The Jin court honoured him as well. The "spirit road" stele written by Yuan Haowen (1190–1257) for Yelü Lü (1131–1191) tells us that Su Shi's works were widely known and generally regarded as unrivalled in the Jin and that the emperor Shizong (r. 1161–1189), through Yelü Lü's introduction, was so impressed by the poet's political observations that he had Su

Shi's official memorials to the Song court published.[14] For all its apparent sincerity, this retrospective appreciation of the literary accomplishments of Su Shi and the Yuanyou faction was grounded in political realities. The Jurchens saw in that persecution a justification for vanquishing the Northern Song and a convenient platform for winning over its people, while the Southern Song court may have hoped to garner popular support for its diminished empire by rescinding earlier edicts.[15]

Against this backdrop, once-stifled affection for Su Shi blossomed and gave rise to paintings inspired by his life and works. Zhou Zizhi (1082–1155) — a student of Su Shi's disciple Li Zhiyi (active late 11th–early 12th century) — inscribed a poem on a painting that alluded to the master's various works on the Red Cliff.[16] Further, the poem's title tells us that the painting in question was to be reproduced as a print, suggesting great demand in the market, and that the print was made in Huangzhou, reflecting its continued association with Su Shi.

Indeed, Huangzhou remained a special place for many simply because it was where Su Shi once lived and created some of his literary masterpieces. More than forty years after the man was last seen there and twenty-five years after his death, visitors were retracing the journey he described in the *Latter Fu-rhapsody on the Red Cliff* and expressing the emotions thus inspired through poems.[17] Thanks to the continued reverence for both the man and his literary output, the Red Cliff in Huangzhou became the subject of choice for painters wishing to pay tribute to Su Shi and his art.[18]

EARLY MODES OF REPRESENTATION

When the first pictorial interpretations of the Red Cliff were created is anyone's guess. The earliest documented example, according to a poem by Yu Ji (1272–1348), is probably that by Wang Shen (active second half of the 11th century), who was a friend of Su Shi's.[19] This attribution is dubious since it is implausible for such an important work to have been omitted from earlier literature; however, there is no doubt the painting in question is datable to no later than the early Yuan, when Yu Ji's poem was composed. The poem sheds some light on what early works of this sort might have looked like. A reference to the painting unrolling to reveal a crane suggests it was a handscroll, while descriptions corresponding to the Red Cliff suggest that the painting might have consisted of a related series of scenes.

Considered in light of other early paintings inspired by literary works, these details bring to mind an extant pictorial representation of the *fu*-rhapsody: *Illustration to the Second Prose Poem on the Red Cliff* (*Hou Chibi fu tu*) by Qiao Zhongchang (active late 11th–early 12th century). Based on its attribution and dating, this scroll is by far the earliest surviving painting of its kind (fig. 1). Like similar early paintings inspired by literary works such as *Admonitions of the Instructress to the Court Ladies* (*Nüshi zhen tu*) and *Fu-rhapsody on the Nymph of the Luo River* (*Luoshen fu tu*), the painting consists of a selection of scenes that

are accompanied by relevant excerpts from the *fu*-rhapsody.[20] Although separated by rocks and trees, the individual scenes are interconnected and form a continuous whole.

The Southern Song painter Ma Hezhi (active 12th century) took a different approach in *Latter Fu-rhapsody on the Red Cliff* (*Hou Chibi fu tu*, fig. 2), which, despite the absence of a signature and artist's seal, has been deemed authentic based on stylistic comparisons to *Illustrations to The Book of Songs* (*Shijing tu*) ascribed to the same painter.[21] Instead of separating the scroll into sections corresponding to various scenes in the *fu*-rhapsody, Ma Hezhi focused on a single scene — a solitary crane skimming past the poet's boat and heading to the west. Details of weather and geography from the poem are translated into the bare autumn trees on the far right and the river lashing against a soaring cliff on the far left to ingeniously establish the setting for the boat trip.

The Jin painter Wu Yuanzhi (active late 12th–early 13th century), who flourished slightly later than Ma Hezhi, also chose to depict a single scene from the poem.[22] His *Fu-rhapsody on the Red Cliff* (*Chibi tu*)[23] has long attracted interest mostly for its authorship and regional style; more recently, however, it prompted the scholar I Lo-fen to ponder which of the works written by Su Shi inspired the painting.[24] Following analyses of the painting, she concluded that Wu Yuanzhi's masterpiece is an amalgam that draws on several works to visualise the poet's visits to the Red Cliff.[25] Although most representations of the Red Cliff are based on Su Shi's two *fu*-rhapsodies, the poet in fact composed two other pieces touching on the same subject: the well-known *Memories of the Past at Red Cliff* and the lesser known *Li*

FIGURE 1

Illustration to the Second Prose Poem on the Red Cliff. Qiao Zhongchang (active late 11th–early 12th century). Northern Song dynasty. Handscroll, ink on paper. The Nelson-Atkins Museum of Art. Purchase: Nelson Gallery Foundation, F80-5. Photograph © The Nelson Gallery Foundation.

Wei Playing the Flute, with Headnote. Taking all these sources into consideration, we can extend I Lo-fen's argument to propose that Wu Yuanzhi drew freely from descriptions common to *all* these works, creating a setting for his narrative painting of the poet's boat trips with friends.

A comparable painting is attributed to Yang Shixian (active early 12th century; fig. 3). Although the debate over its authorship and dating continues, its stylistic features and the partial impression of a seal traceable to an early Ming office help ascribe it to a period no earlier than the Southern Song and no later than the Yuan. The compositions of Wu Yuanzhi and Yang Shixian's paintings almost mirror each other, sharing more or less the same conception and elements. Both portray the Red Cliff, a colossal mass accentuated by smaller rocks in the foreground, over-looking Su Shi's boat on a choppy river that extends to the horizon. However, the towering pine trees so prominent in the paintings find no analogues in the two *fu*-rhapsodies, which only mention deciduous trees. Likewise, the torrents crash onto the shore with frightening waves, echoing *Memories of the Past at Red Cliff*, while the *fu*-rhapsodies describe the river as so calm that ripples hardly form. It is therefore plain that neither painting was intended to faithfully translate its literary counterparts. With pictorial narratives severed from literary sources, the paintings now read as generalised pictures of Su Shi's visits to the Red Cliff.

Among other works on the subject we find three small works that are quite similar. One, in the Nelson-Atkins Museum of Art, is purportedly signed by the Southern Song painter Li Song (1166–1243), and the other two — from the Palace Museum and Palace Museum, Taipei, respectively — bear neither signature nor

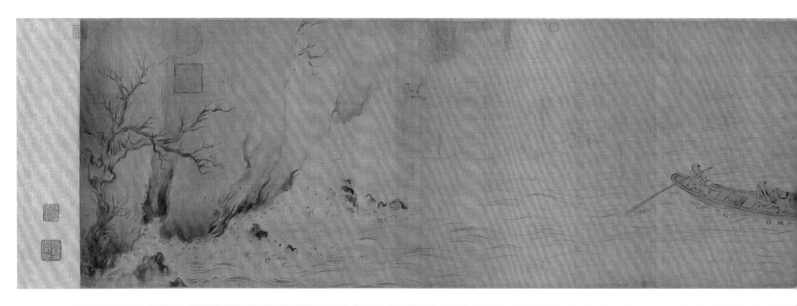

artist's seal. Basically identical in content, they are more or less the same size, despite differences in format.[26] Subtle variations in rendition aside, the most noticeable differences among the paintings are that the Palace Museum example is rendered in blues and greens, while the other two are executed in ink and light colours. Of the three, the Nelson-Atkins painting is datable by style to the Southern Song, making it slightly older than the other two; no definitive evidence exists to establish Li Song as the painter.[27] Let us look at the Nelson-Atkins painting as a representative work. In this "one-corner" or "half-side" composition characteristic of the Southern Song, which has the effect of zooming in on a portion of a larger scene, the Red Cliff is suggested by no more than a cliff face jutting out from the upper right. Attention is instead directed to Su Shi's boat on the river, which is so turbulent that the boating party is unlikely to be in the mood for any amusement.

FIGURE 2
Latter Fu-rhapsody on the Red Cliff.
Ma Hezhi (active 12th century).
Southern Song dynasty. Handscroll,
ink and colour on silk. The Palace
Museum.

Judging from their compositions, all three must have derived from the same source, although there is no way to determine their connection. For such derivations of a common theme to proliferate, the treatment seen in this painting can plausibly be considered typical of Red Cliff paintings of the period.

Also typical of the period are depictions of water, which were exceptionally popular during the Southern Song. In the scroll attributed to Yang Shixian, for example, the meticulous depiction of water so dominates the composition that if the scroll were to be cut in two, the right half would serve as a convincing depiction of the Red Cliff on its own, while the left half would stand as a meditation on and celebration of water. This treatment of the water motif echoes that of the three small-size works noted above. A contrasting approach was taken by Wu Yuanzhi, who lavished much attention and detail on a stretch in the middle section of the

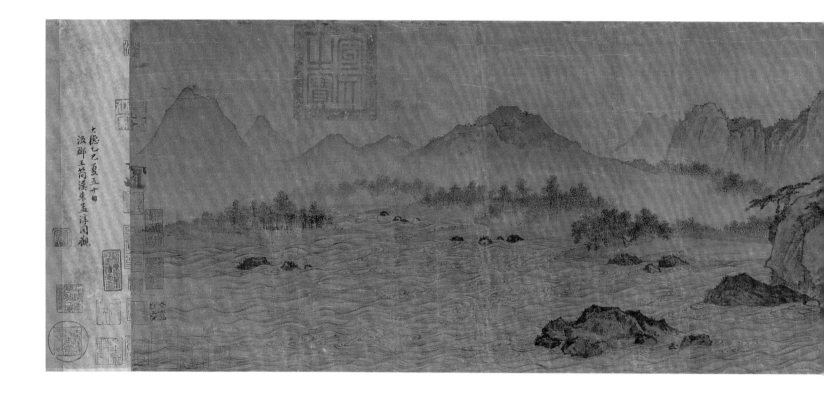

FIGURE 3
The Red Cliff (*Chibi tu*). Attributed to Yang Shixian (active early 12th century). Northern Song dynasty. Handscroll, ink and colour on silk. Museum of Fine Arts, Boston, 59.960. Photograph © 2022 Museum of Fine Arts, Boston.

scroll while leaving the water in the background only scantily described. Ma Yuan (active late 12th–early 13th century) painted *Water* (cat. 14), the quintessential surviving treatment of the subject. Also typical of such works, *Twenty Water Scenes* (*Huashui ershi jing*) – in the Palace Museum, Taipei – is also attributed to Ma Yuan, although its actual date of execution likely post-dates the Southern Song. For its various scenes, the artist drew on myriad geographical, historical, and mythical sources: scenic spots such as Lake Dongting and the Qiantang River; legends arising from historical figures such as Zhang Qian (ca. 164–ca. 114 BCE) and Li Bai (701–762); and, of course, Su Shi's Red Cliff, which opens the scroll. Coincidentally, the legend of Li Bai ascending to heaven on a whale depicted by Ma Yuan is also cited by the Jin scholar Zhao Bingwen (1159–1232) in his colophon to Wu Yuanzhi's *Latter Fu-rhapsody on the Red Cliff*. However much space it takes up or however painstakingly it is rendered, water is arguably the real subject of these mid- and late Southern Song paintings of the Red Cliff.[28] It is clear the Red Cliff provided painters with an opportunity to showcase their superior skill in depicting water, whether or not reference was made to Su Shi's text or the historical event.

An echo of these early representations of the Red Cliff can be found in *After Zhao Bosu's Latter Fu-rhapsody on the Red Cliff* (*Fang Zhao Bosu Hou Chibi tu*) by the Ming artist Wen Zhengming (1470–1559).[29] The colophons of Wen Jia (1501–1583) and Wang Guxiang (1501–1568) tell us that this painting created in appreciation of the Southern Song painter Zhao Bosu (1124–1182) was produced to console a friend over his loss of the original work. Although the authenticity of

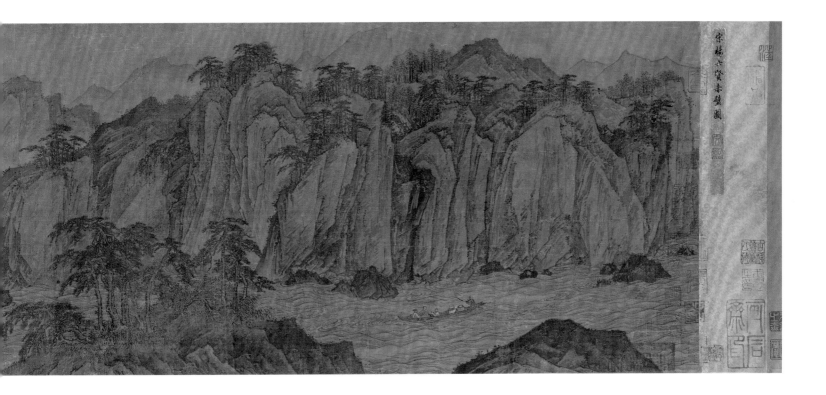

the original can no longer be verified, that work was likely to have preserved some compositional characteristics of early paintings of the Red Cliff. This explains why the copy bears affinities with the Song painter Qiao Zhongchang's *Illustration to the Second Prose Poem on the Red Cliff*. Although Wen Zhengming adhered to the sectioned composition commonly seen in early Red Cliff representations and went out of his way to adopt the intense blue-and-green style reminiscent of Tang and Song painters, the distinctive brushwork is unmistakably his own rather than a slavish imitation of the original. Like the artists who produced their versions of the subject in the latter half of the Southern Song, Wen Zhengming strove to express his own personality rather than Su Shi's poems or biographical vignettes.

THE SIGNIFICANCE OF SONG–JIN RED CLIFF PAINTINGS

This survey of extant Song–Jin paintings helps put in perspective the early treatment of the Red Cliff as a subject. Red Cliff paintings should, first and foremost, be classified as "poetic paintings" — that is, paintings inspired by literary works that were very much in vogue at the Song emperor Huizong's Imperial Painting Academy.[30] Beyond the court, depictions of the Red Cliff immediately attracted admirers among scholar-officials for their strong association with Su Shi.

What sets paintings of the Red Cliff apart from other works inspired by literature is that Su Shi the man was as important as the texts he wrote; those texts are, in fact, autobiographical vignettes written by a man whose greatness has been recognised since the Song dynasty. To the painters inspired by Su Shi, his stories

were based in fact as well as poetic. Drawing on the characters and scenes provided by Su Shi's texts, painters of the Red Cliff had at their disposal both figure and landscape subjects — elements essential to the then-prevalent "landscape with figures" genre — necessary to produce paintings that convey both visual appeal and resonant content.

Analyses of Red Cliff paintings of the Song–Jin periods reveal that compositions with multiple linked scenes sequenced in accordance with the original texts gradually gave way to ones with a single integrated scene that were in effect summations of descriptions scattered among Su Shi's various works on the Red Cliff. Accordingly, artists over time shifted their emphasis from fidelity to narrative towards a more lyrical approach. By combining visualisations of literary masterpieces with the reminiscences of Su Shi, painters of the Red Cliff discovered an artistic vehicle that showcased their ingenious conceptions and unparalleled skill.

Since the Song dynasty painters have been drawn to the Red Cliff and produced some of the finest masterpieces of Chinese painting. The compositional and representational evolution charted in these works not only traces profound changes in Chinese landscape painting but also highlights the development of the Red Cliff as a subject and makes plain its perennial appeal.

NOTES

1 "Chibi tu" in Wang Yan 1986, *juan* 6: 487.

2 This piece is housed in the Palace Museum, Taipei.

3 Tuotuo 1977, *juan* 19: 365.

4 Qin Xiangye et al. 2002, *juan* 21: 255–256.

5 Chen Jun 1986, *juan* 29: 799; Zhu Bian 2002, *juan* 8: 205; Qin Xiangye et al. 2002, *juan* 26: 301.

6 Tuotuo 1977, *juan* 23: 424.

7 Li Xinchuan 1986, *juan* 15: 252; *juan* 46: 637.

8 Tuotuo 1977, *juan* 34: 649, 655.

9 "Chongryu," in *Song huiyao jigao* 2001: 242.

10 Li Xinchuan 2000, *jiaji, juan* 8: 163; "Yuzhi wenji xu" by Zhao Shen in Su Shi 1919: *juanshou*.

11 Lu You 1979, *juan* 8: 100.

12 "Su Wenzhonggong zeng Taishi zhi" by Zhao Shen in Su Shi 1919: *juanshou*.

13 For a concise discussion of Su's popularity in the north, see Hu 1998: 54–60.

14 "Shangshu youcheng Yelü gong shendaobei" in Yuan Haowen 2004, *juan* 27: 586.

15 Liu Qi 1983, *juan* 12: 135–136.

16 "Ti Qi'an xinke Xuetang tu" in Zhou Zizhi 1986, *juan* 28: 191.

17 Zhang Bangji 2002, *juan* 9: 253.

18 Citing Zhao Zizhi's and Monk Baotan's poetic inscriptions to two paintings as evidence, I Lo-fen opined that paintings related to Su Shi were in existence no later than the early Southern Song and that Red Cliff paintings were produced out of admiration for him. However, the relationship between these paintings and policy changes at the Southern Song court has been overlooked. Also yet unexplored are the connections between the poetic inscriptions and the pictorial characteristics of early Red Cliff paintings. See I Lo-fen 2001: 65–66.

19 "Wang Jinqing hua Chibi tu" in Yu Ji 2007: 63.

20 Both Chen P. and I Lo-fen believe the integration of text and painting is characteristic of the Six Dynasties period. See Chen P. 2012: 173–183; I Lo-fen 2001: 67.

21 Xu B. 1995b: 17.

22 Wu Yuanzhi's dates are still controversial. While Zheng Qian thought Wu was active during the reigns of the Jin emperors Taizong and Shizong (1123–1189), Xu Bangda believed

that this painting was produced by Wu after Zhao Bingwen had composed his poem on the paper now attached as a colophon, which is dated to 1228. See Zheng Q. 1979: 3–12; Xu B. 1984, vol. 2: 6.

23 This work is housed in the Palace Museum, Taipei.

24 I Lo-fen 2001: 69.

25 I Lo-fen 2001: 70.

26 The Nelson-Atkins painting is a round fan, measuring 24.8 × 26 cm, while both the Taipei and Beijing paintings are small square sheets, measuring 24 × 23.2 cm and 23.5 × 22.5 cm, respectively.

27 The Taipei version is thought to be datable to as late as the Ming dynasty and is probably a copy of the Nelson-Atkins painting. See Lai 2009: 251. Based on style and technique, the Beijing piece can be roughly dated to the late Yuan or early Ming.

28 For a discussion of how this painting reveals the relationship between Red Cliff paintings and "water paintings" in the Southern Song, see Lai 2009: 251–252.

29 This work is housed in the Palace Museum, Taipei.

30 The "poetic painting" cited here is different from that defined by James Cahill. He calls "poetic painting" that which can "arouse deep and intensive feelings with simple imagery" and appears "more as an object of recognition than as something deliberately produced." In this essay, the term covers paintings that are derived from specific literary sources and were produced with the aim of making the literary origins recognisable. See Cahill 1996: 8. For the use of verse lines as examination questions for recruiting talent to the Song emperor Huizong's Imperial Painting Academy, see Deng Chun 1963b, *juan* 1: 4–5.

David Ake Sensabaugh

The Role of Colophons and Inscriptions in the Unfolding of *Wenrenhua* during the Yuan Dynasty

IN THE AUTUMN OF 1307, A DAOIST PRIEST NAMED WANG XUANQING (active early 14th century) brought paper to an official and painter named Li Kan (1245–1320) and requested a painting. Li was busy and did not turn to the request until the beginning of the next lunar year, early in 1308. After receipt of the painting, Wang Xuanqing composed a poem. Later in 1308, Zhao Mengfu (1254–1322), a friend of Li Kan's and also an official, transcribed the poem as a colophon to the painting following Li's dedication and signature. During the following year, Wang Xuanqing asked Yuan Mingshan (1269–1322), who like Li and Zhao was serving the Mongol government, to add a poem to follow Zhao's transcription.

Personal relationships of the sort recorded in this exchange existed before the Yuan dynasty, but they became more frequent by the early fourteenth century and came to characterise *wenrenhua* — the "painting of the men of culture" — during the Yuan dynasty and subsequent centuries. The colophons appended to their paintings and the inscriptions written on them not only establish the links between figures such as Wang Xuanqing, Li Kan, Zhao Mengfu, and Yuan Mingshan but also trace the chain of influence among the painters of the Yuan — particularly those canonised as the Four Masters: Huang Gongwang (1269–1354), Wu Zhen (1280–1354), Ni Zan (1306–1374), and Wang Meng (d. 1385). Further, these colophons and inscriptions contributed to the understanding of these paintings as masterpieces.

LI KAN

Early in his career Li Kan had served the Mongols in Beijing, and in 1295 he served as an ambassador to Annam to settle border issues. He continued in posts in Jiangxi and Zhejiang until 1306, and was in and around Hangzhou in 1307–1308 during the transition from Emperor Chengzong (r. 1295–1307) to Emperor Wuzong (r. 1308–1311).[1] All the while he devoted himself to painting bamboo, about which he wrote a manual. In a preface to the manual dated 1299 he cited the late Northern Song dynasty painter of bamboo Wen Tong (1019–1079) and the Jin dynasty painter Wang Tingyun (1151–1202) as models he had been able to study.

While in the south Li Kan established friendships with several notable men: Wang Xuanqing (active early 14th century) was serving as an official in the administration of Daoist clergy. Zhao Mengfu was in Hangzhou serving as director of Confucian education for Jiangzhe after serving Khubilai Khan (1215–1294;

FIGURE 1

Ink Bamboo (*Mo zhu*) and *Four Purities* (cat. 21). Li Kan (1245–1320). Yuan dynasty, 1308. Reconstruction of the original handscroll, ink on paper. Scroll now divided between the Nelson-Atkins Museum of Art, Purchase: William Rockhill Nelson Trust, 48–16 (first half and colophons by Zhao Mengfu and Yuan Mingshan); and the Palace Museum (second half and artist's inscription; cat. 21). The stitched image of *Ink Bamboo* was provided by the Center for the Art of East Asia at the University of Chicago, for the East Asian Scroll Paintings Project: https://scrolls.uchicago.edu.

A Reconstruction of the original handscroll

B *Ink Bamboo*, The Nelson-Atkins Museum of Art

C *Four Purities* (cat. 21), The Palace Museum

D Li Kan's inscription

E Zhao Mengfu colophon with Wang Xuanqing poem

F Yuan Mingshan colophon

A

D C B

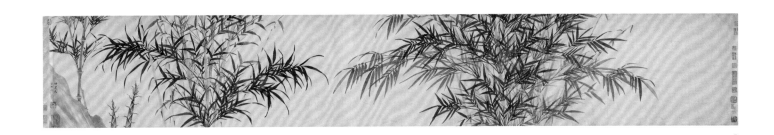

B

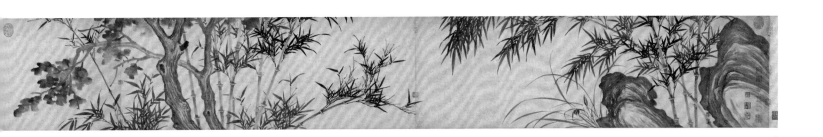

C

慈竹可以庇
倫紀方竹可愧
圓機士篁有筍
兮蘭有芳石秀
西澗樹老蒼李
侯平生竹成癖
渭川子猷在胃
臉笑孚墨卿
為寫真與可復
生至以易多祖
愛竹世所聞致
之不名稱此夫李
侯贈我有餘意
烟綠畫日卷舒
芳朔窗至塵篆
看爾之此樂生人
欹三泥況復洛
峻首着膝

仲賓為玄卿作墨竹玄卿
詩以紀之金友其波至六九年
為書此詩於其波至六九年
仲春既望吳興趙孟頫書

E

玄卿口哦
子昂詩手
持仲賓詩墨
竹枝此詩
此畫真兩
欲忽寒人
肌楓林青
少陵夢無
乃澤畔逢
湘纍楚江小
月晃初夜淇
園苦雨秋行
迷二妃彈瑟
淚如雨幽螫
龍潛春欲飛
天路迢遙衢
後不黑雨挾
風山兒啼老
氣監空根徹
泉地靈上訴
玄冥悲摩拟
老眼久知畫
恍惚吾興神
物移揮盃
三叫象非狂

奇似蒍玄
鄉寫幽姿
日光不下雲
局暗元氣

F

Shizu, r. 1271–1294) in Beijing.[2] Yuan Mingshan had held positions in Jiangxi and Jiangzhe and may have already begun service as instructor to the heir apparent, Ayurbarwada (the future Emperor Renzong, r. 1312–1320).[3]

The handscroll that Li Kan created for Wang Xuanqing was executed in ink on paper (fig. 1). In the carefully orchestrated composition, two groupings of bamboo are followed by a cluster of bamboo, rocks, and orchids and then a final grouping of bamboo and *wutong* trees. Each cluster of bamboo is different, with separately described leaf patterns. Two rocks and the two trunks of the *wutong* trees serve as the centres of the last two groupings. In depicting the bamboo, Li Kan used darker ink to define the foreground and lighter ink to indicate distance, clearly creating a sense of space. All are depicted at midsection following precedents seen in paintings by Wang Tingyun.

Before dating and signing his painting Li Kan stated that his eyesight was bad and the evening dark and thus he could not vouch for what the painting would look like in the morning. Wang Xuanqing was evidently quite happy with what he received and composed the following poem:

> The *ci* bamboo may enrich a man's moral sense;
> The *fang* bamboo may make a dishonest man feel shame.
> While the *gui* bamboo has [by nature myriad] shoots as the orchid
> has fragrance;
> The rocks are elegant and moist and the ancient trees dark green.
> Master Li is profoundly devoted to bamboo,
> Fixing in his mind a thousand *mou* of bamboo along the River Wei.
> He draws its image and rapturously calls it "Ink Gentleman";
> Even if Yuke [Wen Tong] were living today he could not surpass
> such beauty.
> The love my ancestor held for bamboo is well known in the world,
> And [he, too,] respected it, calling it "This Gentleman".
> So Master Li in offering me this painting must have harbored
> a special meaning,
> Wishing that later generations might continue the pure thinking
> of the ancestors.[4]

Wang Xuanqing couched his poem in moral terms and in the historical context of Wen Tong, the most famous Northern Song bamboo painter linked with the Song dynasty master Su Shi (1037–1101). The phrase "my ancestor" in the poem refers to Wang Huizhi (d. 388), who was famous for his love of bamboo and as sixth son of the fourth-century calligrapher Wang Xizhi (303–361).[5] It was this poem that so moved Zhao Mengfu that he wrote it out as a colophon attached to the handscroll following Li Kan's dedication and signature. Later, in 1309, Wang Xuanqing

requested a colophon from Yuan Mingshan. The latter says that his colophon, written quickly, would amuse Li Kan and Zhao Mengfu when they saw it, describing his calligraphy as "wild" (kuang).

The combination of these colophons — particularly Zhao Mengfu's calligraphy — with Li Kan's painting led a collector or dealer to profit from dividing the scroll into two parts sometime before the mid-sixteenth century. It was clearly already thought of as a masterpiece with significant market value. The opening section of the painting was given a spurious Li Kan signature and mounted with Zhao Mengfu's transcription of Wang Xuanqing's poem and Yuan Mingshan's colophon. The concluding section retained Li Kan's original inscription and signature. The two scrolls passed separately through major collections in the late sixteenth, seventeenth, and eighteenth centuries. Only the second scroll, under the title *Four Purities* (cat. 21), entered the Qing court collection from the collection of An Qi (1683–after 1745) in the mid-eighteenth century.[6]

ZHAO MENGFU

With the ascension of Crown Prince Ayurbarwada to the throne as Emperor Renzong in the fourth lunar month of 1311, many scholars and artists from his coterie were elevated to positions in the bureaucracy. Among them were Li Kan, Yuan Mingshan, and Zhao Mengfu.

Zhao Mengfu had been summoned to the capital by Crown Prince Ayurbarwada in 1309, a year after transcribing Wang Xuanqing's poem as a colophon to Li Kan's scroll. He did not go north to Beijing, however, until the end of the following year. After being raised to a position in the Academy of Worthies and having honours bestowed on his ancestors, he returned to his birthplace in Wuxing to erect tombstones for his ancestors. Before returning north to the court, he painted *Watering Horses in Autumn* (cat. 22), inscribing the title in the upper right corner and dating the work to the eleventh month of the first full year of Renzong's reign (1312) at the end of the scroll.

In this short handscroll, Zhao Mengfu depicted a red-robed figure leading horses to drink in a lake (fig. 2). Several horses are already in the water, and two gambol behind as the figure turns to look in their direction. Across the lake two more young horses frolic along the far shore. Framing the scene are large trees that rise from the foreground and continue out of the composition at the top. The carefully described knotted trunks twist and turn. Appropriate to autumn, the leaves of one tree have turned red.

Evoking Tang dynasty landscape painting, Zhao Mengfu used mineral pigments to create the lush landscape. The subject matter of watering horses also recalls Tang paintings, as in Li Gonglin's (1049–1106) copy of Wei Yan's (active 8th century) *Pasturing Horses*. Horses being groomed, fed, and watered symbolised a virtuous ruler supporting upright scholars and preparing them for office. The lushness of

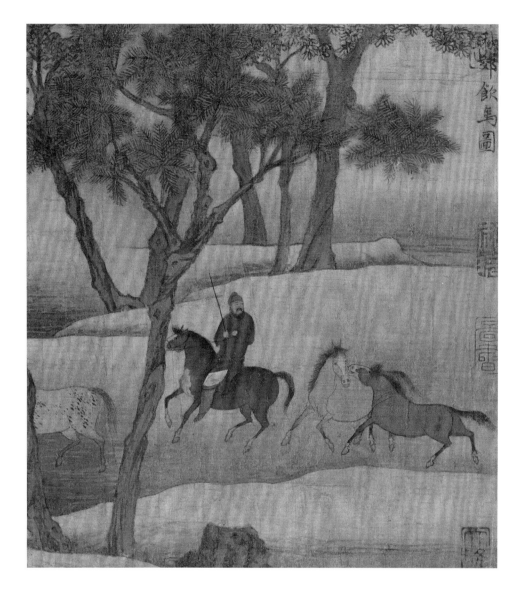

FIGURE 2
Detail of *Watering Horses in Autumn* (cat. 22). Zhao Mengfu (1254–1322) Yuan dynasty, 1312.

the landscape also stands for a well-governed country. The tree with a double trunk (*lianlimu*) was an auspicious omen that only occurred when a ruler's virtue spread throughout the country. All of these symbols point to Renzong at the end of his first full year on the throne. Although the emperor did not reinstate the examination system until 1313, he supported the Confucian education curriculum that Zhao Mengfu espoused. It could well be that Zhao painted the scene as a gift for Renzong.

The colophon by Ke Jiusi (1290–1343) that follows this painting (fig. 3) is more formal than the colophons following Li Kan's bamboo handscroll (fig. 1), for Ke Jiusi was writing as an official connoisseur in the Pavilion of the Star of Literature (Kuizhang ge). He was examining the scroll in the court collection.[7] He reinforced the painting's link to the Tang dynasty by comparing it with works he had seen by the famous Tang horse painters Wei Yan and Pei Kuan (681–755). In his choice of phrases, Ke Jiusi also connected Zhao Mengfu with Wang Xizhi.[8] All of this places

Zhao in the firmament of Chinese culture heroes and helps to equate the mid-Yuan dynasty with the glorious culture of the High Tang. Since Ke Jiusi was also a famous painter of bamboo known for his calligraphy, his colophon added lustre to Zhao's scroll in later centuries and led to its status as a masterpiece.[9] It entered the palace collection in the eighteenth century, and the Qianlong Emperor (r. 1736–1795) added his own colophon in 1776.

HUANG GONGWANG

Evidence suggests that Huang Gongwang was a student of Zhao Mengfu, thus placing him directly within Zhao's circle in Hangzhou. This most likely occurred after Zhao returned to the south in 1299 to take up the post as superintendent of Confucian education in Jiangzhe and before his return to the north in 1310. At the time, Huang Gongwang would have been a clerk in the office of the surveillance

commissioner of Jiangxi. Later, he was a clerk in the investigation bureau of the censorate in Beijing and appears to have been caught up in the land survey and taxation plan proposed by Zhanglü (Jangliu), the administrator of the Branch Secretariat of Jiangzhe. This plan aroused the enmity of rich landowners in Jiangzhe and Jiangxi, and with the fall of Zhanglü around 1316, Huang was implicated and imprisoned. After his release a year or more later, he abandoned his low-level career and returned to the south, settling in the Songjiang area. There he became acquainted with Cao Zhibai (1272–1355), Yang Weizhen (1296–1370), Zhang Yu (1283–1350), and Ni Zan, among other painters and calligraphers. He followed Quanzhen Daoism and late in life lived in the Fuchun Mountains in Zhejiang, where he painted *Dwelling in the Fuchun Mountains* (*Fuchun shanju tu*) between 1347 and 1350.[10]

Huang painted *Stone Cliff at the Pond of Heaven* (cat. 26) in 1341. He dated the painting and dedicated it to a man called Xingzhi — most likely Zhang Yuanshan, who had that sobriquet. A practitioner of the medical arts, Zhang served as supervisor of physicians (*guanyi tiju*) for Jiangzhe. In the following year, Xingzhi asked the "Hanlin Academician Awaiting Instructions" Liu Guan (1270–1342) to inscribe the painting. It is in Liu's long inscription across the top of the painting that Huang's connection to Zhao Mengfu is made: Liu calls Huang "a pupil of Wuxing" referring to Zhao by his native place, Wuxing (fig. 4).[11]

The Pond of Heaven was a scenic spot in the hills to the west of the city of Suzhou and must have had specific meaning for Xingzhi and Huang Gongwang. In the left foreground of the painting, Huang painted overly tall trees that dwarf the buildings immediately behind and to the side of them. In the middle he depicted

FIGURE 5
Detail of central mountain from
Stone Cliff at the Pond of Heaven
(cat. 26). Huang Gongwang (1269–
1354). Yuan dynasty, 1341.

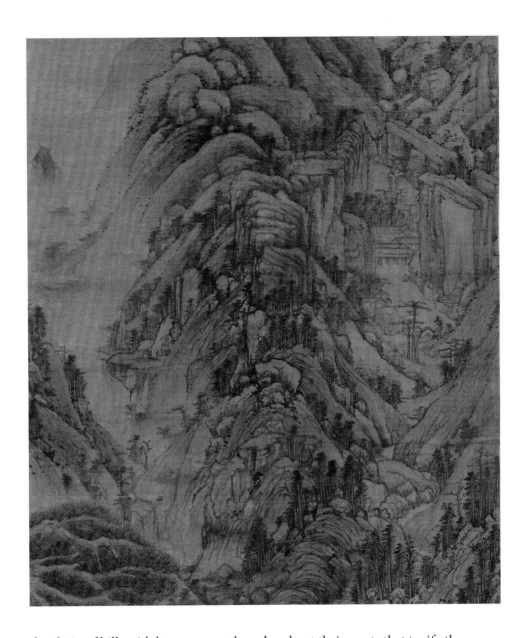

the chain of hills with large square-shaped rocks at their crests that typify the scenery of Mount Hua (Huashan) and Mount Tianchi (Tianchishan) (fig. 5). He showed it as an ascending ridge that creates a V-like composition. On the right, a valley leads to the Pond of Heaven and the Stone Cliff; on the left, Huang opened a view into the surrounding distance. The ridge dominating the centre of the painting is composed of rounded hills that are punctuated by the rocky outcroppings of the local topography along with trees that are found near their crests. Distant hills appear at the top of the painting. This central ridge is constructed of repeating shapes not seen in earlier Yuan painting.

Further evidence for Huang Gongwang's link to Zhao Mengfu is found in a composite handscroll now entitled *Calligraphy and Painting of Timely Clearing After Snowfall* (cat. 24). The title is taken from the four characters — *kuai, xue,*

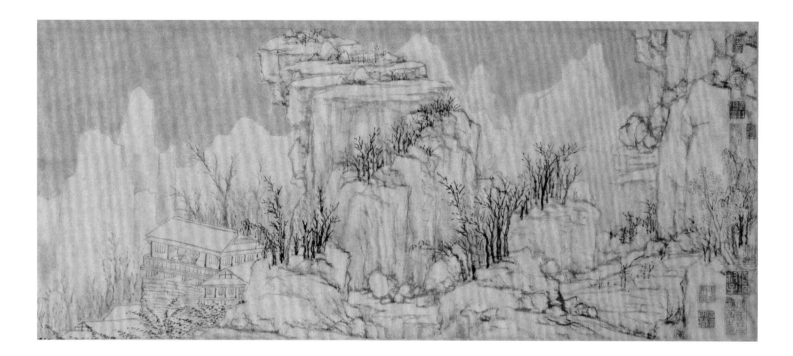

FIGURE 6
Detail of *Calligraphy and Painting of Timely Clearing After Snowfall* (cat. 24). Huang Gongwang (1269–1354). Yuan dynasty, ca. 1345.

shi, and *qing* — written by Zhao Mengfu for Huang Gongwang and mounted as the first section of the scroll. The characters are in turn taken from the name of a famous letter (*tie*) attributed to Wang Xizhi (see Harrist's essay in this volume for a discussion of *tie* and Wang Xizhi, pp. 59–79).[12] In the colophons that are mounted after the four characters, the first of which is dated to 1345, Huang wrote that he was giving Zhao's calligraphy to the poet and collector Mo Chang (active early 14th century), who owned a version of Wang Xizhi's letter, so that the two works — Wang's letter and Zhao's calligraphy — could be together. Huang's painting, presumably inspired by the four characters, comes next in the scroll, followed by a painting attributed to the late Yuan painter Xu Ben (1335–1380).[13]

Huang Gongwang's painting is unlike *Stone Cliff at the Pond of Heaven.* It is a short handscroll executed in ink and light colour on paper (fig. 6). Unlike the earlier work's dense landscape constructed of repeated forms built up in the middle out of draping hemp-fibre strokes and strong contours, *Calligraphy and Painting of Timely Clearing after Snowfall* is a transparent snowscape painted with dry brush. The landscape opens with a cliff face descending from the top of the scroll to the base. A path leading to a cluster of temple buildings in the middle of the composition opens up below. The path passes beneath massive plateau-like mountains. Part of the temple complex is built out on a terrace; through the open doors of the topmost building, an altar and the pedestal of a sculpture can be seen. A pale red sun hangs in a bleak winter sky after a snowstorm has cleared. The composition closes with a final group of mountains brushed in light ink. Without either Huang Gongwang's signature or seal on the painting, the attribution is made on the basis of style: elements of the landscape are particularly close to his *Clearing after Snow*

FIGURE 7
Clearing after Snow at Jiufeng.
Huang Gongwang (1269–1354).
Yuan dynasty, 1349. Hanging scroll,
ink on silk. The Palace Museum.

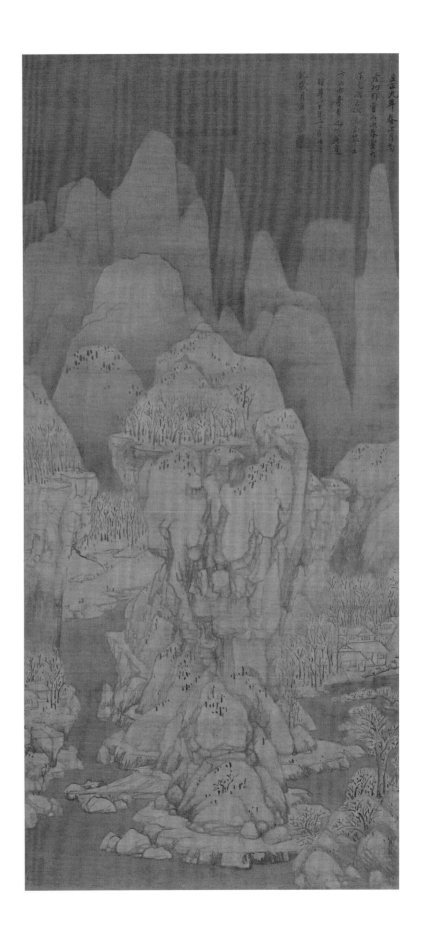

at Jiufeng (Jiufeng xueji) of 1349; and the brushwork at the beginning of *Timely Clearing after Snowfall* appears almost identical to the strokes in the central mountain of *Clearing after Snow at Jiufeng* (fig. 7).[14]

The assemblage of the handscroll that includes *Timely Clearing after Snowfall* is complicated.[15] Zhao Mengfu's four characters written for Huang Gongwang and the colophons now attached to it clearly indicate that Huang gave the calligraphy to Mo Chang to accompany a version of Wang Xizhi's *Timely Clearing after Snowfall* (*Kuaixue shiqing*) letter owned by the Mo family. If the gift and colophons occurred around the time of the first colophon — by Huang Jin (1277–1357), dated to 1345 — Huang Gongwang's painting would have come later. The landscape attributed to Xu Ben (1335–1380) would have come much later, since he was born in 1335 and thus was too young to contribute a painting in the 1340s. This landscape, however, is unlike Xu Ben's dated paintings from around 1370. The painting now mounted with the scroll is in the Li Cheng (919–967)–Guo Xi (active 11th century) style; Xu Ben's mature paintings are in the Dong Yuan (d. 962)–Juran (active mid-to-late 10th century) style. In addition, the signature does not agree with those on his other works.[16] Seventeenth-century catalogues mention the Zhao Mengfu calligraphy, the colophons, and the painting attributed to Xu Ben but not the painting by Huang Gongwang. Additionally, seals of the early Qing collector Zhang Chunxiu (1647–1706) appear on the Zhao Mengfu calligraphy, the colophons, and the painting attributed to Xu Ben but not on the painting by Huang Gongwang. It was not until the early eighteenth century that An Qi and Zhang Ruoai (1713–1746) mentioned the Huang Gongwang painting in their notations at the beginning of the scroll.[17]

Despite all parts of the scroll having seals of the great sixteenth-century collector Xiang Yuanbian (1525–1590), it has been suggested that his seals on the Huang Gongwang painting are forgeries made to give it the same provenance as the other parts of the scroll and that Huang's landscape may not have been mounted together with the other parts until in the early eighteenth century. Huang Gongwang's painting may have gone under a different title before being joined to the other three parts.[18] In this format, the handscroll, which had been in An Qi's collection, was sold in 1744 to Zhang Ruoai and remained in private hands into the twentieth century. It was in the collection of Pang Yuanji (1864–1949) and was acquired by the Palace Museum only after the founding of the People's Republic of China.[19] Its importance to the oeuvre of Huang Gongwang has only recently become apparent with more frequent publication.[20]

WU ZHEN

Wu Zhen (1280–1354) was born the year after the death of the last claimant to the Song throne and appears to have grown up quietly in his hometown of Weitang, Zhejiang, living off inherited wealth. The Wu family had served in the Southern Song government, but in the generations immediately preceding Wu Zhen's birth it

FIGURE 10
Detail of *Fishermen* (*Yufu tu juan*). Wu Zhen (1280–1354). Yuan dynasty, ca. 1345. Handscroll, ink on paper. Shanghai Museum.

had relied on the family shipping business for income.[21] Unlike Huang Gongwang, neither Wu nor his older brother appeared to have sought an official career under the Mongols. They followed their interests in Daoism and Buddhism and led uneventful lives.

Their uncle Wu Sen was known as a collector, and it is through him that Wu Zhen may have been able to see and study early paintings. A large landscape hanging scroll attributed to Wu Zhen, *Autumn Mountains* (*Qiushan tu*) is in the manner of the tenth-century painter Juran.[22] Another large hanging scroll, *Twin Junipers* (*Shanggui tu*) of 1328, follows the tall trees and level distance compositions, though not the brushwork, of Li Cheng.[23] In addition, two handscrolls of fishermen — one dated to around 1341 in an inscription dated 1352, and the other dated to around 1345 — bear inscriptions that mention works by Jing Hao (active mid-9th–early 10th century) that Wu Zhen had seen as his source.[24] The fishermen in both scrolls are accompanied by lyric poems (*ci*) that follow the tune of "The Fisherman" (*Yufu*), a tune pattern associated with the eighth-century poet and painter Zhang Zhihe (ca. 730–ca. 810). The two handscrolls are thus also linked with a poetic form from the Tang dynasty. These works all suggest exposure to a broad range of ancient masters.

Wu Zhen's *Old Fisherman* of 1336 from the Palace Museum collection (cat. 27) depicts an angler who has just paddled his skiff into a cove in the lower part of the painting. With his paddle in one hand and his rod and reel in the other, he sits in the prow of the boat. He has a broad-brimmed hat, and the boat has a roofed section in the middle. Hanging just inside the boat is a double gourd used for wine. The cove or inlet is composed of reedy banks in the foreground and a spit of land with two tall trees of different species jutting out beyond the fisherman from the right. The tall trees serve to link the foreground scene with a landmass of rounded

hills, trees, and distant mountains. The middle-ground trees are splayed to either side with trunks and roots displayed. To the right of the hills a stream appears to zigzag into the distance. The far mountains have mostly squared tops; the central peak is on axis with the trees in the middle ground. Above this scene, the painter has composed and written out a lyric poem (fig. 8):

> The view cut off by misty waves, the azure [sky] between being and
> nonbeing,
> The leaves of the *feng* tree withered by frost, the brocade [of autumn]
> blurred.
> A thousand-foot wave,
> A four-gilled perch,
> A tube for poems faces a bottle gourd for wine.

Following the lyric is an inscription dating the painting to the eighth month of the second year of the Zhiyuan reign (1336) stating that it is one of a suite of four pictures of fishermen. This inscription would indicate that *Old Fisherman* is the concluding (leftmost) painting of the suite. Although the poem suggests an autumnal scene, it does not relate exactly to the painting. Only the bottle gourd suggests that the fisherman is a poet drawing inspiration from wine while angling for the famous perch on the lakes and rivers of Jiangnan.

This painting is one of a group of pictures in Wu Zhen's oeuvre depicting fishermen — a theme going back to the story of "The Fisherman" in *Songs of Chu*

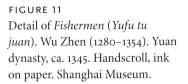

FIGURE 11
Detail of *Fishermen* (*Yufu tu juan*). Wu Zhen (1280–1354). Yuan dynasty, ca. 1345. Handscroll, ink on paper. Shanghai Museum.

(*Chuci*).[25] The group includes the two handscrolls after Jing Hao noted above, both of which combine the depiction of fishermen with a lyric to the tune of "The Fisherman," just as *Old Fisherman* does. In none of these works do the lyrics appear to be specific to the painted images. There are also similarities in the execution of the three paintings. The motif of the splayed trees with exposed roots appears in all three, and in all three the roots, rather than clawing into the earth, ride on the surface of the paper (figs. 9–10). The moss dotting in all three appears to be on the surface of the land formations rather than defining a ridge and thus movement into space (fig. 11). The mountains in the two handscrolls, although overlapping, do not recede into depth. This is comparable to the stream in *Old Fisherman*; it stays as a zigzag surface pattern rather than receding into depth.

These similarities distinguish the three scrolls from another painting traditionally known as *Fishermen* (*Yufu*) despite the inscription by Wu Zhen that names the work *Fisherman's Idyll* (*Yufuyi*). It is a large hanging scroll on silk dated to 1342.[26] Rather than a fisherman, it depicts a scholar boating on a lake in the moonlight. He is experiencing the pleasures of a fisherman rather than fishing. There is a sense of expanding space as the lake surface stretches beyond the foreground to the distant hills. The hills recede into space, and the moss dotting clings to the earth. Hemp-fibre strokes (*pima cun*) and wash define the solidity of the forms. These concerns with depth and the solidity of forms are also seen in *Twin Junipers*.

Fisherman's Idyll and *Twin Junipers* represent a different side of Wu's oeuvre. Whatever the relationships among all of these works, *Old Fisherman* of 1336 would be the earliest of the dated fisherman paintings in Wu Zhen's surviving oeuvre. It would also be the earliest painting of the fisherman theme combining Wu Zhen's skills as painter, poet, and calligrapher. Despite an inscription by Wang Duo (1592–1652) written on the paper mounted above the painting (*shitang*) dated to 1646, the painting and its poem remained unrecorded until the nineteenth century, when it was in the collection of Wu Rongguang (1773–1843).[27] It entered the Palace Museum after the founding of the People's Republic.

NI ZAN

Ni Zan was born into a wealthy family in Wuxi and, like Wu Zhen, did not pursue a career in government. He grew up surrounded by books and antiquities. His elder brother Ni Wenguang (1278–1328) was in the Daoist church and was able to register some of the family property under the church and thus avoid taxes. After the deaths of his brother and mother, however, Ni Zan was without the protection provided by his brother, and in the late 1340s, burdened by heavy taxation and rising civil unrest, he quit the family property for life on a houseboat.[28]

Through his older brother, Ni Zan had become acquainted with Zhang Yu (1283–1350), a prominent Daoist master and calligrapher with close ties to the Shanqing order of that tradition. Zhang had studied calligraphy with Zhao Mengfu

FIGURE 12

Detail of *Wutong, Bamboo, and Elegant Rock* (cat. 29). Ni Zan (1306–1374). Yuan dynasty, before 1350.

FIGURE 13

Detail of *Wutong, Bamboo, and Elegant Rock* (cat. 29). Ni Zan (1306–1374). Yuan dynasty, before 1350.

FIGURE 14
Elegant Rocks, Sparse Trees.
Zhao Mengfu (1254–1322). Yuan
dynasty. Handscroll, ink on paper.
The Palace Museum.

and knew Huang Gongwang and thus served as a link to them for Ni Zan. Zhang
inscribed Ni Zan's *Wutong, Bamboo, and Elegant Rock* (cat. 29), with Zhang's death
in 1350 providing a *terminus ante quem* for the execution of the painting.[29]

Wutong, Bamboo, and Elegant Rock is constructed around a tall garden rock
from Lake Tai (Taihu) in the middle of the composition. Set in a shallow ground,
the rock is executed in dark wash with little or no contouring. Many of the rock's
edges were created by the drying wash. The wash was applied in several layers, with
horizontal accents of darker ink and some dry brushwork. The dry brushwork of
the *wutong* tree to the left contrasts with the inky wetness of its leaves. With no
veining or contours, the leaves are executed in the boneless (*mogu*) technique.
Dark and light stalks of bamboo rise from behind the rock. The leaves of the darker
trunk overlap the leaves of the *wutong* tree, with the patterns of the leaves standing
out against the wash of the *wutong* tree leaves. The lighter tonality of the bamboo
on the right suggests a spatial relationship within the shallow space.

Zhang Yu's inscription appears at the upper right (fig. 12). He composed a poem
in seven-character verse followed by a two-line postscript citing Ni Zan's alternative
names, Yunlin and Yuanzhen:

> In the shade of a green *wutong* tree, an upright rock;
> Rowing back to look at [the painting], the [snow] has not yet melted.
> Opening the scroll is like seeing an image of Yunlin;
> Willingly moving [the painting] in front of the lamp to appreciate the
> thin-waisted women of Chu.
> [Yuanzhen] painted this paper and sent it to me for Puxuan [Calamus
> Studio], thus I was inspired to write this on the picture.[30]

Ni Zan's inscription appears in the middle right and provides considerable
circumstantial information about the Daoist community (fig. 13):

The Daoist Master Zhenju [Zhang Yu] is going to visit the Lofty Hermit
Wang Junzhang [Wang Gui] in the mountains of Changshu. I thus painted
this picture *Wutong, Bamboo, and Elegant Rock* to send to the provincial
graduate Zhongsu [Miao Zhen] and also composed a poem:

A tall *wutong* tree and scattered bamboo at a dwelling south of a stream,
Although it is the fifth month, the sound of the stream gives the chill
 of winter.
At this time one expects to get warmth through the window,
Knocking down the chestnuts in the orchard — clusters of purple.[31]

 — Ni Zan

Wang Gui (ca. 1264–1353) was a Daoist master from Changshu living in retreat
at Yushan. He was a skilled painter whom Zhao Mengfu held in high regard. Miao
Zhen (active mid-14th century) was younger than Zhang Yu and Wang Gui. Also
from Changshu, he called himself "The Woodcutter of Wumu Mountain" and was
known for his calligraphy in several script types.[32]

The subject matter of old tree, bamboo, and rock formed an important genre of
Yuan dynasty painting and is a large component of Ni Zan's surviving oeuvre. The
genre goes back to the circle around Su Shi in the late Northern Song dynasty and
to followers of Su during the Jin dynasty. It was Zhao Mengfu in the early Yuan,
however, who transformed the genre by infusing the brushwork of calligraphy into
his painting.[33] In an inscription accompanying a handscroll called *Elegant Rocks,
Sparse Trees* (*Xiushi shulin tu*, figs. 14, 15) he wrote:

The rocks are like flying-white, the trees like seal script;
The writing of bamboo draws upon the *bafen* [late clerical script] method.
If indeed there are people who can make these links,
They will know that calligraphy and painting grow from the same root.[34]

Ni Zan's many surviving depictions of the subject follow the direction set by
Zhao Mengfu and form a stylistically consistent group within his oeuvre. This can
be seen in *Autumn Wind in Gemstone Trees* (*Qishu qiufeng tu*, fig. 16).[35] It depicts a
rock on a sloping bank surrounded by sprigs of sparse bamboo and two taller stalks
on the right. Two trunks of a tree growing from the same root base are on the left.
The rock is executed with dry brushwork creating the "flying white" effect. There
are a few dark horizontal accents. Overall the brushwork has a spare, dry feel, with
the delicate patterns of the bamboo standing out in dark ink.

In departing from these traits, *Wutong, Bamboo, and Elegant Rock* stands
apart from other works in this genre in Ni Zan's oeuvre. It also stands apart
from other works datable to before 1350. In style of painting and calligraphy it is

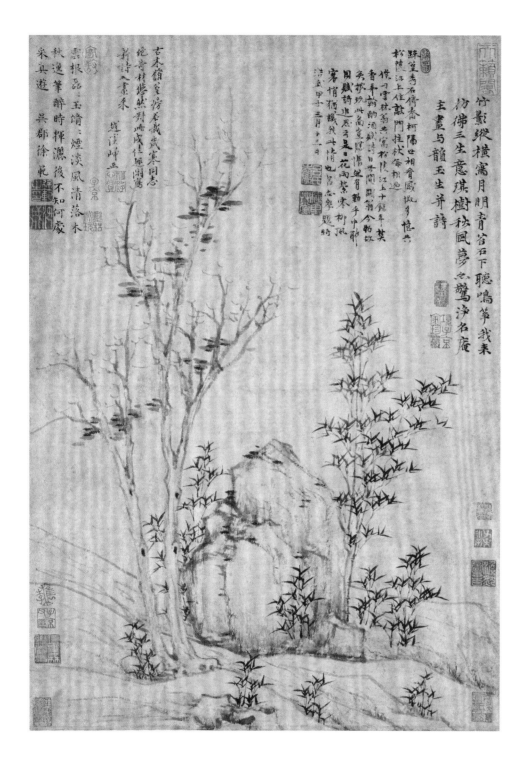

FIGURE 16
Autumn Wind in Gemstone Trees.
Ni Zan (1306–1374). Yuan dynasty.
Hanging scroll, ink on paper.
Shanghai Museum.

unlike *Enjoying the Wilderness in an Autumn Grove* (*Qiulin yexing tu*),[36] dated 1339; *Dwelling amidst Water and Bamboo* (*Shuizhuju tu*),[37] dated 1343; and *The Six Gentlemen* (*Liu junzi tu*),[38] dated 1345. As An Qi remarked, it is a work rarely seen among Ni Zan's bamboo and rock pictures, a work of the "divine-untrammeled"[39] class, thus anticipating its present status as a masterpiece.

Wutong, Bamboo, and Elegant Rock was mentioned by Zhang Chou (1577–1643) in *Calligraphy and Painting Barge at Qinghe* (*Qinghe shuhua fang*) in the early seventeenth century and was in the collection of Liang Qingbiao (1620–1691), whose seals are on the painting.[40] In the eighteenth century, it was recorded by Wu Sheng (active late 17th–early 18th century) in *Inspiring Views* (*Daguan lu*) and An Qi in *Fortuitous Encounters with Ink* (*Moyuan huiguan*), although there are differences in how they record the picture.[41] It was presumably acquired for the palace around 1746 from An Qi's collection after his death. It remained in the palace collection through the eighteenth century, when it was inscribed by the Qianlong Emperor in 1795, and it bears seven Qianlong seals. It was, however, never catalogued for the collection. It seems to have left the palace at some point in the nineteenth century and was acquired by the Shanghai collector Pang Yuanji. It entered the collection of the Palace Museum after the founding of the People's Republic.

Over the centuries the status of all of these paintings was enhanced by the colophons attached to them and by the inscriptions written on them. They became crucial components that defined *wenrenhua*, the painting of the men of culture, as it unfolded from the fourteenth century onward. As the reputations of the Yuan masters rose, the colophons and inscriptions contributed to their paintings being thought of as masterpieces.

NOTES

1 For basic biographical information on Li Kan, see Wang D. et al. 1979–1990, vol. 2: 473–474; Chen G. 2015, vol. 1: 144–170; and Kao 1981.

2 For basic biographical information on Zhao Mengfu, see Wang D. et al. 1979–1990; Chen G. 2015, vol. 1: 39–143; and McCausland 2011.

3 For basic biographical information on Yuan Mingshan, see Wang D. et al. 1979–1990, vol. 1: 30–31.

4 Translation by K. S. Wong and Laurence Sickman in Ho et al. 1980: 104, no. 83.

5 The source for Wang Huizhi's love of bamboo, where he states he could not live a single day without "these gentlemen", comes from *Shishuo xinyu*; see Liu I. 1976: 388–389.

6 For the collecting history of the separated scrolls, see Ho et al. 1980: 102–104, no. 83; and Yu H. 2005: 154–157, no. 80.

7 For basic biographical information on Ke Jiusi, see Wang D. et al. 1979–1990, vol. 1: 344–345; and Chen G. 2015, vol. 1: 262–289. The Pavilion of the Star of Literature (Kuizhang ge) was founded by Emperor Wenzong (r. 1328–1332).

8 Ke Jiusi used a phrase from the "Discussion of Wang Xizhi's Biography" in the *Jin shu*; see McCausland 2011: 185–190.

9 For the collecting history of the scroll, see Yu H. 2005: 29–33, no. 8.

10 For basic biographical information on

Huang Gongwang, see Wang D. et al. 1979–1990, vol. 3: 1483–1485; and Chen G. 2015, vol. 2: 466–487. For Zhanglü (Jangliu), see Wang D. et al. 1979–1990, vol. 4: 2413; and for the case of Zhanglü, see Franke and Twitchett 1994: 523.

11 "Wuxing shinei dadizi". There are several recorded and extant versions of this painting. Most versions are dated to 1341 but not all are dedicated to Xingzhi (Zhang Yuanshan). The Palace Museum painting is the only one to have an inscription by Liu Guan, who composed his inscription at the request of Xingzhi. The Palace Museum painting appears to be the one recorded by Du Mu (1459–1525) in his *Yuyi bian*. It was in the collection of Chen Mengxian and had a seal of Qian Liangyou (1278–1344). Qian was Zhang Yuanshan's father-in-law, thus confirming the identification of Xingzhi as Zhang Yuanshan; see Du Mu 1962. For Zhang Yuanshan, see Wang D. et al. 1979–1990, vol. 2: 1113. For the version dated to 1341 but without a dedication that was collected by the Qing palace in the eighteenth century, see Taibei Gugong Bowuguan 1989–, vol. 4: 97–98.

12 For a study of the Wang Xizhi letter *Kuai-xue shiqing* and its reception during the Yuan dynasty, see Augustin 2017, which deals in detail with the colophons following Zhao Mengfu's calligraphy.

13 See Yu H. 2005: 66–67, no. 23.

14 See Yu H. 2005: 64, no. 21.

15 I have relied on the discussion of the handscroll by Xu Bangda; see Xu B. 1984, vol. 3: 76–79 and vol. 4: 158–165.

16 For Xu Ben paintings and signatures, see Taibei Gugong Bowuguan 1989–, vol. 6: 21–22; and Chou and Chung 2015: 204–206.

17 Wang Keyu 1643: 1099.

18 Xu B. 1984, vol. 3: 77.

19 Pang Yuanji 1971, *juan* 1: 95–102.

20 Barnhart et al. 1997: 168–169. James Cahill sees the painting as important in relation to the dry, linear manner of the Anhui school in the seventeenth century; see Cahill 1997: 168–169.

21 For basic biographical information, see Wang D. et al. 1979–1990, vol. 1: 383–384; and Chen G. 2015, vol. 2: 494–500. For more detailed studies, see Stanley-Baker 1995 and Yu H. 1995.

22 *Autumn Mountains* is in the collection of the Palace Museum, Taipei. See Taibei Gugong Bowuguan 1989–, vol. 1: 21–22, where the painting is traditionally catalogued as a work of Juran.

23 *Twin Junipers* is in the collection of the Palace Museum, Taipei. See Taibei Gugong Bowuguan 1989–, vol. 4: 161–164, where the painting is catalogued as *Shuangsong tu*.

24 The first scroll is *Fishermen, after Jing Hao*, ca. 1341, Freer Gallery of Art (F1937.12); see Cahill 1960: 108. The one dated to around 1345 is in the Shanghai Museum; see Zhongguo Gudai Shuhua Jiandingzu 1999: 158–167.

25 See Hawkes 1985: 206–207

26 For the title of the painting, now in the collection of the Palace Museum, Taipei, and a reading of the picture, see Stanley-Baker 1995: 107–115. The painting is illustrated in Taibei Gugong Bowuguan 1989–, vol. 4: 165–166.

27 Wu Rongguang 1971: 386–397.

28 For basic biographical information, see Wang D. et al. 1979–1990, vol. 2: 837–859; and Chen G. 2015, vol. 2: 546–582. For the use of 1306 as opposed to 1301 for Ni Zan's date of birth, see Huang and Hao 2009: 3–4. On the Ni family and Daoism, see Huang M. 2003: 29–35.

29 Various dates have been offered for the execution of the painting. The Palace Museum, using the 1301 date of birth for Ni Zan, states that the painting was done when the artist was forty-three to forty-five *sui*, thus approximately 1344–1346; see Yu H. 2005: 74, no. 30. Huang Miaozi and Hao Jialin give a date of 1340; see Huang and Hao 2009: 238. Neither source explains how the dating was arrived at.

30 This painting was recorded by Wu Sheng in *Inspiring Views* (*Daguan lu*; 1712) and by An Qi in *Fortuitous Encounters with Ink* (*Moyuan huiguan*; 1742). Both catalogues record three characters that are no longer visible in Zhang Yu's poem and postscript: the character for "snow" (*xue*) in the second line and Ni Zan's alternative name "Yuanzhen" at the beginning of the postscript. See Wu Sheng 1970: 2119–2120; and An Qi 1742: 381. The characters are in brackets in the translation.

31 Depending on how this inscription is punctuated, it could be that Ni Zan painted the picture for Wang Gui, and Miao Zhen was then inspired to compose a poem that Ni Zan then copied out. Cui Yi, for instance, sees the sequence as follows: Ni Zan painted the picture for Zhang Yu; Miao Zhen then composed a poem; and Ni subsequently wrote the inscription incorporating the poem. How this sequence was arrived at is not explained. See Cui 2017.

32 For Wang Gui and Miao Zhen, see Wang D. et al. 1979–1990, vol. 1: 1102 and vol. 4: 2010, respectively.

33 For a discussion of the genre of old trees, bamboos, and rocks and Zhao Mengfu, see McCausland 2011: 265–331.

34 Translation based on McCausland 2011: 321.

35 *Autumn Wind in Gemstone Trees* is in the Shanghai Museum; see Zhongguo Gudai Shuhua Jiandingzu 1999: 134, no. 115.

36 Metropolitan Museum of Art (1989.363.38); see Fong 1992, pls. 116, 116a, and 116b.

37 Zhongguo Gudai Shuhua Jiandingzu 1999: 112–113, nos. 94–95.

38 Shanghai Museum; see Zhongguo Gudai Shuhua Jiandingzu 1999: 114–115, nos. 96–97.

39 An Qi 1742: 381.

40 See Zhang Chou 1616, *juan* 12, 44b.

41 See Wu Sheng 1970: 2119–2120; and An Qi 1742: 381. For a discussion of the differences in describing the painting, see Cui 2017.

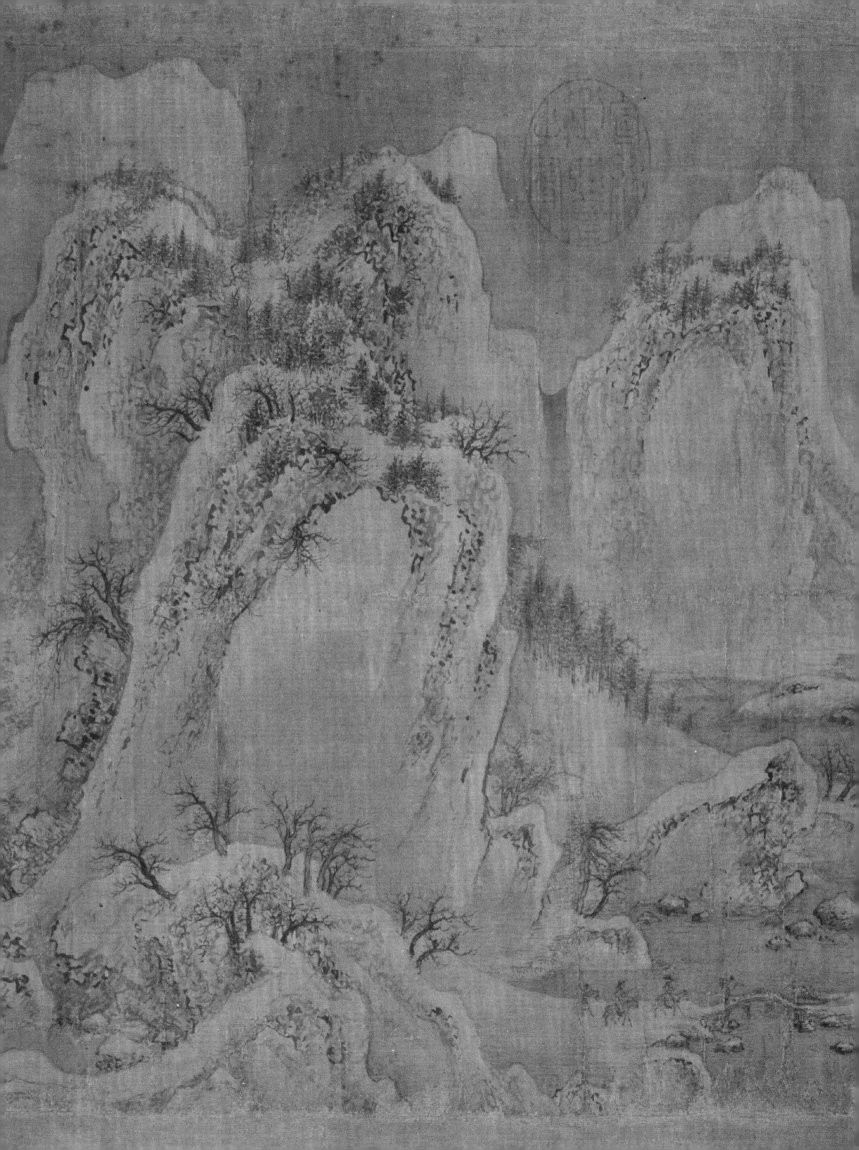

Jiang Fangting

Art Collecting in the Ming Dynasty
A Case Study of *Returning Boats on a Snowy River*

MUCH AS THEY HAVE BEEN CHERISHED AS PART OF AN INVALUABLE cultural heritage, ancient works of painting and calligraphy have dwindled in number from one period to the next. Collecting and authenticating them not only establishes their legitimacy and quality but also sheds light on issues of conservation, transmission, and cultural inheritance. Historically speaking, collections in China were either imperial or private. Since ancient artefacts are literally irreplaceable, the contents of these collections waxed and waned, often one at the expense of the other. Imperial collectors often had the motivation, the resources, and the power of an empire behind them to seek out, obtain, and preserve masterpieces; private collectors took over when the court no longer had the means or interest to do so.

Evidence shows that collecting activities during the Tang and Song dynasties were dominated by the court. This dominance subsided in the Yuan dynasty to the extent that private collections grew to rival those of the court, and during the Ming dynasty, private scholars, artists, and connoisseurs became the driving force behind collecting. From the mid-Ming onward, many masterpieces previously held in imperial collections were dispersed, enabling connoisseur-collectors of means to rise to prominence. Among them were Shen Zhou (1427–1509), Wen Zhengming (1470–1559), Xiang Yuanbian (1525–1590), Wang Shizhen (1526–1590), Han Shineng (1528–1598), Zhan Jingfeng (1528–1602), Dong Qichang (1555–1636), Sun Chengze (1593–1676), Liang Qingbiao (1620–1691), Gao Shiqi (1645–1703), and An Qi (ca. 1683–after 1745). It was not until the Qing dynasty, and the reign of Qianlong Emperor (1736–1795), that the impetus for collecting once again came from the court.

By focusing on a single work — *Returning Boats on a Snowy River* (cat. 10) — and its transmission, we can trace the development of collecting from the mid-Ming to the early Qing and investigate aspects of connoisseurship and the processes that led to the canonisation of a masterpiece.[1]

CREATION, DISAPPEARANCE, AND REAPPEARANCE

Shortly after its founding in 960, the Northern Song court began amassing masterpieces of painting and calligraphy that had been scattered across China since the late Tang dynasty. Initially deposited in the Imperial Archives established by Emperor Taizong (r. 976–997), the collection reached a pinnacle during the reign

of Emperor Huizong (1101–1125), amounting to more than seven thousand works according to the imperially compiled *Xuanhe Catalogue of Calligraphy* (*Xuanhe shupu*) and *Xuanhe Catalogue of Paintings* (*Xuanhe huapu*). If works by Huizong himself and Academy painters included in *Albums for the Imperial Gaze of the Xuanhe Reign* (*Xuanhe ruilan ce*) are counted, the number exceeded ten thousand. Private collectors were no less enthusiastic and active, with scholar-officials vying with the court to acquire extant Jin and Tang masterpieces.

Returning Boats on a Snowy River is the only landscape ever attributed to Huizong. Elegant in execution and serene in atmosphere, it is a quintessential Northern Song winter landscape. The painting is impressed with imperial seals dating to Huizong's reign and bears a poetic colophon responding to the painting written by the Grand Chancellor Cai Jing (1047–1126) in 1110. Soon after its completion, the painting disappeared from public view for 460 years before resurfacing in the mid-Ming. Its transmission during that period is unclear, but some hints may be found in the development of collecting from the Southern Song to the early Ming.

By the time of the Southern Song emperor Ningzong (r. 1195–1224), the imperial collection had shrunk to about a thousand works and did not compare favourably with private collections assembled by scholar-officials such as the Grand Chancellors Han Tuozhou (1152–1207) and Jia Sidao (1213–1275). The Jin emperor Zhangzong (r. 1190–1208) was an admirer of Han culture and fashioned his enviable storehouse of treasures after that of Huizong. The Southern Song and the Jin imperial collections were partially taken over by the Mongols when they unified China and founded the Yuan dynasty. When the Yuan emperor Wenzong (r. 1328–1331) created the Hall of Literature, it became the depository for these and other works of painting and calligraphy. Still other masterpieces resided in the collections of the Grand Princess Sengge Ragi (ca. 1283–1331) and Ke Jiusi (1290–1343), Erudite of Painting and Calligraphy.

With the rise of the Ming dynasty, it took possession of the Yuan imperial collection, though most Ming emperors had little interest in collecting and often gave works of painting and calligraphy as rewards to courtiers or as gifts to foreign leaders. Management of the collection was entrusted to the Office of Eunuch Rectification, and the imperial collection was compromised and looted by eunuchs who meddled in state affairs. By the mid-Ming, many masterpieces previously in the imperial collection were in private hands. During the reigns of the Ming emperors Chenghua (1465–1487), Hongzhi (1488–1505), and Zhengde (1506–1521), the eunuchs Huang Ci (active late 15th century) and Qian Neng (active mid-to-late 15th century) emerged as leading collectors, and Jiangnan and Beijing became important collecting hubs. In Jiangnan, Wang Ao (1450–1524) of Wuxian devoted himself to collecting paintings and calligraphy after his retirement as Grand Academician. Yet his collection was dwarfed by that of the high-ranking official

Lu Wan (1458–1526) of Suzhou, whose property was eventually confiscated by the court after he was suspected of treason. Art collecting in Jiangnan became interwoven with the creation of paintings and calligraphy and the practice of patronage when the Wu School of painting, led by Shen Zhou and Wen Zhengming, rose to prominence during the reigns of emperors Zhengde and Jiajing (r. 1522–1566).

Of the works confiscated from Lu Wan, more than a thousand pieces came into the possession of Grand Chancellor Yan Song (1480–1567) and his son Yan Shifan (1513–1565). Known to be an insatiable collector, Yan Song is said to have had Wang Shu (1507–1560) — then Supreme Commander of Jiliao and the father of Wang Shizhen and Wang Shimao (1536–1588) — killed on a fabricated charge in a feud over the ownership of the masterpiece *Going up the River at the Qingming Festival* (*Qingming shanghe tu*) by the Northern Song painter Zhang Zeduan (ca. 1085–1145).[2] In fact, similar crimes of avarice were not uncommon in the Ming since masterpieces of painting and calligraphy were the gems that the rich and powerful scrambled to collect, even if they had to resort to deviousness. Such villainy grew so rampant that the playwright Li Yu (ca. 1591–ca. 1671) based his work *A Palmful of Snow* (*Yipeng xue*) on Wang Shu's fate in order to denounce it.[3] In 1565, Yan Song himself had his collection — more than three thousand paintings and works of calligraphy — confiscated by the government. Zhu Xizhong (1516–1573), the Duke of Cheng, and his brother Zhu Xixiao (d. 1574), the Grand Guardian, petitioned the throne to have the collections confiscated from Lu Wan and Yan Song auctioned off. Empty coffers during the reigns of emperors Longqing (1567–1572) and Wanli (1573–1620) further accelerated the drain on the imperial collection as paintings and works of calligraphy were given to nobles as emoluments in kind. Reaping the greatest benefit from these practices were the Zhu brothers, Xiang Yuanbian, and Han Shineng (1528–1598).

Zhu Xixiao is the earliest known Ming collector of *Returning Boats on a Snowy River* after it disappeared from the Song court.[4] In his colophon to the work, Wang Shimao recounted how Zhu Xixiao treasured his new acquisition and had it remounted and refitted with precious materials like jade and silk. The painting subsequently became a highly coveted piece that acquired more colophons each time it changed hands. This wealth of textual material has made it an ideal case for uncovering Ming collecting activities.[5]

THE WANG BROTHERS: ACQUISITION, PRESERVATION, AND COLOPHONS

With the 1559 death of Wen Zhengming, who had dominated the art circles of the Wu area for more than three decades, Wang Shizhen — one of the so-called Seven Later Masters — emerged as the doyen of the late Ming literary world. The Taicang native and his brother Wang Shimao were ardent collectors and patrons of painting and calligraphy and had close dealings with Wen's descendants and disciples.

According to Wang Shizhen's *Four-category Works of the Recluse of Yanzhou* (*Yanzhou sibu gao*) and its sequel, he inscribed more than five hundred works of painting and calligraphy. Thanks to the Wang brothers' collecting, patronage, and documentation, Suzhou's literary legacy was promoted and perpetuated. What is more, unlike the callously covetous Yan Song and his son, Wang Shizhen was self-less enough to return the works of Fan Zhongyan (989–1052) and the Wu masters to their descendants.

One of the works in Wang Shimao's collection was none other than *Returning Boats on a Snowy River*. His colophon states that he acquired the masterpiece from Zhu Xixiao's estate in Beijing. Since we know that Zhu Xixiao died in 1574 and Wang Shimao was in Beijing from 1573 to 1576, the acquisition most likely have been made at some point in 1574–1576.[6]

During this period the Jiaxing collector Xiang Yuanbian is known to have viewed a painting called *Returning Boats on a Snowy River*; but as he described it as heavily coloured, it is unlikely that the painting was the work attributed to Huizong.[7] Xiang seldom mingled with Wang Shizhen although the two of them were more or less the same age and had many common friends. By contrast, Zhan Jingfeng of Xiuning was on good terms with Xiang and had the opportunity to admire the latter's treasures in 1576. The friendship between Zhan and the Wangs is believed to have begun in 1582, when Zhan, possibly out of admiration for Wang Shizhen's literary stature, travelled a great distance to request an epitaph for his father.[8] Zhan's *Dongtu's Notes on Masterpieces of Painting and Calligraphy* (*Dongtu xuanlan bian*) describes *Returning Boats on a Snowy River* — bearing Cai Jing's colophon and then in Wang Shimao's collection — as excellently executed and mounted.[9] Based on the whereabouts of Zhan and Wang Shimao, we can deduce that Zhan saw *Returning Boats* around 1583, making it the earliest documentation of the work.

Several colophons were added to *Returning Boats on a Snowy River* during this time. Immediately to the left of Cai Jing's colophon are two by Wang Shizhen and one by Wang Shimao.[10] In the first of his two colophons, Wang Shizhen noted that Huizong was better known for his flower-and-bird paintings, which he judged to be on a par with those of Huang Quan (ca. 1000–1064) and Yi Yuanji (1000–1064), and described the landscape scene of *Returning Boats* to be an embodiment of the ideals of the Tang poet-painter Wang Wei (ca. 701–761). The second says that the painting came from a set of four scrolls.[11] The seals Wang Shizhen impressed after his colophons offer clues to their dating. The two seals following his second colophon are also seen with a colophon dated 1583 that he added to an anonymous Yuan-era painting called *Ge Hong Moving House* (*Ge Hong xiju tu*, fig. 1).[12] Thus Wang may well have written his colophons to *Returning Boats* in 1583, possibly after viewing it together with Zhan Jingfeng.

Wang Shimao's colophon chronicles his acquisition of the painting from the

estate of Zhu Xixiao and illustrates how the pursuit and possession of a much-coveted masterpiece could imperil a collector. The colophon relates how the Grand Chancellor Zhang Juzheng (1525–1582) was attempting to seize treasures that had been in Zhu Xixiao's collection, with *Returning Boats on a Snowy River* at the top of his list. Well aware that he might be risking his life to defy Zhang, Wang refused to part with the much-loved painting. Wang goes on to say that had he surrendered the work, it could have been destroyed in a fire that consumed Zhang's collection after its confiscation in 1582 in the wake of the Grand Chancellor's fall from grace. This reference to the confiscation helps date the colophon to sometime between 1583 and 1588, the year of Wang Shimao's death, and suggests that he had acquired *Returning Boats* years earlier and kept the painting stowed away to avoid arousing Zhang's suspicion. This adds weight to a dating of 1574–1576 for Wang Shimao's acquisition of the painting.

The next clue to the transmission of *Returning Boats on a Snowy River* appears in *Qinghe's Boat of Painting and Calligraphy* (*Qinghe shuhua fang*) by Zhang Chou (1577–1643). His family in Kunshan had been collecting art for six generations, and his father, Zhang Yingwen (ca. 1524–1585), was known to be in awe of the painting. *Qinghe's Boat* states that Wang Shimao gave the painting to Zhang Chou's elder brother, Zhang Decheng (active late 16th–early 17th century), as security for a loan.[13] We know that Wang Shizhen gave another painting — the much-prized

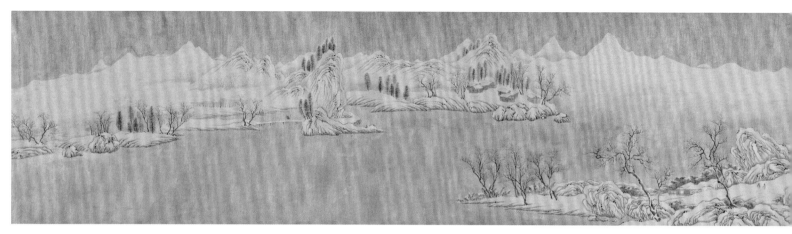

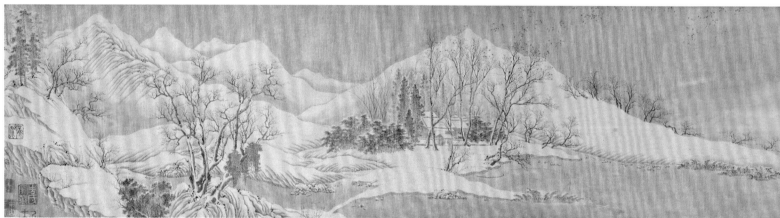

Memorial Recommending Jizhi (*Jian Jizhi biao*) — to Xiang Yuanbian as security
for a loan in or before 1586, suggesting that the cash-strapped Wang transferred
Returning Boats to Zhang Decheng in or after that year.[14]

DONG QICHANG: THEORIES ON THE DEVELOPMENT
OF CHINESE PAINTING

Following Wang Shizhen's death in 1590, Dong Qichang steadily rose to prom-
inence in late Ming literary and art circles. A painter-calligrapher, theorist, and
collector-connoisseur, Dong Qichang served the court as a scholar-official for
more than four decades and was posthumously honoured with a ceremonial burial,
an appointment as Grand Mentor of the Heir Apparent, and an honorific title.
Wherever he went, people from all walks of life — nobles, courtiers, men of letters,
dignitaries, and religious leaders — flocked to strike up friendships with him. As
patriarch of the Songjiang School of painting, he was revered as an unrivalled
master throughout the Ming dynasty and exerted an enduring influence on not
only his contemporaries but also posterity.

In his colophon to *Returning Boats on a Snowy River* — possibly written after
viewing the scroll in 1618, by which time it had passed to Cheng Jibai (d. 1626), a

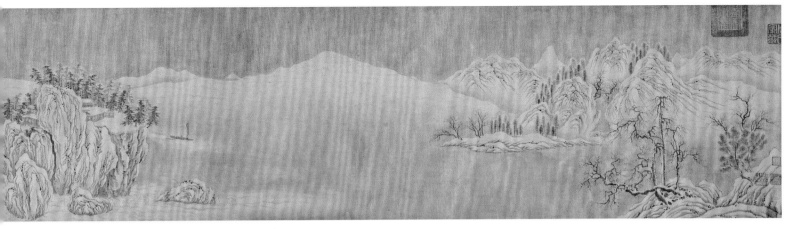

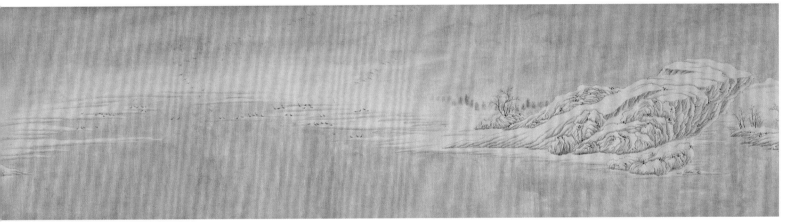

Xin'an collector and friend of Dong's — Dong appraised the work the equal to Wang Wei's *Rivers and Mountains after Snow* (*Jiangshan xueji tu*).[15] The original painting thought to be by Wang Wei is now lost. A possible copy survives in the collection of the Ogawa family, and a possible partial copy is preserved in the first half of *Clearing after Snowfall along the River* (*Changjiang jixue tu*, fig. 2). These works are similar in composition but display different brush and ink techniques. Dong had viewed Wang's masterwork in 1595, when it was in the collection of Feng Mengzhen (1548–1605), and wrote a long colophon to it.[16] There, while putting *Returning Boats* and *Rivers and Mountains after Snow* in the same class, Dong insinuated that the former was in fact painted by Wang Wei — that Huizong was merely the titular author, as was the case with many of his bird-and-flower paintings — and observed that *Returning Boats* was the only landscape ever ascribed to the emperor. Indeed, suspicions were rife in the mid- and late Ming that Huizong took credit for works actually created by painters of the Xuanhe Painting Academy.[17] This view was endorsed in *Dongtu's Notes* (1595) by Zhan Jingfeng, which may in turn have led Sun Kuang (1543–1613) to declare — perhaps without ever actually viewing it — *Returning Boats* to be the creation of an Academy painter in his *Colophons on Calligraphy and Painting* (*Shuhua baba*).[18]

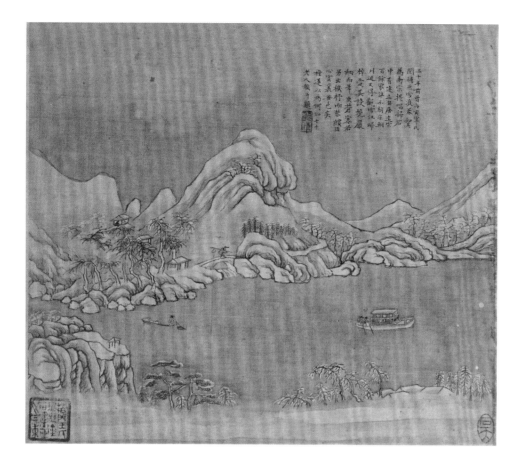

FIGURE 3
Detail of *Landscapes in the Style of Old Masters*. Shen Hao (1586–1661). Ming dynasty, 1625. Album leaves, ink and colour on silk. Shanghai Museum.

From the early Qing to modern times, many scholars — including Wu Qizhen (1607–1678) and Xu Bangda (1911–2012) — have disputed this conclusion and criticised Dong's scepticism.[19] However, most collector-connoisseurs of the late Ming and early Qing had no reservations about ascribing the painting to Huizong, including Dong's student Wang Shimin (1592–1680), who seldom challenged the views of his teacher. In a colophon appended to a snow scene painted by Chen Lian (active 17th century), Wang Shimin recalled viewing *Rivers and Mountains after Snow* with Cheng Jibai in 1624. While Wang opined that *Returning Boats on a Snowy River* and a work called *The Idea of Snow on a River* (*Jianggan xueyi tu*) are in Wang Wei's style and acknowledged Wang as the painter of *Rivers and Mountains after Snow,* he said *Returning Boats* was by Huizong.[20] Years later, inscribing a colophon on Emperor Huizong's copy of *Lofty Scholars* (*Gaoshi tu*) by Wei Xie (active late 3rd century), Dong Qichang himself stated categorically that *Returning Boats* was an authentic work by Huizong.[21]

Authenticity aside, the painting's association with Wang Wei was never disputed and was key to Dong Qichang's theory of Southern and Northern painting lineages.[22] Building on frameworks advanced by earlier scholars, Dong divided the evolution of Chinese landscape painting into two lineages and opined that the Southern Lineage could be traced back to Wang Wei, the Tang dynasty painter from

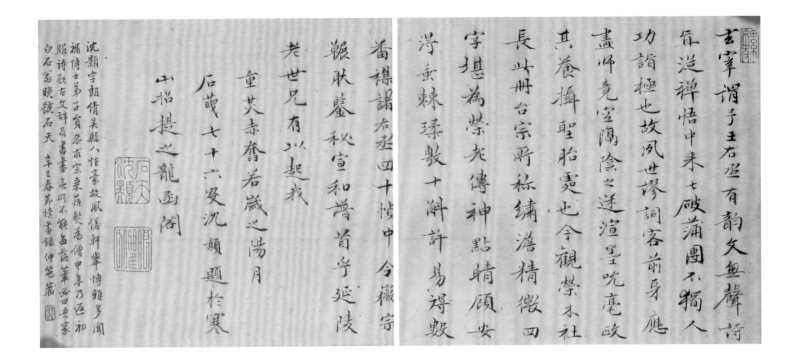

FIGURE 4
Detail of *Landscapes*. Ye Xin (active
mid-to-late 17th century). Qing
dynasty. Album leaves, ink and
colour on silk. Shanghai Museum.

whom literati painting originated.[23] Wang's style was inherited in turn by Zhang Zao
(active late 8th century), Jing Hao (active mid-9th–early 10th century), Guan Tong
(active early 10th century), Guo Zhongshu (d. 977), Dong Yuan (d. ca. 962), Juran
(active mid-to-late 10th century), Mi Fu (1051–1107) and his son Mi Youren (1074–
ca. 1153), and the Four Masters of the Yuan: Huang Gongwang (1269–1354), Wu
Zhen (1280–1354), Ni Zan (1306–1374), and Wang Meng (d. 1385). Thus, by associ-
ating *Returning Boats on a Snowy River* with Wang Wei's style, Dong was bolstering
his argument for distinct Southern and Northern Lineages in Chinese painting —
and, naturally, the inclusion of such an exquisite and celebrated masterpiece in the
Southern Lineage evidenced its superiority.[24]

Returning Boats on a Snowy River was next mentioned in a colophon the
Songjiang painter Shen Hao (1586–1661), who was strongly influenced by Dong
Qichang, wrote for his album *Landscapes in the Style of Old Masters* (*Fanggu shan-
shui tu*, fig. 3). It states that Shen became aware of Dong's advocacy of the Southern
Lineage while viewing a painting with him thirty years earlier, reckoned to be about
1625, and that *Returning Boats*, which Shen had viewed in about 1655, was consid-
ered worthy enough to be mentioned in the same breath as Wang Wei's masterwork
The Wangchuan Villa (*Wangchuan tu*). Another colophon by Shen — to an album
of landscapes by Ye Xin (active mid-to-late 17th century, fig. 4) — makes clear the
connections between the Southern Lineage and Wang Wei, as well as how highly
Huizong esteemed the artist.[25]

Other late Ming texts also contain references to *Returning Boats on a Snowy
River*. From *Net of Corals* (*Shanhu wang*) by Wang Keyu (1587–ca. 1645) we know

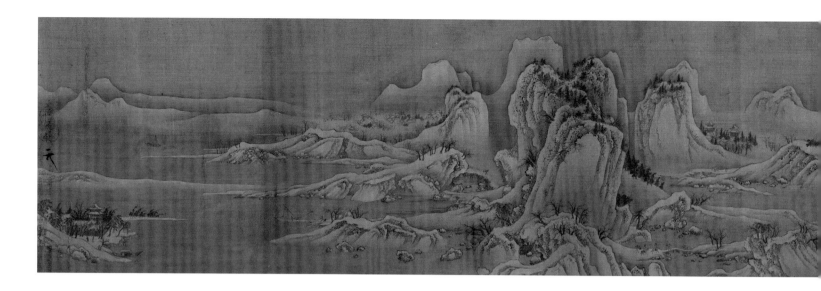

that both *Returning Boats* and *Rivers and Mountains after Snow* were in Cheng
Jibai's collection.[26] Following his death in 1626, most of Cheng's possessions were
disposed of by his son Cheng Mingzhao (active 17th century). *Colophons and
Inscriptions on Calligraphies and Paintings* (*Shuhua tiba ji*), completed around 1637
by Yu Fengqing (active late 16th or early 17th century), also mentions the work.[27]

DOCUMENTING, COPYING, AND IMPERIAL COLLECTING

The avid collecting practices of private individuals during the Ming continued into
the early Qing period. Collections of wealthy merchants and antique dealers —
such as Gui Xizhi (active 17th century), Jiang Mengming (active 17th century),
Wu Qizhen, Wang Yueshi (active 17th century), Wu Sheng (active 17th–early 18th
century) and An Qi — ranked with those of scholar-officials such as Sun Chengze
(1593–1676), Liang Qingbiao, Song Luo (1634–1713), Gao Shiqi (1645–1703), Wang
Hongxu (1645–1723), and Bian Yongyu (1645–1712). Beyond the collecting of
masterpieces themselves, the practice of copying inscriptions and colophons and
circulating them among friends stimulated the development of painting catalogues
during the period.

One such compilation, Wu Qizhen's *On Calligraphy and Painting* (*Shuhua ji*),
completed in 1677, covers more than one thousand paintings and works of callig-
raphy its author had seen and includes an entry on *Returning Boats on a Snowy River*.
Besides some basic information about the painting and a caustic remark refuting
Dong Qichang's ascription of the work to Wang Wei, the entry reveals that the author
had viewed Wang Wei's *Rivers and Mountains after Snow* before 1626 and that he had
seen *Returning Boats* twice: in 1656, courtesy of its collector, Wang Junzheng (active
17th century); and soon afterwards, following its acquisition by Zhang Fanwo (active
17th century).[28] (It is likely Wang Junzheng showed Shen Hao the masterpiece, thus
occasioning his mention of the painting in the colophon discussed above.)

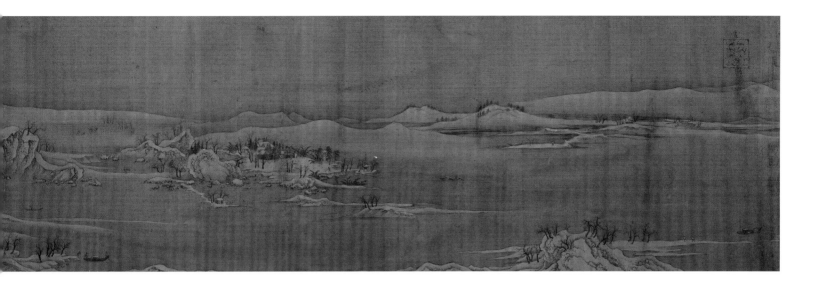

Subsequent transmission *of Returning Boats on a Snowy River* can be traced through the seals impressed on the scroll, which indicate a northward shift of collecting activities as more and more collectors sought collectibles in the Jiangnan region. The next possible possessor of the work was Zhang Yingjia (active 17th century) of Shandong, who made at least two fruitful collecting trips to the Jiangnan area in 1662 and 1667. The collection assembled by Zhang Yingjia and his father, Zhang Ruoqi (d. ca. 1670), was largely dispersed upon the latter's death, and parts of it were acquired by Song Luo and Liang Qingbiao.[29] Liang, an official in Beijing, was arguably the most important collector of the early Qing, making his acquisitions mostly through the dealers Wu Qizhen, Zhang Liu (active 17th century), Wu Sheng, Wang Jizhi (active 17th–early 18th century), and others. More than six hundred works of painting and calligraphy have been established to have once been in his collection. Among them was *Returning Boats,* as attested by a few of his seals. It might have been obtained from Zhang Liu as surmised from one of his seals.[30]

The seal translated as "same as that in Bian Yongyu's *Collected Notes on Paintings and Calligraphy of the Shigu Hall (Shigutang shuhua huikao)*" impressed on *Returning Boats on a Snowy River* is an imperial seal impressed during the Qianlong reign and not Bian Yongyu's collector seal.[31] While he recorded in his *Collected Notes,* it is likely that Bian Yongyu neither saw nor collected the painting, as his compendium, completed in 1682, gathers pre-existing information on works of painting and calligraphy that he may or may not have actually seen or collected.[32]

No known records trace the transmission of the painting immediately following Liang Qingbiao's death in 1691, but references to it continued to appear in compilations. In *Spectacles Viewed in a Lifetime (Pingsheng zhuangguan;* 1692), Gu Fu (active 17th century) of Changshu cited without comment Dong Qichang's colophon under the entry for *Returning Boats on a Snowy River.*[33] In Wu Sheng's *Inspiring*

Views (*Daguan lu*), compiled in 1712 to record the more than six hundred painting and calligraphy works he had viewed, the author commented that *Returning Boats* was so archaistic in style that it embodied the essence of Wang Wei, an opinion that concurred with statements in the colophons of Wang Shizhen and Dong Qichang.[34] Generally dated to the early Qing, a copy of *Returning Boats* was produced (fig. 5). Identical to the original in all aspects, including colophons, it is even impressed with forged Ming seals, revealing the importance attached to the masterpiece at the time.[35]

While private collectors were building their collections and creating catalogues, the Qing emperors were becoming increasingly interested in painting and calligraphy, with the imperial collections ultimately surpassing all others. Emperor Kangxi (r. 1662–1722), whose collection was built mainly with gifts from courtiers, commissioned *Painting and Calligraphy Compendium of the Peiwen Studio* (*Peiwen zhai shuhua pu*). During the reign of the Yongzheng Emperor (1723–1735) the imperial collection grew with treasures confiscated from famous general Nian Gengyao (1679–1726). By the end of the six-decade reign of Qianlong, a passionate lover of painting and calligraphy, most of the private collections in the north and the south had been acquired by the court. A survey of *Treasured Boxes of the Stone Moat* (*Shiqu baoji*) and *Jewel Forest of the Secret Hall* (*Midian zhulin*) shows that a total of more than ten thousand works of painting and calligraphy were in the Qing imperial collection. This led to a drastic decline in private collections and collecting activities.

Returning Boats on a Snowy River is believed to have entered the Qing imperial collection in 1778, based on two log entries concerning its receipt and remounting in *Archives of the Imperial Workshop* (*Huoji dang*).[36] Qianlong inscribed two poems — one in 1779, one in 1780 — and a frontispiece on the work.[37] Around 1791 the painting was recorded in *Treasured Boxes of the Stone Moat Supplement* (*Shiqu baoji xubian*) as "Song Emperor Huizong's *Returning Boats on a Snowy River*".[38] The emperor frequently mentioned the painting. For example, an annotation to a poem entitled "Emperor Huizong's *Crows in a Willow and Wild Geese by Reeds*" states that the recently acquired work deserves to top the list of Song paintings.[39] Ruan Yuan (1764–1849), who was entrusted with the compilation of the *Treasured Boxes of the Stone Moat Supplement* documented it in his *Shiqu Notes* (*Shiqu suibi*).[40]

Despite an infusion of works confiscated from high-ranking official Bi Yuan (1730–1797), the growth of the Qing imperial collection slowed remarkably in the nineteenth century. After Qianlong, paintings and works of calligraphy began to trickle out from the court as emperors bestowed them on princes and meritorious courtiers. The late Qing saw the looting of the Garden of Perfection and Light (Yuanming Yuan), the invasion by the Eight-Nation Alliance, and the removal of artefacts from the imperial palace by Puyi (1906–1967, r. 1908–1911), the former Xuantong Emperor and last emperor of the Qing. As a result, a large number

of painting and calligraphy masterpieces were available for the taking outside the court and abroad. *Returning Boats on a Snowy River* was removed from the palace, ostensibly for bestowal on Puyi's brother Pujie (1907–1994); taken to the Little White House in what was then known as Manchukuo Imperial Palace in Changchun, Jilin; and passed from Hao Baochu (active 20th century), a painting and calligraphy dealer in Beijing, to Zhang Boju (1898–1982). In 1958 the Palace Museum approached the collector to solicit the painting, which was generously donated and has been housed in the Palace Museum since around 1962.[41]

CONCLUSION

Wang Shizhen's comment that *Returning Boats on a Snowy River* encapsulated the essence of Wang Wei; Zhang Chou's assertion that it surpassed any work by an emperor; and Qianlong's opinion that it was the best of Song painting all affirm its artistic merit and help to justify its status as a landmark in the history of Chinese painting. Equally fascinating is the cultural and historical import it accrued over the course of its transmission. For one thing, contributors to the painting's authentication and preservation involved a wide spectrum of people, ranging from members of the imperial household and scholar-officials to antique dealers and mounters. The colophons and written records of collectors and connoisseurs, whether calligraphic gems or simply textual evidence, have burnished the renown of the work and help illuminate the development of Chinese painting. After the act of creation itself, collection and authentication are the keys to ensuring the lasting existence of any masterpiece from the past.

Returning Boats on a Snowy River is just such a work, one that illustrates the transmission of masterpieces during the Ming dynasty. Passing from the north to the south and then back to the north; moving through the hands of collectors of disparate backgrounds and varying motives; vied over, remounted, pledged as collateral, inscribed, imprinted, documented, construed, theorised, and copied, this work has provided posterity with an intriguing narrative. Furthermore, the prominent colophons it has inspired and the reams of documentation it has generated are fair measures of its artistic value. Recent research and the present exhibition and catalogue help us to visualise the canonisation of this masterpiece and understand its place in the history of Chinese painting and calligraphy.

APPENDIX

Transmission history of *Returning Boats on a Snowy River*

- Collected by Zhu Xixiao (before 1574)
- Collected by Wang Shimao (ca. 1574–ca. 1588); viewed by Zhan Jingfeng (ca. 1583); colophons by Wang Shizhen (ca. 1583) and Wang Shimao (ca. 1583–1588)

- Collected by Zhang Decheng (pledged as collateral, after 1586); viewed by Zhang Chou and Zhang Yingwen (after 1586); recorded by Sun Kuang (before 1614)

 …
- Collected by Cheng Jibai (before 1626); colophon by Dong Qichang (1618); viewed by Wang Keyu (before 1626); viewed by Wang Shimin (ca. 1624)
- Collected by Cheng Mingzhao (after 1626); recorded by Yu Fengqing (before 1637)

 …
- Collected by Wang Junzheng (ca. 1650s); viewed by Shen Hao (ca. 1655); viewed by Wu Qizhen (1656)
- Collected by Zhang Fanwo (after 1656)

 …
- Collected by Zhang Yingjia (after 1662–ca. 1670)

 …
- Collected by Liang Qingbiao (before 1691); recorded by Bian Yongyu (before 1682); viewed by Gu Fu (before 1692) and Wu Sheng (before 1712)

 …
- Collected by the Qing imperial court (1778–1922); colophon by Emperor Qianlong (1779, 1780); viewed by Ruan Yuan (ca. 1791); bestowed upon Pujie by Puyi (1922)
- Collected by Hao Baochu (1940s)
- Collected by Zhang Boju (1940s–ca. 1958)
- Collected by the Palace Museum (after ca. 1962)

NOTES

1 For a discussion of the history of painting and calligraphy collecting, see Yang R. 1991: 1–54; Huang P. 2015.

2 Ye 2017: 3–27.

3 Zhang Boju may have been mistaken when he claimed the opera *A Palmful of Snow* was based on the grudge that Zhang Juzheng (1525–1582) held against the Wang brothers over *Returning Boats on a Snowy River*. See Zhang B. 1998: 16–17, 107–108.

4 It has been argued, if inconclusively, that *Returning Boats on a Snowy River* may have once been collected by Yan Song on the basis of the partial inscription "□ *zi liuhao*" on the right border. See Wang J. 2015; for a discussion of the partial inscription, see Wang Y. 2014 and Li W. 2017.

5 The discussion of the transmission of *Returning Boats on a Snowy River* here is based on Wang Jian's research, with revisions. See Wang J. 2014: 145–162; Wang J. 2015.

6 Wang Shizhen 1987, *juan* 140: 47–59; Zheng L. 1993: 218, 227, and 252.

7 See Yu Fengqing, "Ba Song Huizong Zhuose shanshui", *Yushi shuhua tiba ji, Xu shuhua tiba ji*, in Zhongguo Shuhua Quanshu Bianzuan Weiyuanhui 1993–2000, vol. 4, *juan* 4: 700. Xiang had built a distinguished collection of about two thousand ancient and Wu School paintings and works of calligraphy in consultation with Wen Peng (1497–1573) and others. He and Wang Shizhen seldom mingled, possibly owing to a gap in status (Xiang came from a merchant family), values, and character. See Du J. 2014; Yu F. 1993: 700.

8 Ling L. 2002.

9 Zhan J. 1993, *juan* 1: 15.

10 Among the Ming colophons on the endpapers for colophons of *Returning Boats on a Snowy River* is a short one pending investigation that reads: "In the second month of Spring of the *renchen* year, Zhu Yu (Qiming) of Wumen remounted at Guanglingzhizhu Shuguan".

11 Wang Shizhen included these two colophons under the entry "Song Huizong xuejiang guizhao tu" in Wang Shizhen 1987, *juan* 168: 423–424.

12 The seals Wang Shizhen affixed to the colophons on *Returning Boats on a Snowy River* and *Ge Hong Moving House* differ from those seen on earlier works. The author has collated Wang Shizhen's colophons and seals as seen in extant works of painting and calligraphy. See Jiang F. 2017a: 199–204. I am indebted to Ling Lizhong of the Shanghai Museum for information on *Ge Hong Moving House* in the Tianjin Museum.

13 *List of Paintings and Calligraphy in the Qinghe Collection* (*Qinghe miqie shuhua biao*) also says that the painting was in Zhang Decheng's possession. See Zhang Chou 1993: 125, 234.

14 "Ba Zhong Yuanchang Jizhi biao" in Hu Yinglin 1993, *juan* 107: 775; Zhang Yingwen 1871, *juan xia*: 20.

15 Dong Qichang once said, "*Returning Boats on Snowy River* is in my house." See Dong Qichang 2012, vol. 2, *juan* 2: 609.

16 Kohara 1998: 851.

17 Cai Jing's son, Cai Tao, recorded that there were skilled painters in Huizong's Painting Academy who would "ghost-paint for the emperor". See Cai Tao and Zeng Minxing 2012, *juan* 6: 70; and Xu B. 1979.

18 Zhan J. 1992, *juan* 1: 15; Sun Kuang 1993: 990–991.

19 Xu B. 2015b, vol. 10: 349–351; Wang L. 2006.

20 Wang Shimin 1994: 920. The original of *The Idea of Snow on a River* has not survived, but a copy is housed in the Palace Museum, Taipei.

21 Although undated, the colophon likely predates 1635, the date given in the succeeding colophon by his friend Chen Jiru (1031–1095). Wang Keyu 1643: 1018.

22 Ho and Delbanco 1993.

23 These scholars included Zhang Yanyuan (815–907) of the Tang, Shen Kuo (1586–1661) and Wu Zeli (1098–1121) of the Northern Song, Zhang Yu (active 14th century) of the Yuan, and Song Lian (1310–1381), and He Liangjun (1506–1573) and Wang Shizhen of the Ming. See Yin 2005.

24 Ho 1989; Fu 2003.

25 I am grateful to Ling Lizhong of the Shanghai Museum for information on Shen Hao's and Ye Xin's painting albums. For the images, see Shanghai Bowuguan 2018, vol. 4: 74–103.

26 Wang Keyu 1643, vol. 5: 714–1240.

27 Yu F. 1993: 635.

28 Wu Qizhen 1994, *juan* 4: 73–74.

29 Zhang and Bai 2014.

30 Liu J. 2002: 73; Wang Y. 2014: 20.

31 During the Qianlong reign, this seal was impressed on paintings and works of calligraphy recorded in Bian Yongyu's *Collected Notes on Paintings and Calligraphy of the Shigu Hall*. See Zhang X. 2013: 221.

32 Bian Yongyu 1992, vol. 6, *huajuan* 11: 930–931.

33 Gu Fu 1992, *juan* 7: 962–963.

34 Wu Sheng 1994: 391–392.

35 Xu B. 2015b, vol. 10: 349–351; Sensabaugh 2019: 46–50.

36 Zhonguo Diyi Lishi Dang'anguan 2005, vol. 41: 416.

37 "Ti Xuanhe Xuejiang guizhao tu," in Qianlong 2013, vol. 7, *juan* 64: 296; "Zaiti Song Huizong Xuejiang guizhao tu," in Qianlong 2013, vol. 7, *juan* 6: 302–303.

38 Wang Jie et al. 2002, *juan* 28: 349–351.

39 Qianlong 2013, vol. 7, *juan* 74: 427.

40 Ruan Yuan 2002, *juan* 2: 430.

41 Guoli Beiping Gugong Bowuyuan 1934: 8; Yu H. 2014.

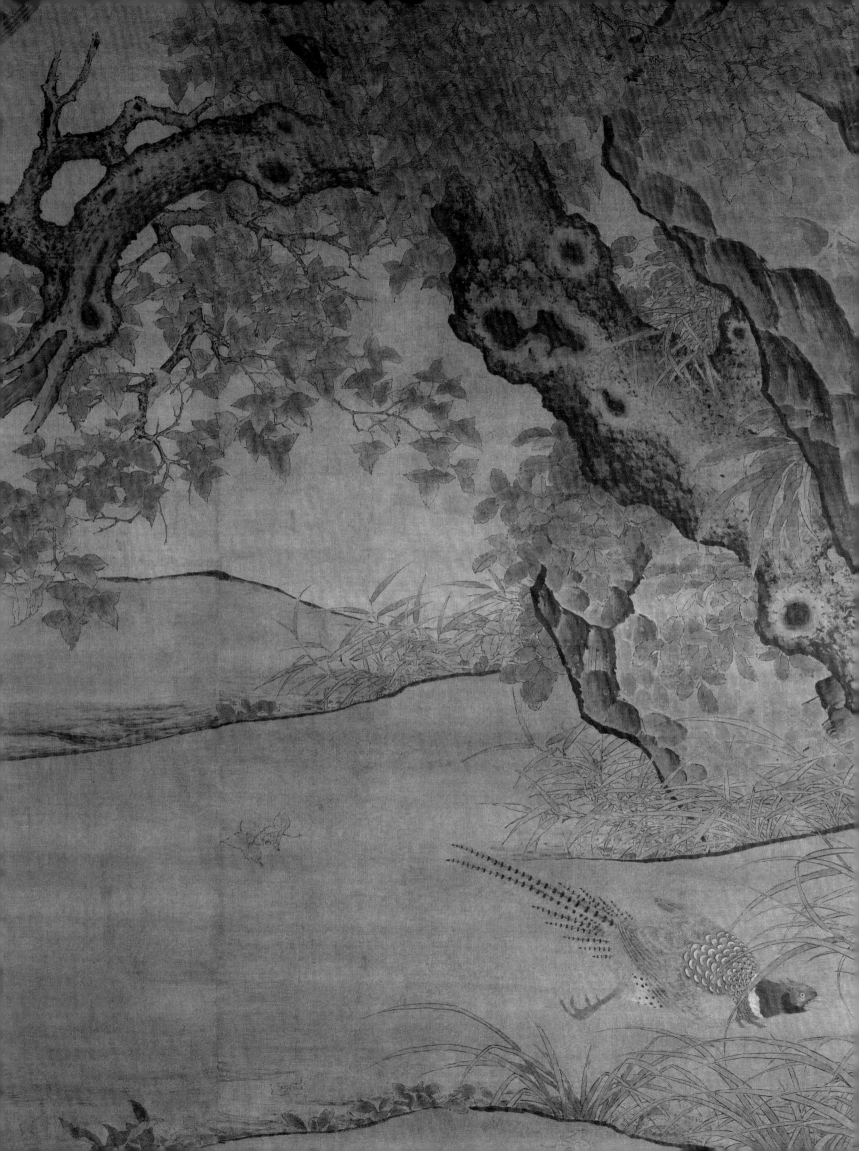

Raphael Wong

Unsung Heroes
The Hong Kong Acquisition Team

IN 2007 THE HONG KONG MUSEUM OF ART AND THE PALACE MUSEUM jointly organised the exhibition "The Pride of China: Masterpieces of Chinese Painting and Calligraphy of the Jin, Tang, Song, and Yuan Dynasties from the Palace Museum" (*Guo zhi zhongbao: Gugong Bowuyuan cang Jin, Tang, Song, Yuan shuhua zhan*). The exhibition included thirty-two "national treasures" — including one of the "Three Rarities" explored below — and discussed Hong Kong's role as trading centre through which some of the works in the exhibition and its accompanying catalogue passed.[1] How the works were rediscovered, authenticated, and acquired, however, was not specified. Drawing on published and newly available materials, this essay sheds light on the role played by the Hong Kong Acquisition Team in the return of important early painting and calligraphy to China and the formation of the canon of Chinese painting and calligraphy.

From 1949 to 1956, the acquisition team rediscovered more than a hundred works of early Chinese painting and calligraphy scattered throughout private collections in Asia — Hong Kong, in particular, America, and Europe. Having facilitated the acquisition of almost sixty works (see Appendix), the team was directly responsible for the formation of the Palace Museum's encyclopaedic collection of Chinese painting and for the grand opening of the Museum's painting gallery in 1953, which had recently been enriched by the addition of Ming and Qing painting and calligraphy from the collection of Pang Yuanji (1864–1949).[2] When the works acquired by the team entered the collection of the Palace Museum, their canonical status was firmly established.

Despite its monumental achievements, little research has been conducted on the history of the acquisition team.[3] Recently, the team's achievement was officially celebrated in the exhibitions "The Journey Back Home: An Exhibition of Chinese Artifacts Repatriated from Abroad on the 70th Founding Anniversary of New China" (*Huigui zhilu: Xin Zhongguo chengli qishi zhounian liushi wenwu huigui chengguo zhan*) at the National Museum of China and "Strive to Save Every National Treasure: Zheng Zhenduo's Epistolary Record on the Repatriation of Historical Objects in Hong Kong" (*Fanshi guobao douyao zhengqu: Zheng Zhenduo deng qiangjiu liusan Xianggang wenwu wanglai xinzha rucang jinian zhan*) at the National Library of China in 2019. Little has been said about how these events came to pass, however. The recent publication of new materials — including memoirs

written by a former director of the Palace Museum and by collectors as well as, more importantly, letters and telegrams written by a member of the team that were auctioned in Hong Kong in 2019 — necessitate a re-examination of the team's activities.[4] Not only does the correspondence provide first-hand, detailed information regarding the team's operations; it also rectifies misconceptions, such as how certain works were acquired. All these materials help to answer questions about why the team came into being and had to work secretly, and how and when various paintings and pieces of calligraphy entered the Palace Museum collection.

FOUNDING OF THE ACQUISITION TEAM

The history of the acquisition team can be traced back to May 1949, when Zheng Zhenduo (1898–1958, fig. 1), later director of the Bureau of Cultural Relics (Guojia wenwu ju) of the People's Republic of China (PRC), discussed the need to retrieve lost historical artefacts.[5] The proposal was accepted by Zhou Enlai (1898–1976), who became the premier of the PRC in that same year. As a British colony close to the Mainland, Hong Kong had remained relatively stable despite upheavals across the border. This stability attracted merchants and scholars, mainly from Shanghai and Guangzhou, who congregated in Hong Kong for safety. Some were collectors who brought with them treasures of Chinese works of art, painting, and calligraphy.[6] Meanwhile, in countries like Japan, post-war inflation and newly imposed property taxes compelled collectors to sell high-quality objects.[7] Since Hong Kong's market economy allowed people to trade freely between themselves and with overseas buyers, the city became a key strategic site for acquiring and building China's national collection of antiquities.

The determination of the Chinese government to retrieve historical artefacts in Hong Kong was probably reinforced by the acquisition in that city of two of the "Three Rarities" of the Qianlong Emperor (r. 1736–1795).[8] The "Three Rarities" are three works of calligraphy from the Jin dynasty collected by the emperor. They include *Timely Clearing after Snowfall* (*Kuaixue shiqing*) by Wang Xizhi (301–361), *Mid-Autumn Manuscript* (*Zhongqiu tie*) by Wang Xianzhi (344–386), and *Letter to Boyuan* (*Boyuan tie*) by Wang Xun (349–400). The works were treasured by the emperor and, being kept in his personal study — the Hall of Three Rarities (Sanxi tang) — in 1746. In November 1951 *Mid-Autumn Manuscript* and *Letter to Boyuan* were found to have been forfeited to a bank in Hong Kong. A report was made to the Chinese government, which assigned responsibility for acquiring the works to Hu Huichun (1910–1995), commonly known as Hu Jenmou. Based in Hong Kong, Hu was a banker, a former member of the Special Committee for Ceramics of the Palace Museum,[9] and at the time a member of the Shanghai Municipal Cultural Relics Preservation Committee (Shanghai wenwu baocun weiyuanhui). Xu Senyu (1881–1971) and his son Xu Bojiao (1913–2002, fig. 2), better known as P. J. Tsu, who later led the Hong Kong Acquisition Team, were also involved. Those two

of the "Three Rarities" were subsequently brought back to and kept in the Palace Museum, where they were regarded as among the most important and popular works in the Museum's collection.

In 1953 the Chinese government decided to formally appoint a team to pursue acquisitions in Hong Kong, even though these activities had already been taking place for two years.[10] Xu Bojiao was appointed to the team; his family background and training made him an ideal candidate for the job. Xu Bojiao's father, Xu Senyu, was the former director of the Gallery of Ancient Relics (Guwu guan) of the Palace Museum. During the Second Sino-Japanese War (1937–1945), Xu Senyu helped Zheng Zhenduo salvage early Chinese manuscripts and books, and managed the massive evacuation of the Palace Museum's objects.[11] After the establishment of the PRC, Xu Senyu was made director of the Shanghai Municipal Cultural Relics Preservation Committee and later director of the Shanghai Museum.[12] He maintained a close working and personal relationship with Zheng Zhenduo over the years. Like his father, Xu Bojiao was a connoisseur of Chinese painting and calligraphy.[13] He is said to have heroically offered himself up as a hostage when bandits attacked the Palace Museum's evacuation team on their journey to Kunming in 1939.[14] During the time the acquisition team operated in Hong Kong, Xu Bojiao sought advice from his father, who was leading the examination of paintings and calligraphy seized in the Northeast.[15] The other members of the team were Shen Yong, an employee of the Bank of China who was also involved in the acquisition of two of the "Three Rarities", and Wen Kanglan, from the Party.[16]

The acquisition team targeted ancient books and paintings of pre-Ming vintage that were both relatively rare and easily dispersed.[17] It also recovered the major

FIGURE 2
Portrait of Xu Bojiao (1913–2002) (fourth left), a connoisseur who led the Hong Kong Acquisition Team. Photograph © Min Chiu Society.

Chinese coin collection of Chen Rentao (1906–1968).[18] Team members were
responsible for different tasks: Xu Bojiao oversaw identification, authentication,
appraisal, and price negotiation. Shen Yong and Wen Kanglan were in charge of
payments and logistics.[19] They worked in parallel with Zheng Zhenduo and experts
in China. Xu Bojiao regularly sent letters to Zheng Zhenduo and Wang Yeqiu,
then deputy director of the Bureau of Cultural Relics, to provide information on
the market and offer his opinions on the quality and prices of works. He would
also send pictures and sometimes the actual works themselves to China for exam-
ination by experts including Xu Bangda (1911–2012).[20] If a work was believed to
be authentic, the team in China would transfer money to the Bank of China. The
purchased works would then be brought back to Guangzhou and subsequently
taken to Beijing by the team or staff members of the bank.[21]

POLITICS, COMPETITORS, AND FORGERIES
The acquisition team faced many challenges. One was the need to work in secrecy.
This was partly due to the wider political environment: China was at war with the

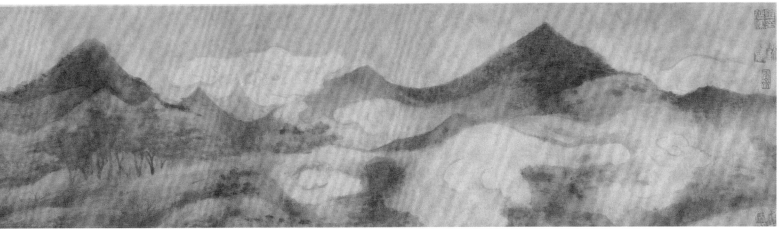

FIGURE 3
Rare Views of Xiao Xiang. Mi
Youren (1074–ca. 1153). Southern
Song dynasty. Handscroll, ink on
paper. The Palace Museum.

United States and Britain in North Korea, and any secretive activity supported
by the Chinese government would have led to diplomatic crises. In fact, Zheng
Zhenduo had stressed repeatedly to Xu Bojiao the importance of keeping a low
profile and exercising caution to avoid trouble.[22]

Another reason that the team had to work in secret was to avoid affecting the
price of the works they were attempting to recover. In one instance, news regarding
a group of paintings being sold to the government reached Hong Kong, causing
prices of paintings and calligraphy in that city to rise sharply.[23] Letters written by
Xu Bojiao tell us that the team tried to acquire paintings from Japan, Europe, and
America, where they faced fierce competition.[24] According to the letters, numerous
paintings published in the 1954 book *Chinese Landscape Painting* by Sherman E.
Lee (1918–2008) were purchased in Hong Kong.[25] Then chief curator of Oriental
art in the Cleveland Museum of Art, Lee worked closely with the dealer Walter
Hochstadter (1914–2007). After beginning his career in China, Hochstadter was
active in the United States in the late 1930s and served as a source of Chinese antiq-
uities for many American museums, such as the Los Angeles Museum of History,

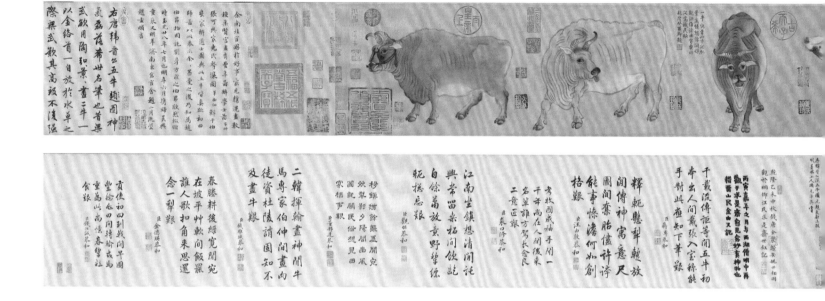

Science, and Art (which later evolved into the Los Angeles County Museum of Art), and for scholar-collectors such as James Cahill (1926–2014).[26] Hochstadter's role in these dealings can be illustrated by a letter in a substantial collection of his correspondence.[27] The 1954 letter was written by curator Henry Trubner of the Los Angeles museum, wherein he noted that he had seen a Song painting acquired by Hochstadter for the Cleveland Museum and asked the dealer to source Chinese paintings of the Song and Yuan dynasties for him.[28] Hochstadter was mentioned in Xu Bojiao's letters when he competed for works such as *Rare Views of Xiao Xiang* (*Xiaoxiang qiguan tu*) by Mi Youren (1074–ca. 1153) (fig. 3), *Ink Orchids* (*Molan tu*) by Zhao Mengjian (1199–1264), and *Four Finches* (*Siqin tu*) by Emperor Huizong of the Song dynasty (r. 1101–1125).[29]

These acquisitions were complicated by the appearance of forgeries in the market, especially those likely to have been produced by Zhang Daqian (1898–1983).[30] Authentication was difficult because many works previously had been kept in the private collections of emperors and collectors and were unseen by the public. Their authentication, therefore, depended heavily on Xu Bojiao's expertise. The scope of this challenge is reflected by the acquisition of *Xiao and Xiang Rivers* (*Xiaoxiang tu*) by Dong Yuan (d. ca. 962), which was considered a forgery at the time it was acquired, a determination that was blamed on Xu Bojiao.[31] The newly imposed Law for the Protection of Cultural Relics, which prohibited the removal of antiquities from China, further complicated matters.[32] When Xu Bojiao bought a painting considered to be a forgery by the Chinese experts, he was repeatedly reminded not to bring it to the mainland because it would be impossible to send the painting back to Hong Kong in exchange for another work.[33]

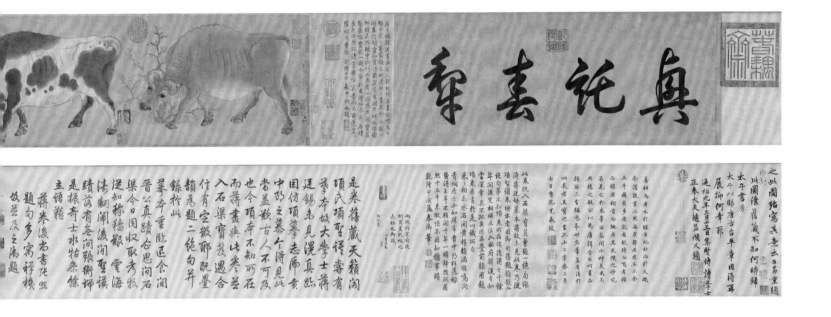

THE MAKING OF MASTERPIECES

The acquisition team's role in defining the Chinese painting canon is vividly demonstrated by the journeys of two paintings in particular: *Four Finches* and *Five Oxen* (*Wuniu tu*, fig. 4). *Four Finches* was first rediscovered in Hong Kong in 1953.[34] Initially, both Xu Bojiao and experts in China had doubts about the painting's authenticity. After examining photographic reproductions, however, the mainland experts decided that the painting was real and that it must be acquired. The acquisition was not completed at that time for unknown reasons, but it was available again two years later. In an October 1955 letter, Xu Bojiao reported that the painting was "goods from the Northeast" (*dongbei huo*) — a term used to refer to painting and calligraphy brought to the Northeast by the last emperor Puyi (1906–1967, r. 1908–1911) — and brought to Hong Kong by collector Tan Jing (1911–1991). It then changed hands several times, passing through the collections of Zhou You and Wang Nanping (1924–1985). When Xu Bojiao expressed interest in the work, Wang was already dealing with the Freer Gallery of Art, and he asked Xu Bojiao to complete the acquisition within a week. Considering the painting the best work by Emperor Huizong and a "national treasure", Xu Bojiao made several requests to delay the deadline to allow the funding to be transferred from China. The complicated procedure for getting funding from China meant making acquisitions in Hong Kong was difficult and had in the past resulted in failures to acquire certain works.[35] This time the response from China was also delayed. The competition took an unexpected turn when the Freer Gallery of Art decided not to proceed with the acquisition, but then the British collector Sir Percival David (1892–1964) joined the combat. According to a recently published biography of Wang Nanping, the painting was eventually sold to collector-dealer Cheng Qi (1911–ca. 1988). After

Cheng passed away, the painting was sold to another collector, and it continues to be inaccessible to the public.[36]

Five Oxen has a different history. It is regarded as the only surviving painting by Han Huang (723–787), chief minister of the Tang dynasty and one of the earliest extant paintings on mulberry paper.[37] It features animals outlined in black and complemented by colours; these figures are depicted from different points of view before a mostly plain background, but their postures make them a coherent group. These qualities show the painter's excellent observational and painting skills. The work was collected by the emperors Huizong and Gaozong (r. 1127–1162) the prominent Yuan literati-painter Zhao Mengfu (1254–1322), who inscribed the painting twice and praised it as a "rare masterpiece"; and the renowned Ming collector Xiang Yuanbian (1525–1590). The painting was presented to the Qianlong Emperor as a birthday gift in 1752.[38] Shortly thereafter, the emperor obtained one copy of the work by Xiang Shengmo (1597–1658), son of Xiang Yuanbian, and another by the official Jiang Tingxi (1669–1732). The emperor was deeply touched by the fact that three paintings whose production stretched across a thousand years had all come together in one collection. According to the *Records of the Studio of Spring Cultivation* (*Chun'ou zhai ji*), the emperor commanded that the paintings be kept in the Studio of Spring Cultivation in the Garden of Harvestable Marshes (Fengze yuan) in the West Park inside the Imperial City.[39] The garden had been built by the Kangxi Emperor (r. 1662–1722) to promote agriculture and occupied an important place in state politics. By keeping *Five Oxen* and its copies there, the emperor elevated the status of the painting to the level of works such as the "Three Rarities" that were likewise kept in a specially designated building.[40] This act also established the painting's importance as a vehicle of state ideology, a status further enhanced by colophons and seals added to the painting by the emperor himself and his officials over several decades.[41]

The painting is believed to have been removed from the Studio of Spring Cultivation by the members of the Eight-Nation Alliance stationed there in the early 1900s.[42] When it emerged in Hong Kong, it was in the possession of a man named Wu Hansun, who first tried to sell the painting in the early 1950s, and then again in 1956 when he was in debt.[43] Xu Bojiao saw the value of the painting and convinced the experts on the mainland to acquire it. Hochstadter was also trying to obtain the work. Xu sent photo reproductions to the mainland and urged the experts to make a decision.[44] Eventually, the painting (badly damaged at the time) was acquired and brought back to its former home, where it was extensively conserved.[45] Unlike *Four Finches*, long hidden from view, *Five Oxen* entered the collection of a national museum in the public eye and was transformed into a first-class "national treasure", symbolising the endeavour of the People's Republic of China.[46] The history of the painting — first lost and later rediscovered — has since been recounted in several publications and exhibitions, bolstering both the painting's and the museum's status

in modern times.[47] Not long after the acquisition of *Five Oxen*, dealings between Xu Bojiao and the Chinese government evolved into a business, meaning commissions would be charged for each purchase. Unfortunately, available materials do not allow us to gain a complete picture of how this process worked.

While many Chinese paintings and pieces of calligraphy in the Palace Museum were inherited from the imperial collections of the Ming and Qing dynasties, acquisitions, donations, and allocations also contributed significantly to the growth of the modern museum's collection. Despite the challenges of politics and the market, the acquisition team successfully recovered a considerable number of works of pre-Ming origin. These constitute an important part of both the collection of the Palace Museum and the canon of Chinese painting and calligraphy. Among the Chinese painting and calligraphy in the Palace Museum today, they continue to occupy an important place that represents and defines Chinese art, culture, identity, as well as the international status of the Palace Museum.

This essay is dedicated to these unsung heroes who acquired these works and contributed to the development of one of the world's most important public collections. Their endeavour benefited generations of scholars, and interested viewers, who are now able to appreciate the legacy of many celebrated Chinese artists. To them we are greatly indebted.

APPENDIX

Selected paintings and calligraphy acquired by the Hong Kong Acquisition Team and now in the collection of the Palace Museum (compiled by Raphael Wong and Lung Tak Chun).

1. *Mid-Autumn Manuscript in Running and Cursive Script* (*Xingcao Zhongqiu tie*). Attributed to Wang Xianzhi (344–386). Jin dynasty. Handscroll, ink on paper.

2. *Letter to Boyuan in Running Script* (*Xingshu Boyuan tie*). Wang Xun (349–400). Jin dynasty. Handscroll, ink on paper.

3. *Five Oxen* (*Wuniu tu*). Han Huang (723–787). Tang dynasty. Handscroll, ink and colour on paper.

4. *Xiao Xiang Landscape* (*Xiaoxiang tu*). Dong Yuan (d. ca. 962). Five Dynasties. Handscroll, ink and colour on silk.

5. *Night Revels of Han Xizai* (Song dynasty copy) (*Han Xizai yeyan tu*). Gu Hongzhong (910–980). Five Dynasties. Handscroll, ink and colour on silk.

6. *Letter on Collection with a Picture of Coral Brush Holder in Running Script* (*Xingshu shanhu tie*). Mi Fu (1051–1107). Northern Song dynasty. Album leaf, ink on paper.

7. *Auspicious Dragon Rock (Xianglong shi tu)*. Zhao Ji (Emperor Huizong, 1082–1135, r. 1101–1125). Northern Song. Handscroll, ink and colour on silk.

8. *Spinning* (*Fangche tu*). Wang Juzheng (active 11th century). Northern Song dynasty. Handscroll, ink and colour on silk.

9. *Islet and Reeds in Snow* (*Luting mixue tu*). Liang Shimin (active 11th century). Northern Song. Handscroll, ink and colour on silk. Note: it is speculated that *Luting mixue tu* per the Palace Museum refers to the same painting as *Lumen mixue* from the letters.

10. *Gathering Edible Wild Herbs* (*Caiwei tu*). Li Tang (active late 11th century–mid-12th century). Song dynasty. Handscroll, ink and colour on silk.

11. *Rare Views of Xiao Xiang* (*Xiaoxiang qiguan tu*). Mi Youren (1074–ca. 1153). Song dynasty. Handscroll, ink on paper.

12. *Ink Orchids* (*Molan tu*). Zhao Mengjian (1199–1264). Song dynasty. Handscroll, ink on paper.

13. *Viewing the Tidal Bore on the Qiantang River* (*Qiantang guanchao tu*). Li Song (1166–1243). Southern Song dynasty. Handscroll, ink and colour on silk. Note: it is speculated that *Qiantang guanchao tu* per the Palace Museum refers to the same painting as *Guanchao tu* from the letters.

14. *Singing and Dancing* (*Tage tu*). Ma Yuan (late 12th century to early 13th century). Southern Song dynasty. Hanging scroll, ink and colour on silk.

15. *Meeting at the Bian Bridge* (*Zhenguan Bianqiao huimeng tu*). Chen Jizhi (active 12th century). Yuan dynasty. Handscroll, ink on paper.

16. *Imperial Tutor Pagba* (*Dishi Danba bei*). Zhao Mengfu (1254–1322). Yuan dynasty. Handscroll, ink on paper.

17. *Zhang Guo Calling to Pay Respect to the Emperor Xuanzong* (*Zhangguo jian Minghuang tu*). Ren Renfa (1254–1327). Yuan dynasty. Handscroll, ink and colour on silk.

18. *Lodge of Beautiful Wilderness* (*Xiuye xuan tu*). Zhu Derun (1294–1365). Yuan dynasty. Handscroll, ink and colour on paper.

19. *Ge Zhichuan Moving to the Mountains* (*Ge Zhichuan yiju tu*). Wang Meng (d. 1385). Yuan dynasty. Handing scroll, ink and colour on paper.

20. *Jade Cave Fairyland* (*Yudong xianyuan tu*). Qiu Ying (1495–1552). Ming dynasty. Hanging scroll, ink and colour on silk.

NOTES

1 Zheng X. 2007: 15; Xiao 2007: 34–35.

2 Zheng Z. 1954; Xu B. 1954; Zhang 1954; Qi 1954; Zheng Zhenduo to Xu Bojiao, 30 December 1952, published in Liu and Chen 1992: 394. Chen Fukang has re-examined the dates of the letters, which are assigned by Liu Zhemin and Chen Zhengwen. See Chen F. 2016: 23–26. See also Zheng Z. 1998c and cat. 29 in this catalogue.

3 To date, research on the acquisition team has been mainly conducted by Liu Xiangchun of the Shanghai Museum. The research has drawn on correspondence collected by the Museum which is otherwise inaccessible; see Liu X. 2018. This

essay builds on Liu's article by including new materials and examining the team in regional and international contexts. The history of the team is also touched upon in research by Szeto 2017: 5–6 and Zheng X. 2018: 19–20.

4 The letters were auctioned at China Guardian in Hong Kong in 2019, purchased by the auction house, and donated to the National Library. All the letters and telegrams not cited in Liu and Chen 1992 come from this auction. As the year is not specified in most of the letters and telegrams, this essay dates them based on their contents. For those that cannot be precisely dated, a (?) appears with the date.

5 Aying 1998: 284 and 292.

6 The situation is exemplified by the founding of the elite collectors' group called the Min Chiu Society, comprised mainly of Shanghainese and Cantonese collectors in Hong Kong in 1960. For the history of the society, see Lam 2010.

7 Scott 2003.

8 For details of the acquisition, see the diary of the Palace Museum director at the time, Ma Han (1881–1955), dated October and November 1951 in Ma H. 2006: 220–221, 223–229; Zheng Zhenduo to Liu Zhemin, 31 October 1951, in Guojia Wenwuju 1998: 498.

9 Hu Huichun was appointed a member Special Committee for Ceramics of the Palace Museum in 1945 or 1947. See Watt 1989: 9 and Zheng X. 2015: 24, respectively.

10 Zheng Zhenduo to Xu Bojiao, 27 March 1953, 8 April 1953 and 28 April 1953, in Liu and Chen 1992: 377–381.

11 Zheng Z. 1998a: 27 and Zheng S. 2005: 68–70.

12 Zheng Z. 1998a: 27.

13 Xu Bojiao later became a member of the Min Chiu Society, see Lam 2010: 46.

14 Zheng S. 2005: 68.

15 Zheng Zhenduo to Xu Senyu, 29 May 1952 and 2 April 1953, in Liu X. 2018: 54. For Xu Senyu's role, see Guojia Wenwuju 1998: 202.

16 Zheng Zhenduo to Xu Bojiao, 8 April 1953, in Liu and Chen 1992: 379–380.

17 The ancient books were mainly those from the collections of Chen Chengzhong (1894–1978) and Xu Bojiao. See Zheng Zhenduo to Xu Bojiao, 15 December 1952, 23 December 1952, 29 January 1953, 19 February 1953, 27 March 1953, 8 April 1953, 28 April 1953, 31 July 1953 and 29 August 1953, in Liu and Chen 1992: 378, 380, 382, 384, 386–387, 390–391, and 395–396. See also Xu Bojiao to Zheng Zhenduo, 10 January

1953, 9 February 1953, 27 February 1953 and 2 July 1953; Xu Bojiao to Wang Yi, 12 July 1955 (?), 21 August 1955, 20 September 1955, 22 October 1955 (?), 31 October 1955, 20 November 1955, 26 January 1956 (?), 2 February (?), 14 March 1956 and 23 March 1956.

18 Zheng Zhenduo to Xu Bojiao, 25 August 1952, 15 December 1952, 23 December 1952, 27 March 1953, 28 April 1953 and 31 July 1953, in Liu and Chen 1992: 377–378, 382–385 and 390–391; Xu Bojiao to Zheng Zhenduo, 23 January 1953, 3 April 1953 (?) and 3 April 1953.

19 Zheng Zhenduo to Xu Bojiao, 8 April 1953, in Liu and Chen 1992: 379–380.

20 For example, see Xu Bojiao to Wang Yi, 2 February (?).

21 Zheng Zhenduo to Xu Bojiao, 26 December 1952 and Xu Bojiao to Zheng Zhenduo, 5 January 1953.

22 Zheng Zhenduo to Xu Bojiao, 25 August 1952, 30 December 1952 and 19 February 1953, in Liu and Chen 1992: 386, 394, and 396. See also Zheng Zhenduo to Xu Senyu, 10 June 1952, in Liu X. 2018: 53–54.

23 Xu Bojiao to Zheng Zhenduo, 20 April 1953.

24 In particular, the team tried to get hold of the collections of Loo Ching Tsai (better known as C. T. Loo) (1880–1957), Wang Chi-chien (commonly known as C. C. Wang) (1907–2003), Wang Zheng (1887–?) and Zhang Daqian. See Zheng Zhenduo to Xu Bojiao 25 August 1952, 23 December 1952, 19 February 1953, 8 April 1953, 28 April 1953 and 31 July 1953, in Liu and Chen 1992: 380–383, 385–386, 391, and 397; Xu Bojiao to Zheng Zhenduo, 27 February 1953 and 20 April 1953; Xu Bojiao to Wang Yi, 12 July 1955 (?), 18 August 1955, 20 September 1955, 1 January 1956, 1 February 1956 and 24 March 1956.

25 Xu Bojiao to Wang Yi, 12 July 1955.

26 For a brief study of Hochstadter, see Giuffrida 2018: 81–86. Cahill documented his trips to Hong Kong with Hochstadter in Cahill 2000. Many paintings that appeared in Hong Kong ended up in private collections. These include purchases by the American collector John M. Crawford (d. 1988), some of which are now in the Metropolitan Museum of Art; see Sickman 1962.

27 Henry Trubner to Walter Hochstadter, 21 June 1954, Box 3, Folder 17, Walter Hochstadter Collection, Center for Jewish History, New York, https://archives.cjh.org/repositories/5/resources/10522.

28 Trubner to Hochstadter.

29 Xu Bojiao to Zheng Zhenduo, 27 January 1953, in Liu and Chen 1992: 378, 383, and 397.

30 Zheng Zhenduo to Xu Bojiao, 25 August 1952, in Liu and Chen 1992: 385.

31 Zheng Zhenduo to Xu Senyu, 2 April 1953, in Liu X. 2018: 54 and Xu Bojiao to Zheng Zhenduo, 21 January 1953.

32 For the law, see The State Council of the People's Republic of China 1950: 5–8.

33 Zheng Zhenduo to Xu Bojiao, 30 December 1952, in Liu and Chen 1992: 394.

34 For details on the acquisition of *Four Finches*, see Zheng Zhenduo to Xu Bojiao, 8 April 1953, 28 April 1953, 31 July 1953 and 29 August 1953, in Liu and Chen 1992: 380, 382–383, and 386. Xu Bojiao to Zheng Zhenduo, 18 April 1953; Xu Bojiao to Wang Yi, 18 August 1955, 22 October 1955, 31 October 1955, 20 November 1955, 1 January 1956, 30 January 1956, 1 February 1956, 4 March 1956, 14 March 1956 and 23 March 1956 and Wang Yi to Xu Bojiao, 7 March 1957.

35 Xu Bojiao to Zheng Zhenduo, 27 January 1953 and 23 March 1956.

36 Wang P. 2019: 62–65.

37 For a biography of Han Huang, see Pan Y. 1999: 132. A similar painting is in the Ohara Museum, Kurashiki, Japan. Yoshiho Yonezawa argues that the version in the Ohara Museum is a faithful copy dated to the Song dynasty, while the one in the Palace Museum is dated to the Yuan. Shane McCausland shares a similar view, arguing that the flattish outline technique shows that the Palace Museum version could be as late as the thirteenth century. Yonezawa's view is contested by Cai Xinyi and James Cahill, who argue that the Ohara version is a forgery by Zhang Daqian. See Yonezawa 1975: 161; Cahill 1999: 48; Cahill 1991; Cahill 2008; Cai X. 2007: 58–66 and McCausland 2011: 149.

38 Dong 2006: 63.

39 Qianlong 2012: 367–368.

40 The Qianlong Emperor kept his prized items of painting and calligraphy in seven buildings, including the Studio of Purification (Chunhua xuan; 1770), the Hall of Studying Poetry (Xueshi tang; 1771), and the Hall of Brief Snow (Kuaixue tang; 1779).

41 Zhang Z. 2015. *Five Oxen* can be considered one of the tools through which the Qianlong Emperor legitimised his role as a rightful successor and ruler of the Qing dynasty. For agrarian labour genre paintings that performed a similar function, see Hammers 2021.

42 Gugong Bowuyuan 1991 and Liu L. 2005.

43 Xu Bojiao to Wang Yi, 1 February 1956. Yang Renkai states that the painting was collected by Zhang Daqian in Yang R. 1991: 33.

44 Xu Bojiao to Wang Yi, 4 February 1956, 14 March 1956 and 23 March 1956.

45 The painting was allocated to the Palace Museum by February 1957. According to the diary of Zheng Zhenduo, he viewed the painting once in the Bureau of Cultural Relics (then Bureau of Cultural Relics Management Enterprises) in Beijing in January 1957 and at the Palace Museum in February of the same year. Zheng Z. 2005: 89 and 101.

46 For the role of the Palace Museum in constructing a national identity after the fall of the Qing dynasty, see Xu W. 2013.

47 See, for example, Gugong Bowuyuan Canghuaji Bianji Weiyuanhui 1978. The formation of artistic canons is a fluid and continuous process that may involve the existence of multiple canons. See Guo H. 2014. According to Noelle Giuffrida, a Chinese painting canon centring on the collection of the Palace Museum, Taipei, was formed during the early 1960s, following a loan exhibition to five major American museums. These select works were closely examined and graded by curators and scholars, and photographs of these works were widely used in research and teaching in American universities. The result is a canon that was widely accepted by American academia and more firmly established by the publication of the survey *A History of Far Eastern Art* by Sherman Lee in 1964. See Giuffrida 2018: 12–43. James Cahill's *Chinese Painting* (1960) was also important in establishing the paintings from the Palace Museum, Taipei, as the accepted canon of Chinese painting. I thank Professor Sensabaugh for drawing my attention to this work. I am also indebted to Daniel Kwok, Sophia Zhou, Phil Chan, Philip Fan, and Kingsley Liu for their help and advice. I would also like to thank Alice Cheng for her generous support.

PART TWO | EXHIBITED WORKS

CAT. 1 | *After Rain in Running Script* (*Xingshu yuhou tie*, Song copy)
Wang Xizhi (303–361)

Northern Song or early Southern Song dynasty, 10th to 12th century
Album leaf, ink on paper
25.7 × 14.9 cm
The Palace Museum

Wang Xizhi came to be known as the Sage of Calligraphy for his profound influence on later calligraphers.[1] He was famous in his own time, but it was the Tang emperor Taizong (r. 627–649) who cemented his reputation, acquiring every available example of Wang Xizhi's writing and having the calligrapher and historian Chu Suiliang (596–658) compile it in his *Inventory of Wang Xizhi's Calligraphy* (*Youjun shumu*).[2] So highly regarded was Wang's calligraphy that his private letters were collected and preserved by copying (*lin*) and tracing (*mo*), thus ensuring that his work would circulate and be studied for generations to come.[3] This copy of *After Rain* is one such work. Seventeenth-century catalogues such as *On Calligraphy and Painting* (*Shuhua ji*) by Wu Qizhen (1607–1678) recorded the authentication process of this calligraphy.[4] Current scholarship dates it to the Northern Song or early Southern Song dynasty, based on the bamboo paper used and the collectors' seals on the letter.[5]

Palace Museum scholars have identified the letter as a freehand copy that preserves much of Wang's original style and technique.[6] Characters with different ink saturation recorded sudden changes in brush directions. The disciplined, rhythmic energy of the plump forms convey the writer's personal touch, and the thin ligatures in the later columns are the product of freer handwriting, perhaps revealing a hint of relaxed nonchalance. The content of this missive is hard to decipher, but to connoisseurs the literary composition of the work is immaterial compared to its aesthetic value as a treasured work of calligraphic art.[7]

After Rain entered the imperial collection under the Emperor Gaozong (r. 1127–1162). Although not found in any engraved compendia (*congtie*), the elegant colophons mounted with the letter — by Deng Wenyuan (1259–1328), Dong Qichang (1555–1636), and Zou Zhilin (1574–ca. 1654) — give it a prestigious pedigree.[8] Early in the Qing dynasty it was mounted in an album with *Death of a Palace Attendant in Running Script* (*Xingshu Zhonglang tie*) by Xie An (320–385; cat. 2). The Qianlong Emperor (r. 1736–1795) documented the album in *Treasured Boxes of the Stone Moat* (*Shiqu baoji*) and kept it in the Hall of Mental Cultivation (Yangxin dian).[9] The album leaf was stored in the Hall of Esteemed Excellence (Jingsheng zhai) during the reigns of the Daoguang Emperor (1821–1850) and the Guangxu Emperor (r. 1875–1908) and moved to the Palace of Heavenly Purity (Qianqing gong) under the Xuantong Emperor (r. 1909–1911).[10] The work was brought to the Manchukuo Imperial Palace in Changchun, left the imperial collection, and subsequently was donated to the Palace Museum by Xue Zhongfu (active mid-20th century).[11] Thus did this ephemeral social note survive as the only freehand copy of Wang Xizhi's calligraphic mastery donated to the Palace Museum within the first three decades of the People's Republic of China's establishment.[12] PYY

NOTES
1 Richter and Chace 2017: 33–37.
2 Harrist 1999: 241–259.
3 Pattinson 2002: 111–113.
4 The letter was once in the private hands of a Huizhou art dealer, Wang Yueshi (active 17th century), at the end of the Ming; see Fan 2018: 116–118. Wu Qizhen's connoisseurship was made possible by seeing the letter in Wang Yueshi's home, where Wu identified the epistle as a work from either the Tang or Song dynasty, see Wu 1963: 206–207. This work is also documented in catalogues such as Gu Fu 2011: 6, An Qi 1742: 365, and Zhang and Liang 1991: 268–269.
5 Xu B. 1980: 57–58; Shu 1982: 53–54; and Li T. 2012: 70.
6 Jin Y. 2008.
7 Clunas 2009: 137. Bai Qianshen concludes: "Reading was subordinated to viewing." See Bai 1999: 385; and Richter 2011: 375.
8 Xu B. 2015b, vol. 10: 6.
9 Zhang and Liang 1991: 268–269.
10 Gugong Bowuyuan 2013: vol. 5 and vol. 37: 40, 199, 559.
11 Yang R. 2007: 226, 243.
12 Shu 1982: 53.

| *Death of a Palace Attendant in Running Script (Xingshu zhonglang tie, Song copy)*
Xic An (320–385)

Southern Song dynasty, 12th century
Album leaf, ink on paper
23.3 × 25.7 cm
The Palace Museum

Xie An was a celebrated hermit and later an influential statesman of the Eastern Jin dynasty. He was purportedly instructed by Wang Xizhi (303–361) in cursive and regular-script calligraphy and attended the famous gathering at the Orchid Pavilion in 353.[1] The art critic Zhang Huaiguan (active early 8th century) rated Xie's calligraphy lower than that of Wang and his son, Wang Xianzhi (344–386).[2] By the Northern Song dynasty, Xie's calligraphy had gained greater recognition, and critics ranked it with that of the Wangs.

Death of a Palace Attendant is a Song-period copy of a letter in which Xie An mourns the death of a "Palace Attendant" — most likely a younger brother who held that title, Xie Wan (320–361).[3] By the Tang dynasty works by the Jin masters were rare and highly sought after.[4] The circulation of the original letter during the Tang and Song dynasties is well documented; it is known that it passed from Cai Jing (1047–1126) to Mi Fu (1051–1107) in 1101.[5] A connoisseur of the Jin tradition, Mi Fu valued the letter highly. In his *Letter to the Grand Preceptor Li (Li Taishi tie)*, he said that Xie's "character surpasses" that of Wang Xianzhi.[6] Mi Fu's advocacy burnished Xie An's reputation, and the significance of his letter was recognised during the late Northern Song.

The original manuscript may have been lost when the dynasty fell, and rubbings and copies of the letter were made during the Southern Song dynasty.

The present work is the only existing free-hand copy of Xie's original, and it is tentatively dated to around the Shaoxing period (1131–1162) to the early reign of the Emperor Xiaozong (r. 1163–1189). A relatively faithful copy in terms of structure and brushwork, its strokes are slim, perhaps indicating the influence of the then dominant style of the Emperor Gaozong (r. 1127–1162). The presence of the imperial seal *Deshou* ("morality and longevity"), used by Gaozong after his abdication, suggests that the former emperor may have ordered this copy for his collection, perhaps made at the Imperial Calligraphy Academy.[7]

This copy was passed down through the collections of a number of Ming dynasty connoisseurs who added their colophons and seals. It entered the imperial collection during the time of the Qianlong Emperor (r. 1736–1795) and was mounted in an album with Wang Xizhi's *After Rain in Running Script* (cat. 1). After the fall of the Qing dynasty, the album was taken to Changchun and then donated to the Palace Museum by Xue Zhongfu (active mid-20th century).[8] LTC

NOTES
1 See Zhang Huaiguan's *Judgments on Calligraphers (Shuduan), juan* 8 of *Fashu Yaolu:* Zhang Yanyuan 1993: 91.
2 Zhang Huaiguan classified Wang Xizhi and Wang Xianzhi as "divine class" (*shenpin*) and Xie An as "wonderful class" (*miaopin*); see Zhang Yanyuan 1993: 87–91.
3 As a letter written to junior family members, it likely related the death of an important relative. Xie Wan was called Xie Zhonglang (the Palace Attendant Xie) in *A New Account of Tales of the World with Annotations (Shishuo xinyu jiaojian)*. Xie Wan (320–361) was Xie An's third youngest brother and served as a palace attendant, and thus may be the subject of the letter. See Liu Yiqing 1987: 76–77.
4 Mok 2013: 491–495.
5 For the transmission history of this work, see Mi Fu 1993b: 963.
6 See Qi and Wang 2002b: 75–9 and 2002a: 8–10. Concerning "character", Mi Fu explained in *Discourse on Calligraphy (Shu lunshu)* that if "cursive calligraphy does not partake of the character of the Jin writer, it is … a work of the lowest grade". Such a notion dominated Mi Fu's calligraphic practice; see Sturman 1997: 128–149.
7 Xu B. 2015b, vol. 10: 25.
8 Yang R. 2007: 243.

八月五日告淵朗廓仾清玄

兂蓍何首酷禍荼集中

郎奄亡逝没一慟痛毞惻

五情破裂不自堪忍痛

當奈何當復去洲其悲

慕斷絕誂他得為參毞

為心奈何奈何安豎

Northern Song dynasty, 11th or 12th century
Handscroll, ink and colour on silk
27 × 572.8 cm
The Palace Museum

Gu Kaizhi was acclaimed for his depictions of people in which he captured their demeanour and countenance in a naturalistic manner.[1] The subject of *Nymph of the Luo River* is a *fu*-rhapsody composed by Cao Zhi in the third year of the Huangchu reign (222) of the Wei Kingdom (220–265).[2] It became an enduring source of inspiration to painters and calligraphers alike through the ages. The pictorial interpretations, whether imaginative creations or copies of previous masterpieces, are manifestations of styles distinctive of their respective periods.

The earliest recorded painter of the subject is Sima Shao, or Emperor Ming (r. 323–325) of the Eastern Jin dynasty.[3] The importance of this copy lies in its preservation of stylistic elements of the fifth and sixth centuries, making it an essential work, along with *Admonitions of the Instructress to the Court Ladies* (*Nüshi zhen tu*) and *Wise and Benevolent Women* (*Lienü tu*), both attributed to Gu Kaizhi, for any study of early painting.[4] For instance, its stylistic features are echoed in stone carvings of the Eastern Han dynasty Wu Liang Shrine in Shandong province; the nymph's attire and the attendants' hair ornaments in the Jin brick relief of a village head in the Palace Museum; its trees in a late Eastern Jin brick relief featuring the *Seven Sages of the Bamboo Grove and Rong Qiqi* (*Zhulin qixian yu Rong Qiqi zhuanhua*) in the Nanjing Museum. Stylistic analyses have established

that this copy is the latest of the three paintings, hence its ascription to the late Northern Song.[5]

According to the Qianlong Emperor's inscription on the frontispiece, there were three versions of *Nymph of the Luo River* in the imperial collection. Included in both the *Treasured Boxes of the Stone Moat* (*Shiqu baoji*) and its *Supplement* (*Shiqu baoji xubian*), the paintings were each assigned a number by the emperor.[6] This version was ranked number one, followed by the version in the Liaoning Provincial Museum.[7] A comparison with the latter version raises speculations that there should be a missing scene that probably illustrates the nymph being offered a jade pendant as a pledge. A seam impressed with straddling imperial seals suggests that the section had already been lost when the work entered the imperial collection.

As explicitly stated by the Qianlong Emperor on the separator to the left of the painting, the *fu*-rhapsody purported to be written by Zhao Mengfu (1254–1322) as well as the colophons by Li Kan (1245–1320), Shen Du (1357–1434) and Wu Kuan (1435–1504) were all forgeries. Yet, this did not dampen his affection for the scroll. From surviving examples in the Palace Museum in Beijing and that in Taipei (Ding Guanpeng's [active ca. 1726–1770] copy), it is evident that the emperor not only copied the painting himself but also ordered court painters to do the same. TYM

NOTES
1 See Fang Xuanling et al, *juan* 92.
2 The date of Cao Zhi's *fu*-rhapsody has also been said to be the 4th year of the Huangchu reign (223).
3 Zhang Yanyuan (*Jindai mishu*, edition, Ming dynasty), *juan* 5: 1.
4 For the former, see British Museum (1903,0408,0.1); the latter is in the Palace Museum collection.
5 The figures resemble those of Li Gonglin (1041–1106) and are comparable with those in the Southern Song ink-outline (*baimiao*) copy of *Admonitions of the Instructress to the Court Ladies* traditionally attributed to Li in the Palace Museum.
6 *Shiqu baoji* (*chubian*), *juan* 8; *Shiqu baoji xubian*, vol. 8, no. 5 and vol. 56, no. 53.
7 There was also a copy attributed to the Tang dynasty recorded in the *Treasured Boxes of the Stone Moat*. See *Shiqu baoji* (*chubian*), *juan* 7.

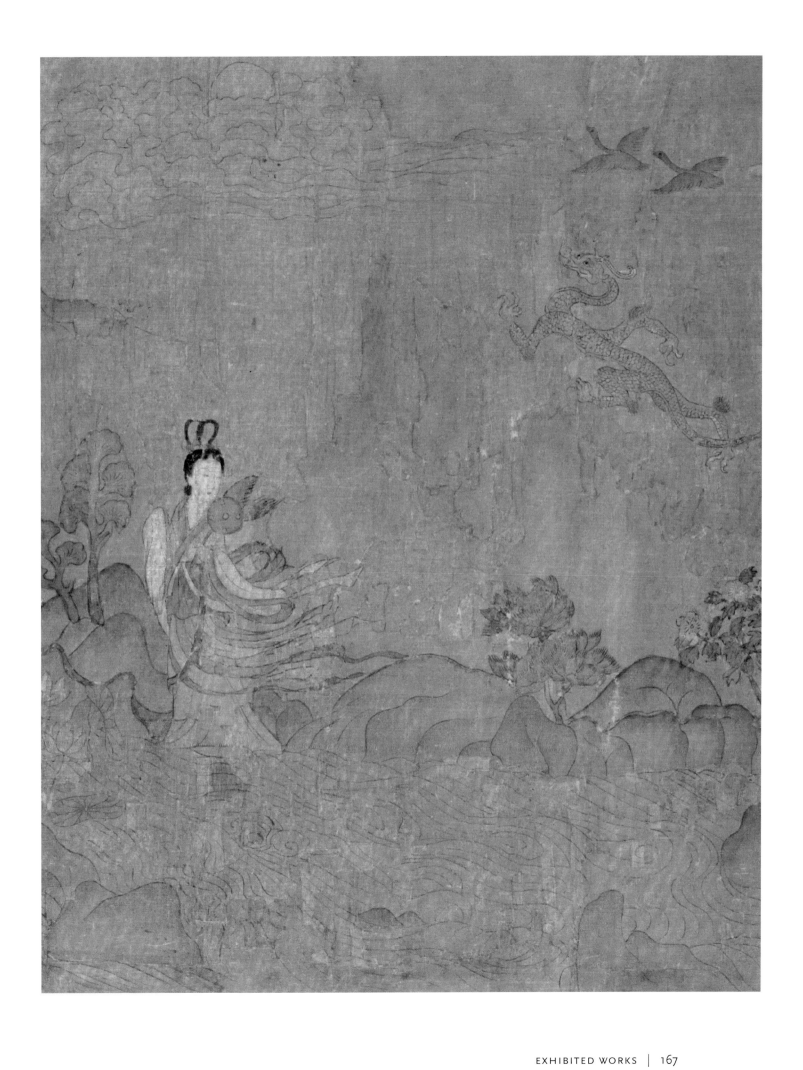

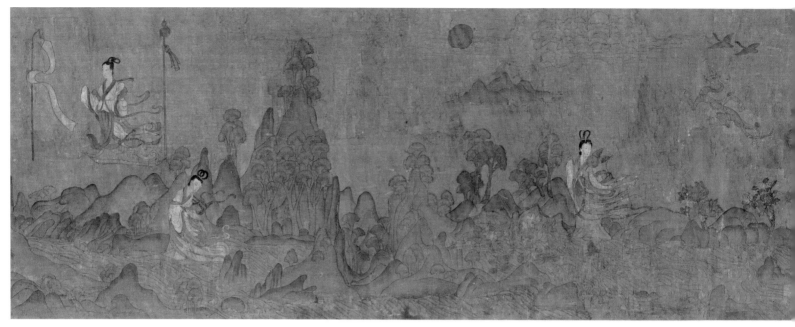

B

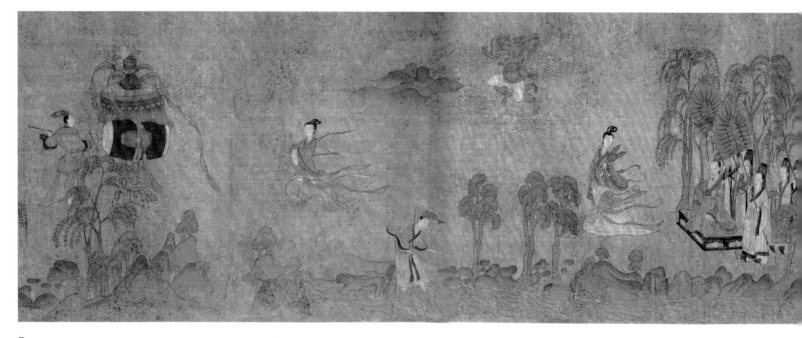

D

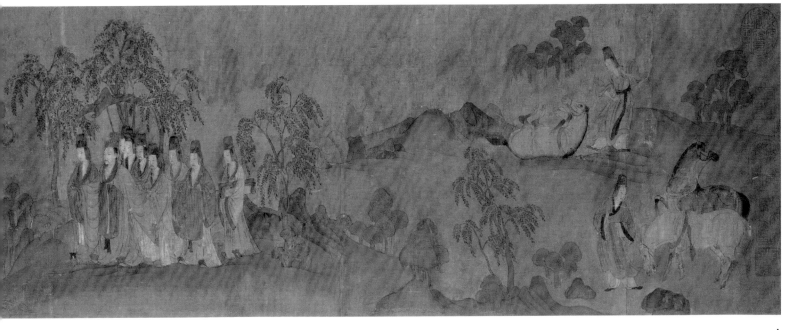

A

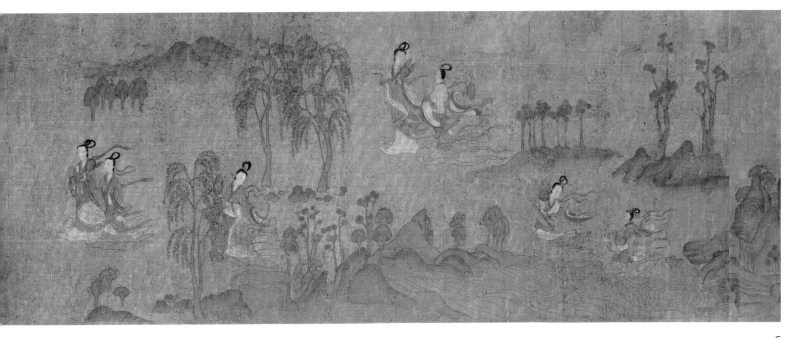

C

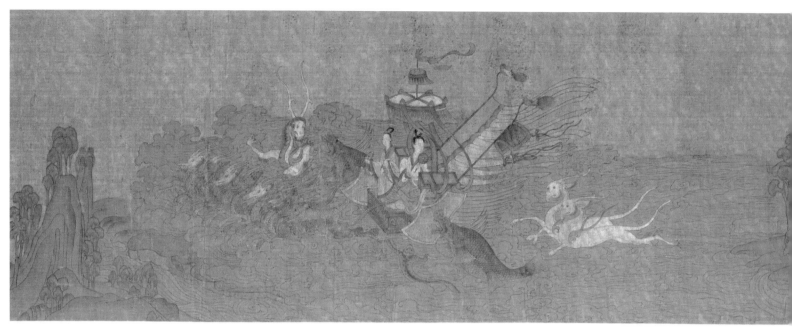

F

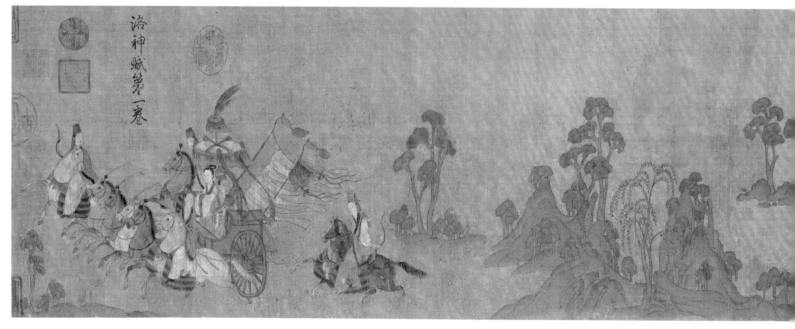

H

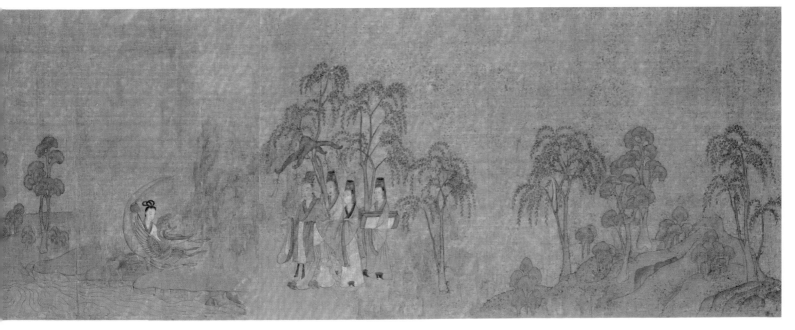

E

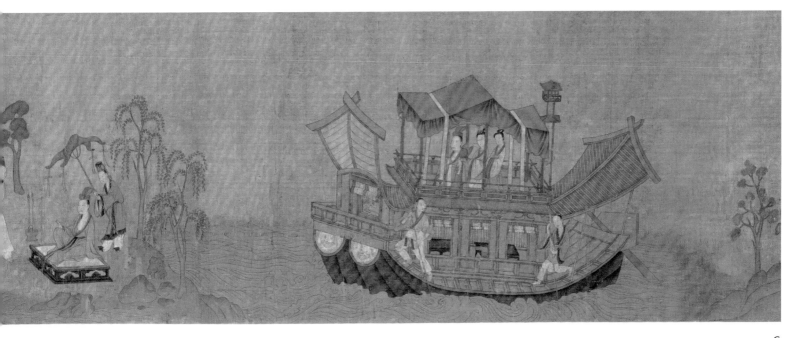

G

CAT. 4 | *Nymph of the Luo River* (*Luoshen fu quantu*, Southern Song copy)
Gu Kaizhi (346–407)

Southern Song dynasty, 12th century
Handscroll, ink and colour on silk
51.2 × 1154.3 cm
The Palace Museum

This scroll — known to have been valued by the Qianlong Emperor (r. 1736–1795) and kept in the Imperial Study (Yu shufang)[1] — is inscribed with just fourteen excerpts from the prose poem (*fu*) that inspired it (see cat. 3), fewer than some versions.[2] Yet it illustrates scenes from the tale — including those depicting the Nymph being offered a jade pendant and celestial beings gathering pearls and kingfishers' plumes — absent from the Northern Song version (cat. 3), justifying this work being judged the "complete rendition" in the imperial catalogue.

This scroll departs from the styles of Gu Kaizhi's time while conforming to Song and Tang traditions, suggesting that the scroll is actually a Song copy of an earlier work. The plump figures parallel those in *Earthly Official Going on Excursion* (*Diguan chuyou tu*) in the Palace Museum by the Tang master Zhou Fang (ca. 780–ca. 810), while their attire recalls that of the Daoist and Buddhist images in the Song dynasty painting *Procession of Immortals Paying Homage to the Primordial* (*Chaoyuan xianzhang tu*). The horses are Tang-like in their varied postures, recalling *A Hundred Horses* (*Tangren baima tu*) (a Song copy of a Tang original) and *Pasturing Horses* (*Lin Wei Yan mufang tu*) by the Song master Li Gonglin (1049–1106), itself a copy of a Tang painting by Wei Yan (active 8th century), both in the Palace Museum. Most striking here are the composition and description of the landscape: the monumental mountains, tortuous trails, and limpid water are typical of the genre that peaked in the Northern Song. Further supporting a Southern Song dating, axe-cut texture strokes are in the style of the followers of Yan Wengui (ca. 967–1044) and Li Tang (active mid-11th–mid-12th century), as is the secularised portrayal of the river god as a woman with her ankles exposed and that of the scantily dressed goddesses — details nowhere to be seen in Northern Song paintings such as *Fairy Riding a "Luan" Phoenix* (*Xiannü chengluan tu*). All in all, this work illustrates well how the tale of the Luo River Nymph was interpreted in the Southern Song as compared with other versions, such as the Northern Song scroll (cat. 3), and casts light on the practice of copying in Chinese painting.

Enthusiasm for *Nymph of the Luo River* continued through the centuries.[3] Shen Zhou (1427–1509), Wen Zhengming (1470–1559), Tang Yin (1470–1523), and Qiu Ying (ca. 1459–1552) — the Four Masters of the Wu School, who have come to define Ming painting — all painted works inspired by the classic, and the collaboration by Wen Zhenming and Qiu Ying was regarded as the finest by Wang Shimao (1536–1588). The Qing painters Gao Qipei (d. 1734), Hua Xu (ca. 1627–ca. 1687), and Fei Danxu (1801–1850) also addressed the subject. Ultimately, this work enlarges our understanding of the development of narrative painting in China. TYM

NOTES
1 See "Wumingshi huajuan shangdeng" in Zhang Zhao et al. 1987, *juan* 7.
2 Such as *Copy of Gu Kaizhi's Nymph of the Luo River* (*Fang Gu Kaizhi Loushen fu tu*) in the Liaoning Provincial Museum.
3 "Luoshen juan" in Shen Zhou 1987: 32; Wang Shimao 1997, *juan* 51: 10.

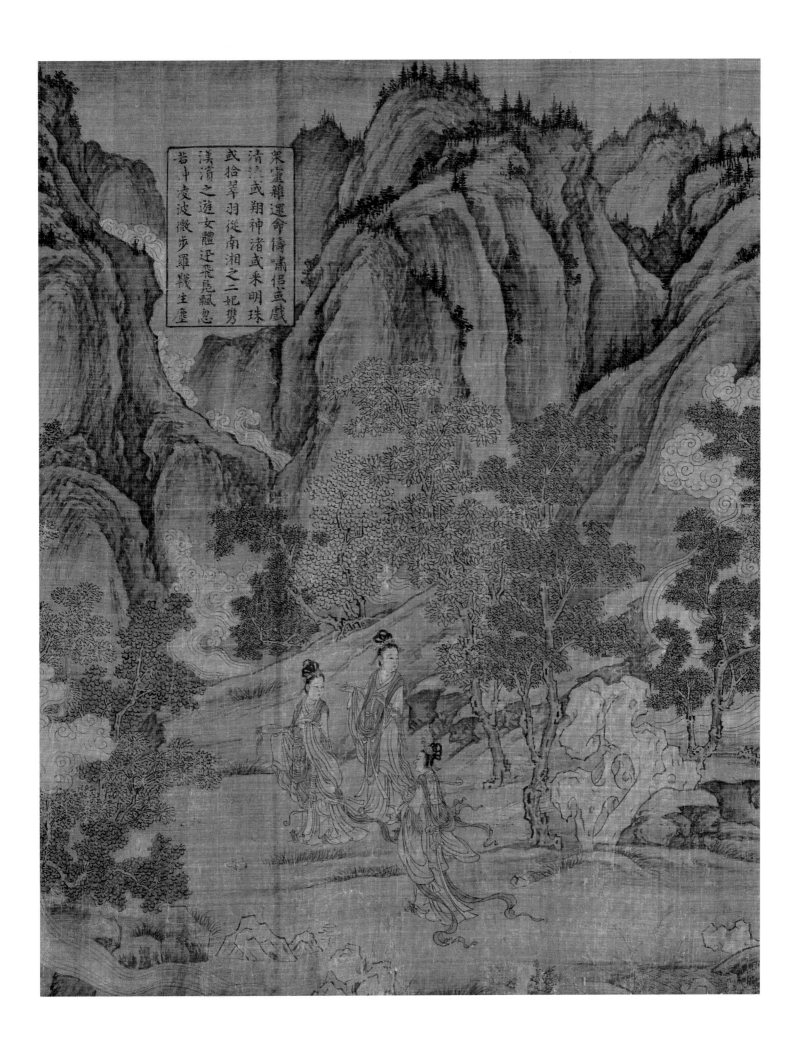

眾靈雜遝命儔嘯侶或戲
清流或翔神渚或采明珠
或拾翠羽從南湘之二妃携
漢濱之遊女體迅飛鳧飄忽
若止凌波微步羅韤生塵

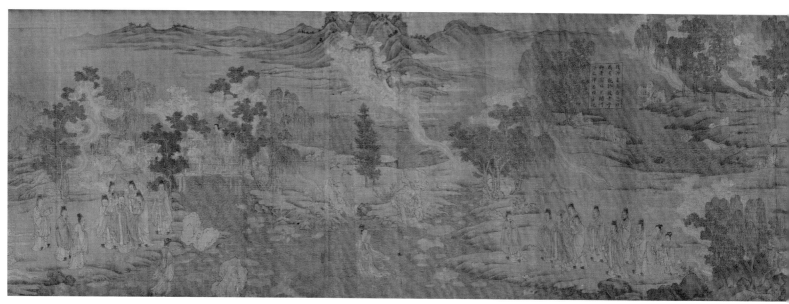

B

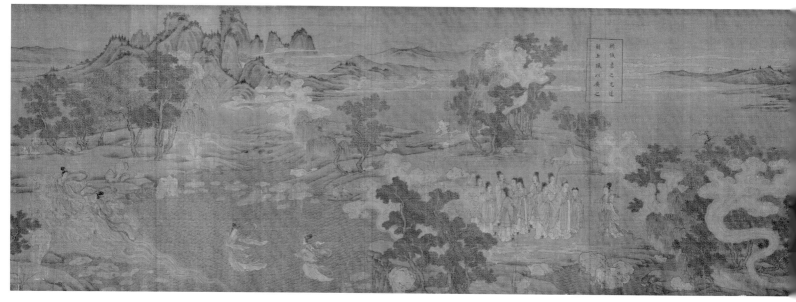

D

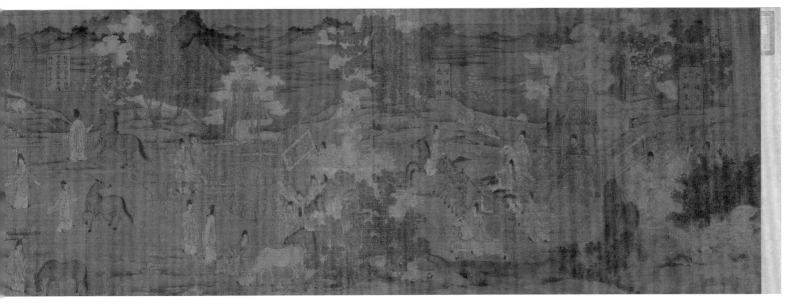

A

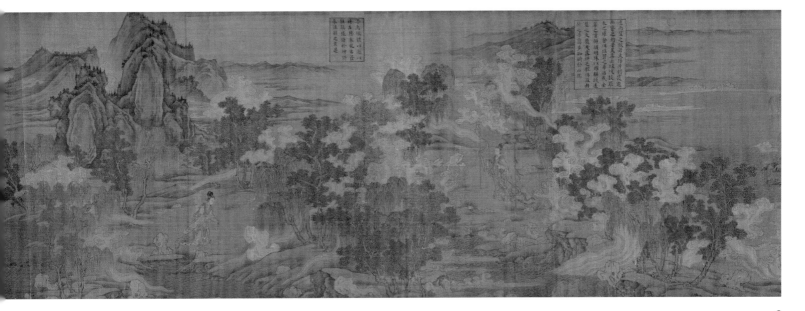

C

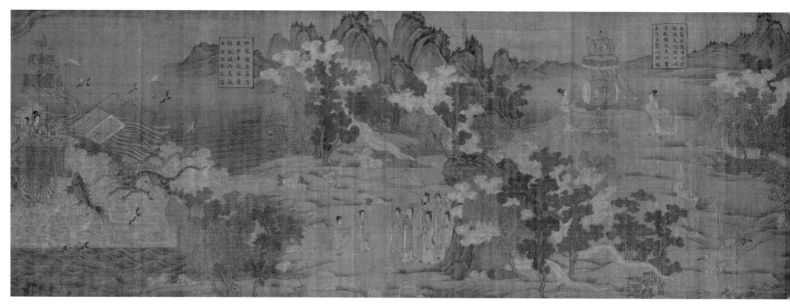

F

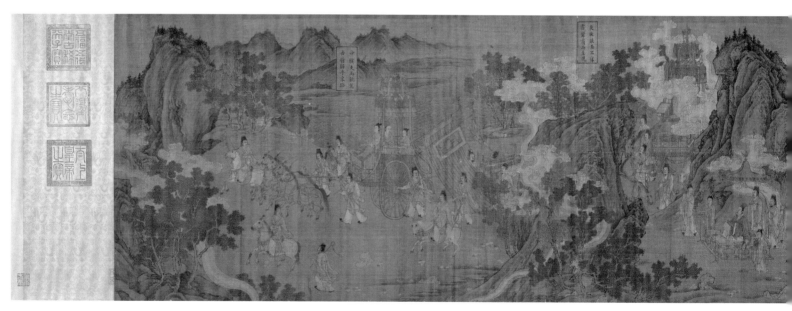

H

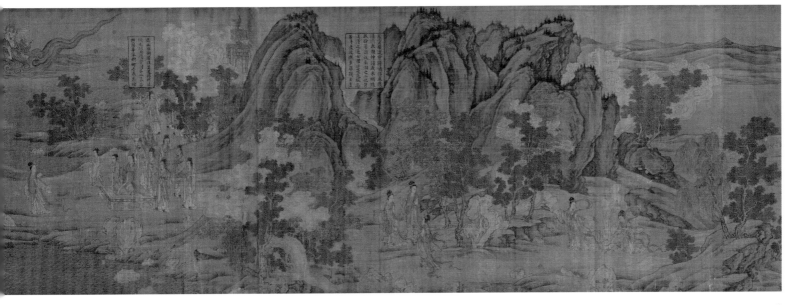

E

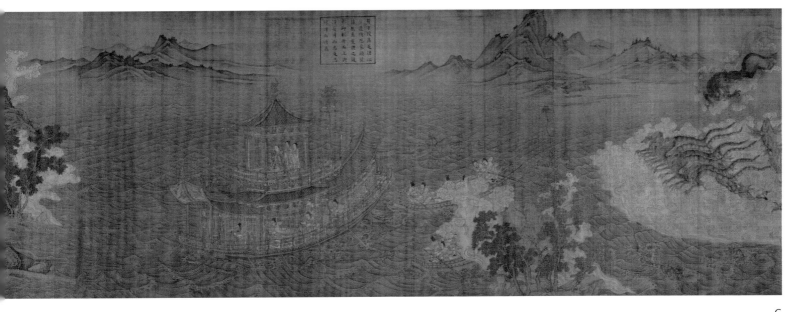

G

CAT. 5 | *Biography of Zhang Han in Running-Regular Script* (*Xingkai shu Zhang Han tie*, Tang copy)
Ouyang Xun (557–641)

Tang dynasty, 7th to 9th century
Album leaf, ink on paper
25.3 × 31.7 cm
The Palace Museum

The text of this work recounts the unambitious yet contented life of Zhang Han, whose biography merited an entry in the *History of the Jin Dynasty* (*Jin shu*), *A New Account of Tales of the World* (*Shishuo xinyu*), and other texts.[1] Although unsigned, this work has been attributed to Ouyang Xun since its entry into the imperial collection during the time of the Northern Song emperor Huizong (r. 1101–1125).[2] Ouyang Xun was an erudite scholar who served in the Sui and Tang courts. A follower of Wang Xizhi (303–361), he was revered for his achievements as a calligrapher.[3] Ouyang's unique style can be seen here in his lank form, robust brushwork, and disciplined execution. Although now recognised as a tracing copy, it is regarded as being on the same level with Ouyang's authentic masterpieces. Only three other works by or copies of Ouyang Xun are known.[4]

Opposite the calligraphy is an unsigned inscription in slender gold script believed to be by Huizong, who had yet to assume the throne, thus explaining the absence of his imperial seals.[5] The inscription's comments on Ouyang Xun's calligraphy tally with those in the *Xuanhe Catalogue of Calligraphy* (*Xuanhe shupu*). The work's prestigious provenance continued with its acquisition by the Southern Song emperor Gaozong (r. 1127–1162). The late Ming–early Qing collector Feng Quan (1595–1672) owned it and included it in his *Model Calligraphy of the Hall of Delightful Snow* (*Kuaixue tang fatie*) before it was passed to the collector An Qi (1683–after 1745), who included it in his catalogue *Fortuitous Encounters with Ink* (*Moyuan huiguan*). It later entered the Qing imperial collection; it was inscribed by the Qianlong Emperor (r. 1736–1795) and received an imperial seal, as recorded in *Model Calligraphy of the Hall of Three Rarities* (*Sanxi tang fatie*), produced under the emperor's auspices. However, both the Qianlong inscription and seal mark have been erased for unknown reasons.

Biography of Zhang Han is one of ten works in the album *A Magnificent Collection of Model Calligraphy* (*Shufa daguan*), which also includes works by Wang Xianzhi (384–386), Cai Xiang (1012–1067), Su Shi (1037–1101), Huang Tingjian (1045–1105), Mi Fu (1051–1107), Wu Ju (active 1145–1207), and Zhao Mengfu (1254–1322). HN

NOTES

1 Fang Xuanling et al. 1982: 2384.
2 *Xuanhe shupu* 1993: 27.
3 Ouyang Xiu and Song Qi 1982: 5645–5646.
4 They are *Thousand-Character Essay* (*Qianziwen juan*), *Confucius Making an Offering in a Dream* (*Mengdian*), and *A Conversation between Confucius and Bu Shang* (*Bu Shang*).
5 Xu B. 2005, vol. 2: 56.

張翰字季鷹吳郡人有
清才善屬文而縱任不拘
時人號之為江東步兵後
齊王同郡顧榮曰天下紛紜
禍難未已夫有四海之名者
求退良難吾本山林間人
無望於時子善以明防前
以智慮後榮執其手愴然
翰因見秋風起乃思吳中
菰菜蓴羹鱸魚遂命駕而歸

CAT. 6 | *Copy of the Orchid Pavilion Preface in Running Script (Xingshu mo Lanting xu tie)*
Attributed to Yu Shinan (558–638)

Tang dynasty, 7th century
Handscroll, ink on paper
24.8 × 75.7 cm
The Palace Museum

In the year 353, forty-one members of the cultural elite gathered at the Orchid Pavilion near Kuaiji to observe the spring purification festival (*Xiuxi*). That day they composed poems that were prefaced by what came to be known as the *Orchid Pavilion Preface* (*Lanting xu*); the preface, written on the spot by Wang Xizhi (303–361), has become a classic of Chinese calligraphy and literature. The original is said to have been buried with the Tang emperor Taizong (r. 627–649) at the Zhao Mausoleum. Before he died, however, Taizong commissioned a number of calligraphers to make copies of the preface; stone engravings of the work were also found in Dingwu during the Song dynasty. Thus, Wang Xizhi's preface has survived in copies and as rubbings taken from the stone engravings.[1]

The two pieces of joined hemp paper that make up the writing surface of this work have been securely dated to the seventh century. Had it not been mounted so poorly in the past, the ink would have better retained its original lustre. The calligraphy itself reveals rounded strokes and the occasional hesitation in execution, leading experts to conclude that it was probably copied from another copy during the Tang dynasty. At one time the work was attributed to the early Tang calligrapher Chu Suiliang (596–658). However, Dong Qichang (1555–1636), one of the most influential Ming calligraphers, argued that Yu Shinan was the more likely artist and put forward his proposal in his colophon to the scroll. His friend Chen Jiru (1558–1639)

and the concubine Yang Wan (d. ca. 1645) of Mao Yuanyi (1594–1640) concurred in their colophons, and the attribution has largely stood ever since.[2] A native of Yuyao (in present-day Zhejiang), Yu Shinan was an Academician in the Institute for the Advancement of Literature and served as Taizong's calligraphy teacher. An inheritor of the tradition of Wang Xizhi and his son Wang Xianzhi (344–386) via Monk Zhiyong (active late 6th–early 7th century) and a virtuoso of regular and running scripts, Yu Shinan is considered one of the Four Masters of the Early Tang.[3]

The scroll opens with a title slip and a long inscription by the Qianlong Emperor (r. 1736–1795) alluding to the fact that the preface was carved onto the first of the pillars memorialised in the model-letters compendium *Eight Pillars of Lanting* (*Lanting bazhu tie*). At the end of the scroll, an inscription states that it was presented to the throne by Zhang Jinjie (active 14th century), a Yuan official. Appended to the work are inscriptions and colophons by various Song and Ming personages.[4] The scroll passed through the collections of the Southern Song emperor Gaozong (r. 1127–1162); the Yuan emperor Wenzong (r. 1328–1331); numerous collectors during the Ming dynasty; and Liang Qingbiao (1620–1691), An Qi (1683–after 1745), and the Qianlong Emperor during the Qing dynasty.[5] References to the work can be found in writings or catalogues of the Ming and Qing, most notably in the *Treasured Boxes of the Stone Moat Supplement* (*Shiqu baoji xubian*). ZZR

NOTES
1 Qi 1999a: 36.
2 Wang L. 2011: 81.
3 For more on Yu Shinan's life, see Yu J. 1981: 1231; and Yang R. 2001: 113.
4 For a discussion of these inscriptions and seals, see Xu B. 2015b: 83.
5 Ibid.

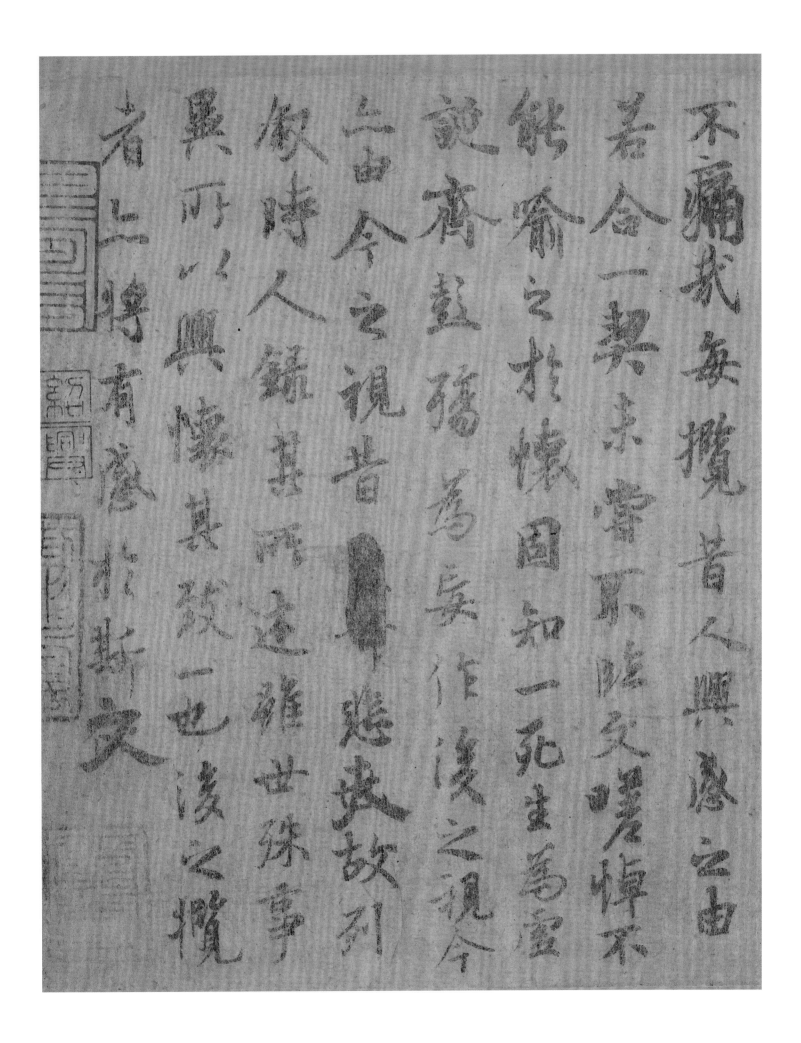

不痛哉每攬昔人興感之由

若合一契未嘗不臨文嗟悼不

能喻之於懷固知一死生為虛

誕齊彭殤為妄作後之視今

亦由今之視昔悲夫故列

敘時人錄其所述雖世殊事

異所以興懷其致一也後之攬

者亦將有感於斯文

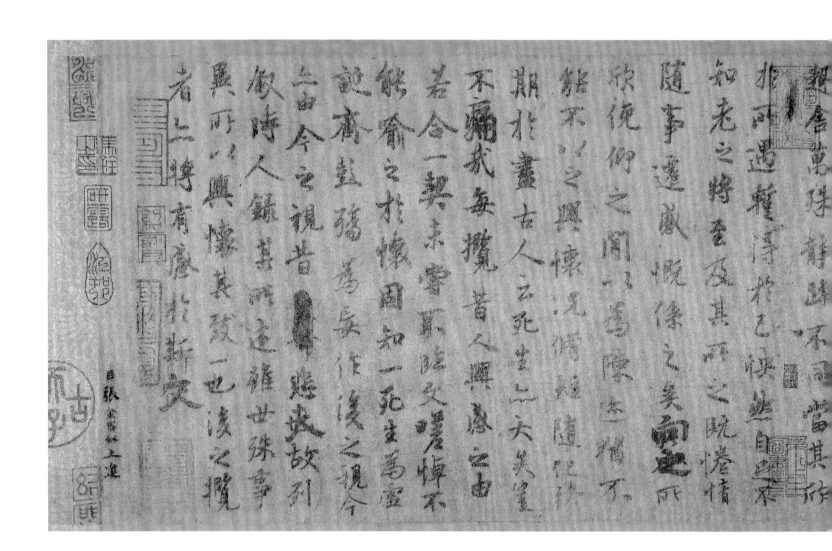

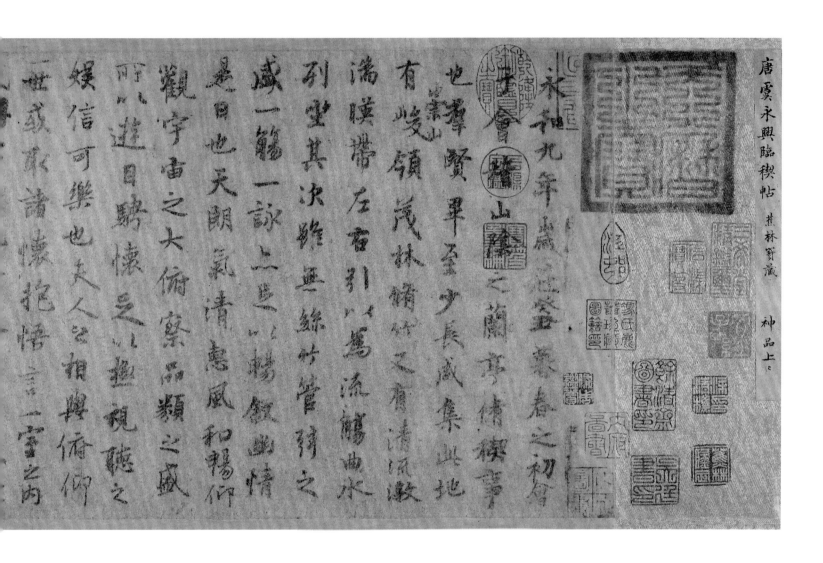

唐虞永興臨禊帖 蕉林鑑藏 神品上

永和九年歲在癸丑暮春之初會
于會稽山陰之蘭亭脩禊事
也群賢畢至少長咸集此地
有峻領茂林脩竹又有清流激
湍暎帶左右引以為流觴曲水
列坐其次雖無絲竹管絃之
盛一觴一詠亦足以暢敘幽情
是日也天朗氣清惠風和暢仰
觀宇宙之大俯察品類之盛
所以遊目騁懷足以極視聽之
娛信可樂也夫人之相與俯仰
一世或取諸懷抱悟言一室之內

CAT. 7 | *Six Arhats* (*Liu zunzhe xiang*, Song copy)
Lu Lengjia (active 730–760)

Southern Song dynasty, 12th or 13th century
Album leaves, ink and colour on silk
30.2 × 59.5 cm
The Palace Museum

These leaves are among the few extant works credited to Lu Lengjia — an attribution, it turns out, based on a spurious signature.[1] Nevertheless, they remain crucial to our understanding of his art. For example, the meticulous and fluent brushwork here is consistent with the description of Lu's iron-wire lines (*tiexian miao*) by the Southern Song art critic Zhao Xihu (ca. 1170–1242).[2] Yet the overall style and decorative traits in these paintings have led many scholars to argue that they are likely Southern Song copies of earlier works by Lu.[3]

Lu Lengjia was a disciple of the Tang master painter Wu Daozi (ca. 686–ca. 760) and a skilled painter of Buddhist subjects.[4] This album consists of six leaves that would likely have been part of a larger group of eighteen.[5] Each leaf depicts one arhat (a person who has attained enlightenment) with one or more accompanying monks, servants, or devotees. The album is an excellent example of the arhat images that circulated and were appropriated widely in China and neighbouring regions during the Song dynasty. Similar figures and compositions are seen in a thirteenth-century Japanese copy of *The Six Patriarchs of the Bodhidharma Sect* (*Damo zong liu zushi xiang*) from the Kōzan-ji temple in Kyoto and a Dali Kingdom (937–1253) handscroll *Scroll of Buddhist Images* (*Hua fanxiang*) by

Zhang Shengwen (active mid-to-late 12th century) in the Palace Museum, Taipei.[6] A notable figure here is the devotee standing beside the eighteenth arhat. Judging by the two distinctive feathers on his headdress, he is very likely an envoy from Goguryeo, located on the Korean peninsula.[7] A comparable figure is seen in the Taipei scroll and in another Northern Song handscroll in the Cleveland Museum of Art.[8] Both figures wear similar garb and hold distinctive lotus-shaped ornaments, either leading or following a retinue of foreigner-worshippers. These examples demonstrate how earlier pictures circulated and were used as models by later painters.[9]

This album was in the collections of the Yuan princess Sengge Ragi (ca. 1283–1331), the Ming and Qing courts, and renowned collectors such as Xiang Yuanbian (1525–1590) and An Qi (1683–after 1745). The Qianlong Emperor (r. 1736–1795) took a special liking to it, not only remounting, inscribing, and studying it, but also ordering the court painter Zhuang Yude (active mid-to-late 18th century) to copy it. In the early 1950s the work was discovered in terrible condition hidden in a mattress located in the Studio of Xunyan in the Hall of Happiness and Longevity (Qingshou tang), a cluster of buildings in the northeast of the Forbidden City.[10] Speedy and efficient conservation allowed it to be preserved and displayed today. LAT

NOTES

1 Xu B. 1981: 63.
2 Zhao Xihu 1849: 40.
3 See Shao 2011: 95–102; Shih 1998: 153–182; and Xu B. 1981: 56–68. For a detailed study of arhats from different traditions, see Hsu 2016: 116–140.
4 *Xuanhe huapu* 1993: 67.
5 Two of the arhats from the album only appear in works with an assembly of eighteen arhats — namely, the arhat who subdues the dragon and the arhat who tames the tiger; see Xu B. 1981: 63.
6 The comparison with the Kōzan-ji drawing was first noted in Huang S. 2002: 105. For images of paintings, see Fontein and Hickman 1971: 2–3. *Scroll of Buddhist Images* (Palace Museum, Taipei) is dated 1172–1175 and is the only surviving painting from the Dali Kingdom; see Liu F. 2018: 114–133.
7 For visuals of delegates from Goguryeo, see murals painted on the western wall of the Afrosiab Palace. Northeast Asian History Foundation 2014.
8 Cleveland Museum of Art, 1957.358; see Chou and Chung 2015: 29–33.
9 The use of earlier paintings as models in Chinese art was first pointed out in Ledderose 2000: 16. He said that these "pictorial modules" are comparable to "interchangeable building blocks" that were "put together in varying combinations".
10 Shao 2011: 96.

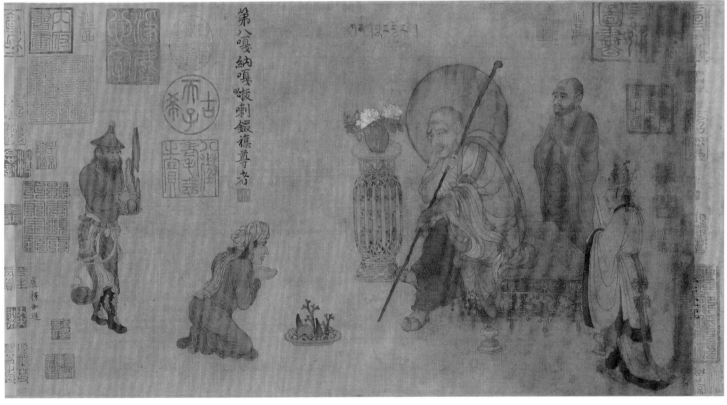

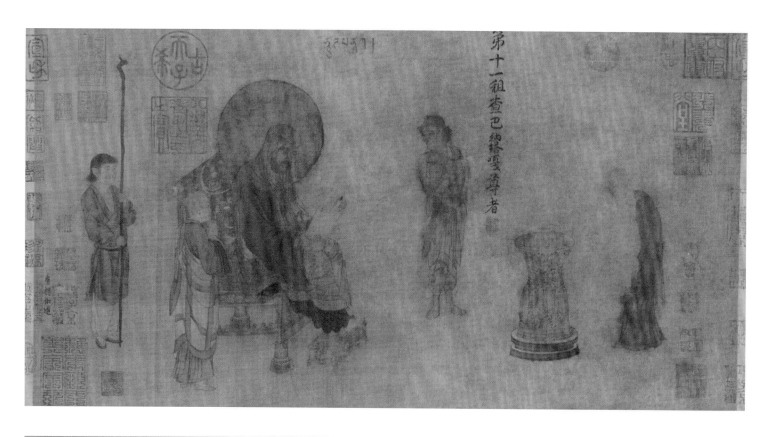

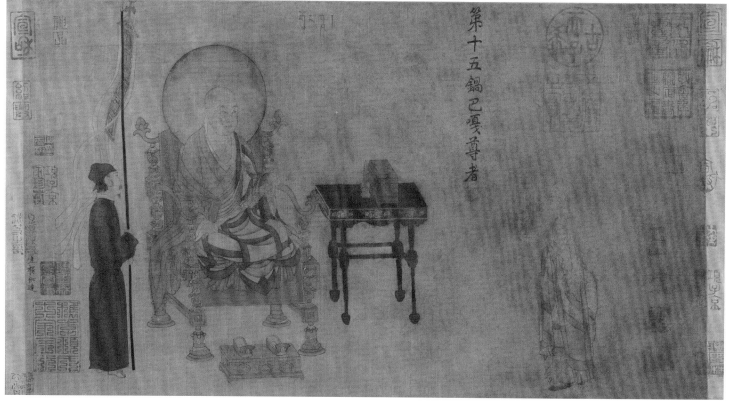

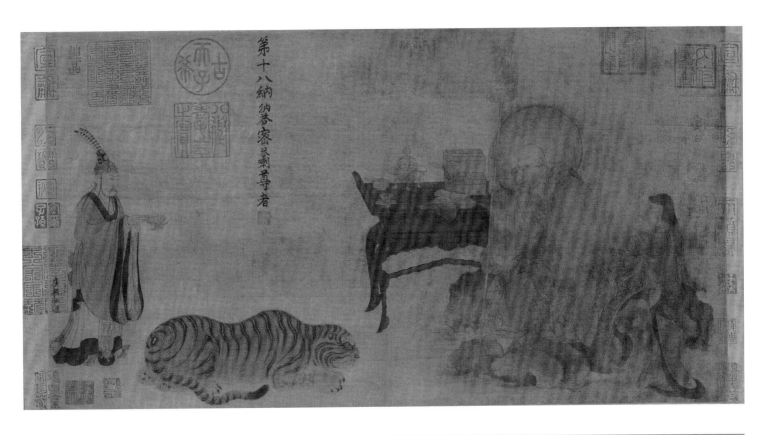

第十八納 納荅密㖦尊者

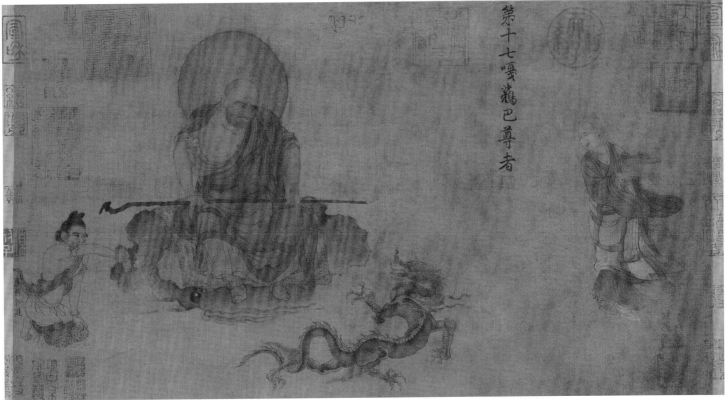

第十七嘎 㶚巴尊者

CAT. 8 | *Female Immortals in Elysium* (*Langyuan nüxian tu*)
Ruan Gao (active 10th century)

Five Dynasties and Ten Kingdoms period, 10th century
Handscroll, ink and colour on silk
42.7 × 178.1 cm
The Palace Museum

Some scholars consider this the only surviving authentic work by Ruan Gao, a celebrated painter of the Five Dynasties period.[1] According to the *Xuanhe Catalogue of Paintings* (*Xuanhe huapu*), Ruan was Court Gentleman for Fasting at the Imperial Ancestral Temple and a skilled painter who excelled in depicting female figures.[2] In the centre of this work executed with dense brushstrokes in blue and green, female immortals participate in a literary gathering while one of them plays the *bo* (a type of cymbal) beside a dancing phoenix. On the right, other immortals prepare food. On the far left and right, still more are shown arriving on a dragon, a crane, the wind, or on foot. Similar compositions and subjects are found in earlier periods. One such example is an inlaid zither from the Tang dynasty that features three male immortals and a peacock.[3] Another can be found on a bronze mirror from a tomb dated to 759 and shows a musical banquet attended by several gentlemen.[4] While numerous comparable examples exist in other formats, it is rare to see this theme on a handscroll or featuring women.

The Qianlong Emperor (r. 1736–1795) was fond of this painting. According to the *Treasured Boxes of the Stone Moat* (*Shiqu baoji*), it was kept in the Imperial Study (Yu shufang).[5]

In 1772 the emperor had court painter Gu Quan (active ca. 1766–1777) copy the painting.[6] In his inscriptions on both Ruan's work and Gu's copy, the emperor echoed an inscription signed by Shang Ting (1209–1299) on the original painting that highlighted the relationship between Zhou Fang (ca. 780–ca. 810), Wang Fei, and Ruan Gao. In fact, that inscription was a forgery, yet by linking Ruan Gao with those earlier masters, it significantly raised Ruan's status.[7] Qianlong's validation further established the canonical status of both Ruan's and Gu's paintings.

During the reign of the Guangxu Emperor (r. 1875–1908), *Female Immortals in Elysium* was kept at the Palace of Established Happiness (Jianfu gong) in the Forbidden City.[8] Gu's copy was housed at another important location, the Mukden Palace, now the Shenyang Imperial Palace Museum.[9] In 1922 Puyi (1906–1967), the former Xuantong Emperor (r. 1909–1911), gave the original copy to his brother Pujie (1907–1994).[10] According to Zheng Zhenduo (1898–1958), former director of the State Administration of Cultural Heritage, the painting was returned to the Palace Museum in 1958 by Liu Tingye, making it the only museum in the world to house a painting by Ruan Gao.[11] RW

NOTES
1 Xie Z. 1996: 83–87; and Gugong Bowuyuan 2008a: 256. Others date it to the Song or Yuan dynasties: Zhongguo Gudai Shuhua Jiandingzu 1987–2000, vol. 19: 332; Cahill 1980: 37; and Huang X. 2008.
2 Xuanhe huapu 1999, *juan* 6: 66.
3 Shoichi et al. 1977–1978: 190, figs. 12–13.
4 Wang and Sun 2007: 68–69.
5 Zhang Zhao et al. 1987, *juan* 32: 21a–23a.
6 Zhongguo Diyi Lishi Dang'anguan 2005: vol. 35: 407, 429, 443, 773. The painting is now in the collection of the Palace Museum, Taipei; see Taibei Gugong Bowuyuan 1989–, vol. 21: 207–208.
7 Huang X. 2008.
8 For the painting's location during the Daoguang, Guangxu, and Xuantong periods see Gugong Bowuyuan 2013, vol. 9: 437; vol. 34: 579; and vol. 36: 32
9 Tie and Li 2008, vol. 47: 65.
10 Guoli Beiping Gugong Bowuyuan 1934: 9.
11 Zheng Z. 2005: 291. In his essay in this volume, Lou Wei provides an alternative identity for the donor of the painting: the daughter of Liu Junye — possibly a member of Liu Tingye's extended family.

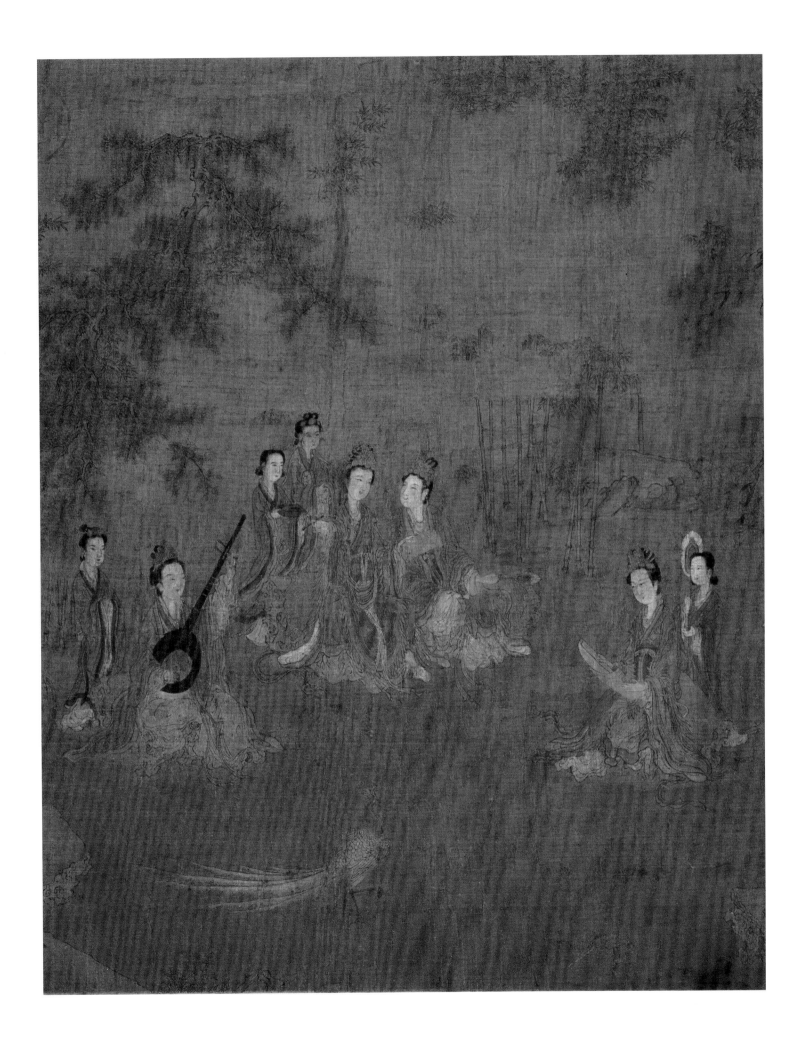

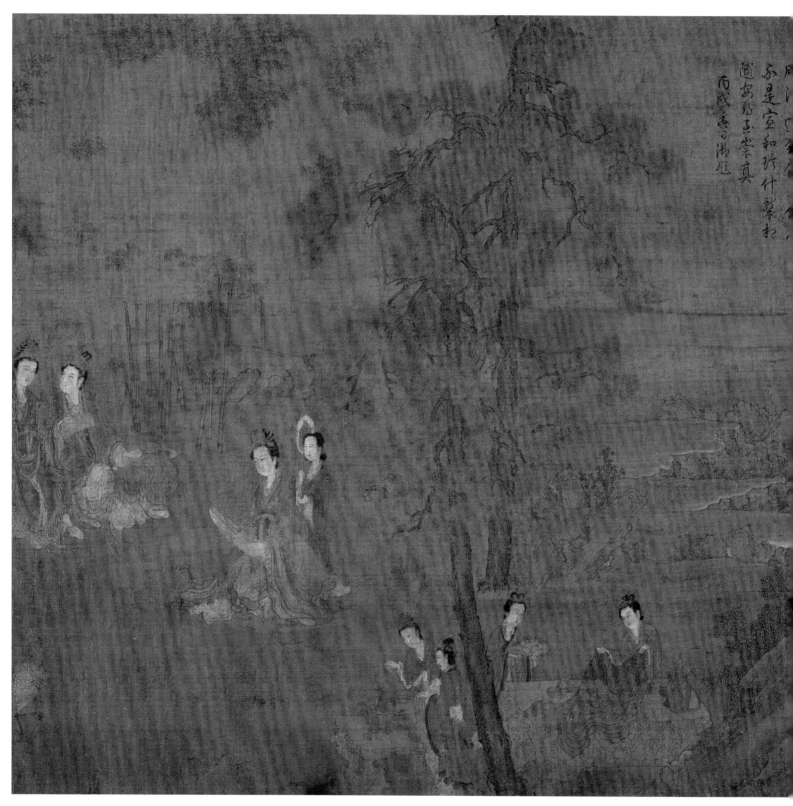

B

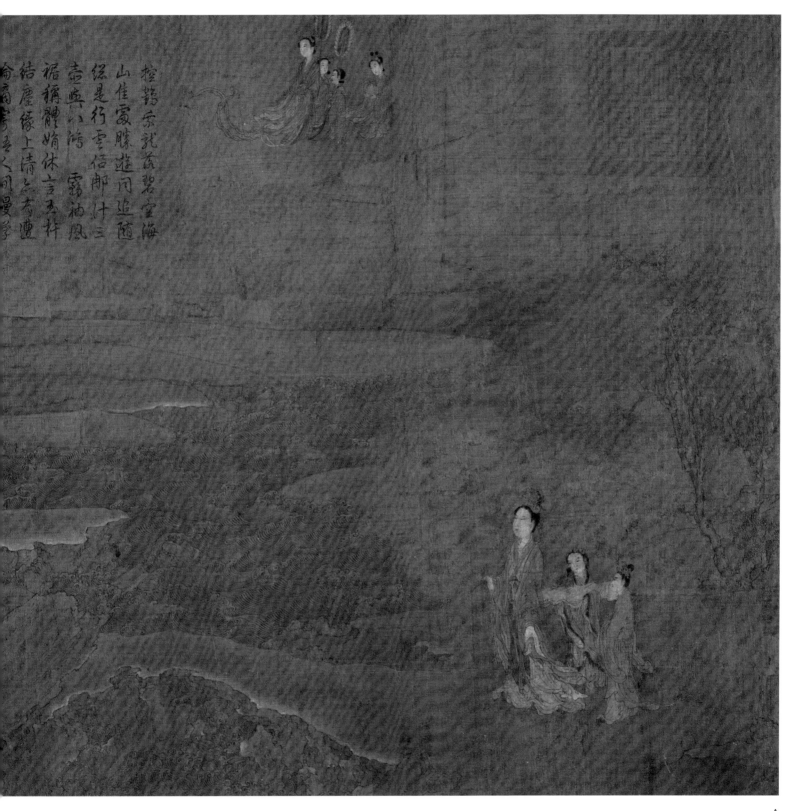

控鶴乘我茂碧雲海
山佳霞膝遊同追隨
綵是行雲佰郎什三
志臨八鴻霧袖風
裙稱體婠休言玉杵
結塵緣上清六奇遭
綸薔善吾人司曼學

A

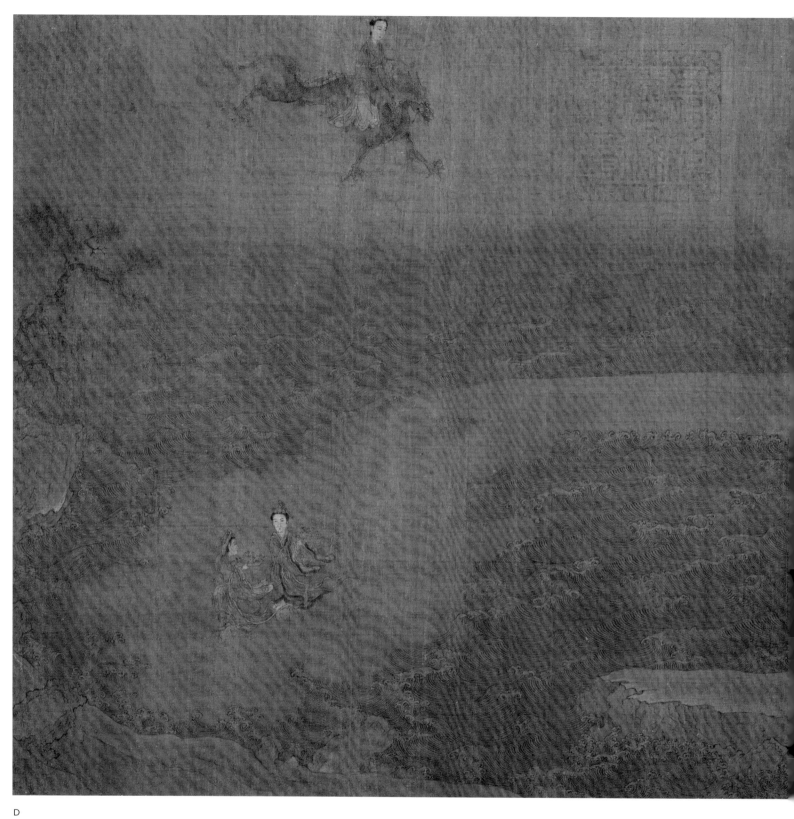

D

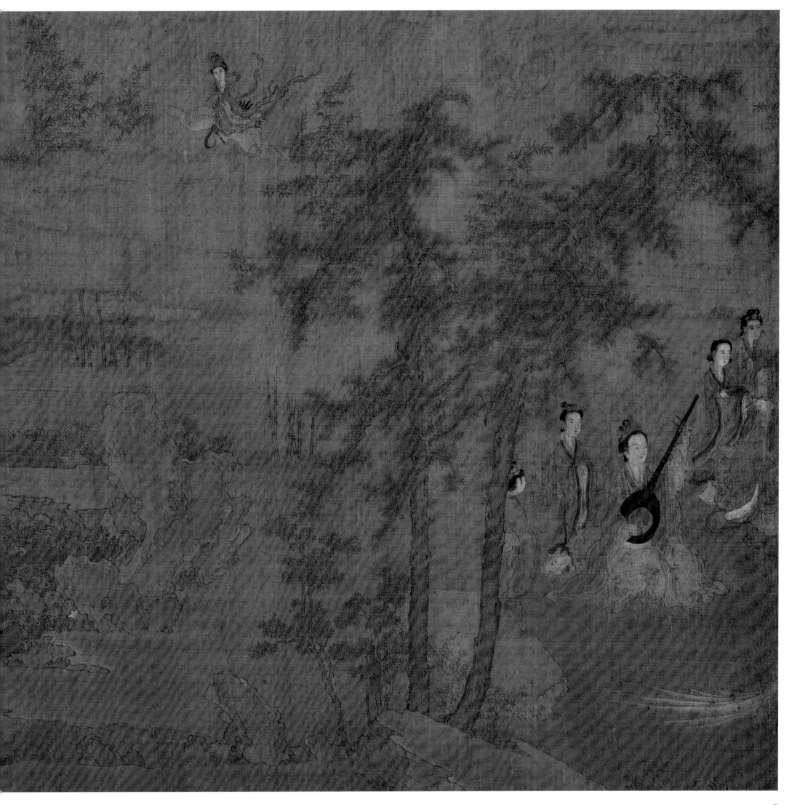

C

CAT. 9 | *Encomium on a Mountain Inkstone in Running Script (Xingshu yanshan ming)*
Mi Fu (1051–1107)

Northern Song dynasty, 11th or 12th century
Handscroll, ink on paper
35.5 × 138.2 cm
The Palace Museum

Mi Fu served at the Song court as Erudite of Painting and Calligraphy and later settled in Zhenjiang, Jiangsu province.[1] He forged his style as a calligrapher by modelling himself first on Tang masters such as Yan Zhenqing (709–784) and Chu Suiliang (596–658) and then on elegant Jin masters like Wang Xianzhi (344–386). Mi Fu was so adept a copyist that the copies he produced can easily pass as authentic. Even in an era notable for its expressive calligraphy, Mi Fu's work stood out for a spontaneity that has been likened to "sails in the wind and chargers on a battlefield".[2] Mi Fu was also known for his interest in stones, which he affectionately addressed as "my elder brothers"; so extreme was his obsession that people called him "Mad Mi". Natural stones that resembled mountains were often used as inkstones during the Tang and Song dynasties, and, according to Cai Tao (1096–1162), Mi Fu had quite a number of such stones in his collection.[3] Among them was an inkstone once in the collection of Li Yu (r. 961–976), the last ruler of the Southern Tang dynasty, that featured thirty-six peaks; this is the inkstone eulogised in this encomium, which is believed to have been written immediately after Mi Fu acquired the stone.

Unsigned and written in large characters in running script on high-quality *chengxintang* paper, this scroll is tentatively dated to after 1101 based on a reference in the text to Mi Fu's Treasuring Jin Studio (Baojin zhai) in Wuwei, Anhui province, which was not built until 1104. The scroll's calligraphy is unpretentious; so cursorily was it done that Mi Fu skipped two characters. At once slanted and upright and varying in thickness, the characters reflect Mi Fu's preference for balance and variety.

A colophon by Mi Fu's son Mi Youren (1074–ca. 1153) was cut off the *Encomium* before it was remounted to make way for an inscription — now considered a forgery — by Wang Tingyun (1151–1202) and an unidentified painter's portrayal of Li Yu's inkstone based on an illustration appearing in *Notes Written during Pauses from Plowing (Nancun chuogeng lu)* by Tao Zongyi (ca. 1329–ca. 1412).[4] The work passed through the collections of the Northern Song court, the Emperor Gaozong (r. 1127–1162) of the Southern Song, and other notables before being taken to Japan during the late Qing dynasty.[5] In 2002 it was acquired by the State Administration of Cultural Heritage and is now housed in the Palace Museum. SHM

NOTES
1 For Mi Fu's biography, see Tuotuo 1977, *juan* 444: 13, 123.
2 Cao B. 2009.
3 See Cai Tao 1983; Weng Fenggang 1916, vol. 5, *juan* 15: 2b–4b.
4 See Yang C. 2002: 78–80.
5 Ke Jiusi's seal has yet to be authenticated. See Yang C. 2002: 78–80.

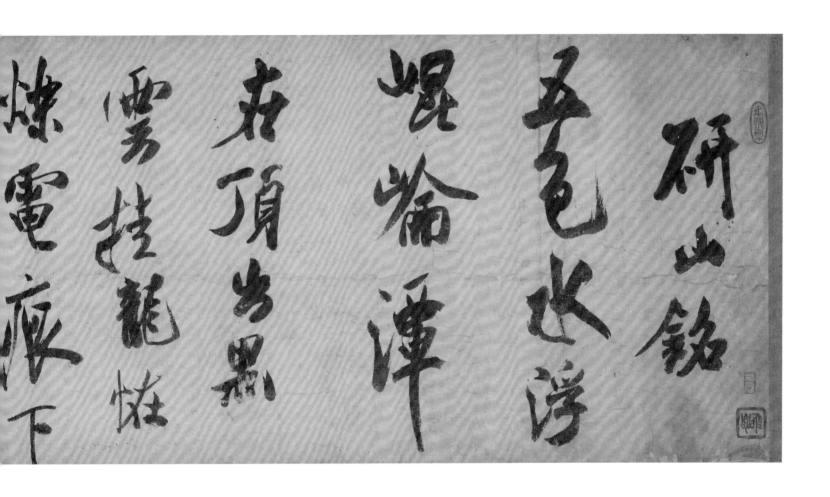

研山銘

五色水浮

崐崘潭

巆岭淬

右頂巑岏

雲挂龍怵

煉電痕下

CAT. 10 | *Returning Boats on a Snowy River (Xuejiang guizhao tu)*
Zhao Ji (Emperor Huizong, 1082–1135, r. 1101–1125)

Northern Song dynasty, around 1110
Handscroll, ink and colour on silk
30.3 × 191.2 cm
The Palace Museum

Emperor Huizong of the Song dynasty — born Zhao Ji — was a devotee of painting and went to great lengths to reorganise the Imperial Painting Academy, cultivate painters, and strengthen the imperial collection.[1] He was also a gifted artist himself.

This work is the only known snowscape associated with Huizong.[2] It depicts a panoramic winter scene, with the rhythmic rise and fall of the mountains and the movements of fishermen revealed as the scene unfolds. The wintry forests were delicately rendered with "crab-claw" strokes (*xiezhua zhi*), while the river and the landscape in the background were applied with light washes of ink, reflecting the influence of the Li Cheng (919–967)–Guo Xi (active 11th century) style. Snowy landscapes were popular in Song art, with Xu Daoning (970–1052), Wang Shen (active second half of the 11th century), and many other painters exploring the subject. This scroll exemplifies Song narrative paintings that present scenes of daily life. Details such as fishing boats, travellers, cottages, and pavilions can also be found in *A Panorama of Rivers and Mountains* (*Qianli jiangshan tu*) by Wang Ximeng (1096–1119), which was likewise produced at court and is dated to 1113. The painting's title is written in Huizong's distinctive slender gold script in the upper right corner of the scroll.[3] A colophon written in 1110 by the politician and calligrapher

Cai Jing (1047–1126) offers insight into the intricacy of court politics, as it is known that Cai had been dismissed as prime minister at the time he wrote it.[4]

In the second half of the Ming dynasty, the scroll subsequently acquired colophons by such scholar-officials as Wang Shizhen (1526–1590), Wang Shimao (1536–1588), and Dong Qichang (1555–1636); Dong's colophon implies that the work could be attributed to the Tang painter Wang Wei (ca. 701–761), a frequently cited statement that enhanced the painting's repute among literati.[5]

The scroll passed through several Qing collections, including those of Zhang Yingjia (active 17th century) and Liang Qingbiao (1620–1691). A copy of the scroll, including colophons, was made during this time, demonstrating the value collectors placed on the original.[6] The original entered the Qing imperial collection and was documented in the *Treasured Boxes of the Stone Moat Supplement* (*Shiqu baoji xubian*). A frontispiece and two poems were inscribed by the Qianlong Emperor (r. 1736–1795). It left the palace when Puyi (1906–1967), the former Xuantong Emperor (r. 1909–1911), gave it to his brother Pujie (1907–1994) in 1922. It was donated to the government by the collector Zhang Boju (1898–1982) and has been housed in the Palace Museum since around 1962.[7] JFT

NOTES
1 For Huizong's biography, see Deng Chun 1963, *juan* 1: 1–4; Xia Wenyan 1963, *juan* 3: 43; Wang J. 2014: 145–162; and Ebrey 2014: 200–218.
2 The majority of paintings attributed to Huizong are bird-and-flower subjects. For a discussion, see Bo 2004: 14–22.
3 For a study of the Xuanhe painting style, see Niu 2005: 53–76.
4 For a discussion of the relationship between Huizong and Cai Jing, see Ebrey 2006: 1–24; and Pang H. 2009: 1–41.
5 Wang L. 2006: 6–19.
6 The copy is recorded in Pang Y. 1972: 63–70. It is now in the collection of Yale University Art Gallery (1952.52.16). For its dating, see Xu B. 1979: 82–67; Xu B. 2015: 349–351; and Sensabaugh 2019: 46–65.
7 Guoli Beiping Gugong Bowuyuan 1934: 8; Yang R. 1991: 185–188; and Yu Hui 2014: 81.

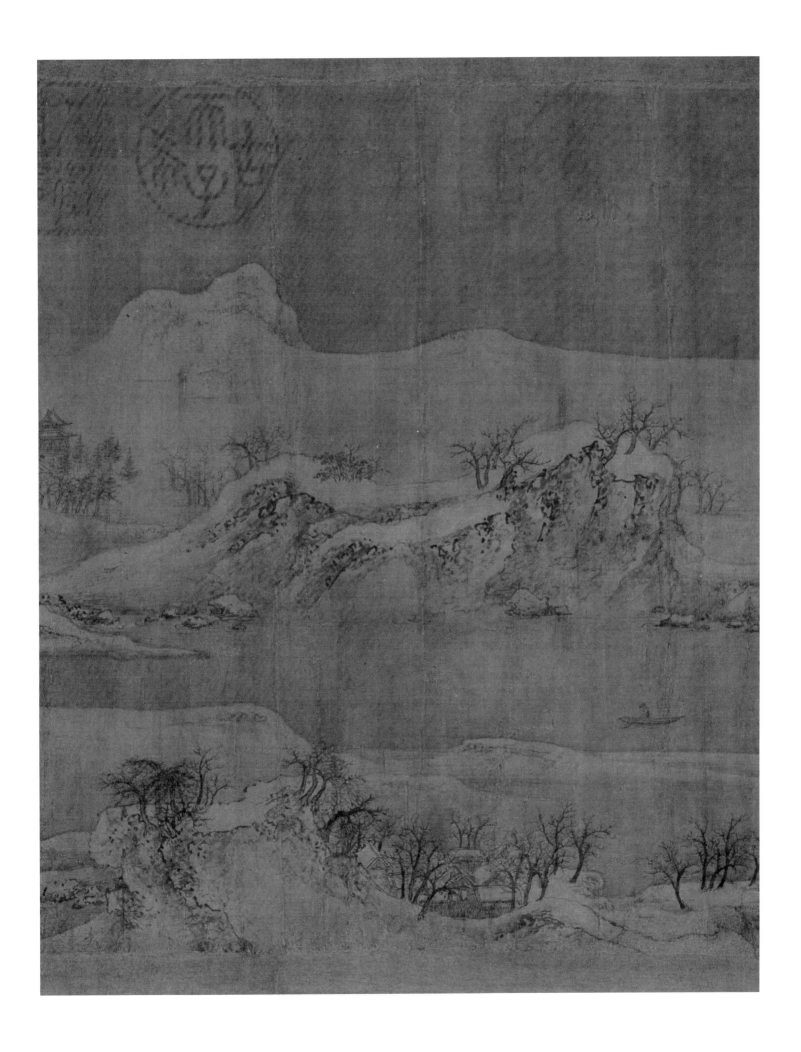

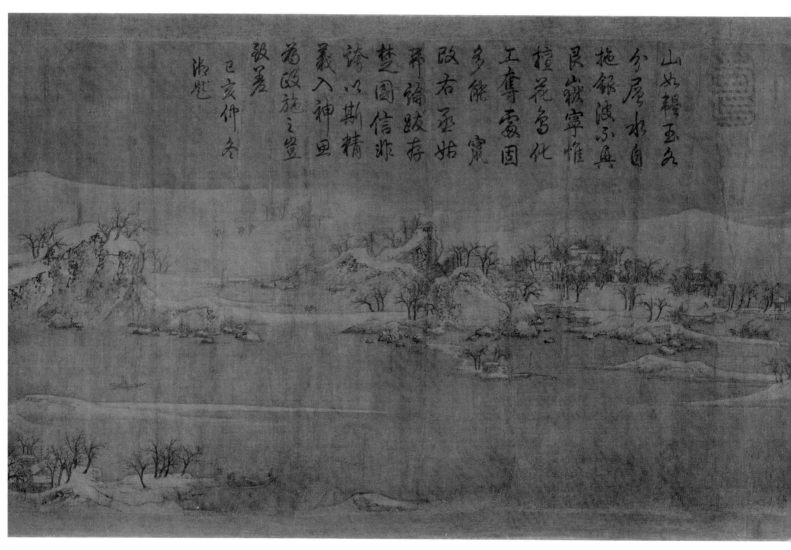

山如輥玉元
分屋水自
拖銀波不真
艮崳寧惟
檀花多化
工奪雲固
多能寬
改右丞姑
邘論跋存
楚國信非
誇以斯精
義入神里
為政施之堂
敦君
己亥仲冬
御題

B

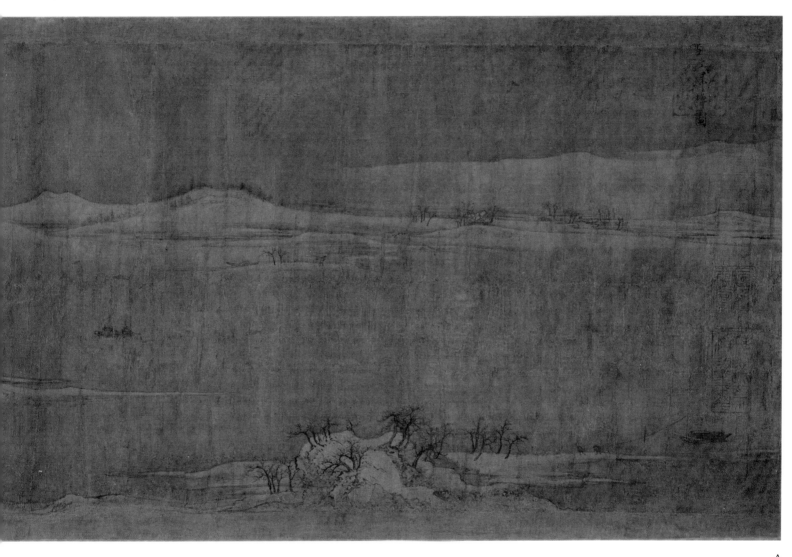

A

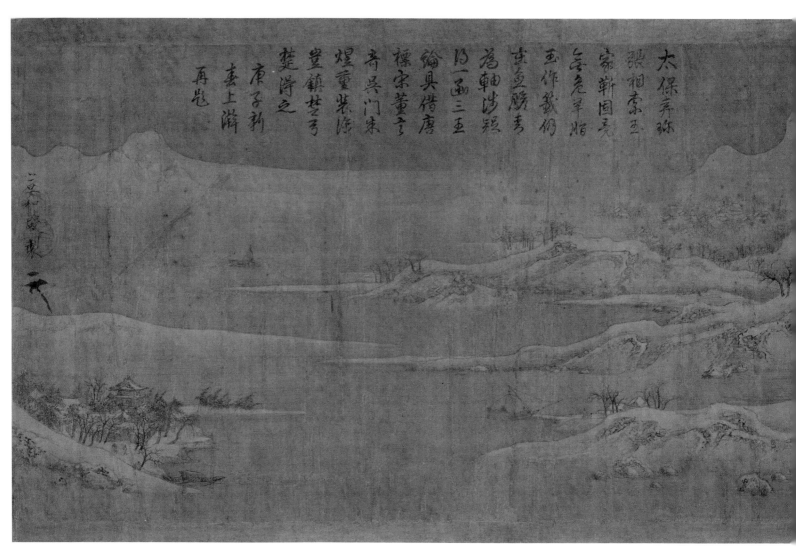

D

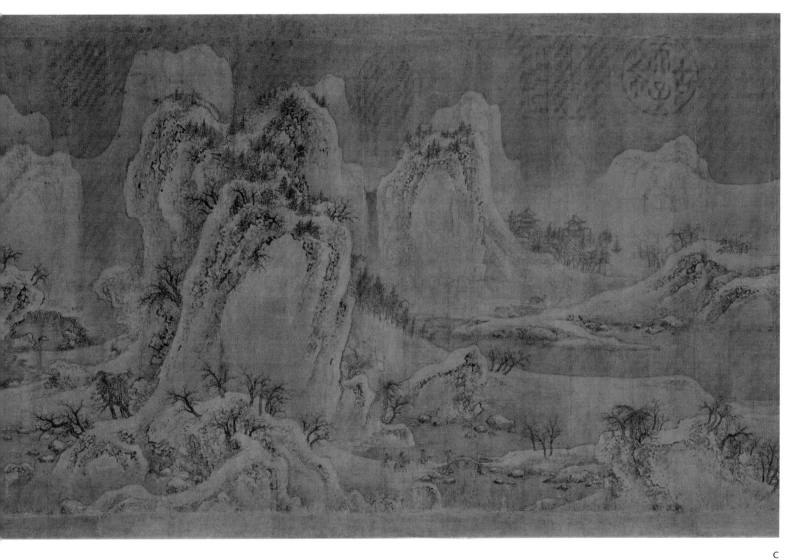

c

| *Poem on a Summer Day in Regular Script (Kaishu xiari shitie)*
Zhao Ji (Emperor Huizong, 1082–1135, r. 1101–1125)

Northern Song dynasty, 11th or 12th century
Album leaf, ink on paper
33.8 × 44.3 cm
The Palace Museum

Emperor Huizong — named Zhao Ji at birth — is more revered for his art, especially painting and calligraphy, than his statecraft.[1] Consumed by this passion, he became a practitioner, promoter, and collector of these arts; set up a dedicated academy for potential and accomplished artists; and compiled catalogues of the imperial collection. Lamentably, part of that collection fell into the hands of the Jurchens in 1127, when they abducted Huizong (by then a retired emperor) along with his son, Emperor Qinzong (r. 1126–1127), and their families. Eight years later, Huizong died a captive in a hostile land.

This poem is an ode to the scenery as seen from a tower after the rain in early summer. The calligraphy features visible brush-tips, pronounced bends, emphatic presses, ligatures between strokes, slender horizontals, and diagonals that resemble bamboo or orchid leaves — all signal characteristics of the mature slender gold script Huizong invented. The evolution of the script — which was clearly influenced by the work of Huang Tingjian (1045–1105), Xue Ji (649–713), Xue Yao (d. ca. 704), and Chu Suiliang (596–658) — can be traced in works of calligraphy, inscriptions, and title slips.[2] With its cautious brush manipulation and stiff character structures, *Thousand-Character Classic (Qianziwen)*, now in the Shanghai Museum, shows the script in its incipient form. *Poem on the Leap Mid-Autumn Moon (Run Zhongqiu yue)* and *Poem on the Japanese Rose (Ditang hua)*, from the Palace Museum, are more mature and uninhibited, resembling *Poem on a Summer Day* in execution. The recurrent ligatures, varied thicknesses, and confident fluidity typical of the script can be seen in inscriptions on such paintings as *Auspicious Dragon Rock (Xianglong shi tu)* and *Auspicious Cranes (Ruihe tu)*, in the Palace Museum and the Liaoning Provincial Museum, respectively. Huizong's script attracted quite a following, with the Jin emperor Zhangzong (Wanyan Jing, r. 1190–1208), for instance, devoting himself to mastering the style and strictly adhering to the mounting and collecting practices of Huizong's reign.[3]

Poem on a Summer Day is documented in *Collected Notes on Paintings and Calligraphy of the Shigu Hall (Shigutang shuhua huikao)* by Bian Yongyu (1645–1712) and now forms two of the eighteen leaves that make up an album of fourteen Song masters assembled by Wu Yun (1811–1883), Kong Zhaoyun (1863–1921), and Xu Lie (1904–1978) in the late nineteenth and early twentieth century.[4] The album was donated by Ding Huizhen (active mid-20th century) to the Shanghai Committee for the Management of Cultural Relics in 1957 and was assigned to the Palace Museum by the State Administration of Cultural Heritage in 1960. QCT

NOTES
1 Chen S. 2013: 55.
2 Tao Zongyi 1987, *juan* 6; Cai Tao 1983, *juan* 1.
3 Zhou Mi 1987.
4 This transmission history has been determined using collectors' seals found in the album.

夏日

清和節後綠枝稠寂寞
黃梅雨乍收畏日正長
疑碧漢薰風微度到丹
樓池荷成蓋開相倚逕
草鋪裀色更柔永晝搖
�絲避繁源杯盤時欲對
清流

| *Autumn Colours over Rivers and Mountains* (*Jiangshan qiuse tu*)
Attributed to Zhao Boju (active 12th century)

Late Northern Song or early Southern Song dynasty, 12th century
Handscroll, ink and colour on silk
55.6 × 322.5 cm
The Palace Museum

The tradition of painting rivers and mountains probably started with depictions of the Sichuan geography. A notable example is a painting of the Jialing River by Li Sixun (651–716) and Wu Daozi (ca. 686–769), cited in Zhu Jingxuan's (active 9th century) *Record of Famous Paintings of the Tang Dynasty* (*Tangchao minghua lu*).[1] The earliest extant example that mentions rivers and mountains in its title is *Pavilions among Rivers and Mountains* (*Jiangshan louguan tu*) by Yan Wengui (ca. 967–1044), in the Osaka City Museum of Fine Arts. The focus of these early works was the majestic landscape itself, with figures and architecture only occasionally accentuating the scene and no routes or trails to guide the viewer's eye.

In contrast to its predecessors, *Autumn Colours over Rivers and Mountains* features a number of potential destinations and suggestions of human activity that draw the viewer into and across the scroll. A comparable, roughly contemporaneous landscape is *A Panorama of Rivers and Mountains* (*Qianli jiangshan tu*) by the court painter Wang Ximeng (1096–1119), in the collection of the Palace Museum. Both scrolls feature peaks that bend to form S-shaped ridges, and together they shed light on the style and subject matter of imperial landscape painting of the early twelfth century. Yet the mountains in *Autumn Colours* are more densely packed, and their precipices are actually twisted rock masses. And unlike the vividly hued *Panorama,*

Autumn Colours employs relatively pale tones so as not to overshadow the texturing in ink.

According to a 1375 colophon written by Zhu Biao (1355–1392), the son of the Ming emperor Taizu (r. 1368–1398), this unsigned work was attributed to Zhao Boju. That colophon makes clear it was in the imperial collection at that time, where it was simply called *Rivers and Mountains* (*Jiangshan tu*). By the time the *Treasured Boxes of the Stone Moat* (*Shiqu baoji*) was compiled under the Qianlong Emperor (r. 1736–1795), it had acquired its present title owing to the unambiguous reference to autumn in the Ming colophon. Zhao Boju — a descendant of the first Song emperor, Taizu (r. 960–976) — was a skilled painter of landscapes, flowers, birds, bamboos, rocks, and especially figures and played a pivotal role in the revival of the blue-and-green landscape style of Li Sixun (651–716) and his son Li Zhaodao (675–758).

The seals on *Autumn Colours* place it in the collections of the Ming court and the Qing emperors Qianlong, Jiaqing (r. 1796–1820), and Xuantong (r. 1909–1911). In 1922 the former Xuantong Emperor, Puyi (1906–1967), removed it from the palace on the pretext of giving it to his brother Pujie (1907–1994); Puyi instead brought it with him to the Manchukuo Imperial Palace in Changchun. In 1945 it was deposited in the Northeast Museum (now the Liaoning Provincial Museum) and remained there until it was allocated to the Palace Museum in 1959. WZX

NOTES
1 See Yu A. 2015: 101–102.

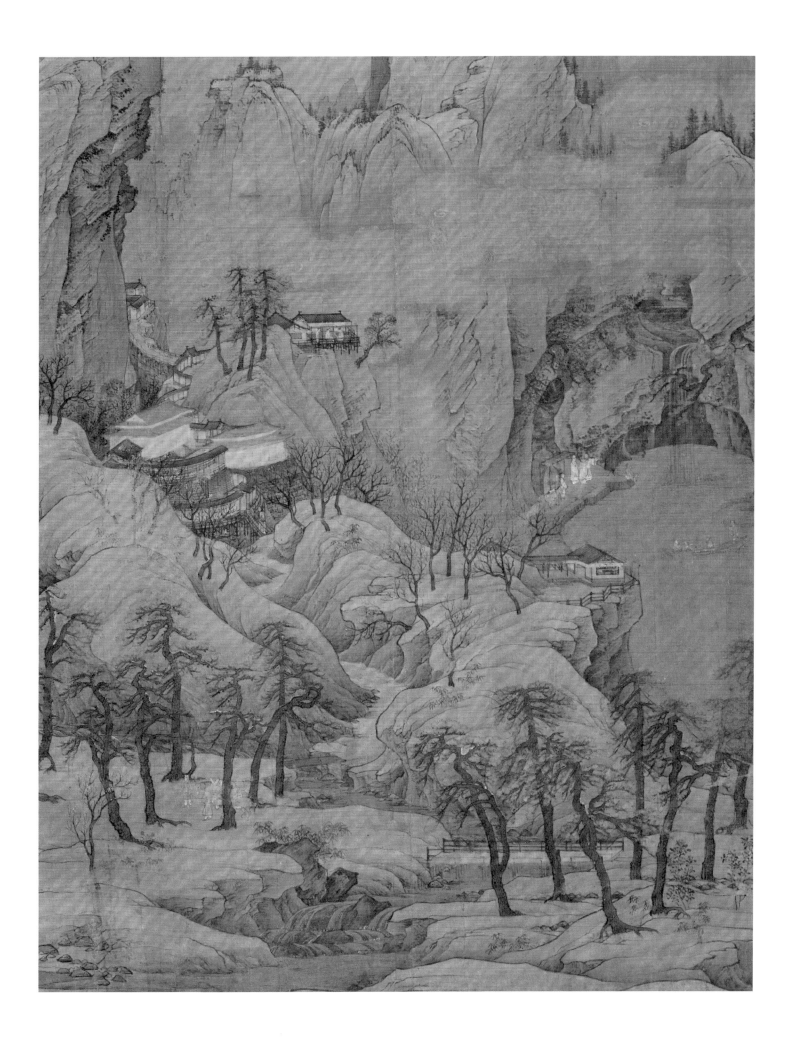

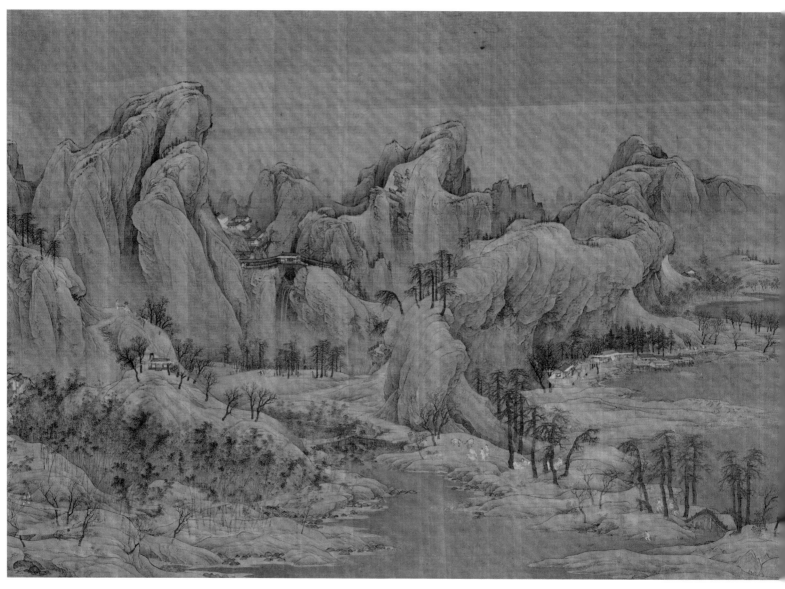

B

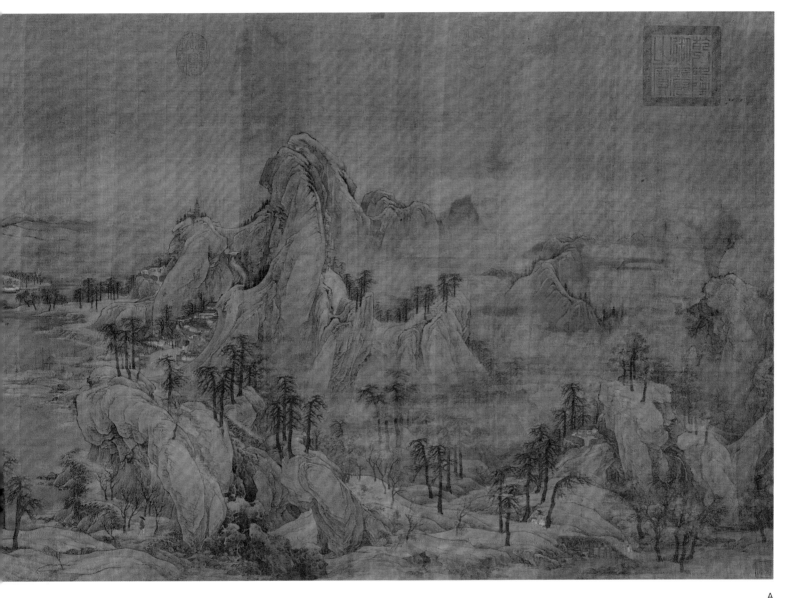

A

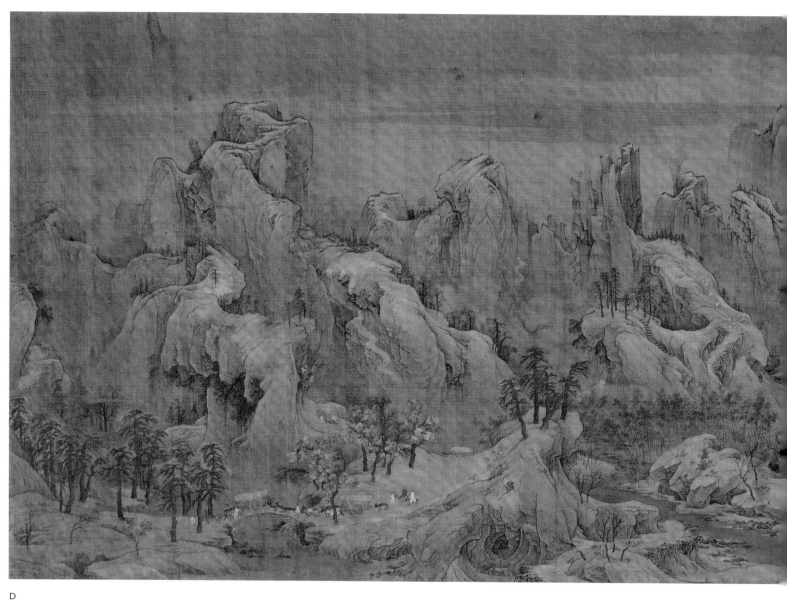

D

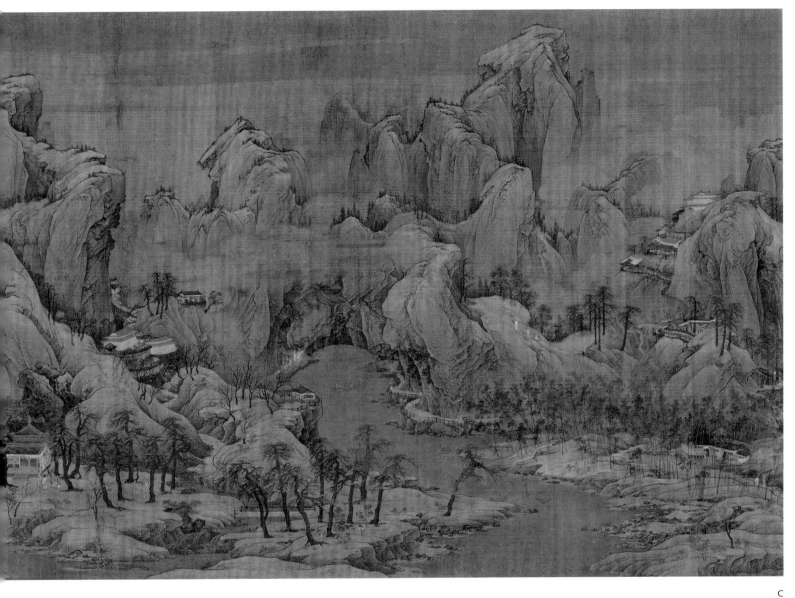

C

Southern Song dynasty, 12th century
Handscroll, ink and colour on silk
28 × 864 cm
The Palace Museum

Ma Hezhi, a native of Qiantang (present-day Hangzhou), earned the title of Metropolitan Graduate (*jinshi*) under the Southern Song emperor Gaozong (r. 1127–1162) and rose through the ranks to become Vice Minister of Works. His landscape and figure paintings were judged to be superior by Gaozong and his successor, Emperor Xiaozong (r. 1163–1189).[1]

According to a survey conducted by Xu Bangda (1911–2012), more than twenty scrolls of illustrations to *The Book of Songs* (*Shijing*) attributed to Ma Hezhi have survived (including duplicates of certain paintings).[2] Among extant examples, *Songs Beginning with "Deer Call"* is an indisputable masterpiece, distinguished by its elegant palette, calligraphic brushwork, flowing drapery, dynamic rocks, and meticulous architectural drawing. The scroll comprises illustrations that accompany the text of ten songs from the *Book of Songs*.

After analysing extant specimens, Xu Bangda concluded that this work was very likely painted by Ma Hezhi, although individual sections such as "Heaven Protects" ("Tianbao") might be replacements judging from the mechanical brushwork they display.[3] The texts have been attributed to Gaozong, but brushwork and character structuring that depart from authentic specimens of his calligraphy as well as the absence of the emperor's seal and signature suggest they could have been written by a member of the Imperial Academy of Calligraphy in imitation of the emperor's style.[4]

In his colophon to this work, the Qing Qianlong Emperor (r. 1736–1795) discussed at length how different versions of *The Book*

of Songs ordered their contents in different ways. He also explained why he preferred the sequencing of *Mao's Version of The Book of Songs* (*Maoshi*), which he found more reliable, over that of *Exegetical Tradition of The Book of Songs* (*Shi jizhuan*) when it came to Ma Hezhi's illustrations; following *Mao's Version*, *Songs Beginning with "Deer Call"* serves as the model for twelve scrolls that were in the imperial collection. The emperor's writings make clear he was personally engaged in ordering the scrolls of *The Book of Songs* in the imperial collection and that they were deposited in the Hall of Learning Poetry (Xueshi tang) in the Palace of Great Brilliance (Jingyang gong) in 1770.[5] Two more scrolls with illustrations from *The Book of Songs* were subsequently deposited there upon their acquisition in 1784 and 1791. According to entries in *Treasured Boxes of the Stone Moat* (*Shiqu baoji*) and *Treasured Boxes of the Stone Moat Supplement* (*Shiqu baoji xubian*), a total of seventeen such scrolls were in the Qing imperial collection by the time those texts were compiled, making it the largest of its kind ever assembled.

The present scroll passed through the collections of the princely household of Qianning and Qian Neng (active mid-to-late 15th century) during the Ming, before being eventually acquired by the Qing court. In 1922, Puyi (1906–1967), the former Xuantong Emperor (r. 1909–1911), removed the painting from the palace, ostensibly for bestowal on his brother Pujie (1907–1994). It entered the Palace Museum collection through acquisition in the 1960s. YWT

NOTES
1 Xia W. 1914.
2 Xu B. 1985: 69.
3 Ibid., 76.
4 Ibid.
5 Qianlong 1982: 350–351.

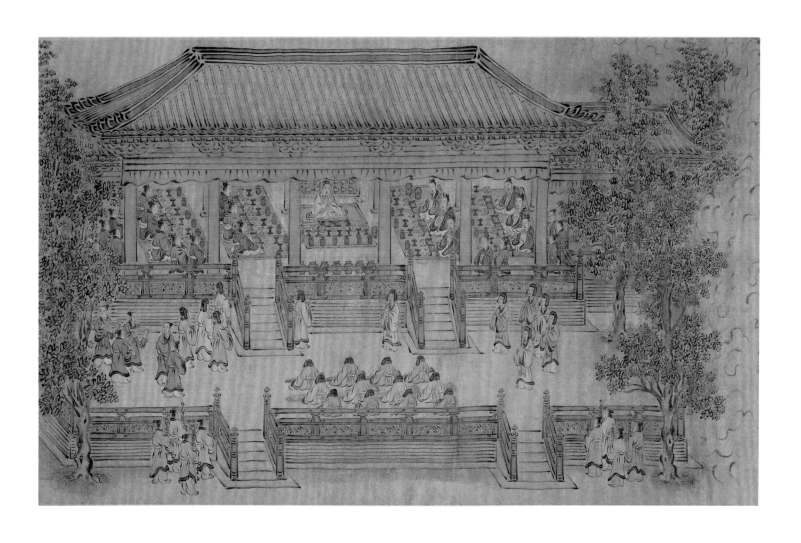

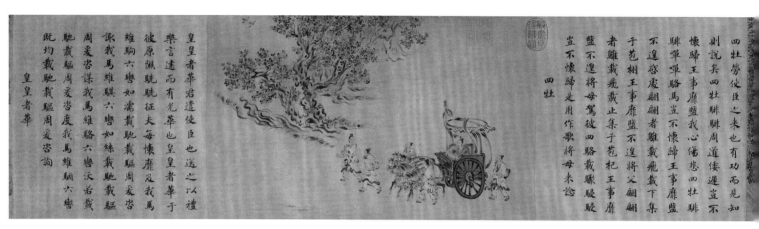

B

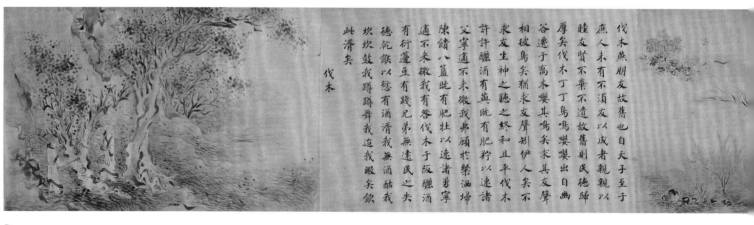

D

四牡勞使臣之來也有功而見知
則說矣四牡騑騑周道倭遲豈不
懷歸王事靡盬我心傷悲四牡騑
騑嘽嘽駱馬豈不懷歸王事靡盬
不遑啟處翩翩者雕載飛載下集
于苞栩王事靡盬不遑將父翩翩
者雕載飛載止集于苞杞王事靡
盬不遑將母駕彼四駱載驟駸駸
豈不懷歸是用作歌將母來諗

四牡

皇皇者華君遣使臣也送之以禮
樂言遠而有光華也皇皇者華于
彼原隰駪駪征夫每懷靡及我馬
維駒六轡如濡載馳載驅周爰咨
諏我馬維騏六轡如絲載馳載驅
周爰咨謀我馬維駱六轡沃若載
馳載驅周爰咨度我馬維駰六轡
既均載馳載驅周爰咨詢
皇皇者華

伐木燕朋友故舊也自天子至于
庶人未有不須友以成者親親以
睦友賢不棄不遺故舊則民德歸
厚矣伐木丁丁鳥鳴嚶嚶出自幽
谷遷于喬木嚶其鳴矣求其友聲
相彼鳥矣猶求友聲矧伊人矣不
求友生神之聽之終和且平伐木
許許釃酒有藇既有肥羜以速諸
父寧適不來微我弗顧於粲洒埽
陳饋八簋既有肥牡以速諸舅寧
適不來微我有咎伐木于阪釃酒
有衍籩豆有踐兄弟無遠民之失
德乾餱以愆有酒湑我無酒酤我
坎坎鼓我蹲蹲舞我迨我暇矣飲
此湑矣

伐木

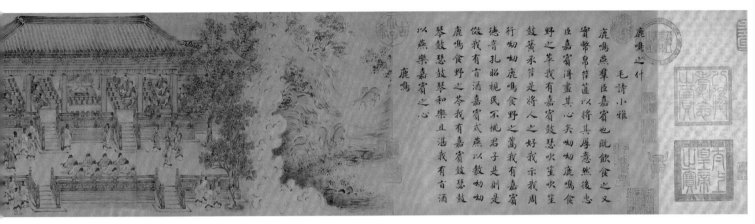

鹿鳴之什
毛詩小雅

鹿鳴燕羣臣嘉賓也既飲食之又
實幣帛筐篚以將其厚意然後忠
臣嘉賓得盡其心矣呦呦鹿鳴食
野之苹我有嘉賓鼓瑟吹笙吹笙
鼓簧承筐是將人之好我示我周
行呦呦鹿鳴食野之蒿我有嘉賓
德音孔昭視民不恌君子是則是
傚我有旨酒嘉賓式燕以敖呦呦
鹿鳴食野之芩我有嘉賓鼓瑟鼓
琴鼓瑟鼓琴和樂且湛我有旨酒
以燕樂嘉賓之心

鹿鳴

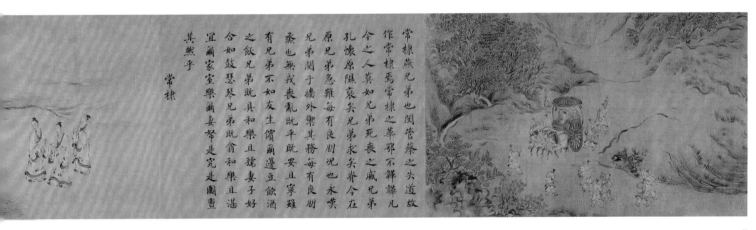

常棣燕兄弟也閔管蔡之失道故
作常棣焉常棣之華鄂不韡韡凡
今之人莫如兄弟死喪之威兄弟
孔懷原隰裒矣兄弟求矣脊令在
原兄弟急難每有良朋況也永嘆
兄弟鬩于牆外禦其務每有良朋
烝也無戎喪亂既平既安且寧雖
有兄弟不如友生儐爾籩豆飲酒
之飫兄弟既具和樂且孺妻子好
合如鼓瑟琴兄弟既翕和樂且湛
宜爾家室樂爾妻帑是究是圖亶
其然乎

常棣

憂心孔疚我行不來彼爾維何
維常之華彼路斯何君子之車
戎車既駕四牡業業豈敢定居
一月三捷彼四牡四牡騤騤
君子所依小人所腓四牡翼翼
象弭魚服豈不日戒玁狁孔棘
昔我往矣楊柳依依今我來思
雨雪霏霏行道遲遲載渴載飢
我心傷悲莫知我哀

采薇

別降赫赫南仲薄伐西戎春日遲
見君子憂心忡忡既見君子我心
畏此簡書憂心悄悄趯趯阜螽未
塗王事多難不遑啟居豈不懷歸
往矣黍稷方華今我來思雨雪載
彼朔方赫赫南仲玁狁于襄昔我
出車彭彭旂旐央央天子命我
悄僕夫況瘁王命南仲往城于方
旐矢彼旟斯胡不旆旆憂心悄悄
出我車于彼郊矢設此旐矣
謂之載矣王事多難維其棘矣
矣自天子所謂我來矣召彼僕夫
出車勞還率也我出我車于彼牧

F

魚麗美萬物盛多能備禮也文武
以天保以上治內采薇以下治外
始共憂勤終於逸樂故魚麗以美萬物盛
多可以告於神明矣魚麗于罶鱨鯊
鯊君子有酒旨且多魚麗于罶魴鱧
鱧君子有酒多且旨魚麗于罶鰋鯉
鯉君子有酒旨且有物其多矣維
其嘉矣物其旨矣維其偕矣物其
有矣維其時矣

魚麗

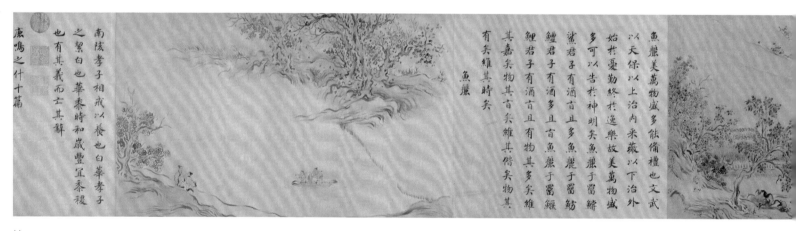

康鳴之什十篇

也有其義而亡其辭
之絜白也華黍時和歲豐宜黍稷
南陔孝子相戒以養也白華孝子

H

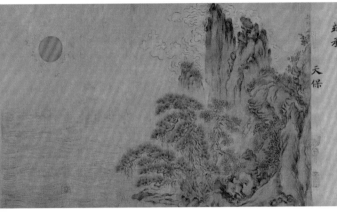

天保下報上也君能下以成其
政臣能歸美以報其上焉天保定
爾亦孔之固俾爾單厚何福不除
俾爾多益以莫不庶天保定爾俾
爾戩穀罄無不宜受天百祿降爾
遐福維日不足天保定爾以莫不
興如山如阜如岡如陵如川之方
至以莫不增吉蠲為饎是用孝享
禴祠烝嘗于公先王君曰卜爾萬
壽無疆神之弔矣詒爾多福民之
質矣日用飲食群黎百姓徧為爾
德如月之恆如日之升如南山之
壽不騫不崩如松柏之茂無不爾
或承

天保

采薇遣戍役也文王之時西有
昆夷之患北有玁狁之難以天
子之命命將率遣戍役以守衛
中國故歌采薇以遣之出車以
勞還林杜以勤歸也采薇采薇
薇亦作止曰歸曰歸歲亦莫止
靡室靡家玁狁之故不遑啟居
玁狁之故采薇采薇薇亦柔止
曰歸曰歸心亦憂止憂心烈烈

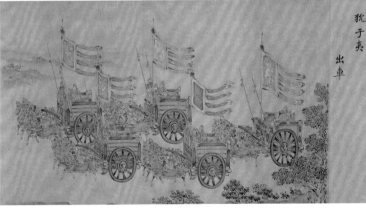

遒卉木萋萋倉庚喈喈采蘩祁祁
執訊獲醜薄言還歸赫赫南仲玁
狁于夷

出車

枤杜勞還役也有枤之杜有睆
其實王事靡盬繼嗣我日日月
陽止女心傷止征夫遑止有枤
之杜其葉萋萋王事靡盬我心
傷悲卉木萋止女心悲止征夫
歸止陟彼北山言采其杞王事
靡盬憂我父母檀車幝幝四牡
痯痯征夫不遠匪載匪來憂心
孔疚期逝不至而多為恤卜筮
偕止會言近止征夫邇止

枤杜

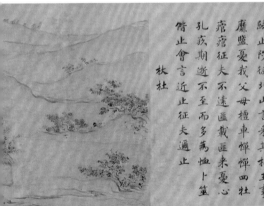

Water (Shui tu)
Ma Yuan (active late 12th–early 13th century)

Southern Song dynasty, around 1222
12 album leaves mounted as a handscroll, ink and colour on silk
Leaf 1: 26.9 × 20.8 cm; leaves 2–12: 26.9 × 41.6 cm
The Palace Museum

Ma Yuan was born in Qiantang (present-day Hangzhou), the Southern Song capital where his grandfather had relocated along with the court in exile of Emperor Gaozong (r. 1127–1162). Following his forebears, Ma Yuan served the emperors Guangzong (r. 1190–1194) and Ningzong (r. 1195–1224) as an Attendant in the Imperial Painting Academy. He expanded his family's painting tradition by studying Li Tang (active mid-11th–mid-12th century), arriving at a style that set him apart from other artists associated with the academy. His unique approach to composition, where all elements are pushed to one corner, earned him the nickname "One Corner Ma". He is considered one of the Four Masters of the Southern Song.[1]

While works portraying water were far from unknown in Chinese painting – Sun Wei (active late 9th century), Sun Zhiwei (active late 9th century), and Cao Renxi (active late 10th–early 11th century) were noted for their waterscapes – Ma Yuan's twelve depictions of water are the only extant examples of their kind. These marvellously captured scenes are a testament to Ma Yuan's keen observational skills and virtuosity with the brush. The paintings were commissioned by Empress Yang (1162 or 1172–1233), Ma Yuan's patron, and are notable for the dedications the empress added in her own beautiful calligraphy and the titles she inscribed on eleven of the leaves: "Delicate Wind over Lake Dongting", "Layered Waves and Piled Billows", "Wintry Pool, Clear and Shallow", "Ten Thousand Acres of the Yangzi River", "Reverse Currents in the Yellow River", "Circling Waves in Autumn Water", "Clouds Borne on the Deep Blue Sea", "Shimmering Lights on the Lake", "Clouds Unfurling, Waves Rolling", "Rising Sun over Highlighted Mountains", and "Illusionary Ripples Floating Lightly".[2] She also impressed on the work a signature seal that contains a date corresponding to 1222. In a short dedication she referred to one of her adopted nephews as the recipient of the album.[3] A title inscription for the entire album, now mounted as a handscroll, was executed in seal script by the renowned Ming calligrapher Li Dongyang (1447–1516). Completing this important work are colophons written by Li Dongyang and other Ming masters.

References to this masterpiece can be found in Ming and Qing literature, such as *Notes from the Liuyan Studio (Liuyanzhai biji)* by Li Rihua (1565–1635), *Manuscripts of the Hermit of Yanzhou (Yanzhou shanren gao)* by Wang Shizhen (1526–1590), and *Painting and Calligraphy Compendium of the Peiwen Studio (Peiwen zhai shuhua pu)*. Many of the numerous seals impressed on the scroll belonged to the major collectors Liang Qingbiao (1620–1691) and Geng Zhaozhong (1640–1686). During the Qing dynasty, the painting was kept in the Imperial Study (Yu shufang) and was catalogued in the *Treasured Boxes of the Stone Moat (Shiqu baoji)*. Puyi (1906–1967), the former Xuantong Emperor (r. 1909–1911), had it taken out of the palace by bestowing it on his brother Pujie (1907–1994).[4] The painting was returned to the Palace Museum after the founding of the People's Republic of China. NH

NOTES
1 Yu J. 1998: 774. For more on Ma Yuan's family, patrons, and style, see Edwards 2011.
2 Lee H. 2010: 215.
3 The empress used an official title rather than the nephew's name. See Qi 1999b: 148.
4 See Guoli Beiping Gugong Bowuyuan 1934: 14b.

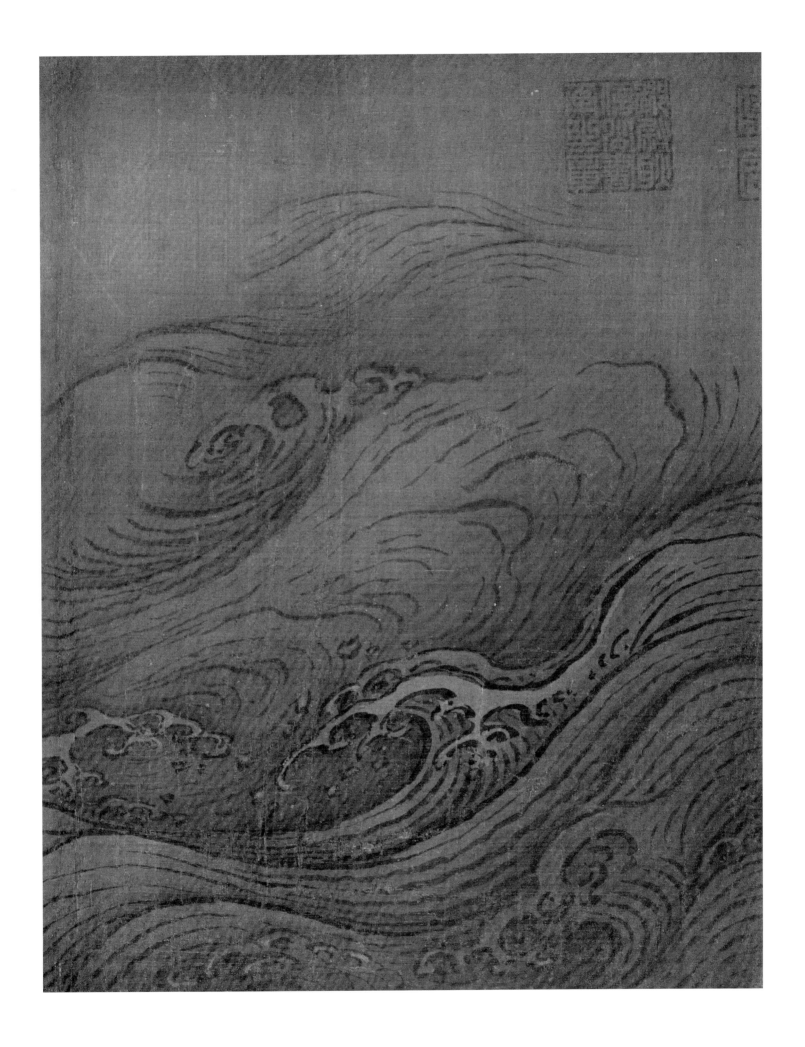

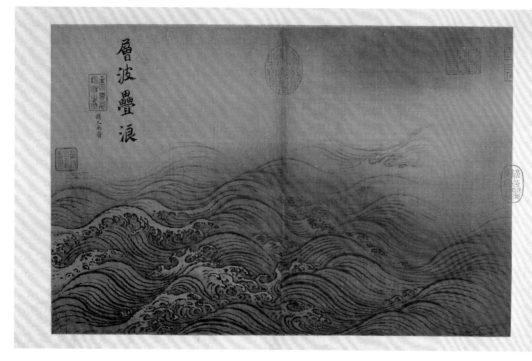
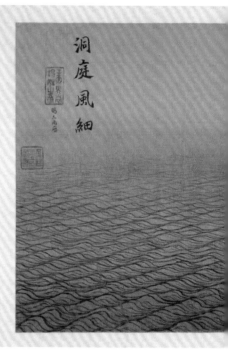

B

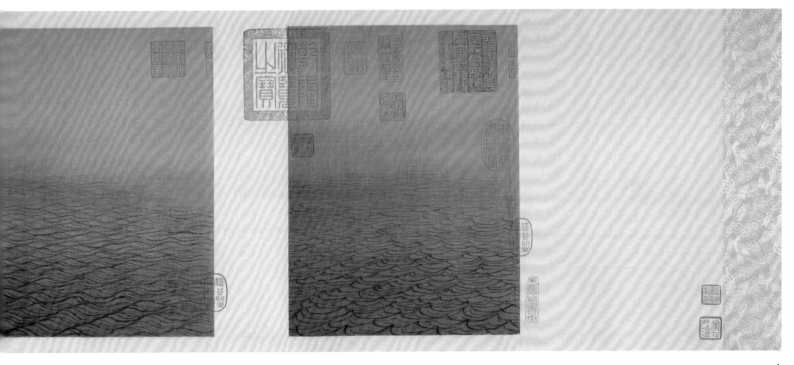

A

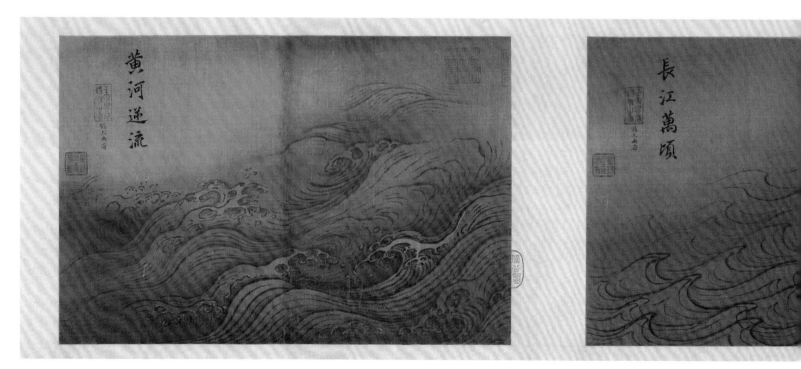

D

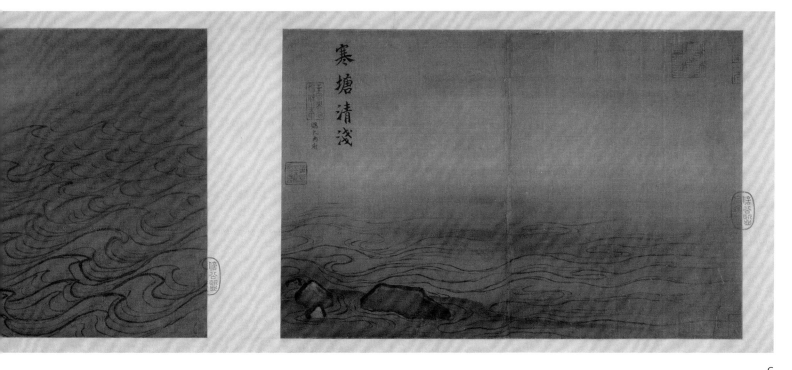

C

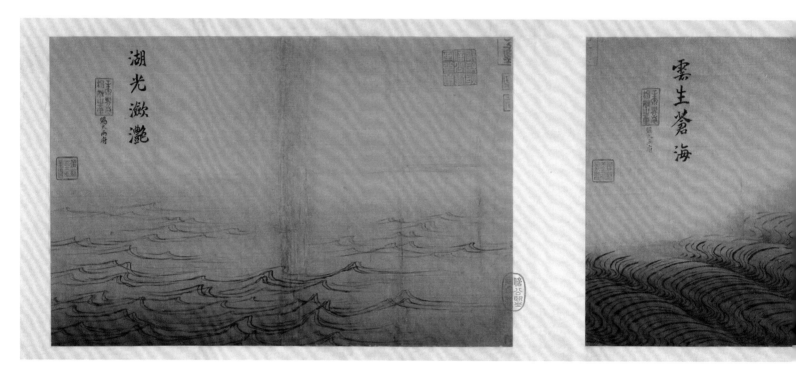

湖光潋滟

雲生碧海

F

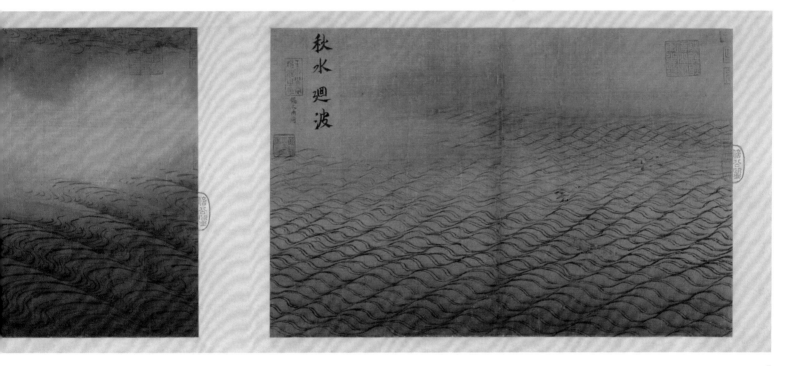

秋水廻波

E

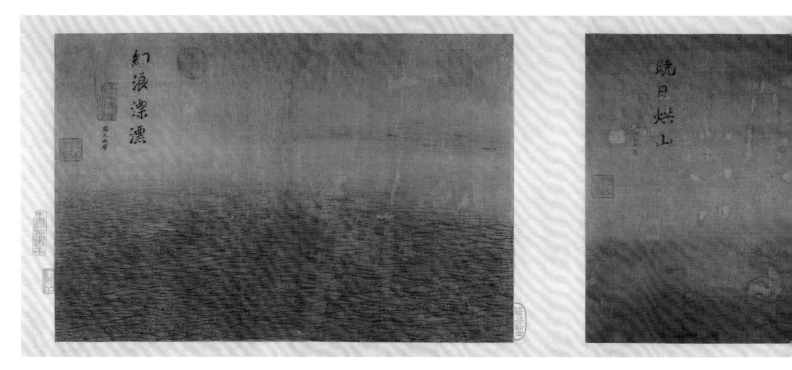

H

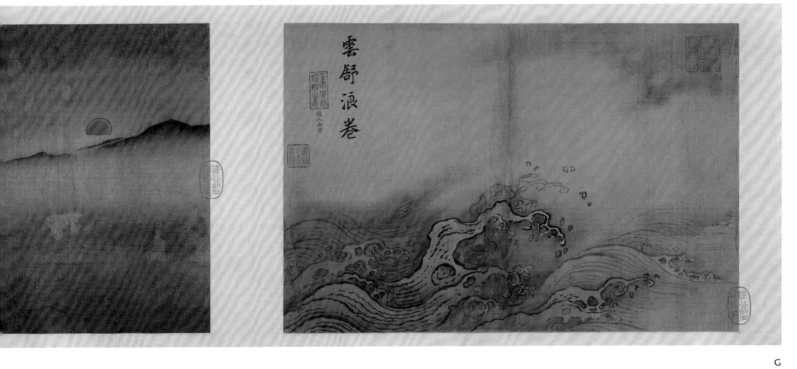

Ten Thousand Li of Rivers and Mountains (Jiangshan wanli tu)
Zhao Fu (active 1131–mid-12th century)

Southern Song dynasty, 12th century
Handscroll, ink on paper
45.3 × 990 cm
The Palace Museum

This is a rare surviving work inscribed with the signature of Zhao Fu.[1] A native of Jingkou (present-day Zhenjiang), the artist was a prolific painter of landscapes, rocks, waves, and figures. He embraced the traditions of earlier masters and deviated from the contemporary imperial academy style. Living on Mount Beigu, near the Yangzi River, he painted numerous scenes of the river and mountains along it.[2]

Paintings addressing the subject of water originated in the late Tang dynasty and grew to prominence in the Song dynasty.[3] Renowned painters such as Wang Ximeng (1096–1119) and Zhao Boju (active 12th century; cat. 12) painted landscapes that depict scenery along a river. However, they often overlooked the details of the water, choosing to represent them with vague lines if they did not leave them entirely blank (*liubai*), and few artists were famous for their water paintings.[4] Zhao's treatment of water here departed from the line-drawing method often seen in Southern Song paintings. Unlike the contemporary court painter Ma Yuan (active late 12th–early 13th century), who primarily used linear patterns to represent water (see cat. 14),[5] Zhao employed layers of subtle wet washes to depict its ever-changing movements. His wet brushstrokes skilfully traced the water's form, creating within the picture frame a spatial depth that animates the surface of the work.

This handscroll belonged to a corrupt Ming official named Yan Song (1480–1567) before it was confiscated and entered the imperial collection in the mid-1560s.[6] On 12 March 1575, it was no longer in the palace as Lu Shusheng (1509–1605) inscribed a colophon on it in his residence, Garden of Ease (Shi yuan). During the time of the Qianlong Emperor (r. 1736–1795), it re-entered the imperial collection and was recorded in the *Treasured Boxes of the Stone Moat (Shiqu baoji)*. The handscroll bears the seals and inscriptions of Qian Weishan (active ca. 1335–1369), Zhang Ning (1426–1496), Lu Shusheng, and Qianlong. The Jiaqing (r. 1796–1820) and Xuantong (r. 1909–1911) emperors also impressed their collectors' seals on the work.[7] In 1922 it was removed from the palace when Puyi (1906–1967), the former Xuantong Emperor, gave it to his brother, Pujie (1907–1994).[8] It was ultimately returned to the Palace Museum in the latter part of the twentieth century. LAT

NOTES

1 Zhejiang Daxue 2010, *juan* 4: 229; and Li A. 1979: 42. The work's title was written on the frontispiece by the Ming official Zhang Ning (1426–1496).
2 See Xia W. 1992: 880; Zhang Chou 1993: 314; and Bian Yongyu 1992: 182.
3 Numerous paintings titled *Ten Thousand Li of the Yangzi River (Changjiang wanli tu)* or *The Yangzi River (Changjiang tu)* were listed in Ming and Qing painting catalogues. For a summary of these paintings, see Orell 2011: 20.
4 See for example *Ten Thousand Li Along the Yangzi River (Changjiang wanli tu)* by Juran (active mid-to-late 10th century) in the Freer Gallery of Art (F1911.168). According to Su Shi (1037–1101), only Sun Wei (active late 9th century), Sun Zhiwei (ca. 976–ca. 1022), and Pu Yongsheng (active early 11th century) excelled at portraying water; see Su Shi 1936, *juan* 10: 40.
5 See Maeda 1971: 247–290.
6 *Tianshui bingshan lu* 1966: 234; and Wen Jia 1966: 12.
7 Zhang Zhao et al. 1987: 312–314.
8 Guoli Beiping Gugong Bowuyuan 1934: 9.

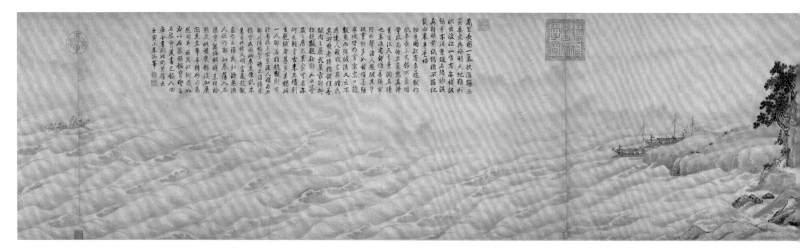

B

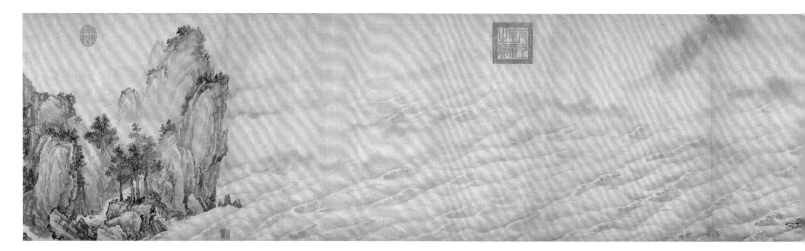

D

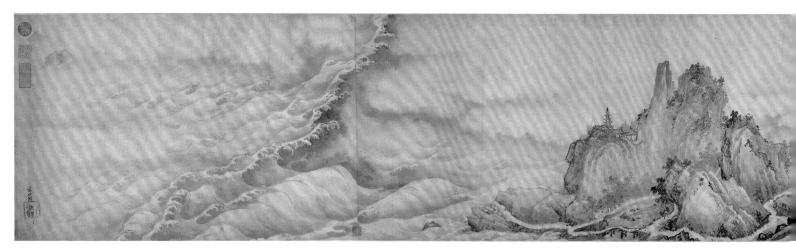

F

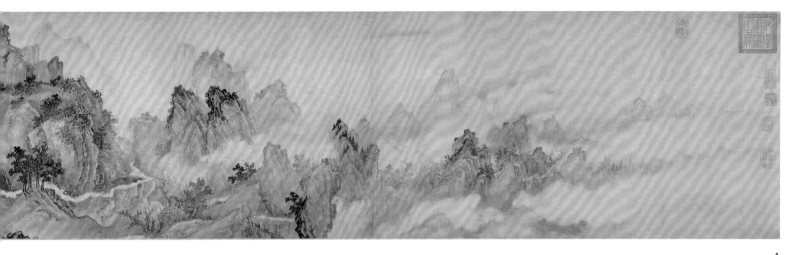

A

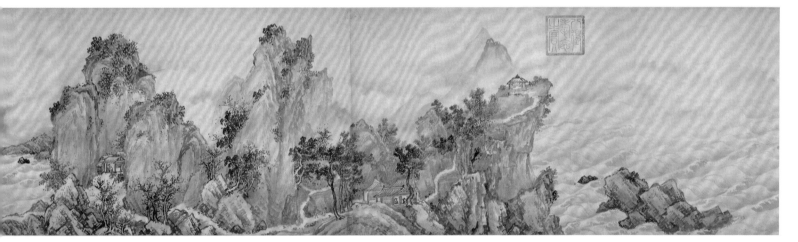

C

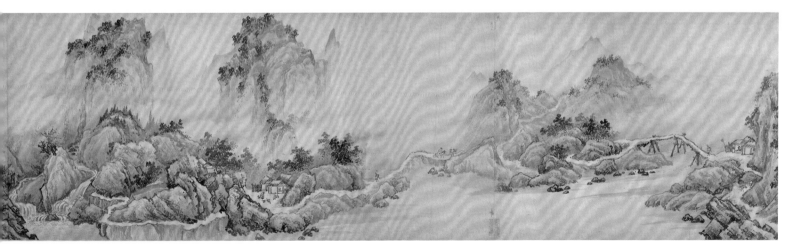

E

CAT. 16 | *Hawk on a Maple Tree Eyeing a Pheasant (Fengying zhiji tu)*
Li Di (active 12th century)

Southern Song dynasty, 1196
Hanging scroll, ink and colour on silk
189.3 × 209.5 cm
The Palace Museum

Li Di served in the Imperial Painting Academy and excelled at painting birds and flowers.[1] His reputation rose significantly during the Yuan and Ming dynasties.[2] At some two metres in width, this is one of the biggest extant paintings of its kind. Demonstrating the artist's ability to paint on a large scale, it may have been mounted on a screen at one time.[3]

Within this diagonal composition, a hawk stands atop a tree, staring and waiting to leap upon the frightened pheasant. The beaks, claws, and feathers of both birds are depicted with remarkable precision and elegance, reflecting the influence of the highly naturalistic Northern Song style.[4] Tree trunks are delineated with saturated ink, while the leaves and grass are rendered in ink outlines and filled with colours. Stones are drawn with "axe-cut" (*fupi cun*) texture strokes.

Raptors hunting prey emerged as popular subject for painting in the early Tang dynasty.[5] When compared with other paintings on this theme, it is clear that Li Di excelled in capturing motion and spontaneity.[6] The influence of this work may be seen in paintings produced in the Yuan and Ming periods. For example, a painting by the Ming court painter Bian Wenjin (active late 14th–early 15th century), titled *Maple and Hawk (Fengying tu)*, is similar to Li's painting in theme and technique, except that it includes another animal: a bear. The combination of these two animals may have been inspired by the Chinese saying "A hero claims his honourable trophy or prize" (*yingxiong duojin*), which includes homonyms for "eagle" (*ying*) and "bear" (*xiong*).[7] Bian's paintings in turn heavily informed the work of the celebrated court painter Lin Liang (ca. 1416–1480), whose influence reached as far as Korea.[8] A survey of similar works shows Li Di to be one of the earliest painters to use a hawk to symbolise heroism.

Hawk on a Maple Tree was once owned by Prince Yi, before it entered the collection of the Palace Museum in the twentieth century. RW

NOTES

1 Xia Wenyan 1963: 101.
2 Edwards 1967: 4–10.
3 Cahill 2011.
4 For bird-and-flower painting and naturalism, see Bickford 2013: 59–67.
5 For paintings of hawks and eagles and their symbolic meanings, see Sung 2009: 7–38.
6 For examples of related works, see Sung 2009: 9, fig. 5; Taibei Gugong Bowuyuan 1989–, vol. 3: 123–124; Seattle Art Museum, 51.38; Taibei Gugong Bowuyuan 1989–, vol. 4: 241–242 and vol. 6: 337–378.
7 Guanxi Zhongguo Shuhua Shoucang Yanjiuhui 2015: 140–142. For a similar work, see Museum of Fine Arts, Boston, 1996.2.
8 Sung 1991: 95–102. *A Brown Eagle Seizing a Rabbit (Haojiu botu)* by the Joseon painter Sim Sa-jeong (1707–1769) is comparable to *Hawk on a Maple Tree Eyeing a Pheasant*. See National Museum of Korea (Deoksu5718).

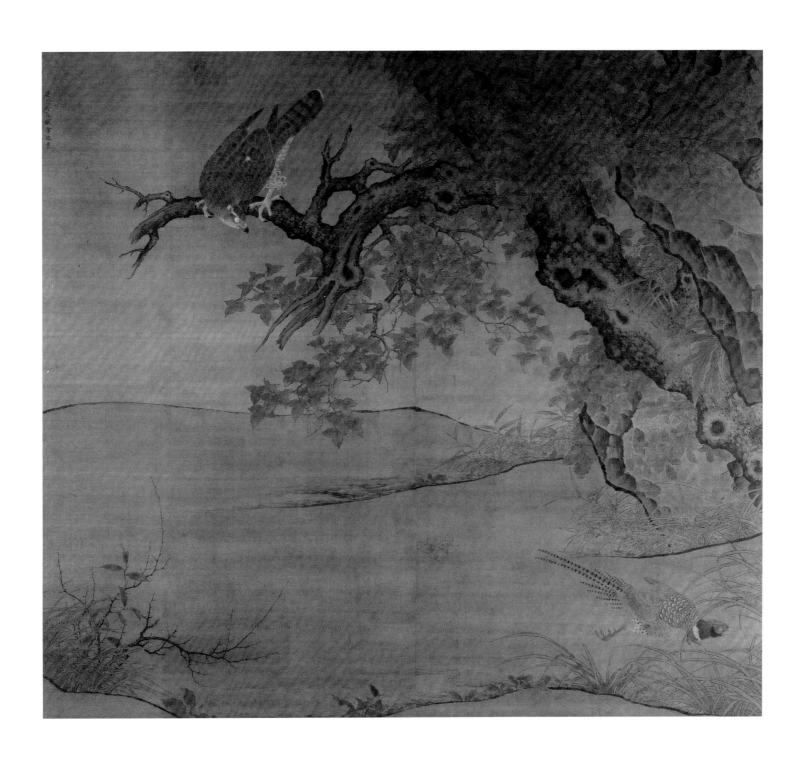

Viewing the Tidal Bore on the Qiantang River (Qiantang guanchao tu)
Li Song (1166–1243)

Southern Song dynasty, late 12th to mid-13th century
Handscroll, ink and colour on silk
17.4 × 83 cm
The Palace Museum

Born into poverty in Qiantang (present-day Hangzhou), Li Song worked as a carpenter in his youth before he was adopted by Li Congxun (active 12th century), an acclaimed Northern Song painter. The great finesse and realism of his figure, landscape, bird-and-flower, and ruled-line paintings earned Li Song a place in the Imperial Painting Academy during the reigns of Emperors Guangzong (r. 1190–1194), Ningzong (r. 1195–1224), and Lizong (r. 1225–1264). This earned him the sobriquet "Veteran Painter of Three Reigns" in his lifetime.

The present handscroll is one of the earliest extant paintings to celebrate the spectacle of the Qiantang River tidal bore — a phenomenon occurring when the incoming tide forms a wave. Watching the bore became a popular custom in China beginning in the Han–Wei period. Here, Li Song captured boats hastening ashore as the river begins to swell and billow. The mistiness and humidity that set in during a flood tide are simulated here through delicate brushwork and a subdued palette. Thanks to the high vantage point, both banks of the river are in plain sight. On the near side of the river, in the foreground, the bank is lined by various architectural structures whose roofs peer over the trees and through mists, bringing to mind the prosperity of the Southern Song capital, Hangzhou, as described by Yang Ji (1326–1378) in his colophon to this work. In stark contrast to these densely packed, man-made structures, sparse hills where birds chirp undisturbed

in tall grasses overlook the river in the background. Pale green washes define the sparingly delineated hills. Lacking both a signature and an artist's seal, this painting was attributed to Li Song. *West Lake* (*Xihu tu*) in the Shanghai Museum, likewise attributed to Li, is very similar in composition and style to this work.

This handscroll bears long inscriptions by the Qianlong Emperor (r. 1736–1795) dated 1751, 1765, 1780, and 1784, as well as colophons by Zhang Renjin (active 14th century) and Yang Ji (1326–1378) of the late Yuan and early Ming. Over fifty collector's seals traceable to An Guo (1481–1534), Xiang Yuanbian (1525–1590), Liang Qingbiao (1620–1691), and the Qing Qianlong, Jiaqing (r. 1796–1820), and Xuantong (r. 1909–1911) emperors are impressed throughout the scroll. In 1922 the former Xuantong Emperor, Puyi (1906–1967), removed it from the palace, giving it to his brother Pujie (1907–1994).[1] It was acquired by the collector Zhang Yuanzeng (active 20th century), as evidenced by his collector's seal, before it was assigned to the Palace Museum in 1955 by the Bureau of Cultural Relics, now the State Administration of Cultural Heritage.

The painting is documented in *Catalogue of the Southern Song Painting Academy* (*Nansong yuanhua lu*), *Wang's Net of Corals* (*Wangshi shanhu wang*), *Painting and Calligraphy Compendium of the Peiwen Studio* (*Peiwen zhai shuhua pu*), and *Treasured Boxes of the Stone Moat Supplement* (*Shiqu baoji xubian*). LS

NOTES
1 Guoli Beiping Gugong Bowuyuan 1934: 15.

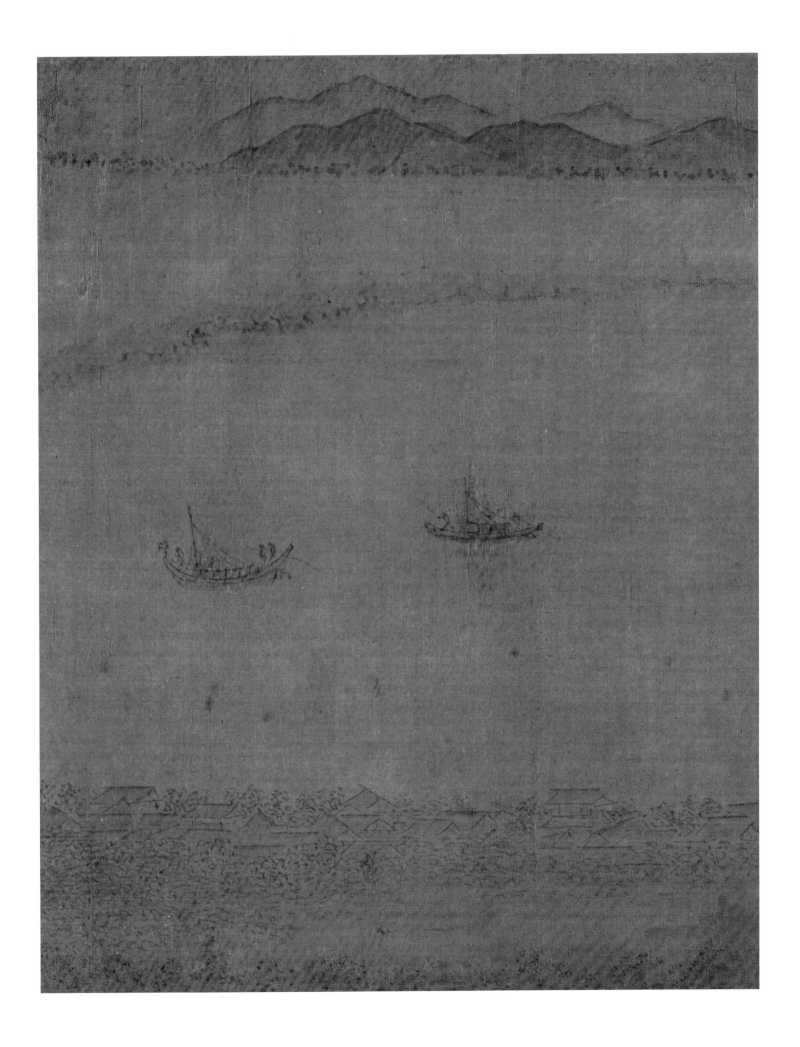

CAT. 18 | *Basket of Flowers (Hualan tu)*
Li Song (1166–1243)

Southern Song dynasty, late 12th or mid-13th century
Album leaf, ink and colour on silk
19.5 × 26.7 cm
The Palace Museum

During the Song dynasty, China enjoyed an extended period of stability and prosperity. Flower arranging became popular among members of the royal family and literati, contributing to a vibrant flower culture. Along with incense burning, tea brewing, and the appreciation of painting, it was considered one of the Four Arts of Life, regarded as elegant pursuits of the Song literati.[1] Paintings featuring flowers in vessels were rarely seen before this time, with figure and landscape subjects given greater prominence from the Six Dynasties period to the Tang dynasty.[2] Thus the decision of Li Song — a native of Qiantang (present-day Hangzhou) and the leading court painter of his time[3] — to create a composition consisting solely of flowers in a basket was pioneering.[4] In addition to reflecting contemporary interest in blooms, such a work allowed later generations to understand the art of flower arranging as it was practised at the time. As the popularity of flower paintings rose during the Northern Song dynasty, an increasing number of court painters pursued the genre.[5] This painting, thus, reflects a Southern Song continuation of the earlier Northern Song trend.

This is one of Li Song's few extant flower paintings. His mastery of fine, precise brushwork (*gongbi*) enabled him to meticulously depict the dense woven patterns of a bamboo basket in which five types of summer flowers — including hollyhocks, gardenias, magnolias, gold and red daylilies, and pomegranate blossoms — are carefully arranged to create a layered effect. Light ink outlines the petals, giving the painting a subtle naturalistic effect. These techniques recall works by Li Song's contemporaries Ma Yuan (active late 12th–early 13th century), Li Di (active 12th century), and Lin Chun (active 1174–1189).[6] Details such as withered branches and irregular holes in leaves reflect the realism pursued by painters of this period.[7] The three-character signature by Li Song in the lower-left corner corresponds with a style of the time, when painters often left simple signatures in the corners or other inconspicuous places of their paintings.[8]

According to *Record of Paintings and Calligraphy* (*Shuhua ji*) by Wu Qizhen (1607–1678), four paintings titled *Basket of Flowers* bear Li Song's signature, including this work.[9] The four paintings were assembled in an album featuring twenty-five paintings by Song artists, only to be later separated into individual album leaves. Three of the four survive, each depicting flowers from different seasons: summer, winter, and spring.[10]

Seals and documentation by connoisseurs show that this work passed through the hands of Ming and early Qing collectors such as Xiang Yuanbian (1525–1590) and Yao Shuiweng (active 17th century).[11] During the twentieth century, it was acquired by the painter Qian Shoutie (1897–1967).[12] The efforts of connoisseur Zhang Heng (1915–1963) later led Qian to sell the painting to the Palace Museum for a low price. YSY

NOTES
1 See Wu Zimu 1980: 185.
2 The *Xuanhe Catalogue of Paintings* (*Xuanhe huapu*) divides paintings into ten categories whose order reflects their relative importance. For example, figure painting is second; landscape painting, sixth; and flower-and-bird painting, eighth. See *Xuanhe huapu* 1963: 5.
3 Li Song served as painter-in-attendance at the Southern Song Imperial Painting Academy. Xia Wenyan 1963: 878.
4 Song X. 2018: 8.
5 Wang Z. 2019a: 16.
6 See two works from the Palace Museum and Tokyo National Museum, TA-137.
7 Gugong Bowuyuan 2019: 120.
8 Wang Z. 2019b: 39.
9 Wu Qizhen 1962: 672.
10 The leaf depicting winter flowers was recorded in the *Treasured Boxes of the Stone Moat* (*Shiqu baoji*); Palace Museum, Taipei; see Tan et al. 2010: 110.
11 Wu Qizhen 1962: 673.
12 Zhang H. 2015, vol. 2: 242.

Southern Song dynasty, 12th or 13th century
Hanging scroll, ink and colour on silk
109 × 49.7 cm
The Palace Museum

Thriving agricultural, handicraft, and commercial industries drove trade during the prosperous Song dynasty. Bullock carts became an important mode of transporting goods overland, and they were often depicted in art, gaining recognition as a distinctive subject in genre painting.[1] Paintings featuring content related to transportation were common in the Tang dynasty. During the Song dynasty, the bullock cart emerged from those motifs to become a popular painting subject on its own.[2] The Northern Song poets Mei Yaochen (1002–1060) and Ouyang Xiu (1007–1072) even wrote poems in appreciation of a work depicting bullock carts.[3]

This take on the subject is superbly rendered with dynamic and fine brushwork in a realistic style. Two fully loaded carts climb a path winding through a landscape of layered peaks and secluded groves; at the centre of the scene stands an inn with camels resting in front.[4] The painter vividly expressed the strenuous effort required to travel uphill, enhancing the dynamism of the composition. Its monumental scale and texture strokes reflect the Northern Song Li Cheng (919–967)–Guo Xi (active 11th century) style.[5] The forms of the towering peaks here recall Guo Xi's masterpiece *Early Spring* (*Zaochun tu*).[6] The artist employed "crab-claw" (*xiezhua zhi*) and "curled cloud" (*juanyun cun*) texture strokes to highlight the quality of the trees and rocks, respectively, while human figures, animals, and structures are outlined in ink. Subtle shades of colour complement the painting.

Extant works featuring bullock carts include handscrolls, hanging scrolls, and album leaves. The handscroll *Bullock Carts at the Water Mill* (*Zhakou panche tu*), formerly attributed to Wei Xian (active 10th century), is regarded as one of the earliest architectural paintings (*jiehua*) — a genre in which buildings are depicted in great detail — and is noted for its use of ruled-lined drawing techniques to depict a vibrant urban scene.[7] The asymmetrical composition of *Oxcarts on Snowy Mountains* (*Xuejian panche tu*), executed in album-leaf format by the Song dynasty court painter Zhu Rui (active early 12th century), displays a strong Southern Song flavour and suggests the influence of Ma Yuan (active late 12th–early 13th century) and Xia Gui (active early 13th century).[8] A hanging scroll whose composition is similar to this unsigned painting is *Bullock Carts Travelling over Rivers and Mountains* (*Panche tu*); it is attributed to Zhu Rui, but the techniques employed are more closely related to the style of Li Tang (ca. 1050–after 1130).[9]

More than five hundred years after it was painted, this work and others like it served as models for Qing painters such as Li Yin (active late 17th–early 18th century) and Yuan Yao (active mid-to-late 18th century) when they created works featuring bullock carts.[10] Collected by the early Qing connoisseur Liang Qingbiao (1620–1691), this painting entered the imperial collection during the reign of the Qianlong Emperor (r. 1736–1795) and was documented in the *Treasured Boxes of the Stone Moat* (*Shiqu baoji*). YSY

NOTES

1 Cheng 2016: 239, 254.
2 Yu H. 1993: 7.
3 For their respective poems, see Ouyang Xiu 1936: 25–26; and Mei 1965: 3b.
4 One is a flat-topped carriage (*pingtou che*), and the other is a single-wheeled cart (*chuan che*). See Xu et al. 2001: 255–256; and Xiang 2017: 15.
5 Yu H. 1993: 8.
6 Palace Museum, Taipei; see Huang and Yu 2020: 80.
7 See Shanghai Bowuguan 2005: 115.
8 Palace Museum, Taipei; see Lin 1989: 58–59.
9 Museum of Fine Arts, Boston, 08.115; see Wu T. 1997: 157–158.
10 Yu H. 1993: 7. For a stylistic analysis of Li Yin's painting, see Wei 1988: 64–65.

| *Spring Morning at the Riverside (Xishan chunxiao tu)*
Unidentified artist

Southern Song dynasty, 12th or 13th century
Handscroll, ink and colour on silk
24.5 × 184.5 cm
The Palace Museum

In this composition, birds can almost be heard chirruping along the expansive riverbank. Denoting the arrival of spring in the Jiangnan area, hillocks are wreathed in mist, and peach trees bloom on the distant slopes. The serenity and tranquillity of the scene call to mind *The Peach Blossom Spring (Taohua yuan ji)*, the otherworldly Shangri-La immortalised by the Jin poet Tao Qian (ca. 365–427).

Unsigned and devoid of artist's seals, the painting was formerly attributed to Monk Huichong (d. 1017).[1] The most highly regarded of the Nine Poet-Monks of the early Song period and a talented and well-travelled painter, he was welcome in the circles of Buddhist monks, Daoist adepts, literati, and high officials alike. He is known to have been proficient in painting geese and herons in especially intimate and peaceful waterscapes that have been dubbed "Huichong's small landscapes" (*Huichong xiaojing*). As a poet-painter he had a profound influence on Song painters, including Liang Shimin (active 11th century), Zhao Shilei (active 11th century), and Zhao Lingrang (active late 11th–early 12th century).[2] A painting by Huichong served as the inspiration for a poem by the Song polymath Su Shi (1037–1101) that contains the famous lines "Beyond bamboos a few twigs of peach blossoms blow; / When spring has warmed the stream, ducks are the first to know" (*zhuwai taohua sanliang zhi, /*

chunjiang shuinuan ya xianzhi).[3] Huichong's paintings were already scarce by the Song dynasty.[4]

Paintings depicting spring in Jiangnan date back to Gu Kuang (ca. 727–ca. 815) of the Tang, whose works have not survived.[5] During the Ming dynasty, a painting attributed to Huichong entitled *Spring in Jiangnan* or *Spring Morning at the Riverside* — generally believed to be the present work — came to the attention of many scholars and collectors.[6] From the mid-Ming to the early Qing it regularly changed hands and was much celebrated and documented by distinguished men of letters. The colophons attached to the scroll suggest that the painting was valued as highly as Huichong's poetic works.[7] While contemporary scholars believe this painting is a Southern Song copy after Huichong, it is thought to be the most representative surviving work to have been attributed to him.

After entering the Qing court collection, it was inscribed by the Qianlong Emperor (r. 1736–1795) with a self-composed poem in 1758. Around 1903 it was deposited in the Pavilion of the Soaring Phoenix (Xiangfeng ge) in the imperial palace in Shengjing; it was accessioned during an inventory conducted in 1913.[8] It was subsequently assigned to the Beiping Ancient Works Display Centre upon its founding in 1914.[9] JFT

NOTES
1 Huichong was probably born around 950 and died around 1017; see Han 2012: 9–12. Huichong's birthplace is variously recorded in Song literature as Huainan (in present-day Anhui province), Jianyang (in present-day Fujian province), or Changsha. For related discussions, see Zheng G. 2002: 264–266; and Han 2012: 9–12.
2 Guo Ruoxu 2001: 44.
3 Su Shi 2011b: 64.
4 The rarity of Huichong's paintings was mentioned in an inscription by Zheng Mengyan (active 13th century); see Zhongguo Gudai Shuhua Jiandingzu 1987: 50.
5 *Shigutang shuhua huikao*, vol. 6: 923.
6 Ling L. 2012: 204–223.
7 See the colophons by Wang Shizhen (1526–1590), Dong Qichang (1555–1636), and Cao Rong (1613–1685) from this scroll.
8 Zhongguo Diyi Lishi Dang'anguan 2005 and Tie and Li 2008, *juan* 47: 69.
9 Jin L. 2014: 606–609.

馥馥蘭芎罏
地陳溪山

B

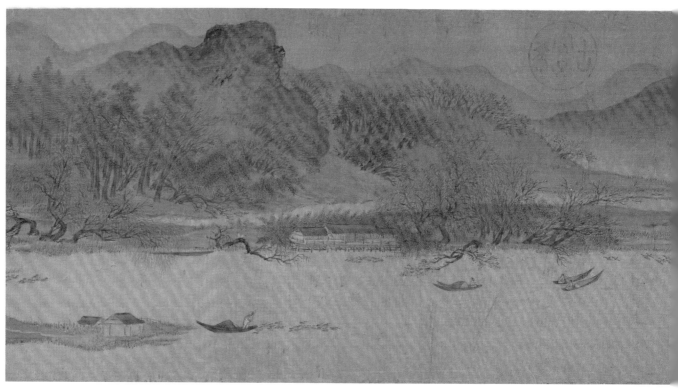

D

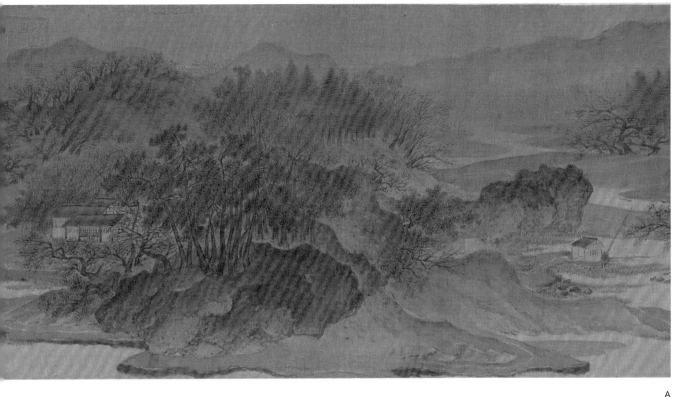

A

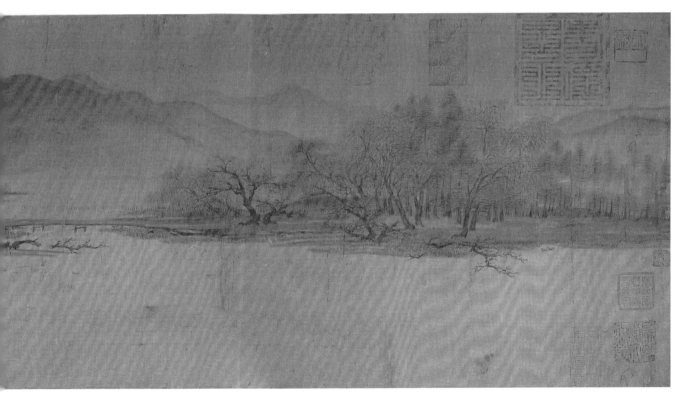

C

CAT. 21 | *Four Purities (Siqing tu)*
Li Kan (1245–1320)

Yuan dynasty, 1308
Handscroll, ink on paper
35.6 × 359 cm
The Palace Museum

Born in Jiqiu (present-day Beijing), Li Kan excelled in portraying bamboo and was a representative figure of the Huzhou Bamboo School during the Yuan dynasty.[1] A bamboo lover, he travelled to different provinces to study the various species of the plant, after which in 1299 he authored a woodblock-printed book entitled *Treatise on Bamboo* (*Zhupu xianglu*) to record his findings.[2]

Most of Li Kan's extant works are hanging scrolls executed on silk, usually depicting one cluster of bamboo in the foreground.[3] This handscroll, painted at the request of his friend Wang Xuanqing (active early 14th century), is a rare example of Li's work in a horizontal format. Here, he depicted the "Four Purities" (bamboo, orchid, rock, and *wutong* tree) using crisply articulated brushstrokes and different ink tones to represent spatial depth. It bears an inscription by the artist and a colophon by the Ming calligrapher Zhou Tianqiu (1514–1595). Although this handscroll looks complete, it is only the second half of the original and its title *Four Purities* was given by one of its collectors, An Qi (1683–after 1745).[4]

Produced after Li Kan compiled his treatise, the entire work (see p. 108 of this volume, fig. 1A) demonstrates his mastery in portraying different types of bamboo. Indeed, this work can be seen as evidence of Li's profound knowledge of the plants, and the characteristics of the three types of bamboo are faithfully represented here when compared to his *Treatise on Bamboo*. As recorded, the *ci* bamboo is prone to

overgrowing and has branches sprouting from its nodes; the *fang* bamboo has square nodes with spikes; and the *cao-gui* bamboo thrives best when planted among rocks.[5] The style and composition of this work hint at Li's knowledge of the Jin dynasty painter Wang Tingyun (1151–1202) and the Northern Song bamboo painter Wen Tong (1019–1079).[6] Its composition cleverly divides the handscroll into three sections, which when unrolled reveal skilfully constructed views of a bamboo forest.

The complete handscroll was collected by Gu An (1289–1365) and Zhang Shen (active 14th century) in the Yuan dynasty before it was divided and dispersed in the late sixteenth century.[7] This work, *Four Purities*, now in the Palace Museum, then passed through the hands of Xiang Yuanbian (1525–1590), Li Zhaoheng (1592–1664), and An Qi before it entered the imperial collection during the time of the Qianlong Emperor (r. 1736–1795). In 1922 it was removed from the palace when Puyi (1906–1967), the former Xuantong Emperor (r. 1909–1911), gifted it to his brother, Pujie (1907–1994).[8] It was ultimately returned to the Palace Museum in the latter part of the twentieth century. Although it is unfortunate that the two halves of the original handscroll are separated, their transmission history — close to three hundred years together and four hundred years apart — nonetheless makes it a fascinating case study in the history of Chinese painting and collecting. LAT

NOTES

1 Wu Zhen 1967: 4.
2 See Sensabaugh's essay in this volume, p. 107.
3 For a list of paintings attributed to Li Kan, see Kao 1980: 244–245.
4 The first half survives as *Ink Bamboo* (Nelson-Atkins Museum of Art; 48–16); see Wang S. 1948: 54. This painting was recorded as "Li Kan *Bamboo Wutong Tree Orchid and Rocks Four Purities* Scroll" (*Li Kan zhu wu lan shi siqing tujuan*) in An Qi 1742: 377.
5 For illustrations and descriptions of these types of bamboo, see Li Kan 1992: 736–742.
6 For Li Kan's biography, see Kao 1980: 12–34.
7 For a discussion of the date when the original scroll was divided, see Kao 1980: 67–68; Yang R. 2008: 347; Chen X. 2021: 36; and David Ake Sensabaugh's essay in this volume.
8 Guoli Beiping Gugong Bowuyuan 1934: 11.

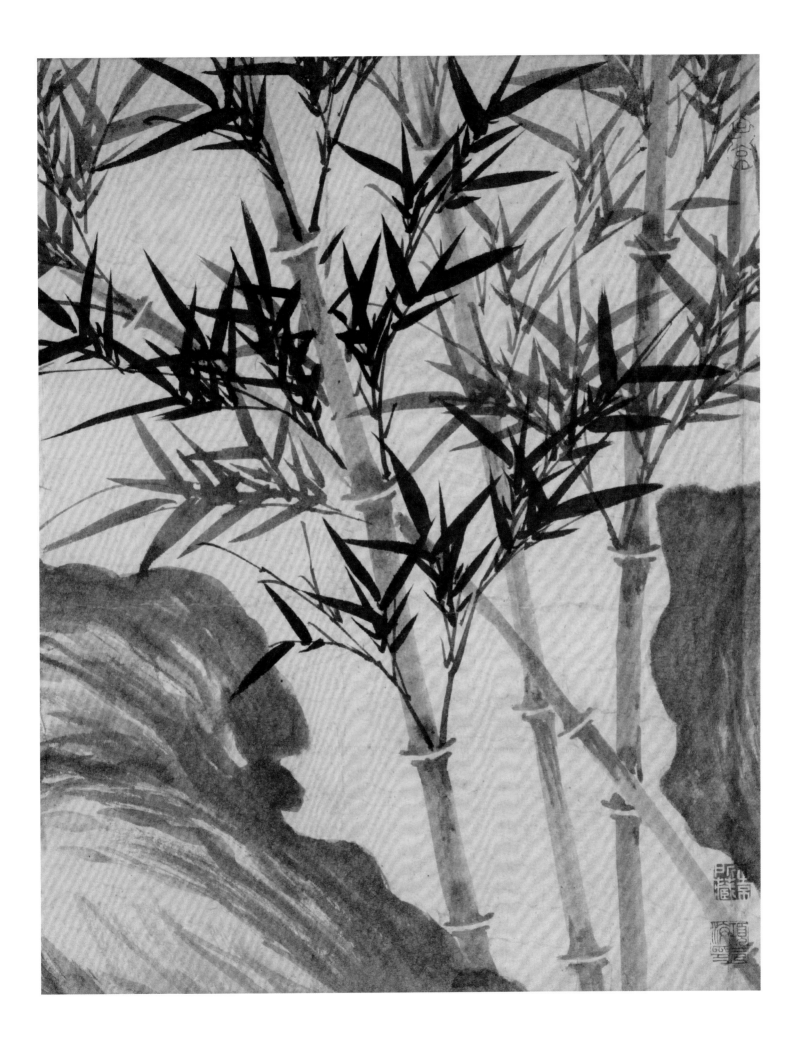

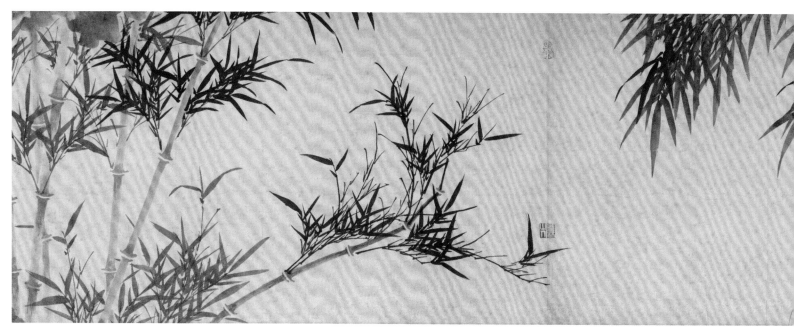

B

大德丁未秋九月
王玄卿道錄送
至此幣求予拙
筆事多未暇
明年春正月一
日始得了罷燈
暗目昏白日視之
不知何如也息
齋道人薊丘
李衎仲賓題

D

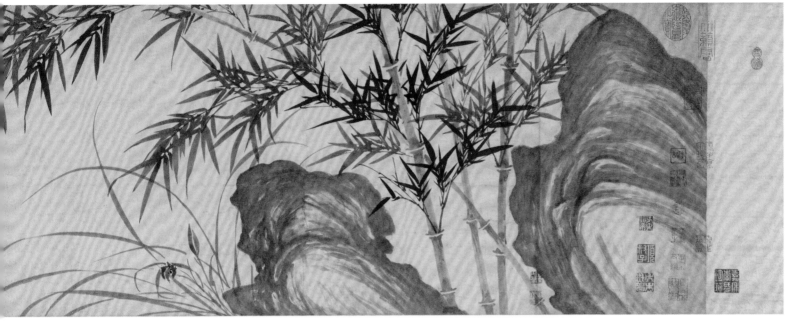

A

C

Watering Horses in Autumn (*Qiujiao yinma tu*)
Zhao Mengfu (1254–1322)

Yuan dynasty, 1312
Handscroll, ink and colour on silk
23.7 × 58.8 cm
The Palace Museum

Zhao Mengfu was a descendant of the founding Song emperor Taizu (r. 960–976) and a witness to the conquest of his dynasty by the Mongol Yuan in 1279. Under this alien regime, he served the court for five successive reigns, rising to the rank of Director of the Hanlin Academy and was posthumously honoured as Lord of Wei.[1] He was a versatile painter who worked effortlessly across genres and styles, employing both fine-line and expressive brushwork in both blue-and-green and monochrome ink. Whatever the genre or style, he prized calligraphic brushwork and believed that honouring the past should take precedence over technical finesse.[2]

These precepts are fully realised in *Watering Horses in Autumn*, painted when Zhao was 59.[3] Take, for instance, the horses — a favourite subject since Zhao's youth.[4] Described in fluid, robust, rounded strokes like those used in seal script, the animals fall within a long-standing tradition originating with Wei Yan (active late 7th–early 8th century), Cao Ba (active 8th century), and Han Gan (active 8th century) and continuing through Li Gonglin (1049–1106). Yet embracing tradition in no way stifled Zhao Mengfu's creativity. Departing from the convention of dividing the painting into three horizontal bands representing sky,

mountains, and ground, Zhao Mengfu chose to fill the entire surface of the painting with what would normally occupy the foreground and middle ground of a composition. This serves to draw the viewer's attention to the groom and the horses he is herding. The bold composition and rich palette, exemplified by the deep red of the groom's robe and the maple leaves against the green riverbank and brown ochre water, are typical of the artist's individualistic style in his later years.[5]

The painting was collected by Liang Qingbiao (1620–1691) and documented in *Net of Corals* (*Shanhu wang*), *Painting and Calligraphy Compendium of the Peiwen Studio* (*Peiwen zhai shuhua pu*), and *Inspiring Views* (*Daguan lu*). The emperor was so elated that he inscribed it and had it remounted in 1767 (as it remains) before adding another inscription in 1776.[6] Upon Qianlong's death, the painting was deposited in the Hall of Offerings (Longen dian) in the imperial mausoleum complex before it was transferred to the palace by Puyi (1906–1967), the former Xuantong Emperor (r. 1909–1911). It was removed from the palace in the 1920s and was returned to the Palace Museum by the United States Marine Corps following its discovery in a safe in the Tianjin residence of Puyi in 1946.[7] LY

NOTES
1 Wang and Gugong Bowuyuan 2017: 8.
2 See Zhao Mengfu's colophon in Zhang Chou 2011: 515.
3 For Zhao Mengfu's chronicle, see Ren 1984: 151.
4 See Zhao's inscription on *Mounted Official* in the Palace Museum collection.
5 Yang C. 1982: 111.
6 Zhongguo Diyi Lishi Dang'anguan and Beijing Tieyuan Taoci Yanjiusuo 2005, vol. 30: 845–846.
7 Xu B. 2015a: 61; and Fang Y. 1996: 69.

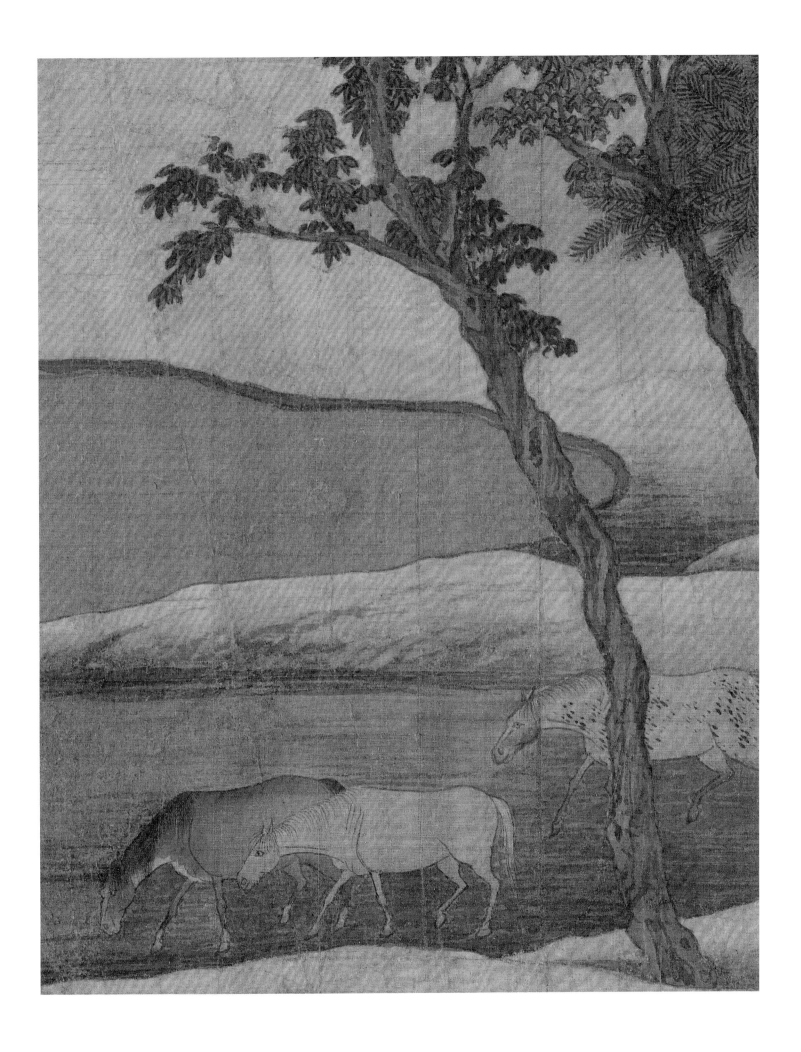

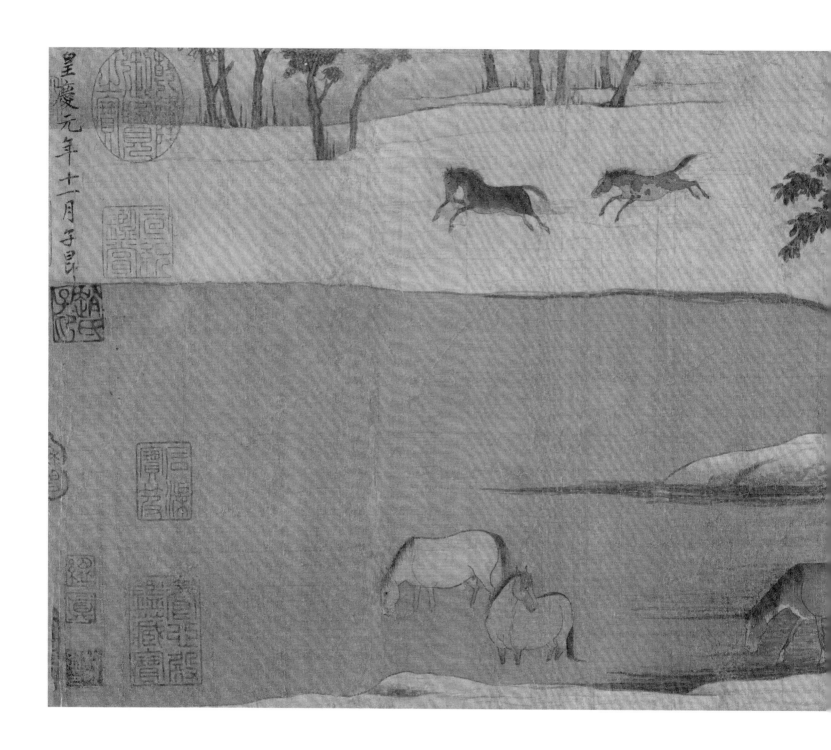

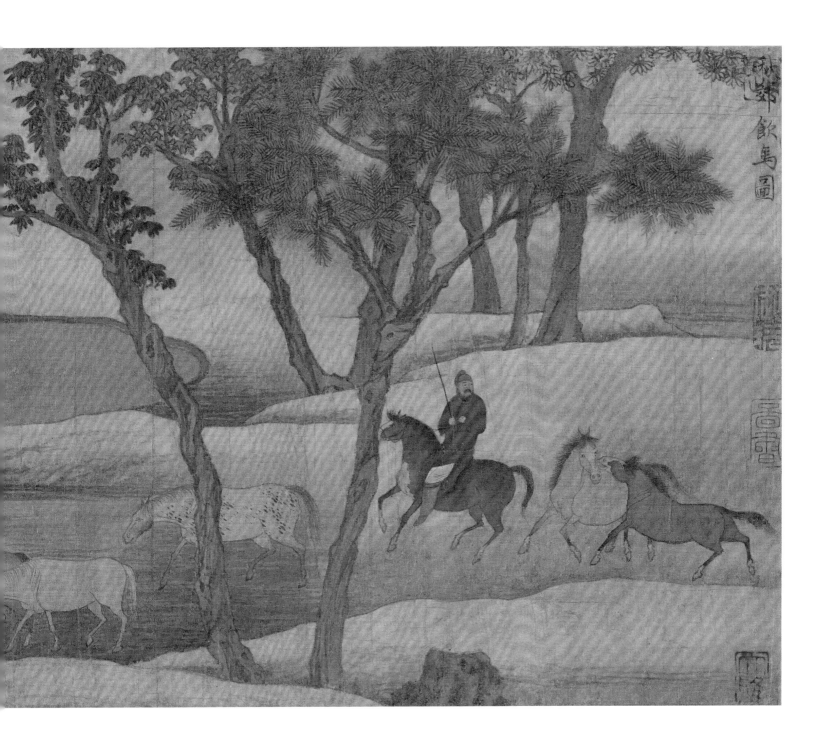

CAT. 23 | *Late Autumn in Running Script (Xingshu qiushen tie)*
Signed Guan Daosheng (1262–1319); calligraphy by Zhao Mengfu (1254–1322)

Yuan dynasty, 1319 or earlier
Letter mounted as an album leaf, ink on paper
26.8 × 53.2 cm
The Palace Museum

This letter, signed by Guan Daosheng and addressed to her aunt, begins with an exchange of pleasantries followed by a description of the gifts she has sent, including fruit, fish, and candles. It closes with Guan sending good wishes on behalf of her husband and her signature. Guan was a celebrated calligrapher. The Yuan emperor Renzong (r. 1312–1320) once ordered her to copy the *Thousand-Character Classic* (*Qianziwen*) for his collection, and praised Guan by saying that "future generations will know that my court has a woman who is good at calligraphy. The fact that the whole family can write is also a surprising thing."[1] But the letter was actually written by her even more famous husband, Zhao Mengfu, whose signature was covered by Guan's.[2] Zhao was a descendant of the royal family of the Song dynasty, Director of the Hanlin Academy, and a prominent literati painter.[3] He was the grandfather of Wang Meng (d. 1385), who was later recognised as one of the Four Masters of the Yuan dynasty (see cat. 30). The expressive and powerful brushstrokes here recall Zhao's calligraphic style in his later years after he studied the *Dingwu* version of the *Orchid Pavilion Preface* (*Lanting xu*), leading Wang

Lianqi to suggest that the letter was written between 1309 and 1311.[4]

The letter became a collectible as early as the Ming dynasty, when it came into the possession of Li Zhaoheng (1592–1664), a collector of the Zhao family's works who impressed his seal on the letter.[5] Li also collected *Four Purities* by Li Kan (1245–1320; cat. 21), which bears Zhao Mengfu's colophon, and *Fishing Boat in a Stream with Pine Trees* by Zhao Mengfu's son Zhao Yong (after 1293–1361; cat. 28).[6] The letter entered the collection of the Qianlong Emperor (r. 1736–1795), probably through a Manchu named Aerxipu (active late 17th–early 18th century), whose seal can be seen on the work. Its inclusion in the *Treasured Boxes of the Stone Moat* (*Shiqu baoji*) as well as the *Model Calligraphy of the Hall of Three Rarities* (*Sanxi tang fatie*) — works that established a canon of orthodox writing styles in standard, running, and cursive scripts — firmly asserted its status as a masterwork and model for future calligraphers. In the seventeenth year of his reign (1752), the Qianlong Emperor further bestowed numerous copies of the book on family members and officials, making the work widely known among the educated elite.[7] RW

NOTES
1 See "Weiguo furen Guanshi muzhiming" in Zhao Mengfu 1970: 481–482. As a painter, Guan was included in Xia Wenyan's *Precious Mirror of Painting* (*Tuhui baojian*). For an introduction to Guan, see Chen P. 1977; and Zhou G. 2017; for a study of Guan's status in the Ming dynasty, see Purtle 2011.
2 Zhang H. 1964: 13, figs. 14–15. Zhao Mengfu wrote other letters for his wife; see McCausland 2000: 41.
3 For a monograph on Zhao Mengfu, see McCausland 2011.
4 Wang L. 1984: 43.
5 For a list of works bearing Li Zhaoheng's seal, see the Appendix in Ling L. 2015: 280–282. See also Yang D. 2006: 318–319.
6 For more on this work, see David Ake Sensabaugh's essay in this volume and cat. 21.
7 Zhongguo Diyi Lishi Dang'anguan 2005, vol. 19: 206–211.

道昇踧覆
孃孃夫人糚前 道昇久不幸
字不勝馳
想秋深漸寒忉惟
㫑履清安丘
尊堂太夫人與
合姓吉沛又皆在此 一再相
气起
孃孃二巳知之芘有叅采四
盤糚雰餙四包邜果薑廿
屩相媽百條祥
納聊见激亭辱
眀扚鈙誠感掌何如未言
晤間笑
萬對弥愛官人不乡作去附
此致言
三揔营壴曰安勝邜媽
隹住不宣九月廿曰道昇踧覆

CAT. 24 | *Calligraphy and Painting of Timely Clearing after Snowfall* (*Kuai Xue Shi Qing shuhua hebi*)
Zhao Mengfu (1254–1322), Huang Gongwang (1269–1354), and Xu Ben (1335–1380)

Yuan dynasty, ca. 14th century
Handscroll, ink and colour on paper
Zhao's calligraphy: 29.8 × 102.4 cm; Huang's painting: 29.8 × 104.6 cm; Xu's painting: 29.8 × 96.6 cm
The Palace Museum

The first part of this scroll consists of four large characters (*kuai*, *xue*, *shi*, *qing* — "timely clearing after snowfall") written by Zhao Mengfu. According to Song Lian (1310–1381), the calligrapher derived his calligraphy first from his ancestor, Emperor Gaozong (r. 1127–1162), and then from earlier masters such as Zhong You (151–230), Wang Xizhi (303–361), Wang Xianzhi (344–386), and Li Yong (674–746).[1] The characters here were modelled on a letter ascribed to the great Eastern Jin calligrapher Wang Xizhi. Completing the scroll are paintings by Huang Gongwang and Xu Ben and a group of colophons by various Yuan scholars, including an important copy of Wang Xizhi's letter by Zhang Yu (1283–1350).

That letter by Wang Xizhi was known in two versions in the early Yuan period, and Zhao Mengfu seems to have had knowledge of both. Later in his life, he was commanded by the Yuan emperor Renzong (r. 1312–1320) to write a colophon for the version then in the imperial collection, considered a Tang tracing copy, which is now in the Palace Museum, Taipei.

The four large characters in this scroll appear to have been based on the other version of Wang Xizhi's letter, acquired by the Yuan dynasty collector Mo Chang (active early 14th century) and now lost. Although different in size, Zhao's larger copy closely follows the form and vigour of the version in Mo's collection, according to one of the colophon writers.[2] From the colophons following Zhao's calligraphy, including those of Huang Jin (1277–1357), Zhang Zhu (1283–1350), Duan Tianyou (active 14th century), Ni Zhong (active

14th century), and Mo Chang himself, it is clear that Zhao dedicated the four large characters to his student Huang Gongwang, then Huang presented it to Mo Chang, so Zhao's calligraphy and Wang's letter, collected by Mo, could be together. Mo probably requested the colophons from his contemporaries.

Huang Gongwang was a renowned landscapist and follower of Dong Yuan (d. ca. 962) noted for his rocky summits.[3] In the landscape here, the background is washed in light ink to set off a snowy scene in which mountains textured with a dry brush contrast starkly with trees delineated in scorched ink. The otherwise bleak view is brightened by the rising sun in the distance, evoking the notion of clearing. Although unsigned and slightly scraped at the lower left, the painting has been accepted as authentic in light of the affinities its brushwork shares with the artist's *Nine Peaks after Snow* (*Jiufeng xueji tu*) in the Palace Museum.[4]

In the painting by the poet and landscape painter Xu Ben, a rising sun again denotes clearing weather.[5] Judging from the calligraphy, painting, and the crab-claw tree branches — all typical of the Li Cheng (919–967)–Guo Xi (active 11th century) style — this signed work is believed to be from the artist's early years.[6]

If catalogues from the seventeenth century are to be trusted, Xu Ben's was the only painting originally included in the scroll. Since Huang Gongwang's painting was not mentioned before *Fortuitous Encounters with Ink* (*Moyuan huiguan*), written in the early eighteenth century by An Qi (1683–after 1745), it is possible that An Qi himself added it to the scroll in order to match the theme. MXY

NOTES
1 Yu J. 1981: 1281.
2 See Ni Zhong's comment in his colophon to this scroll.
3 Xia Wenyan 1993: 887.
4 Xu B. 2015b, vol. 12: 127.
5 Wang Ao 1987, *juan* 57: 20.
6 Xu B. 2015b, vol. 12: 127

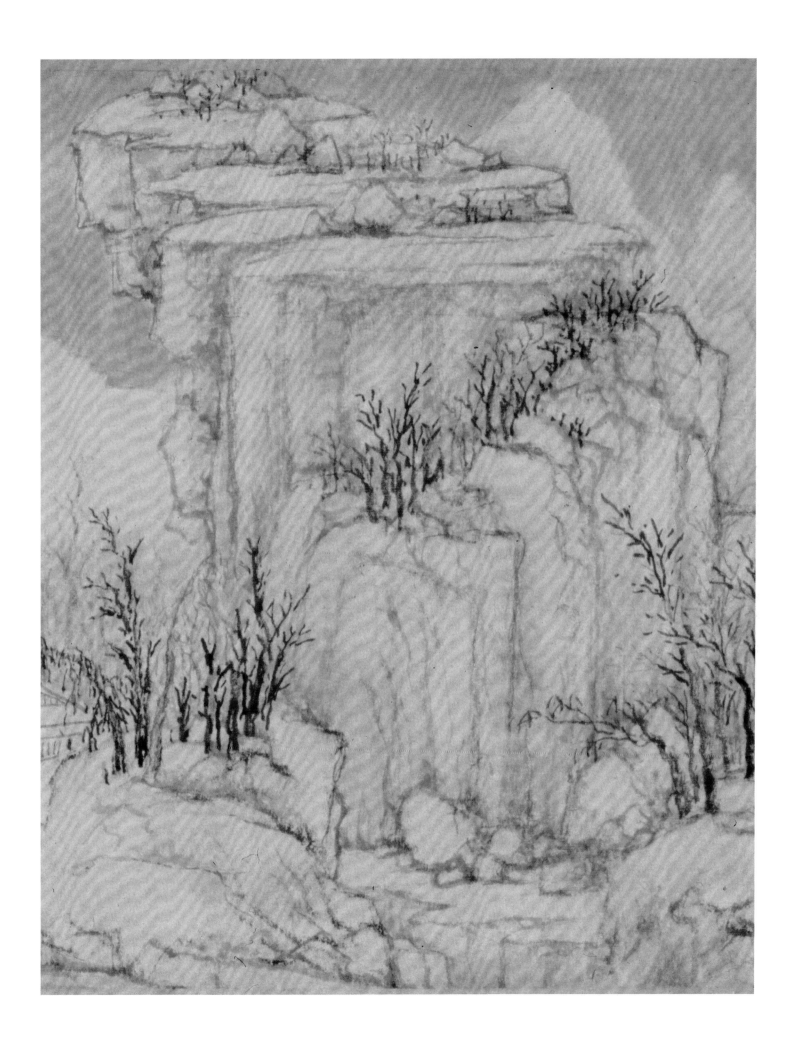

Zhao Mengfu

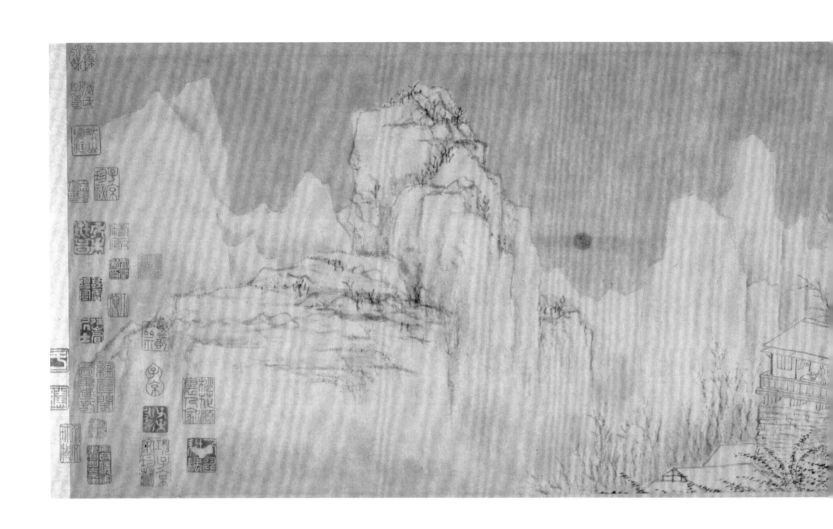

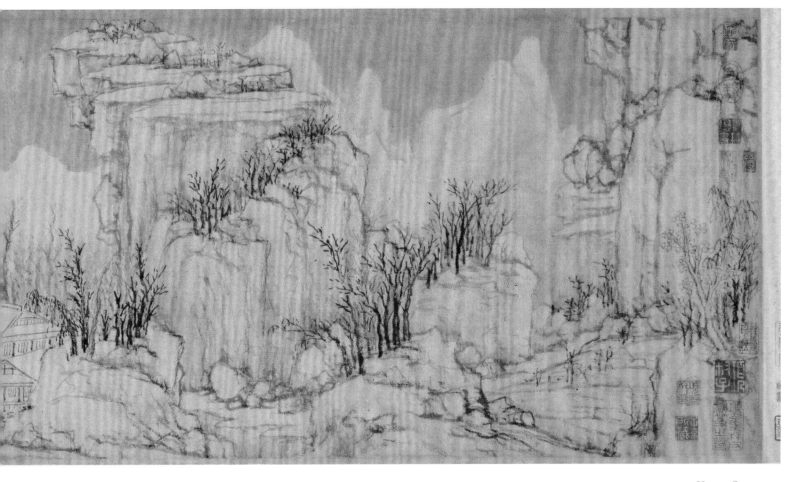

Huang Gongwang

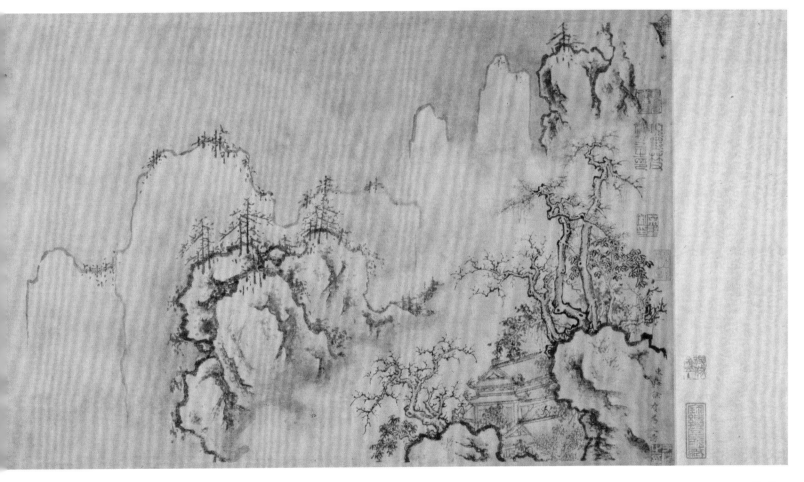

Xu Ben

CAT. 25 | *Hasty Writing in Draft-Cursive Script* (*Zhangcaoshu jijiu zhang*)
Deng Wenyuan (1259–1328)

Yuan dynasty, 1299
Handscroll, ink on paper
23.3 × 366 cm
The Palace Museum

A native of Mianzhou in present-day Sichuan province, Deng Wenyuan was a Southern Song loyalist and famous calligrapher.[1] Towards the end of the thirteenth century he participated in elegant gatherings in the Zhejiang region with, among other literati, Zhao Mengfu (1254–1322) and Xianyu Shu (1246–1302). The three had frequent exchanges on calligraphy and advocated a return to the style of the Wei and Jin periods.[2] Such was the trio's impact on the development of calligraphy that Yu Ji (1272–1348), a junior member of their circle, described them as the "best of their generation in the arts of ink and brush".[3]

The original composition of *Hasty Writing* by Shi You (active mid-1st century BCE) is no longer extant. Written in poetic form, the text is purportedly a reader for children. While other versions of *Hasty Writing* in clerical script are known from textual records and discoveries of bamboo strips, fragments, and tomb bricks during the late nineteenth and early twentieth centuries, the most popular early version in circulation is attributed to the calligrapher Huang Xiang (active 3rd century).[4] Its draft-cursive style, which carries traits of "broken wave" (*bojie*) or wave-like strokes, evolved during the fourth century into what is known as "modern cursive" (*jincao*).[5] This modern cursive script was dominant from the Eastern Jin dynasty on until the draft-cursive style was re-evaluated by Zhao Mengfu, who influenced his friends Xianyu Shu and Deng

Wenyuan. Committed to a revival of the antique spirit, the trio would have regarded the Han dynasty–vintage draft-cursive script an excellent model for emulation.[6] All three likely copied *Hasty Writing* in draft-cursive script, but only Deng's work has survived, making it an important example of how early Yuan masters practised and interpreted the antique style.[7]

Deng Wenyuan's contemporaries — such as Zhang Yu (1283–1350) and Yang Weizhen (1296–1370) — held his copy of *Hasty Writing* in high regard, inscribing admiring colophons on the work. Created at the height of Deng's career — the year after he earned fame for transcribing the sutras for the Yuan emperor Chengzong (r. 1295–1307) — it is representative of his oeuvre and was created for Li Zhongyong (active late 13th century), a friend from Khotan, in the Yuan capital of Dadu (present-day Beijing). The work was critically acclaimed in scholarly circles during the Ming dynasty. Yao Guangxiao (1335–1418), for example, wrote commentaries and observations in his colophons. When Deng's *Hasty Writing* entered the imperial collection, the Qianlong Emperor (r. 1736–1795) wrote a frontispiece and ordered the court artist Dong Bangda (1696–1796) to paint a landscape at the end of the handscroll. Removed from the palace in the 1920s, it was rediscovered in 1946 in the Tianjin residence of Puyi (1906–1967), the former Xuantong Emperor (r. 1909–1911), and returned to the Palace Museum. LTC

NOTES

1 For a discussion of Deng Wenyuan's birthyear, see Li F. 2013: 5.
2 See Hsiao 1997: 193–195.
3 See Yu Ji 1987, *juan* 10: 13.
4 Draft-cursive script (*zhangcao*) was derived from clerical script (*lishu*), then current. See Fu 1977: 81. A Ming ink rubbing of *Hasty Writing* in the Songjiang Museum features this script. Modern scholars believe it is the closest version to Huang Xiang's calligraphy. See also Fang M. 2018: 83–86.
5 Sturman 1999: 200–201.
6 For the evolution of draft-cursive script in the early Yuan, see Fu 1977: 84–89.
7 Xu B. 1995a: 126–128.

烏絲欄文衆桑雌孫诸物

宪姪字孙弟郎右不雅

豹少珠快言勉力弱必藏番

壽清邕云宰宋巡重節子方

術卷壽史步民周子秋緒弱以

爰展世高雄毫第二裝萬秉秦

眇厉邦书祝冯灌强载波邦來

男明董車徐柜笑民任途时尾

B

D

A

C

CAT. 26 | *Stone Cliff at the Pond of Heaven* (*Tianchi shibi tu*)
Huang Gongwang (1269–1354)

Yuan dynasty, 1341
Hanging scroll, ink and colour on silk
139.8 × 57.7 cm
The Palace Museum

Huang Gongwang served as an official in the Yuan government before being imprisoned for his involvement in a scandal related to reform efforts. After his release, he devoted himself to travelling, painting and calligraphy. Under the tutelage of Zhao Mengfu (1254–1322) he studied the work of Dong Yuan (d. 962), Monk Juran (active mid-to-late 10th century), Jing Hao (active mid-9th–early 10th century), Guan Tong (active early 10th century), and Li Cheng (919–967), which transformed his approach to painting and led to his unique late style.[1] His writings on painting were collected in *The Secrets of Landscape Painting* (*Xie shanshui jue*).[2] Considered one of the Four Masters of the Yuan, Huang had a profound influence on the development of painting in the Ming and Qing periods.

From Zhao Mengfu, Huang acquired not only skill and technique but also an enlightened perspective on painting. He kept his teacher's emphasis on tradition — in conception, composition, and execution — uppermost in his mind.[3] It is apparent from the present painting that the landscapes he favoured featured the majestic vistas seen in works by Jing Hao and Monk Juran of the Five Dynasties period and Fan Kuan (active late 10th–early 11th century) of the Northern Song rather than the diagonal, one-cornered compositions of the Southern Song.

Although Huang is said to have produced many paintings throughout his career, this complex yet eloquent composition — produced when the painter was an elderly man — is his earliest extant dated work. His use of Dong Yuan's hemp-fibre strokes for the rocks and the horizontal dots of Mi Fu (1051–1107) and his son Mi Youren (1074–ca. 1153) for the trees are typical of his style. In similar landscapes like this that emphasise light colours — ochre and green, here — delineation and texturing in ink, used to emphasise the lush vegetation, dominate.

Documented in *Allegorical Meanings* (*Yuyi bian*) by Du Mu (1458–1525) of the Ming, this masterpiece was donated to the People's Republic of China by Shen Zhongzhang (1905–1987) in 1958 and was subsequently housed in the Palace Museum. WQ

NOTES
1 See Xie C. 1986: 70–71.
2 Tao Zongyi 1959, *juan* 8: 94–97.
3 Zhao Mengfu's view of painting is recorded in Zhang Chou 2011: 515.

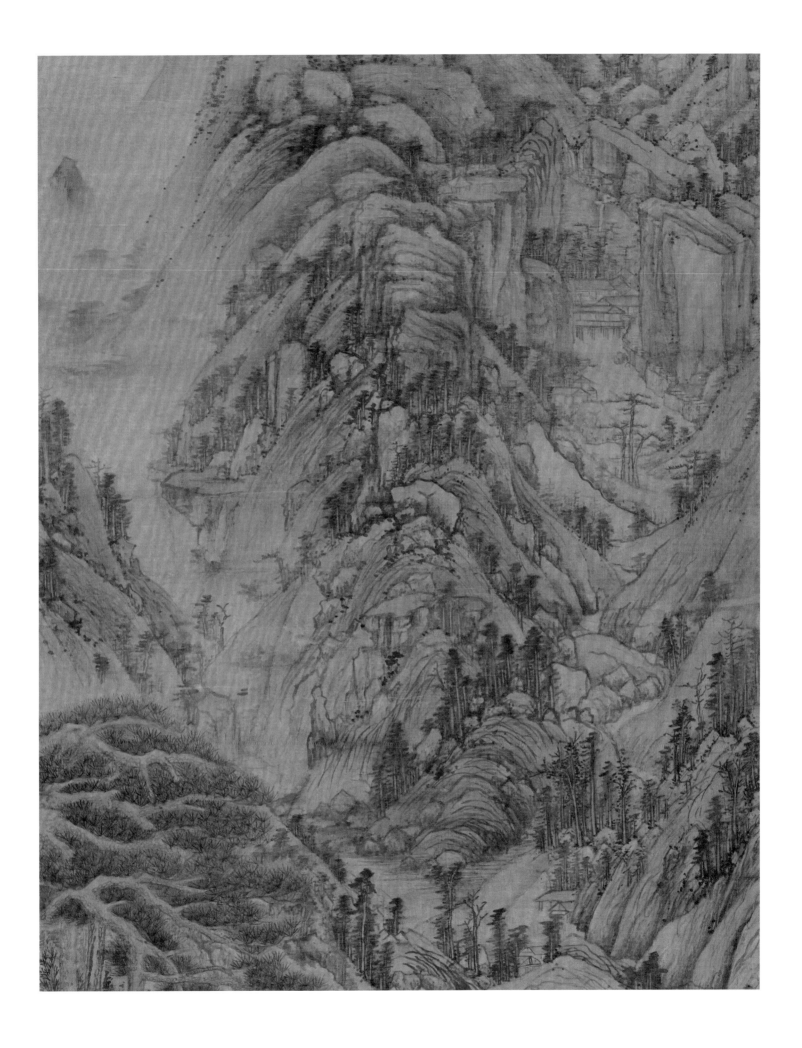

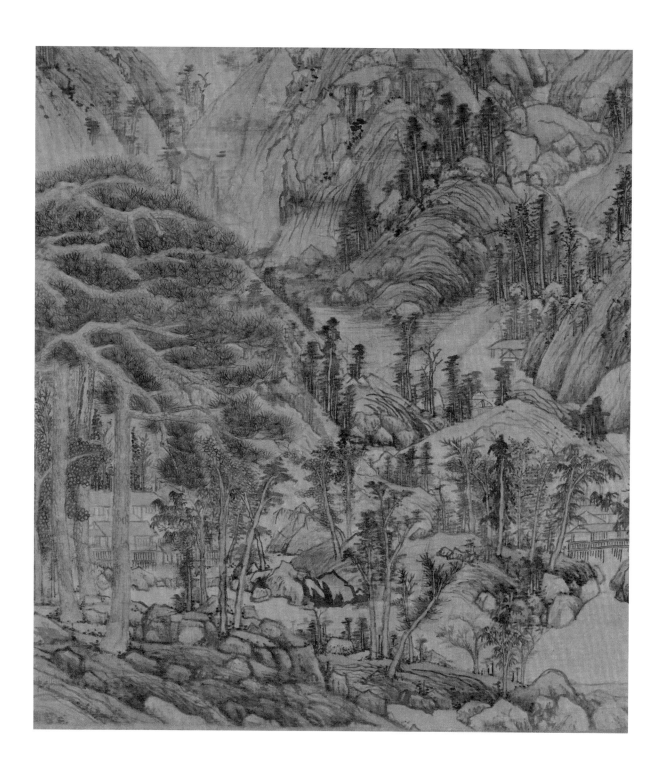

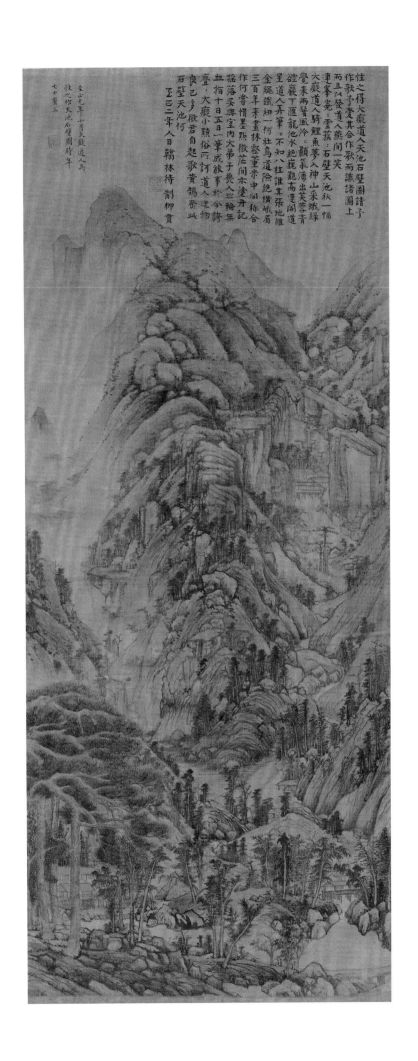

性之得大癡道人天池石壁圖請予
作歌予愛其合作歌而讀諸圖上
而且以發道人燕閒一笑
重峯崒兀雲菸石壁天池秋一幅
大癡道人騎鯉魚入神山采娥綠
覺來兩鬢風泠泠顧昇湯出芙蓉青
磴巖下滙龍池水起處觀看建閣道
里道人弄筆不知八柱誰其派地維
金題鐵紐一何壯林密董采中間稱合
三百年來畫林密董采中間稱合
作何嘗惜墨點微范間宗凌丹記
搖落吳興室內大弟子義人恐輪無
血指十日五日一筆成就事於分誘
臺大癡小隸俗所訂道人建物
良已多徹君自起歌黃鵠奈此
石壁天池何
至正二年人日翰林待制柳貫

七十翁王
致之作天池石壁圖時年
至正元年十月天藐道人為

Yuan dynasty, 1336
Hanging scroll, ink on silk
83.7 × 29.5 cm
The Palace Museum

Wu Zhen, a native of Jiaxing, Zhejiang, was a consummate painter and poet. Counted with Huang Gongwang (1269–1354), Wang Meng (d. 1385), and Ni Zan (1306–1374) as one of the Four Masters of the Yuan, he is venerated for his ink bamboo and landscapes with fishermen that signify seclusion.[1] He is said to have sojourned in Hangzhou and Wuxing before spending his late years as a reclusive fortune-teller in his native city.[2] Shunning dignitaries, he kept to himself to preserve his integrity.[3] A genealogical record entitled *Genealogy of the Wu Family in Yimen* (*Yimen Wushi pu*) discovered in 1981 has shed light on the painter's family background. Far from living in poverty as portrayed by late-Ming literati, Wu Zhen was in fact a descendant of well-to-do officials.

Reminiscent of the works of Monk Juran (active mid-to-late 10th century), which Wu Zhen took as a model, the present picture awes with its saturated ink and mellow beauty. The composition is typical of the Jiangnan riverscapes that prevailed in the Yuan dynasty, emphasising here the solitary fisherman absorbed in angling on the expansive water, while the rich and round moss dots on the rocks are borrowed from not only Juran but also Dong Yuan (d. 962). Inscribed by the painter with a self-composed *ci* (a type of song or poem), this masterpiece in itself embodies the three perfections of poetry, calligraphy, and painting. No wonder it was lauded as unrivalled by Wang Duo (1592–1652) in his inscription above the painting.

The fisherman emerged as a figure of exceptional wisdom in Chinese literature during the Warring States period in such classics as *Zhuangzi* and *Songs of Chu* (*Chuci*); this was followed by *Song of the Fisherman* (*Yu gezi*), in which the great Tang poet Zhang Zhihe (ca. 730–ca. 810), who preferred an unambitious life to officialdom, immortalised the contentment of being a fisherman. From then on, the fisherman became an allegory of seclusion or liberation from fame and fortune — and strife. In its way, this painting offers a glimpse of life for the Han Chinese under Mongol rule; together with Wu Zhen's poem, which recalls Zhang Zhihe's *Song of the Fisherman*, it expresses the painter's desire to withdraw from society.

This work has travelled through the collections of Zhan Xi (active late 15th–early 16th century), Wu Rongguang (1773–1843), and Pan Zhengwei (1791–1850); it is catalogued in Wu Rongguang's *Notes from the Summer of the Xinchou Year* (*Xinchou xiaoxia ji*). The painter's inscription states this is one of a set of four paintings. Wu Zhen created numerous fishermen paintings. Other than the present work, three other paintings of the same title have survived and are housed in the Palace Museum, Taipei (dated 1342), the Shanghai Museum, and the Freer Gallery of Art.[4] JT

NOTES
1 For Wu Zhen's life, see Chen C. 1983; Chang 2000a, 2000b, and 2000c.
2 "Ti Wu Zhen Mei zhu song lan siyou tu" in Li Zhaoheng 1992: 756.
3 Sun Zuo 1987: 493.
4 For more on the authenticity of the works in the Shanghai Museum and Freer Gallery of Art, see Yang R. 2015: 501.

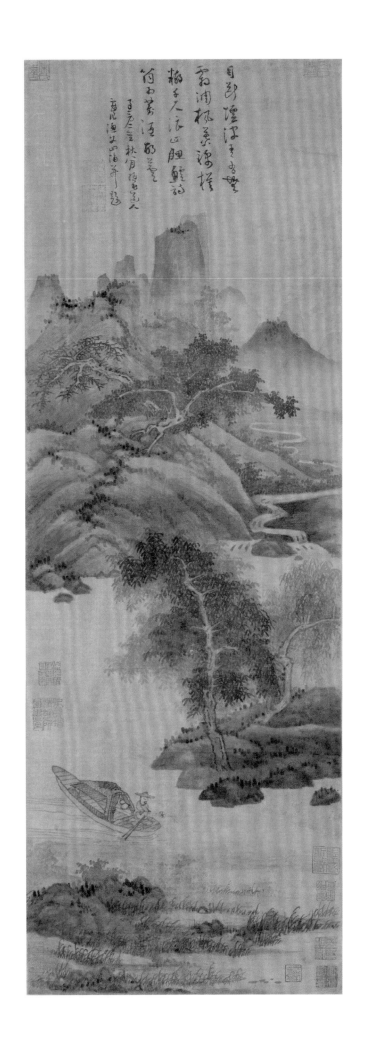

CAT. 28 | *Five Paintings by Yuan Masters (Wujia hehui)*
Zhao Yong (after 1293–1361), Wang Mian (1287–1359), Zhu Derun (1294–1365),
Zhang Guan (active 14th century), and Fang Congyi (active 14th century)

Yuan dynasty, mid-to-late 14th century
Handscroll, ink on paper
Zhao: 30.2 × 53.3 cm; Wang: 32 × 51.3 cm; Zhu: 31.8 × 52.9 cm; Zhang: 25.8 × 60.3 cm; Fang: 26.2 × 45 cm
The Palace Museum

This handscroll is composed of five paintings — four landscapes and one ink plum — by five scholar-painters of the Yuan dynasty, when literati painting reached an unprecedented level. The subject matter addressed by these paintings reflects the social situation and desires of educated elites under Mongol rule. Many such men chose to live in reclusion and express themselves through art. Taken together, these works trace the evolution of painting styles over the course of the second half of the Yuan dynasty.

Fishing Boats in a Stream with Pine Trees (Songxi diaoting tu) is by Zhao Yong, the second son of Zhao Mengfu (1254–1322), the most prominent scholar-official-painter of the Yuan.[1] Here, a lone hermit-scholar in a boat fishes on the river, pine trees in the foreground. Like many of his contemporaries, Zhao combined the Li Cheng (919–967)–Guo Xi (active 11th century) "crab-claw" (*xiezhua zhi*) technique and the Dong Yuan (d. 962)–Monk Juran (active mid-to-late 10th century) "hemp-fibre" texture stroke (*pima cun*).

Boating in the Stream with Pine Trees (Songxi fangting tu) is by Zhu Derun. One of the Eight Talents of Wuxing (*Wuxing bajun*), Zhu was a scholar, official, and painter who was once recommended by Zhao Mengfu.[2] Here, two scholars in a boat float along a pine-covered bank. Zhu inscribed a poem on it by the Northern Song scholar-bureaucrat Su Shi (1037–1101).[3] Zhu was representative of Yuan painters who over the course of their careers abandoned the tradition of Li Cheng and Guo Xi for the Dong-Ju style. Here, Zhu mainly employed the Li-Guo technique, indicating it may have been created during Zhu's transition between styles.[4]

Zhang Guan's *Thatched Cottage in Sparse Wood (Shulin maowu tu)* depicts one scholar sitting in a hut while another is in a boat, both seemingly recluses. The brushstrokes in this rare work are mostly derived from the Li-Guo tradition. The Daoist Fang Congyi painted *Seclusion in a House in the Woods (Shanshui tu)*, which shows two scholars sitting by the windows in two separate thatched huts. The brushwork is mainly from the Dong-Ju tradition.

Ink Plum Blossom (Momei tu) combines painting, poetry, and calligraphy by the erudite Wang Mian, who once studied with Zhao Mengfu.[5] It is a typical scholar-amateur painting depicting the plum blossom, a symbol of noble character and, with the orchid, the bamboo, and the chrysanthemum, one of the "Four Noble Ones" (*si junzi*). Here, Wang followed the scholarly tradition of depicting the plum in ink only, recalling the style of Song painters such as Yang Wujiu (1097–1171) and Zhao Mengjian (1199–1264).[6]

These works passed through various collections as separate pieces before they were collected by An Qi (1683–after 1745). The scroll entered the imperial collection during the time of the Qianlong Emperor (r. 1736–1795), who inscribed a poem on each painting. Documented in the *Treasured Boxes of the Stone Moat Supplement (Shiqu baoji xubian)*, it was kept in the Palace of Double Brilliance (Chonghua gong). In 1922 it was removed from the palace when Puyi (1906–1967), the former Xuantong Emperor (r. 1909–1911), bestowed it on his brother Pujie (1907–1994). It was kept briefly by the collector Zhang Boju (1898–1982) before being donated to the Palace Museum.[7] JFT

NOTES
1 See Chen G. 2004: 274–302; Ma S. 2018: 92–100; and Chen Y. 2021: 41–45. For a discussion of literati painting of the Yuan dynasty, see Fong and Chen 1984: 94–129; Hearn 2009: 78–106; and McCausland 2014: 147–176.
2 See Chen G. 2004: 303–321; and Cahill 2009: 81–85.
3 The poem is titled "Ti Wang Jinqing huahou"; see Su Shi 2011: 352.
4 For a discussion of the transformation of landscape painting styles during the Yuan dynasty, see Barnhart 1977: 105–123; Shih 1996: 131–180; Jiang T. 2016: 109–115; and Jiang F. 2017: 161–179. For more on Zhu's style, see Ho 1992: 246–274; and Hearn 2009: 94–97.
5 For Wang Mian's biography, see Chen G. 2004: 550–571; and Cahill 2009: 178–190. Xu Bangda praised this painting as the best surviving work by the artist; see Xu B. 2015a: 243.
6 This is the only known work by Wang Mian that employs "ink wash" without contour lines. For more on his plum blossom painting, see Duan 2021: 64–81.
7 Guoli Beiping Gugong Bowuyuan 1934: 8; and Xiangcheng 2011: 404.

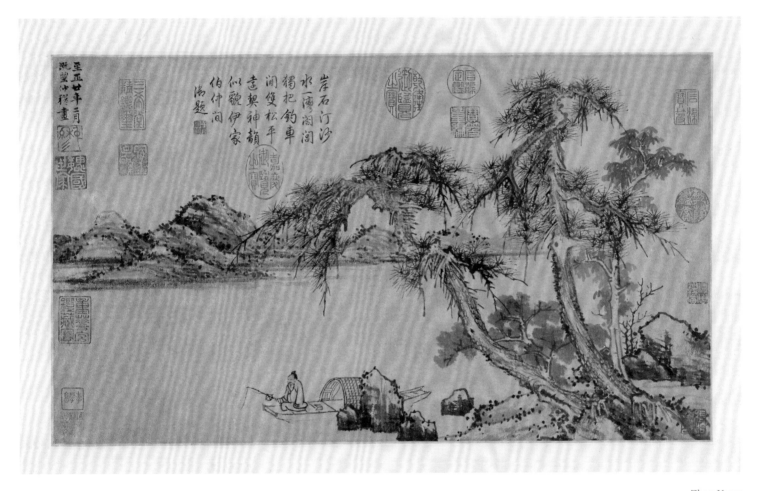

岸石汀沙
水一灣渺渺
獨把釣竿
澗竹松平
遠契神韻
似貌伊家
伯仲間
淵題

Zhao Yong

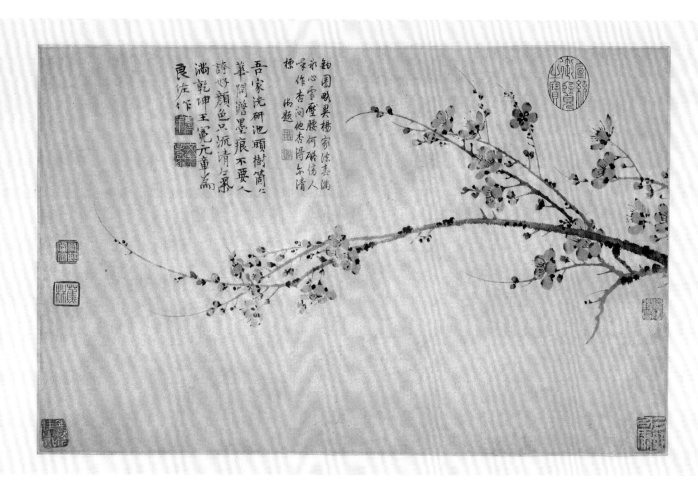

Wang Mian

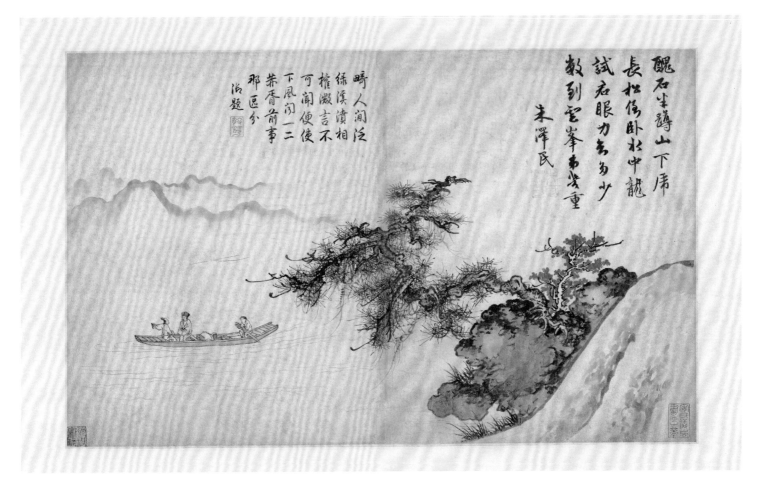

醉石坐尊山下屛
長松偃卧水中龍
試君眼力舍多少
數到雲峯幾叠重
　　朱澤民

　　時
人間泛
相
溪濱
不
權激言
使
可聞便
一二
下風閑
事
茶盾前
分
那匼
題

Zhu Derun

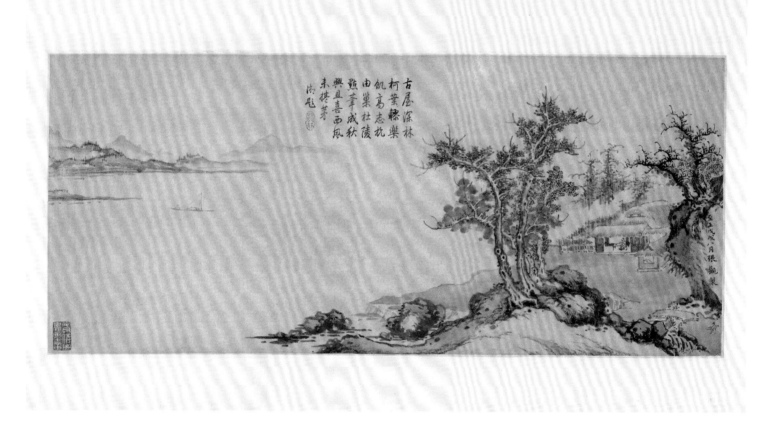

古屋深林
柯葉轉樂
飢高志抗
由巢杜陵
題筆成秋
興且喜西風
未搖茅
涂毛

Zhang Guan

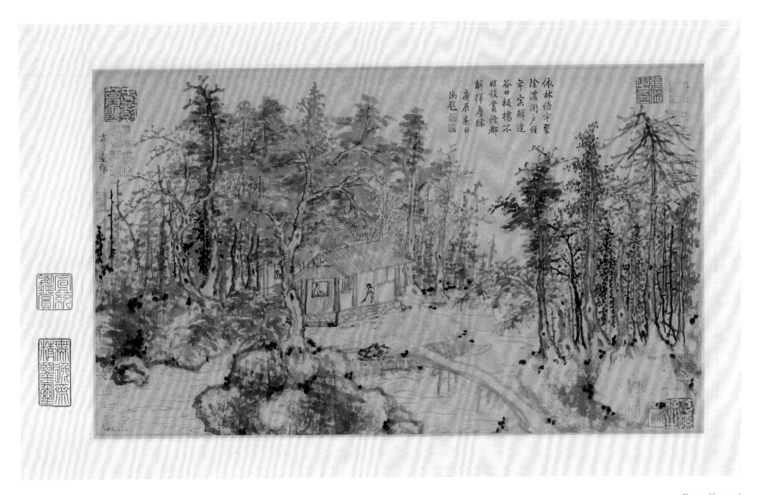

依林結宇翠
陰濃闢戶牖
年家解逅
谷口板橋不
須設賞係郷
解揮塵蹤
庚辰春日
尚題

方從義

Fang Congyi

Wutong, Bamboo, and Elegant Rock (Wuzhu xiushi tu)
Ni Zan (1306–1374)

Yuan dynasty, probably 1340s
Hanging scroll, ink on paper
96 × 36.8 cm
The Palace Museum

Regarded as one of the Four Masters of the Yuan (*yuan sijia*), Ni Zan was a wealthy land-owner who indulged his passion for books, paintings, and calligraphy in his studio, the Pure and Secluded Pavilion (Qingbi ge).[1] His comfortable life was disrupted by the unrest of the Yuan dynasty, which led Ni to escape his hometown, Wuxi, in the 1350s. In his later years, Ni distributed his possessions and withdrew into a recluse's life.[2] Admired by connoisseurs such as Dong Qichang (1555–1636), Ni Zan's artistic style influenced literati painters of later dynasties.

Ni Zan probably created *Wutong, Bamboo, and Elegant Rock* when he was in his mid-forties, and his technique here transcended conventional depictions of a familiar topic.[3] Departing from his signature dry brush, here he painted with wetter strokes. The clean arrangement of desolate landscapes commonly seen in his painting is also absent.[4] Ming and Qing catalogues called it superb — Ni Zan's "one and only" bamboo-and-rock painting in this style.[5]

The painting also records key social inter-actions in the Yuan dynasty. In the first part of his inscription, Ni Zan wrote: "The Daoist Master Zhenju [Zhang Yu] is going to visit the Lofty Hermit Wang Junzhang [Wang Gui] in the mountains of Changshu. I thus painted this picture *Wutong, Bamboo, and Elegant Rock* to send to the provincial graduate Zhongsu [Miao Zhen]."[6] This not only details corre-spondence among four people but also shows how paintings and calligraphy aided social networking among cultivated men.[7]

Before entering the Qing imperial collec-tion, the painting was acquired by notable collectors such as Liang Qingbiao (1620–1691) and An Qi (1683–after 1745). It bears an impe-rial inscription similar to the one found on Ni Zan's *Woods and Valleys of Mount Yu* (*Yushan linhe tu*), suggesting that the Qianlong Emperor (r. 1736–1795) viewed and inscribed multiple Ni Zan works in the spring of 1759.[8] Qianlong's poem reiterates the essence of this painting:

Rain gracing the *wutong* tree and the bamboo
swaying in the wind;
Mutually supportive on the rock bank, they are
of similar nature.
[The emperor is] marvelling that after several
hundred years, Ni Zan's ink play,
when viewing the scroll unrolled, is still
dynamic and moist [as if just painted].[9]

During the week when the inscription was written, in the 24th year (1759) of the Qianlong Emperor's reign, a lack of rain was causing food shortage in Gansu province, prompting the emperor to send aid to the area.[10] Possibly viewing the work while thinking about Gansu, the emperor echoed the dampness and rainy weather in his inscription. After leaving the imperial collection, the painting was acquired by the collector Pang Yuanji (1864–1949) and eventually returned to the Palace Museum in the early 1950s.[11] PYY

NOTES

1 Ke Shaomin 1935: 454–455.
2 Zhou Nanlao 1970, *juan* 11: 489–494; Zhu Mouyin 1997, *juan* 2: 658–659.
3 Wang C. 1967: 33; Yu and Li 2014: 218. Ni Zan's painting bears an inscription by Zhang Yu (1283–1350). Zhang's death provides a *terminus ante quem* for the work.
4 Wang H. 2020: 87–91.
5 An Qi 1742: 381. Zhang Chou and Bian Yongyu point out that the painting is "unlike any of his usual works" (*juebu leiqi pingshi*); see Zhang Chou 2011, *juan* 7: 352; and Bian Yongyu 1987, *juan* 50: 182. Wu Sheng further states that the work "has no presence of Ni's distinctive character" (*juewu Yuweng yidian bense*); see Wu Sheng 2001, *juan* 17: 522.
6 See David Ake Sensabaugh's essay in this volume.
7 Clunas 2004: 65.
8 See *Woods and Valleys of Mount Yu* (*Yushan linhe yu*) in the Metropolitan Museum of Art (1973.120.8); and Qianlong 1993: 693.
9 Based on the *Collection of Qian-long's Imperial Poems* (*Qianlong yuzhi shiwen quanji*), the painting in this exhibition was inscribed sometime between the 23rd day and the 28th day of the second month. See Qianlong 1993: 706.
10 Zhao Erxun 1986: 421–427.
11 Zheng Z. 1998c: 205–206.

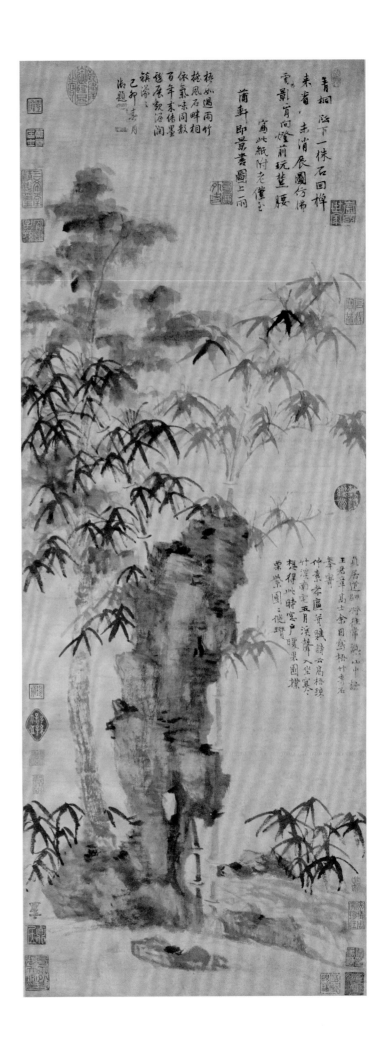

青桐瓜下一株石回檀
来者未消晨圖彷彿
雲影向燈前玩藍腰
寫此紙附老僕云
蒲軒即景書圖上丽

梧桐遇雨竹
搖風石畔相
依氣味同載
百年素佐墨
後晨叙海間
箴滂之
己卯素月
御題

真居道品将雅常敬小小語
王君庄高士余日飲枥竹秀石
峯寶
仲東茅廬苜賤詩云高梧頭
竹溪南室五月溪聲入坐寒
想得此時窗戶暖果圆撲
栗縈圆之饱蹬

CAT. 30 | *Dwelling in the Summer Mountains (Xiari shanju tu)*
Wang Meng (d. 1385)

Yuan dynasty, 1368
Hanging scroll, ink on paper
118.6 × 36.5 cm
The Palace Museum

Known as one of the Four Masters of the Yuan, Wang Meng was the grandson of Zhao Mengfu (1254–1322) and served as a minor official in the Yuan and Ming governments.[1] Accused (falsely, as it turned out) of conspiring against the Hongwu Emperor (r. 1368–1398), Wang spent the last five years of his life in prison.[2] As an artist, he was influenced by his grandfather and was associated with such leading painters as Huang Gongwang (1269–1354), Ni Zan (1306–1374), and Yang Weizhen (1296–1370). He combined close observation of nature with his knowledge of Dong Yuan (d. 962) and Monk Juran (active mid-to-late 10th century) to arrive at a distinct style of his own. He is considered the inventor of the ox-hair texture stroke and was an expert in calligraphic texturing with a dry brush. Strikingly complex in their spatial arrangement, his landscapes often allude to literati living in seclusion in a humid and lush Jiangnan setting.[3]

About twenty ink monochrome or colour paintings by Wang Meng survive. This landscape bears a signature inscription that, besides identifying the recipient, includes a date that corresponds to 1368, making it a product of the painter's later years. With its rocks textured in hemp-fibre strokes, dotting with a dry brush, and use of scorched ink for some of the leaves, this exemplary painting is comparable to other works by Wang from the same period: *Dwelling in Seclusion in the Summer Mountains (Xiashan gaoyin tu)*, in the Palace Museum, and *Dwelling in the Qingbian Mountains (Qingbian yinju*

tu), in the Shanghai Museum. His landscapes celebrate mundane life through the inclusion of family scenes in an otherwise uninhabited wilderness. At the lower left of this painting, a cottage at the edge of a stand of towering pine trees contains two figures seemingly engaged in conversation; the woman on the right may have a baby in her arms. Inhospitable at first glance, the lofty mountains in fact lend themselves to dwelling.

Wang Meng's elaborate landscapes and robust brushwork broadened the scope of Chinese painting and left behind a legacy that was enthusiastically embraced by many Ming and Qing masters. Indeed, some of the copies made after Wang Meng have become classics in Chinese art history, including *Lofty Mount Lu (Lushan gao tu)* by Shen Zhou (1427–1509), in the Palace Museum, Taipei,[4] *Thatched Cottage in Autumn Mountains (Qiushan caotang tu)* by Wang Hui (1632–1717), and *Playing the Qin-zither in the Pine Ravine (Songhe mingqin tu)* by Wu Li (1632–1718) — the latter two in the Palace Museum collection.

After entering the Qing imperial collection, this work was inscribed with a poem by the Qianlong Emperor (r. 1736–1795) and merited an entry in the *Treasured Boxes of the Stone Moat Supplement (Shiqu baoji xubian)*. During the nineteenth century it passed out of the palace collection and was owned by Pang Yuanji (1864–1949). In 1953 the Bureau of Social and Cultural Enterprises Management allocated it to the Palace Museum. MSP

NOTES

1 Wu Xiu (1764–1827) proposed 1308 as Wang Meng's birth date. Although adopted by some modern scholars (such as Yang Renkai), the claim proved to be unfounded and is no longer valid. See Wu Xiu 2008: 869. See Chen G. 2015, vol. 2: 501–515; see also Zhu Yizun 1936, vol. 11: 1003.
2 "Tao Zongyi, ku Wang Huanghe" in Qian Qianyi 2000, *jibu* vol. 95: 414.
3 For more on Wang Meng's painting style, see Yang C. 1990: 835.
4 Palace Museum, Taipei.

PART THREE | INSCRIPTIONS AND SEALS

Inscriptions and Seals for Exhibited Works

CAT. 1

After Rain in Running Script (Song copy)
Wang Xizhi (303–361)

本幅：

東晉　王羲之：

「今日雨後未果奉狀，想□能於言話，可定便得書問，永以為訓。妙絕無已，當其使轉。與都下曾信，戴適過於糧也。羲之。」（宋人臨摹）

題跋：

清　梁清標（外題簽）：

「王謝雨後中郎二帖，棠村珍藏。」

時代不詳　佚名（本幅）：

「禹民。」

元　鄧文原（第一開對頁）：

「右王右軍《雨後帖》真跡。明窗棐几，夜雪初晴，得此展玩，良一快也。延祐己未（1319）十二月望，左綿鄧文原觀于武林寓舍之素履齋。」

　鈐印：「巴西鄧氏善之」白文方印、「素履齋」朱文方印

明　董其昌（第二開）：

「右軍《蘭草帖》、《雨後帖》真跡，皆有虞永興私印。《蘭草》已刻於吳用卿餘清齋，此華學士家藏，海內無兩。

元時柳貫跋《戎輅表》云：鍾、王真跡，雖千金一字，亦不可見，猶幸有流落人間如此卷者。董其昌題。」

　鈐印：「董其昌印」白文方印、「太史氏」白文方印

明　鄒之麟（第三開）：

「《雨後》一帖，係兄終身人品所關，惟兄自為計。茂如兄，麟生頓首。」

　鈐印：「布衣之俠」白文方印

明　鄒之麟（第四開）：

「撮炮雨前茶，閑展《雨後帖》。如此粗遣過，與世無交涉。與秋澗看右軍帖，口占似一石道丈笑笑。逸麟。」

　鈐印：「明」朱文圓印、「衣白」朱文方印、「臣虎」朱文方印

鑒藏印：

唐　李世民：

「貞觀」墨描橢圓印（偽）

唐　虞世南：

「世南」墨描長方印（偽）

北宋　蘇激：

「志東奇玩」朱文方印（偽）
「四代相印」朱文方印（偽）

南宋　趙構：

「紹」「興」朱文連珠方印

清　弘曆：

「乾隆御覽之寶」朱文方印
「石渠寶笈」朱文長方印
「養心殿鑒藏寶」朱文長方印
「乾隆御賞之寶」朱文方印
「三希堂精鑒璽」朱文長方印
「宜子孫」白文方印

清　顒琰：

「嘉慶御覽之寶」朱文橢圓印

清　溥儀：

「宣統御覽之寶」朱文方印

其他：

「竹□」朱文長方印
「□□」半印
「□□」半印

LTC, LAT

*Death of a Palace Attendant in
Running Script* (Song copy)
Xie An (320–385)

本幅：

東晉　謝安：

「八月五日，告淵、朗、廓、攸、靖、
玄、允等。何圖酷禍暴集，中郎奄至逝
沒。哀痛崩慟，五情破裂，不自堪忍，
痛當奈何！當復奈何！汝等哀慕斷絕，
號咷深至，豈可為心。奈何！奈何！
安疏。」（宋人臨）

題跋：

清　梁清標（外題簽）：

「王謝雨後中郎二帖，棠村珍藏。」

南宋　張逸、陸瑛（第二開）：

「淳熙戊申（1188）正月，武陵張逸、
南陽陸瑛。」

時代不詳　璿政（第二開）：

「右晉《六十五字帖》詳載書譜，與右
軍書同日得觀，豈不至幸！吾生千百載
後，譬之樹杪，回視根柯，寥遠不能
相及。然情懷意思，古今相同。前人所
書言語足準，後學讀其文、覽其書，竟
忘其寥遠。回視斯帖，不覺恍然忻戚若
相關焉。又千百年後，境象當何似？竊
以為亦猶是耳。至其一時運筆用墨之妙，
雖竭力摹擬，卒難相肖。孫叔敖學在優
孟，人以為逼真，吾謂外或近之，其中
豐骨自別，是以識者必求真跡觀之。既
刻之石，又摹搨人為，奚啻木末回視根
柯耶？璿政。」

明　王鏊（第三開）：

「自晉迄今蓋千有餘年，其間世故，凡幾
變滅，而片紙宛然獨完，信神物有呵護
者耶？拙叟鏊。」

　　鈐印：「濟之」朱文長方印

明　焦竑（第四開）：

「《宣和書譜》謝公行書三，此所謂
《中郎帖》也。晉人簡牘率於吊喪問疾用
之，往往如出一轍，豈可因語同遂目為
右軍書耶？王、謝並擅臨池，然謝書比
之逸少，尤為艱得，當是世之一寶。丙
午（1606）冬，秣陵焦竑題。」

　　鈐印：「弱侯」白文方印、「澹園居
士」白文方印

清　張英（第五開）：

「壬戌（1682）初秋，龍眠張英敬觀於真
州舟中，王謝風流，千載如新，良平生
一快事也！」

　　鈐印：「龍眠張英」白文方印、
「圃翁」朱文方印

鑒藏印：

南宋　趙構：

「德」「壽」朱文連珠方印

元　吾丘衍：

「吾衍私印」白文方印半印
（據《餘清齋法帖》補）（偽）

明　夏杲：

「雪蓑清暇」朱文方印半印
（據《餘清齋法帖》補）（偽）

明　黃琳：

「琳印」白文長方印
「黃琳美之」朱文方印

明　吳楨：

「吳楨」朱文方印

明　吳廷：

「新安吳廷」白文方印

清　梁清標：

「蒼巖子」朱文圓印
「觀其大略」白文方印

清　弘曆：

「乾隆鑒賞」白文圓印
「乾隆御覽之寶」白文方印

清　溥儀：

「宣統鑒賞」朱文方印
「無逸齋精鑒璽」朱文長方印

其他：

「□□」白文圓印半印
「□□」朱文長方印
「許叔次家藏」白文方印（二次）
「楊嘉」白文方印
「河申堵氏」白文方印半印
　　（據《餘清齋法帖》補）
「許」白文方印
「叔次氏」白文方印
「子孫保之」白文方印半印
　　（據《餘清齋法帖》補）
「謝褒」白文方印半印
　　（據《餘清齋法帖》補）
「□□有道」白文方印半印
　　（據《餘清齋法帖》補）
「□弘□印」白文方印半印
　　（據《餘清齋法帖》補）
「士林中人」白文方印半印
　　（據《餘清齋法帖》補）

LTC, LAT, JL

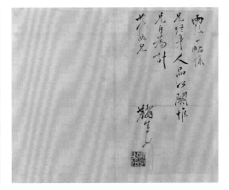
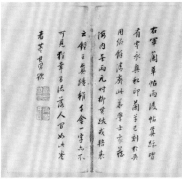

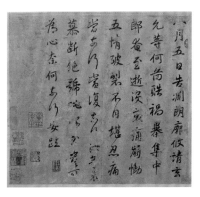

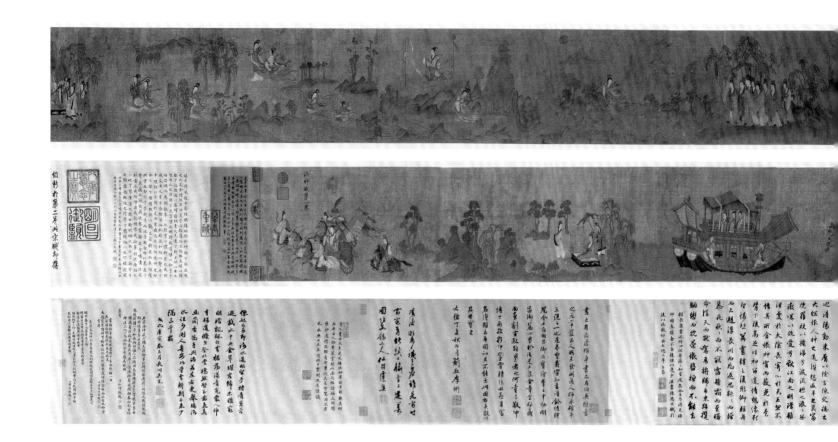

CAT. 3

Nymph of the Luo River
(Northern Song copy)
Gu Kaizhi (346–407)

本幅:

無作者款識。

題跋:

清 弘曆（外題簽）:

「顧愷之洛神圖，趙孟頫書賦。」

清 弘曆（引首）:

「妙入毫顛。」

　　鈐印:「乾隆宸翰」朱文方印

元 趙孟頫（尾紙）:

「《洛神賦並序》。黃初三年，余朝京師，還濟洛川。古人有言，斯水之神，名曰宓妃。感宋玉對楚王神女之事，遂作斯賦。其詞曰：余從京域，言歸東藩。背伊闕，越轘轅，經通谷，陵景山。日既西傾，車殆馬煩。爾乃稅駕乎蘅皋，秣駟乎芝田，容與乎楊林，流眄乎洛川。於是精移神駭，忽焉思散。俯則未察，仰以殊觀，睹一麗人，于巖之畔。乃援御者而告之曰：爾有覿於彼者乎？彼何人斯？若斯之艷也！御者對曰：臣聞河洛之神，名曰宓妃。則君王之所見，無乃是乎？其狀若何？臣願聞之。余告之曰：其形也，翩若驚鴻，婉若游龍。榮曜秋菊，華茂春松。髣髴兮若輕雲之蔽月，飄颻兮若流風之迴雪。遠而望之，皎若太陽升朝霞；迫而察之，灼若芙蕖出淥波。穠纖得衷，修短合度。肩若削成，腰如約素。延頸秀項，皓質呈露。芳澤無加，鉛華弗御。雲髻峨峨，脩眉聯娟。丹唇外朗，皓齒內鮮。明眸善睞，靨輔承權。瑰姿艷逸，儀靜體閑。柔情綽態，媚於語言。奇服曠世，骨像應圖。披羅衣之璀璨兮，珥瑤碧之華琚；戴金翠之首飾，綴明珠以耀軀。踐遠游之文履，曳霧綃之輕裾；微幽蘭之芳藹兮，步踟躕於山隅。於是忽焉縱體，以敖以嬉。左倚采旄，右蔭桂旗。攘皓腕於神滸兮，采湍瀨之玄芝。余情悅其淑美兮，心振蕩而不怡。無良媒以接歡兮，託微波而通辭。願誠素之先達兮，解玉佩而要之。嗟佳人之信修，羌習禮而明詩。抗瓊珶以和余兮，指潛淵而為期。感交甫之棄言兮，悵猶豫而狐疑。收和顏以靜志兮，申禮防以自持。於是洛靈感焉，

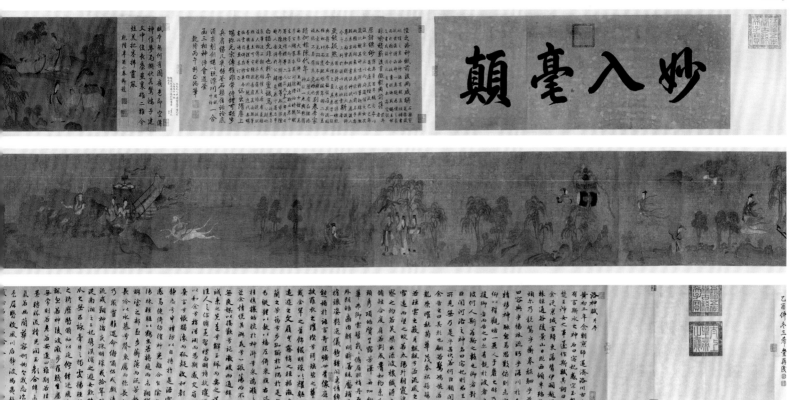

徙倚仿徨，神光離合，乍陰乍陽。竦輕軀以鶴立，若將飛而未翔。踐椒塗之郁烈，步蘅薄而流芳。超長吟以永慕兮，聲哀厲而彌長。爾乃眾靈雜遝，命儔嘯侶，或戲清流，或翔神渚，或採明珠，或拾翠羽。從南湘之二妃，攜漢濱之游女。歎匏瓜之無匹，詠牽牛之獨處。揚輕袿之猗靡，翳修袖以延佇。體迅飛鳧，飄忽若神，陵波微步，羅襪生塵。動無常則，若危若安。進止難期，若往若還。轉盼流精，光潤玉顏。含辭未吐，氣若幽蘭。華容婀娜，令我忘餐。於是屏翳收風，川后靜波。馮夷擊鼓，女媧清歌。騰文魚以警乘，鳴玉鸞以偕逝。六龍儼其齊首，載雲車之容裔，鯨鯢踊而夾轂，水禽翔而為衛。於是越北沚，度南岡，紆素領，迴清陽，動朱唇以徐言，陳交接之大綱。恨人神之道殊，怨盛年之莫

當。抗羅袂以掩涕兮，淚流襟之浪浪。無微誠以效愛兮，獻江南之明璫。雖潛處於太陰，長寄心於君王。忽不悟其所舍，悵神宵而蔽光。於是背下陵高，足往神留，遺情想像，顧望懷愁。冀靈體之復形，御輕舟而上遡。浮長川而忘返，思綿綿而增慕。夜耿耿而不寐，霑繁霜而至曙。命僕夫而就駕，吾將歸乎東路。攬騑轡以抗策，悵盤桓而不能去。顧長康畫流傳世間者，落落如星鳳矣。今日乃得見《洛神圖》真跡，喜不自勝，謹以逸少法，書陳思王賦於後，以誌敬仰云。大德三年（1299）子昂。」（偽）

鈐印：「趙」朱文方印（偽）、「大雅」朱文方印（偽）、「松書齋圖書印」朱文方印（偽）、「趙氏子昂」朱文方印（偽）、「趙孟頫印」朱文方印（偽）

元 李衎（尾紙）：

「畫之有長康，猶草書之有伯英，楷書之元常，發前人所未發，開後人師承，確乎三絕之一也。是卷曾載《宣和書譜》，鈐縫贉尾今止存「明昌」、「御府寶繪」、「群玉中秘」、「明昌御覽」四璽於後，是又經金章宗秘藏，而剪割宣、政題、璽者也。何幸為敬仲博士所收，敬仲鑒賞精絕，收藏甚富，名繪雖多，吾固知其不能出此圖右矣。敬仲其世寶之。大德丁未（1307）秋九月薊丘李衎。」（偽）

鈐印：「襄世家李氏」朱文方印（偽）、「李衎仲賓」白文方印（偽）、「息齋」朱文方印（偽）

元　虞集（尾紙）：

「凌波微步襪生塵，誰見當時窈窕身。能賦已輸曹子建，善圖惟數錫山人。仙井虞集。」（偽）

　　鈐印：「虞集」朱文方印（偽）

明　沈度（尾紙）：

「晉人畫世不多見，況烜烘如虎頭者耶？觀其樹石奇古，人物秀麗，實開六法之祖，譜稱天材獨步，妙造精微，雖荀、衛、曹、張、未足方駕，洵不虛也。永樂十五年脩禊日，雲間沈度謹識。」（偽）

　　鈐印：「自樂軒」朱文長方印（偽）、「雲間沈度」白文方印（偽）、「侍講學士之章」白文方印（偽）

明　吳寬（尾紙）：

「僊妃不可即，洛水遙相望。手持青芙蓉，游戲水中央。金翠耀容飾，木難最明瑲。飄飖白雲裾，蕩漾青霓裳。人神本殊道，倏忽登北堂。嫣然啟玉齒，氣若幽蘭香。馮夷與海若，左右更舉觴。洛水詎可測，人壽安能量。雲軿期再來，少隔三千霜。成化庚寅春三月長洲吳寬。」（偽）

　　鈐印：「吳寬」朱文方印（偽）、「原博」朱文方印（偽）

清　弘曆

（一題，隔水）：

「賦本無何有，圖應色即空。傳神惟夢雨，擬狀若驚鴻。子建文中俊，長康畫裏雄。二難今並美，把卷拂靈風。乾隆辛酉（1741）小春御題。」

　　鈐印：「幾暇臨池」白文方印、「稽古右文之璽」白文方印

（二題，尾紙）：

「嬉。左倚采旄，右蔭桂旗。攘皓腕於神滸兮，採湍瀨之元芝。余情悅其淑美

兮，心振蕩而不怡。無良媒以接歡兮，託微波以通辭。願誠素之先達兮，解玉珮以要之。嗟佳人之信脩兮，羌習禮而明詩。抗瓊珶以和予兮，指潛淵而為期。執拳拳之款實兮，懼斯靈之我欺。感交甫之棄言，悵猶豫而狐疑。收和顏以靜志兮，申禮防以自持。於是洛靈感焉，徙倚仿徨。神光離合，乍陰乍陽。擢輕軀以鶴立，若將飛而未翔。踐椒塗之郁烈兮，步衡薄而流芳。超長吟以慕遠兮，聲哀厲而彌長。爾乃眾靈雜遝，命疇嘯侶。或戲清流，或翔神渚，或採明珠，或拾翠羽。從南湘之二姚兮，攜漢濱之游女。歎匏瓜之無匹兮，詠牽牛之獨處。揚輕袿之猗靡兮，翳脩袖以延佇。體迅飛。此與三希堂王氏真跡，皆足為《石渠寶笈》中書畫壓卷。後幅紙極佳，因背臨子敬十三行，以志欣賞，乾隆己巳（1749）小除夕御識。」

　　鈐印：「幾暇怡情」白文方印、「得佳趣」白文方印

（三題，隔水）：

「是卷用筆設色，非近代繪法，特李息齋，虞伯生等跋，並以為顧長康作，未識何據。內府別藏愷之《女史箴圖》，偶一展閱，其神味渾穆，筆趣亦異是卷。乃悟前人評鑒，多涉傅會，然要為宋以前名手無疑也。卷末吳興書《洛神賦》，當亦屬後人摹本，予臨大令《十三行》既竟，復加審定，輒識數語，以示具正法眼藏者。乾隆御筆。」

　　鈐印：「澄觀」朱文長方印、「會心不遠」白文方印、「德充符」朱文方印

（四題，尾紙）：

「絹新於第二卷，此宋牋卻舊。乙酉（1765）仲冬三希堂再識。」

　　鈐印：「乾」朱文圓印、「隆」朱文方印

（五題，引首二）：

「愷之《洛神賦》，前後兩成駢（《石渠寶笈》舊藏顧愷之畫洛神，後有趙孟頫補書賦，茲復得《洛神》一卷，題為愷之畫，而於圖中分段書賦語，或稱王獻之書，或稱愷之，自書亦無定說）。非喻積薪後，重徵數典前。舊（前弆者）原訝縹緲（舊卷辛酉年題句，本以為長康真跡，及己巳年復加審定，且以內府藏愷之《女史箴》比較，其神味渾穆，筆趣殊異，然此雖非顧畫，要為宋以前名手無疑，卷末吳興書《洛神賦》，亦屬後人摹本，因重加題識，並臨大令十三行於後，以誌欣賞），新（後得者）更致疑然（茲新得之卷，梁清標題為愷之畫，其卷首一段，與舊本不合，且有補綴痕，其後段雖相似，而遺脫「明珠」、「翠羽」二句，蓋亦宋元間臨本，而脫落補緝，不若舊卷完好也）。別卷李家跡，何標陳代年。（《石渠》又有白描《洛神賦》一卷，與新舊兩卷大略仿佛。王澍、汪士鋐跋為李公麟摹本，其所據僅「伯時」、「龍眠」朱墨二印，並無公麟名款；且卷中署徐僧權等六人及天嘉二年月日，乃陳文帝年號，僧權等亦皆梁、陳時人，安得於公麟畫卷中署名乎）白描允非也，粉本宣誠焉（此卷與公麟他畫筆法不類，或顧愷之原有是圖，後人相傳粉本，新舊卷均從此脫胎，亦未可定。雖非長康真面，然筆墨楮素深秀古雅，迥越近代，亦堪珍賞，因併存珍弆，各書此詩兼為訂正）。總出隋唐上，堪珍元宋傳。雖非常侍體，可擬步兵肩。緁几幾餘鑒，石渠佳話詮。底須求刻劍，堪以玩浮川（用賦中語）。一合函三相，神傳會道筌。乾隆丙午（1786）新正御筆。」

　　鈐印：「古稀天子之寶」朱文方印、「猶日孜孜」白文方印

（六題，本幅）：
「《洛神賦》第一卷。」
　　鈐印：「古稀天子之寶」朱文方印

清　董誥（本幅前裱邊）：
「此卷已入《石渠寶笈》。辛酉、己巳、乙酉、丙午四經題識，定為第一卷，貯御書房，臣董誥奉敕敬書。」
　　鈐印：「臣」朱文方印、「誥」白文方印

清　和珅（尾紙）：
「石渠洛神藏二圖，長康繪事公麟仿。茲復得一仍愷之，題詞鑒跋相標榜。舊弆非真見睿題，新圖一手如出兩。白描亦非顧所長。梁陳時日多霄壤。筆墨古雅楮素佳，臨摹應在隋唐上。採珠拾翠或糢糊。春松秋菊堪神往。三而一焉合貯宜，分題屬賦欣宸賞。臣和珅敬題。」
　　鈐印：「臣」朱描方印、「和坤之印」白文方印

清　梁國治（尾紙）：
「虎頭妙筆陳思賦，遺跡千年尚艷稱。一自石渠留煥爛，更披新卷見騰凌。天題最有傳神賞，粉本從矜絕代能。幾度彷徨證離合，欲因風御碧霄層。臣梁國治敬題。」
　　鈐印：「臣」朱文方印、「治」朱文方印

清　董誥（尾紙）：
「長康寫洛神，新舊卷聚訟。別撰龍眠圖，證之疑益貢。豈知卅載前，披茲鑒早洞。藍本有流傳，精審片言中。真面識丹青，贋鼎辨唐宋。翰藻三復題，聲價千秋重。驪珠綴十三，行行光燭棟。鷗波既凡庸，大令亦駭恫。虎頭三絕傳，瞠乎仰天縱。囪三茲權輿，後來洵季仲。臣董誥敬題。」

　　鈐印：「臣」朱文方印、「誥」白文方印

鑒藏印：
金　完顏璟：
「明昌」白文長方印（偽）
「御府寶繪」朱文方印（偽）
「群玉中祕」朱文長方印（「群玉」二字
　　為描補）
「明昌御覽」朱文方印

元　趙孟頫：
「松雪齋圖書印」朱文方印（偽）

清　弘曆：
「五福五代堂古稀天子寶」朱文
　　方印（二次）
「垂露」朱文長方印
「大塊假我以文章」白文長方印
「執兩用中」白文方印
「妙意寫清快」朱文長方印（二次）
「萬有同春」朱文方印
「追琢其章」白文方印
「齊物」朱文長方印
「乾隆御覽之寶」朱文橢圓印
「石渠寶笈」朱文長方印
「御書房鑒藏寶」朱文橢圓印
「三希堂精鑒璽」朱文長方印
「宜子孫」白文方印
「敲詩月下周還久」朱文方印
「㳤芳潤」白文方印
「虛衷澄照」朱文方印
「乾隆鑒賞」白文圓印
「石渠繼鑒」朱文方印
「古希天子」朱文圓印
「八徵耄念之寶」朱文方印
「落華滿地皆文章」白文長方印
「太上皇帝之寶」朱文方印
「書史研求遵寶訓」朱文長方印
「個中自有玉壺冰」朱文橢圓印

「靜中觀造化」朱文長方印
「叢雲」朱文長方印
「涵虛朗鑒」白文方印
「研露」朱文長方印
「煙雲舒卷」白文方印
「成性存存」朱文方印

清　顒琰：
「嘉慶御覽之寶」朱文橢圓印

清　溥儀：
「宣統御覽之寶」朱文方印

其他：
「合同」朱文長方印（二次）

LTC, RW

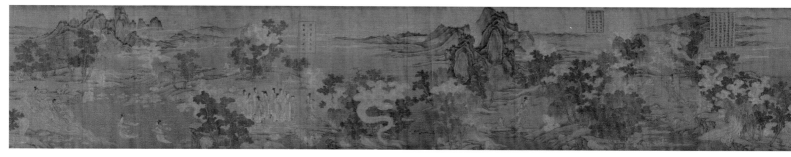

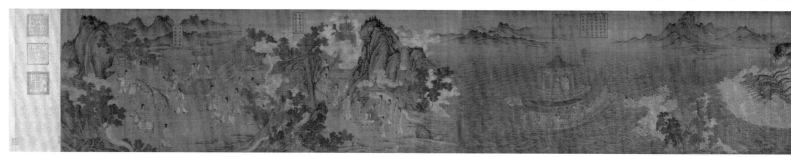

CAT. 4

Nymph of the Luo River
(Southern Song copy)
Gu Kaizhi (346–407)

本幅：

無作者款識。

南宋　佚名
（一題）：

「洛神賦。」

（二題）：

「余從京師，言歸東藩。」

（三題）：

「背伊闕，越轘轅。」

（四題）：

「稅駕乎蘅皋，秣駟乎芝田；容與乎陽
林，流眄乎洛川。」

（五題）：

「授御者而告之曰：爾有覿於彼
者乎？御者對曰：臣聞河洛之神，
名曰宓妃。」

（六題）：

「遠而望之，皎若太陽升朝霞；迫而察
之，灼若芙蕖出綠波。披羅衣之璀粲，
珥瑤碧之華琚；戴金翠之首飾，綴明珠
以耀軀。踐遠游之文履，曳霧綃之輕裾；
微幽蘭之芳藹，步踟躕於山隅。」

（七題）：

「忽焉縱體，以遨以嬉。左倚采旄，
右蔭桂旗。攘皓於神滸，采湍瀨之
玄芝。」

（八題）：

「願誠素之先達，解玉珮以要之。」

（九題）：

「衆靈雜遝，命儔嘯侶。或戲清流，或翔
神渚。或采明珠，或拾翠羽。從南湘之
二妃，攜漢濱之游女。體迅飛鳧，飄忽
若神。凌波微步，羅襪生塵。」

（十題）：

「進止難期，若往若還。轉眄流精，光潤
玉顏。含詞未吐，氣若幽蘭。華容婀娜，
令我忘餐。」

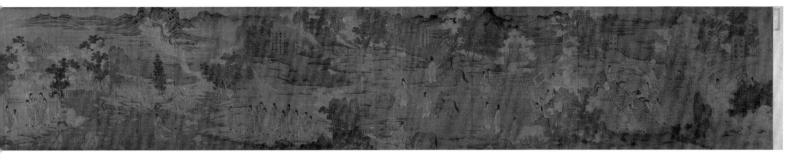

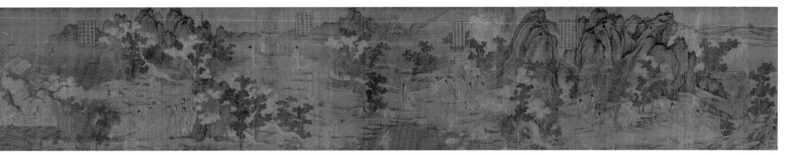

（十一題）：
「屏翳收風，川后靜波。馮夷鳴鼓，女媧清歌。騰文魚以警乘，鳴玉鸞以偕逝。」

（十二題）：
「六龍儼其齊首，載雲車之容裔；鯨鯢踊而夾轂，水禽翔而爲衛。」

（十三題）：
「背下陵高，足往心留。遺情想象，顧望懷愁。冀靈體之復形，御輕舟而上溯。浮長川而忘反，思綿綿而增慕。」

（十四題）：
「夜耿耿而不寐，霑繁霜而至曉。」

（十五題）：
「命僕夫而就駕，吾將歸乎東路。」

鑒藏印：
清　弘曆：
「乾隆御覽之寶」朱文方印
「石渠寶笈」朱文長方印
「御書房鑒藏璽」朱文橢圓印
「三希堂精鑒璽」朱文長方印
「宜子孫」白文方印
「太上皇帝之寶」朱文方印（二次）
「古希天子」朱文圓印
「乾隆鑒賞」白文圓印
「天地為師」朱文長方印
「五福五代堂古稀天子寶」朱文方印
「八徵耄念之寶」朱文方印
「筆華春雨」白文方印

清　顒琰：
「嘉慶御覽之寶」朱文長方印

清　溥儀：
「宣統鑒賞」朱文方印
「無逸齋精鑒璽」朱文長方印
「宣統御覽之寶」朱文橢圓印

PYY, YSY

CAT. 5

Biography of Zhang Han in Running-Regular Script (Tang copy)

Ouyang Xun (557–641)

本幅：

唐　歐陽詢：

「張翰，字季鷹，吳郡人。有清才，
善屬文，而縱任不拘，時人號之爲
『江東步兵』。後謂同郡顧榮曰：天下
紛紜，禍難未已。夫有四海之名者，
求退良難。吾本山林間人，無望於時。
子善以明防前，以智慮後。榮執其（脫
字「手」）愴然。翰因見秋風起，乃思吳
中菰菜鱸魚，遂命駕而歸。」（唐人摹）

題跋：

北宋　趙佶：

「唐太子率更令歐陽詢書《張翰帖》。
筆法險勁，猛銳長驅，智永亦復避鋒。
雞林嘗遣使求詢書，高祖聞而嘆曰：
詢之書名遠播四夷。晚年筆力益剛勁，
有執法面折庭爭之風，孤峰崛起，
四面削成，非虛譽也。」

鑒藏印：

南宋　趙構：

「紹」「興」朱文連珠方印
「紹」「興」朱文連珠方印半印（二次）
「紹」「興」朱文連珠方印
「紹」「興」朱文連珠方印

南宋　賈似道：

「長」朱文方印

清　安岐：

「朝鮮人」白文長方印
「安岐之印」白文方印
「儀周鑒賞」白文方印

CAT. 5

其他：

「□□」白文半印
「□□□□」朱文半印
「□□之印」朱文方印半印

LTC, JL

CAT. 6

Copy of the Orchid Pavilion Preface in Running Script
Attributed to Yu Shinan (558–638)

本幅：

唐　虞世南（傳）：

「永和九年，歲在癸丑，暮春之初，會于會稽山陰之蘭亭，脩禊事也。群賢畢至，少長咸集。此地有崇山峻領，茂林脩竹；又有清流激湍，映帶左右。引以為流觴曲水，列坐其次。雖無絲竹管弦之盛，一觴一詠，亦足以暢敘幽情。 是日也，天朗氣清，惠風和暢。仰觀宇宙之大，俯察品類之盛，所以游目騁懷，足以極視聽之娛，信可樂也。 夫人之相與，俯仰一世。或取諸懷抱，悟言一室之內；或因寄所託，放浪形骸之外。雖趣舍萬殊，靜躁不同，當其欣於所遇，暫得於己，快然自足，不知老之將至。及其所之既惓，情隨事遷，感慨係之矣。向之所欣，俯仰之間，以為陳跡，猶不能不以之興懷。況脩短隨化，終期於盡。古人云：死生亦大矣。豈不痛哉！ 每攬昔人興感之由，若合一契，未嘗不臨文嗟悼，不能喻之於懷。固知一死生為虛誕，齊彭殤為妄作。後之視今，亦由今之視昔，悲夫！故列敘時人，錄其所述，雖世殊事異，所以興懷，其致一也。後之攬者，亦將有感於斯文。」

題跋：

清　董邦達（畫套內側）：

「臣董邦達恭繪。」

　　鈐印：「臣」朱文方印、「邦達」白文方印

清　無名款（畫套內側）：

「虞世南臨蘭亭序。董其昌畫禪室舊藏。」

清　弘曆（外題簽）：

「唐虞世南臨蘭亭帖。內府珍玩。」

　　鈐印：「御賞」朱文長方印、「乾隆宸翰」朱文方印

清　弘曆（內題簽，包首）：

「蘭亭八柱第一。」

　　鈐印：「乾隆宸翰」朱文方印

清　梁清標（內題簽，前隔水）：

「唐虞永興臨禊帖。蕉林寶藏。神品上上。」

南宋　魏昌、楊益（尾紙）：

「淳熙五年（1178）十月朔，魏昌、楊益同觀。」

元　張金界奴（本幅補紙）：

「臣張金界奴上進。」

元末明初　宋濂（尾紙）：

「搨書至難，必鈎勒而後填墨，最鮮得形神兩全者，必唐人妙筆始為無愧，如此卷者是也。外簽乃趙文敏公所題，則其賞愛不言可知矣。翰林學士承旨金華宋濂謹題。洪武九年（1376）六月廿二日。」

明　王祐（尾紙）：

「天順甲申（1464）五月望後二日，王祐與徐尚賓同往崑山，閱于雪篷舟中。」

明　張弼（尾紙）：

「成化戊戌（1478）二月丙午葉萱、周同軌、古中靜與予同觀于楊士傑之衍澤樓。張弼記。」

明　蔣山卿（尾紙）：

「右軍墨妙，盡於《蘭亭》一帖，其真跡不傳矣。見其仿佛者尚能使人玩賞不置，何怪乎當時珍愛之耶？吳人蔣山卿。」

　　鈐印：「蔣氏子雲」白文方印

明　揚明時（尾紙）：

「萬曆戊戌（1598）除夕，用卿從董太史索歸是卷。同觀者吳孝父治、吳景伯國遜、吳用卿廷、揚不棄、明時。焚香禮拜，時在燕臺寓舍。執筆者，明時也。」

明　朱之蕃（尾紙）：

「定武佳刻、世已希遘，矧唐人手筆妙得神情，可稱嫡派者乎！此卷古色黯澹中，自然激射，淵珠匣劍，光怪離奇，前人所共賞識，用卿宜加十襲藏之。金陵朱之蕃。」

　　鈐印：「聽默」朱文長方印、「元介」白文方印、「朱之蕃印」朱文方印

明　王衡（尾紙）：

「甲辰（1604）閏九月九日，王衡敬觀于春水船。」

　　鈐印：「王衡之印」白文方印

明　董其昌（一題，後隔水）：

「萬曆丁酉（1597）觀於真州，吳山人孝甫所藏，以此為甲觀。後七年甲辰（1604）上元日吳用卿攜至畫禪室，時余已摹刻此卷於《鴻堂帖》中。董其昌題。」

（二題，尾紙）：

「趙文敏得獨孤長老定武《禊帖》，作十三跋。宋時尤延之諸公聚訟爭辨，祇為此一片石耳，況唐人真跡墨本乎！此卷似永興所臨，曾入元文宗御府，假令文敏見之，又不知當若何欣賞也！

久藏余齋中，今為止生所有，可謂得所歸矣。戊午（1618）正月董其昌題。」

明 吳廷（尾紙）：
「戊午（1618）正月廿二，新安吳廷、京山王制、楊鼎熙、王應侯同觀於董太史世春堂。」

明 楊宛（尾紙）：
「唐虞永興臨定武《蘭亭》，自董玄宰太史流傳至石民內子楊宛收藏。」
鈐印：「水中央」朱文長方印、「楊宛私印」白文方印、「宛朱氏」白文方印

明 陳繼儒（尾紙）：
「世人僅見褚摹《禊本》，今此卷為虞永興所摹，尤是希有無上之觀。玄宰割

贈茅止生，永不落劫矣。陳繼儒獲觀敬題。」
鈐印：「眉公」朱文方印、「一腐儒」白文方印

明 楊嘉祚（尾紙）：
「先文貞輔仁廟監國時，學士王偁進唐摹《禊帖》。睿旨命勒石大本堂，以榻本賜焉。予家藏此帖，晉人典刑，遂覺未遠。茲復睹止生藏永興墨跡，所謂『欲窮千里目、更上一層樓』也。楊嘉祚敬題。」
鈐印：「邦隆父」白文方印、「楊嘉祚印」白文方印

清 弘曆
（一題，引首）：
「《題蘭亭八柱冊並序》。自永和之脩禊，觴詠初傳；迨貞觀之搜珍，鉤摹迭出。惟定武馳聲籍甚，而闕文聚訟紛如。寖

至翻刻失真，亦復操觚求似。顧善本之難覯，贗鼎無慮百千；且好手之罕逢，名跡或存什一。緊諫議寫其篇帙，波折又新泊香光倣彼筆蹤，抒機獨運。余既使舊卷之離而重合，因從幾暇再臨尋復。惜原本之剝而不完，詔付文臣遍補，於是四冊並教刻鵠。然而一編不外《戲鴻》，繼披柳跡於石渠，兼集唐模於壁府。仍琬琰之咸列，俾甲乙以分函。允為藝苑聯珠，題曰「蘭亭八柱」。若承天之八山峻嶺，極和布而為埏；譬畫卦之八體流形，奇偶比而依次。分詠已舉其要，匯吟更括其全。

賺來自蕭翼，舉出本元齡。真已堂堂佚，搨猶字字馨。誰知聯後璧，原賴弄前型（柳公權書《蘭亭詩》，惟於《戲鴻堂帖》見之，初不知其墨跡已入內府，近閱《石渠寶笈》書，始知其卷久列名書上等。《石渠寶笈》乃張照等所

校定，而其昌所臨柳卷即藏照家。且戲鴻堂刻本亦照所深悉，乃柳卷無其昌題識。及卷後黃伯思諸跋，未經刻入，皆其中之可疑者，照曾未一語及之，亦不免疏漏矣。）。恰爾排八柱，居然承一亭。擎天徒蜼語，特地示真形。摹固得骨髓（謂褚、虞、馮。），書猶闖逕庭（謂柳，見董其昌臨帖自識語。）。董臨傳聚散（董其昌臨公權卷，初藏張照家，本屬全卷，後以『四言詩』並《後序》及『五言詩』析而為二卷。蓋照身後為人竊取也。及二卷先後入內府，經比較，知其故，復令聯綴成卷，俾為完璧。名跡流傳，離而復合，或默有呵護之者耶？），于補惜凋零（戲鴻堂所刻柳詩，漫漶闕筆者多，去歲特命于敏中就邊傍補之。）。殿以幾餘筆，藝林嘉話聽。乾隆己亥（1779）暮春之初御筆。」

鈐印：「乾」朱文圓印、「隆」朱文方印

（二題，後隔水）：
「此卷經董其昌定為虞永興摹，以其於褚法外別有神韻也。香光得之吳氏，後雖以贈茅元儀，而在香光齋頭頗久，故歸之畫禪室中。御題。」

鈐印：「乾」朱文圓印、「隆」朱文方印

（三題，尾紙）：
「搶豪快睹永興書，林靜煙新改火餘。
何似山陰王逸少，崇山曲水暮春初。
坦腹東床意欲仙，由來字必以人傳。
若從肥瘦論形似，逐塊錐舟我不然。
米家寶晉漏傳名，學士風流儼若生。
腕覆廓填都不管，春風即景獨怡情。
於停蓄處有波濤，真比長安薛刻高。

甲乙何須誇博辨，幾多優孟效孫敖。
丁卯（1747）上巳觀因題。」

鈐印：「澄觀」朱文長方印、「幾暇怡情」白文方印、「得佳趣」白文方印

鑒藏印：
南宋　趙構：
「內府圖書」朱文方印
「紹」「興」朱文連珠方印
「紹」「興」朱文連珠方印
「紹」「興」朱文連珠方印
「御前之印」朱文方印（偽）

南宋　滕袍：
「滕袍伯壽永存珍秘」朱文長方印

元　張氏：
「張氏珍玩」白文方印

「北燕張氏寶藏」朱文方印

元　圖帖睦爾：
「天曆之寶」朱文方印

明　吳國遜：
「吳國遜印」朱文方印 (二次)

明　吳廷：
「餘清齋圖書印」朱文方印 (二次)
「吳廷書印」朱文方印 (二次)
「江村」朱文葫蘆印 (三次)
「吳廷之印」白文方印 (二次)
「用卿氏」白文方印 (二次)
「吳廷」朱文長方印 (二次)

明　楊明時：
「楊明時印」朱文方印
「不弃」朱文方印
「楊明時印」白文方印
「不弃」朱文方印

明　茅元儀：
「茅止生圖書印」朱文長方印

明　楊宛：
「楊宛叔圖書記」白文長方印

明末清初　馮銓：
「馮氏鹿庵珍藏圖籍印」朱文方印
「馮銓之印」朱文方印

清　梁清標：
「梁清標印」白文方印
「蕉林鑒定」白文方印
「蒼巖子梁清標玉立氏印章」朱文方印
「蕉林秘玩」朱文方印
「蕉林玉立氏圖書」朱文方印
「觀其大略」白文方印 (二次)
「安定」朱文長方印 (二次)

「蒼巖子」朱文圓印
「蕉林」朱文方印

清　安岐：
「儀周鑒賞」白文方印 (二次)
「安氏儀周書畫之章」白文長方印 (二次)
「朝鮮人」白文長方印
「安岐之印」白文方印

清　弘曆（畫套內側）：
「畫禪室」朱文方印
「研精固得趣」白文長方印
「契理亦忘言」朱文方印
「石渠寶笈」朱文長方印
「乾隆御覽之寶」朱文橢圓印

（卷內）：
「畫禪室」朱文方印
「研精固得趣」白文長方印
「契理亦忘言」朱文方印
「石渠寶笈」朱文長方印
「乾隆御覽之寶」朱文橢圓印
「五福五代堂古稀天子寶」朱文方印
「八徵耄念之寶」朱文方印
「寓意於物」朱文方印
「用筆存心」白文方印
「妙意寫清快」朱文長方印
「幾暇鑒賞之璽」朱文方印 (二次)
「御賞」朱文長方印 (四次)
「乾隆鑒賞」白文圓印
「三希堂精鑒璽」朱文長方印
「宜子孫」白文方印
「內府圖書」朱文方印 (二次)
「石渠定鑒」朱文圓印
「寶笈重編」白文方印
「研露」朱文長方印
「古希天子」朱文圓印
「壽」白文方印
「乾隆御玩」白文方印
「重華宮鑒藏寶」朱文長方印

「內府書畫之寶」白文方印
「太上皇帝之寶」朱文方印

其他：
「□□」朱文葫蘆印
「□□□□」朱文方印半印
「□□圖書」朱文方印半印
「□□」半印
「□□」半印
「□壽」白文長方印半印
「□□」朱文方印半印
「□□□□」白文長方印
「司馬家藏翰墨圖書」朱文葫蘆印
「西□司馬氏圖書記」朱文長方印
「杏花村酒人」朱文方印

LTC, RW

CAT. 7

Six Arhats (Song copy)
Lu Lengjia (active 730–760)

本幅：
唐　盧楞伽
（第二開）：
「盧楞伽進。」（後添款）

（第三開）：
「盧楞伽進。」（後添款）

（第四開）：
「盧楞伽進。」（後添款）

（第五開）：
「盧楞伽進。」（後添款）

（第六開）：
「盧楞伽進。」（後添款）

（第七開）：
「盧楞伽進。」（後添款）

題跋：
清　弘曆（內題簽，冊頁前副頁）：
「盧楞伽畫六尊者像。真跡神品。」
　　鈐印：「畫禪室」朱文橢圓印

清　無款（內題簽，第一開右上裱邊）：
「盧楞伽畫六尊者像一冊。應續入《秘殿珠林》上等。」

清　弘曆（第一開，引首）：
「六通證果。」
　　鈐印：「乾隆御筆」白文方印

元 / 明　內府（第二開本幅與右側裱邊騎縫）：
「二字壹號。」（千字文編號）

清　弘曆（第一開，對題）：
「《般若波羅蜜多心經》。觀自在菩薩，行深般若波羅蜜多時，照見五蘊皆空，度一切苦厄。舍利子。色不異空，空不異色；色即是空，空即是色。受、想、行、識，亦復如是。舍利子。是諸法空相，不生不滅，不垢不淨，不增不減。是故空中無色，無受、想、行、識，無眼、耳、鼻、舌、身、意，無色、聲、香、味、觸、法，無眼界，乃至無意識界。無無明，亦無無明盡；乃至無老死，亦無老死盡；無苦集滅道；無智亦無得。以無所得故，菩提薩埵，依般若波羅蜜多故，心無罣礙，無罣礙故，無有恐怖，遠離顛倒夢想，究竟涅槃。三世諸佛，依般若波羅蜜多故，得阿耨多羅三藐三菩提。故知般若波羅蜜多，是大神咒，是大明咒，是無上咒，是無等等咒，能除一切苦，真實不虛。故說般若波羅蜜多咒，即說咒曰：答達鴉塔阿。噶得噶得。巴阿喇噶得。巴阿喇桑噶得。玻提娑訶。般若波羅蜜多心經。乾隆丙戌（1766）春二月朔，御筆。」
　　鈐印：「得大自在」白文方印、「乾隆宸翰」白文方印

（第二開，本幅）：
「第八嘎納嘎拔哈喇�雜尊者。」
　　鈐印：「乾隆宸翰」朱文方印

（第二開，對題）：
「嘎納嘎拔合喇�雜尊者。發願度人，繼佛出世。相示傴僂，風清月霽。波斯長跪，獻寶於前。金剛四句，卻在汝邊。御贊。」

　　鈐印：「歡喜園」朱文方印、「乾隆宸翰」白文方印

（第三開，本幅）：
「第三拔納拔西尊者。」
　　鈐印：「乾隆宸翰」朱文方印

（第三開，對題）：
「拔納拔西尊者。趺坐竹床。南無雙手。語乎默乎。學人稽首。僧雛擊磬。聲徹大千。三藏轉畢。法爾如然。御贊。」
　　鈐印：「歡喜園」朱文方印、「乾隆宸翰」白文方印

（第四開，本幅）：
「第十七嘎沙鴉巴尊者。」
　　鈐印：「乾隆宸翰」朱文方印

（第四開，對題）：
「嘎沙鴉巴尊者。瓶不滿尺，倒則瀉水。獰龍逾丈，躍出其裏。是何游戲，是何神通。尊者按扙，刄空外空。御贊。」
　　鈐印：「歡喜園」朱文方印、「乾隆宸翰」白文方印

（第五開，本幅）：
「第十八納納答密答喇尊者。」
　　鈐印：「乾隆宸翰」朱文方印

（第五開，對題）：
「納納答密答喇尊者。入山則猛。入禪則伏。嗟爾牛哀。倍三即六。或謂上座。有大威神。話成兩橛。未識應真。御贊。」
　　鈐印：「歡喜園」朱文方印、「乾隆宸翰」白文方印

（第六開，本幅）：
「第十五鍋巴嘎尊者。」
　　鈐印：「乾隆宸翰」朱文方印

（第六開，對題）：
「鍋巴嘎尊者。有僧擎前，寶像金蓮。化身千億，如拂絲然。億亦非多，一亦非少。以拂拂之，如如了了。御贊。」

　　鈐印：「歡喜園」朱文方印、「乾隆宸翰」白文方印

（第七開，本幅）：
「第十一租查巴納塔嘎尊者。」

　　鈐印：「乾隆宸翰」朱文方印

（第七開，對題）：
「租查巴納塔嘎尊者。苾芻炷香，篆成卍字。與佛胸前，無同無異。慧緣淨業，薰習法華。問誰作此，盧氏楞伽。御贊。」

　　鈐印：「歡喜園」朱文方印、「乾隆宸翰」白文方印

（第八開上）：
「盧楞伽畫冊六頁相好各具。初未詳其名目，因詢之章嘉。則首頁為十八應真中第八嘎納嘎拔哈喇雜尊者、次為第二拔納拔西尊者、三為第十七嘎沙鴉巴尊者、四為第十八納納答密答喇尊者、五為第十三巴納塔嘎尊者、六為第十一租查巴納塔嘎尊者。復證以貫休十八應真畫軸，不但降龍伏虎適當其神通，即其餘結相供具，亦髣髴印合。蓋畫本十八，茲僅存其三之一，既已失去大半，則裝裱時前後次第顛倒，亦理所必有。然楞伽至今千餘年，尺素流傳，雖蠹剝，尚足寶貴。矧此縑墨完好，屈指而計，恰得六度圓成耶。夫阿羅漢果本無我相人相，而一一佛，各有因緣，合之千億不為多，分之一亦不為少，更何必於全提半提間生分別想耶？昔西湖煙霞洞有石刻羅漢六尊，吳越王時因夢訪求，為補刻十二，以符靈跡，神物所在，合有天龍護持，他日或為煙霞之合，亦未可

知也。因標其名，各係以贊而識其梗概如此。丙戌（1766）仲春月御筆。」

　　鈐印：「如是觀」白文橢圓印、「乾隆御筆」朱文方印

清　于敏中（第八開下）：
「御題貫休十八羅漢贊。履杖飛行。非空非地。作不二觀。示第一諦。雪山證道。首聞雷音。作麼生會。如風竹吟。右第一阿迎阿機達尊者。

枯槎貫月。負鬼夷區。尊者抱膝。不動如如。圓相一筆。傳吳道子。問誰師承。貫休作此。右第二阿資答尊者。

嵌巖宴坐。似水中月。是卅二相。是恒沙劫。曰嘎禮嘎尊者。比肩光光相映。萬法如然。右第三拔納拔西尊者。

開眼見明。閉眼見暗。誰是上座。於何置念。舉人稽首。侍者擊磬。曰如不覺。其見墮聖。右第四嘎禮嘎尊者。

袒胸赤腳。不着雙屐。撫掌啞然。一闔一闢。禿髮龐眉。面若凍梨。喜少惡老。非慈其誰。右第五拔雜哩連答喇尊者。

合掌詢法。示之隻手。曰再請益。問汝會否。如是說法。豈不甚易。本來不難。汝自的置。右第六拔哈達喇尊者。

眉目清揚。示少年相。曾見威音。其壽無量。手托鍵鎝。盛食及水。渴飲飢餐。不異人耳。右第七嘎納嘎巴薩尊者。

拄杖過橋。拊侍者背。無畏上人。乃若有恃。貯琴於囊。急緩都忘。我聞如是。四十二章。右第八嘎納嘎拔哈喇雜尊者。

盤膝扁石。非默非語。着敝衲衣。破則自補。猴子齚蝨。蹲踞于旁。金鍼度彼。正自不妨。右第九拔嘎沽拉尊者。

傴僂台背。瘦如柴枯。雖事爬搔。不倩麻姑。痛痒自知。誰痛痒者。局局解頤。南無般若。右第十喇乎拉尊者。

怪石長松。於焉小憩。展卷而觀。亦無文字。五蘊皆妄。四大本空。咨憩觀者。曾何異同。右第十一租查巴納塔嘎尊者。

念珠在手。誦佛於口。是一是二。曰楊即柳。聞法最初。亦不執法。賓頭盧是。阿育設榻。右第十二畢那楂拉拔哈喇雜尊者。

如意拄膝。睟面盎背。蘊玉山輝。涵珠川媚。綠芭幾葉。覓心則空。設云即法。墮異道中。右第十三巴納塔嘎尊者。

手擎窣堵。高不滿尺。三千大千。納之無跡。諸佛開塔。法華所云。奚童烹茶。乃如不聞。右第十四納阿噶塞納尊者。

注目於鼻。叉手於胸。息踵達臚。內空外空。身既如幻。護指作麼。示大圓鏡。行六波羅。右第十五鍋巴嘎尊者。

偏袒右肩。合十雙手。即佛即魔。非空非有。波斯長跪。獻甘露漿。受觸辭背。真妄幻常。右第十六阿必達尊者。

淨瓶貯水。中育龍子。獰龍欲取。怒目以視。爾慈用猛。我猛用慈。慈猛俱幻。皈依導師。右第十七嘎沙鴉巴尊者。

手撫牛哀。如愛花狸。童子怖覰。不知所為。變相十八。貫休所傳。相即非相。朵朵青蓮。右第十八納納答密答喇尊者。

震旦所稱阿羅漢之號十六、十八，傳聞異辭。曩咨之章嘉國師而得其說，因證以《法住記》及《納納達答喇傳》，定為十六應真。而以《同文韻統》合音字正其名，命丁觀鵬視西湖貫休畫本，一再仿之，而再製贊焉。今重閱《秘殿珠林》《貫休羅漢像》十幀，其八並列二像，與前所定數悉合。其二像各一，則世所為降龍、伏虎者也。始覽而疑之，復詢諸章嘉，則一為嘎沙鴉巴尊

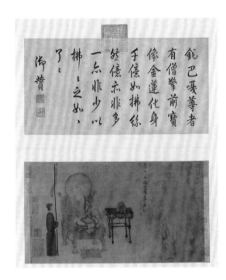

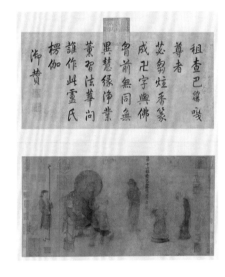

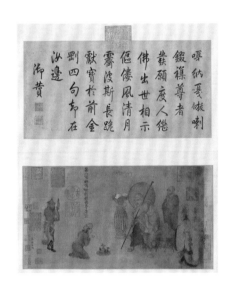

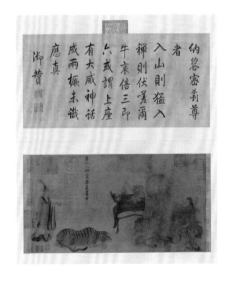

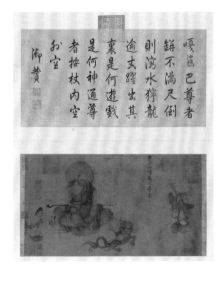

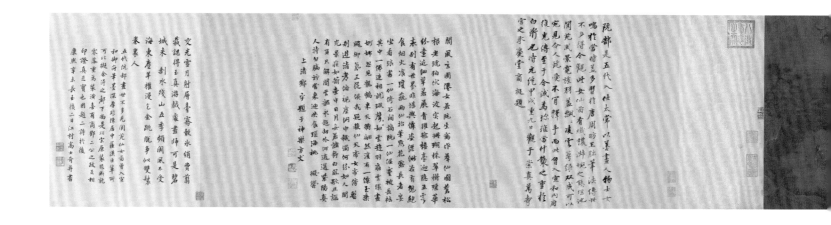

者，一為納納答密答喇尊者，乃知西域
十六應真之外，原別有降龍、伏虎二尊
者，以具大神通法力故，亦得阿羅漢名。
夫佛初出家時，阿難、迦葉為佛二大弟
子已，復合舍利弗以下八人，有「十大
弟子」之號；而俱鄰婆敷二比丘，亦隨
佛脩道為大弟子，乃不列於十者之數，
則二尊者之於阿羅漢，或分或合，亦如
是而已矣。況乎得阿羅漢果者，梵力圓
成，不復有我。人眾生壽者相，若五百、
若五千、乃至二萬五千，如恒河沙算
數，譬喻所不能盡，皆可作平等觀。顧
於十六、十八，生分別想耶？向嘗正蘇
軾《十八羅漢贊》重出之訛，今復取其
文而讀之，其於羅怙羅尊者則曰：「龍象
之姿，魚鳥所驚。」於伐那婆斯尊者則
曰：「逐獸于原，得箭忘弓。」非即降
龍、伏虎乎？蓋既誤以慶友賓頭名複
見，而所云羅怙羅即喇乎拉尊者，伐
那婆斯即拔納拔西尊者，賓度羅跋羅
墮闍即畢那楂拉拔哈喇錣雜尊者，蓋以
唐音切梵音故，舛訛至此，不如《同文
韻統》合音之為得正也。軾又有蜀金
水張氏畫《十八大阿羅漢頌》，其標題
有曰：「正坐入定，大蟒出其下者」。有
曰：「有虎過前，童子怖匿竊窺者。」而
其序若跋，多引十六羅漢神變事，則
以軾之《頌》印軾之《贊》，可；以軾

之《頌》、《贊》印章嘉之說，亦無不可。
若夫羅漢顯示圓通，不可究竟；讚歎亦
不可究竟。一偈一句，具大因緣，瓶水
雲天，隨指應現。佛聞如是，或亦拈花，
一囅然乎，係以華梵合音從其類。押
以「珠林繼鑒」璽者，自今以後，凡有
重題，將胥以此識之。臣于敏中奉敕敬
書。」（文中缺字據《御製文集》補）

　　鈐印：「臣于敏中」朱文方印、
「依光日月」白文方印

清　無款（第二開至第七開，本幅）：
朱筆梵文書畫像尊者名。

鑒藏印：
北宋　趙佶：
「宣」「龢」朱文連珠方印（偽）（六次）
「宣和」朱文長方印（偽）（六次）

南宋　趙構：
「紹」「興」朱文連珠方印（偽）（五次）
「內府書畫」朱文方印（偽）（六次）
「紹」「興」朱文連珠方印（偽）（五次）
「紹」「興」朱文連珠方印（偽）（二次）

元　祥哥剌吉公主：
「皇姊圖書」朱文方印

元／明　內府：
「禮部評驗書畫關防」朱文長方印

明　項元汴：
「子孫永保」白文方印（四次）
「桃花源裏人家」朱文長方印
「項叔子」白文方印（二次）
「項墨林父秘笈之印」朱文長方印（八次）
「退密」朱文葫蘆印（三次）
「項元汴印」朱文方印（七次）
「子京父印」朱文方印（五次）
「項墨林鑒賞章」白文長方印（六次）
「神」「品」朱文連珠方印（十二次）
「項元汴印」白文方印（四次）
「項氏子京」白文方印（二次）
「檇李項氏士家寶玩」朱文長方印（六次）
「神游心賞」朱文方印（三次）
「神」「奇」朱白文連珠方印
「子京珍秘」朱文方印（三次）
「子孫世昌」白文方印
「墨林秘玩」朱文方印（四次）
「墨林項季子章」白文長方印（三次）
「平生真賞」朱文方印（二次）
「天籟閣」朱文長方印（三次）
「墨林主人」白文方印
「項子京家珍藏」朱文長方印（八次）
「項元汴印」白文方印
「若水軒」朱文方印（二次）

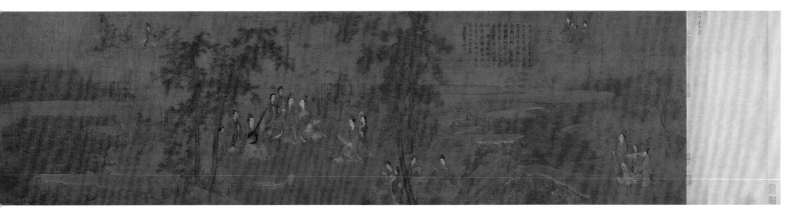

「蘐廬」白文長方印（二次）
「神」「品」朱文連珠橢圓印
「寄敖」朱文橢圓印

清　耿昭忠：
「琴書堂」白文方印
「珍秘」朱文方印（二次）
「宜爾子孫」白文方印

清　耿嘉祚：
「耿會侯鑒定書畫之章」
　　朱文方印（五次）
「耿嘉祚氏一字會侯書畫之章」
　　朱文方印（四次）
「會侯珍藏」白文方印（三次）
「湛思記」白文方印
「漢水耿會侯書畫之章」白文方印

清　安岐：
「儀周珍藏」朱文長方印（六次）

清　弘曆：
「五福五代堂古稀天子寶」朱文方印
　　（八次）
「古希天子」朱文圓印（六次）
「八徵耄念之寶」朱文方印（六次）
「秘殿珠林」朱文長方印
「乾隆御覽之寶」朱文橢圓印

「淨塵心室」白文長方印
「乾隆鑒賞」白文圓印
「三希堂精鑒璽」朱文長方印
「宜子孫」白文方印
「八徵耄念之寶」朱文方印

LAT, JL

CAT. 8

Female Immortals in Elysium
Ruan Gao (active 10th century)

本幅：
無作者款識。

題跋：
無款（前隔水）：
「養字拾玖號。」（半字編號）

元　商挺（尾紙）：
「阮郜是五代入仕太常，以善畫人物士女
鳴於當時，蓋多習於唐周昉、王朏筆法，
傳世不多得。今觀此《女仙圖》，有纖穠
淑婉之態，瑤池閬苑風景，霓旌羽蓋，
飄飄凌雲，蕚綠雙成，可以宛見，令人
玩愛不肯釋手。而此曾入宣和內府，復
克傳至于今，誠為珍寶。當什襲之重於
白珩也。時元統甲戌（1334）重九日，觀
于崇真萬壽宮之承慶堂，商挺題。」（偽）

元末明初　鄧宇（尾紙）：
「閬風玄圃僊女居，阮生寫作群仙圖。
蒼松根老琥珀伏，海波突起珊瑚株。
翠樹瑤華紛遠近，細草若展青氍毹。
樓臺迴隱五雲表，別有世界非堪輿。

僊姿縹緲若有態，絕食煙火餐瓊蔬。
兩仙拈筆點花露，長者宴坐看琅書。
一僊倚石閑摘阮，一僊偃蹇被長袪。
其中一僊遽相就，珮聲微響如雲趨。
羽扇雲環盡嫣娜，忽見龍鶴來天衢。
翩然復有一僊至，乘颷御氣三從俱。
我疑數僊天帝女，帝傍暫別游清都。
俯視塵網中，穢濁何紛如。人間光景
疾如箭，壺中日月無居諸。舞白鳳，
歌且謠，有耳祇解聞雲韶，永超劫外何
逍遙。紫陽真人持勿驕，竚當來迎共食
瑤海桃。上清鄧宇題於神樂方丈。」（偽）

鈐印：「鄧宇印」白文方印（偽）、
「鄧子方」白文方印（偽）、「清壑樵叟」
朱文方印（偽）

清 高士奇（尾紙）：
「交光雪月射層臺，霧縠冰綃費翦裁。認
得玉真游戲處，畫師可是碧城來。剩水
殘山五季頻，閬風不受海東塵。羊權漫
乞金跳脫，爭似雙鬟卷裏人。五代阮郜
畫世不多見，《閬苑仙女圖》曾入宣和
御府，筆墨深厚，非陳居中、蘇漢臣輩
所可比擬。余得之都下，尚是北宋原裝，
恐漸就零落，重為裝潢。喜有商、鄧二
公之跋，足相印證，真足寶也。因題二
詩於後。康熙辛未（1691）長至後二日，
江村高士奇並書。」

鈐印：「高士奇印」白文方印、
「澹人」朱文方印

清 弘曆（本幅）：
「控鶴乘龍落碧空，海山佳處勝游同。追
隨總是行雲侶，那計三壺與八鴻。霧袖

風裾稱體娟，休言玉杵結塵緣。上清亦
有遭淪謫，寄語人間漫學仙。周家昉與
王家胐，津逮猶餘五代人，不是宣和珍
什襲，相隨安得至崇真。丙戌（1766）春
日御題。」

鈐印：「乾」朱文圓印、「隆」朱文
方印

鑒藏印：

清 李振裕：
「白石山房書畫之印」朱文方印

清 高士奇：
「北墅」朱文長方印
「朗潤堂印」白文方印
「竹窗」朱文長方印
「高士奇」朱文方印
「高士奇圖書記」朱文長方印

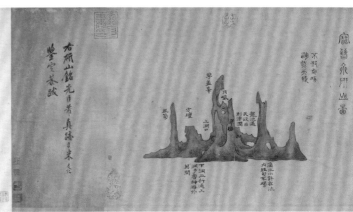

「黻香齋」朱文方印

「蕭兀齋」白文方印

「江村秘藏」朱文方印

「高詹事」白文方印

清 弘曆：

「御書房鑒藏寶」朱文橢圓印

「石渠寶笈」朱文長方印

「三希堂精鑒璽」朱文長方印

「宜子孫」白文方印

「乾隆御覽之寶」朱文方印

「古希天子」朱文圓印

「石渠繼鑒」朱文方印

「天恩八旬」朱文圓印

「五福五代堂古稀天子寶」朱文方印

「乾隆鑒賞」白文圓印

「八徵耄念之寶」朱文方印

清 顒琰：

「嘉慶御覽之寶」朱文橢圓印

清 溥儀：

「宣統御覽之寶」朱文方印

「宣統鑒賞」朱文方印

「無逸齋精鑒璽」朱文長方印

其他：

「□□」半印

「軍司馬印」白文方印（二次）

「□□朗□」白文方印

「□□□□」朱文方印

YSY, RW

CAT. 9

Encomium on a Mountain Inkstone in Running Script
Mi Fu (1051–1107)

本幅：

北宋 米芾：

「研山銘。五色水。浮崑崙。潭在頂。出黑雲。掛龍怪。燦電痕。下震霆。澤厚坤。極變化。閟道門。寶晉山前軒書。」

題跋：

近代 犬養毅（引首）：

「鳶飛魚躍。木堂老人毅。」

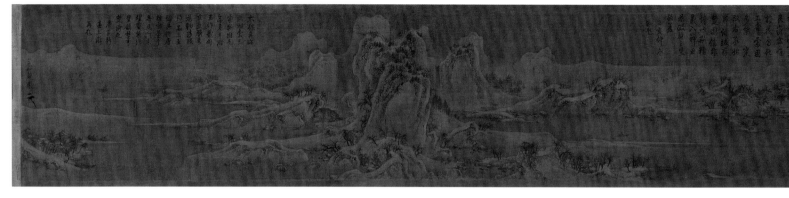

南宋 米友仁（尾紙）：

「右《研山銘》，先臣芾真跡，臣米友仁鑒定恭跋。」

金 王庭筠（尾紙）：

「鳥跡雀形，字意極古。變態萬狀，筆底有神。黃華老人王庭筠。」（偽）

無款（尾紙）：

「《寶晉齋研山圖》。不假雕琢，渾然天成。華蓋峰。月巖。上洞口。方壇。翠巒。玉筍。龍池遇天欲雨則津潤。滴水小許在池內，經旬不竭。下洞三折通上洞，予嘗神游於其間。」（後配）

清 陳浩（尾紙）：

「研山為李後主舊物。米老生平好石，獲此一奇，而銘以傳之。宜其書跡之尤奇也。昔董思翁極宗仰米書，而微嫌其不淡。然米書之妙在得勢，如天馬行空，不可羈勒，故獨能雄視千古，正不必徒以淡求之。若此卷則樸拙疏瘦，豈其得意時，心手兩忘，偶然而得之耶？使思翁見之，當別有說矣。乾隆戊子（1768）十一月，昌平陳浩題。」

鈐印：「陳浩之印」白文方印、「七十四翁」朱文方印、「夢德星庵」白文方印

清 周於禮（尾紙）：

「《研山銘》矯矯沉雄，米老本色如是如是。亦園周於禮題。」

鈐印：「聽雨樓主人」朱文方印

清 錢天樹（尾紙）：

「米老真跡生平茲見《陽關圖詩》及白粉箋上草書杜詩，後有三橋一跋，又婺源齊梅麓所藏尺牘與文公尺牘合裝一卷，後董思翁跋。《陽關圖》亦有思翁跋。並此而四件，俱是舊人雙鉤本，已覺可貴。此卷惜為庸妄人偽作《研山圖》，並將小米跋割裂，深為痛恨耳。道光三年（1823）癸未冬日，嘉興錢天樹記。」

鈐印：「錢天樹印」白文方印

鑒藏印：

北宋 趙佶：

「宣」「和」朱文連珠方印（偽）
「雙龍璽印」朱文圓印（偽）

南宋 趙構：

「內府書印」朱文方印
「紹」「興」朱文連珠方印
「內府書印」朱文方印（偽）（二次）。

南宋 賈似道：

「悅生」朱文葫蘆印（二次）
「長」朱文方印

元　柯九思：

「玉堂柯氏九思私印」朱文葫蘆印（偽）

清　周於禮：

「周於禮印」白文方印

「立厓」朱文方印

清　錢天樹：

「夢廬審定真迹」朱文方印

清　徐麟光：

「受釐」白文長方印（二次）

「石父」朱文方印

「受釐私印」白文方印

「石甫」朱文方印

清　于騰：

「于」「騰」白文連珠方印（二次）

「味腴軒」朱文橢圓印

「飛卿」朱文方印

「于騰私印」朱文方印（二次）

「東海郯人」白文方印

其他：

「湘石過眼」白朱文方印（二次）

「石禪弆子」白文方印

LTC, LAT

CAT. 10

Returning Boats on a Snowy River
Zhao Ji (Emperor Huizong, 1082–1135,
r. 1101–1125)

本幅：

北宋　趙佶

（一題）：

「雪江歸棹圖。」

（二題）：

「宣和殿製，天下一人（畫押）。」

　　鈐印：「御書」朱文葫蘆印

題跋：

清　弘曆（引首）：

「積素超神。」

　　鈐印：「乾隆御筆」朱文方印

無款（前隔水）：
「口字陸號。」（半字編號）

北宋 蔡京（尾紙）：
「臣伏觀御製《雪江歸棹》，水遠無波，天長一色，群山皎潔，行客蕭條，鼓棹中流，片帆天際，雪江歸棹之意盡矣。天地四時之氣不同，萬物生天地間，隨氣所運，炎涼晦明。生息榮枯，飛走蠢動。變化無方，莫之能窮。皇帝陛下以丹青妙筆，備四時之景色，究萬物之情態於四圖之內，蓋神智與造化等也。大觀庚寅（1110）季春朔，太師楚國公致仕臣京謹記。」

明 王世貞
（一題，尾紙）：
「宣和主人，花鳥雁行黃、易，不以山水人物名世，而此圖遂超丹青蹊逕，直闖右丞堂奧，下亦不讓郭河中、宋復古。其同雲遠水，下上一色，小艇戴白，出沒於淡煙平靄間。若輕鷗數點，水窮鼈得，積玉之島，古樹槎枒，皆少室三花，快哉觀也！度宸游之跡，不能過黃河艮嶽一舍許。何所得此景，豈秘閣萬軸一展翫間，即得本來面目耶！後蔡楚公元長跋，雖沓拖不成文，而行筆極楚楚，與余所藏題《聽阮圖》同結構。一時君臣於翰墨中作俊事乃爾，令人思藝祖韓，王椎朴狀。瑯琊王世貞題。」
　　鈐印：「弇山人」白文花印

（二題，尾紙）：
「據蔡楚公題有四圖，此當是最後景耳。題之十又六年，而帝以雪時避（狄字挖去）幸江南，雖黃麾紫仗斐亹於瑠浪瑤島中，而白羽旁午，更有羨於一披蓑之漁翁而不可得。又二年，而北竄五國，大雪沒駝足，縮身窮廬，與殨氈子卿伍。吾嘗記其《渡黃河》一小詞有云：『孟婆、孟婆，你做個方便，吹個船兒倒轉。』於戲，風景殺且盡矣。視《雪江歸棹》中王子猷，何啻天壤。題畢不覺三歎。世貞又題。」
　　鈐印：「元美」白文方印、「五湖長」白文方印

明 王世懋（尾紙）：
「朱太保絕重此卷，以古錦為褾，羊脂玉為簽，兩魚膽青為軸，宋刻絲龍衮為引首，延吳人湯翰裝池。太保亡後，諸古物多散失，余往宦京師，客有持此來售者，遂粥裝購得之。未幾，江陵張相盡收朱氏物，索此卷甚急，客有為余危者，余以尤物賈罪，殊自愧米顛之癖。顧業已有之，持贈貴人，士節所係，有死不能，遂持歸。不數載，江陵相敗，法書名畫，聞多付祝融，而此卷幸保全余所，乃知物之成毀，故自有數也。宋君相流飲（「披」字點去）技藝，已盡余兄跋中，乃太保、江陵，復抱桑滄之感，而余亦幾罹其釁，乃為紀顛末，示儆懼，令吾子孫毋復蹈而翁轍也。吳郡王世懋敬美甫識。」
　　鈐印：「敬美甫」白文方印、「損齋道人」白文方印

明 朱煜（尾紙）：
「壬辰春仲，吳門朱煜啟明重裝於廣陵之主書館。」

明 董其昌（尾紙）：
「宣和主人寫生花鳥，時出殿上捉刀，雖著瘦金、小璽，真贗相錯，十不一真。至於山水，惟見此卷。觀其行筆布置，所謂雲峰石色，迥出天機；筆意縱橫，參乎造化者，是右丞本色。宋時安得其匹也！余妄意當時天府收貯維畫尚夥，或徽廟借名，而楚公曲筆，君臣間自相倡和，為翰墨場一段簸弄，未可知耳。王元美兄弟藏為世寶，雖權相跡之不得，季白得之，若過溪上吳氏，出右丞《雪霽》長卷相質，便知余言不謬。二卷足稱雌雄雙劍，瑞生莫生嗔妒否。戊午（1618）夏五，董其昌題。」
　　鈐印：「太史氏」白文方印、「董其昌」朱文方印

清 弘曆
（一題，本幅）：
「山如韞玉各分層，水自拖銀波不興。艮岳寧惟擅花鳥，化工奪處固多能。竄改右丞姑弗論，跋存楚國信非誇。以斯精義入神思，為政施之豈致差。己亥（1779）仲冬，御題。」
　　鈐印：「幾暇怡情」白文方印、「得佳趣」白文方印

（二題，本幅）：
「太保弄珍張相索，王家靳固竟無危。羊脂玉作簽仍在，魚膽青為軸涉疑。得一函三王論具，借唐標宋董言奇。吳門朱煜重裝識，豈鎮楚弓楚得之。庚子（1780）新春上澣，再題。」
　　鈐印：「乾隆宸翰」朱文方印

鑑藏印：
北宋 趙佶：
「雙龍」朱文方印
「宣」「和」朱文連珠方印
「大觀」朱文長方印（二次）
「宣和」朱文長方印
「政」「和」朱文連珠印
「內府圖書之印」朱文方印

明 王世懋：
「敬美」朱文長方印半印
「牆東居士」白文方印半印

明　張鏐：
「張鏐」白文方印

清　張應甲：
「膠西張應甲先三氏圖書」朱文方印
「張應甲」朱白文方印
「東海張應甲字先三號希逸寶藏書
　　畫印」朱文方印
「張應甲印」朱文方印
「希逸氏」白文方印

清　梁清標：
「梁清標印」白文方印
「蕉林鑒定」白文方印（二次）
「蕉林梁氏書畫之印」朱文方印
「子孫世保」白文方印
「蕉林書屋」朱文長方印
「蒼巖子」朱文圓印（二次）
「觀其大略」白文方印

清　弘曆：
「垂露」朱文長方印
「烟雲舒卷」白文方印
「游六藝囿」朱文長方印
「含英咀華」朱文方印
「卞永譽書畫匯考同」朱文長方印
「筆華春雨」白文方印
「石渠寶笈」朱文長方印
「乾隆御覽之寶」朱文橢圓印
「石渠定鑒」朱文方印
「寶笈重編」白文方印
「壽」白文長方印
「古希天子」朱文圓印
「八徵耄念之寶」朱文方印
「重華宮鑒藏寶」朱文長方印
「乾隆鑒賞」白文圓印
「三希堂精鑒璽」朱文長方印
「宜子孫」白文方印
「落紙雲煙」白文方印
「八徵耄念之寶」朱文方印

「太上皇帝」朱文方印
「意在筆先」朱文橢圓印
「學鏡千古」白文長方印
「茹古含今」朱文橢圓印
「觀書為樂」白文長方印
「天地爲師」朱文長方印

清　顒琰：
「嘉慶御覽之寶」朱文橢圓印

清　溥儀：
「宣統鑒賞」朱文方印
「無逸齋精鑒璽」朱文長方印
「宣統御覽之寶」朱文橢圓印

近現代　張伯駒：
「張伯駒珍藏印」朱文長方印
「京兆」朱文葫蘆印

其他：
「馨□」白文方印
「臣雍」朱白文方印
「□□張□□□□」朱文長方印

JFT, LAT

*Poem on a Summer Day
in Regular Script*
Zhao Ji (Emperor Huizong, 1082–1135,
r. 1101–1125)

本幅：
北宋　趙佶：
「夏日。清和節後綠枝稠，寂寞黃梅雨乍
收。畏日正長凝碧漢，薰風微度到丹樓。
池荷成蓋閑相倚，逕草鋪裀色更柔。
永晝搖紈避繁溽，杯盤時欲對清流。」

鑒藏印：
北宋　趙佶：
「政龢」朱文連珠方印

清　孔昭鋆：
「嶽雪樓主人六孫昭鋆私印」白文長方印
「清淑齋印」白文方印

清　許烈：
「許子儁鑒定印」朱文長方印
「許烈之印」白文方印

其他：
「受青」朱文長方印

PYY, YSY

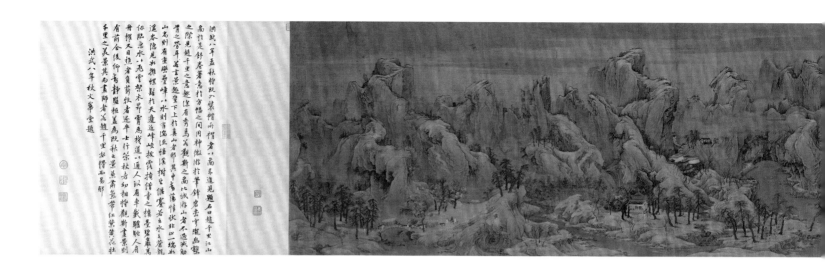

CAT. 12

Autumn Colours over Rivers and Mountains
Attributed to Zhao Boju
(active 12th century)

本幅：
無作者款識。

題跋：
明　朱標（尾紙）：
「洪武八年（1375）孟秋，將既入裝褙。
所褙者以圖來進見，題名曰《趙千里江
山圖》。於是舒卷著意於方幅之間，用
神微游於筆鋒、岩巒、穹瓏、幽壑之際，
見趙千里之意趣，深有秀焉。若觀斯之
圖，比誠游山者，不過減勌骨之勞耳。
若言景趣，豈下上於真山者耶！其中動
蕩情狀，非止一端，如山高，則有重巒
疊嶂；以水，則有湍流蟠溪。樹生偃蹇，
若出水之蒼龍，遙岑隱見，如擁螺髻於
天邊；近峰峻拔，露掩僧寺之樓臺，碧
巖萬仞，臨急水以飛雲。架木昂霄，為
棧道以通人，致有車載、驢駝、人肩、
舟櫂，又目樵者負薪，牧者逐牛，士行
策杖，老幼相將。觀斯畫景，則有前合

後仰，動靜盤桓，蓋為既秋之景，兼肅
氣，帶紅葉黃花，壯千里之美景。其為
畫師者，若趙千里安得而易耶！洪武八
年（1375）秋文華堂題。」

鑒藏印：
清　梁清標：
「蕉林玉立氏圖書」朱文方印
「觀其大略」白文方印
「蕉林書屋」朱文方印（二次）
「蒼巖」朱文方印（三次）
「蕉林鑒定」朱文方印
「蒼巖子」朱文圓印
「梁清標印」白文方印
「蕉林秘玩」朱文方印

清　弘曆：
「石渠寶笈」朱文方印
「重華宮鑒藏寶」朱文方印
「樂善堂圖書印」朱文雙龍長方印
「乾隆御覽之寶」朱文方印

清　顒琰：
「嘉慶御覽之寶」朱文圓印

清　溥儀：
「宣統御覽之寶」朱文圓印

「宣統鑒賞」朱文方印
「無逸齋精鑒璽」朱文方印

現代　東北博物館：
「東北博物館珍藏之印」朱文方印

LAT, RW

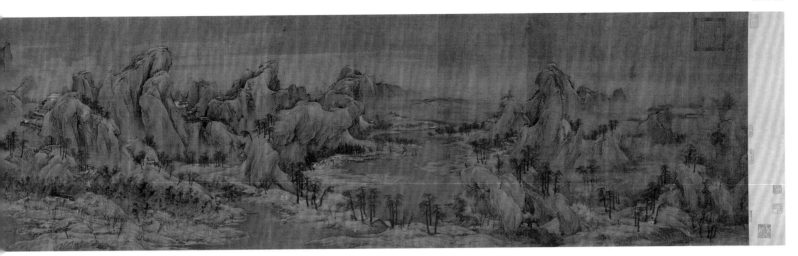

CAT. 13

Illustrations to The Book of Songs:
Songs Beginning with "Deer Call"
Ma Hezhi (active 12th century)

本幅：

無作者款識。

南宋　趙構（傳）
（第一段）：

「《鹿鳴之什》。《毛詩‧小雅》。《鹿鳴》，燕群臣嘉賓也。既飲食之，又實幣帛筐篚，以將其厚意。然後忠臣嘉賓，得盡其心矣。呦呦鹿鳴，食野之苹。我有嘉賓，鼓瑟吹笙。吹笙鼓簧，承筐是將。人之好我，示我周行。呦呦鹿鳴，食野之蒿。我有嘉賓，德音孔昭。視民不恌，君子是則是傚。我有旨酒，嘉賓式燕以敖。呦呦鹿鳴，食野之芩。我有嘉賓，鼓瑟鼓琴。鼓瑟鼓琴，和樂且湛。我有旨酒，以燕樂嘉賓之心。《鹿鳴》。」

（第二段）：

「《四牡》，勞使臣之來也。有功而見知則說矣。四牡騑騑，周道倭遲。豈不懷歸，王事靡盬，我心傷悲。四牡騑騑，嘽嘽駱馬。豈不懷歸，王事靡盬，不遑啟處。翩翩者鵻，載飛載下，集于苞栩。王事靡盬，不遑將父。翩翩者鵻，載飛載止，集于苞杞。王事靡盬，不遑將母。駕彼四駱，載驟駸駸。豈不懷歸，是用作歌，將母來諗。《四牡》。」

（第三段）：

「《皇皇者華》，君遣使臣也，送之以禮樂，言遠而有光華也。皇皇者華，于彼原隰。駪駪征夫，每懷靡及。我馬維駒，六轡如濡。載馳載驅，周爰咨諏。我馬維騏，六轡如絲。載馳載驅，周爰咨謀。我馬維駱，六轡沃若。載馳載驅，周爰咨度。我馬維駰，六轡既均。載馳載驅，周爰咨詢。《皇皇者華》。」

（第四段）：

「《常棣》，燕兄弟也。閔管、蔡之失道，故作《常棣》焉。常棣之華，鄂不韡韡。凡今之人，莫如兄弟。死喪之威，兄弟孔懷。原隰裒矣，兄弟求矣。脊令在原，兄弟急難。每有良朋，況也永嘆。兄弟鬩于牆，外禦其務。每有良朋，烝也無戎。喪亂既平，既安且寧。雖有兄弟，不如友生。儐爾籩豆，飲酒之飫。兄弟既具，和樂且孺。妻子好合，如鼓瑟琴。兄弟既翕，和樂且湛。宜爾家室，樂爾妻帑。是究是圖，亶其然乎。《常棣》。」

（第五段）：

「《伐木》，燕朋友故舊也。自天子至于庶人，未有不須友以成者。親親以睦，友賢不棄，不遺故舊，則民德歸厚矣。伐木丁丁，鳥鳴嚶嚶。出自幽谷，遷于喬木。嚶其鳴矣，求其友聲。相彼鳥矣，猶求友聲。矧伊人矣，不求友生。神之聽之，終和且平。伐木許許，釃酒有藇。既有肥羜，以速諸父。寧適不來，微我弗顧。於粲洒掃，陳饋八簋。既有肥牡，以速諸舅。寧適不來，微我有咎。伐木于阪，釃酒有衍。籩豆有踐，兄弟無遠。民之失德，乾餱以愆。有酒湑我，無酒酤我。坎坎鼓我，蹲蹲舞我。迨我暇矣，飲此湑矣。《伐木》。」

（第六段）：

「《天保》，下報上也。君能下下以成其政，臣能歸美以報其上焉。天保定爾，亦孔之固。俾爾單厚，何福不除。俾爾多益，以莫不庶。天保定爾，俾爾戩穀。罄無不宜，受天百祿。降爾遐福，維日不足。天保定爾，以莫不興。如山如阜，如岡如陵。如川之方至，以莫不增。吉

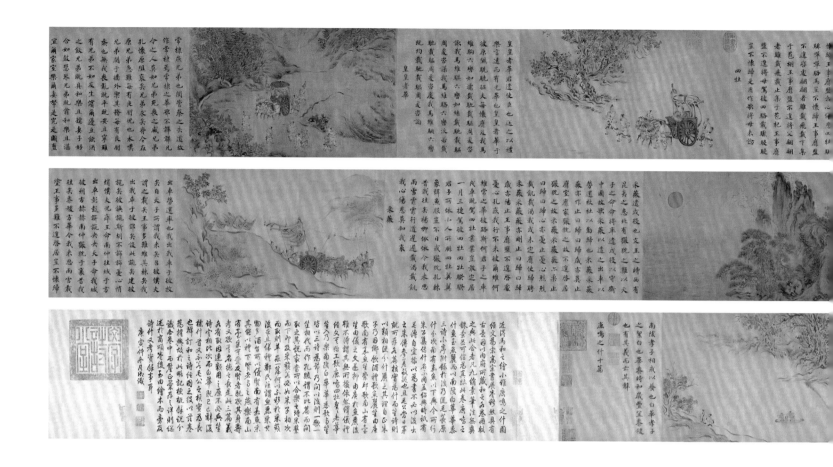

蜀為饎，是用孝享。禴祠烝嘗，于公先
王。君曰卜爾，萬壽無疆。神之弔矣，
詒爾多福。民之質矣，日用飲食。群黎
百姓，徧為爾德。如月之恒，如日之升。
如南山之壽，不騫不崩。如松柏之茂，
無不爾或承。《天保》。」

（第七段）：
「《采薇》，遣戍役也。文王之時，西
有昆夷之患，北有玁狁之難。以天子之
命，命將率遣戍役，以守衛中國。故
歌《采薇》以遣之，《出車》以勞還，
《杕杜》以勤歸也。采薇采薇，薇亦作
止。曰歸曰歸，歲亦莫止。靡室靡家，
玁狁之故。不遑啟居，玁狁之故。采薇
采薇，薇亦柔止。曰歸曰歸，心亦憂止。
憂心烈烈，載飢載渴。我戍未定，靡使
歸聘。采薇采薇，薇亦剛止。曰歸曰歸，

歲亦陽止。王事靡盬，不遑啟處。憂心
孔疚，我行不來。彼爾維何，維常之華。
彼路斯何，君子之車。戎車既駕，四牡
業業。豈敢定居，一月三捷。駕彼四牡，
四牡騤騤。君子所依，小人所腓。四牡
翼翼，象弭魚服。豈不日戒，玁狁孔棘。
昔我往矣，楊柳依依。今我來思，雨雪
霏霏。行道遲遲，載渴載飢。我心傷悲，
莫知我哀。《采薇》。」

（第八段）：
「《出車》，勞還率也。我出我車，于彼
牧矣。自天子所，謂我來矣。召彼僕夫，
謂之載矣。王事多難，維其棘矣。我出
我車，于彼郊矣。設此旐矣，建彼旄矣。
彼旟旐斯，胡不旆旆。憂心悄悄，僕夫
況瘁。王命南仲，往城于方。出車彭彭，
旂旐央央。天子命我，城彼朔方。赫赫

南仲，玁狁于襄。昔我往矣，黍稷方華。
今我來思，雨雪載塗。王事多難，不遑
啟居。豈不懷歸，畏此簡書。喓喓草蟲，
趯趯阜螽。未見君子，憂心忡忡。既見
君子，我心則降。赫赫南仲，薄伐西戎。
春日遲遲，卉木萋萋。倉庚喈喈，采蘩
祁祁。執訊獲醜，薄言還歸。赫赫南仲，
玁狁于夷。《出車》。」

（第九段）：
「《杕杜》，勞還役也。有杕之杜，有睆
其實。王事靡盬，繼嗣我日。日月陽止，
女心傷止，征夫遑止。有杕之杜，其葉
萋萋。王事靡盬，我心傷悲。卉木萋止，
女心悲止，征夫歸止。陟彼北山，言采
其杞。王事靡盬，憂我父母。檀車幝幝，
四牡痯痯，征夫不遠。匪載匪來，憂心

孔疚。期逝不至，而多為恤。卜筮偕止，會言近止，征夫邇止。《杕杜》。」

（第十段）：
「《魚麗》，美萬物盛多，能備禮也。文、武以《天保》以上治內，《采薇》以下治外；始於憂勤，終於逸樂，故美萬物盛多，可以告於神明矣。魚麗于罶，鱨鯊。君子有酒，旨且多。魚麗于罶，魴鱧。君子有酒，多且旨。魚麗于罶，鰋鯉。君子有酒，旨且有。物其多矣，維其嘉矣。物其旨矣，維其偕矣。物其有矣，維其時矣。《魚麗》。」

（第十一段）：
「《南陔》，孝子相戒以養也；《白華》，孝子之絜白也；《華黍》，時和歲豐，宜

黍稷也。有其義而亡其辭。鹿鳴之什十篇。」

題跋：

清　弘曆（外題簽）：
「宋高宗書馬和之畫小雅鹿鳴之什圖。」
　　鈐印：「乾隆宸翰」朱文方印

清　弘曆（引首）：
「治賅內外。」

清　弘曆（尾紙）：
「近得馬和之繪《小雅鹿鳴之什圖》。經文為宋高宗書，展卷穆然，具有古意。因以內府所藏和之各卷冊較之，與此合者凡九。絹素筆法無爽銖黍，並可信為真跡。此卷《鹿鳴之什》，畫至《魚麗》，而以《南陔》、《白華》、

《華黍》三詩小《序》附錄於後，乃從毛萇原什分次。《南有嘉魚》以下與今所行朱子《集傳》什名不同，蓋紹興時祇有《毛傳》，自宜據以為書，不必以後出之朱《傳》參差致疑也。且毛公當日第就所存各篇核實為什，而笙詩則以類相從，分什麗之，其理自正。朱子乃因《鄉飲酒禮》『歌《魚麗》，笙《由庚》；歌《南有嘉魚》，笙《崇邱》；歌《南山有臺》，笙《由儀》』之文，遂抑《由庚》於《魚麗》後。雖不得謂其無所據依，然繹《儀禮》經文，其始，工歌《鹿鳴》、《四牡》、《皇皇者華》；笙入，乃樂《南陔》、《白華》、《華黍》。歌與笙皆以三詩為節，乃間以後，則一歌一笙，相代而作。孔《疏》謂『不比篇而間取之』，其說最當。所以合樂之詩，《采蘩》而下，即

及《采蘋》，若必如朱子相次而取，則《草蟲》一篇何以不移於《采蘋》後乎？且《儀禮》鄭氏《注》謂：《魚麗》采其物多酒旨，所以優賢；《南有嘉魚》采其能以禮下賢者，與之燕樂；《南山有臺》采其愛友賢者，既欲其身壽考，又欲其名德之長。是此三篇義各有取，因連類用之，原不必與笙詩定相比次。而《白華》既已亡辭，復標什首，又不若毛公之核實為長也。辯訂和之《詩經圖》之役，以茲卷為權輿，故於此略記梗概，餘說分識各卷中，而釐正匯存之詳，則總述於《商頌》卷後，至由繪本而旁及詩什，又考資餘事耳。庚寅（1770）仲冬月御識。」

　　鈐印：「乾」朱文蟠螭紋方印、「隆」白文蟠螭紋方印、「漱芳潤」白文方印

鑑藏印：
明　沐昂：
「黔寧王子子孫孫永保之」白文方印

明　沐璘：
「繼軒」朱文長方印
「沐璘廷章」白文方印
「沐氏珍玩」白文方印

明　錢能、錢寧：
「錢氏素軒書畫之記」朱文圓印
「錢氏合縫」朱白文鼎形印（五次）
「素軒清玩珍寶」白文方印

清　全魁
「穆齋珍賞」朱文方印

清　弘曆：
「五福五代堂古稀天子寶」朱文方印
「壽」白文長方印
「落紙雲煙」白文方印

「八徵耄念之寶」朱文方印
「太上皇帝之寶」朱文方印
「石渠寶笈」朱文長方印
「學詩堂」朱文長方印
「乾隆御覽之寶」朱文橢圓印
「古希天子」朱文圓印
「石渠定鑒」朱文圓印
「寶笈重編」白文方印
「御書房鑒藏寶」朱文橢圓印
「乾隆鑒賞」白文圓印
「心氣和平」白文方印
「事理通達」朱文方印
「三希堂精鑒璽」朱文長方印
「宜子孫」白文方印
「天地為師」朱文長方印
「學詩堂」朱文方印

清　顒琰：
「嘉慶御覽之寶」朱文方印

清　溥儀：
「宣統御覽之寶」朱文橢圓印

其他：
「野芳亭清賞」朱文長方印
「在東珍玩」朱文方印

LTC

CAT. 14

Water
Ma Yuan (active late 12th–early 13th century)

本幅：
無作者款識。

題跋：
清　梁清標（外題簽）：
「馬遠水圖，蕉林珍玩。」

明　李東陽（引首）：
「馬遠水。西涯。」

南宋　楊妹子
（第二幅）：
「洞庭風細。賜大兩府。」
　　鈐印：「壬午坤寧楊姓之章」朱文長方印

（第三幅）：
「層波疊浪。賜大兩府。」
　　鈐印：「壬午坤寧楊姓之章」朱文長方印

（第四幅）：
「寒塘清淺。賜大兩府。」
　　鈐印：「壬午坤寧楊姓之章」朱文長方印

（第五幅）：
「長江萬頃。賜大兩府。」
　　鈐印：「壬午坤寧楊姓之章」朱文長方印

（第六幅）：
「黃河逆流。賜大兩府。」

鈐印：「壬午坤寧楊姓之章」
朱文長方印

（第七幅）：
「秋水回波。賜大兩府。」
　　鈐印：「壬午坤寧楊姓之章」
朱文長方印

（第八幅）：
「雲生蒼海。賜大兩府。」
　　鈐印：「壬午坤寧楊姓之章」
朱文長方印

（第九幅）：
「湖光激灩。賜大兩府。」
　　鈐印：「壬午坤寧楊姓之章」
朱文長方印

（第十幅）：
「雲舒浪卷。賜大兩府。」
　　鈐印：「壬午坤寧楊姓之章」
朱文長方印

（第十一幅）：
「曉日烘山。賜大兩府。」
　　鈐印：「壬午坤寧楊姓之章」
朱文長方印

（第十二幅）：
「細浪漂漂。賜大兩府。」
　　鈐印：「壬午坤寧楊姓之章」
朱文長方印。

題跋：
明　李東陽（尾紙一）：
「右馬遠畫水十二幅，狀態各不同，而
江水尤奇絕。出筆墨蹊徑之外，真活水
也。予不識畫格，直以書法斷之。長沙
李東陽。」

明　王鏊（尾紙一）：
「山林、樓觀、人物、花木、鳥獸、蟲
魚，皆有定形，獨水之變不一，畫者每
難之。故東坡以為盡水之變，蜀兩孫，
兩孫死，其法中絕。今觀遠所畫水，紆
餘平遠，盤迴澄深，洶湧激撞，輸瀉跳
躍，風之漣漪，月之激灩，日之湏洞，
皆超然，有咫尺千里之勢，所謂盡水之
變，豈獨兩孫哉！戊申（1488）歲長至後
十日，王鏊題。」
　　鈐印：「濟之」朱文方印

明　吳寬（尾紙一）：
「馬遠不以畫水名，觀此十二幅，曲盡水
態，可謂多能者矣。全卿家江湖間，
蓋真知水者，宜其有取於此。戊申
（1488）十月晦日，吳寬在海月庵題。」
　　鈐印：「原博」朱文方印

明　陳玉（尾紙一）：
「馬河中畫山水人物，種種臻妙，邊角小
景益清遠。水作縠紋狀者，精絕。院人
中稱獨步。信然，信然。陳玉。」
　　鈐印：「東沂」朱文長方印

明　俞允文（尾紙二）：
「馬遠畫水十二圖意記。宋馬遠以善畫
冠絕當時。時稱長於小景。王元美得遠
畫水十二幅，意匠縱橫，尤能曲盡水之
變態，余既欣賞久之，而又慮覽者或不
能得遠之旨，遂各為之張引其詞爾。其
（「霜」字點去）陰扶岫戶、氣溢河宗。
始輪囷而出谷，俄溶渤而從龍。騰八紘
而摧隤，蒸萬象於鴻濛。淵客之珠乍泣，
鮫人之室奚從。是曰：雲生滄海。衝風
四會，乘流拂擊。沓灌增澆，奔灑噴射。
乍失魚鼈之勢，莫定黿鼉之窟。是曰：
層波疊浪。壯嶮介而攏括百川，鼓靈潮
而控會萬里。盤礴元氣，經營星紀。滈
汗焉瀰，流形天地。是曰：長江萬頃。

玉壺洞澈而遠水無波，寶鏡虛懸而浮光
不定。沖融晶了，漫減潛泳。熬金柱而
凝照，漉銀礫而留映。是曰：湖光激灩。
其氣淒淒，其流瀰瀰。潦盡而清明在中，
泉寒而咫尺見底。媚芙蓉之始華，寫衰
顏於暮齒。是曰：寒塘清淺。翔鳥始駭，
浮陽乍炳。紫霧霏崖，丹霞蔚嶺。沿漚
礐石而分瓊，高沫影沙而散錦。是曰：
曉日烘山。天吳噫氣，靉靆紛披。雲日
之所開吐，激勢之所相排。若白龍之倒
飲，似素車之張幰。是曰：雲舒浪捲。
勁節爽，寒雲深。龍鱗隱起，暮景沉沉。
稍縈紆而沏迭，復汀濘而浸淫。是曰：
波蹙金風。霜宇漱月，煙空發晴。韻鮮
飀於蘋末，獵蘅蕙於洞庭。緣洄淤淥，
翱翔圖淪。與秋煙而一色，共春縠而起
文。是曰：洞庭風細。長波汨深，來往
港漣。湛千尋而無滓，聚百折而流圓。
感灌纓於楚父，悟寓言於莊篇。是曰：
秋水迴波。山暄收，天英炯。文枝斂
聲，餘波猶涌。蹴葩華而微瀉，順沿溯
而莫竦。是曰：細浪影影。出昆侖，下
龍門。夏禹導其流，漢將窮其源。竹箭
方駛，桃花漲春。陽侯之波不息，武王
之鉞空聞。是曰：黃河逆流。夫遠之畫
水至此，真可謂曲盡其變矣。而所謂遠
之旨，又寧止乎是而已。是故水之性本
乎順也，故能與物為行止。體本乎靜也，
故能與時為消息。恬憺也，故能溥利乎
庶類。虛謙也，故能弘納乎群形。柔弱
也，故至人以之體道。清净也，故廉士
以之洗心。處上善而不讓，居下流而不
爭。如衡之平，如鑒之明。推其源則同
出，分其地則異名。信乎，具靈長之德，
為天下之尊。是以覽遠之畫者，以余言
參之，而遠之旨可得矣。元美世家海壖，
而性復通明知水，於余言必有合者。隆
慶二年（1568）夏五月十八日，掩關居士
俞允文撰並書。」

鈐印：「仲蔚」白文長方印、
「馬安左曲」白文方印

明　文伯仁（尾紙二）：

「馬畫盡水之變，俞記窮水之態。元美世
居海上，其於水之變態，當自得之。
余近寄寓包山，風帆往來，亦嘗領略。
今觀此卷，頗會於衷。元美方出為世用，
既有得於水之變態，尤宜觀水之體以自
致，嘗言狂妄，不知以為然否？同在坐
者錢叔寶穀、顧季狂聖之、尤子求求。
隆慶戊辰（1568）六月十八日，五峰山人
文伯仁。」

明　王世貞：

（一題，尾紙二）：

「上帝兩帶垂，長江黃河流。昆侖觸天漏，
下貯海一杯。震澤與洞庭，匯作東南漚。

風雲出千變，日月浴雙輈。泓淳寫秋星，
蕭瑟競素湫。木落清淺出，石壓琮琤抽。
其細沬貫珠，巨者膏九州。誰能傳此神，
毋乃宋馬侯。解衣盤礴初，已動馮夷愁。
天一臆間吐，沠九筆底收。生綃十二幅，
幅幅窮雕鎪。憶昔進御時，（「涉」字
點去）陛豁神龍眸。遂令大同殿，濤聲
撼床頭。六宮攝其魄，所以不欲留。
楊妹即大家，女史司校讎。朱填六玉箸，
墨宛四銀鉤。錦縹賜兩府，青箱潤千秋。
晴窗乍開閱，如練沾衣裯。怳作銀漢翻，
浸我白玉樓。當其鬱怒筆，楣表騰蛟虬。
及乎泪舒徐，遙頸延鷖鷗。動則開智樂，
淵然與心謀。老思鑒湖曲，興盡剡溪舟。
左壁桑氏經，右圖供臥游。那能學神禹，
胼胝終荒丘。隆慶庚午（1570）春日，
吳郡王世貞咏此圖，得二十五韻二百五
十字。」

鈐印：「王元美印」白文方印、
「天弢居士」白文方印

（二題，尾紙二）：

「右馬河中遠畫水（「十二幅」三字點
去）。馬不以水名，而所畫曲盡其情狀。
吾不知於吳道子、李思訓、孫知微若何。
然自昆侖西來，至弱水之沼，中間變態
非一。無復遺致矣。畫凡十二幀，幀各
有題字，如雲生滄海、層波疊浪之類，
雖極柔媚而有韻，下書「賜兩府」三字，
其印章有楊娃語。長輩云：楊娃者，皇
后妹也。以藝文供奉內廷，凡遠畫進
御及頒賜貴戚，皆命娃題署云。然不能
舉其代。及遍考畫記、稗史，俱無之。
獨（「遠」字點去）往往於遠它畫見楊
跡如一。按：遠在光、寧朝後，先待詔
藝院，最後寧宗后楊氏承恩執內政。所

謂楊娃者，豈即其妹耶。又后兄石、谷俱以節鉞領宮觀，位至太師。時稱大兩府、二兩府。則所謂賜大兩府者，疑即（「谷」字點去）石也。此卷初藏陸太宰全卿家，李文正、吳文定、王文恪諸公俱有跋而不能詳其事，聊記以俟再考。世貞又識。」

鈐印：「太僕寺印」朱文方印、「撫治鄖陽等處關防」朱文長方印、「御史中丞印」白文方印

明　梁孜（尾紙一）：

「隆慶壬申（1572）冬日，羅浮山人梁孜，借閱於心遠堂。」

明　文嘉（尾紙二）：

「馬遠水十二幅，楊妹子所題，往時陳道復嘗誇余，謂是世間奇物，今四十餘年矣，始得一見，豈勝快哉！萬曆五年（1577）仲夏六日，文嘉。」

鈐印：「休承」朱文長方印

明　張鳳翼（尾紙二）：

「馬遠水十二段，段各一狀，試一展玩，可無俟登龍門、觀呂梁，而風水之極觀備矣。楊妹題辭與筆意俱雅，絕無韓疏妖冶態，其亦女史之良哉。張鳳翼識。」

鈐印：「張鳳翼印」白文方印、「張氏伯起」白文方印

明　陳永年（尾紙二）：

「辛卯（1591）八月風雨中，同郭次甫觀十二水于凌波鷁。至長江萬里，湖光潋灩，尤在心手筆墨之外。余江湖人也，即欲操小刀泛此以往，不使向生獨私五嶽也。時長世、安世二幼子侍。因卷剡補空書此。京口陳永年。」

鈐印：「從」「訓」朱文連珠印

鑒藏印：

明　王世貞：

「貞」「元」朱文連珠方印半印（十二次）

「伯（或『仲』）雅」朱文長方印半印

清　梁清標：

「蕉林梁氏書畫之印」朱文方印

「家在北潭」朱文方印

「蕉林玉立氏圖書」朱文方印（十二次）

「蒼巖子」朱文圓印

「蕉林秘玩」朱文方印

「觀其大略」白文方印

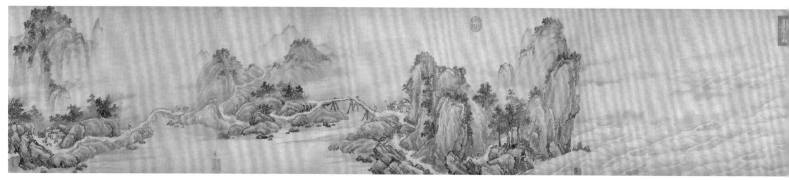

清　耿昭忠：

「信公鑒定珍藏」朱文橢圓印（十八次）

「耿昭忠信公氏一字在良別號長白山長收
　　藏書畫印記」白文方印

「都尉耿信公書畫之章」白文方印
　　（十一次）

「半古軒書畫印」白文長方印

「珍秘」朱文方印

「宜爾子孫」白文方印

清　弘曆：

「御書房鑒藏寶」朱文橢圓印

「三希堂精鑒璽」朱文長方印

「宜子孫」白文方印

「石渠寶笈」朱文長方印

「乾隆御覽之寶」朱文長方印

「乾隆鑒賞」白文圓印

「五福五代堂古稀天子寶」朱文方印

「八徵耄念之寶」朱文方印

清　顒琰：

「嘉慶御覽之寶」朱文橢圓印

清　溥儀：

「宣統御覽之寶」朱文橢圓印

「宣統鑒賞」朱文方印

「無逸齋精鑒璽」朱文長方印

現代　朱光：

「朱光所藏書畫」朱文長方印（二次）

其他：

「默盦」朱文長方印半印（十三次）

LAT

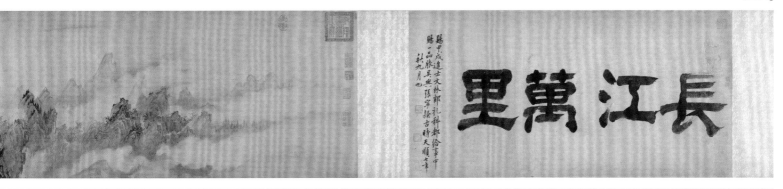

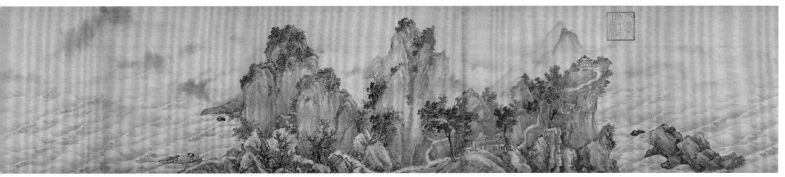

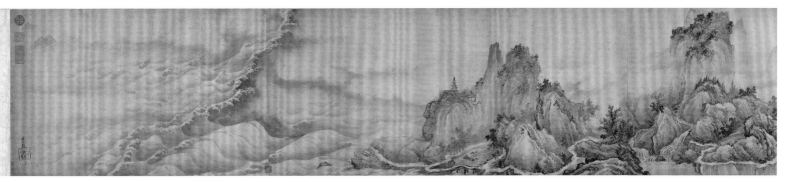

CAT. 15

Ten Thousand Li of Rivers and Mountains

Zhao Fu (active 1131–mid-12th century)

本幅：

南宋　趙黻：

「京口趙黻作。」

鈐印：「黻」朱文方印

題跋：

清　弘曆（外題簽）：

「趙黻江山萬里圖真跡，內府鑒定神品。」

鈐印：「乾隆宸翰」朱文方印

明　張寧（引首）：

「長江萬里。賜甲戌進士文林郎禮科都給事中賜一品服。吳興張寧隸古。時天順七年（1463）秋九月也。」

鈐印：「鷗伴」朱文方印、「清」「遠」朱文連珠方印、「靖之」朱文方印、「吳興」朱文方印、「方洲草堂」朱文方印

明　錢惟善（尾紙一）：

「萬里江山入畫圖，遠從西蜀到東吳。
屏藩形勝今猶昔，煙雨溟濛有若無。
晨唱蠻歌開巨艦，暮投野店問前途。
初陽迎曙千峰見，急浪飛花片月孤。
自古殊方連越嶲，從來遺俗帶巴渝。
重重梵剎高僧隱，處處旗亭倦客酤。
地氣濕蒸雲夢澤，天光倒入洞庭湖。
劍門鳥道矚能過，巫峽猿聲若可呼。

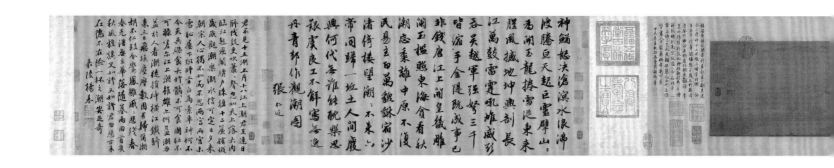

擊楫中流空自誓，據鞍南向謾長吁。
御風我欲游茲境，擬作煙波一釣徒。
右畫宋京口趙黻所作《長江萬里圖》也。
布景之妙，千態萬狀，有不可得而悉
形容者。邇來兵火之餘，法書名畫廢棄
沉沒，何可勝數，迺獲見此大幅巨軸，
若有神護，而默相之者。今歸之展武
□□□家，何其幸歟！一日焚香請觀，
觀罷復請賦詩以識，爾其珍襲而寶藏之。
洪武丁巳（1377）暮春上巳，曲江老人錢
惟善書於客舍。」

　　鈐印：「武夷山樵者」白文方印、
「曲江居士」白文方印、「錢氏思復」
白文方印

明　張寧（尾紙一）：
「宋趙黻所畫《江山萬里圖》，經營布
置，雖出一筆，其間煙雲風雨、晴陰
旦暮，隨地不同，真得萬里之景，奇作
也。況畫家惟風水尤難造妙，風猶可假
物附見，水以平遠委順之體，乃欲具見
沿洄、溯湍、激揚、起伏、急緩之情狀，
以盡天下之變。若此筆墨餘流，非因
精專妙絕不能也。豈趙氏世居京口，朝
夕所習見，故其發諸意象者，獨得其真
耶？曲江老人所題，有「晨倡（唱）」、
「莫（暮）歌」、「初陽」、「片月」，且云
「千態萬狀，不可得而悉形容之」，真此
圖之注疏也！跋語謂「今歸展武某家」，
不遇達人，致毀去其姓氏。而今方為金
氏家物，亦可謂徙不出鄉矣。披閱之頃，

為之悵然。成化丁未（1487）春正月二十
四日，展武方洲歸老吳興張寧書于一笑
山拄頰亭中。」

　　鈐印：「清」「遠」朱文連珠印、
「靖之」朱文方印、「吳興」朱文方印、
「方州草堂」朱文亞字形方印

明　陸樹聲（尾紙二）：
「長江上接三巴水，下際滄溟萬里餘。
誰將東絹寫成圖，渺渺茫茫生眼底。
君從何處得此奇，滄波渾欲濕我衣 。
五湖四海在胸臆，然後筆端能發之。
我昨狂游走淮甸，中間景物半曾見。
黃州喚渡過武昌，江北江南古戰場。
遙望烏江叫項羽，醉登赤壁酬周郎。
凡此一行經幾處，長記潯陽秋日雨 。
掀蓬把酒對盧君，溢浦鳴撓到秋浦。
放舡一夕下金陵，石首城連鐵瓮城。
英雄割據雖已矣，至今江浪猶未平。
十載舊游今見畫，妙手信能通造化 。
驚濤翻空蛟鱷橫，平沙無人鷗鷺下。
悠然物色真境同，天機到處非人工。
恍疑身在柂樓底，令人一見開心胸。
萬曆乙亥（1575）仲春朔日，雲間平泉
居士陸樹聲書于適園修竹齋。」

　　鈐印：「世德堂」朱文長方印、
「陸氏与吉」朱文方印、「玉堂學士」
朱文方印

清　弘曆（本幅）：
「萬里長圖一氣扶，濫觴西蜀委東吳。
晦明天地難形狀，出沒江山乍有無。
錢跋張書率疑案，趙名陸詠混真符。
眼前紙絹猶不辨，紀載由來半是誣。
按：是圖款署京口趙黻作。紙本長三丈
餘，所畫煙雲風雨，倏忽變態，真得萬
里江天之景，洵名跡也。卷後有錢惟善、
張寧、陸樹聲諸人題跋，其中疑竇頗多。
如錢惟善、張寧跋，皆明言宋京口趙黻
畫。而張跋後又云「不遇達人，致毀去
其姓氏」。其所毀者，將指錢維善跋內
之展武某家耶？抑指趙黻題款耶？如云
鑒藏之「展武某家」，其有無何足輕重。
古來名跡割去題跋者甚多，奚獨此一人
耶？若指趙黻，則其款固存未毀，豈後
人補為者耶？又陸樹聲詩云「誰將東絹
寫成圖」。此卷直係紙本，萬目共睹。
又明言是趙黻畫而云誰，或知款為後人
偽作耶？此卷舊入《石渠寶笈》，編輯時
未經檢點及此，茲幾餘復加展閱，見其
筆墨精妙，因為題句，並辨其訛，附識
如右。以「石渠繼鑒」寶證之。《石渠
寶笈》書已錄入《四庫全書》，則姑仍其
舊云。壬寅（1782）小春御筆。」

　　鈐印：「乾」朱文圓印、「隆」朱文
方印

鑒藏印：
清　弘曆：
「乾隆御覽之寶」朱文方印

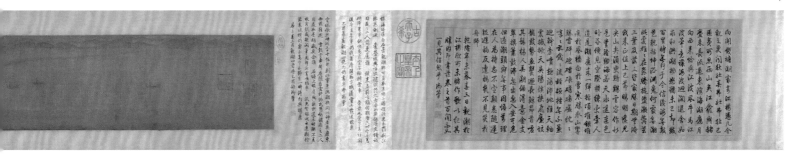

「三希堂精鑒璽」朱文長方印

「宜子孫」白文方印

「石渠寶笈」朱文長方印

「御書房鑒藏寶」朱文橢圓印

「五福五代堂古稀天子寶」朱文方印

「石渠繼鑒」朱文方印

「古希天子」朱文圓印

「八徵耄念之寶」朱文方印

「太上皇帝之寶」朱文方印

「乾隆鑒賞」白文圓印

清　顒琰：

「嘉慶御覽之寶」朱文橢圓印

清　溥儀：

「宣統御覽之寶」朱文橢圓印

「宣統鑒賞」朱文方印

「無逸齋精鑒璽」朱文長方印

其他：

「梅室」朱文長方印（四次）

「嚴」朱义圓印（三次）

「鶴汀子震」白文方印（三次）

「鶴汀嚴氏收藏圖書」朱文長方印（四次）

「江南草衣」朱文方印

「軍司馬印」朱文方印

「飛□」朱文圓印左右半印

LAT

CAT. 16

*Hawk on a Maple Tree
Eyeing a Pheasant*
Li Di (active 12th century)

本幅：

南宋　李迪（本幅）：

「慶元丙辰（1196）歲李迪畫。」

鑒藏印：

清　怡親王府：

「怡親王寶」朱文方印

YSY

CAT. 17

*Viewing the Tidal Bore
on the Qiantang River*
Li Song (1166–1243)

本幅：

無作者款識。

題跋：

元　張仁近（尾紙）：

「神鰌怒決滄溟水，浪沸波騰亙天起。
巨靈擘山山為開，玉龍捲雪從東來。
腥風撼地坤輿剖，長江萬鼓雷霆吼。
雄威欲吞吳越軍，強弩三千皆縮手。
金隉既成事已非，錢塘江上開皇畿。
雕闌玉檻照東海，貪看秋潮忘黍離。
中原不復民易主，百萬貔貅宿沙渚。
倚樓望潮潮不來，六帝同歸一坏土。
人間廢興何代無，誰能耽樂思艱虞。
良工不解寫無逸，丹青卻作觀潮圖。
張仁近。」

　　鈐印：「仁近」朱文圓印、「如心」
白文方印

元末明初　楊基（尾紙）：

「君不見，十五湖上月，十八江上潮。君
王連日醉，伐鼓更吹簫。簫聲忽如天上
落，大內臨江起飛閣。綉戶珠榅十二簾，
嬪娥歲歲觀潮樂。潮水信可定，日夕來
朝宗。人心獨不如，而不思兩宮。兩宮

未雪恥，屢下班師旨。白馬素車神，何不令天吳。磔食大奸贍，奸贍不可食，國恥不可滌。嗟爾江上潮，雖雄亦何益？潮無益於人，看潮徒損神。橫江鐵騎來，三日飛埃塵。曆數固有歸，爾潮胡不仁。致令鸞鳳雛，戚戚悲殘春。春光浩無主，華落隨暮雨。回首幾秋風，旌旗又如許，又如許，君勿悲。古來在德不在險，一杯之潮安足奇。嘉陵楊基。」

鈐印：「荔枝林」朱文橢圓印、「務白齋圖書」朱文方印、「楊基之印」白文方印、「楊孟載」白文方印

清　弘曆
（一題，引首）：
「向聞錢塘潮最奇，江樓憑几今觀之。更聞秋壯春弗壯，弗壯已匪夷所思。兩山夾江龕與赭，壺束長流逼東瀉。海潮應月向西來，恰與江波風牛馬。江波畢竟讓海波，迴瀾退舍如求和。洪潮拗怒猶未已，卻數百里時無何。于今信識海無敵，苞乾括坤浴淵魄。何處無潮此處雄，雄在奔騰旋蕩激。莫茁三葉及落三，皆最勝日期無淹。我來正值上巳節，晴明遙見尖山尖。須臾黯黮雲容作，似是豐隆助海若。天水遙連色暗昏，倏見空際橫練索。旁人道是潮應來，一彈指頃堆銀堆。疾於風檣白於雪，寒勝冰山響勝雷。砰磄礌硍礔磅磕，紞紞哼哼吼哦哦。流離頓挫無不兼，迴翰旁噴極滂沛。地維天軸震撼掀，天吳陽侯挾飛廉。蛟龍鼓勢魚蟹遁，長鯨昂首噓其髯。榜人弄潮偏得意，金支翠旗簫鼓沸。忽出忽入安其危，但過潮頭寂無事。因悟萬理在人為，持志不定顛患隨。遲疑避禍反遭禍，幾不見笑於舟師。乾隆辛未（1751）暮春三日，觀潮於江樓，欣所未睹，作歌以紀其勝，

因即書茲卷之首。百聞不如一見，其信然乎。御筆。」

鈐印：「乾隆宸翰」朱文方印、「幾暇臨池」白文方印

（二題，前副隔水）：
「鎮海塔傍白石臺，觀潮那可負斯來。塔山濤信須臾至，羅剎江流為倒迴。橐籥堪輿呼吸隨，混茫太古合如斯。伍胥文種誠司是，之二人前更屬誰。候來底藉鳴雞伺，朔望六時定不差。斫陣萬軍馳快馬，飛空無輗轉雷車。當前也覺有奇訝，閱後本來無事仍。我甫廣陵辨方域，漫重七發述枚乘。乙酉（1765）暮春，觀潮四絕句，仍書卷中。御筆。」

鈐印：「幾暇怡情」白文方印、「得佳趣」白文方印

（三題，前隔水）：
「穹塔依然峙迴臺，十餘年別此重來。海潮欲問似神者，幾度東西茲往迴。雷鼓雲車聲應隨，自宜神物式憑斯。設非之二人司是，如是雄威更合誰。石塘上略肩輿駐，報道未時潮不差。枚客賦成擬閣筆，周郎宿寄喚推車。流光瞥眼誠云速，潮信茲來試攬仍。審至奇中至靜在，一時得句興堪乘。庚子（1780）春三月，觀潮四首疊乙酉韻。御筆。」

鈐印：「古稀天子」朱文方印、「猶日孜孜」白文方印

（四題，後隔水）：
「鎮海寺傍臨海臺，行春觀處正潮來。逮今三度詩十二，不擬石塘重往迴。詠事酉年信筆隨，悔慫子歲亦於斯。謂當鑒我漲沙矣，仍看北坍更籲誰？李嵩妙跡攜行笈，相證雄觀信弗差。詩讀張楊刺南宋，風霜二帝忘行車。

一帶石塘工已就，魚鱗擬築向西仍。亦惟此日盡人力，敢冀他年幾可乘。甲辰（1784）暮春，觀潮再疊前韻。御筆。」

鈐印：「會心不遠」白文方印、「德充符」朱文方印

鑒藏印：
明　王濟：
「吳」「興」朱文連珠方印
「王濟賞鑒過物」朱文長方印

明　安國：
「明安國玩」白文橢圓印（三次）

明　項元汴：
「神」「品」朱文連珠印
「項元汴印」朱文方印
「子京父印」朱文方印
「墨林秘玩」朱文方印
「神」「奇」朱白文連珠方印
「子京父印」白文方印
　　　（二次，一為半印）、
「墨林山人」白文方印
「子京」朱文葫蘆印半印
「桃花源裏人家」朱文長方印半印
「子京珍秘」朱文長方印
　　　（二次，一為半印）
「寄敖」朱文橢圓印
「墨林嬾叟」白文方印
「會心處」白文方印
「項子京家珍藏」朱文長方印
　　　（二次，一為半印）、
「墨」「林」朱文連珠方印
「田疇耕耨」白文方印
「長病仙」白文方印
「遠方之外」白文方印
「酉」朱文肖形圓印
「赤松仙史」白文方印
「項氏子京」白文方印

「墨林子」白文亞形印半印
「西疇耕耦」白文方印半印
「子孫永保」白文方印半印

清　梁清標：
「蕉林」朱文橢圓印
「梁清標印」白文方印
「家在古棠村」朱文方印

清　弘曆：
「古希天子」朱文圓印
「太上皇帝之寶」朱文長方印
「石渠繼鑒」朱文方印
「乾隆鑒賞」白文圓印
「石渠寶笈」朱文長方印
「養心殿鑒藏寶」朱文長方印
「乾隆御覽之寶」朱文橢圓印
「三希堂精鑒璽」朱文長方印
「宜子孫」白文方印
「意在筆先」朱文橢圓印
「五福五代堂古稀天子寶」朱文方印
「八徵耄念之寶」朱文方印

清　顒琰：
「嘉慶御覽之寶」朱文橢圓印

清　溥儀：
「宣統御覽之寶」朱文方印
「宣統鑒賞」朱文方印
「無逸齋精鑒璽」朱文長方印

近代　張元曾：
「張元曾家珍藏」朱文長方印

其他：
「□□」朱文方印
「□□□□□□」朱文長方印半印
「協壹堂珍玩書畫圖章」朱文方印

LAT

CAT. 18

Basket of Flowers
Li Song (1166–1243)

本幅：
南宋　李嵩：
「李嵩畫。」

鑒藏印：
明　項元汴：
「項子京家珍藏」朱文長方印半印

YSY

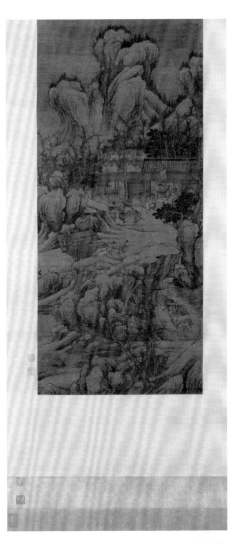

CAT. 19

Travelling Bullock Carts
Unidentified artist

本幅：
無作者款識。

鑒藏印：
明　孫承澤：
「長宜子孫」白文方印
「北海」白文方印

清　梁清標：
「蕉林玉立氏圖書」朱文方印
「觀其大略」白文方印

清　弘曆：
「乾隆御覽之寶」朱文方印
「石渠寶笈」朱文長方印
「御書房鑒藏寶」朱文橢圓印
「三希堂精鑒璽」朱文長方印
「宜子孫」白文方印

清　顒琰：
「嘉慶御覽之寶」朱文橢圓印

清　溥儀：
「宣統御覽之寶」朱文方印

近現代：
「教育部點驗之章」朱文長方印

其他：
「□□□□」朱文圓印

YSY

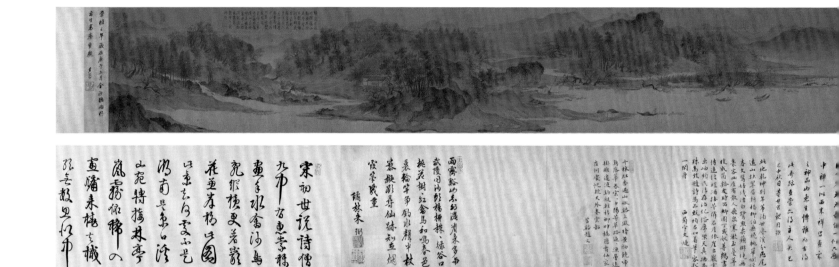

CAT. 20

Spring Morning at the Riverside
Unidentified artist

本幅：

無作者款識。

題跋：

明 李兆蕃（引首）：

「谿山春曉圖。長沙李兆蕃。」

鈐印：「繼伯」白文長方印、
「茶陵世家」朱文方印

元 陶振（尾紙）：

「浣花谿頭春畫閑，綠水恍接銀河灣。
參天柳色自遠近，上有好鳥鳴關關。
錦雲夾谿三十里，千樹萬樹桃花斑。

武陵天台在仿佛，玄都白兆相廻環。
其中豈無仙子宅，微聞雜珮聲珊珊。
黃茅野屋星散住，酒旗斜出青林間。
漁郎采魚谿上去，艇子打鴨波心還。
釣鰲野客居塵寰，十年行歌行路難。
尋真謾思窮海嶽，鑿翠空想棲林巒。
揭來披圖苔渚上，使我一笑開心顏。
於戲！不知人間何處有此境，
杖履直欲相躋攀。潯陽陶振。」

鈐印：「滄州趣」朱文長方印、
「乾川青比坤水」白文方印、「陶振」
白文方印、「釣鰲海客」白文方印、
「華陽真逸後人」白文方印

元 哈珊沙（尾紙）：

「鰲溪杏花春雨足，疊澗爭流溢深谷。
嵐氣空濛暖翠浮，波光滉瀁蒲萄綠。
柳外人家白板扉，漁罾曉掛蒼苔磯。

鳧鷖泛渚傍舟楫，沙禽浦樹相因依。
川廻野迴林麓斷，輕煙漠漠開平遠。
白鳥孤飛雲水寬，青山一抹蛾眉淺。
惠崇畫史天機精，晴窗寫出滄洲情。
胸襟淑氣寄毫素，展卷使吾雙眼明。
圖中風景堪重惜，越上吳鄉相仿佛。
石田茅屋久荒涼，杜宇苦啼歸未得。
天涯半生羈旅客，隨處林泉聊自適。
烏紗白髮照滄浪，杖履逍遙歌隱逸。
古弘沙可學。」

鈐印：「壬午進士」白文方印

元 鄭椅（尾紙）：

「重重洲渚見鳧鷖，柳暗華明水閣低。
記得雨晴湖上路，畫船曾繫六橋西。
粵鄭椅。」

鈐印：「鄭彥才」白文方印、
「石室老樵」白文方印

元　陳莊（尾紙）：

「江南二月春光好，紅錦千機絢春曉。一溪流出武陵花，四郊綠遍王孫草。是中元有隱者居，碧波萬頃搖窗虛。阿翁早晚尋歸歟，酒酣自玩雙明珠。四明陳莊。」

元　宇文燧（尾紙）：

「此地乾坤別，年華隔世塵。溪分燕尾遠，山抹翠眉新。楊柳低垂曉，桃華爛熳春。文鴛嬉淺渚，白鷺點柔蘋。僻境無豪客，幽居有散人。飛泉寒漱玉，蔓草暖成茵。谿友時留鯽，園丁或献蕁。鶴書傳遠信，蟹酒接芳隣。石屋依崖古，巖雲出岫頻。民淳存治化，俗厚樂天真。撫卷殊高致，題詩為品甄。煩君如着筆，容我一閑身。西蜀宇文燧。」

鈐印：「宇文敬陽」白文方印

元　趙文（尾紙）：

「千林紅杏遍山椒，谿上風晴景物饒。啼鳥落華春寂寂，夕陽芳草路超超。漁罾遠掛鷗邊渡，釣艇輕移柳畔橋。應有仙家在何處，恍疑天外奏雲韶。茗谿趙文。」

鈐印：「清茗生」白文長方印、「趙以文印」白文方印、「東陽子孫」白文方印

明　朱弼（尾紙）：

「雨霽谿山分外濃，看來多與武陵同。沙頭楊柳株株綠，谷口桃花樹樹紅。禽鳥和鳴春色裏，輪竿爭釣水聲中。杖藜擬欲尋仙跡，知在煙霞第幾重。璃林朱弼。」

鈐印：「四勿齋」白文長方印、「公佐」白文方印、「辛丑進士」白文方印

明　李東陽（尾紙）：

「宋初世說詩僧九，中有惠崇稱畫手。水禽沙鳥亂縱橫，更着巖花兼岸柳。此圖此景知何處，不是湖南是京口。溪山宛轉接林亭，嵐霧依稀入窗牖。來檣去檝絕無數，忽似中流遇賓友。風翎露翼滿晴空，乍見如無索還有。應將目力極秋毫，未許長林容自朽。禪心忽與天機動，指點人間盡飛走。從來詩畫可通神，問渠清思還能否。石淙詩翁百無好，見畫真能辨妍醜。多情為謝水村翁，半幅生綃一杯酒。兩翁卜築今相近，共向青雲回白首。

嗟予本是好游人，亦欲江湖問署笱。李東陽。」

鈐印：「長沙」朱文長方印、「賓之」朱文方印、「西涯」朱文長方印

明　王穉登（尾紙）：
「少時曾見惠崇畫《江南小景》，王介甫題詩贊其超絕。然菰蘆只尺，意興蕭瑟。不如此卷長逾半尋，而禽魚花鳥、林霏岫靄，縱橫爛妙，筆法清潤，類趙大年。至於寄思綿密，用墨穠蔚，毫丹縷碧，宛盡人巧，大年有所不迨也。讀長沙公題，則此圖蓋長洲陸太宰物，後舉贈遂庵相國。兩公並好古博物之士，宜其饋遺，莫非名品。今歸陳文學從訓，從訓尚慎嗇之，勿為他人所攘。雖然，空諸所有，禪宗之緒言，何我何人，一切皆幻。惠公而在，且將拊掌余言矣。太原王穉登敬書。」

鈐印：「穉登」白文方印、「王氏百穀」白文方印

明　顧大典
（一題，尾紙）：
「余自束髮以至登朝，十餘年間，每過京口，輒弭櫂者旬日。見其山水秀潤，信如米南宮之言，而今睹是卷，則宛然似之。陳君從訓，京口人也。行將挾策壯游，攜之以行，則故國江山之勝，無適而不在几席間矣。從訓其寶之哉。至於畫品之精絕，則余友百穀論之詳矣。己卯（1579）冬日，武陵顧大典書。」

鈐印：「武陵」白文長方印、「顧大典印」白文方印、「道行父」白文方印、「天官大夫」白文方印

（二題，尾紙）：
「辛巳（1581）立夏日，從訓攜來重閱。江南春色，如貯生綃半幅閱也。大典識。」

鈐印：「隱幻居士」白文方印、「清音閣」白文方印

明　王世懋（尾紙）：
「山水橫幅，能作萬樹桃花，百種禽鳥，故是五代遺法，李、范、董、巨輩所無也。惠崇以詩僧鳴宋初，聲價當與貫休比肩，黃筌父子不足比也。景似京口，又為京口故物，天以授從訓者，從訓其寶之。瑯琊王世懋謹識。」

鈐印：「王氏敬美」白文方印、「損齋道人」白文方印

明　王世貞（尾紙）：
「惠崇，詩僧也，畫品不能當荊、關半。而今所睹平湖小嶼、汀花水禽、漁舟茅舍，便娟映帶，種種天趣，故非南渡後人所及。昔老米謂五季以來畫江南景稍清遠者，輒以為王摩詰，而實非。使不作惠崇題識，將無以為摩詰耶。此卷自楊先生應寧而歸之陳從訓，從訓亦京口人也。春時喚小刀泛焦山、北固間，出圖而歌張志和「桃花流水」，按之當與江山俱響應矣。弇山人王世貞題。」

鈐印：「王世貞印」朱文方印

明　王叔承（尾紙）：
「題陳從訓所藏惠崇《溪山春霽圖》卷。惠崇一詩僧，宋首柴周尾。丹青入禪觀，別自通玄理。能於尺素間，點染千山水。昨登金焦興不孤，陳郎示我《溪山圖》。灑然江舟夢欲破，景象歷歷含模糊。畫家精工多近俗，寫意得神形不足。此僧妙趣種種兼，瀟灑天機更繁縟。不滿三尺吳興縑，疊嶂層巒天堪探。桃花半指萬家紅，柳紛寸地千樹綠。林霏水靄映茅堂，魚罾酒旗帶煙竹。黃鶯白鷺雜錦雞，百鳥群飛恍聲逐。兩點三點漁舠來，似聞頻乃瀟湘曲。鐵頭毫末皆纖細，鳥辨翎毛人辨服。

有如蟭螟寄蚊睫，生氣晴光藹團簇。當時筆有神鬼憑，大地微茫化工縮。千年故跡拂若新，昨夜溪山雨初沐。或言工勝趙大年，又云妙超董巨源。祇須三日坐其下，眼輕南宋何論元。若使寫時無印款，清美好作王維看。畫直千黃金，秀色飢可餐。出自楊閣老，來從陸天官。陳郎故是楊家倩，怪來玉潤饒奇觀。老米小圖倪大幅，別開四壁江山寒。陳郎揮灑信有本，亦常落筆生林巒。才情不自羈，往往託伎倆。山僧後世圖，無乃前生障。不能一空觀，借虛影欲表，乾坤具幻相。我昔游桃源，仙洞不知處。變為驛路塵，桃花盡空樹。滄桑幻化相有無，翻覺披圖是真遇。維摩游戲亦僧寶，手拈萬界空花聚。把杯一笑避人間，便挾金焦畫中去。萬曆丁亥（1587）五月，梅雨中嘗鰣魚，還自焦山賦此。其明年戊子（1588）七月，將溯大江入白門，秋旱得涼雨，從從訓酒間書之一助游興。松陵王叔承。」

鈐印：「王子幻」白文方印、「焦螟寄」白文方印

明　董其昌
（一題，尾紙）：
「五代時僧惠崇與宋初僧巨然皆工畫山水。巨然畫，米元章稱其平淡天真；惠崇以右丞為師，又以精巧勝，《江南春》卷為最佳。一似六度中禪，一似西來禪，皆畫家之神品也。惠生博雅好古，得此奇跡，惠崇亦得主人矣。己巳（1629）中秋日，董其昌觀因題。」

鈐印：「董其昌印」白文方印

（二題，尾紙）：
「崇禎三年（1630）歲在庚午五月，金沙聽雨，於惠生高齋重觀。其昌。」

鈐印：「昌」朱文方印

清　曹溶（尾紙）：
「自輞川翁後，畫分南北二派。評者謂
北為劣，惠崇有融會兩家之意，不妨與
詩並傳。康熙癸卯（1663）正月，檇李
曹溶。」
　　鈐印：「曹溶之印」白文方印

清　張應甲（尾紙）：
「余再過江南，得此幀於王奉常煙客。來
札云：此先人精意所注，愛之不啻腦髓。
先翁海內精鑒，可謂得所歸矣。然侯門
一入，蕭郎路人，分袂掩泣，情景仿佛
過之，其珍重如此。余每當風日晴好，
一再披對，輒怡然永日，不知身之在塵
世也。淳其寶藏之。辛酉（1681）重九前
一日，先三老人識。畫押。」

清　弘曆（尾紙）：
「馥馥蘭芬鑪地陳，溪山動植共熙春。
摩挲七百餘年物，潤手桃花帶露新。
禪宗南北畫還同，六度中禪屬惠崇。
奇跡千秋貴得所，真詮拈出是思翁。
個僧工畫又工詩，妙構溪山春曉時。
若識本來無一物，淡皴濃抹更奚為。
乾隆戊寅（1758）御題。」
　　鈐印：「乾隆宸翰」朱文方印

鑒藏印：
明　李東陽、李兆蕃：
「長沙」朱文長方印

明　楊一清：
「耆德忠正」朱文方印

清　張應甲：
「膠西張應甲先三氏圖書」朱文方印
「張應甲」朱白文方印

清　宋犖：
「商丘宋犖審定真跡」朱文長方印

清　弘曆：
「壽」白文長方印
「石渠寶笈」朱文長方印
「樂壽堂鑒藏寶」白文長方印
「乾隆御覽之寶」朱文橢圓印
「古希天子」朱文圓印
「八徵耄念之寶」朱文方印
「乾隆鑒賞」白文圓印
「三希堂精鑒璽」朱文長方印
「宜子孫」白文方印

近代　古物陳列所：
「寶蘊樓藏」朱文方印

其他：
「王鍇」朱文方印
「左軍榮祿大夫之章」朱文方印
「喬木世家清奇珍玩」朱文方印
「□□」朱文方印

JFT

本幅：
元　李衎：
「大德丁未（1307）秋九月，王玄卿道錄
送至此紙，求予拙筆，事多未暇。明年
春正月一日，始得了辦，燈暗目昏，白
日視之，不知何如也。息齋道人薊丘李
衎仲賓題。」
　　鈐印：「李衎仲賓」白文方印、
「息齋」朱文方印

題跋：
明　周天球（尾紙）：
「乙亥（1575）二月六日，新雨洗宿霾，
研几生潤，余在都城南李銀臺琦齋中，
獲觀息齋尚書此卷，真是風籟泠然，
盡去胸次塵垢。東華馬上郎恐不能得
此清思也，莞爾識之。六止生周天球。」
　　鈐印：「周天球」白文方印、「周氏
公瑕」白文方印、「群玉山樵」朱文方印

鑒藏印：
明　項元汴：
「寄傲」朱文橢圓印（二次，一爲半印）、
「墨林山人」白文方印（四次，一爲半印）、
「天籟閣」朱文長方印（二次）
「項子京家珍藏」朱文長方印（二次）
「平生真賞」朱文方印（二次）
「桃里」朱文圓印
「淨因庵主」朱文方印
「子京父印」朱文方印
「項墨林鑒賞章」白文長方印（二次）
「子孫永保」白文方印（二次）
「項叔子」白文方印（二次）
「子孫世昌」白文方印
「子京」朱文葫蘆印（四次）

「子京所藏」白文方印（二次）

「項元汴印」朱文方印（二次）

「墨林生」朱白文方印

「項墨林父秘笈之印」朱文長方印（二次）

「墨林父」白文亞形印

「墨林秘玩」朱文方印

明　李肇亨：

「嘉禾李氏珍藏」白文長方印

「李肇亨」朱文方印

「檇李李氏鶴夢軒珍藏記」朱文方印

（二次）。

清　安岐：

「安儀周家珍藏」朱文長方印

「心賞」朱文葫蘆印

「朝鮮人」白文方印

「安岐之印」白文方印

清　弘曆：

「石渠寶笈」朱文長方印

「乾隆御覽之寶」朱文橢圓印

清　溥儀：

「宣統御覽之寶」朱文橢圓印

「宣統鑑賞」朱文方印

「無逸齋精鑒璽」朱文長方印

近現代　惠均：

「雪漁」朱文葫蘆印

「惠孝同鑒賞章」朱文長方印

「晴廬」朱文方印

LAT, YSY

CAT. 22

Watering Horses in Autumn
Zhao Mengfu (1254–1322)

本幅：

元　趙孟頫（一題、二題）：

「《秋郊飲馬圖》。皇慶元年（1312）

十一月，子昂。」

　　鈐印：「趙」朱文方印、「大雅」朱文

長方印、「趙氏子昂」朱文方印

題跋：

清　弘曆（外題簽）：

「趙孟頫秋郊飲馬圖。御府珍藏。」

　　鈐印：「乾隆宸翰」朱文方印

清　弘曆（引首）：

「清泉坰牧。」

　　鈐印：「乾隆宸翰」朱文方印

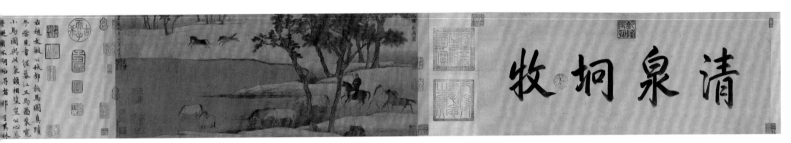

元 柯九思（尾紙）：

「右趙文敏公《秋郊飲馬圖》真跡，予嘗見韋偃《暮江五馬圖》、裴寬《小馬圖》，與此氣韻相望，豈公心慕手追，有不期而得者邪？至其林木活動，筆意飛舞，設色無一點俗氣，高風雅韻，沾被後人多矣。奎章閣學士院鑒書博士柯九思跋。」

鈐印：「丹丘柯九思章」朱文方印、「柯氏敬仲」朱文方印、「緼真齋」朱文長方印

清 弘曆（一題，尾紙）：

「細草清泉坰牧宜，偶看駩扎動遐思。大凌河畔丹楓樹，報我去年秋杪時。御題。」

鈐印：「幾暇鑒賞之璽」朱文長方印、「乾隆宸翰」朱文方印

清 汪由敦（尾紙）：

「御製玉甕歌。玉有白章，隨其形刻為魚獸，出沒於波濤之狀，大可貯酒三十餘石，蓋金、元舊物也。曾置萬壽山廣寒殿內，後在西華門外真武廟中，道人作菜瓮，見《輟畊錄》及《金鰲退食筆記》。命以千金易之，仍置承光殿中，而繫以詩。昔夏有德聲教訖，九牧貢金來魏闕。鑄鼎象物備神奸，山澤遍逮遺海物。化工為鑒敷土心，藍田日暖露山骨。工倕縮手不敢斲，乃借剛斧來月窟。含形內虛象海德，葆苞元氣洞芒芴。駭波澔溔迴迤涎，驚瀾灝溔涌潏汩。習坎有孚坤厚載，魄淵朝夕輪出沒。浮黍幾粒見三山，泰華安能詡昂屹。何奇不有怪不儲，湯湯潭渴鬱呵欻。駕山之鰲橫海鯨，天吳罔象紛恍欻。元蟲紫貝朱鱉黿，肥遺螭蟥蝑蛢蚏。赤龍焚蘊修罷浮，蒼虬挺鬐海馬突。鱅鮨鰍� 鯤鮪鮓，鮠鱧�鯣鱠鯊鱖。珊瑚瑪瑁鮫人珠，孕珍產瑰宏泱鬱。用協上下承天庥，重逾九鼎光朝覿。千秋法物昭靈奇，欵雲吐景鎮溟渤。匪同器寶乃待人，方周大訓楚檮杌。瓊罍繡箟吁奇洿，商彝晉鐸埋蓬蔚。瓊島春陰萬景全，廣寒高殿青雲拂。倒茄下垂紅猋獵，

沉香橫泥氣蓬勃。從臣敬獻南山頌，樽擬白獸頒章敍。存亡蠶市閱荊凡，谷陵秦項紛遺仡。金露秋風憶桂香，悽傍山人煨榾柮。五陵年少重金刀，誰從蘭若尋荒碣。惜乎占器就湮滅，有如獻璧連遭刖。刮苔滌垢露光晶，天然豈用拖剒刷。波臣水族群蹩跬，夏畟秦丁難撓扪。承光相望接堆雲，人有懷歸物豈不。信哉安得如汝壽，漢京銅仙應愧黜。 乾隆丙寅（1746）上巳日，臣汪由敦敬書。」

鈐印：「臣」白文方印、「汪由敦」朱文方印

清 弘曆（二題，尾紙）：

「權輿十駿圖驕皇，癸亥歲命世寧郎。至今歷卅餘年長，繼厥後者頗多良。十中亦或備數常，原非匹匹供御繮。和闐貢珍犴天閶，肖形事俾玉人襄。合先躋後惟掄藏，爰成八數古語償。引領仍屬萬吉驦，以德弗以力致祥。騮稱闟虎星降房，雄姿威伏於菟藏。俊逸獨是霹靂驤，木蘭圍裏殲天狼。

赤花鷹似朵雲翔，歘彼飛隼相低昂。
有騮佶閑鳥中凰，海子驀嶭胯下獐。
厄魯所進如意驄，麟身汗血氣開張。
錦雲雒穩坐玉床，雪山潦途健步康。
寶吉騮來最後行，洪豁爾遠天一方。
凡茲八者真駿英，無慚琢彼瓊瑤相。
紫檀為屏美牧場，飲齕適性樂無央。
龍為友固可年忘，遐想造父事穆王。
以車御行窮八荒，何足數哉肆游狂。
朝家詰戎馬射蔑，夙所資力應表章。
壽之貞珉允所當，峻坂馳下為弗徨，
作歌識興微慨慷。掄前後《十駿圖》
各四，命玉工肖其形，鏤檀為屏，
位置成八駿，作歌紀之。山莊多暇，
偶憶子昂此圖。郵致之，書於卷後。
丙申（1776）秋月御筆。」

　　鈐印：「寫生」朱文長方印、「幾暇
怡情」白文方印、「得佳趣」白文方印

鑒藏印：

元　柯九思：
「緼真」朱文連珠印
「柯九思印」墨文方印

清　梁清標：
「秋碧」朱文葫蘆印（二次）
「河北棠村」朱文方印
「蒼巖子梁清標玉立氏印章」朱文方印
「觀其大略」白文方印
「冶溪漁隱」朱文長方印
「蒼巖子」朱文圓印
「蕉林鑒定」白文方印

清　弘曆：
「三希堂」白文長方印
「懋勤殿鑒定章」白文方印（二次）
「乾隆御賞之寶」朱文方印（二次）
「五福五代堂古稀天子寶」朱文方印
　　（二次）
「八徵耄念之寶」朱文方印
「乾隆御玩」白文方印（二次）
「內府圖書」朱文方印（三次）
「乾隆御覽之寶」朱文橢圓印（二次）
「石渠寶笈」朱文長方印
「養心殿鑒藏寶」朱文長方印
「御賞」朱文長方印
「神品」朱文連珠方印
「古希天子」朱文圓印

「壽」白文長印
「稽古右文之璽」白文方印
「太上皇帝之寶」朱文方印
「欽文之璽」朱文圓印
「有孚惠心」白文方印

清　溥儀：
「宣統鑒賞」朱文方印
「無逸齋精鑒璽」朱文長方印
「宣統御覽之寶」朱文方印

其他：
「□□」半印

LTC, LAT, JL

CAT. 23

Late Autumn in Running Script
Signed Guan Daosheng (1262–1319);
calligraphy by Zhao Mengfu
(1254–1322)

本幅：

元　管道昇：
道昇跪覆嬸嬸夫人妝前：道昇久不奉字，
不勝馳想。秋深漸寒，計惟淑履請安。
近尊堂太夫人與令侄吉師父，皆在此一
再相會，想嬸嬸亦已知之。茲有蜜果
四盞、糖霜餅四包、郎君蒜廿尾、柏燭
百條拜納，聊見微意，辱略物領誠，
感當何如！未會晤間，冀對時珍愛。
官人不別作書，附此致意。三總管想即
日安勝，郎、娘悉佳。不宣。九月廿日，
道昇跪覆。（趙孟頫代筆）

鑑藏印：

明　李肇亨：
「檇李李氏鶴夢軒珍藏記」朱文方印

明　李應徵：
「李應徵印」白文方印半印

明　李士標：
「李霞舉鑒賞章」白文長方印半印

清　阿爾喜普：
「東平」朱文方印

清　溥儀：
「宣統御覽之寶」朱文圓印

RW, LAT

CAT. 24

*Calligraphy and Painting of
Timely Clearing after Snowfall*
Zhao Mengfu (1254–1322),
Huang Gongwang (1269–1354),
and Xu Ben (1335–1380)

本幅：

元　趙孟頫（第一幅，引首）：
「快雪時晴。子昂為子久書。」
　　鈐印：「趙氏子印」朱文方印

元　黃公望（第三幅）：
無作者款識。

明　徐賁（第四幅）：
「東海徐賁為之圖。」

題跋：

清　朱孝臧（外題簽）：
「快雪時晴卷。趙松雪書，黃子久、徐幼
文補圖，龐虛齋珍秘。甲子（1924）春日
重裝。彊村題端。」

鈐印：「孝臧」朱文長方印

清　安岐、張若靄（內題簽）：
「元趙文敏書『快雪時晴』四大字，
黃公望、徐幼文補圖。麓村珍藏。
甲子（1744）夏月得於安氏價值叁拾
伍兩，原簽附存於此，晴嵐記。」

清　于騰（內題簽）：
「元趙文敏「快雪時晴」四大字。
黃子久、徐幼文二圖。」
　　鈐印：「于騰之印」白文方印

元　黃溍（第二幅）：
「趙公展『快雪時晴』為大書，與昔人
促《蘭亭》為小本同一機括。如畫龍者，
胸中先有全龍，則或小或大，隨時變化
在我矣。此四字公為黃君子久作，子久
以遺莫君景行，而景行遂以名其齋云。
至正五年（1345）九月二十日黃溍觀。」

元　張翥（第二幅）：
「右軍《張侯帖》，唐人硬黃所臨，米南
宮定為神品，並敘其傳者本末，而字多
朽闕，趙文敏公為書于後。帖中『快雪
時晴』一語，最為佳絕，文敏復展書之，
筆執結密，咄咄逼真，使南宮復起，見
當斂袵。二者俱藏莫景行氏。嗟乎！徑
寸之珠，盈赤之璧，小大或殊，皆至寶
也。得而合之，是豈偶然也邪？河東張
翥敬題于武林史局。」
　　鈐印：「張白舉父」白文方印、
「襄陵張氏」朱文方印

元　黃公望（第二幅）：
「文敏公大書右軍帖字，余以遺景行，當
與真跡並行也。黃公望敬題。」
　　鈐印：「黃公望印」朱文方印

元　張雨（第二幅）：
「羲之頓首，快雪時晴，佳！想安善，
未果為結，力不次。王羲之頓首。
山陰張侯。張雨臨。」
　　鈐印：「句曲外史」朱文方印

元　段天祐（第二幅）：
「晉尚清談，雖片言隻字亦清。《快雪帖》
□尾廿四字耳，字字非後人所能道。
右軍□高風雅致，豈專於書耶。趙文敏
公以松雪名齋，特表章之四言而大書之，
亦豈□謂歟。此幅可與帖並傳天地間，
散□異處，何幸而合於莫君！寶之，寶之。
汴段天祐。」
　　鈐印：「學文齋」朱文長方印、
「段氏」朱文方印

元　倪中（第二幅）：
「晉人為書，每能徑丈一字，方寸千言，
蓋其胸中自□全牛，故或大或小，皆
有游刃之地。若趙文敏書法雖特起今
代，而其所造詣實追晉人。及觀『快雪
時晴』四字，信乎！與右軍帖高致無
異，想當其運筆之時，意合手從，亦不
自知有今昔。小大之間，故能得其神趣
之妙，使第以形骸索諸古人，惡足以及
是哉。藁城倪中敬書于武林安國里和陶
軒。」

元　莫昌（第二幅）：
「古人臨帖，妙在得其意度，不特規規於
形似而□。□文敏公臨右軍帖為尤多。
予家藏《快雪帖》久矣，公□覆題識于
上，可見其珍重之深也。又摘此四字展
□之，雖大小形似之或殊，其意度則得
之矣，遂揭之齋中，以並傳不朽云。南
屏隱者莫昌識。」
　　鈐印：「莫景行印」白文方印、「時習
齋」朱文長方印

明　項元汴（尾紙）：
「元趙子昂《快雪時晴帖》，名賢品識。
項元汴清秘。」

清　于騰（尾紙）：
「同治二年（1863）癸亥秋日，以安氏原
值得之都市。于騰。」
　　鈐印：「東海郯人」白文方印

鑒藏印：
明　項元汴：
「天籟閣」朱文長方印（二次）
「項子京家珍藏」朱文長方印（五次）
「項元汴印」朱文方印（四次）
「項叔子」白文方印（二次）
「項墨林父秘笈之印」朱文長方印（三次）
「檇李項氏士家寶玩」朱文長方印（二次）
「子孫世昌」白文方印（二次，一為半印)、
「神」「品」朱文連珠方印
「子京」朱文葫蘆印
「墨林秘玩」朱文方印（二次）
「項墨林鑒賞章」白文長方印
「平生真賞」朱文方印（二次）
「墨林山人」白文方印（三次）
「墨」「林」朱文連珠方印
「子孫永保」白文方印
「宮保世家」白文方印
「幻浮」白文長方印（偽）
「神」「奇」朱白文連珠方印（偽）
「寄敖」朱文橢圓印（偽）
「墨林懶叟」白文方印（偽）
「項叔子」白文方印（偽）
「項墨林父秘笈之印」朱文長方印（偽）
「項元汴印」朱文方印（偽）
「子京所藏」白文方印（偽）
「桃花源裏人家」朱文長方印（偽）
「西疇耕耦」白文方印（偽）
「虛朗齋」朱文方印（偽）
「子京」朱文葫蘆印（偽）
「子孫永保」白文方印（偽）

「項子京家珍藏」朱文長方印（偽）
「子京珍秘」朱文長方印（偽）
「子孫世昌」白文方印（偽）
「子京所藏」白文方印

明　顧從德：
「顧氏芸閣珍藏」朱文方印
「顧」「從德」朱白文連珠方印

清　張純修：
「見陽子珍藏記」朱文方印
「見陽圖書」朱文方印（二次）
「子安珍藏記」白文方印

清　安岐：
「安儀周家珍藏」朱文方印
「安氏儀周書畫之章」白文方印
「心賞」朱文葫蘆印

清　張若靄：
「張晴嵐」朱文方印（二次）
「晴嵐珍藏」朱文長方印（三次）
「鍊雪」朱文葫蘆印（三次）
「人生一樂」白文方印
「繍真閣圖書記」朱文長方印（二次）
「張晴嵐收藏印」朱文長方印
「鍊雪鑒定」白文方印（三次）
「子子孫孫永保」朱文圓印
「張氏子印」朱文方印
「晴嵐居士」白文方印
「鍊雪」白文方印
「清河張若靄晴嵐氏珍玩之章」
　　朱文長方印
「繍真閣」朱文長方印

清　董洵：
「董洵之印」白文方印
「董洵見過」白文橢圓印
「小池」朱文方印

清　查瑩：
「映山秘玩」白文方印
「查瑩之印」白文方印
「竹南逸史」朱文方印
「竹南珍藏」朱文方印（二次）
「查瑩私印」白文方印
「映山珍藏」朱文方印
「依竹堂圖書印」朱文方印

清　宋葆淳：
「是本曾藏宋葆淳家」朱文長方印
「宋氏寶墨齋審定書畫記」朱文長方印
「宋葆淳印」白文方印
「宋帥初」白文方印

清　英龢：
「英龢私印」白文方印（四次）。

清　介文：
「介文珍藏」朱文長方印（四次）。

清　于騰：
「于騰之印」白文方印（三次）
「于騰私印」朱文方印（三次）
「于」「騰」白文連珠方印（二次）
「飛卿秘玩」白文方印（二次）

清　龐元濟：
「虛齋墨緣」朱文方印（三次）
「退修盦主人珍藏圖書」朱文方印
「御賜含純履軌」朱文雙龍長方印
「龐元濟書畫印」白文長方印（二次）
「龐萊臣珍藏宋元真跡」朱文方印（四次）
「虛齋審定」朱文長方印（三次）
「虛齋審定」白文方印（二次）
「吳興龐氏珍藏」朱文方印（二次）
「萊臣心賞」朱文方印
「虛齋鑒定」朱文方印
「退修庵」朱文長方印
「萊臣眼福」朱文方印

「虛齋珍賞」朱文方印
「虛齋至精之品」朱文長方印（二次）
「退修庵主」朱文方印
「寶繢室所藏」朱文長方印
「有餘閑室寶藏」朱文長方印（二次）
「萊臣審藏真跡」朱文方印
「龐萊臣珍賞印」朱文長方印

LAT, RW

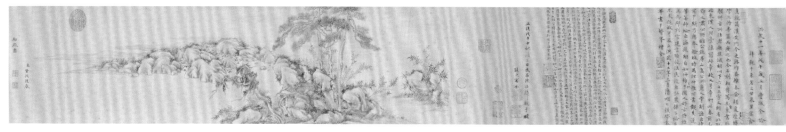

CAT. 25

Hasty Writing in Draft-Cursive Script
Deng Wenyuan (1259–1328)

本幅：

元　鄧文原：

「急就奇觚與眾異。羅列諸物名姓字。
分別部居不雜廁。用日約少誠快意。
勉力務之必有憙。請道其章。宋延年。
鄭子方。衛益壽。史步昌。周千秋。
趙孺卿。爰展世。高辟兵。

第二。鄧萬歲。秦眇房。郝利親。
馮漢強。戴護郡。景君明。董奉德。
桓賢良。任逢時。侯仲郎。由廣國。
榮惠常。烏承祿。令狐橫。朱交便。
孔何傷。師猛虎。石敢當。所不侵。
龍未央。伊嬰齊。

第三。翟回慶。畢稚季。昭小兒。
柳堯舜。藥禹湯。淳于登。費通光。
柘恩舒。路正陽。霍聖宮。顏文章。
莞財曆。遍呂張。魯賀憙。灌宜王。
程忠信。吳仲皇。許終古。賈友倉。
陳元始。韓魏唐。

第四。掖容調。柏杜楊。曹富貴。
李尹桑。蕭彭祖。屈宗談。樊愛君。

崔孝襄。姚得賜。燕楚嚴。薛勝客。
聶邗將。求男弟。過說長。祝恭敬。
審無妨。龐賞贛。蒦士梁。成博好。
范建羌。閻驩喜。

第五。寧可忘。苟貞夫。茅涉臧。
田細兒。謝內黃。柴桂林。溫直衡。
奚驕叔。邗勝箱。雍弘敬。劉若芳。
毛遺羽。馬牛羊。尚次倩。丘則剛。
陰賓上。翠鴛鴦。庶霸遂。萬段卿。
泠幼功。武初（脫「昌」字）。

第六。褚回池。蘭偉房。減罷軍。
橋竇陽。原輔福。宣棄奴。殷滿息。
充申屠。夏脩俠。公孫都。慈仁他。
郭破胡。虞荀偃。憲義渠。蔡游威。
左地餘。譚平定。孟伯徐。葛咸軻。
敦錡蘇。耿潘扈。

第七。錦繡縵旄離雲爵。乘風縣鍾
華贖樂。豹首落莽兔雙鶴。春草雞翹鳧
翁濯。鬱金半見霜白蘥。縹綟綠紈皂紫
硟。烝栗絹紺縉紅繎。青綺羅縠靡潤鮮。
絩雒繡練素帛蟬。

第八。絳緹絓紬絲絮綿。杮幣囊素
不直錢。服瑣俞此與繒連。貰貸賣買販
肆便。資貨市贏匹幅全。絡紵枲緼裹約
纏。綸組縌綬以高遷。量丈尺寸斤兩銓。
取受付予相因緣。

第九。稻黍秫稷粟麻秔。餅餌麥飯甘
豆羹。葵韭蔥蓼韰蘇薑。蕪夷鹽豉醯醬
漿。芸蒜薺介茱萸香。老菁蘘何冬日藏。
梨柿柰桃待露霜。棗杏瓜棣饊飴餳。
園（脫「菜」字）果蓏助米糧。

第十。甘麮恬美奏諸君。袍襦表裏
曲領裙。襜褕袷複袴褌縳。單衣蔽膝布
毋尊。蒇縷補袒撽緣循。履舃鞜裒越緞
紃。鞣鞮印角褐襪巾。尚韋不借為牧人。
完堅耐事愈比倫。

第十一。屐蓑素韜羸窶貧。旃裘索
擇蠻夷民。去俗歸義來附親。譯導贊拜
稱妾臣。戎貊總閱什伍陳。稟食縣守帶
金銀。鐵鈇錐鑽金鍑鍪。鍛鑄鉛錫鐙錠
（脫「鐎」字）。鈐鐊鈎斧鉦鑿鉏。

第十二。銅鍾鼎鈃銅匜銚。釭鐗鍵
鉆冶（脫「錮」字）鑄。竹器簦笠簟籧
篨。笔筩筊笥篅筴篝。筵簟箕帚筐篋簍。
櫝盂槃案桮閜碗。魁斗參升半斗匰。樽
榽榐樋匕（脫「箸」字）籫。缶甀瓨甕甖
甖瓷壺。

第十三。甌觛㽶甌瓨甖盧。絫繘繩
索紡絞纑。簡札檢署梨檟家。板柞所產
谷口荼。水虫科斗蚖蝦蟇。鯉鮒蟹鱔鮐
鮑鰕。妻婦聘嫁齎媵僮。奴婢私隸枕床
杠。蒲蒻藺席（脫「帳帷幰」三字）。

（脱「第十四」三字。）（脱「承塵」二字）戶簾條潰縱（此五字原誤入「賁」字之後）。鏡籢疏比各異工。賁（脱「熏脂粉膏」四字）澤笥。沐浴揃㩉寡合同。褖飭刻畫無等雙。係臂琅玕虎魄龍。璧碧珠璣玫瑰甕。玉瑵環佩靡從容。射魃辟邪除群凶。

第十五。竽瑟空侯琴筑鉏。鐘磬韶簫鼙鼓（脱「鳴」字）。五音雜會歌謳聲。倡優俳笑觀倚庭。侍酒行觴宿昔醒。廚宰切割給使令。薪炭㭲葦孰炊生。膹臇炙胾各有形。酸鹹酢淡辨濁清。

第十六。肌䐈脯腊魚臭腥。沽酒釀醪稽緊程。棋局博戲相易輕。冠幘簪黃結髮紐。頭頷頰准麖目耳。鼻口唇舌齗牙齒。頰頤頤（衍「頤」字）頸項肩臂肘。卷捥節搔母指手。肫胅㔯臀喉膺髃。

第十七。腸胃腹肝（脱「肺」字）心主。脾腎五臟膍臍乳。尻寬脊膂要背僂。股腳膝臏脛為柱。腨踝跟踵相近聚。矛（脱「鋌」字）鑲盾刃刀鉤。鈒鈹鎔劍鐖鐔緱。弓弩箭矢鎧兜鍪。鐵垂樾杖桃柲殳。

第十八。輻（脱「軺」字）轅軸輿輪康。輻轂輨鐧柔樧桑。軹軾軫軨軼納衡。蓋轑椑梘㫄縛棠。轡（脱「勒」字）靻

羈絆羈彊。茵茯薄杜鞍鑣鍚。靳䩶茸鈷色焜煌。革齒髹漆猶黑倉。室宅廬舍樓壑堂。

第十九。門戶井竈廡庚京。榱櫺薄廬瓦屋梁。泥塗堊暨壁垣薔。幹楨板栽度員方。屏廁溷渾糞土壤。墼絫廧廡庫東箱。碓磑扇隤舂簸揚。頃町界畝畦畤窳。彊畔畷佰耒犁鉬。

第廿。種樹收斂賦稅（脱「租」字）。擭穫秉把叴拔杷。桐梓樅松榆檽椿。槐檀荊棘葉枝扶。驊騮雒駮驪（脱「騮」字）驢。騏駬馳騁怒步超。牂羖羯羠挑（脱「羘」字）羭。六畜番息豚彘豬。豽豱狡狗野雞雛。貍兔飛鳬狼麇麞。

第廿一。㺑牸特犗羜犢駒。雄（脱「雌」字）牝牡相隨趨。糟糠汁滓豪塋蒭。鳳爵鴻鵠（脱「雁」字）鶩雉。鷹鷂鳩鴿鷖貂尾。鳩鴿鶉鴳中罔死。戴鵲鴟梟驚相視。豹狐距虛犳犀兕。貍兔飛鳬狼麇麞。

第廿二。麞麈麇鹿皮給履。寒氣泄注腹臚張。痂疕疥癬癡聾忘。癰疽癭瘧瘻疚疢。疝瘕顛疾狂失響。瘧瘚（脱「瘀」字）痛痹溫病。消湯歐㵣欶逆讓。癉熱瘻痔眵瞙眼。篤癃衰廢迎醫匠。

第廿三。灸刺和藥逐去邪。黃芩伏令礜茈胡。牡蒙甘草菀梨盧。烏喙付子椒元華。半夏皂夾艾槀吾。弓窮厚朴桂栝樓。款東貝母薑狼牙。遠志續斷參土瓜。亭歷桔梗龜骨枯。

第廿四。雷矢雚菌蓋兔盧。卜夢譴祟父母恐。祠祀（脱「社」字）保叢臘奉。行觴塞禱鬼神寵。棺槨槥櫝遺送踴。喪弔悲哀面目腫。哭泣醊祭墳墓冢。諸物盡訖五官出。宦學諷詩孝經論。

第廿五。春秋尚書律令文。治禮掌故底厲身。知能通達多見聞。名顯絕殊異等倫。超擢推舉白黑分。積行上究為牧人。丞相御史郎中君。進近公卿傅僕勳。前後常侍諸將軍。

第廿六。列侯封邑有土臣。積學所致無鬼神。（「馮」字點去）馮翊京兆執治民。廉絜平端拊順親。變化迷惑別故新。姦邪並塞皆理馴。更卒歸誠自詣因。司農少府國之淵。援衆錢穀主辦均。

第廿七。皋陶造獄法律存。誅罰詐偽劾罪人。廷尉正監承古（脱「先」字）。總領煩亂決疑文。鬥變殺傷捕伍鄰。游徼亭長共賊診。盜賊繫囚榜笞臀。朋黨謀敗相引牽。欺誣詰狀還反真。

第廿八。坐生患害不足憐。辭窮情得具獄堅。籍受驗證記問年。閭里鄉縣趣辟論。鬼新白粲鉗釱髡。不肯謹慎自令然。輸屬冶作谿谷山。菰菽起居課後先。斬伐材木斫株根。

第廿九。犯禍事危置對曹。謾訑首匿愁勿聊。縛購脫漏亡命流。攻擊劫奪檻車膠。嗇夫假佐扶致牢。疵瘈保辠訧呼獋。乏興猥逮詗讇求。輒覺沒入檄報留。受賕枉冤忿怒仇。

第卅。讒諛爭語相牴觸。憂念緩急悍勇獨。乃肯省察諷諫讀。江水涇渭街術曲。筆研投算膏火燭。賴赦救解貶秩祿。邯鄲河間沛巴蜀。潁川臨淮集（脫「課」字）錄。依恩汙擾貪者辱。

第卅一。漢地廣大。無不容盛。萬方來朝。臣妾使令。邊竟無事。中國安寧。百姓承德。陰陽和平。風雨時節。莫不滋榮。蝗蟲不起。五穀孰成。賢聖並進。博士先生。長樂無極老復丁。大德三年（1299）三月十日，為理仲雍書于大都慶壽寺僧房。巴西鄧文原。」

　　鈐印：「鄧文原印」白文方印、「巴西鄧氏善之」白文方印、「素履齋」朱文方印

題跋：

清　弘曆（外題籤）：
「鄧文原章草真跡。內府鑒藏。」
　　鈐印：「乾隆宸翰」朱文方印

清　弘曆（引首）：
「草聖。」
　　鈐印：「乾隆宸翰」朱文方印

元　石巖（本幅）：
「天曆庚午（1330）清明日，汾亭石巖民瞻觀于武林宗陽明復齋。」
　　鈐印：「巖」朱文方印、「石民瞻印」白文方印

元　楊維禎（本幅）：
「至正八年（1348）六月廿日，會稽楊維禎偕河南陸仁同展卷于東滄聽海閣，仁嘗學章草者，以此卷（「為」字點去）入臨品之能云。」
　　鈐印：「楊維禎印」白文方印、「楊氏廉夫」白文方印

元　張雨（本幅）：
「至正庚寅（1350）夏五月廿又四日，方外張雨謂素履齋書，此奮年大合作。中歲以往，爵位日高，而書學益廢，與之交筆研者，始以余言為不妄。殆暮年章草如隔世矣。信為學不可止如此。」
　　鈐印：「句曲○□」朱文方印半印

元　余詮（尾紙）：
「洪武十一年（1378）戊午歲五月，豐城余詮拜觀于東倉之甘泉里寓舍。」

元末明初　袁華（尾紙）：
「《急就篇》，漢黃門令史游作。蓋推本《蒼頡》、《爰歷》、《博學》、《凡將》等篇而廣之也。今石刻相傳為吳皇象書，比顏師古所注者無「焦滅胡」以下六十三字，又頗有訛脫。始東漢人用稿法寫此章，故又號章草。此卷前元鄧文肅公所臨，公繇房山高公（「所」字點去）薦入，掌制誥，出持憲節，斯乃應奉翰林。時為理仲雍所書，觀其運筆，若神蜧出海，飛翔自如。仲雍名熙，于闐人。好古博雅，為吳郡判官，建言助役法，民便之。弘農楊子綸出示求題，故並及之。洪武十二年（1379）三月清明日，後學袁華書于鰲峰精舍。」
　　鈐印：「袁華之印」白文長方印、「袁子英」白文方印

明　姚廣孝（尾紙）：
「嘗論《急就篇》，此小學家之說。漢史游效《凡將》為之也。末叙長安涇、渭街術，後或增以《齊國》、《山陽》二章。宋歐陽修居史館，日以餘力及於是篇，取州名裒次之。然是篇去古逾遠，脫漏訛舛，不無人欲辨其失得而增補，亦徒自勞爾。漢人以稿法書之，故曰章草，此草書之祖也。近世人多尚草，真、行未始學而先習草，如人未能立而欲走，蓋可笑也！況章草之來，本於科斗、籀篆。觀其運筆圓轉，用意深妙，烏有不通籀篆而能學者哉？苟有聰明之人，雖不通籀篆，能彷彿其形似猶可，其奈刻鵠不成者耶？自東漢以降，臻乎妙者，惟皇象、鍾繇、王右軍而已。唐宋間人臨鍾、王所書亦不多見，欲習之者不通籀篆，誠難乎哉！此卷巴西鄧文肅公所臨，公在元時不獨以文章名世，而又以能書名世，號稱「三大家」，公與焉。觀公運筆用意，甚合古人之妙，此卷實希世之寶也。亮上人出示，乞余題。余故以草書之難習，並錄于卷末。非但以警於人，而有以自警也。洪武二十七年（1394）倉龍甲戌秋七月，獨庵道衍寫于海雲東軒。」
　　鈐印：「道衍私印」白文方印、「獨闇」白文方印

元　陳謙（尾紙）：
「正統戊午（1438）中秋後二日，武昌陳謙拜觀于毗陵之寓舍。」
　　鈐印：「陳謙」朱文方印、「吶菴」朱文方印

明　項元汴（本幅卷首）：
「得。」（千字文編號）

清　董邦達（尾紙）：
「臣董邦達奉敕恭畫。」

鈐印：「臣邦達印」白文方印、
「文學侍從」朱文方印

鑒藏印：

元末明初　袁華：
「袁華私印」白文方印

明　項元汴：
「寄敖」朱文橢圓印（二次）
「淨因菴」白文方印
「檇李」朱文圓印（二次）
「項元汴印」朱文方印
「墨林秘玩」朱文方印（二次）
「退密」朱文葫蘆印
「子京父印」朱文方印
「墨林父」白文亞形印（二次）
「野處」白文長方印
「子京所藏」白文方印（二次）
「項墨林父秘笈之印」朱文長方印
「墨林山人」白文方印
「檇李項氏士家寶玩」朱文長方印
「若水軒」朱文方印
「子孫世昌」白文方印
「天籟閣」朱文長方印
「項墨林鑒賞章」白文長方印
「墨」「林」朱文連珠方印
「宮保世家」白文方印
「桃里」朱文圓印
「項子京家珍藏」朱文長方印

清　梁清標：
「蒼巖子」朱文圓印
「蕉林鑒定」白文方印

清　姜紹書：
「二酉」朱文橢圓印
「姜紹書印」白文方印

清　弘曆：
「御書」朱文長方印

「乾」雙龍紋朱文圓印
「隆」蟠螭紋朱文方印
「太上皇帝」朱文方印
「乾隆御玩」白文方印（二次）
「乾隆御覽之寶」朱文橢圓印（二次）
「石渠寶笈」朱文長方印
「乾清宮鑒藏寶」朱文長方印
「幾暇臨池」白文方印
「意在筆先」朱文橢圓印
「內府圖書」朱文方印（二次）
「乾隆御賞」朱文方印
「幾暇怡情」白文方印
「御賞」朱文長方印（二次）
「內府書畫之寶」白文方印
「古希天子」朱文圓印
「壽」白文長方印
「幾暇鑒賞之璽」朱文方印
「五福五代堂古稀天子寶」朱文方印
「八徵耄念之寶」朱文方印

清　溥儀：
「宣統御覽之寶」朱文方印
「宣統鑒賞」朱文方印
「無逸齋精鑒璽」朱文長方印

其他：
「□千□游」白文方印半印

LTC, JL, YSY

Stone Cliff at the Pond of Heaven
Huang Gongwang (1269–1354)

本幅：

元　黃公望：
「至正元年（1341）十月，大癡道人為性之
作天池石壁圖，時年七十有三。」
　鈐印：「黃公望印」朱文方印、
「黃氏子久」白文方印、「一峰道人」
朱文方印

題跋：

現代　謝稚柳（外題簽）：
「黃大癡天池石壁圖真本。定定館藏。」
　鈐印：「定定館」朱文長方印

元　柳貫（本幅）：
「性之得大癡道人《天池石壁圖》，
請予作歌。予愛其合作，歌而識諸圖上，
而且以發道人燕間一笑。連峰嶤嶤雲
蔟蔟，石壁天池秋一幅。大癡道人騎鯉魚，
夢入神山采蛾綠。覺來兩鬢風泠泠，
顥氣涌出芙蓉青。谾巖下匯龍池水，
（「絕」字點去）巍觀高連閣道星。
道人弄筆筆不知，八柱誰其張地維。
金繩鐵紐一何壯，鳥道險絕橫峨眉。
三百年來畫林壑，董米中間称合作。
何嘗惜墨點微茫，間亦塗丹記搖落。
吳興室內大弟子，幾人斫輪無血指。
十日五日一筆成，能事於今誇疊疊。
大癡小點俗所訶，道人迕物良已多。
微君自起歌黃鵠，奈此石壁天池何。
至正二年（1342）人日，翰林待制柳貫。」
　鈐印：「柳氏道傳」朱文方印

鑒藏印：

元　錢良佑：
「錢氏翼之」白文方印半印

明　鄒迪光：
「迪光」白文方印

清　李蔚：
「心遠堂」朱文長方印

現代　謝稚柳：
「杜齋」朱文長方印
「調嘯閣」朱文方印

其他：
「安氏吳卿圖籍」朱文長方印

LAT, JL

Old Fisherman

Wu Zhen (1280–1354)

本幅：
元　吳鎮：
「目斷煙波青有無，霜凋楓葉錦模糊。
千尺浪，四腮鱸，詩筒相對酒胡蘆。
至元二年（1336）秋八月，梅花道人戲作
漁父四幅並題。」
　　鈐印：「梅花盦」朱文方印、
「嘉興吳鎮仲圭書畫記」白文方印

題跋：
近代　胡毅（外題簽）：
「梅花道人漁父圖軸。吳氏筠清館舊藏。
民國七年（1918）八月隋齋重裝。」
　　鈐印：「隋齋」朱文方印

明　王鐸（上詩堂）：
「淡秀古雅，鮮有其儔。吳鎮筆不一，層
崿複嶂之外，復有此閑遠者，更以潤滋
勝。二弟仲和善為護持此圖，固不易也。
丙戌（1646）正月廿七日，王鐸題。」
　　鈐印：「王鐸之印」白文方印、
「煙潭漁叟」白文方印

鑒藏印：
清　王鏞：
「仲和珍藏」白文方印

清　吳榮光：
「南海吳氏賜書樓印」朱文長方印
「吳榮光印」朱文方印
「吳氏荷屋平生真賞」白文方印（二次）
「伯榮審定」朱文方印
「吳伯榮氏秘笈之印」朱文方印
「吳氏筠清館所藏書畫」朱文方印

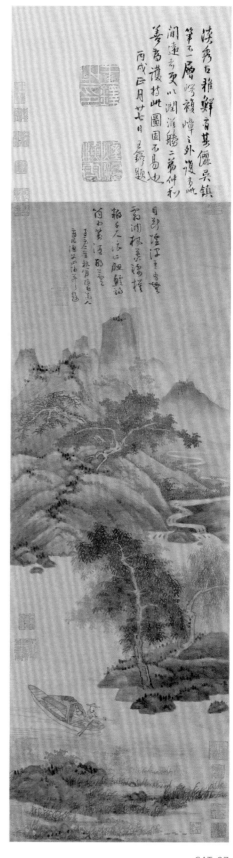

CAT. 27

清　潘正煒：
「季彤審定」朱文方印（二次，一爲倒鈐）

近代　胡毅：
「隋齋所藏」朱文方印

其他：
「十二樓藏印」朱文長方印（二次）
「一笠齋珍藏」白文方印

YSY, LAT

Five Paintings by Yuan Masters
Zhao Yong (after 1293–1361),
Wang Mian (1287–1359),
Zhu Derun (1294–1365),
Zhang Guan (active 14th century),
and Fang Congyi (active 14th century)

本幅一：
趙雍松溪釣艇圖

元　趙雍：
「至正廿年（1360）二月既望，仲穆畫。」
　　鈐印：「仲穆」朱文方印、「魏國世家」白文方印

題跋：
清　弘曆：
「岸石汀沙水一灣，閣閬獨把釣車閑。
雙松平遠契神韻，似貌伊家伯仲間。
御題。」
　　鈐印：「乾隆宸翰」朱文方印

鑑藏印：
明　李肇亨：
「李肇亨」朱文方印
「檇李李氏鶴夢軒珍藏記」朱文方印

清　安岐：
「儀周鑒賞」白文方印

清　張洽：
「張洽之印」白文方印

清　弘曆：
「石渠寶笈」朱文方印
「乾隆鑒賞」白文圓印
「石渠定鑒」朱文圓印

「寶笈重編」白文方印
「乾隆御覽之寶」朱文橢圓印
「三希堂精鑒璽」朱文長方印
「宜子孫」白文方印
「重華宮鑒藏寶」朱文長方印

清　顒琰：
「嘉慶御覽之寶」朱文橢圓印

本幅二：
王冕墨梅圖

元　王冕：
「吾家洗研池頭樹，個個華開澹墨痕。
不要人誇好顏色，只流清氣滿乾坤。
王冕元章為良佐作。」
　　鈐印：「王元章」白文方印
「文王子孫」白文方印
「方外司馬」白文方印
「會稽佳山水」白文方印

題跋：
清　弘曆：
「鉤圈略異楊家法，春滿冰心雪壓腰。
何礙傍人呼作杏，問他杏得爾清標。
御題。」
　　鈐印：「幾暇怡情」白文方印、
「得佳趣」白文方印

鑑藏印：
清　梁清標：
「棠村審定」白文方印
「蕉林」朱文方印

清　安岐：
「儀周鑒賞」白文方印

清　溥儀：
「宣統御覽之寶」朱文橢圓印

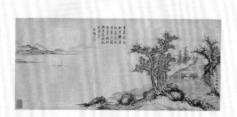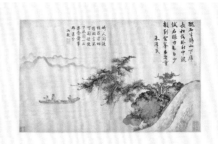

本幅三：

朱德潤松溪放艇圖

元　朱德潤：

「醜石半蹲山下虎，長松倒臥水中龍。
試君眼力知多少，數到雲峰第幾重。
朱澤民。」

　　鈐印：「朱氏澤民」朱文方印

題跋：

清　弘曆：

「畸人閑泛綠溪濆，相榷微言不可聞。
便使下風聞一二，赫胥前事那區分。
御題。」

　　鈐印：「叢雲」朱文長方印

鑒藏印：

明　沈周：

「沈周寶玩」朱文方印

清　安岐：

「安氏儀周書畫之章」朱文長方印

本幅四：

張觀疏林茅屋圖

元　張觀：

「至正戊戌（1358）八月，張觀製。」

題跋：

清　弘曆：

「古屋深林柯葉耰，樂飢高志抗由巢。
杜陵點筆成秋興，且喜西風未捲茅。
御題。」

　　鈐印：「中心止水靜」朱文橢圓印

鑒藏印：

清　安岐：

「安氏儀周書畫之章」白文長方印

本幅五：

方從義山水圖

元　方從義：

「方方壺作。」

題跋：

清　弘曆：

「依林結宇翠陰濃，閉戶經年客鮮逢。
谷口板橋不妨設，叢條都解掃塵踪。
庚辰（1760）春日御題。」

　　鈐印：「比德」朱文方印、「朗潤」
白文方印

鑒藏印：

明　李日華：

「君實父印」朱文方印

明　李肇亨：

「醉鷗」朱文方印

「檇李李氏鶴夢軒珍藏記」朱文方印

明　項元汴：

「若水軒」朱文方印半印

「項子京家珍藏」朱文長方印
　　（二次，一爲半印）

「項元汴印」朱文方印（二次）

「平生真賞」朱文方印（二次，一爲半印）

「項墨林鑒賞章」白文長方印

「墨林秘玩」朱文方印

「墨」「林」朱文連珠方印半印

「子京父印」白文方印半印

清　安岐：

「儀周鑒賞」白文方印

清　張洽：

「張洽之印」白文方印

清　溥儀：

「宣統鑒賞」朱文方印

「無逸齋精鑒璽」朱文長方印

其他：

「子孫保之」白文方印

「春樹暮雲」白文方印

JFT, JL

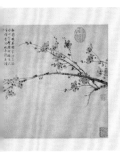
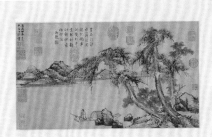

CAT. 29

Wutong, Bamboo, and Elegant Rock
Ni Zan (1306–1374)

本幅：
元　倪瓚：
「貞居道師將往常熟山中訪王君章高士，
余因寫梧竹秀石奉寄仲素孝廉，並賦詩
云：高梧疏竹溪南宅，五月溪聲入坐寒。
想得此時窗戶暖，果園撲栗紫團團。
倪瓚。」

題跋：
清　龐元濟（題簽）：
「倪雲林梧竹秀石圖。虛齋藏。」
　　鈐印：「虛齋鑒藏」朱文方印

元　張雨（本幅）：
「青桐陰下一株石，回棹來看口未消，
展圖仿佛雲林影，肯向燈前玩楚腰。
寫此紙附老僕至蒲軒，即景書圖上。
雨。」
　　鈐印：「幻僊」朱文橢圓印、
「句曲外史」朱文方印

清　弘曆（本幅）：
「梧如過雨竹搖風，石畔相依氣味同。
數百來傳墨戲，展觀濕潤鎮濛濛。
己卯（1759）春月御題。」

鈐印：「乾隆宸翰」朱文方印（殘損）、
「幾暇臨池」白文方印（殘損）。

鑒藏印：
元　張雨：
「崇國世家」白文方印
「左廉察祭酒」白文方印
「貞居」白文方印
「句曲外史張天雨印」朱文長方印

明　徐復祚：
「徐篤孺印」白文方印

清　梁清標：
「蒼巖」朱文方印
「蕉林居士」白文方印

清　安岐：
「安儀周家珍藏」朱文長方印
「珍秘」朱文方印
「子孫保之」白文菱形印

清　弘曆：
「石渠寶笈」朱文長方印
「乾隆鑒賞」白文圓印
「乾隆御覽之寶」朱文橢圓印
「三希堂精鑒璽」朱文長方印
「宜子孫」白文方印

清　龐萊臣：
「元濟恭藏」朱文長方印
「龐萊臣珍藏宋元真跡」朱文方印
「虛齋至精之品」朱文長方印

其他：
「少村眼福」朱文方印
花押印

PYY, JL

Dwelling in the Summer Mountains
Wang Meng (d. 1385)

本幅：
元　王蒙（本幅）：
「夏日山居。戊申（1368）二月，黃鶴山
人王叔明為同玄高士畫于青村陶氏之嘉
樹軒。」

題跋：
清　龐元濟（外題簽）：
「王叔明夏日山居圖。」
　　鈐印：「虛齋鑒藏」朱文方印

明　林瀚（上詩堂）：
「黃鶴山人標格清，胸中丘壑何縱橫。
興來捉筆一揮灑，蒼崖翠石煙雲生。
人家住在山之麓，隱映門牆蔽林木。
橫經讀罷鼓瑤琴，薰風微動窗前竹。
司業先生最愛山，無緣長得青山看。
時張此圖向高壁，仿佛揚子江天寬。
三山林瀚為少司成費先生題。」
　　鈐印：「泉山書屋」朱文長方印、
「亨大」朱文方印、「玉堂清暇」白文
方印

清　弘曆（上本幅）：
「蒼山雅解朱明障，灌木還饒翠蔭籠。
結宇名符瀫水上，不☐今昔辨殊同。
（瀫陽別墅亦有嘉樹軒，與山樵寫圖處
名同，故云。）乾隆戊寅（1758）御題。」
　　鈐印：「乾隆宸翰」朱文方印、
「幾暇臨池」白文方印

鑒藏印：
清　安岐：
「心賞」朱文葫蘆印
「安儀周家珍藏」朱文長方印

清　弘曆：
「乾隆御覽之寶」朱文橢圓印
「石渠定鑒」朱文圓印
「寶笈重編」白文方印
「石渠寶笈」朱文長方印
「淳化軒圖書珍秘寶」白文方印
「淳化軒」朱文長方印
「乾隆宸翰」白文方印
「信天主人」朱文方印
「三希堂精鑒璽」朱文長方印
「宜子孫」白文方印
「太上皇帝」朱文方印
「乾隆鑒賞」白文圓印

清　龐元濟：
「虛齋秘笈之印」朱文方印
「虛齋至精之品」朱文長方印
「元濟恭藏」朱文長方印
「龐萊臣珍藏宋元真跡」朱文方印
「虛齋審定」白文方印
「臣龐元濟恭藏」朱文長方印

YSY

Contributors to the Catalogue

Contributors to catalogue entries and
transcriptions of inscriptions and seals:

HN	Hua Ning
JFT	Jiang Fangting
JL	Jay Lee
JT	Jiang Tong
LAT	Li An Tan
LS	Li Shi
LTC	Lung Tak Chun
LY	Lu Ying
MSP	Ma Shunping
MXY	Mao Xiangyu
NH	Nie Hui
PYY	Phoebe Yiu Yin
QCT	Qin Chongtai
RW	Raphael Wong
SHM	Shi Hanmu
TYM	Tian Yimin
WQ	Wang Qi
WZX	Wang Zhongxu
YSY	Yau Sum Yin
YWT	Yu Wentao
ZZR	Zhao Zir

Bibliography

An Qi 1742
An Qi. Preface (1742) to *Moyuan huiguan*, 4 *juan,* supplement 2 *juan*. In Zhongguo Shuhua Quanshu Bianzuan Weiyuanhui 1993–2000, vol. 10: 315–416.

Augustin 2017
Birgitta Augustin. "Wang Xizhi's Letter *Kuaixue shiqing* and Its Reception in the Yuan Dynasty". *Gugong xueshu jikan* 35, no. 1 (2017): 133–179.

Aying 1998
Aying. *Aying riji*, edited by Wang Haibo (Taiyuan: Shanxi Jiaoyu Chubanshe, 1998).

Bai 1999
Qianshen Bai. "Chinese Letters: Private Words Made Public". In Harrist et al. 1999: 381–399.

Barnhart 1977
Richard Barnhart. "Yao Yen-ch'ing, T'ing-mei, of Wu-hsing". *Artibus Asiae* 39, no. 2 (1977): 105–123.

Barnhart et al. 1997
Richard Barnhart et al. *Three Thousand Years of Chinese Painting*. New Haven, CT: Yale University Press, 1997.

Bian Yongyu 1987
Bian Yongyu. *Shigu tang shuhua huikao*. In *Siku quanshu*, vol. 829. Shanghai: Shanghai Guji Chubanshe, 1987.

Bian Yongyu 1992
Bian Yongyu. *Shigu tang shuhua huikao*. In Zhongguo Shuhua Quanshu Bianzuan Weiyuanhui 1993–2000, vol. 6: 127–384.

Bickford 2013
Maggie Bickford. "Useful Pictures, Useless Art? Looking Again at Bird-And-Flower Painting". *Orientations* 44, no. 1 (2013): 59–67.

Bloch 1992
Marc Bloch. *The Historian's Craft*. Translated by Peter Putnam. Manchester: Manchester University Press, 1992.

Bo 2004
Bo Songnian. "Song Huizong mobi huaniao hua chutan". *Gugong Bowuyuan yuankan*, no. 3 (2004): 14–22.

Cahill 1960
James Cahill. *Chinese Painting*. Geneva: Skira, 1960.

Cahill 1980
James Cahill. *An Index of Early Chinese Paintings and Painters: Tang, Sung, Yuan*. Berkeley: University of California Press, 1980.

Cahill 1991
James Cahill. "Chang Ta-ch'ien Forgeries of Old Master Paintings". Paper presented at the symposium "Chang Dai-chien and His Art," at the Arthur M. Sackler Gallery, Washington, DC, 22 November 1991. James Cahill website. https://jamescahill.info/the-writings-of-james-cahill/cahill-lectures-and-papers/33-clp-16-1991-qchang-ta-chiens-forgeries-of-old-master-paintingsq-symposium-sackler-museum-dc.

Cahill 1996
James Cahill. *The Lyric Journey: Poetic Painting in China and Japan*. Cambridge, MA: Harvard University Press, 1996.

Cahill 1997
James Cahill. "The Yuan Dynasty (1271–1368)". In Barnhart et al. 1997: 139–195.

Cahill 1999
James Cahill. "The Case Against *Riverbank*: An Indictment in Fourteen Counts". *Issues of Authenticity in Chinese Painting*, edited by Judith G. Smith and Wen C. Fong (New York: Metropolitan Museum of Art, 1999): 13–63.

Cahill 2000
James Cahill. "Seeing Paintings in Hong Kong (Ching Yuan Chai so-shih III)". *Kaikodo Journal* XVIII (2000): 20–25.

Cahill 2008
James Cahill. "Chang Ta-ch'ien's Forgeries". James Cahill website. July 2008. http://jamescahill.info/the-writings-of-james-cahill/chang-ta-chiens-forgeries/211-chang-ta-chiens-forgeries.

Cahill 2009
James Cahill. *Gejiang shanse: Yuandai huihua*. Translated by Song Weihang. Beijing: Sanlian Shudian, 2009.

Cahill 2011
James Cahill. Notes for Lecture 10a: Bird-and-Flower Painting: The Early Centuries, from the lecture series "A Pure and Remote

View". University of California, Berkeley Institute of East Asian Studies website. https://ieas.berkeley.edu/sites/default/files /aparv_lecture10b.pdf.

Cai Tao 1983
Cai Tao. *Tieweishan congtan*. Annotated by Feng Huimin and Shen Xilin. Beijing: Zhonghua Shuju, 1983.

Cai Tao and Zeng Minxing 2012
Cai Tao and Zeng Minxing. *Tieweishan congtan, Duxing zazhi*. Annotated by Li Mengsheng and Zhu Jieren. Shanghai: Shanghai Guji Chubanshe, 2012.

Cai X. 2007
Cai Xinyi. "Liangjuan *Wuniu tu* kaobian". *Zhongguo shuhua*, no. 9 (2007): 58–66.

Cao B. 2009
Cao Baolin. *Zhongguo shufa shi: Song Liao Jin juan*. Nanjing: Jiangsu Fenghuang Jiaoyu Chubanshe, 2009.

Cao Q. 2013
Cao Qing. *Yuandai Jiangsu huihua yanjiu*. Nanjing: Dongnan Daxue Chubanshe, 2013.

Chang 2000a
Chang Kuang-pin. "Yuan sidajia nianbiao (shang)". *Taiwan Daxue meishushi yanjiu jikan*, no. 9 (2000): 101–178.

Chang 2000b
Chang Kuang-pin. "Yuan sidajia nianbiao (zhong)". *Taiwan Daxue meishushi yanjiu jikan*, no. 10 (2001): 161–244.

Chang 2000c
Chang Kuang-pin. "Yuan sidajia nianbiao (xia)". *Taiwan Daxue meishushi yanjiu jikan*, no. 11 (2001): 133–205.

Chen C. 1983
Chen Ching-kuang. *Yuandai huajia Wu Zhen*. Taipei: Gugong Bowuyuan, 1983.

Chen F. 2016
Chen Fukang. *Wei guojia baocun wenhua: Zheng Zhenduo qiangjiu zhenxi wenxian shuxin riji jilu*. Beijing: Zhonghua Shuju, 2016.

Chen G. 2004
Chen Gaohua, ed. *Yuandai huajia shiliao huibian*. Hangzhou: Hangzhou Chubanshe, 2004.

Chen G. 2015
Chen Gaohua, ed. *Yuandai huajia shiliao (zengbu ben)*. 2 vols. Beijing: Zhongguo Shudian Chubanshe, 2015.

Chen Jun 1986
Chen Jun. *Jiuchao biannian beiyao*. In *Yingyin Wenyuange siku quanshu*, vol. 328, edited by Ji Yun et al. (Taipei: Taiwan Shangwu Yinshuguan, 1986).

Chen P. 1977
Chen Pao-chen. "Guan Daosheng he ta de zhushi tu". *Gugong jikan* 11, no. 4 (1977): 51–84.

Chen P. 2012
Chen Pao-chen. *Luoshen fu tu yu Zhongguo gudai gushihua*. Hangzhou: Zhejiang Daxue Chubanshe, 2012.

Chen S. 2013
Chen Shizeng. *Zhongguo huihua shi*. Hangzhou: Zhejiang Renmin Meishu Chubanshe, 2013.

Chen Si and Chen Shilong 1987
Chen Si, comp., and Chen Shilong, suppl. *Liangsong mingxian xiaoji*. In *Siku quanshu*, vol. 1362, edited by Ji Yun et al. (Shanghai: Shanghai Guji Chubanshe, 1987).

Chen X. 2021
Chen Xiangfeng. "Lun Meiguo Naierxun– Atejinsi Yishu Bowuguan cang Yuan Li Kan *Mozhu tu* zhong de zhulei zhuwu yu xingli biaoxian". *Meishu daguan*, no. 1 (2021): 36–39.

Chen Y. 2021
Chen Yunhai. "Zhao Yong shengnian ji xiangguan wenti xinkao". *Meishu yanjiu*, no. 2 (2021): 41–45.

Chen Zhensun 2005
Chen Zhensun. *Zhizhai shulu jieti*. Shanghai: Shanghai Guji Chubanshe, 2005.

Cheng 2016
Cheng Wen-Chien. "Paintings of Traveling Bullock Carts (*Panche Tu*) in the Song Dynasty (960–1279)". *Archives of Asian Art* 66, no. 2 (2016): 239–269.

Ching 1999
Dora C. Y. Ching. "Wang To (1592–1652), *Calligraphy after Wang Hsi-chih*". In Harrist et al. 1999, 178–179.

Chou and Chung 2015
Ju Hsi Chou and Anita Chung. *Silent Poetry: Chinese Paintings from the Collection of the Cleveland Museum of Art*. Cleveland: Cleveland Museum of Art, 2015.

Chu 1991
Chu Hui-liang. "Imperial Calligraphy of the Southern Song". In *Words and Images: Chinese Poetry, Calligraphy, and Painting*, edited by Alfreda Murch and Wen C. Fong (New York: Metropolitan Museum of Art, 1991): 289–312.

Clunas 2004
Craig Clunas. *Elegant Debts: The Social Art of Wen Zhengming, 1470–1559*. Honolulu: University of Hawaii Press, 2004.

Clunas 2009
Craig Clunas. *Art in China*. Oxford: Oxford University Press, 2009.

Cui 2017
Cui Yi. "Ruhe bianshi Yuandai Ni Zan". *Wenhua*, 18 April 2017. https://kknews .cc/culture/z6onm8l.html.

Deng Chun 1963
Deng Chun. *Huaji*. In Yu A. 1963, vol. 1.

Deng Chun 1963b
Deng Chun. *Huaji*. Beijing: Renmin
Meishu Chubanshe, 1963.

Dong 2006
Dong Jianzhong. "Wuniu tu liuru Qing-
gong di queqie riqi". *Gugong Bowuyuan
yuankan*, no. 2 (2006): 63.

Dong Qichang 2012
Dong Qichang. *Rongtai ji, bieji*. Annotated
by Shao Haiqing. Hangzhou: Xiling Yinshe,
2012.

Du J. 2014
Du Juan. "Wang Shizhen yu Xiang Yuan-
bian: Mingdai zhonghouqi liangzhong
butong leixing de shuhua jiancangjia:
jianlun erzhe jiaoyou shuli zhi yuanyin".
Gugong Bowuyuan yuankan, no. 6 (2014):
58–76.

Du Mu 1962
Du Mu. *Yuyi bian*. *Yishu congbian*,
edited by Yang Jialuo (Taipei: Shijie Shuju,
1962).

Duan 2021
Duan Ying. "Fangfu luofu cengjian shi:
Wang Mian meihua yu Yuandai wenrenhua
zhongde Nansong chuantong". *Zijin Cheng*,
no. 1 (2021): 64–81.

Duan Y. 2004
Duan Yong. "Guwu Chenleisuo de xing-
shuai ji qi lishi diwei pingshu". *Gugong
Bowuyuan yuankan*, no. 5 (2004): 14–39,
154.

Ebrey 2006
Patricia Ebrey. "Literati Culture and the
Relationship Between Huizong and Cai
Jing". *Journal of Song-Yuan Studies*, no. 36
(2006): 1–24.

Ebrey 2014
Patricia Ebrey. *Emperor Huizong*.
Cambridge, Massachusetts: Harvard
University Press, 2014.

Edwards 1967
Richard Edwards. *Li Ti*. Washington, DC:
Smithsonian Institution 1967.

Edwards 1993
Richard Edwards. "Li Gonglin's Copy
of Wei Yan's 'Pasturing Horses'".
Artibus Asiae 53, nos. 1–2 (1993): 168–181,
184–194.

Edwards 2011
Richard Edwards. *The Heart of Ma Yuan:
The Search for a Southern Song Aesthetic*.
Hong Kong: Hong Kong University
Press, 2011.

Fan 2018
Fan Jinmin. "Shangren yu wenren: Mingmo
Huizhou shuhuashang Wang Yueshi yu
jiancangjia de jiaowang". *Shihezi Daxue
xuebao*, no. 4 (2018): 112–118.

Fan Ye 1991
Fan Ye. *Houhan shu*. Beijing: Zhonghua
Shuju, 1991.

Fang M. 2018
Fang Min. "Jijiuzhang chuanben shulue".
Hubei Daxue xuebao, no. 5 (2018): 83–86.

Fang Xuanling et al. 1982
Fang Xuanling et al. *Jin shu*. Beijing:
Zhonghua Shuju, 1982.

Fang Xuanling et al. 1993
Fang Xuanling et al. *Jin shu*. Beijing:
Zhonghua Shuju, 1993, *juan* 80.

Fang Y. 1996
Fang Yujin. "Puyi shang Pujie huanggong
zhong guji ji shuhua mulu (xia)". *Lishi
dang'an*, no. 2 (1996): 62–73.

Feng 2014
Feng Legeng. "*Youchun tu Wuniu tu* chong-
biao guangan". *Zijin Cheng*, supplement 1
(2014): 38–41.

Fong 1992
Wen C. Fong. *Beyond Representation:
Chinese Painting and Calligraphy, 8th–
14th Century*. New York: Metropolitan
Museum of Art, 1992.

Fong and Chen 1984
Wen C. Fong and Pao-chen Chen, eds.
*Images of the Mind: Selections from the
Edward L. Elliott Family and John B. Elliott
Collections of Chinese Calligraphy and
Painting at The Art Museum, Princeton
University*. Princeton, NJ: Princeton
University Art Museum, 1984.

Fontein and Hickman 1971
Jan Fontein and Money L. Hickman. *Zen
Painting and Calligraphy*. Boston: Museum
of Fine Arts, 1971.

Foong 2015
Ping Foong. *The Efficacious Landscape:
On the Authorities of Painting at the
Northern Song Court*. Cambridge, MA:
Harvard University Press, 2015.

Franke and Twitchett 1994
Herbert Franke and Denis Twitchett, eds.
*The Cambridge History of China, Volume 6:
Alien Regimes and Border States, 907–1368*.
Cambridge: Cambridge University Press,
1994.

Fu 1977
Fu Shen. *Traces of the Brush*. New Haven,
CT: Yale University Art Gallery, 1977.

Fu 1996a
Fu Shen. "Yuandai Shufa Jianlun". *Shushi
yu shuji: Fu Shen shufa lunwen ji (1)*. Taipei:
Lishi Bowuguan, 1996: 59–79.

Fu 1996b
Fu Shen. "Yuandai shujia Deng Wenyuan jiqi shuji". *Shushi yu shuji: Fu Shen shufa lunwen ji (1)*. Taipei: Lishi Bowuguan, 1996: 207–247.

Fu 2003
Fu Shen. "Dong Qichang shuhuachuan shuishang xinglü yu jianshang, chuangzuo guanxi yanjiu". *Meishushi yanjiu jikan* (September 2003): 205–297.

Fu Z. 1990
Fu Zhenlun. "Zhuiyi Gugong xiqian shuhua gaobie xinan fulao zhanlan". *Zijin Cheng*, no. 5 (1990): 8, 40.

Ge Lifang 1984
Ge Lifang. *Yunyu yangqiu*. Shanghai: Shanghai Guji Chubanshe, 1984.

Giuffrida 2018
Noelle Giuffrida. *Separating Sheep from Goats: Sherman E. Lee and Chinese Art Collecting in Postwar America*. Oakland: University of California Press, 2018.

Gu Fu 1993
Gu Fu. *Pingsheng zhuangguan*. In Zhongguo Shuhua Quanshu Bianzuan Weiyuanhui 1993–2000, vol. 4: 962–963.

Gu Fu 2011
Gu Fu. *Pingsheng zhuangguan*. Annotated by Lin Yusheng. Shanghai: Shanghai Guji Chubanshe, 2011.

Guanxi Zhongguo Shuhua Shoucang Yanjiuhui 2015
Gu Guanxi Zhongguo Shuhua Shoucang Yanjiuhui. *Zhongguo shuhua Riben shoucang: Guanxi bainian shoucang jishi*. Translated by Lingyi Su, Liyun Huang, and Jianzhi Chen. Taipei: Diancang Yishu Jiating Gufen Youxian Gongsi, 2015.

Gugong Bowuyuan Canghuaji Bianji Weiyuanhui 1978
Gugong Bowuyuan Canghuaji Bianji Weiyuanhui. *Zhongguo lidai shuhua: Gugong Bowuyuan canghuaji 1 Dong Jin, Sui, Tang, Wudai bufen*. Beijing: Renmin Meishu Chubanshe, 1978.

Gugong Bowuyuan 1991
Gugong Bowuyuan. *Gugong Bowuyuan 50 nian rucang wenwu jingpin ji*. Beijing: Zijin Cheng Chubanshe, 1991.

Gugong Bowuyuan 2008a
Gugong Bowuyuan. *Gugong Bowuyuan cangpin daxi: huihua bian 1 Jin, Sui, Tang, Wudai*. Beijing: Zijin Cheng Chubanshe, 2008.

Gugong Bowuyuan 2008b
Gugong Bowuyuan. *Gugong Bowuyuan cangpin daxi: huihua bian 2: Song*. Beijing: Zijin Cheng Chubanshe, 2008.

Gugong Bowuyuan 2013
Gugong Bowuyuan. *Gugong Bowuyuan cang Qinggong chenshe dang'an*. Edited by Zhu Saihong. 45 vols. Beijing: Gugong Chubanshe, 2013.

Gugong Bowuyuan 2019
Gugong Bowuyuan. *Wanzi Qianhong: Zhongguo gudai huamu ticai wenwu tezhan*. Beijing: Gugong Chubanshe, 2019.

Gugong Bowuyuan and Xiangcheng 2010
Gugong Bowuyuan and Xiangcheng Shizhengxie. *Gugong Bowuyuan cang Zhang Boju juanxian zuopin: Zhongguo gudai shuhua zuopinji*. Beijing: Zijin Cheng Chubanshe, 2010.

Guo H. 2014
Guo Hui. "Canonization in Early Twentieth-Century Chinese Art History". *Journal of Art Historiography* 10 (2014): 1–16.

Guo Ruoxu 2001
Guo Ruoxu. *Tuhua jianwen zhi*. Annotated by Wang Qiyi. Shenyang: Liaoning Jiaoyu Chubanshe, 2001.

Guojia Wenwuju 1998
Guojia Wenwuju. *Zheng Zhenduo wenbo wenji*. Beijing: Wenwu Chubanshe, 1998.

Guoli Beiping Gugong Bowuyuan 1934
Guoli Beiping Gugong Bowuyuan. *Gugong yiyi shuji shuhua mulu sizhong*. Beijing: Guoli Beiping Gugong Bowuyuan, 1934.

Hammers 2021
Roslyn Lee Hammers. *The Imperial Patronage of Labor Genre Paintings in Eighteenth-century China*. New York: Routledge, 2021.

Han Shaoyun 2012
Han Shaoyun. 'Shiyi chanqu: Huichong xiaojing hua yanjiu'. Master's diss., Henan Daxue, 2012.

Harrist 1995
Robert E. Harrist, Jr. "The Artist as Antiquarian: Li Gonglin and His Study of Early Chinese Art". *Artibus Asiae* 55, nos. 3–4 (1995): 237–280.

Harrist 1998
Robert E. Harrist, Jr. *Painting and Private Life in Eleventh-Century China: Mountain Villa by Li Gonglin*. Princeton, NJ: Princeton University Press, 1998.

Harrist 1999
Robert E. Harrist, Jr. "A Letter from Wang Hsi-chih and the Culture of Chinese Calligraphy". In Harrist et al. 1999: 241–259.

Harrist 2002
Robert E. Harrist, Jr. "Copies, All the Way Down: Replication in Chinese Calligraphy". *East Asian Library Journal* 10, no. 1 (2002): 176–196.

Harrist 2004
Robert E. Harrist, Jr. "The Aesthetics of Replication and Deceptions in Calligraphy of the Six Dynasties Period". *Ordering the World: Word and Image in the Aesthetics of the Six Dynasties Period*, edited by Zong-qi Cai (Honolulu: University of Hawaii Press, 2004): 4–24.

Harrist et al. 1999
Robert E. Harrist, Jr. et al., eds. *The Embodied Image: Chinese Calligraphy from the John B. Elliott Collection*. Princeton, NJ: Princeton University Art Museum, 1999.

Hawkes 1985
David Hawkes, trans. *The Songs of the South: An Anthology of Ancient Chinese Poems by Qu Yuan and Other Poets*. Harmondsworth: Penguin, 1985.

Hearn 2009
Maxwell K. Hearn. "Shifting Paradigms in Yuan Literati Art: The Case of the Li-Guo Tradition". *Ars Orientalis*, no. 37 (2009): 78–106.

Ho 1989
Ho Wai-kam. "Dong Qichang de xin zhentong guannian ji qi nanzong lilun". *Wenrenhua yu nanbeizong lunwen huibian*, edited by Zhang Lian and Kohara Hironobu (Shanghai: Shanghai Shuhua Chubanshe, 1989): 728–752.

Ho 1992
Ho Wai-kam. "Yuandai wenren hua xushuo". *Haiwai Zhongguo hua yanjiu wenxuan*, edited by Hong Zaixin (Shanghai: Shanghai Renmin Meishu Chubanshe, 1992): 246–274.

Ho and Delbanco 1993
Wai-kam Ho and Dawn Ho Delbanco. "Dong Qichang dui lishi he yishu de chaoyue". Translated by Qian Zhijian. *Meishu yanjiu*, no. 1 (1993): 8–20.

Ho et al. 1980
Wai-kam Ho et al. *Eight Dynasties of Chinese Painting: The Collections of the Nelson-Atkins Museum of Art, Kansas City, and the Cleveland Museum of Art*. Cleveland: Cleveland Museum of Art; Bloomington: Indiana University Press, 1980.

Hsiao 1997
Hsiao Chi-ching. "Yuanchao duozu shiren de yaji". *Zhongguo Wenhua Yanjiusuo xuebao*, no. 6 (1997): 179–204.

Hsu 2016
Eileen Hsiang-ling Hsu. *Monks in Glaze: Patronage, Kiln Origin, and Iconography of the Yixian Luohans*. Boston: Brill, 2016.

Hu 1998
Hu Chuanzhi. "'Suxue shengyu bei' de lishi kaocha". *Wenxue yichan*, no. 5 (1998): 54–60.

Hu Yinglin 1993
Hu Yinglin. *Shaoshi Shanfang ji*. Shanghai: Shanghai Guji Chubanshe, 1993.

Huang M. 2003
Huang Miaozi. "Du Ni Yunlin zhuan zhaji". *Yilin yizhi: gumeishu wenbian*. Beijing: Sanlian Shudian, 2003: 26–55.

Huang and Hao 2009
Huang Miaozi and Hao Jialin. *Ni Zan nianpu*. Beijing: Renmin Meishu Chubanshe, 2009.

Huang P. 2015
Huang Peng. *Wumen juyan — Mingdai Suzhou shuhua jiancang*. Shanghai: Shanghai Shuhua Chubanshe, 2015.

Huang S. 2002
Susan Shih-shan Huang. 'The Triptych of Daoist Deities of Heaven, Earth and Water and the Making of Visual Culture in the Southern Song'. PhD diss., Yale University, 2002.

Huang X. 2008
Huang Xiaofeng. "Yaochi qingshou: *Langyuan nüxian tu* niandai yu neirong xiaokao". *Zhongguo lishi wenwu*, no. 2 (2008): 10–21, 90–93.

Huang and Yu 2020
Yung-Tai Huang and Pei-Chin Yu, eds. *Guidebook to the Palace Museum, Taipei*. Taipei: Palace Museum, Taipei, 2020.

Hucker 1995
Charles O. Hucker. *A Dictionary of Official Titles in Imperial China*. Taipei: SMC Publishing, 1995.

I Lo-fen 2001
I Lo-fen. "Zhanhuo yu qingyou: *Chibi tu* tiyong lunxi". *Gugong xueshu jikan*, vol. 18, no. 4 (2001): 65–66.

Jiang F. 2017a
Jiang Fangting. "Wang Shizhen de zhouxing huanlu: Mingdai Wumen huajia Yunhe jixing tu ce yanjiu". PhD diss., Chinese University of Hong Kong, 2017.

Jiang F. 2017b
Jiang Fangting. "Yandi fengchen hun wang-que, zuokan liushui wokan shan: du Yao Tingmei You yuxian tu". *Yueming shi'er lou: Jiedu yuanhua*, edited by Shao Yan (Beijing: Renmin Meishu Chubanshe, 2017): 161–179.

Jiang T. 2016
Jiang Tao. 'Cong Li-Guo huapai lun huihua fengge yu Yuandai wenhua huanjing de hudong'. PhD diss., Zhejiang Daxue, 2016.

Jiang T. 1962
Jiang Tiange. "Bian Zhao Mengjian he Zhao Mengfu zhijian de guanxi". *Wenwu*, no. 12 (1962): 26–31.

Jin L. 2014
Jin Liang. *Shengjing Gugong shuhua lu*. Hangzhou: Zhejiang Renmin Meishu Chubanshe, 2014, *juan* 2.

Jin Y. 2008
Jin Yunchang. "Yuhou tie ye". *Gugong lidai shuhua*, edited by Yang Danxia (Beijing: Zijin Cheng Chubanshe, 2008): 8.

Kao 1981
Arthur Mu-sen Kao. "Li Kan, an Early Fourteenth Century Painter". *Chinese Culture* 22 (1981): 85–101.

Ke Shaomin 1935
Ke Shaomin. *Xin Yuan shi*. Shanghai: Kaiming Shudian, 1935.

Ke L. 2016
Ke Lüge (Craig Clunas). *Fanping: Mingdai Zhongguo de huangjia yishu yu quanli*. Translated by Huang Xiaojuan. Henan: Henan Daxue Chubanshe, 2016.

Kitagawa 1994
Kitagawa Hirokuni. *Shōsō daijiten*. Tokyo: Yuzankaku, 1994.

Kohara 1998
Kohara Hironobu. "Wanming de hua-ping". *Dong Qichang yanjiu wenji*, edited by Duoyun Bianjibu (Shanghai: Shanghai Shuhua Chubanshe, 1998): 841–857.

Lai 2009
Lai Yu-chih. "Wenren yu Chibi: cong *Chibi fu* dao Chibi tuxiang". In *Juanqi qiandui xue: Chibi wenwu dazhan*, edited by Li Tianmin and Lin Tianren (Taipei: Gugong Bowuyuan, 2009).

Lam 2010
Peter Y. K. Lam. "The Min Chiu Society: The First Fifty Years". *The Grandeur of Chinese Art Treasures: Min Chiu Society Golden Jubilee Exhibition*, edited by Hong Kong Museum of Art (Hong Kong: Leisure and Cultural Services Department, 2010): 35–56.

Ledderose 1979
Lothar Ledderose. *Mi Fu and the Classical Tradition of Chinese Calligraphy*. Princeton, NJ: Princeton University Press, 1979.

Ledderose 1984
Lothar Ledderose. "Some Taoist Elements in the Calligraphy of the Six Dynasties". *T'oung Pao* 70 (1984): 246–278.

Ledderose 2000
Lothar Ledderose. *Ten Thousand Things: Module and Mass Production in Chinese Art*. Princeton, NJ: Princeton University Press, 2000.

Lee H. 2010
Hui-shu Lee. *Empress, Art, and Agency in Song Dynasty China*. Seattle: University of Washington Press, 2010.

Lee S. 1964
Sherman E. Lee. *A History of Far Eastern Art*. London: Thames & Hudson, 1964.

Lee and Fong 1954
Sherman E. Lee and Wen Fong. "Streams and Mountains without End: A Northern Sung Handscroll and Its Significance in the History of Early Chinese Painting". *Artibus Asiae*, Supplementum 14 (1954): 1–57, I-XXV.

Li A. 1979
Li An. "Zhao Fu Jiangshan wanli tu juan". *Meishu*, no. 8 (1979): 42–46.

Li F. 2013
Li Fengying. "Deng Wenyuan shiwen yanjiu". Master's diss., Zhejiang Shifan Daxue, 2013.

Li Kan 1992
Li Kan. *Zhupu xianglu*. In Zhongguo Shuhua Quanshu Bianzuan Weiyuanhui 1993–2000, vol. 2: 728–760.

Li Rihua 1995
Li Rihua. *Weishuixuan riji*. In *Xuxiu siku quanshu*, vol. 558, edited by Xuxiu Siku Quanshu Bianzuan Weiyuanhui (Shanghai: Shanghai Guji Chubanshe, 1995).

Li T. 2012
Li Tianchi. "Wu Qizhen shuhua jianding fangfa chutan". *Zhongguo shuhua*, no. 12 (2012): 70–73.

Li W. 1992
Li Weikun. "Xiangguang Du Ni: jiegou shubi shanshui tushi". *Nanzong beidou: Dong Qichang shuhua xueshu yantaohui lunwenji*, edited by Macao Museum of Art (Beijing: Gugong Chubanshe, 2015): 180–189.

Li W. 2017
Li Wankang. "Zhongguo gudai shuhua zhong de banzi bianhao yu Mingdai kanhezhi". *Nanjing Yishu Xueyuan xuebao* (meishu yu sheji), no. 3 (2017): 140–154.

Li Xinchuan 1986
Li Xinchuan. *Jianyan yilai xinian yaolu*. In *Yingyin Wenyuange siku quanshu*, vol. 325, edited by Ji Yun et al. (Taipei: Taiwan Shangwu Yinshuguan, 1986).

Li Xinchuan 2000
Li Xinchuan. *Jianyan yilai chaoye zaji*. Annotated by Xu Gui. Beijing: Zhonghua Shuju, 2000.

Li Zhaoheng 1992
Li Zhaoheng. *Daguan lu*. In *Xuxiu siku quanshu*, vol. 1066, edited by Xuxiu Siku Quanshu Bianzuan Weiyuanhui (Shanghai: Shanghai Guji Chubanshe, 1992): 756.

Lin 1989
Lin Lina. "Song Zhurui Xuejian panche". *Dongjing shanshui hua tezhan tulu*, edited by Lin Lina and Zhang Huazhi (Taipei: Gugong Bowuyuan, 1989): 58–59.

Lin and Zhang 1989
Lin Lina and Zhang Huazhi, eds. *Dongjing shanshui hua tezhan tulu* (Taipei: Gugong Bowuyuan, 1989).

Ling L. 2002
Ling Lizhong. "Zhan Jingfeng shengping xinian". *Shanghai Bowuguan jikan*, no. 9 (2002): 353–373.

Ling L. 2012
Ling Lizhong. "Cong Huichong dao Zhao Danian: ji 'Huichong xiaojing' ji *Jiangnanchun tujuan* kao". In *Hanmo huicui: xidu Meiguo cang Zhongguo Wudai Song Yuan shuhua zhenpin*, edited by Shanghai Bowuguan (Beijing: Beijing Daxue Chubanshe, 2012): 204–223.

Ling L. 2015
Ling Lizhong. "Dong Qichang daibiren Changying shifou jiushi Li Zhaoheng". *Nanzong beidou: Dong Qichang shuhua xueshu yantaohui lunwenji*, edited by Aomen Yishu Bowuguan (Beijing: Gugong Chubanshe, 2015): 270–283.

Ling L. 2021
Ling Lizhong. "Haishang qiannian shu-hua yu wenren huashi de guanxi chutan". *Wannian changchun: Shanghai lidai shuhua yishu teji*, vol. 1, edited by Shanghai Bowuguan (Shanghai: Shanghai Shuhua Chubanshe, 2021): 16–55.

Ling Y. 2019
Ling Yuzhi. "Li Gonglin yu Du Fu". *Zhongguo dianji yu wenhua*, no. 3 (2019): 131–136.

Liu F. 2018
Liu Fang-ju. *Guobao de xingcheng: Shuhua jinghua tezhan*. Taipei: Gugong Bowuyuan, 2018.

Liu H. 2002
Heping Liu. "The Water Mill and Northern Song Imperial Patronage of Art, Commerce, and Science". *Art Bulletin* 84, no. 4 (2002): 566–595.

Liu I. 1976
Liu I-ch'ing. *Shih-shuo hsin-yu: A New Account of Tales of the World*. Translated by Richard B. Mather. Minneapolis: University of Minnesota Press, 1976.

Liu L. 2005
Liu Langqing. "Baguo lianjun jielue Zhongnanhai". *Zijin Cheng*, no. 6 (2005): 140–145.

Liu Qi 1983
Liu Qi. *Guiqian zhi*. Annotated by Cui Wenyin. Beijing: Zhonghua Shuju, 1983.

Liu S. 2021
Liu Shi. *Fashu yaolu jiaoli*. Beijing: Zhong-hua Shuju, 2021.

Liu Su 1997
Liu Su. *Sui Tang jiahua*. Beijing: Zhong-hua Shuju, 1997.

Liu X. 2018
Liu Xiangchun. "Yanmo zai lishi hongliu zhong de xinlao yu gongji: Zheng Zhenduo yu Xianggang wenwu shougou". *Zijin Cheng*, vol. 286, no. 11 (2018): 44–61.

Liu Xu 1995
Liu Xu. *Jiu Tang shu, juan* 198 *shang*. Beijing: Zhonghua Shuju, 1995.

Liu Yiqing 1987
Liu Yiqing. *Shishuo xinyu jiaojian*. Annotated by Xu Zhen'e. Hong Kong: Zhonghua Shuju Xianggang Fenju, 1987.

Liu Yiqing 2001
Liu Yiqing. *Shishuo xinyu jiaojian*. Annotated by Xu Zhen'e. Beijing: Zhonghua Shuju, 2001.

Liu and Chen 1992
Liu Zhemin and Chen Zhengwen, eds. *Qiangjiu zuguo wenxian de zhengui jilu: Zheng Zhenduo xiansheng shuxinji*. Shanghai: Xuelin Chubanshe, 1992.

Liu et al. 1991–.
Liu Zhengcheng et al., eds. *Zhongguo shufa quanji*. 108 vols. Beijing: Rongbaozhai Chubanshe, 1991–.

Lu 2011
Lu Sufen. "Guti Xinyun: Zhao Yong Zhangcao Qianzi". *Gugong wenwu yuekan* 338, no. 5 (2011): 56–70.

Lu You 1979
Lu You. *Louxue'an biji*. Annotated by Li Jianxiong and Liu Dequan. Beijing: Zhonghua Shuju, 1979.

Lu You 2019
Lu You. *Louxue'an biji*. Beijing: Zhong-hua Shuju, 2019.

Lü 2018
Lü Zhangshen, ed. *Yan Liu Bai Mi sijia fatie*. Hefei: Anhui Meishu Chubanshe, 2018.

Ma H. 2006
Ma Heng. *Ma Heng riji: Yijiusijiu nian qianhou de Gugong (fu shichao)*. Beijing: Zijin Cheng Chubanshe, 2006.

Ma S. 2018
Ma Shunping. "Zhao Yong shengnian wenti xinlun: Yi Ke Jiusi yu Zhao Mengfu jiaoyou wei xiansuo". *Gugong Bowuyuan yuankan*, no. 4 (2018): 92–100.

Maeda 1971
Robert J. Maeda. "The 'Water' Theme in Chinese Painting". *Artibus Asiae* 33, no. 4 (1971): 247–290.

McCausland 2000
Shane McCausland. "Private Lives, Public Face — Relics of Calligraphy by Zhao Mengfu (1254–1322), Guan Daosheng (1262–1319), and Their Children". *Oriental Art* 46, no. 5 (2000): 38–47.

McCausland 2011
Shane McCausland. *Zhao Mengfu: Calligraphy and Painting for Khubilai's China.* Hong Kong: Hong Kong University Press, 2011.

McCausland 2014
Shane McCausland. *The Mongol Century: Visual Cultures of Yuan China, 1271–1368.* London: Reaktion, 2014.

McNair 1994
Amy McNair. "Engraved Model Letters Compendia of the Song Dynasty". *Journal of the American Oriental Society* 114, no. 2 (1994): 106–111.

Mei 1965
Mei Yaochen. *Wanling ji.* Taipei: Taiwan Zhonghua Shuju, 1965.

Mi Fu 1985
Mi Fu. "Taishi xing ji Wang taishi Yanzhou". *Baojin yingguang ji.* (Beijing: Zhonghua Shuju, 1985), *juan* 3.

Mi Fu 1993a
Mi Fu. *Huashi.* In Zhongguo Shuhua Quanshu Bianzuan Weiyuanhui 1993–2000, vol. 1: 978–989.

Mi Fu 1993b
Mi Fu. *Shushi.* In Zhongguo Shuhua Quanshu Bianzuan Weiyuanhui 1993–2000, vol. 1: 963–975.

Mok 1992
Kar Leung Harold Mok. 'Zhao Mengjian and Southern Song calligraphy'. DPhil diss., University of Oxford, 1992.

Mok 1999
Kar Leung Harold Mok. "Seal and Clerial Scripts of the Sung Dynasty". *Character and Context in Chinese Calligraphy*, edited by Cary Y. Liu, Dora C. Y. Ching and Judith G. Smith (Princeton, NJ: Princeton University Art Museum, 1999): 175–194.

Mok 2011
Kar Leung Harold Mok. "Nansong shufa zhong de Beisong qingjie". *Gugong xueshu jikan* 28, no. 4 (2011): 59–94.

Mok 2013
Kar Leung Harold Mok. "Songdai shufa zhong de chidu". *Shangfa yu shangyi: Tang Song shufa yanjiu lunji*, edited by Li Yuzhou (Taipei: Wanjuanlou Tushu Gufen Youxian Gongsi, 2013): 491–523.

Murray 1993
Julia K. Murray. *Ma Hezhi and the Illustrations of the Book of Odes.* Cambridge: Cambridge University Press, 1993.

Niu 2005
Niu Kecheng. "Xuanhe yufu yin geshi yanjiu". *Gugong Bowuyuan yuankan*, no. 1 (2005): 53–76.

Northeast Asian History Foundation 2014
"Afrosiab Palace Wall Painting". Northeast Asian History Foundation website, 2014. http://contents.nahf.or.kr/goguryeo/afrosiab/english.html.

Orell 2011
Julia C. Orell. 'Picturing the Yangzi River in Southern Song China (1127–1279)'. PhD diss., University of Chicago, 2011.

Ouyang Xiu 1936
Ouyang Xiu. *Ouyang Wenzhong Gongji (1)*, vol. 6. Shanghai: Shangwu Yinshuguan, 1936.

Ouyang Xiu 2001
Ouyang Xiu. *Jigu lu bawei.* In *Ouyang Xiu quanji*, vol. 5. Beijing: Zhonghua Shuju, 2001.

Ouyang Xiu and Song Qi 1982
Ouyang Xiu and Song Qi. *Xin Tang shu.* Beijing: Zhonghua Shuju, 1982, *juan* 198.

Ouyang Xun 1982
Ouyang Xun. *Yiwen leiju.* Shanghai: Shanghai Guji Chubanshe, 1982, *juan* 4.

Pan A. 2000
An-Yi Pan. "Painting and Friendship, Political and Private Life: The Case of Li Gonglin". *Journal of Song-Yuan Studies*, no. 30 (2000): 97–113.

Pan A. 2007
An-Yi Pan. *Painting Faith: Li Gonglin and Northern Song Buddhist Culture.* Leiden: Brill, 2007.

Pan Y. 1999
Pan Yungao, ed. *Xuanhe huapu.* Changsha: Hunan Meishu Chubanshe, 1999.

Pang H. 2009
Huiping Pang. "Strange Weather: Art, Politics, and Climate Change at the Court of Northern Song Emperor Huizong," *Journal of Song-Yuan Studies*, no. 39 (2009): 1–41.

Pang Yuanji 1971
Pang Yuanji. *Xuzhai minghua xulu.* In *Yishu shangjian xuanzhen*, ser. 3. Taipei: Hanhua Wenhua Shiye Gufen Youxian Gongsi, 1971.

Pang Yuanji 1972
Pang Yuanji. *Xuzhai minghua lu*. Taipei: Hanhua Wenhua Shiye Gufen Youxian Gongsi, 1972.

Pattinson 2002
David Pattinson. "Privacy and Letter Writing in Han and Six Dynasties China". *Chinese Concepts of Privacy*, edited by Bonnie S. McDougall and Anders Hansson (Leiden: Brill, 2002): 97–118.

Purtle 2011
Jennifer Purtle. "The Icon of the Woman Artist: Guan Daosheng (1262–1319) and the Power of Painting at the Ming Court c. 1500". *A Companion to Asian Art and Architecture*, edited by Rebecca M. Brown and Deborah S. Hutton (Somerset: Wiley-Blackwell, 2011): 290–317.

Qi 1954
Qi Gong. "Zai Gugong Bowuyuan Huihua Guan zhong xuexi". *Wenwu cankao ziliao* (1954): 49–52.

Qi 1999a
Qi Gong. "Lanting tie kao". *Qi Gong conggao: lunwen juan*, edited by Yao Jinggan and Liu Shi (Beijing: Zhonghua Shuju, 1999): 36–56.

Qi 1999b
Qi Gong. "Tan Nansong huashang tizi de 'Yang Meizi'". *Qi Gong conggao: lunwen juan*, edited by Yao Jinggan and Liu Shi (Beijing: Zhonghua Shuju, 1999): 148–155.

Qi 1999c
Qi Gong. "Tangren mo *Lanting tie* lianzhong". In *Qi Gong conggao: tiba juan*, edited by Yao Jinggan and Liu Shi (Beijing: Zhonghua Shuju, 1999): 153–154.

Qi and Wang 2002a
Qi Gong and Wang Jingxian. "Song Baojinzhai fatie". *Zhongguo fatie quanji*, vol. 11, edited by Zhongguo Fatie Quanji Bianji Weiyuanhui (Wuhan: Hubei Meishu Chubanshe, 2002), *juan* 1.

Qi and Wang 2002b
Qi Gong and Wang Jingxian. "Song Songguitang tie. *Zhongguo fatie quanji*, vol. 12, edited by Zhongguo Fatie Quanji Bianji Weiyuanhui (Wuhan: Hubei Meishu Chubanshe, 2002): 75–79.

Qian Qianyi 2000
Qian Qianyi. *Liechao shiji*. In *Siku jinhuishu congkan, jibu*, vol. 95–97. Beijing: Beijing Chubanshe, 2000.

Qian Qianyi 2008
Qian Qianyi. *Leichao shiji xiaozhuan*. Shanghai: Shanghai Guji Chubanshe, 2008.

Qianlong 1982
The Qianlong Emperor. *Yuzhiwen erji*. In *Yingyin Wenyuange siku quanshu*, vol. 1301, edited by Ji Yun et al. (Taipei: Taiwan Shangwu Yinshuguan, 1982).

Qianlong 1993
The Qianlong Emperor. *Qianlong yuzhi shiwen quanji*. 10 vols. Beijing: Zhongguo Renmin Daxue Chubanshe, 1993.

Qianlong 2012
The Qianlong Emperor. "Chun'ou zhai ji". *Qianlong yuzhi shiwen*, vol. 10. Beijing: Zhongguo Renmin Daxue Chubanshe, 2012.

Qianlong 2013
The Qianlong Emperor. *Qianlong yuzhi shiwen quanji*, vol. 7. Beijing: Zhongguo Renmin Daxue Chubanshe, 2013.

Qin Xiangye et al. 2002
Qin Xiangye et al. *Xu zizhi tongjian changbian shibu*. In *Xuxiu siku quanshu*, vol. 349, edited by Xuxiu Siku Quanshu Bianzuan Weiyuanhui (Shanghai: Shanghai Guji Chubanshe, 2002).

Ren 1984
Ren Daobin. *Zhao Mengfu xinian*. Zhengzhou: Henan Renmin Chubanshe, 1984.

Richter 2011
Antje Richter. "Beyond Calligraphy: Reading Wang Xizhi's Letters". *T'oung Pao* 96, nos. 4–5 (2011): 370–407.

Richter 2013
Antje Richter. *Letters and Epistolary Culture in Early Medieval China*. Seattle: University of Washington Press, 2013.

Richter and Chace 2017
Antje Richter and Charles Chace. "The Trouble with Wang Xizhi". *T'oung Pao* 103, nos. 1–3 (2017): 33–93.

Rowland 1951
Benjamin Rowland, Jr. "The Problem of Hui Tsung". *Archives of the Chinese Art Society of America*, no. 5 (1951): 5–22.

Ruan Yuan 1995
Ruan Yuan. *Shiqu suibi*. In *Xuxiu siku quanshu*, vol. 1081, edited by Xuxiu Siku Quanshu Bianzuan Weiyuanhui (Shanghai: Shanghai Guji Chubanshe, 1995).

Ruan Yuan 2002
Ruan Yuan. *Shiqu suibi*. In *Xuxiu siku quanshu*, vol. 1081, edited by Xuxiu Siku Quanshu Bianzuan Weiyuanhui. Shanghai: Shanghai Guji Chubanshe, 2002.

Schwartz 2012
Wendy Schwartz. "Revisiting the Scene of the Party: A Study of the Lanting Collection". *Journal of the American Oriental Society* 132, no. 2 (2012): 275–300.

Scott 2003
Geoffrey R. Scott. "Cultural Property Laws of Japan: Social, Political, and Legal Influences". *Washington International Law Journal* 12, no. 2 (2003): 316–387.

Sensabaugh 2019
David Ake Sensabaugh. "Wang Hui mogu yu weigu: Yelu Daxue Yishuguan cang *Xuejiang guizhao tu* zuozhe wenti kaobian". Translated by Chen Xuan. *Gugong Bowuyuan yuankan*, no. 5 (2019): 46–65.

Shaanxi Sheng Bowuguan 1974a
Shaanxi Sheng Bowuguan, comp. *Tang Li Xian mu bihua*. Beijing: Wenwu Chubanshe, 1974.

Shaanxi Sheng Bowuguan 1974b
Shaanxi Sheng Bowuguan, comp. *Tang Li Xian and Li Chongrun mu bihua*. Beijing: Wenwu Chubanshe, 1974.

Shan 2004
Shan Guoqiang. "Mozhong youchuang, duchu jizhu: Li Gonglin *Lin Wei Yan mufang tu*". *Zhonghua yichan*, no. 2 (2004): 76–83.

Shanghai Bowuguan 2005
Shanghai Bowuguan, comp. *Shuhua jingdian*. Beijing: Zijin Cheng Chubanshe, 2005.

Shanghai Bowuguan 2018
Shanghai Bowuguan. *Danqing baofa: Dong Qichang shuhua yishu teji*. Shanghai: Shanghai Shuhua Chubanshe, 2018

Shao 2011
Shao Xiaofeng. "Cong jiaju kan *Liu zunzhe xiang* de duandai". *Minzu yishu*, no. 4 (2011): 95–102.

Shen Zhou 1987
Shen Zhou. *Shitian shi xuan*. In *Siku quanshu*, vol. 1249, edited by Ji Yun et al. (Shanghai: Shanghai Guji Chubanshe, 1987).

Shi Su 1986
Shi Su. *Jiatai Kuaiji zhi*. In *Siku quanshu*, vol. 486. Taipei: Taiwan Shangwu Yinshuguan, 1986.

Shi Y. 2019
Shi Yuemei. *Li Zhiyi wenji jianzhu*. Beijing: Zhongguo Shuili Shuidian Chubanshe, 2019.

Shih 1996
Shih Shou-chien. "Youguan Tang Di ji Yuandai Li-Guo fengge fazhan zhi ruogan wenti". *Fengge yu shibian: Zhongguo huihua shilun ji*. Taipei: Yunchen Wenhua Shiye Gufen Youxian Gongsi, 1996: 131–180.

Shih 1998
Shih Shou-chien. "Guchuan Riben zhi Nansong renwu hua de huashi yiyi — jianlun Yuandai de yixie xiangguan wenti". *Meishu shi yanjiu jikan*, no. 5 (1998): 153–182.

Shoichi et al. 1977–1978
Shoichi Uehara et al. *Tempyo no bijutsu*. Tokyo: Gakushu Kenkyusha, 1977–1978.

Shu 1982
Shu Hua. "Wang Xizhi de Yuhou tie". *Gugong Bowuyuan yuankan*, no. 2 (1982): 53–54, 100–101.

Sickman 1962
Laurence Sickman, ed. *Catalogue of the Exhibition of Chinese Calligraphy and Painting in the Collection of John M. Crawford Jr*. New York: Pierpont Morgan Library, 1962.

Song huiyao jigao 2001
Song huiyao jigao. Annotated by Miao Shumei et al. Kaifeng: Henan Daxue Chubanshe, 2001.

Song X. 2018
Song Xuxu. *Li Song hualan tu (sanzhong)*. Shanghai: Shanghai Shuhua Chubanshe, 2018.

Stanley-Baker 1995
Joan Stanley-Baker. *Old Masters Repainted: Wu Zhen (1280–1354), Prime Objects and Accretions*. Hong Kong: Hong Kong University Press, 1995.

Sturman 1997
Peter C. Sturman. *Mi Fu: Style and the Art of Calligraphy in Northern Song China*. New Haven, CT: Yale University Press, 1997.

Sturman 1999
Peter C. Sturman. "Wine and Cursive: The Limits of Individualism in Northern Song Calligraphy". *Character and Context in Chinese Calligraphy*, edited by Cary Y. Liu, Dora C. Y. Ching, and Judith G. Smith (Princeton, NJ: Princeton University Art Museum, 1999): 200–231.

Sturman 2002
Peter C. Sturman. "Sung Loyalist Calligraphy in the Early Years of the Yuan Dynasty". *Gugong xueshu jikan* 19, no. 4 (2002): 59–102.

Su Shi 1919
Su Shi. *Jingjin Dongpo wenji shilue*. Annotated by Lang Ye. *Sibu congkan chubian* edition. Shanghai: Shangwu Yinshuguan, 1919.

Su Shi 1936
Su Shi. *Dongbo quanji*. Shanghai: Zhongyang Shudian, 1936.

Su Shi 2011a
Su Shi. *Su Shi wenji biannian jianzhu (shicifu)*. Annotated by Li Zhiliang. Chengdu: Bashu Shushe, 2011.

Su Shi 2011b
Su Shi. *Su Shi shici xuanzhu*. Annotated by Xu Peijun. Shanghai: Shanghai Yuandong Chubanshe, 2011.

Sun Kuang 1993
Sun Kuang. *Shuhua baba*. In Zhongguo Shuhua Quanshu Bianzuan Weiyuanhui 1993–2000, vol. 3: 921–994.

Sun Zuo 1987
Sun Zuo. *Cangluo ji*. In *Siku quanshu*, vol. 1229, edited by Ji Yun et al. (Shanghai: Shanghai Guji Chubanshe, 1987).

Sung 1991
Hou-mei Sung. "Lin Liang and His Eagle Painting". *Archives of East Asian Art*, vol. 44 (1991): 95–102.

Sung 2009
Hou-mei Sung. "Eagle and Hawk (*Ying*)". *Decoded Messages: The Symbolic Language of Chinese Animal Painting*. New Haven, CT: Yale University Press, 2009: 7–38.

Szeto 2017
Szeto Yuen Kit. "*Shiqu baoji* zhi xiangjiang yizhu". *Mingbao yuekan*, no. 1 (2017): 4–15.

Taibei Gugong Bowuyuan 1989–
Taibei Gugong Bowuyuan, comp. *Gugong shuhua tulu (yi)*. Taipei: Gugong Bowuyuan, 1989–.

Tan et al. 2010
Tan Yiling et al., eds. *Manting fang: Lidai huahui mingpin tezhan*. Taipei: Gugong Bowuyuan, 2010.

Tang Hou 1993
Tang Hou. *Gujin huajian*. In Zhongguo Shuhua Quanshu Bianzuan Weiyuanhui 1993–2000, vol. 2: 894–903.

Tao Zongyi 1959
Tao Zongyi. *Nancun chuogeng lu*. Beijing: Zhonghua Shuju, 1959.

Tao Zongyi 1987
Tao Zongyi. *Shushi huiyao*. In *Siku quanshu*, vol. 814, edited by Ji Yun et al. (Shanghai: Shanghai Guji Chubanshe, 1987).

The State Council of the People's Republic of China 1950
The State Council of the People's Republic of China. "Jinzhi zhengui wenwu tushu chukou zanxing banfa". *Wenwu cankao ziliao 1* (1950): 5–8.

Tian 2017
Tian Miaomiao. 'Deng Wenyuan zhi Baxi wenji yanjiu'. Master's diss., Zhongyang Mingzhu Daxue, 2017.

Tianshui bingshan lu 1966
Tianshui bingshan lu. In *Baibu congshu jicheng*, vol. 29, compiled by Bao Tingbo. *Zhibuzu zhai congshu*, vol. 14. Taipei: Yiwen Yinshuguan, 1966.

Tie and Li 2008
Tie Yuan and Li Guorong, eds. *Qinggong ciqi dang'an quanji*. 52 vols. Beijing: Zhongguo Huabao Chubanshe, 2008.

Tuotuo 1977
Tuotuo. *Song shi*. Beijing: Zhonghua Shuju, 1977.

Wang Ao 1987
Wang Ao. *Gusu zhi*. In *Siku quanshu*, vol. 493, edited by Ji Yun et al. (Shanghai: Shanghai Guji Chubanshe, 1987).

Wang C. 1967
Wang Chi-Ch'ien. "Ni Yunlin zhi hua". *Gugong jikan* 1, no. 3 (1967): 15–47.

Wang D. et al. 1979–1990
Wang Deyi et al. *Yuanren zhuanji ziliao suoyin*. 5 vols. Taipei: Xinwenfeng Chuban Gongsi, 1979–1990.

Wang and Sun 2007
Wang Ganghuai and Sun Kerang, eds. *Tangdai tongjing yu tangshi*. Shanghai: Shanghai Guji Chubanshe, 2007.

Wang H. 2020
Wang Hongbo. "*Wuzhu xiushi tu* kaobian". *Zhongguo meishu*, no. 4 (2020): 84–93.

Wang J. 2014
Wang Jian. 'Song Huizong huazuo jiancang yanjiu'. PhD diss., Zhongyang Meishu Xueyuan, 2014.

Wang J. 2015
Wang Jian. "*Xuejiang guizhao tu* de liuchuan". *Dajiang zhimeng 4*, edited by Wang Mingming. (Nanning: Guangxi Meishu Chubanshe, 2015): 104–115.

Wang Jie et al. 1995
Wang Jie et al. *Qinding shiqu baoji xubian*. In *Xuxiu siku quanshu*, vols. 1069–1074, edited by Xuxiu Siku Quanshu Bianzuan Weiyuanhui (Shanghai: Shanghai Guji Chubanshe, 1995).

Wang Jie et al. 2002
Wang Jie et al. *Qinding shiqu baoji xubian*. In *Xuxiu siku quanshu*, vol. 1071, edited by Xuxiu Siku Quanshu Bianzuan Weiyuanhui (Shanghai: Shanghai Guji Chubanshe, 2002).

Wang Keyu 1643
Wang Keyu. Preface (1643) *Shanhuwang*. In Zhongguo Shuhua Quanshu Bianzuan Weiyuanhui 1993–2000, vol. 5: 714–1240.

Wang L. 1984
Wang Lianqi. "Zhao Mengfu weiqi daibi". *Zijin Cheng*, no. 1 (1984): 42–43.

Wang L. 2006
Wang Lianqi. "Cong Dong Qichang de tiba kan tade shuhua jianding". *Gugong Bowuyuan yuankan*, no. 2 (2006): 6–19.

Wang L. 2011
Wang Lianqi. "*Lanting xu* zhongyao chuanben jianshuo". *Zijin Cheng*, no. 9 (2011): 76–115.

Wang and Gugong Bowuyuan 2017
Wang Lianqi and Gugong Bowuyuan, eds. *Zhao Mengfu shuhua quanji*. Beijing: Gugong Chubanshe, 2017.

Wang P. 2019
Wang Poren. *Yuzhai jiancang ji: Wang Nanping xiansheng shilue*. Hong Kong: Zhonghua Shuju, 2019.

Wang R. 2003
Wang Rutao. "Gu Yongxinsi zhai Shaoxing kao". *Wang Xizhi jiqi jiazu kaolun*. Beijing: Zhongguo Wenshi Chubanshe, 2003.

Wang S. 1948
Wang Shih-hsiang. "Chinese Ink Bamboo Paintings". *Archives of the Chinese Art Society of America*, no. 3 (1948): 49–58.

Wang Shimao 1997
Wang Shimao. *Wang Fengchang ji*. In *Siku quanshu cunmu congshu, jibu* vol. 133, edited by Siku Quanshu Cunmu Congshu Bianzuan Weiyuanhui (Tainan: Zhuangyan Wenhua Shiye Youxian Gongsi, 1997).

Wang Shimin 1994
Wang Shimin. *Wang Fengchang shuhua tiba*. In Zhongguo Shuhua Quanshu Bianzuan Weiyuanhui 1993–2000, vol. 7: 908–936.

Wang Shizhen 1987
Wang Shizhen. *Yanzhou xugao*. In *Siku quanshu*, vol. 1284, edited by Ji Yun et al. (Shanghai: Shanghai Guji Chubanshe, 1987).

Wang Y. 2014
Wang Yao-t'ing. "Chuan Gu Kaizhi *Nushizhen tu* huawai de jige wenti". *Meishushi yanjiu jikan* (September 2014): 1–51.

Wang Yan 1986
Wang Yan. *Shuangxi leigao*. In *Yingyin Wenyuange siku quanshu*, vol. 1155, edited by Ji Yun et al. (Taipei: Taiwan Shangwu Yinshuguan, 1986).

Wang Z. 2019a
Wang Zhongxu. "Hewei huamu hua? Tang Song Yuan shiqi huamu hua zhi duli yu xingsheng". *Wanzi qianhong: Zhongguo gudai huamu ticai wenwu tezhan*, edited by Gugong Bowuyuan (Beijing: Gugong Chubanshe, 2019): 14–24.

Wang Z. 2019b
Wang Zhongxu. "Yuxing jiqing yuhua chuanshen — Tang Song Yuan huamu hua gaishu". *Zijin Cheng*, no. 9 (2019): 32–53.

Watt 1989
James Watt. Preface to *Selected Ceramics from the Collection of Mr. and Mrs. J. M. Hu*, edited by Wang Qingzheng and George Fan (Shanghai: Shanghai Museum, 1989): 9.

Wei 1988
Wei Jia. "Tan Qing Li Yin *Panche tu zhou*". *Gugong Bowuyuan yuankan*, no. 4 (1988): 64–65.

Wen Jia 1966
Wen Jia. *Qianshan tang shuhua ji*. In *Baibu congshu jicheng*, vol. 29, compiled by Bao Tingbo. *Zhibuzu zhai congshu*, vol. 14. Taipei: Yiwen Yinshuguan, 1966.

Weng Fenggang 1916
Weng Fenggang. *Fuchuzhai wenji*. 10 vols. Annotated by Li Yanzhang. Shanghai: Tongwen Tushuguan, 1916.

Weng T. 1977
Weng Tongwen. "Wang Meng zhifu Wang Guoqi kao". *Yilin congkao*. Taipei: Lianjing, 1977: 145–154.

Whitaker 1954
Katherine P. K. Whitaker. "The Nymph of the Luo River". *Asia Major*, n.s., 4, pt. 1 (1954): 36–56.

Whitfield 2011
Roderick Whitfield. "A Tale of Two Scrolls: The *Luo Nymph Rhapsody* in Peking and London". *Bridges to Heaven: Essays on East Asian Art in Honor of Professor Wen C. Fong*, edited by Jerome Silbergeld et al. (Princeton, NJ: Princeton University Press, 2011): 453–478.

Wong 1981
Marilyn Wong. "The Impact of the Reunification: Northern Elements in the Life and Art of Hsien-yu Shu (1257?–1302) and Their Relation to Early Yuan Literati Culture". *China under Mongol Rule*, edited by John D. Langlois Jr. (Princeton, NJ: Princeton University Press, 1981): 371–433.

Wong 1983
Marilyn Wong. 'Hsien-Yu Shu's Calligraphy and his "Admonitions" scroll of 1299'. PhD diss., Princeton University, 1983.

Wu Qizhen 1962
Wu Qizhen. *Shuhua ji*. Shanghai: Shanghai Renmin Meishu Chubanshe, 1962.

Wu Qizhen 1994
Wu Qizhen. *Shuhua ji*. In Zhongguo Shuhua Quanshu Bianzuan Weiyuanhui 1993–2000, vol. 8: 1–123.

Wu Rongguang 1971
Wu Rongguang. *Xinchou xiaoxia ji*. In *Yishu shangjian xuanzhen*, ser. 2. Taipei: Hanhua Wenhua Shiye Gufen Youxian Gongsi, 1971.

Wu Sheng 1970
Wu Sheng. *Yishu shangjian xuanzhen*, ser. 1. Taipei: Hanhua Wenhua Shiye Gufen Youxian Gongsi, 1970.

Wu Sheng 1994
Wu Sheng. *Daguan lu*. In Zhongguo Shuhua Quanshu Bianzuan Weiyuanhui 1993–2000, vol. 8: 124–582.

Wu Sheng 1995
Wu Sheng. *Daguan lu. Xuxiu siku quanshu*, vol. 1066, edited by Xuxiu Siku Quanshu Bianzuan Weiyuanhui. Shanghai: Shanghai Guji Chubanshe, 1995.

Wu Sheng 2001
Wu Sheng. *Daguan lu*. In *Guojia Tushuguan guji wenxian congkan*, edited by Chen Zhanqi (Beijing: Quanguo Tushuguan Wenxian Suowei Fuzhi Zhongxin, 2001): 493–534.

Wu T. 1997
Wu Tung. *Tales from the Land of Dragons: 1,000 Years of Chinese Painting*. Boston: Museum of Fine Arts, 1997.

Wu Xiu 2008
Wu Xiu. *Xu yinian lu. Guangzhou dadian*, vol. 45, edited by Guangzhou Dadian Bianzuan Weiyuanhui (Guangzhou: Guangzhou Chubanshe, 2008).

Wu Y. 2005
Wu Ying. *Gugong chenmeng lu*. Beijing: Zijin Cheng, 2005.

Wu Zhen 1966
Wu Zhen. *Wen Huzhou zhupu*. In *Baibu congshu jicheng* 24, vol. 14. Taipei: Yiwen Yinshuguan, 1966.

Wu Zimu 1980
Wu Zimu. *Mengliang lu*. Hangzhou: Zhejiang Renmin Chubanshe, 1980.

Xia Wenyan 1914
Xia Wenyan. *Tuhui baojian. Chenhanlou cangshu* edition, 1914.

Xia Wenyan 1963
Xia Wenyan. *Tuhui baojian*. In Yu A. 1963, vol. 2.

Xia Wenyan 1993
Xia Wenyan. *Tuhui baojian*. In Zhongguo Shuhua Quanshu Bianzuan Weiyuanhui 1993–2000, vol. 2: 847–893.

Xiang 2017
Xiang Yuting. 'Songhua zhong de cheyu yanjiu'. Master's diss., Zhejiang Daxue, 2017.

Xiangcheng 2011
Xiangcheng Shizhengxie, ed. *Zhang Boju xiansheng zhuisi ji*. Beijing: Zijin Cheng Chubanshe, 2011.

Xiao 1985
Xiao Yanyi. "Deng Wenyuan lin *Jijiuzhang*". *Zijin Cheng*, no. 1 (1985): 22–25.

Xiao 2007
Xiao Yanyi. "'The Pride of China' and the Shiqu Catalogue". *The Pride of China: Masterpieces of Chinese Painting and Calligraphy of the Jin, Tang, Song and Yuan Dynasties from the Palace Museum*. Hong Kong: Leisure and Cultural Services Department, 2007: 31–35.

Xie C. 1986
Xie Chenglin. "Huang Gongwang shengping shiji kao". *Meishu yanjiu*, no. 3 (1986): 70–71.

Xie Z. 1996
Xie Zhiliu. "Wudai Ruan Gao *Langyuan nüxian tu*". *Jianyu zagao*. Shanghai: Renmin Meishu Chubanshe, 1996: 82–87.

Xu B. 1954
Xu Bangda. "Cong Huihuaguan chenliepin kan woguo huihua de fazhan shi." *Wenwu cankao ziliao* (1954): 41–46.

Xu B. 1979
Xu Bangda. "Song Huizong Zhao Ji qinbi hua yu daibi hua de kaobian". *Gugong Bowuyuan yuankan*, no. 1 (1979): 62–67.

Xu B. 1980
Xu Bangda. "Santan gu shuhua jianbie: shuhua suoyong zhi, juan, ling". *Gugong Bowuyuan yuankan*, no. 1 (1980): 57–86.

Xu B. 1981
Xu Bangda. "Wutan gu shuhua jianbie — dui zuowei de fangshi, fangfa de jianding". *Gugong Bowuyuan yuankan*, no. 2 (1981): 56–68.

Xu B. 1984
Xu Bangda. *Gu shuhua wei'e kaobian*. 4 vols. Nanjing: Jiangsu Guji Chubanshe, 1984.

Xu B. 1985
Xu Bangda, "Chuan Song Gaozong Zhao Gao Xiaozong Zhao Shen shu Ma Hezhi hua Maoshi juan kaobian". *Gugong Bowuyuan yuankan*, no. 3 (1985): 69–78.

Xu B. 1995a
Xu Bangda. "Lin Huang Xiang *Jijiupian* cejuan de kaozheng". *Zhao Mengfu yanjiu lunwen ji*, edited by Li Weikun and Shao Feng (Shanghai: Shanghai Shuhua Chubanshe, 1995): 126–128.

Xu B. 1995b
Xu Bangda. "Zhao Gou shu Ma Hezhi hua *Maoshi* xinkao". *Gugong Bowuyuan yuankan, jianyuan qishi zhounian jinian tekan* (1995): 11–24.

Xu B. 2005
Xu Bangda. *Gushuhua guoyan yaolu:
Jin Sui Tang Wudai Song shufa (er)*.
Xu Bangda ji. 2 vols. Edited by Gugong
Bowuyuan (Beijing: Zijin Cheng
Chubanshe, 2005).

Xu B. 2015a
Xu Bangda. *Gushuhua guoyan yaolu:
Yuan Ming Qing huihua. Xu Bangda ji*,
vol. 9, edited by Gugong Bowuyuan
(Beijing: Gugong Chubanshe, 2015).

Xu B. 2015b
Xu Bangda. *Gushuhua wei'e kaobian*.
In *Xu Bangda ji*, vols. 10–13, edited by
Gugong Bowuyuan (Beijing: Gugong
Chubanshe, 2015).

Xu et al. 2001
Xu Jijun et al. *Zhongguo fengsu tongshi
(Songdai juan)*. Shanghai: Shanghai Yiwen
Chubanshe, 2001.

Xu J. 1997
Xu Juan, ed. *Zhongguo lidai shuhua yishu
lunzhu congbian*. Beijing: Zhongguo
Dabaike Quanshu Chubanshe, 1997.

Xu Shen 1977
Xu Shen. *Shuowen jiezi*. Beijing: Zhonghua
Shuju, 1977.

Xu W. 2013
Xu Wanling. "Bowuguan yu guojia rentong
zhi jiangou — yi Gugong Bowuyuan
kaiyuan wei zhongxin". *Gugong xuekan*
no. 2 (2013): 396–413.

Xu Y. 2013
Xu Yuanchong. *Xu Yuanchong jing-
dian yingyi shige 1000 shou: Su Shi
shici, hanying duizhao*. Beijing: Haitun
Chubanshe, 2013.

Xuanhe huapu 1963
Xuanhe huapu. In Yu A. 1963, vol. 2.

Xuanhe huapu 1982
Xuanhe huapu. Edited by Pan Yungao.
Changsha: Hunan Renmin Meishu
Chubanshe, 1982.

Xuanhe huapu 1993
Xuanhe huapu. In Zhongguo Shuhua
Quanshu Bianzuan Weiyuanhui 1993–
2000, vol. 2: 60–131.

Xuanhe shupu 1993
Xuanhe shupu. In Zhongguo Shuhua
Quanshu Bianzuan Weiyuanhui 1993–
2000, vol. 2: 4–59

Xue 2019
Xue Lei. *Eulogy on Burying a Crane and
the Art of Chinese Calligraphy*. Seattle:
University of Washington Press, 2019.

Xue 2021
Xue Lei. "Xie An *Bayue wuri tie* yuanliu
kao". *Gugong Bowuyuan yuankan*, no. 3
(2022): 61–72.

Yang C. 1982
Yang Chenbin. "Zhao Mengfu *Qiujiao
yinma tu*". *Wenshi zhishi*, no. 11 (1982):
110–111.

Yang C. 1990
Yang Chenbin. "Wang Meng". In *Zhongguo
dabaike quanshu: meishu juan*, edited
by Zhongguo Dabaike Quanshu Bianji
Weiyuanhui (Beijing: Zhongguo Dabaike
Quanshu Chubanshe, 1990): 835.

Yang C. 2002
Yang Chenbin. "Mi Fu de *Yanshan ming*".
Mi Fu Yanshan ming yanjiu, edited by Yi
Suhao (Beijing: Changcheng Chubanshe,
2002): 78–80.

Yang D. 2006
Yang Danxia. "Li Zhaoheng, Shi Chang-
ying shuhua bianxi". *Gugong xuekan*, no. 3
(2006): 315–347.

Yang R. 1991
Yang Renkai. *Guobao chenfu lu: Gugong
sanyi shuhua jianwen kaolue*. Shenyang:
Liaohai Chubanshe, 1991.

Yang R. 2001
Yang Renkai. *Zhongguo shuhua*. Shanghai:
Shanghai Guji Chubanshe, 2001.

Yang R. 2007
Yang Renkai. *Guobao chenfu lu: Gugong
sanyi shuhua jianwen kaolue*. Shanghai:
Shanghai Guji Chubanshe, 2007.

Yang R. 2008
Yang Renkai. *Guobao chenfu lu*.
Shanghai: Shanghai Renmin Meishu
Chubanshe, 2008.

Yang R. 2015
Yang Renkai. *Zhongguo shuhua jianding
xuegao*. Shenyang: Liaoning Renmin
Chubanshe, 2015.

Ye 2017
Ye Kangning. *Fengya zhihao — Mingdai
Wanli nianjian de shuhua xiaofei*. Beijing:
Shangwu Yinshuguan, 2017.

Yin 2005
Yin Ji'nan. "'Dong Yuan' gainian de lishi
shengcheng". *Wenyi yanjiu*, no. 2 (2005):
92–101.

Yonezawa 1975
Yonezawa Yoshiho. *Suiboku bijutsu taikei I:
hakubyō kara suibokuga e no hatten*. Tokyo:
Kodansha, 1975.

Yu A. 1963
Yu Anlan, ed. *Huashi congshu*. 5 vols.
Shanghai: Shanghai Renmin Meishu
Chubanshe, 1963.

Yu A. 2015
Yu Anlan, ed. *Hualun congkan*. Kaifeng:
Henan Daxue Chubanshe, 2015.

Yu F. 1993
Yu Fengqing. *Yushi shuhua tiba ji — Xu Shuhua tiba ji*. In Zhongguo Shuhua Quanshu Bianzuan Weiyuanhui 1993–2000, vol. 4: 580–764.

Yu H. 1993
Yu Hui. "Songdai panche ticai hua yanjiu". *Nanjing Yishu Xueyuan xuebao (meishu yu sheji ban)*, no. 3 (1993): 7–11.

Yu H. 1995
Yu Hui. "Wu Zhen shixi yu Wu Zhen qi ren qi hua — ye tan *Yimen Wushi pu*". *Gugong Bowuyuan yuankan*, no. 4 (1995): 51–67.

Yu H. 2005
Yu Hui, ed. *Gugong Bowuyuan cang wenwu zhenpin daxi* (Shanghai: Shanghai Kexue Jishu Chubanshe, 2005).

Yu H. 2014
Yu Hui. *Gugong canghua de gushi*. Beijing: Zijin Cheng Chubanshe, 2014.

Yu H. 2018
Yu Hui. *Huali jiangshan yousheng: bainian yishu jiazu zhi Zhaosong jiazu*. Hangzhou: Zhongguo Meishu Xueyuan, 2018.

Yu and Li 2014
Yu Hui and Li Shi. *Gugong jingdian: Gugong huihua tudian*. Beijing: Gugong Chubanshe, 2014.

Yu Ji 1987
Yu Ji. *Daoyuan xuegu lu*. In *Siku quanshu*, vol. 1207, edited by Ji Yun et al. (Shanghai: Shanghai Guji Chubanshe, 1987).

Yu Ji 2007
Yu Ji. *Yu Ji quanji*. Annotated by Wang Ting. Tianjin: Tianjin Guji Chubanshe, 2007.

Yu J. 1981
Yu Jianhua. *Zhongguo meishujia renming cidian*. Shanghai: Shanghai Renmin Meishu Chubanshe, 1981.

Yu J. 1998
Yu Jianhua. *Zhongguo meishujia renming cidian*. Shanghai: Shanghai Renmin Meishu Chubanshe, 1998.

Yuan Haowen 2004
Yuan Haowen. *Yuan Haowen quanji*, edited by Yao Dianzhong and enlarged by Li Zhengmin (Taiyuan: Shanxi Guji Chubanshe, 2004).

Zeng Hongfu 1985
Zeng Hongfu. *Shike puxu*. In *Congshu jicheng xinbian*, vol. 51. Taipei: Taiwan Xinwenfeng Chuban Gongsi, 1985.

Zhang B. 1998
Zhang Boju. *Chunyou jimeng*. Shenyang: Liaoning Jiaoyu Chubanshe, 1998.

Zhang Bangji 2002
Zhang Bangji. *Mozhuang manlu*. Annotated by Kong Fanli. Beijing: Zhonghua Shuju, 2002.

Zhang Chou 1616
Zhang Chou. Preface (1616) to *Qinghe shuhua fang*. Reprint of 1888 edition. Taipei: Xuehai Chubanshe, 1975.

Zhang Chou 1993
Zhang Chou. *Qinghe shuhua fang*. In Zhongguo Shuhua Quanshu Bianzuan Weiyuanhui 1993–2000: 4: 127–384.

Zhang Chou 2011
Zhang Chou. *Qinghe shuhuafang*. Annotated by Xu Deming. Shanghai: Shanghai Guji Chubanshe, 2011.

Zhang D. 2011
Zhang Duoqiang. '*Sanxi tang fatie* yanjiu'. PhD diss., Jilin Daxue, 2011.

Zhang H. 1954
Zhang Heng. "Gudai huihua de eyun yu xingyun". *Wenwu cankao ziliao* (1954): 47–49.

Zhang H. 1964
Zhang Heng. "Zenyang jianding shuhua". *Wenwu*, no. 3 (1964): 3–22.

Zhang H. 2015
Zhang Heng. *Muyanzhai shuhua jianshang biji*. 4 vols. Shanghai: Shanghai Shuhua Chubanshe, 2015.

Zhang H. 2015a
Hongxing Zhang. *Masterpieces of Chinese Painting 700–1900*. London: Victoria and Albert Museum, 2013.

Zhang and Bai 2014
Zhang Hui and Bai Qianshen. "Qingchu fuzi shoucangjia Zhang Ruoqi he Zhang Yingjia". *Xin meishu* no. 8 (2014): 37–48.

Zhang X. 2013
Zhang Xiaozhuang. *Qingdai biji riji huihua shiliao huibian*. Beijing: Rongbao Zhai, 2013.

Zhang Yanyuan 1993
Zhang Yanyuan. *Fashu yaolu*. In Zhongguo Shuhua Quanshu Bianzuan Weiyuanhui 1993–2000, vol. 1: 30–118.

Zhang Yanyuan 1998
Zhang Yanyuan. *Lidai minghua ji*. In Zhongguo Shuhua Quanshu Bianzuan Weiyuanhui 1993–2000, vol. 1: 119–158.

Zhang Yingwen 1871
Zhang Yingwen. "Xu suoxu suojian". *Qingmi cang*. In *Qing Tongzhi shinian cangxiu shuwu keben*. China, 1871.

Zhang Zhao et al. 1987
Zhang Zhao et al. *Shiqu baoji*. In *Siku quanshu*, vol. 825, edited by Ji Yun et al. (Shanghai: Shanghai Guji Chubanshe, 1987).

Zhang Zhao et al. 1988
Zhang Zhao et al. *Midian zhulin Shiqu baoji hebian*. Shanghai: Shanghai Shudian, 1988.

Zhang Zhao and Liang Shizheng 1991
Zhang Zhao and Liang Shizheng. *Shiqu baoji*. Shanghai: Shanghai Guji Chubanshe, 1991.

Zhang Z. 2015
Zhang Zhen. "Han Huang *Wuniu tu* jinru Qinggong yu Chun'ou zhai mingming". *Zijin Cheng*, no. 9 (2015): 86–91.

Zhao Erxun 1986
Zhao Erxun, ed. "Gaozong Chunhuangdi Shilu". *Qing shilu*, vol. 21. Beijing: Zhonghua Shuju, 1986: 411–431.

Zhao Mengfu 1970
Zhao Mengfu. *Songxue zhai wenji*. Taipei: Xuesheng Shuju, 1970.

Zhao Xihu 1849
Zhao Xihu. *Dongtian qinglu*. In *Haishan Xianguan congshu*, vol. 45, edited by Pan Shicheng (China, 1849).

Zhejiang Daxue 2010
Zhejiang Daxue Zhongguo Gudai Shuhua Yanjiu Zhongxin. *Songhua quanji*. Zhejiang: Zhejiang Daxue Chubanshe, 2010.

Zheng G. 2002
Zheng Gong. "Songdai huajia Huichong, Chen Rong, Zheng Sixiao shengping ji zuopin kaoding". *Wenhua de jiexian: Fujian minsu yu Fujian meishu yanjiu*. Fuzhou: Haichao Sheying Yishu Chubanshe, 2002: 264–276.

Zheng L. 1993
Zheng Lihua. *Wang Shizhen nianpu*. Shanghai: Fudan Daxue Chubanshe, 1993.

Zheng Q. 1979
Zheng Qian. "Jindai huajia Wu Yuanzhi jiqi *Chibi tu*". *Shumu jikan* 13, no. 3 (1979): 3–12.

Zheng S. 2005
Zheng Shanshan. "Dianpei, quebu liuli: Guobao xiqian". *Zijin Cheng* 123 (2005): 68–76.

Zheng W. 1978
Zheng Wei. "*Zhakou panche tu juan*". *Yiyuan duoying*, no. 2 (1978): 18–19; 24–25.

Zheng X. 2007
Zheng Xinmiao. Foreword to *The Pride of China: Masterpieces of Chinese Painting and Calligraphy of the Jin, Tang, Song and Yuan Dynasties from the Palace Museum*, edited by Hong Kong Museum of Art (Hong Kong: Leisure and Cultural Services Department, 2007): 15–18.

Zheng X. 2015
Zheng Xinmiao. "Gugong Bowuyuan xueshushi de yitiao xiansuo: yi Minguo shiqi Zhuanmen Weiyuanhui wei zhongxin de kaocha". *Gugong Bowuyuan yuankan*, vol. 180 (2015): 20–40.

Zheng X. 2018
Zheng Xinmiao. "Zheng Zhenduo yu Gugong Bowuyuan". *Zijin Cheng* 286, no. 11 (2018): 15–33.

Zheng Z. 1998a
Zheng Zhenduo. "Diwei de wenwu nali qule". In Zheng Z. 1998d: 26–31.

Zheng Z. 1998b
Zheng Zhenduo. "Guanyu jianding Puyi suodao shuhua de qingkuang baogao". In Zheng Z. 1998d: 202.

Zheng Z. 1998c
Zheng Zhenduo. "Guanyu shougou gu shuhua shi dai Wenhuabu nigao". In Zheng Z. 1998d: 205–206.

Zheng Z. 1998d
Zheng Zhenduo. *Zheng Zhenduo wenbo wenji*, edited by Ma Zishu (Beijing: Wenwu Chubanshe, 1998).

Zheng Z. 1998e
Zheng Zhenduo. "Zhi Liu Zhemin". In Zheng Z. 1998d: 496–505.

Zheng Z. 2005
Zheng Zhenduo. *Zuihou shinian (1949–1958)*. Zhengzhou: Daxiang Chubanshe, 2005.

Zhongguo Dabaike Quanshu Bianji Weiyuanhui 1993
Zhongguo Dabaike Quanshu Bianji Weiyuanhui. *Zhongguo dabaike quanshu: wenwu bowuguan juan*. Beijing: Zhongguo Dabaike Quanshu Chubanshe, 1993.

Zhongguo Diyi Lishi Dang'anguan 2005
Zhongguo Diyi Lishi Dang'anguan and Xianggang Zhongwen Daxue Wenwuguan, comp. *Qinggong Neiwufu Zaobanchu dang'an zonghui*. 55 vols. Beijing: Renmin Chubanshe, 2005.

Zhongguo Gudai Shuhua Jiandingzu 1987–2000
Zhongguo Gudai Shuhua Jiandingzu, comp. *Zhongguo gudai shuhua tumu*. 23 vols. Beijing: Wenwu Chubanshe, 1987–2000.

Zhongguo Gudai Shuhua Jiandingzu 1999
Zhongguo Gudai Shuhua Jiandingzu, ed. *Zhongguo huihua quanji*, vol. 8. Beijing: Wenwu Chubanshe, 1999.

Zhongguo Shuhua Quanshu Bianzuan
Weiyuanhui 1993–2000
Zhongguo Shuhua Quanshu Bianzuan
Weiyuanhui, comp. *Zhongguo shuhua
quanshu*. 14 vols. Shanghai: Shanghai
Shuhua Chubanshe, 1993–2000.

Zhou G. 2017
Zhou Gongxin. "Yigu guanjin: kan
nüxing juese de banyan: Yuandai cainü
Guan Daosheng de hunyin shenghuo".
Gugong wenwu yuekan, no. 2 (2017):
37–47.

Zhou Mi 1987
Zhou Mi. *Guixin zashi*. In *Siku quanshu*,
vol. 1040, edited by Ji Yun et al. (Shanghai:
Shanghai Guji Chubanshe, 1987).

Zhou Nanlao 1970
Zhou Nanlao. "Yuan Chushi Yunlin xian-
sheng muzhiming". *Qingbi ge quanji*,
edited by Cao Peilian (Taipei: Zhongyang
Tushuguan, 1970): 489–494.

Zhou Zizhi 1986
Zhou Zizhi. *Taicang timi ji*. In *Yingyin
Wenyuange siku quanshu*, vol. 1141, edited
by Ji Yun et al. (Taipei: Taiwan Shangwu
Yinshuguan, 1986).

Zhu Bian 2002
Zhu Bian. *Quwei jiuwen*. Annotated by
Kong Fanli. Beijing: Zhonghua Shuju,
2002.

Zhu Hongwen et al. 2016
Zhu Hongwen et al. *Gugong Bowuyuan
zaoqi yuanshi*. Beijing: Gugong
Chubanshe, 2016.

Zhu Jingxuan 1993
Zhu Jingxuan. *Tangchao minghua lu*. In
Zhongguo Shuhua Quanshu Bianzuan
Weiyuanhui 1993–2000, vol. 1: 161–169.

Zhu Mouyin 1997
Zhu Mouyin. *Shushi huiyao*. In Xu J. 1997,
vol. 1: 557–740.

Zhu S. 2011
Zhu Saihong. "Gugong Bowuyuan chuban
shiye de shoudu huihuang – Minguo
shiqu chuban zonglun". *Gugong Bowuyuan
yuankan*, no. 1 (2011): 124–148, 161.

Zhu Yizun 1936
Zhu Yizun. *Baoshuting ji*. Shanghai:
Shangwu Yinshuguan, 1936.

Zhuang 2006
Zhuang Yan. *Qiansheng zaoding
Gugong yuan*. Beijing: Zijin Cheng
Chubanshe, 2006.

Zong 1987
Zong Baihua. *Yijing*. Beijing: Beijing
Daxue Chubanshe, 1987.

Index